The Great Italian Painters

From the Gothic to the Renaissance

DUCCIO, GIOTTO, SIMONE MARTINI
PIETRO AND AMBROGIO LORENZETTI
MASACCIO, FRA ANGELICO
FILIPPO LIPPI, BENOZZO GOZZOLI

SCALA

© 2003 SCALA Group S.p.A.
Antella, Florence
All rights reserved

Photographs: SCALA PICTURE LIBRARY, except p. 23 a (Bern, Kunstmuseum);
pp. 26, 36, 47, 48, 158 c, 385, 401, 511, 514, 567 a, (London, National Gallery);
pp. 37, 44 a, 482, 483, 528, 529, 601 a, 639 b (Washington, National Gallery of Art);
p. 43 (New York, Frick Collection); p. 46 (Madrid, Thyssen-Bornemisza Collection);
p. 49 (Fort Worth, Kimbell Art Museum); p. 79 a (Budapest, Szépmüveszéti Muzeum);
pp. 146, 242, 327, 387, 388, 389, 398, 399 a, 512, 513 (Berlin, Gemäldegalerie);
p. 213 (Cambridge, Fitzwilliam Museum); p. 214 (Cologne, Wallraf-Richartz Museum);
pp. 219 b, 220 (New York, Art Resource); pp. 237, 259 b (Paris, Giraudon); pp. 240,
241 (Antwerp, Musée Royal des Beaux-Arts); p. 243 (Liverpool, Walker Art Gallery);
p. 333 (Boston, Isabella Stewart Gardner Museum); p. 391 (Malibu, Paul Getty
Museum); p. 392 (Altenburg, Lindenau Museum); p. 413 (Gauting-bei-München, Kunst-
Dias Blauel); p. 432 (Paris, Réunion des musées nationaux); pp. 516, 521, 624 b
(New York, Metropolitan Museum of Art); pp. 531, 555 (Munich, Alte Pinakothek);
p. 582 a (Vienna, Kunsthistorisches Museum); p. 600 d (Philadelphia, Museum of Art,
The John G. Johnson Collection); 601 b (London, Hampton Court, The Royal
Collection); p. 602 (Detroit, Institute of Arts); p. 617 (Bergamo, Accademia Carrara);
p. 624 a (Ottawa, National Gallery of Art); p. 626 (Cassa di Risparmio di Pisa S.p.A.)

The images from the SCALA PICTURE LIBRARY reproducing cultural assets that
belong to the Italian State are published with the permission of the Ministry for Cultural
Heritage and Activities

Produced by SCALA Group
Printed by: Lito Terrazzi, Cascine del Riccio (Florence), 2003

This volume is a digital version of the SCALA series "The Great Masters of Art"

CONTENTS

DUCCIO

An Outline of the Life and Works of Duccio

Considering the general scarcity of documents regarding the lives of Italian medieval painters, information concerning Duccio di Buoninsegna is unusually plentiful. This allows us not only to trace the more important stages of his artistic career but also reveals the restless temperament underlying the elegant dignity of his style. During the course of his lively existence the artist incurred a number of fines and debts on the basis of which we can make a fairly accurate estimation of his character and, although not occurring within a strictly professional context, these show him to be rebellious to any form of authority. The first of the frequent fines inflicted on him by the Commune of Siena was in 1280: the nature of the offence is not recorded but the hefty sum of one hundred lire suggests that it must have been serious. Encouraged and protected perhaps by his artistic renown, Duccio's hotheadedness frequently led him into trouble. In 1289 he refused to swear allegiance to the commander of the local militia, and in 1302 declined to take part in the war in Maremma, for which he was fined eighteen lire and ten soldi. On 22 December of the same year he was again fined, for an incident apparently connected with the practice of sorcery, since he was taken "before the magistrate for witchcraft in the district of Chamomillia". This accusation cannot have been very serious since he was fined the modest amount of five soldi. We know that in 1292 he owned a house in Camporegio near the Church of Sant'Antonio in Fonte Branda, which may have been the one in which he grew up since in 1229 it appears that a Buoninsegna, usually identified as the artist's father, was actually living in Camporegio. He also owned fields and vineyards in the country and in 1313 was joint owner of a house in the Stalloreggi quarter where he lived and had his workshop. However, the fines for nonpayment of debts, which appear regularly in written sources, confirm a disorganized way of life and difficulties with managing money. Despite continual reprimands from the law-courts, showing his persistence in a disrespectful attitude especially towards public authority, Duccio was able to follow a brilliant career which progressed and reached its peak thanks to the same authorities that penalized him. His defects as a citizen were effectively overshadowed by his creative inspiration which, although still attached to the Byzantine world, was discovering new stylistic solutions that were to become the measuring stick for the most important local artists.

Duccio is first mentioned in 1278: a document of

1. *Maestà (rear)*
The Entry into Jerusalem, detail
Siena, Museo dell'Opera del Duomo

the Commune of Siena records the payment of forty soldi to *Duccio pictori* for painting some of the wooden tablets which covered the account books of the *Biccherna* — the revenue office of the Commune. Duccio's probable date of birth has been calculated from this document. To receive payment in his own name the painter must have already reached the age of majority and therefore have been born about twenty years earlier, between 1255 and 1260. The designation *pictor* confirms not only his attainment of professional independence but also the beginning of an artistic style which was soon to develop the distinct character shown a few years later, in 1285, when Buoninsegna painted the *Rucellai Madonna* for the Church of Santa Maria Novella in Florence. Payments for jobs of the kind mentioned above, all *picturae librorum* of which unfortunately no trace remains, are registered for the years 1279, 1285, 1286, 1287, 1291, 1292, 1294 and 1295. These paintings were to represent only the badge of the administrator in office and it was not until later, halfway through the fourteenth century, that the iconography of the *Biccherna* was to include more elaborate elements with sacred and profane motifs.

We know nothing of Duccio's very early style, but an examination of a series of works attributed to him in the period immediately before the *Rucellai Madon-*

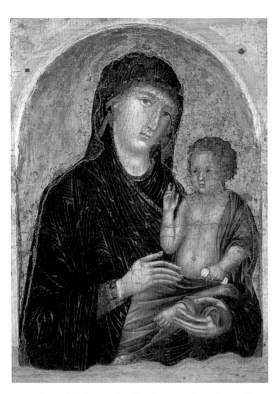

2. *Madonna and Child*
67x48 cm
Buonconvento, Museo d'Arte Sacra della
Val d'Arbia

3. *Crevole Madonna*
89x60 cm
Siena, Museo dell'Opera del Duomo

na — also called the *Laudesi Madonna* — places him among the followers of the great Cimabue. Because of the strong formal affinities between the two painters apparent in these pictures, they have been subject to numerous disputes over authorship. The only ones attributable to his early period — around 1280 — and accepted by most art historians as the work of Duccio are the *Madonna* of Buonconvento and the *Crevole Madonna*.

The theory of Roberto Longhi, formed in 1948 and seconded at various times by other critics, that Duccio stayed in Assisi, appears to be the most plausible explanation for the controversial problem of his formation. From an accurate examination of the style of the early works and of the documents it would seem that between the end of the 1270's and the first half of the 1280's, when no written mention is made of Duccio's presence in Siena, he was part of Cimabue's following at the Upper Church of San Francesco at Assisi, where his hand can be detected in the frescoes in the transepts and the nave. In assuming Cimabue to be the probable link between Duccio and Florence, the Florentine commission of the *Laudesi Madonna* immediately afterwards finds a reasonable justification.

Traces of the period Duccio spent as a pupil of Cimabue can be seen in the round stained-glass window of the choir of Siena Cathedral, executed in 1288, the preparatory drawings of which have been rightly attributed to Duccio by Enzo Carli.

From the mid-thirteenth century Siena broadened its artistic horizons to welcome the innovating spirit of Frederic II and the refined tastes from beyond the Alps, marking a cultural transition towards new stylistic tendencies. Many factors contributed to transforming Siena into one of the most vital centres of artistic experimentation: the presence of the Pisano family, first Nicola then his son Giovanni, of Arnolfo di Cambio, of the goldsmith Guccio di Mannaia, and of enterprising local artists who did not hesitate to go to France to study the Gothic trends *in loco*. In this highly receptive environment the name of Buoninsegna caused increasing comment. In 1295 Duccio is mentioned as the only painter called upon to be a member of a special committee, formed by the masters of the Opera del Duomo, amongst whom was Giovanni Pisano, set up to decide where the new fountain, the Fonte d'Ovile, should be placed. As Ferdinando Bologna asserts: "in those days the various areas of artistic

10

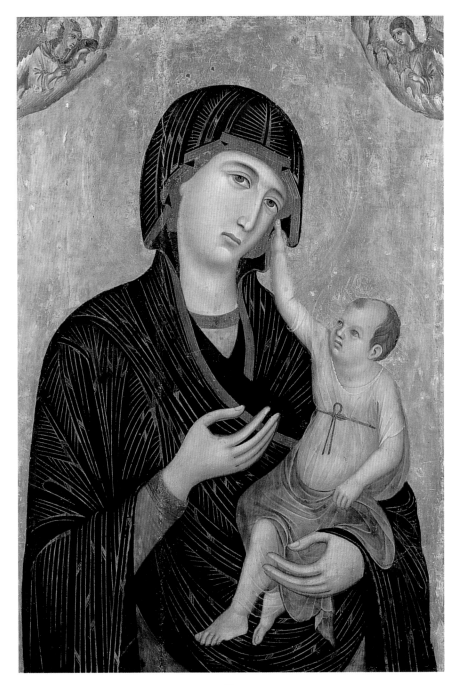

experience involved culture, technical training, operational ability, practical aims, structural and aesthetic requirements, all of equal importance and interchangeable on the level of an essential basic unity". This seems to be the case of Duccio who in undertaking to decorate the covers of the *Biccherne*, to supply the designs for the window in the Cathedral and to execute a work of such monumental importance as the *Maestà*, shows a proficiency which is versatile and skilled in the extreme.

His artistic production between the *Rucellai Madonna* and the *Maestà* for Siena Cathedral, placed on the main altar on 9 June 1311, consists of a group of works of now indisputed attribution: the *Madonna* in the Kunstmuseum in Bern, the *Madonna of the Franciscans* in the Pinacoteca in Siena, the *Madonna and Child* known as the *Stoclet Madonna*, previously in Brussels, the *Madonna and Child with Six Angels* in the National Gallery of Umbria, in Perugia, and the little *Triptych no. 566* in the National Gallery of London. A stylistic analysis reveals a progressive abandonment of the more conservative forms (rigid head and shoulders posture of Eastern tradition and light and shade treatment from Cimabue), giving place to innovating trends in painting: curving outlines, delicate colouring and intimacy of gesture.

The evident Gothicism of the *Maestà*, both in form and arrangement, and the absence of Duccio's name from Sienese records of the last years of the thirteenth century, could be evidence of a possible trip to Paris; however it appears that the *Duch de Siene* or the *Duch le lombart*, mentioned in the *Livre de la Taille* of Paris as resident in Rue des Prêcheurs, in the quarter of Saint-Eustache, was only someone with a similar name (thus the theory advanced by James Stubblebine did not find much support among art historians). A "maestà which he painted and a predella", executed for the Cappella dei Nove in the Palazzo Pubblico and for which on 4 December 1302 forty-eight soldi were paid to "maestro Duccio the painter as his salary", is unfortunately lost. Some critics have attempted to reconstruct it, seeing it as a work of great significance chiefly because of the collaborators involved. Many "workshop productions" follow earlier standards too far removed from the *Maestà* of 1311 and should therefore be connected with this previous work. It was certainly one of the earliest examples of an altarpiece with a predella.

On the eve of the Battle of Montaperti, which was to result in the defeat of the Florentine troops on 4 September 1260, in front of the *Madonna with the Large Eyes* on the main altar of the Cathedral, Siena declared an "act of donation", in which it placed itself publicly under the protection of the Virgin. This gesture of loyalty formally sanctions the beginning of the intense cult of the Virgin which was to reach its peak in the extraordinary *Maestà* painted by Buoninsegna between 1308 and 1311. In its structural complexity, its size and its compositional excellence the painting marks the culminating point in the evolution of the altarpiece while the pictorial achievement conveys the city's intention: Mary, indisputed protagonist, rules over the community of the faithful.

Many theories have been advanced regarding authorship of the works of his last years, but the only painting in which the hand of Duccio can be detected is the *Polyptych no. 47* in the Pinacoteca of Siena.

3 August 1319 represents the *terminus ante quem* in determining when he died. On this date ser Raniero di Bernardo drew up the official deed in which the painter's seven children — Ambrogio, Andrea, Galgano, Tommè, Giorgio, Margherita and Francesco — who with his wife Taviana, outlived him, renounced their paternal inheritance. The document was legally registered on 16 October of the same year. Of the children, Galgano and Ambrogio appear to have taken up an artistic career (although this is not supported by any documentary evidence), as Duccio's nephew, son of his brother Bonaventura, the well-known Segna and father of Niccolò and Francesco, had already done.

It is not possible here to make an exhaustive study of the collaborators in the workshop; however it should be remembered that the new creative impulse carried on after Duccio's death. From the thirteenth-century 'Master of the Badia at Isola', to Ugolino di Nerio, the works of minor artists reveal clear traces of Duccio's style. This is reflected with faithful precision by the 'Master of Città di Castello' and the 'Master of Monte Oliveto', for example, but it also reappears in the more delicate contemplative interpretation of the young Simone Martini and of Pietro Lorenzetti.

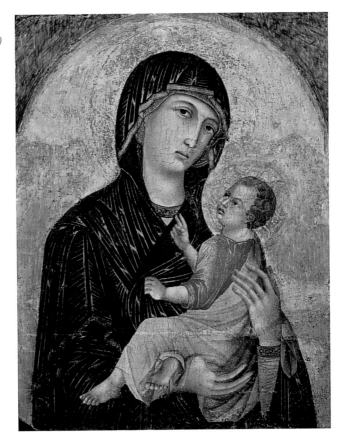

Duccio: "Not merely a Pupil, but practically the Creation of Cimabue"

Roberto Longhi's theory (*Giudizio sul Duecento*) that the style of Duccio was formed by Cimabue at Assisi has, with a few exceptions, been generally accepted and upheld insofar as it sheds light on both the obscure period of the painter's youth and the frequent connections between Florentine and Sienese art. The case of Duccio is an illustration of the cultural exchange between the two cities, which also affected other Sienese artists, evidently the more sensitive and alert, who were orientated towards Florence. The first actual meeting of the ways occured with Coppo di Marcovaldo, who had been taken prisoner after the Battle of Montaperti and in 1261 bought his freedom by painting the *Madonna del Bordone* for the Church of the Servites. A faithful adherence to Cimabue's standards is apparent in miniatures of the choir-book 33-5 in the Opera del Duomo of Siena and of the gradual no. 1 of the Accademia Etrusca in Cortona, in the anonymous author of the *Crucifix* of San Gimignano, the well-known Vigoroso from Siena, and in the Master of the *St Peter Altarpiece* in the Pinacoteca of Siena. In comparison with these, the significance of the almost contemporary work of Duccio stands out for its effortless individual interpretation of the careful-

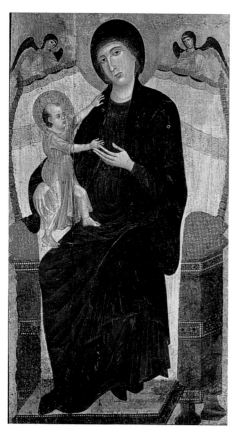

5. Gualino Madonna
157x86 cm
Turin, Galleria Sabauda

6. Cimabue and Duccio
Madonna and Child
68x47 cm
Castelfiorentino, Church of Santa Verdiana

ly studied lesson of the master. On the basis of penetrating observations by Longhi and Carlo Volpi, Ferdinando Bologna has tackled the problem of the formation of Duccio's style more than once, and has clearly outlined the development of the master-pupil relationship. This was established very early on "even earlier than 1278-79", when the first scaffolding for the frescoes had already been erected in the Upper Church of San Francesco, and it ended during the time of closest collaboration, around 1283-84 "when work had got as far as the vault of the Doctors". These are the most likely stages of their association: the *Angel* on the splay of the big window of the north transept in the Upper Church at Assisi, the *Madonna* in the Church of the Servites in Bologna, the *Madonna Gualino* in the Galleria Sabauda in Turin, the *Madonna* of Castelfiorentino, the *Crucifix* in the Odescalchi Collection, the *Madonna* in the Museo d'Arte Sacra of the Val d'Arbia in Buonconvento, the *Crevole Madonna* in the Museo dell'Opera del Duomo in Siena, the *Expulsion of the Forefathers* and the *Crucifixion* in the third bay of the south wall of the Franciscan Basilica, two of the *Winged Genii* which occupy the four corners of the vault of the Doctors in Assisi. Executed in a time-span of little more than five years, the paintings show strong stylistic affinities. In some cases (the *Madonna* in Bologna and the *Madonna* in Castelfiorentino) the painters seem to have achieved a real joint effort: the earlier style of the conception of these paintings suggests that the plan was Cimabue's, while the luminous treatment of colour implies that Duccio executed the work. The very fine *Odescalchi Crucifix* has also been considered the result of team-work and the iconographical motif portraying *Christus triumphans*, suggests an early date. The *Blessing Christ* of a private collection in Lugano has recently been recognized by Bologna as the original top piece of the Crucifix (now missing, together with the boards of the horizontal arms). For its "high quality and poetical tendency" the *Angel* of the large window resembles the *Gualino Madonna*, which is also very similar to the Bologna altarpiece, and together they anticipate the skill Duccio was to show in modifying the traits of his teacher, softening the over-harsh contrasts of line and colour. This is immediately apparent in the *Madonna* of Buonconvento and the *Crevole Madonna*, unanimously considered the earliest works attributable to Duccio. The basic approach of the two paintings is of evident Byzantine tradition: the elegant stylization of the hands, the typical downward curving nose, the red *maphórion* under Mary's veil, the dark drapery animated by shining gilded lines. New details appear, to a lesser extent in the Buonconvento *Madonna* and repeated with greater confidence in the Crevole painting, such as the subtle play of light on the Virgin's face, over her chin and cheeks, and a clear attempt at plasti-

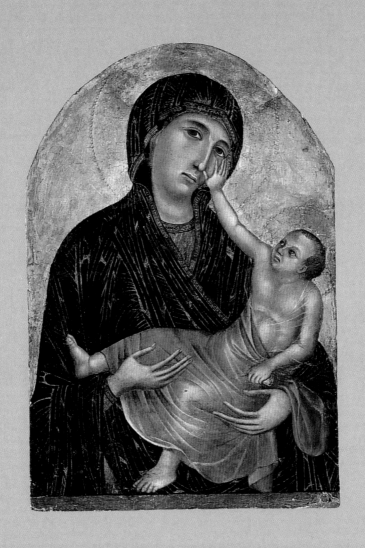

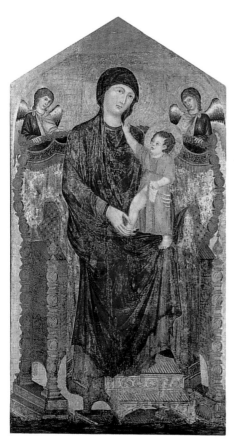

cism in the folds of the garment around the face.

The more carefully considered compositon of the *Crevole Madonna* shows a faint but decided French influence: the elegant forms of the angels in the upper corners, the veiled transparency of the Child's garment, held up by a curious knotted cord, and most of all, the intimate gesture of the Infant Jesus, held in a tender embrace. With regard to the anonymous 'Master of the Badia at Isola' it is worth recording Bologna's comment that in all probability "having been formed by Duccio very early on, he was at the beginning in such close relations with the master as to lend credibility to the opinion that Duccio's hand can be detected in some of his early works". As an example of this, Bologna cites "the very beautiful Madonna no. 593 in the Pinacoteca of Siena whose face is really so close to Duccio's *Crevole Madonna* that it could easily be attributed to him and dated to that period".

The paintings of Buonconvento and Crevole show clear similarities with the Assisi fresco of the *Expulsion of the Forefathers* where, although his characteristic style is perhaps less evident, the same melancholy spirit reigns and the same technique and brushwork are used. Greater formal maturity and feeling for the Gothic style appear in the scene of the *Crucifixion*, executed shortly afterwards. Although in a poor state of preservation, an attempt at greater plasticism is visible, almost a forerunner of the spacious volumes of Giotto, although not fully realized because of the ties still binding the young Duccio to Byzantine art. If, on the one hand, the group of mourning angels, in particular the left one, echoes the typical features of the "Madonnas" examined up till now, on the other, it clearly anticipates the *Rucellai Madonna*. Duccio's presence at Assisi appears to end with his work on the vault of the Doctors, where two corner putti show strong similarities with the Child of the *Madonna* of Castelfiorentino and that of the *Crevole Madonna*, and in comparison reveal Duccio's progress as an artist. But by then, on the eve of 1285, the proof of his artistic maturity was soon to appear in the outstanding Florentine altarpiece.

7. *Cimabue and Duccio*
Maestà (before restoration)
218x118 cm
Bologna, Church of the Servites

8. *Rucellai Madonna*
450x290 cm
Florence, Uffizi

16

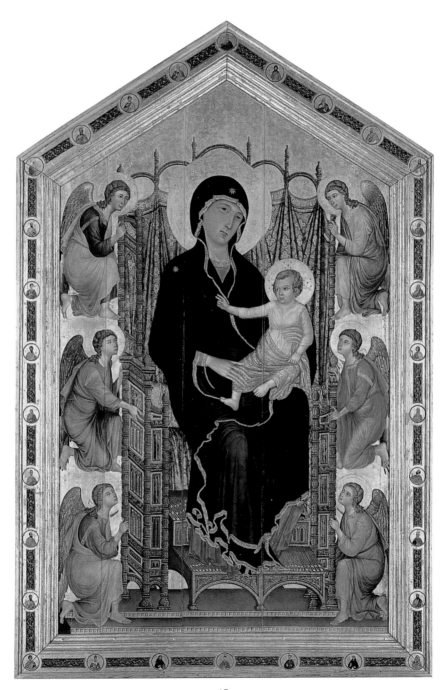

The Rucellai Madonna

The picture's name derives from the Rucellai Chapel of Santa Maria Novella where it remained, after being moved to several different places inside the church, from 1591 to 1937, the year of the Giotto exhibition. It was then transferred to the Uffizi. On 15 April 1285 the Confraternity of the Laudesi of the Church of Santa Maria Novella commissioned *Duccio quondam Boninsegne pictori de Senis* to paint a *tabulam magnam... ad honorem beate et gloriose Virginis Marie.* Although the employment contract was published at the end of the eighteenth century, it was a long time before the document was correctly associated with the *Rucellai Madonna*, which was then assigned to Duccio. The painting has been the subject of much controversy among critics. In the fifteenth century it was thought to be the work of Cimabue, and this attribution, supported by Vasari, was accepted until the beginning of present century. The design of the frame decorated with roundels, the three pairs of angels flanking the throne and the sweeping gesture of the Child's blessing hand, show undeniable similarities to Cimabue's *Maestà*, now in the Louvre but at that time in the Church of San Francesco in Pisa. This may have been the inspiration of Duccio; Giorgio Vasari, in his *Lives* (not always completely reliable), documents a not improbable sojourn in Pisa. Another detail of Florentine origin is the punching on some of the haloes, decorated with relief granulation, an engraving technique not practised in Siena, where incising the surface with a chisel was preferred. The elements from Cimabue are enriched with delicate Gothic overtones, unknown at that time, but which were to become a permanent feature of Sienese art. The brilliance of colour, the curving outlines and the sinuous movement of the gilded edging of Mary's cloak are all new. The entire structure of the throne reflects the influence from beyond the Alps: the panels are slender mullioned windows, the foot-rest is supported by a light double arch, the back is crowned with delicate arching and little pinnacles.

The iconographical interpretation is also new in that the angels holding up the throne no longer form the crowning part of a solemn and magnificent background but are all looking towards the Virgin in attitudes of intense emotional participation. The connection with the 1285 contract is borne out by the painted frame that fulfils a specific iconographical purpose in accordance with the intentions of the Confraternity of the Laudesi. This was founded within the Dominican order, around 1244-45, with the object of fighting heresy by means of an intensive preaching programme. In the medallion placed at the top is the image of Christ. On his left are twelve figures, mostly

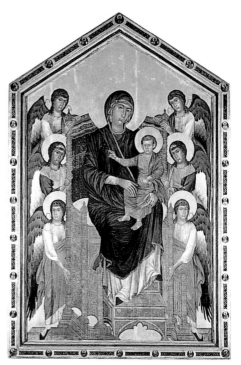

9. Cimabue
Maestà
Paris, Louvre

10. *Rucellai Madonna*, detail
Florence, Uffizi

prophets and patriarchs, among whom are: John the Baptist immediately next to the Redeemer, King David crowned and with the psalms, the young Daniel holding a roll. On the right of the Virgin, the Apostles, to whom the Child is turning to give his blessing, represent the New Testament. Peter and John the Evangelist are the first of the saints, many of whom are complete with books and scrolls that refer to the Gospel and in a more general sense underline the importance of preaching. The roundels in the lower section, more easily visible to the faithful, contain images of the saints to whom the Laudesi and the Dominicans were particularly devoted. In the centre is St Augustine of Hippo, whose rule guided the Dominican

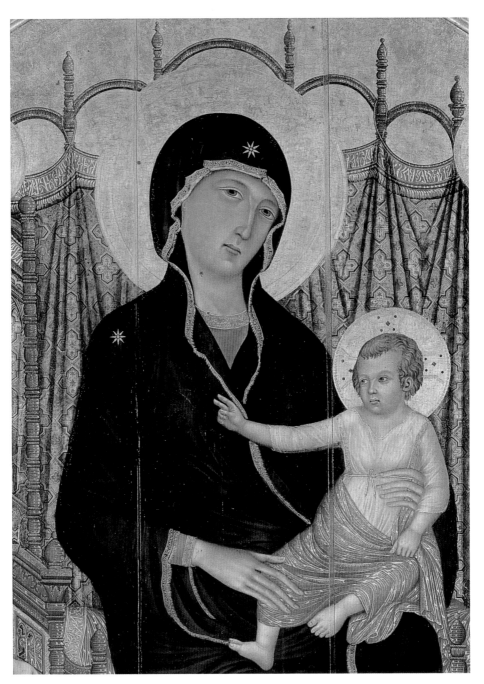

friars. On the left are Catherine of Alexandria and Dominic. On the right is Zenobius, early medieval bishop and patron of the city, accompanied by Peter the Martyr, the then recently canonized founder of the Confraternity. The significance of the frame and the medallions is therefore not solely ornamental but conveys the commissioners' desire for self-proclamation: the Dominican brotherhood was to be visualized as a lay group championing the cult of the Virgin.

From the Rucellai Madonna to the Maestà

The Cathedral Window

Between 1285 and 1308, the year the Sienese *Maestà* was commissioned, documented information exists only on the stained-glass window in Siena Cathedral. The large "oculus" on the wall of the apse is divided into nine compartments, of which five form a cross, while the other four occupy the remaining sectors. On the vertical arm is the story of the Virgin with the *Coronation*, the *Assumption* and the *Burial*. On the horizontal arm, from the left, are the patron saints Bartholomew, Ansano, Crescenzio and Savino. In the corner compartments are the four Evangelists with their names and symbols: in the top left St John and in the top right St Matthew; below are St Luke and St Mark. Nothing is known about the identity of the master glazier who undertook the job. However, on the basis of Carli's thorough research it may be safely asserted that it was Duccio who made the preparatory drawings. In September 1287 the Commune of Siena entrusted the administrator of the Opera del Duomo with the task of arranging for the execution of a stained-glass window for the *fenestra rotunda magna que est post altare Beate Marie Virginis Maioris Ecclesiae*, and undertook to supply the necessary money for expenses. This agreement was evidently not kept because in May of the following year the Commune threatened to fine the camerlengo, or papal treasurer, and the administrators of the *Biccherna* if they did not reimburse the workman with the money for the purchase of the glass. The debt was then paid in two instalments of 100 and 25 lire, to "frate Magio". The presence of St Bartholomew, Siena's ancient patron saint, bears out the early dating since, as the *Maestà* of 1308-11 shows, he was later substituted by St Victor. At that particular moment in history, as Carli has correctly deduced, the only Sienese painter able to perform such an exacting task, and whose artistic ability had already been proved, was Duccio. A stylistic analysis further supports this conclusion. Although the work shows marked traces of Cimabue, apparent in the *Burial* scene and the figures of the Evangelists, it

is exemplary in that it anticipates some typical compositional solutions of the *Maestà*. The angels in the *Coronation of the Virgin*, resting lightly on the back of the throne, and the solid architectural structure of the latter, assay a new conception of space where the rigidity of the contours, although confined within the lead edgings, is softened by subtle upward movements. The angels' wings extending beyond the frame of the *Assumption* break up the geometrical severity both of the mandorla enclosing Mary and of the background decorated with insets, and lend a rhythmic energy which adapts well to the overall proportions. The solid polychrome sarcophagus in the foreground of the *Burial* scene, and the crowded gathering of figures with haloes reveal an austere monumentality to be faithfully echoed later on in the section of the *Maestà* dedicated to the same subject. They also clearly reflect Cimabue's style. But perfect harmony between the window and the *Maestà* was reached in 1311 when the completed altarpiece glowed beneath the rays of the coloured glass, and the iconographical project of the glorification of the Virgin was magnificently realized.

The tiny *Triptych* belonging to the Fogg Museum in America and attributed to Buoninsegna by B. Rowland, appears to date from around 1285-90. The painting is in very poor condition, rendering impossible an exact interpretation and correct attribution. The most recent critics have therefore ascribed it more generally to Duccio's immediate circle. Bologna, in affirming its masterliness, cautiously suggests that Duccio executed the central panel.

11. Stained-glass window
700 cm (diameter)
Siena, Cathedral

20

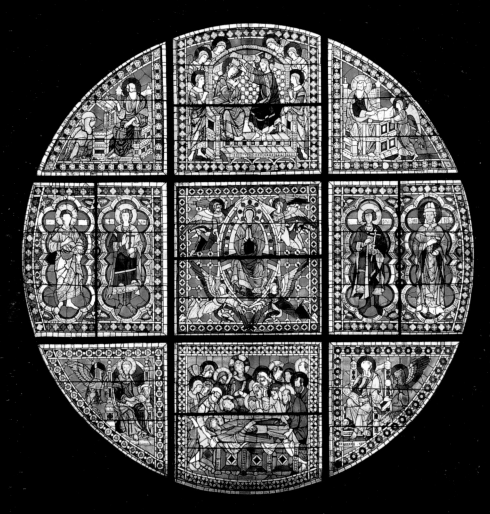

The "Small" Madonnas

When examining the *Madonna* of Bern and the *Madonna of the Franciscans*, Buoninsegna's extraordinary versatility must again be stressed. A feeling of uncertainty must arise when placing these small paintings (respectively 31.5 x 22.5 cm and 23.5 x 16 cm) side by side with works of such impressive grandeur as the *Rucellai Madonna* and the Cathedral window, so different in size and structural organization. However, a careful analysis of the two paintings leaves no room for doubt as to authorship. The self-confident ease Duccio reveals, in a type of pictorial art which has almost become the miniature, leads us to assume that a series of works now unfortunately all lost were of similarly high quality. An examination of the covers of the *Biccherna* account books, decorated by Duccio at various intervals from 1278, would have thrown light on the subject. These little paintings, so close in size to the *Madonnas* in question, would certainly have been a further proof of the skill as a miniaturist which stands out in these last two works.

A feeling of tenderness permeates the radiant *Madonna* of Bern, where the Virgin and Child are portrayed in a loving embrace. The gesture of intimate affection is taken from Byzantine iconography, from the motif of the *Glykophiloùsa*, in which Mary, with a presentiment of the sad future, clasps the Infant Jesus urgently to her breast. A closer reference can be seen in the *Madonna* in Bologna on which Duccio worked as an assistant of Cimabue, but its size and the barely indicated gesture greatly reduce the sense of intimate tenderness. The typology of the throne, decorated with Cosmati-like inlays and already experimented in several variations in the window of the apse, follows the lines of Gothic architecture, while the characteristic curling edge of Mary's dress evens out into a smooth gilt border.

The *Madonna of the Franciscans* shows greater structural articulation, and was probably part of a diptych or triptych intended for private worship, perhaps of a small group of Friars Minor. Iconographically it follows the "Madonna of Mercy" type: while looking towards the spectator the Virgin holds back the edge of her robe the better to receive and protect the three kneeling friars, for whom the Child's blessing is intended. This elaborate intermingling of echoes from Cimabue and Byzantine art, with the added softness of Duccio's personal touch, includes elements of the new artistic language from beyond the Alps. The tiny square panels of the backcloth, an innovation substituting the usual gold ground, are of clear French derivation, similar solutions appearing in the miniatures of the St Louis psalter and of the evangelistary in Sainte-Chapelle. Thus, the measured breadth of

contour, the sinuous curving of the robe's hem and the smooth masses of colour form part of a wider spatial dimension, where the Gothic predilection for linearity and flowing outlines reaches its maximum expression. The features of the supplicating friars and the throne, a simple wooden seat placed obliquely to create an effect of perspective, reflect the teaching of Cimabue. The unusual posture of the Child's legs belongs entirely to Duccio, however, who repeats the gestures of the early *Madonna* of Buonconvento and the *Laudesi Madonna.*

A *Madonna and Child*, better known as the *Stoclet Madonna* (present whereabouts unknown), has been assigned to the last years of the thirteenth century. Because of its size (27 x 21 cm) and the new approach to space, it fits into the art of Duccio well at this particular moment.

12. Maestà
31.5x22.5 cm
Bern, Kunstmuseum

13, 14. Madonna of the Franciscans, and detail
23.5x16 cm
Siena, Pinacoteca

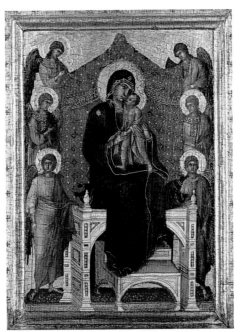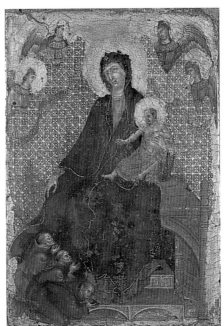

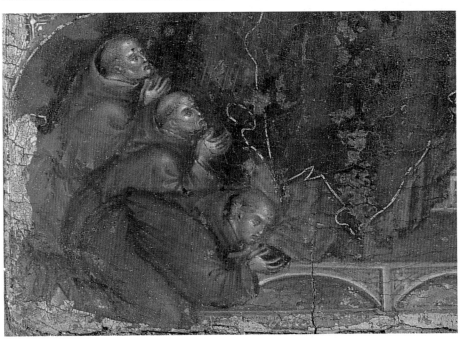

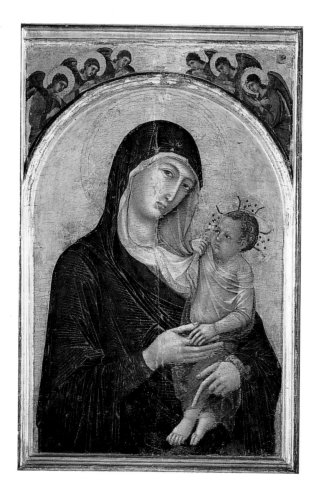

The Perugia Madonna

This painting, now in the local National Gallery, was kept perhaps *ab antiquo* up until 1863 in the monastery of San Domenico in Perugia, hung above the sacresty door or in the "Winter Choir". It was ascribed to Duccio in 1911 by Curt Weigelt and subsequent restoration revealed it to be the central panel of a dismantled polyptych. The formal stylistic elements of the traditional half-length portrait of the Madonna and Child develop into the portrayal of a solid mother and son relationship, showing a greater naturalness of gesture. Remarkable spontaneity is shown in the move-

ment of the Child who is sitting on his mother's curved arm (a position shared by the *Stoclet Madonna*), clutching the soft folds of her veil. This detail in dress is of importance since it takes the place of the red Byzantine *maphórion*, evidently considered old-fashioned by the painter. The Virgin's gesture, showing the Child's hand and pointing to his feet, is also significant: it seems to allude to the future Passion of Christ. The original splendour of the painting is marred by its poor state of preservation, but although of high pictorial value it had no influence on local artistic production.

24

15. Madonna and Child with Six Angels
97x63 cm
Perugia, Galleria Nazionale dell'Umbria

16, 17. Polyptych no. 28, and detail
128x234 cm
Siena, Pinacoteca

Carli ascribes "definite Duccio authorship" to the Madonna of the *Polyptych no. 28* in the Pinacoteca of Siena. The whole work is assigned to the production of the workshop (perhaps partly because of its very bad condition) since it reveals a considerable amount of help, valuable but extensive, in the side panels and the pinnacles.

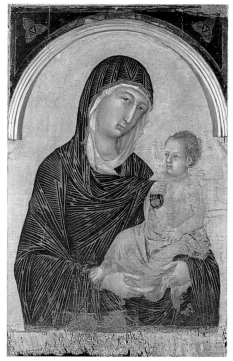

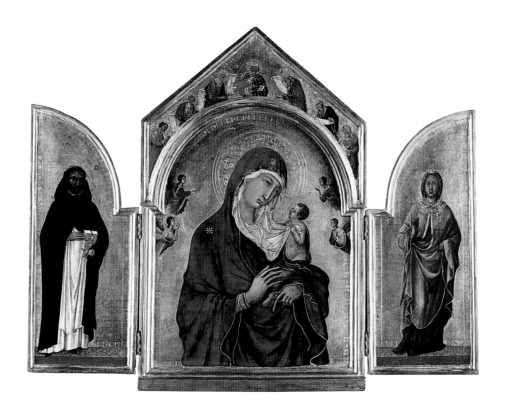

The London Triptych

This work, in the National Gallery in London, is a portable altarpiece of medium size (61.5 x 78 cm), consisting of three panels. On the sides, to the left and right respectively, are saints Dominic and Agnes: the latter was for a long time thought to be the very rare St Aurea until Cesare Brandi gave her back her true identity on the basis of the symbol of the double cross. On the central panel is the Virgin and Child with four angels. The upper section shows seven prophets, identified by the Bible verses contained in their scrolls; from the left they are: Daniel, Moses, Isaiah, David (in a perfect central position and distinguished by his name and crown), Abraham, Jacob and Jeremiah. Opinions vary as to the dating of the triptych, but it is generally agreed to be by Duccio. The overall arrangement of the central piece belongs to the same stylistic phase as the *Stoclet Madonna*, where the figure of the Child (painted very small according to oriental cus-

tom) and the slight twist of Mary's body to allow for the wide gesture of her outspread arm, are similar. On the other hand, the obvious taste for decorativeness and the rhythmic linearity of contour, displaying a wholly Gothic tendency, suggest a much later date, some years after the *Maestà*. Owing to its perfect state of preservation it is still possible to appreciate the glowing tints of the drapery, with its inevitable gilded edges, and the delicate transparency of St Agnes's veil and the Child's little garment.

18. Triptych
61.5x78 cm
London, National Gallery

The Maestà — the Masterpiece

The employment contract concerning the *Maestà*, drawn up on 4 October 1308 between the Cathedral workman Jacopo, son of the late Giliberto Mariscotti, and Duccio di Buoninsegna, is preserved in the State Archives of Siena. The *carta di pacti fatti col maestro Duccio per cagione della tavola Sancte Marie* contains a set of clauses which, rather than giving practical advice regarding the execution of the work, lay down certain rules of conduct: the painting should be entirely by the artist's own hand (*laborabit suis manibus*), he must undertake the task with all the skill and ingenuity that God has granted him (*pingere et facere dictam tabulam quam melius poterit et sciverit et Dominus sibi largietur*), and must work uninterruptedly accepting no other jobs until the great picture should be completed. As further security he swore on the Gospel to abide by the agreement *bona fide, sine fraude*. It seems that Duccio's restlessness, mentioned earlier on, had to be curbed by a promise in writing. The daily wage was sixteen soldi, a substantial sum considering the vastness of the undertaking which would require years of work and large quantities of materials (preparation of the panels, colours, gold), for the cost of which Duccio was not liable. No expense was to be spared. Agnolo di Tura del Grasso, a chronicler of the mid-fourteenth century, records that "it was the most beautiful picture ever seen and made, and cost more than three thousand gold florins". The figure was certainly exaggerated but was nevertheless very large, one of the highest paid to an artist. About three years later the *Maestà* was ready to be shown to the worshipping crowds of the faithful. An unknown contemporary writer gives an account of what happened in Siena on 9 June 1311, which for the occasion was declared a public holiday: "and on the day that (it) was carried to the Cathedral, the shops were closed and the Bishop ordered a great and devout company of priests and brothers with a solemn procession, accompanied by the Signori of the Nine and all the officials of the Commune, and all the people, and in order all the most distinguished were close behind the picture with lighted candles in their hands; and the women and children were following with great devotion: and they all accompanied the picture as far as the Cathedral, going round the Campo in procession, and according to custom, the bells rang in glory and in veneration of such a noble picture as this, ... and all that day was spent in worship and alms-giving to the poor, praying to the Mother of God, our protectress, to defend us by her infinite mercy from all adversity, and to guard us against the hand of traitors and enemies of Siena".

As already stated, the sacred picture takes on a new meaning: side by side with its religious significance (publicly decreed in 1260 when the Virgin was elected supreme protectress) is the political aspect, referring to specific local events. It is no accident that the saints surrounding Mary include the city's four patrons (from the left Ansano, Savino, Crescenzio and Victor), easily recognisable by their names in writing and depicted, significantly, on their knees in supplication: if the Virgin is the intercessor between Christ and humanity, it is Siena who is praying and the patron saints intercede for her. The words painted on the step of the throne clearly confirm everything that the iconography is meant to convey: *Mater Sancta Dei sis causa Senis requiei sis Ducio vita te quia pinxit ita* (O Holy Mother of God, grant peace to Siena and life to Duccio who has painted you thus). The focal point is the urban reality, a community united only in a very general sense, and extremely varied in its social make-up with sharply divided secular and ecclesiastical powers. The members of the local government ("the Signori of the Nine") and their officials also took part in the procession, along with the community of the faithful and clergy. The event therefore goes beyond a solely religious context and involves the entire populace. The Commune met part of the expenses for the celebrations, such as paying the "players of trumpets, bagpipes and castanets" who accompanied the long procession with their music. This seems to pave the way for when, a few years later in 1315, Simone Martini's *Maestà* fresco was painted not in a church (the usual place for veneration), but in the Town Hall, in the Sala del Mappamondo, where the Council of the Nine carried out its governmental duties. In this profane setting the sacred element merges with the earthly dimension, becoming the symbol of the city.

Originally Duccio's *Maestà*, painted on both sides, was complex in its structural organization. The central panel, showing on the front side the *Madonna and Child Enthroned with Angels and Saints* and on the back side, in twenty-six compartments, *Stories of the Passion of Christ*, had a predella with episodes from the *Early Life of Christ* alternating with six prophets on the front, and scenes from *His Public Life* on the back. It was surmounted by panels (on the front, the *Last Days of the Virgin*, on the back, stories of *Christ after the Resurrection*) that culminated in pinnacles representing angels. An inventory of 1423 shows that the painting had been provided with a baldachin with three small tabernacles and carved angels; when set in motion by a special mechanism the latter held out to the priest the necessities for celebrating Mass: "a panel painted all over with figures of Our Lady and numerous Saints, with the three little vaults at the top in four

MAESTÀ, RECTO

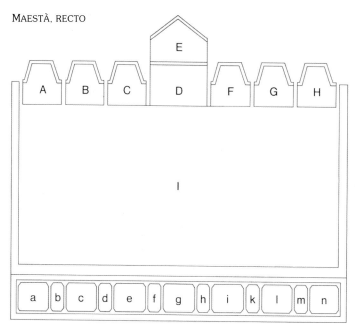

19. *Hypothetical reconstruction of the Maestà*

Front crowning section
A Announcement of Death to the Virgin
B Parting from St John
C Parting from the Apostles
D Assumption of the Virgin?
E Coronation of the Virgin
F Death
G Funeral
H Burial

I Madonna and Child Enthroned with Angels and Saints

Front predella
a Annunciation
b Isaiah
c Nativity
d Ezekiel
e Adoration of the Magi
f Solomon
g Presentation in the Temple
h Malachi
i Slaughter of the Innocents
k Jeremiah
l Flight into Egypt
m Hosea
n Disputation with the Doctors

MAESTÀ, VERSO

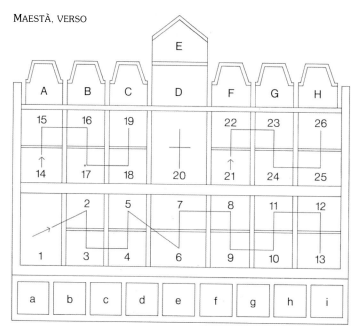

Back crowning section
A Appearance behind Locked Doors
B Doubting Thomas
C Appearance on Lake Tiberias
D Ascension?
E Christ in Glory?
F Appearance on the Mountain in Galilee
G Appearance While the Apostels are at Table
H Pentecost

Central panel
1 Entry into Jerusalem
2 Washing of the Feet
3 Last Supper
4 Christ Taking Leave of the Apostles
5 Pact of Judas
6 Agony in the Garden
7 Christ Taken Prisoner
8 Christ Before Annas
9 Peter Denying Jesus
10 Christ Before Caiaphas
11 Christ Mocked
12 Christ Accused by the Pharisees
13 Pilate's First Interrogation of Christ
14 Christ Before Herod
15 Christ Before Pilate Again
16 Flagellation

28

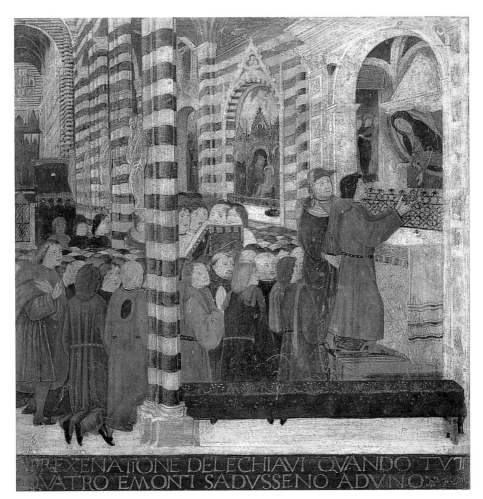

17 Crown of Thorns
18 Pilate Washing his Hands
19 Way to Calvary
20 Crucifixion
21 Deposition
22 Burial
23 The Three Marys at the
 Tomb
24 Descent into Hell
25 Noli Me Tangere
26 Meeting on the Road to
 Emmaus

Back predella
a Baptism of Christ?
b Temptation on the Temple
c Temptation on the Mount
d Calling of Peter and
 Andrew
e Wedding at Cana
f Christ and the Samaritan
g Healing of the Blind Man
h Transfiguration
i Resurrection of Lazarus

20. *Sienese painter of the second half of the 15th century*

Biccherna tablet of 1482 depicting the offering of the keys of the city to the Virgin Mary in the Cathedral

Siena, State Archives

iron borders, and three small tabernacles with tiny golden angels in relief inside, coming down to celebrate the holy mass with the eucharist and vessels and hand cloths". A small picture in the tax office, of 1482, representing the offering of the city keys to the Madonna, shows the Cathedral interior where part of the *Maestà* is visible, painted as described in the inventory; above, on the left, the round window can also be seen.

The picture remained on the high altar until 1505, when owing to repairs it was placed beside the altar of St Sebastian, now the altar of the Crucifixion. Because of this move Vasari, perhaps rather inattentive in spite of the effort he claimed to have made, did not manage to see it in 1568: "I tried to discover where the picture now is, but for all my diligence I was never able to find it". On 1 August 1771 the altarpiece was dismembered. In order to separate the two painted surfaces it was roughly sawn into seven parts and split up in correspondence with the single panels, sparing neither the predella nor the crowning section. The poplar boards, glued together and tightened with nails, proved very hard to cut away and the result was ruinous; the figures of the Virgin and Child on the front were damaged by the blade striking through. The panels were carelessly deposited "in some mezzanines on the third floor of the house of the Opera del Duomo ... in a low, dark place" and were then reassembled and placed in the Cathedral again, in the chapels of Sant'Ansano and the Sacrament. The scholar Guglielmo Della Valle, protesting in his *Lettere Sanesi* of 1785 against the havoc wrought, observes with good reason that "the picture has suffered greatly both from the mutilation to which it was subjected and from the various moves it underwent". As a consequence of all this, not only was the carpentry destroyed (frames, pinnacles, dividing elements) but several compartments of the predella and crowning section were lost — eight of these turned up in foreign museums and collections. In 1878 those parts still in Siena were brought together again in the Museum of the Opera del Duomo, where they have remained to the present day.

This division of the altarpiece in the eighteenth century has made it difficult to determine the exact structure of the original work and the sequence of the sections in the predella and crowning parts. In any case, the loss of four panels which, in pairs, made up the centre of the crowning section means that any reconstruction is incomplete. It is thought that these panels were: on the front, the *Assumption* and *Coronation of the Virgin*; on the back, the *Ascension* and *Christ in Glory*. In the opinion of Alessandro Conti, Duccio's hand can be recognized in a *Coronation of the Virgin* in the Szépmüvészéti Muzeum in Budapest. He believes that this was the central panel of the

crowning section. The fifteenth-century *Commentary* by Lorenzo Ghiberti, would seem to support the suggestion that the *Maestà* included this scene: "and on the front the Coronation of Our Lady and on the back the New Testament". Every trace has been lost of the first scene on the back of the predella which most probably represented a *Baptism of Christ*. Furthermore, if we accept Miklòs Boskovits' suggestion that there were two painted panels on the shorter side of the predella, it would seem that the altarpiece is also missing a *Baptist Pointing at Christ*, which the art historian believes is in the museum in Budapest, as well as a *Temptation in the Desert*, the present whereabouts of which are unknown. A document in the Archives of the Opera del Duomo (of uncertain date, perhaps 1308-9) makes mention of some "little angels above"; on the basis of this information Stubblebine has suggested that the altarpiece had seven pinnacles with busts of angels above the topmost crowning. Four of these panels have come to light (Stoclet Collection, Brussels; Museum of Art, Philadelphia; the J. H. van Heeck Collection, 's Heerenbergh; Mount Holyoke College, South Hadley, Massachussetts), but only the *Angels* in Brussels and Philadelphia are held to be Duccio's work.

Eight of the missing panels are scattered around various museums in America and Europe: *Annunciation*, *Healing of the Blind Man*, and *Transfiguration* (National Gallery, London), *Nativity* between the prophets *Isaiah* and *Ezekiel* and the *Calling of Peter and Andrew* (Washington, National Gallery of Art), *Temptation of Christ on the Mount* (Frick Collection, New York), *Christ and the Samaritan* (Thyssen-Bornemisza Collection, Lugano), *Resurrection of Lazarus* (Kimbell Art Museum, Fort Worth, Texas).

Since thirty-two months are held to be insufficient timewise for the execution of the altarpiece, recent criticism has put forward alternative suggestions regarding the time of execution. Traditionally, the work was done between October 1308 and June 1311. On the one hand, John Pope-Hennessy has argued that since the contract of 9 October 1308 contains no practical suggestions on the execution of the altarpiece, it is not the first draft but a secondary agreement. The work would thus have begun before this date. On the other hand, John White maintains that 9 June 1311 should not be considered the *terminus ante quem* for the completion of the work because the predellas and crowning sections were carried out after its solemn removal to the Cathedral.

Another complicated problem is that of the painter's assistants. Although the contract includes the clause obliging Duccio to work *suis manibus*, it is reasonable to suppose that he had help. For a work of this size it is likely that Duccio made use of artists in his workshop, which was much frequented according to Tizio,

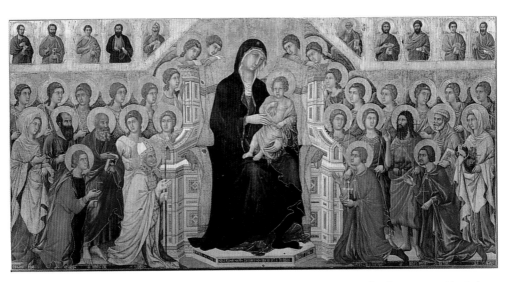

21. Madonna and Child Enthroned with Angels and Saints
370x450 cm
Siena, Museo dell'Opera del Duomo

who wrote, circa 1530: *ex cujus officina veluti ex equo Troiano pictores egregii prodierunt* (from whose workshop distinguished painters emerged as heroes emerged from the horse of Troy). Stubblebine has suggested a radical division of labour between the master of the workshop and his helpers. On the front, only the prospect and the predella are considered to be Duccio's work (excluding the *Apostles*, attributable to Ugolino di Nerio), while the *Last Days of the Virgin* in the crowning section were painted by Segna di Bonaventura, and the *Angels* in the pinnacles by the Master of the fresco of Casolo. On the back, the *Stories of the Passion* are divided between the Master of Città di Castello, the Master of the Tabernacle no. 35, Simone Martini and Ambrogio Lorenzetti. The crowning section is also assigned to Ambrogio, and the predella to his brother Pietro. The uniformity of style evident throughout the whole work was achieved by strict adherence to a common model imposed by Duccio, which was faithfully reproduced on a large scale by the assistants. This theory, although interesting, has not received much support since it seems to ignore the whole concept of the medieval workshop. In surroundings where taste and inclination were identical, the stylistic alternatives adopted by the head of the workshop were realized in a spirit of close collaboration, aiming for overall unity rather than individual characterization. The works produced were therefore formally very similar, stamped by the same basic approach. Bearing in mind the strong diversity of expression apparent in the artists referred to by Stubblebine, it seems impossible to be able to pick out such distinctly separate personalities in a work of such uniformity of feature.

Due to its prevalently narrative character, the interpretation of the work progressed along specific rational lines. It began with the episodes from the *Early Life of Christ*, which were a suitable complement to the prospect, entirely devoted to maternity and the mother-and-son relationship. The narration continued on the back with episodes from the *Public Life of Christ* anticipating the events contained in the twenty-six compartments, where from the *Entry into Jerusalem* to the *Meeting on the Road to Emmaus*, the most dramatic moments of the New Testament are illustrated in great literal detail. In the crowning section the stories of *Christ after the Resurrection*, carrying on from the last episodes of the main composition, completed the back of the work. Finally, the narrative ended with the *Last Days of the Virgin* on the front of the crowning section.

Madonna and Child Enthroned with Angels and Saints

The main feature of the altarpiece is its horizontal form. This is entirely new. Unlike the *Rucellai Madonna* and the Maestà in the Cimabue tradition, the Sienese painting is larger, the picture being extended in width. Originally, complete with predellas, crowning section, pinnacles and frames, it must have measured about five metres by five and covered the whole length of the altar, dominating the apse. Its formal grandeur is justified by the nature of the work: as a great devotional picture it was intended for common worship, for the gaze of the faithful. The inscription along the lower edge of the throne, by which the city consecrates its spiritual submission, is not the only confirmation of its votive nature. Accurate restoration (from 1953 to 1958) revealed that the faces of the Madonna and Child were badly damaged as a result of being "riddled with nails driven in to hold up rosaries and other ornaments". The altarpiece was therefore not only an object of sacred monumentality but fulfilled a specific cult role in direct and tangible ways.

The movements of the heavenly court are articulated with subtle symmetry: the characters surrounding the Virgin are divided into two ranks by the throne, which is the central axis of the entire composition. While the mirror-like correspondence of the two sides is broken up by tiny details (the gestures of the saints or the glance of an angel), Mary stands out from the rest of the group. Her extraordinary size proclaims her as the unchallenged protagonist, even in respect of the Child, who is neither making a gesture of benediction nor turning towards his mother but is silently watching the faithful. The angels, perfectly distributed spatially, acquire greater naturalness around the throne, on which they are lightly leaning. The throne itself, decorated with inlaid polychrome marble, is depicted "open like a book" (an appropriate definition by Giulio Carlo Argan), in a frontal position with widened-out sides. Next to the angels, from left to right, are saints Catherine of Alexandria, Paul, John the Evangelist, John the Baptist, Peter, and Agnes, recognizable by their symbols and names painted on the lower edge (the inscriptions are missing only for Paul and Peter). On the bottom row are the four patron saints, also identifiable by their names: Ansano, baptizer of the Sienese and decapitated in the Val d'Arbia in the fourth century; Savino, a martyred bishop; Crescenzio, a boy martyred under Diocletian, whose remains were transferred to the Cathedral in 1058; Victor, a Christian soldier, native of Syria, proclaimed patron after 1288. Above, in little arches whose frames have been lost, are the apostles distinguished by their abbreviated names against the gold background. Again

from left, they are, Thaddeus, Simon, Philip, James the Great, Andrew, Matthew, James the Less, Bartholomew, Thomas and Matthias. The use of gold as a precious complement to the glorification of Mary is essential. The background, the haloes, the garments of the Child, of Catherine, Savino, and Agnes, the cloth covering the back of the throne and the Cosmatesque inlays of the latter, all dazzle the onlooker with their splendid glitter. The fabric of the garments and the backcloth are embroidered with a continuous small golden pattern which gives the effect of real material. Little space is left for the use of other colours. In harmony with the profusion of gold, the choice falls on warm tints (shades of opaque reds, greens, blues and browns) while the Virgin is wrapped in a mantle of an intense ultramarine blue.

22-25. Madonna and Child Enthroned with Angels and Saints, details
Siena, Museo dell'Opera del Duomo

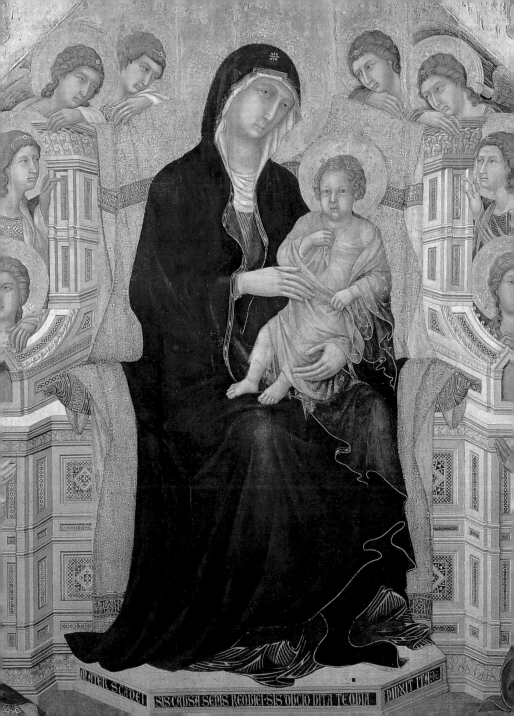

MATER SCAELI S̄IS CAUSA S̄E̅S REQIIEI SIS DUCIO DETA TE QDIA PINXIT ITER

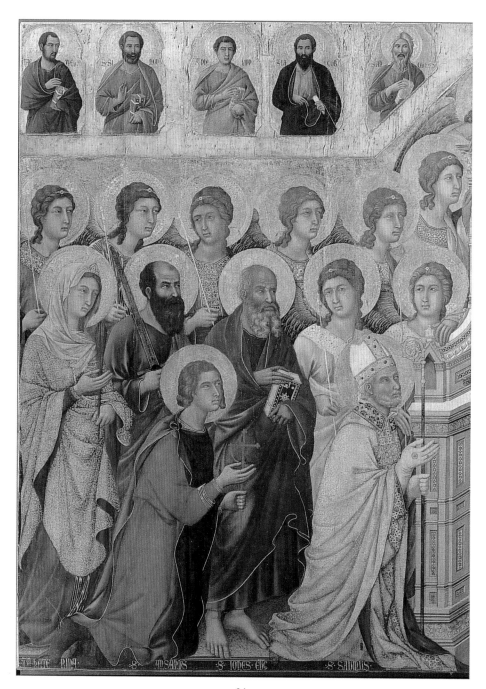

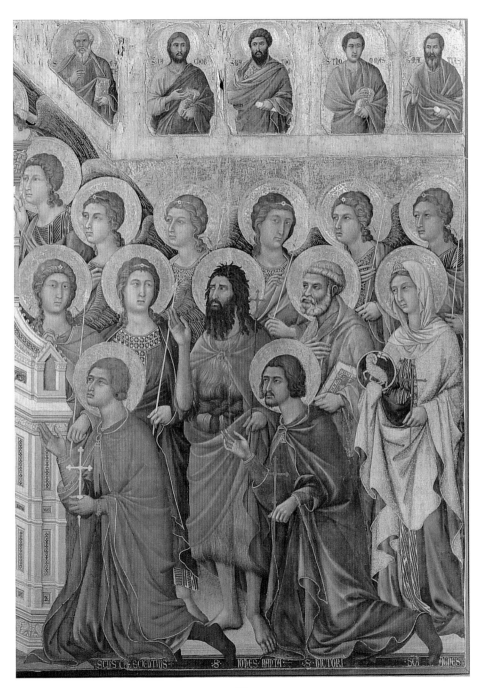

The Early Life of Christ, front predella

An analysis of the style confirms the theory that the predellas and crowning sections were executed after the main panels; the spatial solutions, the slender forms and the harmonic interchange between the action and the setting reveal firmness and confidence. Again, there is stylistic evidence that the episodes of the *Early Life of Christ* were the first to be painted. Critics generally agree over the reconstruction of the predella. From the left were the *Annunciation*; *Isaiah*; the *Nativity*; *Ezekiel*; the *Adoration of the Magi*; *Solomon*; the *Presentation in the Temple*; *Malachi*; the *Slaughter of the Innocents*; *Jeremiah*; the *Flight into Egypt*; *Hosea*; the *Disputation with the Doctors*.

ANNUNCIATION; ISAIAH; NATIVITY; EZEKIEL
The episode of the Annunciation, told only by Luke, is set in vividly articulated architectural surroundings, where consistency of line and colour lend harmonic energy to the whole. Gabriel is portrayed in movement, in the act of greeting (his hand and right foot are the opposite ends of a perfect diagonal), while Mary appears to be drawing back. She is illuminated by the ray of the Holy Spirit, in the form of a small white dove, penetrating from a cusped arch. The unreal perspective of the vase of lilies, reminiscent of Oriental art, has often been noted. The panel is in the National Gallery of London.

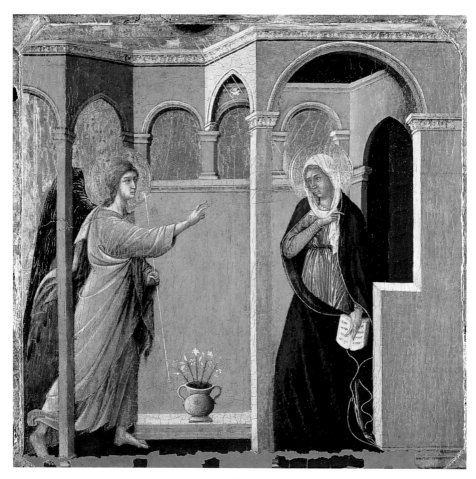

Although remaining faithful to Byzantine iconography, the *Nativity* scene pays greater attention to space, which is well distributed and amplified by the measured rhythm of the gestures. The narrative is enriched with descriptive details, combining facts drawn from Luke and from the apocryphal gospels, such as the two midwives bathing the Child (probably Salome and Zelomi) and the ox and the ass, while Joseph is portrayed in his usual thoughtful attitude, sitting outside the grotto.

The statues carved on the Cathedral facade have been identified as the most likely models for the figures of the *prophets*. In spite of their small size they preserve a solemn aspect, and the linearity of contour is enhanced by the gleaming gold ground. The words written on the angel's scroll are unfortunately illegible, but the prophet Isaiah's can be read: *Ecce virgo concepiet et pariet filium et vocabitur nomen eius Emmanuel* (Isaiah 7, 14: And a virgin will conceive and bear a son and his name will be Emmanuel). Ezekiel's scroll reads: *Porta haec clausa erit; non aperietur, et vir non transibit per eam* (Ezekiel 44, 2: This gate shall be kept shut: it shall not be opened, and no man may pass through it). The panel is in the National Gallery of Art in Washington.

26. *Annunciation*
43x44 cm
London, National Gallery

27, 28. *Isaiah; Nativity, with*
detail (27); Ezekiel
Each prophet 43.5x16 cm
Central scene 43.5x44.5 cm
Washington, National Gallery of
Art

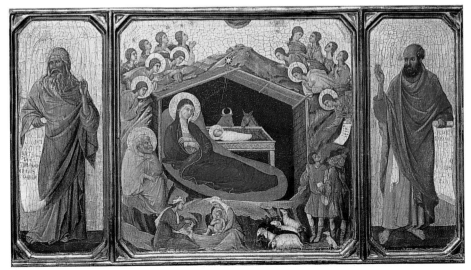

ADORATION OF THE MAGI; SOLOMON; PRESENTATION IN THE TEMPLE; MALACHI
The prophet with a crown could be either David or Solomon, but the inscription on the roll, referring to the *Adoration of the Magi*, seems to be more appropriate to the latter: *Reges Tarsis et insulae munera offerunt; reges arabum et Saba dona adducent* (Psalms 72, 9: The kings of Tarshish and the islands shall bring offerings; the kings of the Arabs and of Sheba shall present gifts). The other prophet is Malachi, whose figure in Carli's opinion is reminiscent of the *Plato* by Giovanni Pisano on the Cathedral facade, and who announces the theme of salvation: *Veniet ad templum sanctum suum dominator dominus quem vos queritis, et angelum testamenti quem vos vultis*

(Malachi 3,1: The Lord whom you desire will enter his holy temple, and the messenger of the convenat whom you yearn for).

In the *Adoration of the Magi* the detail of the king holding his crown on his arm while bending to kiss the child's feet is taken from the pulpit by Nicola Pisano. It is equally interesting to note the two camels, an evident reminder of the eastern origins of the Magi, while a star, badly damaged through loss of colour, shines above the grotto.

In the *Presentation in the Temple* the consecration rite takes place in a graceful architectural setting of marble enlivened by polychrome inlays, that reproduces the ecclesiastical environment with strong allusion to contemporary religious buildings.

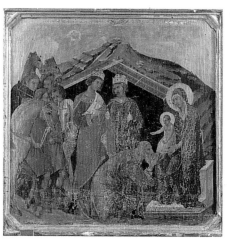

29. *Adoration of the Magi*
42.5x43.5 cm
Siena, Museo dell'Opera del Duomo

30. *Solomon*
42.5x16 cm
Siena, Museo dell'Opera del Duomo

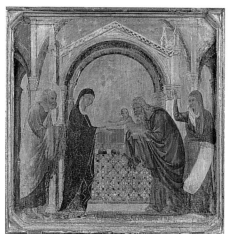

31. *Presentation in the Temple*
42.5x43
Siena, Museo dell'Opera del Duomo

32. *Malachi*
42.5x16 cm
Siena, Museo dell'Opera del Duomo

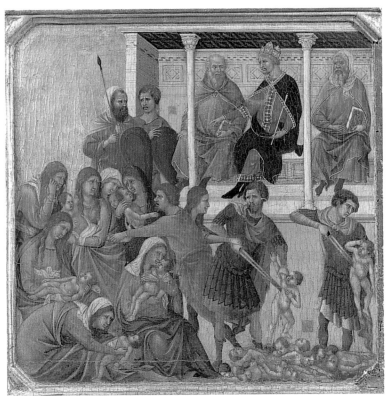

33. Slaughter of the Innocents
42.5x43.5 cm
Siena, Museo dell'Opera del Duomo

34. Jeremiah
42.5x16 cm
Siena, Museo dell'Opera del Duomo

SLAUGHTER OF THE INNOCENTS; JEREMIAH; FLIGHT INTO EGYPT; HOSEA; DISPUTATON WITH THE DOCTORS

The scene of the *Slaughter of the Innocents* (which also portrays Herod in the act of ordering the slaughter) is fully explained in the scroll of the prophet Jeremiah, where one can read: *Vox in Rama audita est, ploratus et ululatus multus: Rachel plorans filios suos* (Jeremiah 31, 15: A cry is heard in Rama, a groaning and bitter lamentation: Rachel is weeping for her sons). The despair of the weeping mothers who form an animated group is dramatically conveyed; they are in contrast to the rhythmic, unhurried gestures of the two soldiers who continue the destruction unmoved.

The *Flight into Egypt* also includes two scenes. On the left is the figure of Joseph asleep. The writing on the scroll consisting of the words of the angel who appeared to him explains his warning dream: *Accipe puerum et matrem eius et fuge in Egitum* (Matthew 2, 13: Take the child and his mother and go into Egypt). The harsh rocky crags and small green trees are the

39

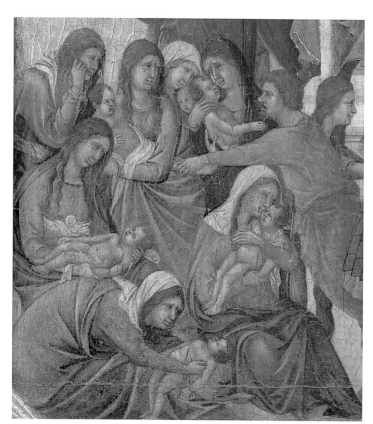

35. Slaughter of the
Innocents, detail
Siena, Museo
dell'Opera del
Duomo

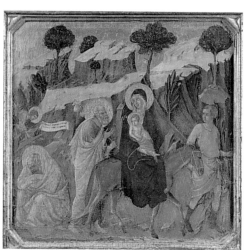

36. Flight into Egypt
42.5x44 cm
Siena, Museo
dell'Opera del
Duomo

37. Hosea
42.5x16 cm
Siena, Museo
dell'Opera del
Duomo

38,39. Disputation with the Doctors, and detail 42.5x43 cm Siena, Museo dell'Opera del Duomo

background to the journey (the boy leading the donkey is not mentioned in the canonical gospels), while Hosea's roll gives the following comment on the scene: *Ex Egipto vocavi filium meum* (Hosea 11, 1: I have called my son out of Egypt).

The last compartment of the front predella is devoted to the *Disputation with the Doctors*, recounted both in the gospel according to Luke and in the apocryphal writings of Matthew and the Infancy of Christ. The interior of the temple, dominated by a gaily coloured floor (described by Brandi as a "Caucasian carpet"), includes sophisticated details such as the four Cupids enclosed in little niches and the capitals of the slender pillars silhouetted against the gold background.

41

Scenes from the Public Life, back predella

Originally the *Scenes from the Public Life*, which formed the subject of the compartments of the back predella, began logically with a *Baptism of Christ*, now lost. Of the various suggestions as to the original order, the most generally accepted one is the following: the *Baptism* (lost), the *Temptation on the Temple*, the *Temptation on the Mount*, the *Calling of Peter and Andrew*, the *Wedding at Cana*, *Christ and the Samaritan*, the *Healing of the Blind Man*, the *Transfiguration* and the *Resurrection*.

TEMPTATION ON THE TEMPLE; TEMPTATION ON THE MOUNT
The panels illustrating the second and third temptations of Christ (the first one, in the wilderness, is

thought to have been on the smaller side, imagining the predella as a three-dimensional structure) display considerable progress in the composition and arrangement of space. The tiled floor and the pillars, visible in the interior of the building in the *Temptation on the Temple*, are rendered successfully in perspective; they accompany the polygonal form of the building, without breaking up its rigorous geometry.

In the *Temptation on the Mount* the majesty grandeur of all the kingdoms of the world is depicted with superb skill. The imaginative power of the architecture, in clear and luminous shades, is extraordinary: loggias and battlements alternate with round bell-towers, red-tiled roofs and Gothic windows, all protected by solid encircling walls. The panel is in the Frick Collection in New York.

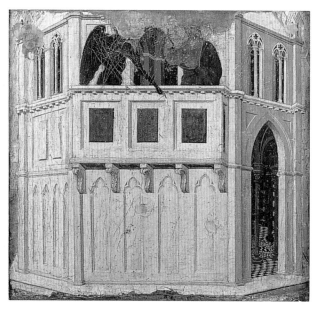

40, 41. Temptation on the Temple, and detail
48x50 cm
Siena, Museo dell'Opera del Duomo

42. Temptation on the Mount
43x46 cm
New York, Frick Collection

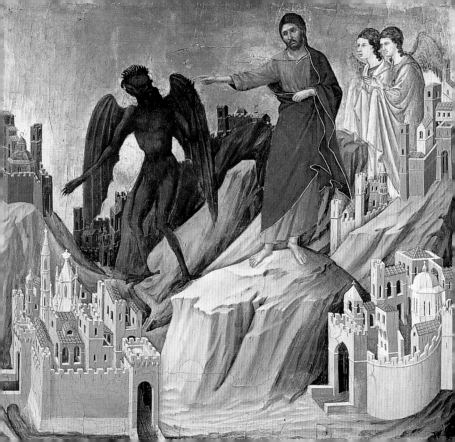

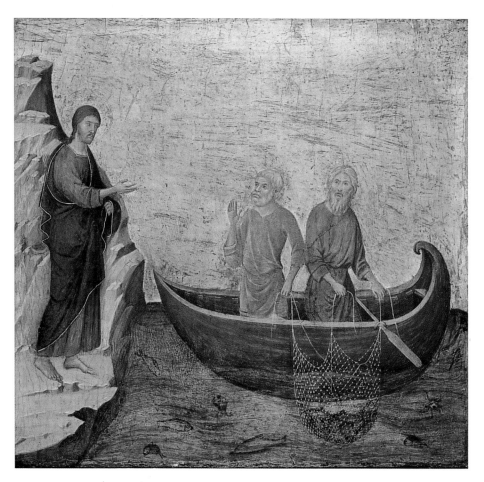

CALLING OF PETER AND ANDREW; WEDDING AT CANA

The panel with the *Calling of Peter and Andrew* is in the National Gallery of Art in Washington. Although adhering to the iconographic schemes of Byzantine and local art (clearly related to the scene on the same subject in the thirteenth-century *Altarpiece of St Peter* in the Pinacoteca at Siena) it pays greater attention to the overall composition. The distribution of space is regular and the surroundings simple; the figures are felicitously placed between the transparency of the sea and the gold of the sky.

The panel with the *Wedding at Cana* is livelier and greater importance seems to have been given to the descriptive details than to the narration. The eye is drawn to the cheerfully laid table, embellished with the

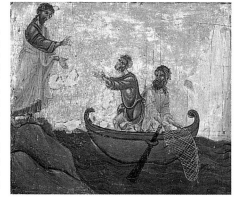

43. *Calling of Peter and Andrew*
43.5x46 cm
Washington, National Gallery of Art

44. *'Master of St. Peter', second half of the 13th century*
St Peter Altarpiece, detail of the Calling of Peter and Andrew
Siena, Pinacoteca

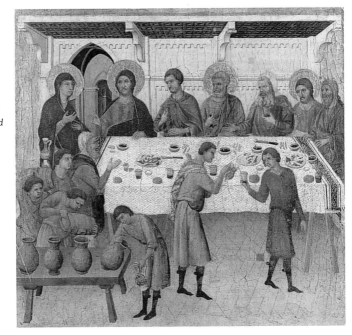

45, 46. *Wedding at Cana, and detail*
43.5x46.5 cm
Siena, Museo dell'Opera del Duomo

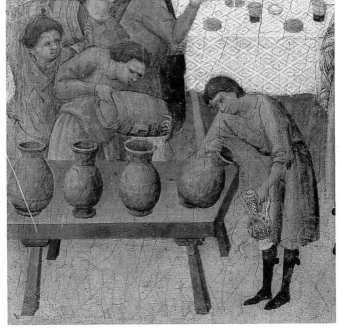

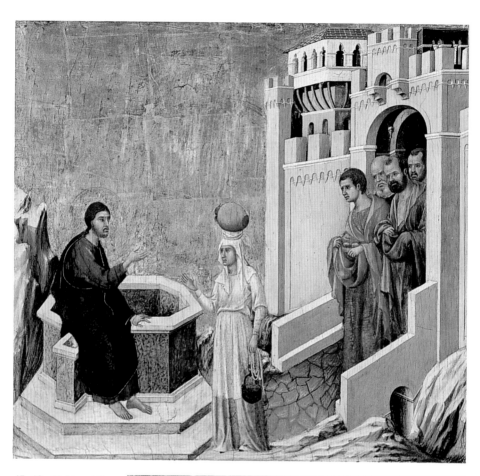

47, 48. Christ and the
Samaritan, and detail
43.5x46 cm
Lugano, Thyssen-
Bornemisza Collection

46

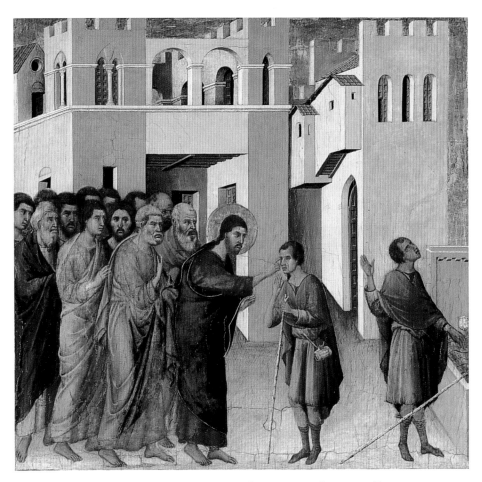

49. Healing of the Blind Man
43x45 cm
London, National Gallery

precision of a miniaturist, and to the quick movements of the servants. Without the presence of the bride and groom the picture has a genuine commemorative purpose: that of celebrating the first miracle performed by Christ. In the foreground are small casks out of which water is gushing, fat-bellied water jars, jugs and glasses now full of wine.

CHRIST AND THE SAMARITAN; HEALING OF THE BLIND MAN
Once again urban architecture, accurate and regular in its structural lay-out, lends colour to the scenes. In *Christ and the Samaritan* (in the Thyssen-Bornemisza Collection in Lugano) the geometrical compactness of the city of Sichar and the well on which Christ is sitting are in contrast with the slight figure of the woman.

The same use of space through a delicate balance of scene is to be found in the *Healing of the Blind Man*. The followers of Christ are grouped in front of a massive crenellated building, while the figure of the blind man, repeated in two distinct narrative moments, is placed in a more open area: the short stretch of road. The compartment is in the London National Gallery.

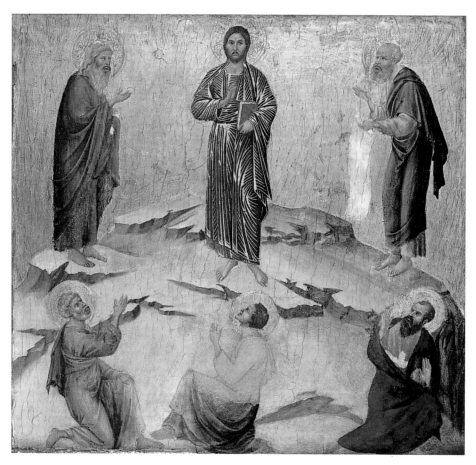

TRANSFIGURATION; RESURRECTION OF LAZARUS
The abundant use of gold in the *Transfiguration*, giving it an atmosphere of luminous transparency, is most appropriate to this scene. Peter, John and James, with Moses and Elijah, surround Christ, who is standing immobile in his lavishly highlighted robe. This last particular is conspicuous in the episodes after Christ's death, as if to underline the miraculous nature of the appearances. The painting is in the London National Gallery.

On the bottom right of the *Resurrection of Lazarus* is what remains of a fairly drastic change of mind. Originally the tomb was a horizontal sarcophagus placed at the foot of the hill on which Lazarus was probably sitting. The result was evidently not to the artist's satisfaction and the sarcophagus was transformed

50. Transfiguration
48x50.5 cm
London, National Gallery

51. Resurrection of Lazarus
43.5x46 cm
Fort Worth (Texas), Kimbell Art Museum

into a sepulchre dug out of the rock. This change also affected the resurrected figure, which as a consequence assumes a peculiar oblique position. The spontaneous gesture of the character sitting beside the open tomb and holding his nose is remarkably lifelike. The picture is in Texas in the Kimbell Art Museum at Fort Worth.

Stories of the Passion

It is interesting to note the different function of the scenes represented on the two sides of the *Maestà*. The front side was a devotional image destined for the community of the faithful (which explains its size, clearly visible from every corner of the church), while the back was essentially a narrative cycle intended for the closer observation of the clergy in the sanctuary. The main element of the back consisted of fourteen panels, originally separated by little columns or pilasters (of about 4 cm) which were lost, together with the outside frame, in the dismembering of 1771. Except for the *Entry into Jerusalem* and the *Crucifixion*, each panel contains two episodes. The central part of the lower row with the *Agony in the Garden* and *Christ taken Prisoner* is twice as wide as the other compartments (but the same as the *Crucifixion* panel) because the events portrayed are composed of different narrative units. Numerous contrasting theories have been advanced by critics for the order of interpretation, rendered problematical by the variety of New Testament sources drawn on by Duccio. It is certain that the cycle began at the bottom left and ended at the top right, proceeding from left to right first on the lower row and then on the upper.

ENTRY INTO JERUSALEM
The scene is unusual because of the attention given to the landscape, which is rich in detail. The paved road, the city gate with battlements, the wall embrasures, the slender towers rising up above and the polygonal building of white marble reproduce a remarkably realistic layout, both urbanistically and architecturally. The small tree, withered and leafless, that shows behind Christ's halo, is the fig-tree that Christ found without fruit. Florens Deuchler has suggested that the literary source is a historical work of the first century A.D., the *De Bello Judaico* by Flavius Josephus which was well-known in the Middle Ages. The panel by Duccio is a faithful reproduction of the description of Jerusalem in Book V. Infrared photography during restoration has revealed several changes of mind regarding the area around the tree in the centre and the road.

52. Stories of the Passion
212x425 cm
Siena, Museo dell'Opera del Duomo

53. Entry into Jerusalem
100x57 cm
Siena, Museo dell'Opera del Duomo

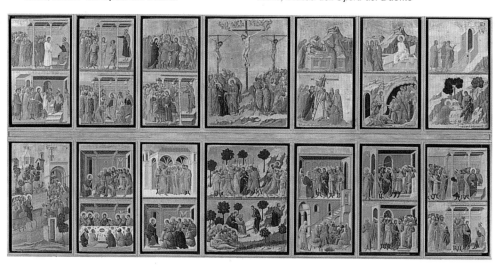

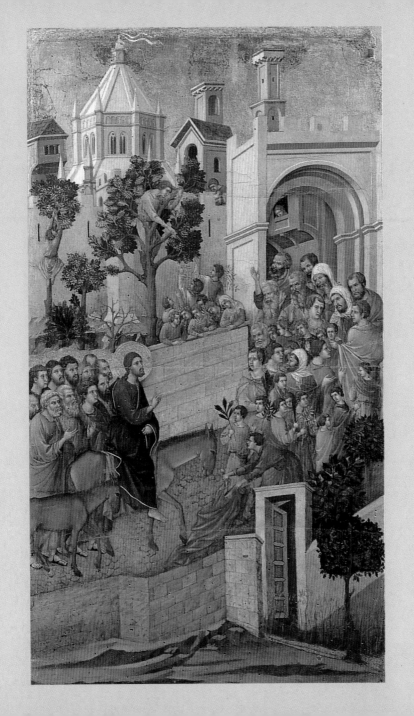

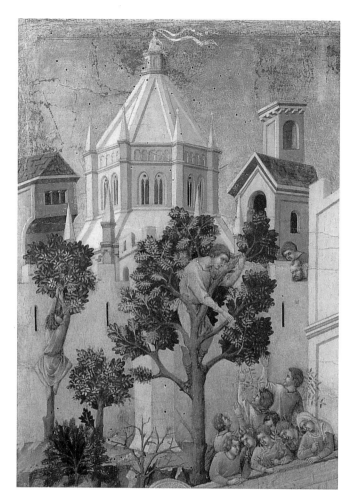

54. Entry into Jerusalem,
detail
Siena, Museo dell'Opera
del Duomo

55, 56. Washing of the
Feet; Last Supper
100x53 cm
Siena, Museo dell'Opera
del Duomo

WASHING OF THE FEET; LAST SUPPER

Only John tells the story of the *Washing of the Feet* and the events should therefore be read from the top downwards, according to the order in which they occur in this gospel. The setting is the interior, in central perspective, of an unadorned room; the only decorative elements are the coffered ceiling and the multifoiled insert placed on the rear wall. This detail must also be imagined in the *Last Supper*, hidden by Christ's halo, since it reappears in *Christ Taking Leave of the Apostles*, which according to the gospel occurs in the same place.

Echoes from Byzantine art can be seen in the *Washing of the Feet*, in the crowded throng of the apostles and Peter's gesture, while Christ's position recalls

Western models. The shape of the black sandals, aptly described by Cesare Brandi "as if they were precious onyx scarabs", is typical.

The *Last Supper* is dominated by the central figure of Jesus who, to the astonishment of the onlookers, is offering bread to Judas Iscariot (shown in other panels with the same features). An unusual experiment with space has been made with John, whose position is traditional: the head of the favourite disciple is painted in front of the figure of Christ, and his halo behind Christ's shoulders. Wooden bowls, knives, a decorated jug and a meat dish, and the paschal lamb, are set on the table, which is covered with a simple tablecloth woven in a small diamond pattern.

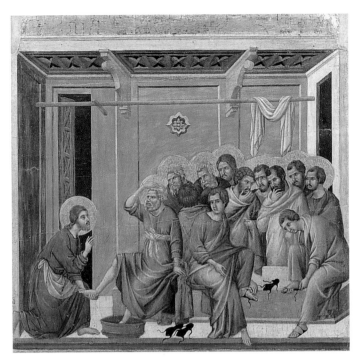

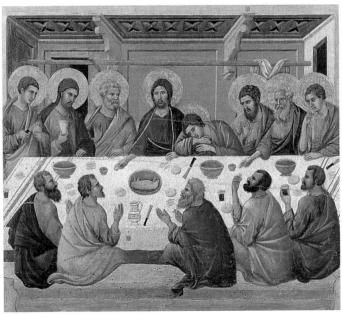

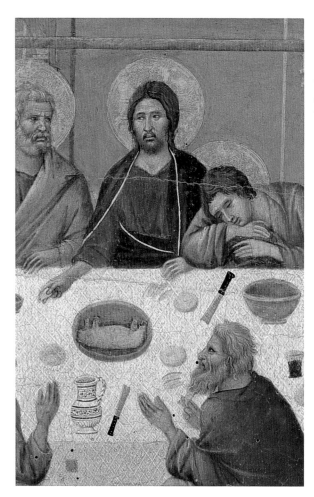

57. Last Supper, detail
Siena, Museo dell'Opera del
Duomo

58, 59. Christ Taking Leave of the
Apostles; Pact of Judas
100x53 cm
Siena, Museo dell'Opera del
Duomo

CHRIST TAKING LEAVE OF THE APOSTLES; PACT OF
JUDAS

Following the story in John again, the scenes succeed each other from the bottom upwards although occurring simultaneously. While Jesus is giving the new commandment to the apostles (now eleven), Judas betrays him for thirty pieces of silver. In *Christ Taking Leave of the Apostles*, his sideways position, shown up by the half-open door, is in contrast to the close-knit group of disciples. They are all turning the same way in thoughtful attitudes, the soft drapery of their coloured robes animating the whole scene. As in the *Washing of the Feet* and the *Last Supper* Duccio has avoided haloes since the conspicuous shape of the golden discs might have created an overpowering effect, besides taking up most of the space in the picture.

The *Pact of Judas* is set in external surroundings where the space is arranged in varying degrees of depth. The group in the foreground, on the same level as the pillar on the right, is gathered in front of a loggia with cross-vaults and round arches. The polygonal tower, a little behind the central building, completes the background.

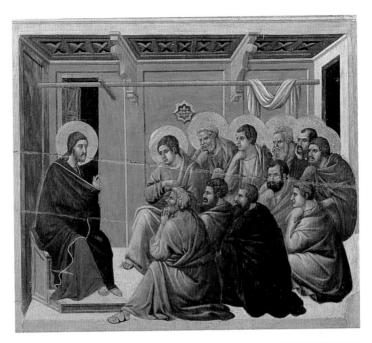

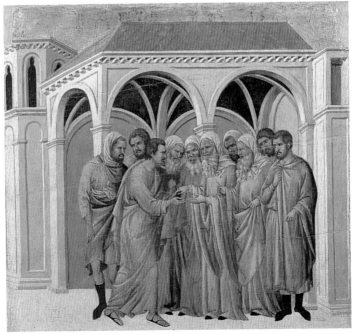

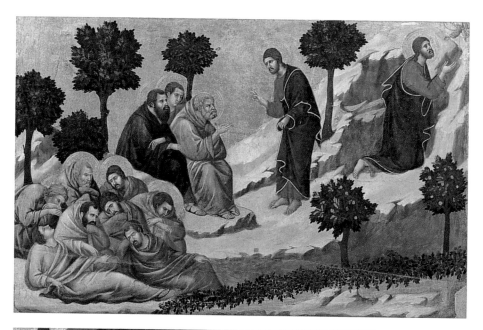

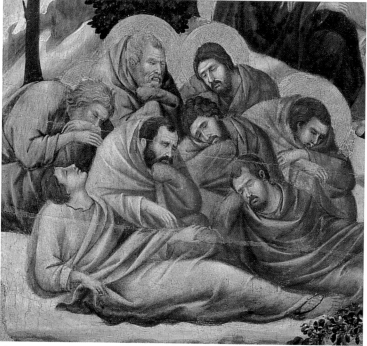

60-63. Agony in the Garden; Christ Taken Prisoner, and details 102x76 cm Siena, Museo dell'Opera del Duomo

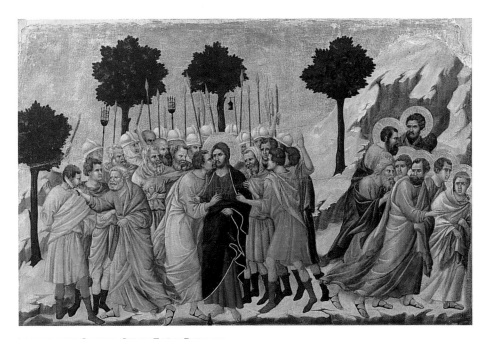

AGONY IN THE GARDEN; CHRIST TAKEN PRISONER

This should be read from the bottom upwards, each scene containing different narrative units. In the *Agony in the Garden*, Jesus is turning to Peter, James the Great and John, shaking them and warning them not to fall into temptation, while the other disciples are sleeping. On the right, in accordance with the Gospel of St Luke, which is the only one to mention an angel appearing, he withdraws in prayer. In this quiet setting, both episodes are visualized through the gestures of Christ, Peter and the angel.

The Mount of Olives becomes the scene of unexpected agitation in *Christ Taken Prisoner*, containing three separate episodes: in the centre the kiss of Judas, to the left Peter cutting off the ear of the servant Malchus, to the right the flight of the apostles. The dramatic intensity of the scene, heightened by the crowded succession of spears, lanterns and torches, shows in the excited movements of the characters and the expressiveness of their faces. The landscape, after long being an anonymous feature of minor importance, takes on a new scenic role. The vegetation and rocky crags of Byzantine inspiration seem to be an integral part of the action: in the *Agony in the Garden* the three trees on the right isolate Christ, while in *Christ Taken Prisoner* they enclose the main episode, as if allowing the disciples to escape.

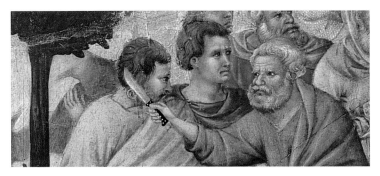

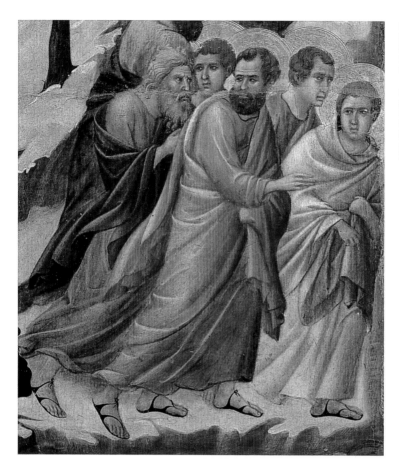

64. Christ Taken
Prisoner, detail
Siena, Museo
dell'Opera del
Duomo

65. Christ Before
Annas and Peter
Denying Jesus
99x53.5 cm
Siena, Museo
dell'Opera del
Duomo

CHRIST BEFORE ANNAS AND PETER DENYING JESUS

The rule of absolute autonomy being given to each single scene is successfully broken in this panel. The two episodes, told by John, occur simultaneously but in different places and the stairs, a material link in space, also connect the time-factor. While Jesus is brought before the High Priest Annas, Peter remains in the courtyard where a servant-girl recognizes him as a friend of the accused: his raised hand indicates the words of denial. The surroundings are full of vivid architectural detail: the doorway with a pointed arch opening onto the room with a porch, the Gothic window of the small balcony, the pilaster strips on the back wall of the upper floor and the coffered ceiling, this time with smaller squares. Peter, whose halo in a curious fashion includes the head and shoulders of the person next to him, is warming his feet at the fire in a highly realistic manner. Lastly, because of her vertical position and arm resting on the handrail, the figure of the serving-maid about to go up the stairs was evidently the cause of much indecision since several "changes of mind" have been discovered around the skirt.

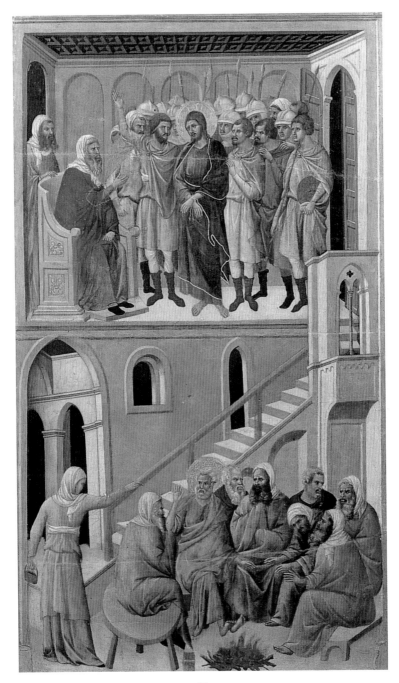

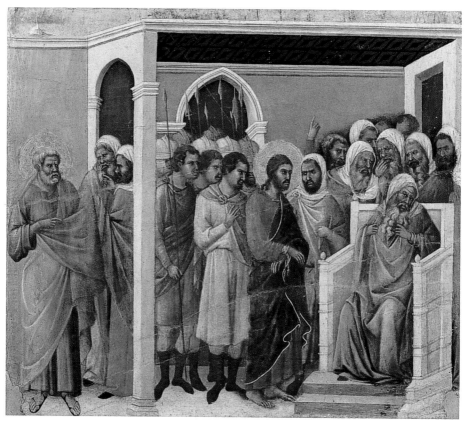

CHRIST BEFORE CAIAPHAS; CHRIST MOCKED
According to the Gospel of St. Matthew, the compart-
ment should be read from the bottom upwards. The
scenes take place in the same surroundings, the law-
court of the Sanhedrin, where Christ is brought before
the High Priest Caiaphas and the Elders. Outside the
room, the cock painted at the top alludes to the
second and third denials of Peter. In *Christ Before
Caiaphas*, great importance is given to the person with
raised hand and pointing finger looking significantly at
the onlooker; the affronted gesture, isolated among a
crowd of helmets and anonymous faces, catches the
attention of the viewer. Caiaphas too is depicted in an
attitude of wrath and indignation at the words of Je-

*66-69. Christ Before Caiaphas; Christ Mocked, and
details 98.5x53.5 cm
Siena, Museo dell'Opera del Duomo*

sus: with his hands on his breast he tears his red robes,
showing the tunic underneath (this detail is told by
Matthew and Mark).

Gestures are more agitated in the scene above
where Christ blindfolded (according to the version in
Mark and Luke) and immobile in his dark cloak, is
mocked and beaten by the Pharisees.

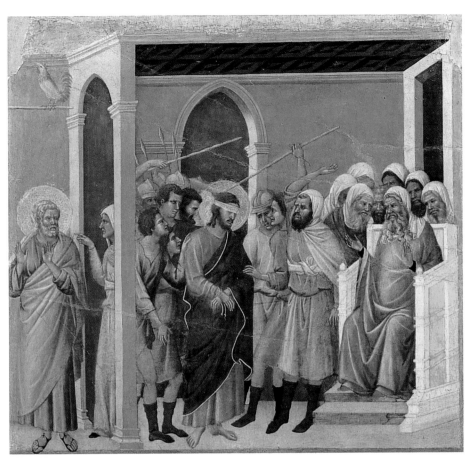

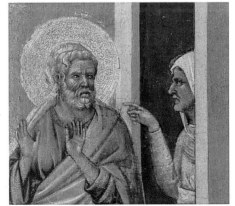

70-72. Christ Accused by the Pharisees, and detail; Pilate's First Interrogation of Christ 98x57 cm Siena, Museo dell'Opera del Duomo

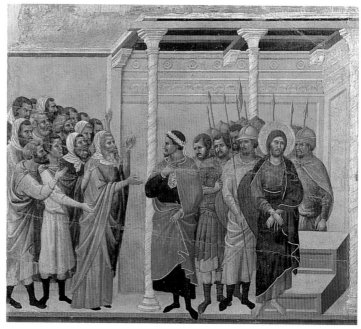

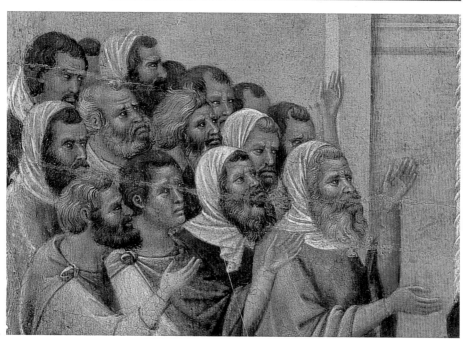

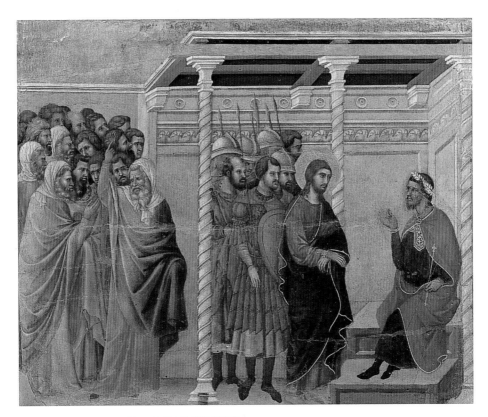

CHRIST ACCUSED BY THE PHARISEES; PILATE'S FIRST
INTERROGATION OF CHRIST

The order of the episodes is from the top downwards.
The surroundings for the scenes in which Pilate ap-
pears are new since the events take place in the gover-
nor's palace. The slender spiral columns of white mar-
ble and the decoration carved along the top of the
walls seem to refer to classical architecture. Pilate too,
portrayed with the solemnity of a Roman emperor and
crowned with a laurel wreath, evokes the world of
classical antiquity. It is interesting to note how the lat-
ter's face still bears the slashings caused by medieval
religious fervour. The function of the beams placed on
the capitals supporting a light and apparently unstable
wooden roof is harder to explain. As in the gospel, the
group of Pharisees, animated by lively gestures (again
the hand with pointing finger), is depicted outside the
building: the Jews avoid going inside in order not to
be defiled and to be able to eat the Passover meal. In
the upper scene, an overwhelming aura of solitude
surrounds Christ.

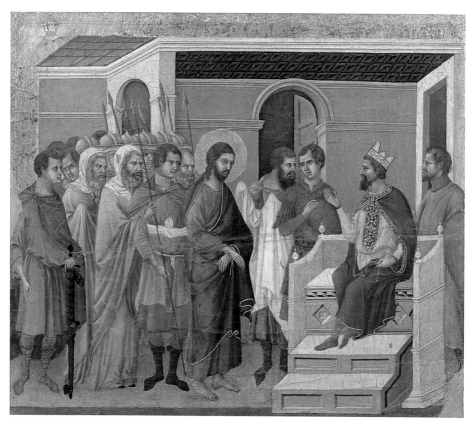

CHRIST BEFORE HEROD; CHRIST BEFORE PILATE
AGAIN
The narrative continues on the upper row with two
episodes passed down by Luke only. Pilate, on learn-
ing that Jesus belonged to the jurisdiction of Herod,
sent the prisoner to the king to be judged by him. After
questioning Jesus and treating him with ridicule and
contempt, Herod sent him back to the Roman gover-
nor dressed in a conspicuous garment, the white robe
that distinguished lunatics. Action proceeds from the
bottom upwards; in the lower scene a servant is hold-
ing out to Christ the robe which in the upper scene he
is already wearing. Although placed in different
architectural surroundings (the governor's palace
present in the last compartment on the lower row ap-
pears again), the arrangement of the two scenes is

*73-75. Christ Before Herod; Christ Before Pilate
Again, and detail
100x57 cm
Siena, Museo dell'Opera del Duomo*

almost identical, both in the distribution of the charac-
ters and in their movements. Christ, gazing with ex-
treme sadness at the onlooker, is withdrawn in total
silence. Herod anticipates and repeats (*Pilate's First
Interrogation of Christ*) the position of Pilate where the
solemn movement gives a rather static effect. The
king's throne with steps, its basic structure embellished
and adorned, is more ornate than the governor's sim-
ple wooden seat.

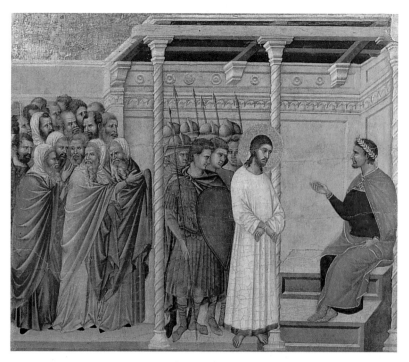

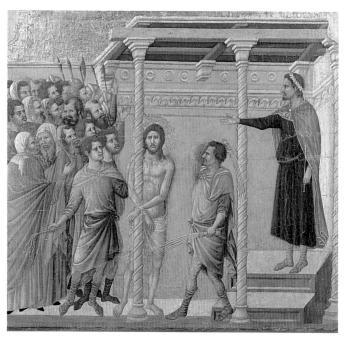

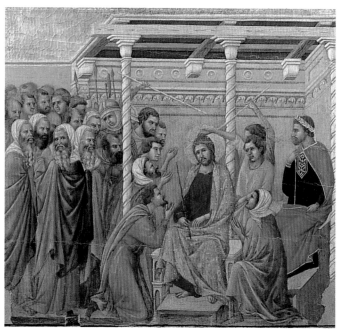

76-78. Flagellation, and detail; Crown of Thorns
100x53.5 cm
Siena, Museo dell'Opera del Duomo

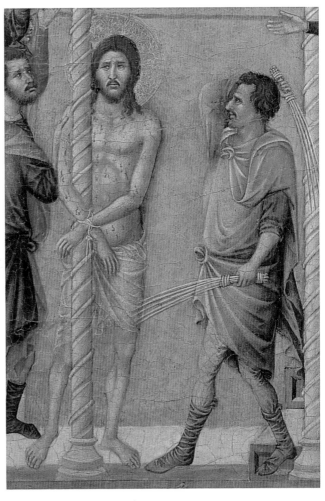

FLAGELLATION: CROWN OF THORNS

The scenes should be read from top to bottom even though at this point the pictorial narrative unexpectedly abandons the gospel order of events. Matthew affirms that the episode of Pilate washing his hands comes before both the Flagellation and the Crown of Thorns. Instead in the picture the order is inverted. However, it still adheres faithfully to the written source and the scenes are illustrated in minute detail. Considering that the *Flagellation* is barely mentioned in the gospels, the descriptive details show remarkable inventiveness, aimed at illustrating each moment of the Passion. The figure of Pilate disobeys all the rules of perspective: although obvious from the seat on which he is standing that he is inside the building, he manages to stretch his arm in front of the pillar, in a position parallel to the horizontal level of the floor.

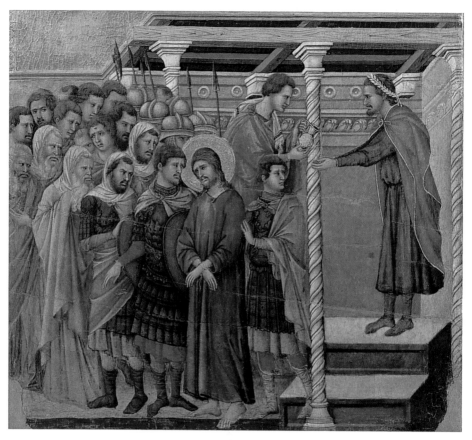

PILATE WASHING HIS HANDS; WAY TO CALVARY
The story continues from the bottom to the top. An entire compartment is devoted to Pilate's action, although the story is told briefly and only by Matthew. Again, to lend vitality to each single movement, different planes of perspective are superimposed in the scene, both in the figure of Pilate, and in the large group crowding in front of the left pillar. The base of this should be parallel to that of the column next to it, but it is much further back.

The scene on the *Way to Calvary*, as Duccio represents it, has the specific purpose of acting as an intermediary between past and future events. On the

79-81. Pilate Washing his Hands, and detail; Way to Calvary
102x53.5 cm
Siena, Museo dell'Opera del Duomo

one hand, the slender, erect figure of Christ, with his hands still tied, refers the onlooker to the various stages of the trial. On the other hand, the direction in which all the characters are moving (to the right, towards the panel with the *Crucifixion*) and the cross borne by Simon of Cyrene, allude to the terrible conclusion.

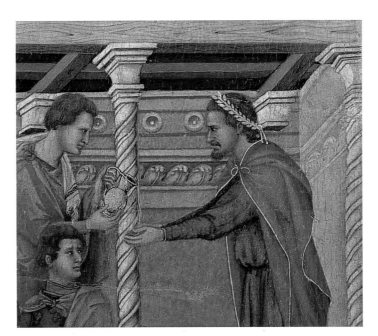

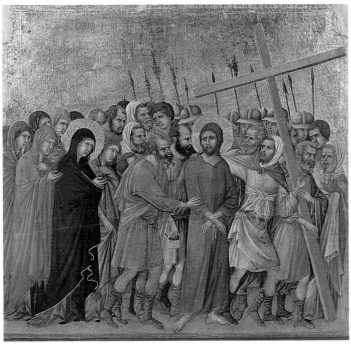

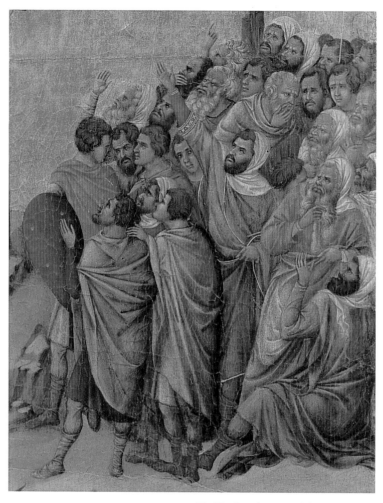

CRUCIFIXION
The emotional intensity of the *Stories of the Passion*, from *Christ Taken Prisoner* to the *Way to Calvary*, reaches its most dramatic moment in the *Crucifixion* which, placed in the middle of the upper row, dominates the whole of the back section. The slender cross stands out against the gold ground, dividing the crowd into two separate groups. On the left are Christ's followers, subdued and orderly, their faces drawn with grief, amongst whom are Mary of Clopas, Mary Mother of Jesus, Mary Magdalene (dressed in red with her long hair unbound) and John the Evangelist. On the right, the priests and soldiers are shown mocking and insulting, with rough movements. The

82, 83. Crucifixion, and detail
100x76 cm
Siena, Museo dell'Opera del Duomo

fine modelling of the figure of Christ is reminiscent of the plasticism of Gothic ivories, while the strong contrast of movement which opposes the characters has evident connections with the *Crucifixion* on the Cathedral pulpit, carved by Nicola Pisano from 1266-68. The surroundings are bare and scanty, the jagged rocks clearly alluding to Golgotha.

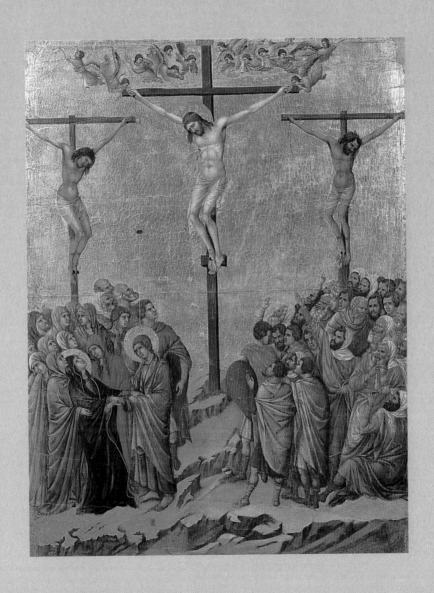

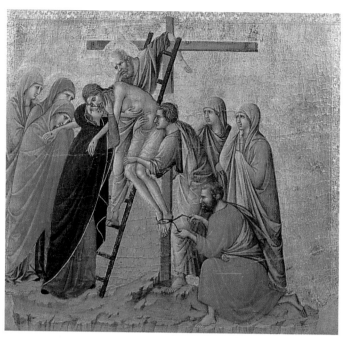

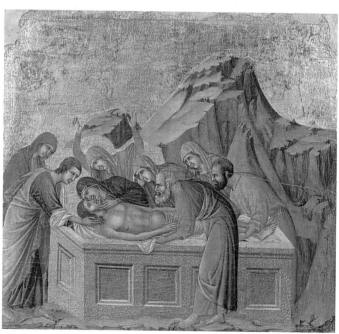

DEPOSITION; BURIAL

The *Deposition*, with the same gold background as the *Crucifixion* (excluding any possibility of distraction), is represented as intense embracing. Joseph of Arimathaea and John support the lifeless body, while Nicodemus removes the nails from the feet and the Virgin reaches out yearningly to her son, looking into his closed eyes. One of the Marys holds Christ's arm to her face, while the others, their hands covered by their veils, are tragic masks of grief. The little stream of blood under the cross, also present in the previous scene, has a dramatic realism.

The same characters appear in the *Burial* (of the three women, the one with the blue garment is missing), all leaning over Christ's body. Joseph arranges the shroud, John gently lifts Christ's head, Mary kisses him for the last time. Only Mary Magdalene expresses her despair emotionally, lifting both her arms to heaven.

THE THREE MARYS AT THE TOMB; DESCENT INTO HELL

The original order is difficult to establish because the episode of the *Descent into Hell* is not mentioned in the canonical gospels, but recounted in the apo-cryphal gospel of Nicodemus. Although there are some reservations, most critics agree that the panel should be read from the top downwards. The subtlety of posture in the scene of the *Marys at the Tomb* is outstanding. The women are portrayed in attitudes of wonder and fear; their delicate backwards movement and gesticulating hands show their astonishment at the sudden apparition. For the design of the three figures it would seem that Duccio was inspired by the *Sibyl* carved by Giovanni Pisano on the facade of Siena Cathedral. Opposite, the angel is sitting quietly on the rolled-away stone and pointing to the empty tomb. His white robe (lighter than the shroud draped over the edge of the sarcophagus) wraps him in soft folds which show up well against the dark rocks and illuminate the whole composition.

The Descent into Hell, an iconographic theme little diffused in Western painting, shows clear traces of Byzantine art in the abundant use of gold on Jesus' robe and the unimaginative layout of the scene itself. Having burst open the gates of hell, Christ arrives in limbo to set his forefathers free: while helping Adam to rise, he treads on a hideous Satan, who lies vanquished and blind with rage.

*84, 85. Deposition;
Burial
101x53.5 cm
Siena, Museo
dell'Opera del Duomo*

*86, 87, 89. The Three
Marys at the Tomb, and
detail; Descent into Hell
102x53.5 cm
Siena, Museo
dell'Opera del Duomo*

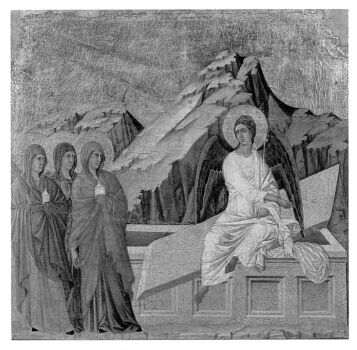

APPEARANCE TO MARY MAGDALENE (NOLI ME
TANGERE); MEETING ON THE ROAD TO EMMAUS
The two episodes are read from the bottom to the top.
In the *Appearance to Mary Magdalene* the rocky land-
scape becomes a stage setting: the steep ravines iso-
late the intimate dialogue in surroundings of absolute
solitude, while the trees (which have not appeared,
since *Christ Taken Prisoner*) are the only witnesses.
Jesus is portrayed as in the *Descent into Hell*, with a
cruciform staff from which a standard is flying, while
Mary Magdalene catches the eye with her vivid red
mantle. The slant of the rocks accompanies and em-
phasizes the form of her bending body.

Only the Gospel of Luke mentions that Christ,
dressed like a pilgrim, appeared to the disciples on
their way to Emmaus. Duccio adhered to the Gospel
text, reproducing the portrait of an authentic medieval
pilgrim: he is distinguished by the knapsack on his
shoulder, the pilgrim's staff and the typical wide-
brimmed hat. As in the lower scene, the composition
is directed towards the right, where there is a village
on a hill. An interesting detail is the paved road ap-
pearing in two variations: partly with round cobble-
stones and, below the main gate, with regularly cut
stones geometrically laid out.

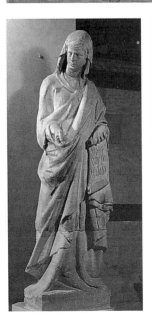

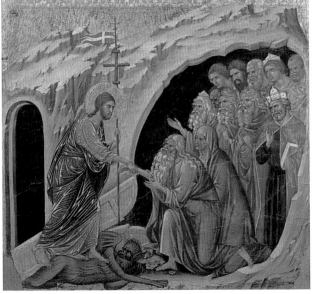

74

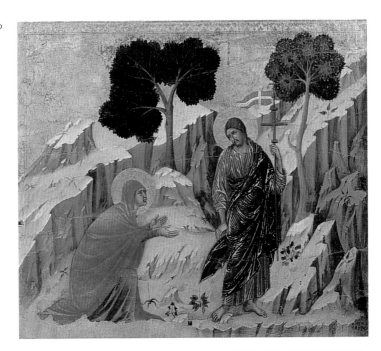

*88. Giovanni Pisano
Sibyl
Siena, Museo
dell'Opera del
Duomo*

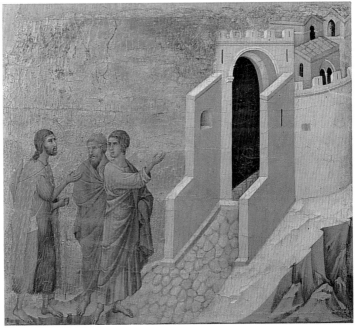

*90, 91. Appearance
to Mary Magdalene;
Meeting on the
Road to Emmaus
102x57 cm
Siena, Museo
dell'Opera del
Duomo*

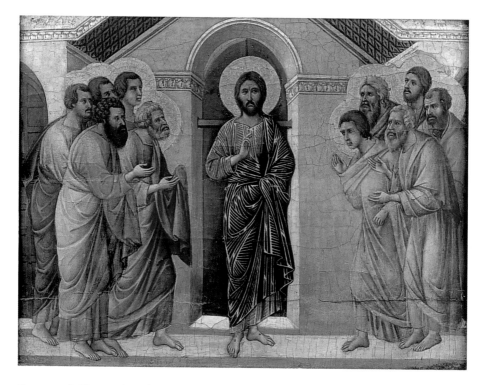

Stories of Christ after the Resurrection, back crowning section

The order of the compartments dedicated to the *Stories of Christ after the Resurrection* was probably the following: from the left, the *Appearance behind Locked Doors*; the *Doubting Thomas*; the *Appearance on Lake Tiberias*, the *Appearance on the Mountain in Galilee*; the *Appearance while the Apostles are at Table*; the *Pentecost*. A seventh panel is supposed to have existed in the centre, perhaps containing the *Ascension* and culminating in a representation of *Christ in Glory*. Unfortunately nothing is known of either scene.

APPEARANCE BEHIND LOCKED DOORS; DOUBTING THOMAS

Both episodes take place in the same surroundings, the house where the apostles took refuge for fear of the Jews. The door in the centre, firmly shut with a horizontal bar (a detail which emphasizes the miraculous nature of the event), frames and shows up the dominant figure of Christ, towards whom the two groups of apostles are converging.

The *Doubting Thomas* is the only panel, apart from

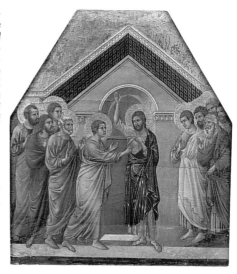

the *Funeral of the Virgin* from the front crowning section, still in its probable original form. The position of Thomas's feet is curious: the right foot is painted as if his legs were crossed under his robe.

APPEARANCE ON LAKE TIBERIAS; APPEARANCE ON THE MOUNTAIN IN GALILEE

In the *Appearance on Lake Tiberias* the vertical position of the figures of Christ and Peter is in opposition to the compact volume of the group of apostles, giving balance and harmony to the spatial distribution. The painting is superior in narrative description to the scene of the *Calling of Peter and Andrew* (very similar in its basic layout), and greater significance is given to the actions of the characters. The two disciples are bending over to lift the heavy catch in a most lifelike pose.

The *Appearance on the Mountain in Galilee* is simpler and barer and descriptive details are deliberately left out: Christ is entrusting the apostles with the task of spreading the faith (the books that two of the disciples are holding are a reminder of preaching) and nothing must distract attention from his words.

92. Appearance Behind Locked Doors
39.5x51.5 cm
Siena, Museo dell'Opera del Duomo

93. The Doubting Thomas
55.5x50.5 cm
Siena, Museo dell'Opera del Duomo

94. Appearance on Lake Tiberias
36.5x47.5 cm
Siena, Museo dell'Opera del Duomo

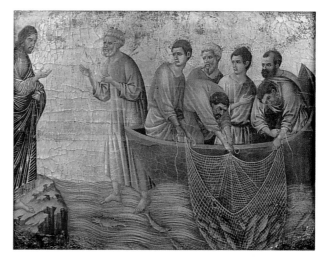

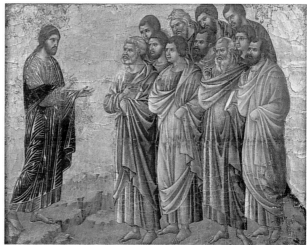

95. Appearance on the Mountain in Galilee
36.5x47.5 cm
Siena, Museo dell'Opera del Duomo

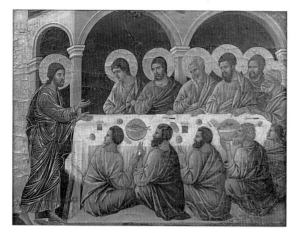

96. *Appearance While the Apostles are at Table*
39.5x51.5 cm
Siena, Museo dell'Opera del Duomo

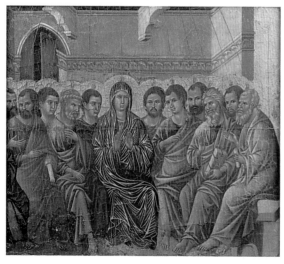

97. *Pentecost*
37.5x42.5 cm
Siena, Museo dell'Opera del Duomo

APPEARANCE WHILE THE APOSTLES ARE AT TABLE;
PENTECOST

Rather than referring to the episode told by Mark (in which Christ reproaches the eleven for not believing those who said they had seen him after his death), the *Appearance at Table* alludes to the story in Luke, where Jesus appears before the disciples and, to dispel all their doubts, eats with them. The detail of the fish painted on the plates repeats the gospel text to the letter.

In the *Pentecost* Duccio goes back to traditional iconographic schemes and includes the Virgin, of whom no mention is made in the Acts of the Apostles,

the source of the episode. Mary's entire figure, illuminated by the highlights of her robe, becomes a form with strongly curved outlines contrasting with the loose drapery of the disciples' garments. The succession of haloes echoes the group in a shining golden frame, on which twelve tongues of flame are burning — the symbol of the descent of the Holy Spirit. The panel has obviously been cut on the left side, where the twelfth apostle is missing; only the red ray descending from above remains.

The Last Days of the Virgin, front crowning section

Various conjectures have been made to establish both the number of panels and their original layout: they were probably seven (six are remaining) and the missing part, from the centre, was probably an *Assumption of the Virgin*, with the Budapest *Coronation* above it. The stories of the Virgin, drawn mainly from the *Legenda Aurea* by Jacob di Varagine, are in the following order: from the left, the *Announcement of Death*, the *Parting from St John*, the *Parting from the Apostles*, the *Death (Dormitio Virginis)*, the *Funeral*, the *Burial*.

ANNOUNCEMENT OF DEATH; PARTING FROM ST JOHN
In the simple architectural frame enclosing the scenes space is articulated with effortless accuracy. The beamed ceiling, the linearity of the horizontal pattern on the back wall, the slender arches opening onto the room where Mary is sitting, lend calm elegance to the surroundings. In the *Announcement of Death* the angel, his robe light and fluttering, offers the palm branch to the Virgin — the *palma mortis* is present in all the episodes as an emblem of death and a symbol of paradise to come. The gesture of affection and intimacy between Mary and John, the favourite apostle to whom Christ on the point of death entrusted his mother, gives an atmosphere of tenderness to the next scene. Outside the room the disciples are present at a more restrained embrace between Peter and Paul (included in the stories of the Virgin according to a tradition handed down by a few of the literary sources).

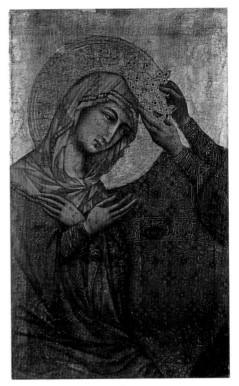

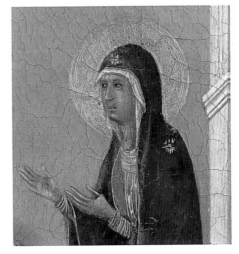

98. Coronation of the Virgin
51.5x32 cm
Budapest, Szépmüveszéti Muzeum

99. Announcement of Death, detail
Siena, Museo dell'Opera del Duomo

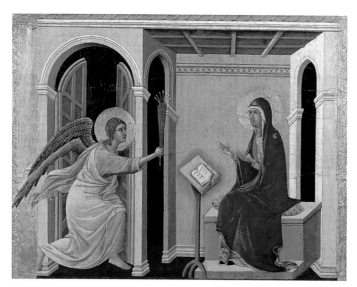

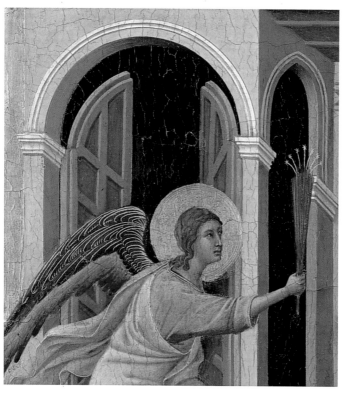

*100,101. Announcement of Death, and detail
41.5x54 cm
Siena, Museo dell'Opera del Duomo*

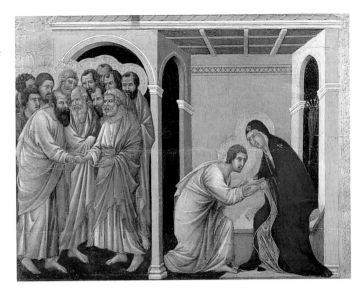

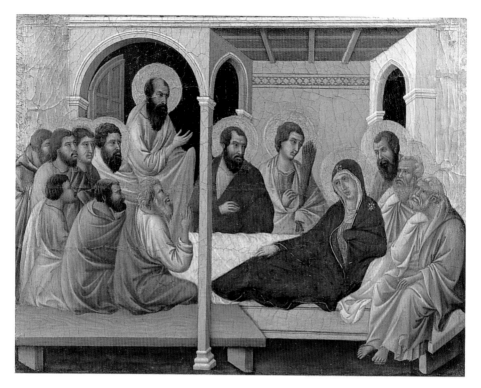

PARTING FROM THE APOSTLES; DEATH (DORMITIO
VIRGINIS)
In the *Parting from the Apostles* the spatial element is
harmoniously articulated by the slender pillar in the
foreground which, respecting the distribution of
characters, divides the room into two. The prominent
figure of the standing apostle, identified as Paul, is
clearly outlined against the dark space formed by the
open door, balancing the horizontal image of Mary.

The moving scene of the *Death* shows a traditional
approach drawn from Byzantine models, combined
with freshness of composition. A multitude of haloed
figures, orderly and dignified, recall the solemn court
of heaven in the prospect. Only the apostles in the
foreground, Peter and John, are portrayed in more
spontaneous attitudes, while Christ holds up the
animula, the soul of Mary who has just died.

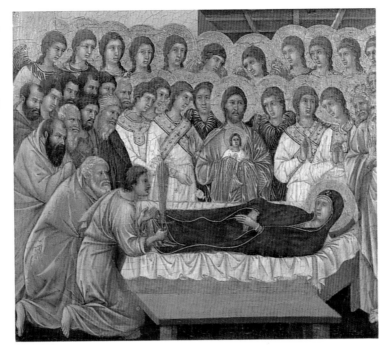

104. Parting from the Apostles 41.5x54 Siena, Museo dell'Opera del Duomo

105, 106. Death of the Virgin, and detail 40x45.5 cm Siena, Museo dell'Opera del Duomo

FUNERAL; BURIAL

The apostles, led by John with the palm, are carrying the bier on which the body of the Virgin is laid. At the same time a Jew attempts to desecrate it and is struck by sudden paralysis; this is caused by the movement of Peter who turns round in anger, disturbed by the sacrilegious gesture. The polygonal building of white marble already seen in the *Entry into Jerusalem* appears again, enclosed by battlemented walls against which the shining gold circles of the haloes stand out.

In the following scene the background of deeply indented rocks with small leafy trees evokes the valley of Jehoshaphat where the burial took place. The disciples, grouped quietly round the tomb in attitudes of tender affection, show their heartfelt participation in the sad event, particularly the person on the left who is lifting his hand to his mouth in grief.

107. Funeral 58x52.5 cm Siena, Museo dell'Opera del Duomo

108. Funeral, detail
Siena, Museo dell'Opera del Duomo

109. Burial
41x54.5 cm
Siena, Museo dell'Opera del Duomo

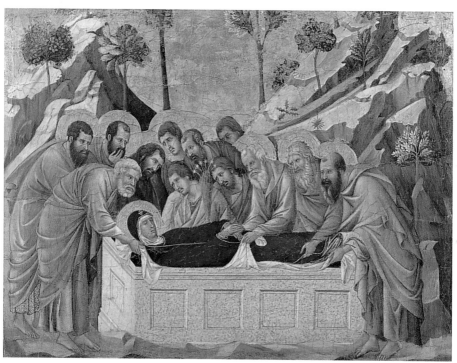

The Last Years

No reliable information exists on Duccio's artistic output during the years which elapsed from the completion of the *Maestà* up till his death some time between the end of 1318 and the first half of 1319. During recent restoration work (1979-80) in the Sala del Mappamondo of the Palazzo Pubblico in Siena, a new fresco was discovered below the imposing *Guidoriccio da Fogliano*, representing a castle on a hill and two people in the foreground. The attempt to discover the identity of the unknown author of this work has given rise to much controversy among critics. Max Seidel and Luciano Bellosi are in favour of Duccio, Brandi prefers Pietro Lorenzetti, Carli opts for Memmo di Filippuccio, Chiara Frugoni and Federico Zeri suggest Simone Martini (denying his authorship of the *Guidoriccio*). However, Duccio is known principally as a painter of panels and the problem remains unsolved. The fresco, of outstanding executive quality both in the skilful choice of descriptive detail and in its overall coherence, was badly damaged by the *Mappamondo*, a large, revolving, circular painting by Ambrogio Lorenzetti, which was placed on top of it in 1345.

The *Polyptych no. 47*, originally in the Hospital of Santa Maria della Scala and now in the Pinacoteca of Siena, is less problematic. Only the central part of the work is of indisputable Duccio authorship; the remaining panels are ascribed to an able, but as yet unknown, assistant. The poor condition of the panel with the Virgin and Child has reduced both its attractiveness and the possibility of more thorough research on it. However the superb monumentality of the half-length figures and the tender embrace of the mother and son reveal the undeniable presence of Duccio.

The unusual posture of the legs of the Infant Jesus reappears here, a repetition of a solution already achieved in earlier Madonnas (from the *Crevole Madonna* to the *Stoclet Madonna*).

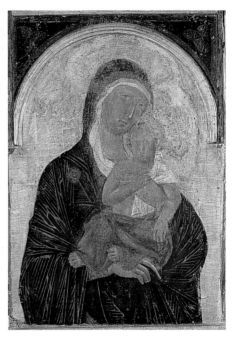

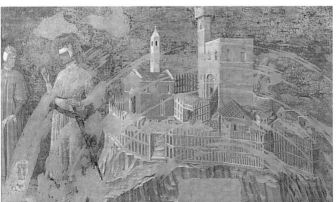

110. *Polyptych no. 47 Detail of the Madonna and Child Siena, Pinacoteca*

111. *Fresco discovered below the Guidoriccio da Foligno Siena, Palazzo Pubblico*

GIOTTO

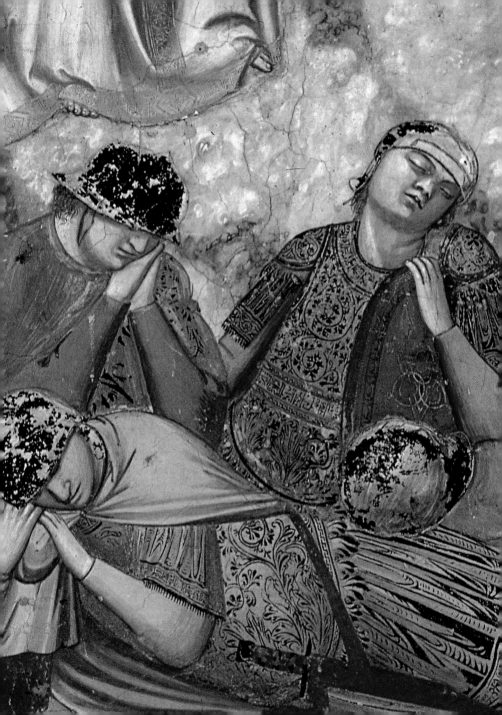

Early Works

For most people Giotto is the first name in European painting since antiquity. That he had breathed fresh life into painting was recognized by his contemporaries, and later by Ghiberti and Vasari. He had "that art which had been buried for centuries by the errors of some who painted more to please the eyes of the ignorant than the intellect of the wise," wrote Boccaccio (some ten years after the artist's death) in a tale of the *Decameron*, in which he stressed both the physical ugliness and lively wit of "the best painter in the world."

Before Giotto, painting was still considered a craft, a "mechanical" art. Giotto came to occupy a position of great respect in Florence, a city that was one of the most important centers of trade and commerce in Europe. He was representative of that spirit of rationality and efficiency typical of the Florentine mercantile class of the time. Though he was employed by the Bardi and Peruzzi families, owners of the most important European banking houses of the day, he never limited his activity to Florence, and prestigious commissions in other parts of Italy kept him constantly on the move. He worked at the basilica of San Francesco at Assisi, then one of the most prominent churches in Christendom; for the pope; for Enrico Scrovegni, the richest and most influential citizen of Padua; for the king of Naples; and for Azzone Visconti, the *signore* of Milan. He also provided the high altarpiece for St. Peter's in Rome. At a time when Italy's flourishing economy made every Italian city an independent cultural and artistic center, Giotto transcended regional barriers and the impact of his art was felt throughout the peninsula.

He was born in about 1265, and must have been active before the last decade of the thirteenth century. The first clear signs of the nature of his artistic revolution are to be found in fresco decorations in the Upper Church at Assisi: the Old Testament scenes starting with *Isaac Blessing Jacob*, the vault decorated with the *Doctors of the Church*, the New Testament scenes including *Christ Among the Doctors* and the *Lamentation*, and the St. Francis cycle. Despite the lack of knowledge surrounding Giotto's formative years, these frescoes can be considered the turning point of his early career.

Not *everyone* agrees that they were conceived and executed by the artist who later painted the frescoes in the Arena Chapel in Padua. Indeed, some feel that the Assisi frescoes were merely influenced by Giotto's art, that they were painted after the Paduan frescoes, or that they are a product of the Roman school. These views were first advanced by art historians of undoubted competence and are still held by many.

It is unlikely that the Assisi frescoes were painted after those at Padua. Space does not permit me to go into detail, but I shall give one example. If we consider the small angels (or would it be better to call them angelic spirits?) that appear in scenes such as the *Lamentation* and the *Confession of the Woman from Benevento* in the St. Francis cycle, we notice that they are cut off at the waist and terminate in drapery. This is in complete accordance with thirteenth-century iconography, and can also be seen in paintings by Cimabue. This detail, then, would appear to date the Assisi frescoes to a pre-Paduan period, and other details link them more specifically to the style of Cimabue.

There is a tendency to overlook the link between Giotto and his great Florentine predecessor, Cimabue. If we compare the Paduan and Assisi frescoes, we notice the difference between the softness and fluidity of the former and the sharp incisiveness of the latter, which gives the drapery an almost metallic appearance while the colors seem almost transparent.

Cimabue, from the destroyed *Crucifix* in Santa Croce to the *Evangelists* in the vault of the crossing of the Upper Church at Assisi, had employed similar "transparent" color. In this respect his *Madonna and Child* in the collegiate church of Castel Fiorentino is particularly close to Giotto's frescoes in the Upper Church. Duccio, whose style was, in part, derived from the work of Cimabue, had borrowed the splendid chromatic subtleties of his *Rucellai Madonna*, now in the Uffizi, from the Florentine master. This use of color in Giotto's Assisi frescoes separates them in time from the Paduan ones. It also suggests a parallel between Giotto's early activity and Duccio's development, from the transparency of color in early works like the *Rucellai Madonna* of 1285 to the chromatic density of his *Maestà* in Siena, painted between 1308 and 1311.

Giotto was probably working in Assisi by about 1290, more than a decade before he started on the Arena Chapel. The St. Francis cycle was probably painted at about this time, though it is usually dated after 1296 (Vasari records that the cycle was commissioned by Giovanni da Murro, who only became general of the Franciscans in 1296). This is not the place to examine the reason for this dating. Suffice it to say that Cimabue's influence, mentioned above, plus the suggested parallel with Duccio's painting, and the irreconcilable stylistic differences between the Assisi and Paduan frescoes can be only explained by the existence of a long interval between the execution of the two cycles. The difference between the St. Francis and Paduan cycles is much greater than that between the St. Francis cycle and Giotto's other fres-

1. *View of the nave of the Upper Church at Assisi with the Legend of St. Francis*

2. *The north transept of the Upper Church at Assisi with Cimabue's frescoes*

3. *Detail of Giotto's decoration of the Upper Church at Assisi*

coes in the Upper Church. This indicates that the interval between the St. Francis and Paduan cycles must have been much longer than that between the St. Francis cycle and the other Assisi frescoes.

In spite of the impression of unity created by the Upper Church frescoes, those by Giotto are easily distinguished, not only for their style, but also because they display a completely new concept. That fresco technique had changed radically by the time Giotto began work on his frescoes is evident from their state of preservation. The disastrous condition of Cimabue's frescoes (already noted by Vasari) is due to his faulty use of pigments and to the old practice of plastering as large an area as the scaffolding would permit. Giotto painted on several relatively small patches of plaster, as large as could be comfortably painted in a day. As the plaster was always wet, the pigment penetrated deeply and uniformly, ensuring the preservation of the colors. In this way only the final touches had to be painted on dry plaster, whereas the method used by Cimabue required large areas to be painted *a secco*, (i.e. when the plaster was dry).

However, the technique was not the only novelty, since the very conception of the fresco had changed drastically. Cimabue and his contemporaries had regarded the wall as a surface to be covered with two-dimensional representations. The decorations around the margins of the pictures were conceived as flat ornamentation, similar to that of a tapestry or miniature, and included large plant motifs, ribbons and other ornamental elements painted in flat, bright colors. But Giotto's frescoes create the impression of being framed by the very architecture of the church, and the scenes are represented three-dimensionally, as they would appear in the real world.

The walls on which the scenes of the life of St. Francis appear, which project out slightly beyond the upper part of the wall, have been decorated with painted mock architectural elements. These begin with the painted curtain running beneath the scenes of St. Francis and culminate in the simulated architectural framing of the scenes. Each bay of the nave

is divided into three sections (four in the case of the wider bay nearest the entrance) by twisted columns rising from the base, painted so that they appear to project above the architrave.

So resolute was Giotto's desire to impose this system of architectural illusionism that when the mock framings meet the projection of a real rib descending from the vault they are seen to slant downwards when viewed from the side. The fact that the same framing appears to be perfectly horizontal when viewed from the center provides a valuable indication of what the artist considered to be the ideal position for looking at the frescoes.

The scenes of the life of St. Francis appear to be set in space behind the mock architectural framework, which has been painted to look like part of the walls of the church. This gives the effect of peering into a series of small rooms, and calls to mind Leon Battista Alberti's concept (when discussing painting in the fifteenth century) of the surface of a painting as an open window through which we imagine we are seeing what is represented.

The scenes are planned according to principles of perspective that were first formulated in the two scenes from the life of Isaac on the upper walls. In these frescoes the delicate yet rationally articulated architectural setting creates a space that is clearly defined: the pale ocher sheet, whose edges are clearly detached from the bed underneath it; the partly drawn curtain and the horizontal rods that support it, one in the foreground, the other in the background; the foreshortened side wall with its oblique opening; the light-colored columns in the foreground; the small windows in the dark wall at the back; Isaac's halo, which blocks out part of the head of the servant who supports him from behind. The space thus created is very shallow, but it is just this constriction that makes it seem perfectly measurable. The effect of coherence is heightened by the disposition and treatment of the figures, whose solidity is established by the gravity of their attitude, the depth of the folds in the clothing, the strong modeling and the single light source.

There can be no doubt that such a coherent conception of space was regarded as an innovation, and that it was a discovery of immeasurable value to the future of Western painting. It was just this methodically constructed space of the Assisi frescoes that met with immediate and widespread acclaim, first in Italy and then abroad, especially from the second half of the fourteenth century.

Giotto was prepared to eliminate unnecessary complexity for the sake of putting his new ideas into effect with maximum clarity and consistency. His painting is much less ornate than that which preceded it, especially when compared with the intricate, teeming compositions of Cimabue and the young Duccio, who with their cold, transparent colors sometimes achieved extraordinarily soft and ethereal effects. By contrast, Giotto's painting is much simpler and more succinct, despite the many sculptural folds that characterize the drapery in his early frescoes, a legacy from the classical-style drapery of thirteenth-century painting.

The concept of space evident at Assisi had been known to the ancient world, and lost in the Dark Ages. But it was not merely a question of a new way of painting. The idea of reconstructing three-dimensional space illusionistically on a two-dimensional surface restored importance to that reality perceived by the senses which had been lost in the intervening

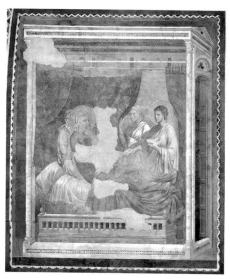

4, 5. *Isaac Blessing Jacob and detail of the scene depicting Isaac Rejecting Esau*
Upper Church, Assisi

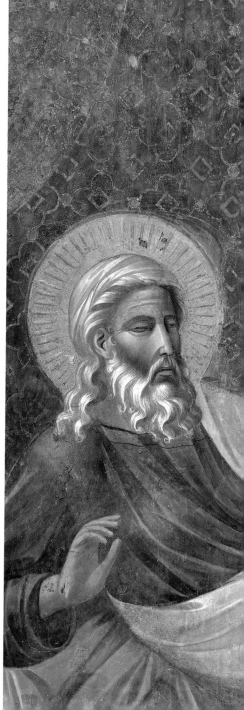

years, when the only true reality was considered to be that of the spiritual world. Giotto's reversal of this concept paralleled certain trends of thought, especially prominent among Franciscan intellectuals, that were to culminate in the Nominalist philosophy of Giotto's English contemporary, William of Ockham.

Giotto's architectural settings are not merely a means of creating pictorial depth, but also a reflection of contemporary Italian architecture. At times they are reproductions of real buildings like the Palazzo Pubblico and the Temple of Minerva in the Piazza del Comune at Assisi, both of which appear in the *Homage of a Simple Man*. The mosaic inlays which decorate the architectural structures in his Assisi frescoes, and which subsequently became commonplace in fourteenth-century frescoes, are nothing more than reproductions of the Cosmati work made by Roman marble workers throughout many parts of central and southern Italy.

Giotto's capacity for renewing the art of painting by observing reality through his own eyes becomes even more impressive if we consider the number of Byzantine conventions which were then firmly rooted in Italian painting. As prescribed by the Orthodox Church, Byzantine painting was based on the repetition of preexistent models and on faithfulness to established formulas. For the architectural setting of a "sacred story," Italian Byzantine painters resorted to stereotyped structures like the dome-shaped baldachin, evidently of Eastern origin. Even in representations of the *Leg-*

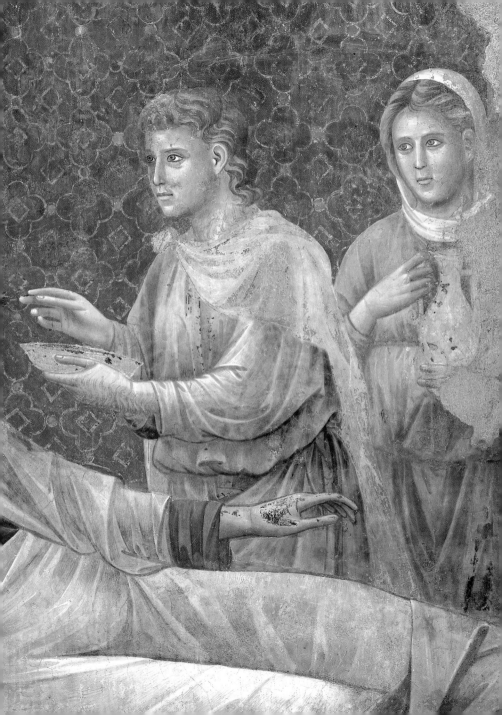

6. *Mosaic with Angel*
San Pietro Ispano, Boville Ernica (Frosinone)

end of *St. Francis*, which was more or less contemporary, and certainly not Oriental, the Berlinghieri family of painters and other thirteenth-century Tuscan masters had frequently used such pictorial clichés.

With Giotto's frescoes at Assisi, this tradition was discarded, together with pictorial formulas of an abstract significance, intended as reminders of a reality different from that of this world. Still present in the art of Cimabue and the young Duccio, these were banished by Giotto, and the painting of human beings regained a more normal, earthly appearance and a naturalness whose only immediate precedent can be found in French cathedral sculpture.

Christ's heavy body in the Santa Maria Novella *Crucifix*, which was soon to become a basic prototype (in 1301 Deodato Orlandi was already copying it in his *Crucifix* in San Miniato al Tedesco), is of such earthliness that some have considered it unworthy of being attributed to the sublime artist of the Arena Chapel frescoes. Yet the work is so much in keeping with the ideas Giotto was developing at that time in his Assisi frescoes that the figures of the mourning Virgin and St. John in the side panels are almost interchangeable with those of Esau and Jacob in the scenes of the *Story of Isaac*. The two groups of figures have enough features in common for us to be certain that they were conceived by the same artist: the wide, square shoulders; the intense gaze (sorrowful, as befits the occasion, in the two Florentine figures; slightly clouded by a melancholy reminiscent of Cimabue in the Assisi figures); the solemnity and stiffness of attitude; the many fine folds in the classical clothing; the ears shaped to

resemble the handles of an amphora; and, in the figures of the Virgin and Jacob, the nose flattened to form a sharp angle, the cheek defined by the shallow cavity that begins at the nostrils and the high cheekbones. Ghiberti cites the *Crucifix* in Santa Maria Novella as a work of Giotto's and a document of 1312 records a crucifix by Giotto in the same church.

These figures also bear a striking resemblance to the two half-length figures of angels, one at Boville Ernica and the other in the Vatican Grottoes, which are the only remains of Giotto's most famous work: the mosaic of the *Navicella* (*Christ Walking on the Water*), designed for the facade of St. Peter's in Rome and almost completely remade during the seventeenth century, following the reconstruction of the basilica, begun by Julius II in the sixteenth. The similarity is apparent in the old-fashioned way of draping the cloak over one shoulder.

After the two scenes of the *Story of Isaac*, the frescoes in the Upper Church at Assisi continue in the bay nearest the entrance. The work began, as was the custom, in the vault, where the four *Doctors of the Church* are depicted, and probably proceeded along the upper walls in the large lunettes flanking the windows where scenes from the Old and New Testament are arranged on two levels. Of the Old Testament scenes, the two of Joseph (*Joseph Cast into the Pit by His Brothers* and *Joseph and His Brethren*) in the lower tier are still partially legible, while there remains only a fragment of the scene above, the *Death of Abel*. The fragmentary New Testament scenes include *Christ among the Doctors*, the *Baptism of Christ*, the *Lamentation* and the *Resurrection*. This series is concluded on the entrance wall with the large scenes of the *Ascension* and the *Pentecost*, which are surmounted by tondi with busts of *St. Peter* and *St. Paul* and surrounded by a series of full-length figures of *Saints* arranged in pairs on the soffit of the entrance arch. The saints stand within lovely mullioned shrines painted illusionistically using the same technique that was to be applied to the framings of the *Legend of St. Francis*.

Since the frescoes in this series are not up to the standard of the two Isaac scenes, they are probably the work of the artists who later assisted Giotto in painting the *Legend of St. Francis*. The difference is especially evident in the scenes of *Joseph and His Brethren* and the *Pentecost*, the fresco of *St. Ambrose* on the vault, the bust of *St. Paul*, many of the figures of saints and the small busts of saints on the soffits of the two arches linking the vault to the side walls. But here, too, the treatment is faithful to the new vision that first appears in the *Story of Isaac*. Looking at these frescoes, one gets the impression that Giotto's ideas have been interpreted in a somewhat archaic manner, (especially in the fresco of *St. Ambrose*), and in the apparent reluctance on the part

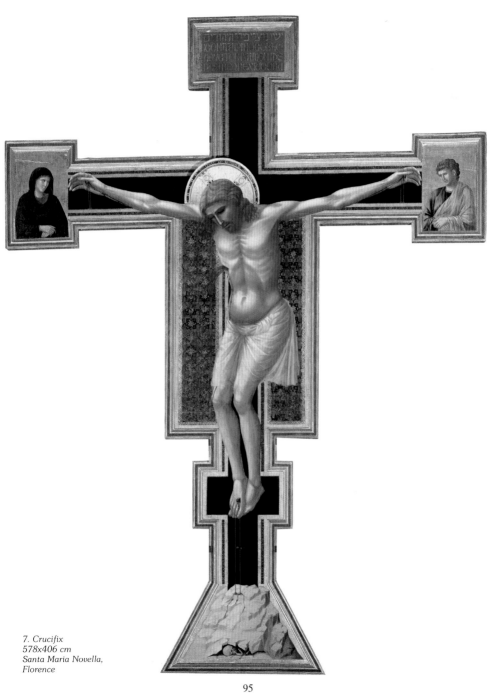

7. *Crucifix*
578x406 cm
Santa Maria Novella,
Florence

8. The inside of the façade of the Upper Church at Assisi

of the painters to abandon abstract pictorial formulas of Byzantine origin (see the small busts of saints), a less convincing solidity of figure (see *Joseph and His Brethren*), and an excessive attention to detail in certain parts (see the figures in the *Pentecost*).

Yet most of the frescoes maintain a dramatic tension and pictorial incisiveness that places them on a

level with the scenes from the story of Isaac and the *Crucifix* in Santa Maria Novella. Certain aspects of these works are of a very high quality indeed: the intensity of expression of the young Christ among the doctors; the solemn expression of grief in the *Lamentation*; the profound, concentrated gaze of St. Peter in the tondo; the remarkable foreshortening of the sleeping soldier in the *Resurrection* (strongly reminiscent of the foreshortening used in the figure of the

9-11. Joseph Cast into the Pit by His Brothers;
The Cup Found in Benjamin's Sack; Lamentation over
Christ's Body
Upper Church, Assisi

friar kissing the saint's hands in the *Death of St. Francis* in the Bardi Chapel of Santa Croce); the acolyte who writes at the saint's dictation in the fresco of *St. Gregory*, (the same face, the same air of melancholy as in the figure of Jacob); the imposing composition of the *Ascension*, where Christ, who has Isaac's slender, tapering fingers, is borne aloft on a cloud which is both soft and yet strangely rock-like.

The frescoes of the entrance bay are so fragmentary that it is difficult to evaluate the innovations in composition and spatial experiments first seen in the *Story of Isaac*.

Nevertheless, a few words should be devoted to the *Doctors of the Church*, which are in a good state of preservation. Each of the four learned men is accompanied by his acolyte, and above each pair is a bust of Christ, framed in a cloud. Following the model of Cimabue's four *Evangelists* in the vault above the altar, the various objects represented in each fresco are made to converge towards the vertex of the triangular field. It is almost as if the artist had attempted a kind of view from below upwards, and therefore incorporated the convergence towards the vertex into the foreshortening.

The chief interest of these frescoes lies in the fact that for the first time in the history of painting they represent the polychrome effects of bright marble, inlaid with mosaic decorations and embellished with colored molding, which had been used on the facades of the most important churches in Central and Southern Italy, and in their furnishing – ambones, episcopal thrones, altars and tabernacles.

So great were Giotto's interest in physical reality and his capacity for expressing it in painting that even his wooden furniture assumes an amazing, almost *trompe-l'œil* tangibility. Some of the objects are depicted down to the last detail, as can be seen in the writing desk of St. Gre-

gory's acolyte, and in the scroll on which he writes, where even the two eyelets in the paper are shown.

One is reminded of the panel painting, clearly the same *Madonna and Child* by Giotto described by Ghiberti, in the church of San Giorgio alla Costa in Florence and now in the Museo Diocesano di Santo Stefano al Ponte. The panel has been cut on both sides, but from what remains we can reconstruct the bright marble throne embellished with rose-colored moldings and strips of Cosmati work, terminating in a Gothic cusp edged with foliage-scrolls – exactly like those on the aedicules of the *Doctors of the Church* at Assisi. Here, too, small details, such as the rings and cord by which the cloth is suspended from the throne, are rendered with great clarity. In this painting we find the same deliberate contrast of fragility and strength, of

12. Madonna and Child, detail
Upper Church, Assisi

the delicately rendered minutiae of the supporting structure and the ponderous weight of the figures, that also characterizes the *Ognissanti Madonna*, now in the Uffizi. But let us return to Assisi, bearing in mind the image of the two elegant, slightly melancholy angels in the Florentine painting so that we can compare them with the figures in the Upper Church frescoes. Of particular interest is the angels' hairstyle, consisting of wide coils above the ears and loose waves at the back, which is exactly like that of the elderly Isaac.

The decoration of the Upper Church was planned from the very beginning to conclude with the *Legend of St. Francis* on the lower walls, which protrude slightly beyond the upper walls. The whole was conceived according to a scheme which incorporated both the iconographical and the decorative aspects of the frescoes. No representation in the Upper Church is duplicated, except for the *Crucifixion*, which appears among the scenes in the nave, and is repeated on either side on the east walls of the transept. In this case the repetition was intentional and must have been planned from the beginning, as is demonstrated by the fact that the two scenes appear in the same position in the Lower Church, where the aim of the old thirteenth-century decorations, destroyed when the side chapels were built, was to establish parallels between the life of Christ and that of St. Francis. This idea was repeated in the Upper Church with greater richness and with the inclusion of scenes from the Old Testament. At certain points the parallel becomes very evident; for instance, the *Confirmation of the Rule* appears below *Isaac Blessing Jacob*, and the *Death and Ascension of St. Francis* (who has just received the stigmata) below the *Crucifixion*.

13. *Vault of the Doctors Upper Church, Assisi*

14. *Madonna and Child Museo Diocesano di Santo Stefano al Ponte, Florence*

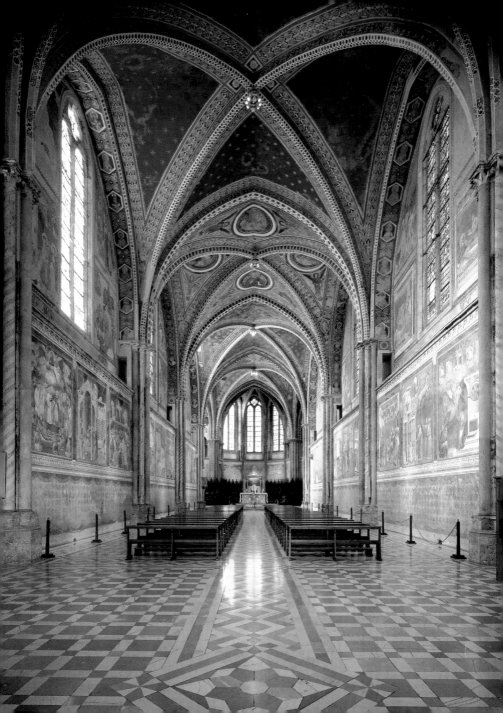

The *Legend of St. Francis* in the Upper Church at Assisi

A strong argument for the idea of a general plan for the whole nave is provided by the system of decoration, in which an impression of continuity is maintained in spite of the radical change in the pictorial conception which occurred over the course of the work. In fact, the decorative motif of the row of mock corbels which support the mock architrave at the top of the projecting wall where the *Legend of St. Francis* appears had already been used for the same purpose by Cimabue in his frescoes in the transept. This fact alone suggests that the decoration of the church, which was begun at a time when the basilica of San Francesco was perhaps the most important place of worship in Christendom – the center of the most widespread religious movement the West had known since the advent of Christianity – was carried out with few interruptions. And it might reasonably be supposed that the decoration of such an important church would not have been left incomplete for very long, nor the unsightly scaffolding employed in its decoration tolerated any longer than was necessary.

As for the part of the decoration carried out by Giotto, the motif of the mock corbels can be used as an indication of the order in which the *Scenes from the Old and New Testament* and the *Legend of St. Francis* were painted. We have already seen that Cimabue employed the same corbels in the frescoes in the transept, though his way of painting them was completely different from the manner in which Giotto was to use them above the St. Francis cycle. Cimabue's corbels are two-dimensional, and painted in inverted perspective, i.e. the side brackets are made to diverge – instead of converge, as they would appear to the eye – from the central one. The painted corbels above the *Legend of St. Francis* correspond much more to visual reality since they are represented as solid objects and converge towards the central corbel. The row of corbels on the ribs of the vault of

the *Doctors of the Church* was painted according to the system used by Cimabue, but in a small section of the upper walls, between *Joseph and His Brethren* and the *Pentecost* and between the *Resurrection* and the *Ascension*, the fake architecture is surmounted by a row of brackets painted by the same method Giotto was to use for the ones above the St. Francis cycle. This is evidently a method that he worked out gradually as the decoration proceeded.

There is another aspect to be considered. Work on the St. Francis cycle began with *St. Francis Giving His Mantle to a Poor Knight*, the second of the twenty-eight scenes, while the first scene, the *Homage of a Simple Man*, was probably painted last. This is because the beam of the iconostasis, or rood screen, a piece of which is still visible, was to be inserted into the wall in the area occupied by the first scene. Evidently, it was only towards the end of the work that it was decided to fresco the first and last areas of the wall as well, painting them in such a way that the beam could be inserted into the neutral area of the blue background.

There is a remarkable difference between the first and second scenes of the cycle. In the *Homage of a Simple Man* the painting has become softer, the transitions of color are more delicate and the clothing has a very soft, velvety consistency which, especially in the case of the figure on the far right, already looks forward to the Arena Chapel frescoes. But *St. Francis Giving His Mantle to a Poor Knight* is still distinguished by a transparent, almost metallic color which creates the effect of granite in the rocks of the landscape. Moreover, the head of the young St. Francis in this fresco is closer to those of Esau, Jacob, St. Gregory's acolyte, and the two mourners in the Santa Maria Novella *Crucifix* than it is to the softer, more mature head of the saint in the *Homage of a Simple Man*. In short, there would appear to be less differ-

15. Interior of the Upper Church at Assisi

ence between Giotto's frescoes on the upper walls and the early works of the St. Francis cycle than there is between the first and last frescoes of the St. Francis cycle. This suggests that as soon as they had finished the frescoes on the upper walls, Giotto and his team of painters began work on the *Legend of St. Francis*, taking more time over it because there was a larger surface to cover, and because the work, being nearer the observer, had to be carried out with greater care.

The execution of large parts of the twenty-eight scenes of the *Legend of St. Francis*, especially the final ones, (for instance, the kneeling friars in the *Confirmation*, *St. Francis before the Sultan*, some of the figures in the *Institution of the Crib at Grec-*

cio) is doubtless of a somewhat lower standard than one would expect from Giotto himself. But even though the contributions made by his assistants are sometimes so individual in their treatment that we can attempt to identify the individual artists (Memmo di Filippuccio? The Master of the Montefalco Crucifix? The Master of St. Cecilia? Marino da Perugia?), all the scenes, including the final ones, are distinguished by a unity of conception and a consistency of outlook found only in the work of Giotto. In fact, the works executed by these artists independently reveal that they never approached Giotto's level of achievement; the style of one painter is insufficiently articulated, another is over-expressive, yet another is excessively

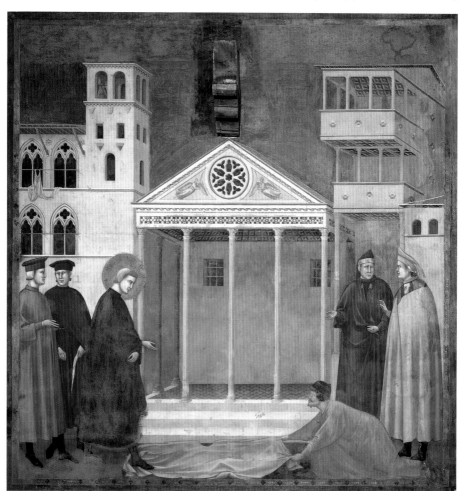

16-18. Legend of St. Francis: Homage of a Simple Man; St. Francis Giving His Mantle to a Poor Knight; Dream of the Palace Filled with Weapons

concerned with detail. Only one work bears comparison with these frescoes: the *St. Francis Receiving the Stigmata* in the Louvre. And it is signed by Giotto.

I have already dealt with the mock architectural framework, so beautifully depicted in its detail, surrounding the *Legend of St. Francis*. Each bay is divided into three almost square panels, save for the bay nearest to the entrance, which has four compartments, and the facade wall, which has two sections higher than they are wide. The vanishing points are located in the center of each bay, as is indicated by the disposition of the painted corbels. This, the most extensive of all St. Francis cycles, and one which was to serve as a model for many years, consists of twenty-eight stories based on the official biography of the saint, St. Bonaventure's *Legenda Maior*. Each scene has an accompanying explanatory inscription in Latin.

The scene of *St. Francis Giving His Mantle to a Poor Knight*, the first to be painted, takes place in the open air, at the foot of two rocky hills. The town perched on the hill on the left is Assisi; we can see its crenelated walls, the profile of its towers and roofs against the sky and the church of San Damiano outside the walls. Anyone who has had the opportunity to see hillside towns such as Cortona, Spello and Assisi from the plain below can fully understand the accuracy of this painting. A rocky landscape like the one shown here, a legacy of Byzantine painting, may have first appeared in *Joseph Cast into the Pit by His Brothers* (as far as we can tell from what remains) or, more likely, in the *Death of Abel*, which has al-

most completely disappeared. It is a conception that was to be beautifully expressed in the *Miracle of the Spring* and *St. Francis Receiving the Stigmata* and adopted by nearly all painters up to the beginning of the fifteenth century. It was codified in the celebrated passage in Cennino Cennini's *Trattato della Pittura,* doubtless inspired by Giotto's principles: "If you want to paint natural-looking mountains, take some large jagged rocks, and paint them from nature, adding light and shade as reason dictates."

The beautifully rendered cloak in *St. Francis Giving His Mantle to a Poor Knight* is reminiscent of the blanket that covers the old patriarch's legs in *Isaac Blessing Jacob*. The folds of this garment have such convincing thickness that it almost seems possible to insert a hand into them. In the next scene, the *Dream of the Palace*, the blanket that covers St. Francis as he sleeps has a similar tangibility. The composition of this scene is very similar to that of the third fresco in the next bay, the *Dream of Innocent III*. The bedchambers in the two frescoes call to mind the scenes of Isaac, though the furnishings and architecture appear to be more in keeping with the style of Giotto's time. The two dreams are depicted very literally: the first dream is of a strange and narrow palace in the Italian Gothic style, which stands next to the bed as if it formed part of the chamber's sumptuous furnishings; the second is that of Innocent III. In his dream the pope saw the Church upheld by the Franciscans. The painter showed St. Francis literally propping up the church of San Giovanni in Laterano as it appeared at that date, after Nicholas IV's restoration of 1290. The facial expression of the youthful St. Francis as he supports the church is one of the most intense in the whole cycle.

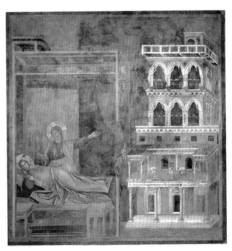

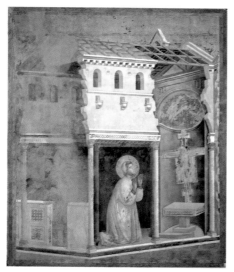

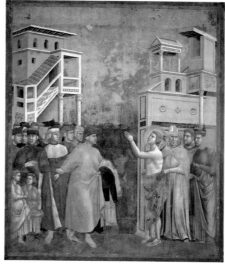

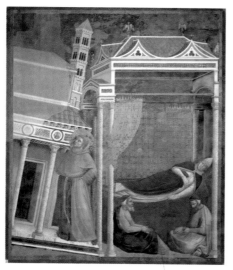

19-22. Legend of St. Francis: The Miracle of the Crucifix;
The Renunciation of Worldly Goods; The Dream of
Innocent III and detail

As if they were intended to emphasize the personal and private nature of the saint's early life, these first scenes are very simple, and contain few figures. This is especially evident in the *Miracle of the Crucifix*, where there are only two basic elements, the dilapidated church – where we can see the crucifix on the altar – and the young St. Francis. The church, set at an oblique angle, is shown with segments of the wall removed (like a broken vase) both to symbolize its state of moral decay and to enable us to see the inte-

rior with the speaking crucifix. St. Francis is there symbolically rather than actually, painted on a larger scale than the building.

This treatment of figure and architecture as independent elements was to remain a feature of fourteenth-century painting, becoming accentuated in the early fifteenth century, and employed in a deliberately unnatural way in certain late Gothic works. This trait can also be seen in the painters of the Early Netherlandish School; Jan van Eyck's *Virgin in a Church*, in which the Virgin's head is on a level with the capitals in the nave, is a typical example, and one that can be compared to the *Miracle of the Crucifix*. The conception of a pictorial story as an agglomeration of separate incidents was to be greatly simplified in Giotto's later works, especially in the frescoes in the Bardi and Peruzzi Chapels in Santa Croce. But it took the rationalism of Brunelleschi, and the art of Donatello and Masaccio, to do away with it completely.

The next scene gives us an opportunity to examine one of the most important of Giotto's innovations. Although the mastery of the method of representing the third dimension is of fundamental importance, there are other innovations which are no less significant to the development of Western painting. Among these must be included the use of eloquent gesture, the communication of strong emotions through attitude and facial expression. In the *Renunciation of Worldly Goods*, St. Francis's father ex-

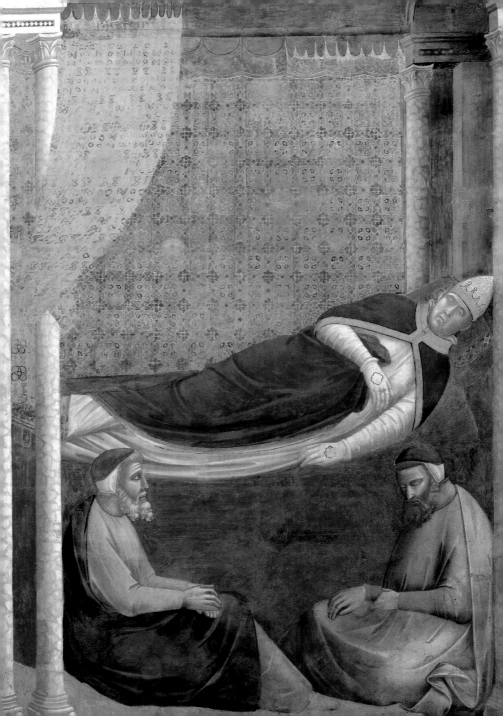

23-26. Legend of St. Francis: The Confirmation of the Rule and detail; The Vision of the Flaming Chariot; The Vision of the Thrones

presses his anger in his grimace, in his gesture of lifting the hem of his gown (as if he were about to dash at his son), and in his clenched fist; the effect is heightened by the gesture of his friend, who holds him back by the arm. Within the limits of the dignity and self-restraint that Giotto impresses on all his characters, the father's anger is expressed clearly and vividly.

St. Francis Preaching before Honorius III is one of the scenes of the *Legend of St. Francis* in which gesture, attitude and facial expression are essential to the story, and in this respect it was to become a model for fourteenth-century painters. Although some have felt St. Francis's gesture to be vulgar, it was certainly not considered coarse in Giotto's day: that lively way of indicating with the thumb was to reappear in such paintings as Pietro Lorenzetti's *Virgin with St. Francis and St. John* in the Lower Church of San Francesco. The prelates' gestures of meditation and wonder were to become extremely common in the course of the fourteenth century, but here they were total innovations.

Of the frescoes on the upper walls, it is the *Lamentation* which provides a rich display of profoundly expressive gestures of sorrow. This scene was usually depicted with the mourners screaming and thronging around the dead Christ, but here it becomes a masterly interpretation of grief reminiscent of the attitudes of classical statuary. The tone is livelier and less rhetorical in the scenes of sorrow of the St. Francis cycle – the *Death of the Knight of Celano,* the *Death and Ascension of St. Francis,* and *St. Francis Mourned by St. Clare.* It should be remembered, however, that the *Legend of St. Francis* tells the story of a man who had died within living memory and deals with events that were almost contemporary, and with men and women who lacked the legendary glory of Old and New Testament figures. There can be no doubt that the tone of the frescoes

106

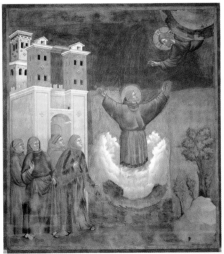

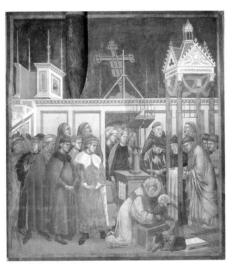

27-31. Legend of St. Francis: Expulsion of the Devils from Arezzo; The Ordeal by Fire before the Sultan and detail; The Ecstasy of St. Francis; Institution of the Crib at Greccio

on the upper walls is more courtly and more solemn, as it was to be in the frescoes depicting the lives of the Virgin and Christ in the Arena Chapel at Padua, while in the *Legend of St. Francis* the narrative tone is livelier and more direct to suit the characters.

At that time Dante was theorizing about various styles: a "superior" style for tragedy, an "inferior"

style for comedy (his *Divine Comedy*), and a style "of compassion" (*miserorum*) for elegy. The three styles had their respective idioms in an "illustrious vernacular," a "vernacular sometimes mediocre, sometimes humble," and an "exclusively humble vernacular." And when Jacopo Torriti included St. Francis and St. Anthony of Padua among the time-honored saints of the Gospels in his apse mosaics in San Giovanni in Laterano and Santa Maria Maggiore, in Rome, he made them on a smaller scale than the others. Thus a lesser dignity was conferred on these new saints,

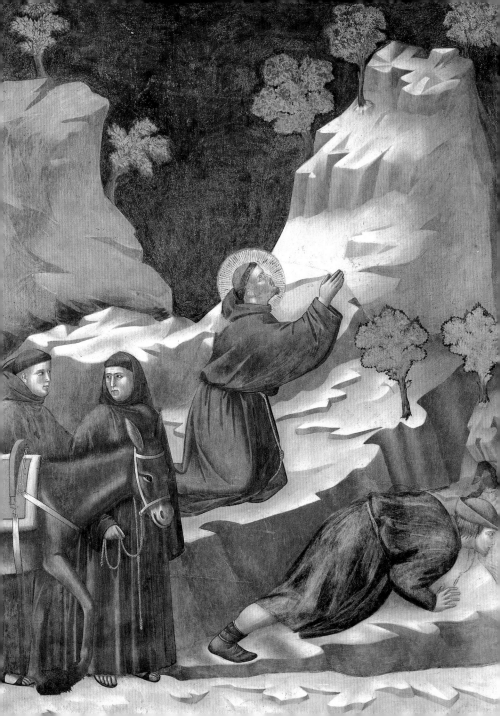

who were felt to be intruders in such a solemn gathering. Boniface VIII even planned to have them removed from the apse of San Giovanni in Laterano.

However unsatisfactory the execution of the figures may be, the *Confirmation of the Rule* and *St. Francis Preaching before Honorius III* have the most organic spatial constructions of all the Upper Church frescoes. These scenes, which have a perfectly centralized viewpoint, are two of the most outstanding examples of Giotto's conception of space as a cubic box that is open at the front. Notice how cleverly this space has been contrived. Our attention appears to be drawn to the upper part of each fresco, occupied by a series of protruding arches supported by sturdy consoles in the *Confirmation of the Rule*, and by the first surviving depiction of a groin vault in the history of Italian painting in *St. Francis Preaching before Honorius III*. Such perfection of spatial construction is found only in the frescoes in the Arena Chapel, Padua, and the Bardi Chapel in Santa Croce, and those in the right transept of the Lower Church at Assisi, all of which are by Giotto.

Another noteworthy feature of the *Confirmation of the Rule* is the arrangement in depth of rows of kneeling friars behind St. Francis. The first time anything of the kind appears in Italian painting is in the scene of *Joseph and His Brethren* on the upper wall, where Joseph's brothers are always painted in horizontal rows parallel to the picture plane, as if they were standing on a series of progressively higher stools. Duccio still preferred this arrangement for the saints in his *Maestà* at Siena, while Simone Martini showed the rows of figures around the Virgin at a slightly oblique angle in his *Maestà* in the Palazzo Pubblico, Siena. The latter system had been introduced and systematically employed by Giotto, in perfect harmony with his conception of pictorial space.

The five scenes from the *Vision of the Flaming Chariot* to *St. Francis in Ecstasy* are characterized by inferior workmanship, especially in the figures, though they do contain some remarkable inventions. The conception of the sleeping friars in the *Vision of the Flaming Chariot* is extraordinary; one of them is a more expressionistic version of the foreshortened soldier who sleeps with his head resting on the back of his hand in the upper-wall scene of the *Resurrection*. Worthy of note in the *Vision of the Thrones* are the trompe-l'œil clarity of the thrones suspended in space and the representation of the lamp in front of the altar, which has a cord for lowering it to replenish the oil. The *Expulsion of the Devils from Arezzo* is impressive for its depiction of a walled city, which is shown as a vertical mass of houses, towers, chimneys, roofs and roof terraces, all perceived as components of a single entity. The large church on the left, seen from the end with the apse, bears a

strong resemblance to the parish church of Santa Maria in Arezzo.

In many respects the *Institution of the Crib at Greccio* is one of the most interesting scenes in the cycle. It is set inside the church, viewed from the presbytery, in front of the transept dividing the latter from the nave. As women were not allowed in the presbytery, they are shown looking on from the doorway of the transept. Everything in the church is seen from behind: the pulpit with its lighted candles; the table of the lectern, on which is placed the antiphonary, or book of responses, of the four singing friars; the tabernacle in the style of Arnolfo di Cambio, decorated with Christmas garlands above the altar; and the cross, which leans towards the nave, its wooden backing and supporting structure clearly visible, something that was unheard-of at the time. In this scene too, many of the figures have been executed somewhat mechanically by Giotto's assistants (especially the heads of the priest and the acolytes standing behind him on the right), though the highly expressive, lifelike figures of the singing friars are among the best in the whole of the St. Francis cycle.

The two scenes on the entrance wall, the *Miracle of the Spring* and the *Preaching to the Birds*, the

32, 33. Legend of St. Francis: Miracle of the Spring; Preaching to the Birds

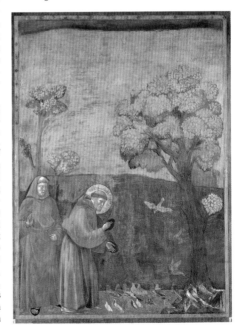

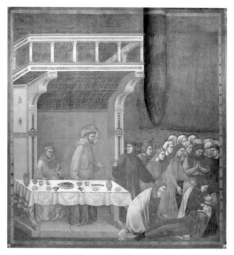

34-37. Legend of St. Francis: Death of the Knight of Celano; St. Francis Preaching before Honorius III; The Apparition in the Chapter House at Arles; St. Francis Receiving the Stigmata

compositions in which Giotto's hand is most apparent, are too famous to require a lengthy description. As Giotto's conception of the landscape in the former has already been mentioned, I shall merely point out the amazing precision with which the ass's packsaddle has been rendered. The *Preaching to the Birds*, on the other side of the doorway, provides an obvious foil for the *Miracle of the Spring*. The former is set on an open plain, where the figures are overshadowed by tall trees, while the vegetation in the latter consists of the wild scrub of the Mediterranean region, which must have been typical of the uncultivated uplands in Giotto's day.

Between these scenes, above the entrance, Giotto frescoed a large tondo of the *Virgin and Child* and two smaller tondi of angels. Although in a very poor state, these images are among the finest in the Upper Church, especially for the way in which the figure of the Virgin spreads out like a dome, the vividness of her veil and the sturdy grip of her left hand. In the Child we see the first smile in Italian painting.

The four scenes in the first bay of the left wall deal with the last events in the saint's life, and are among the most fascinating in the cycle. Some of them have already been described, so it will be enough to point out the table in the *Death of the Knight of Celano*, which is covered with a lovely embroidered tablecloth and laid with food, crockery and cutlery. Worthy of notice in *St. Francis Preaching before Honorius III* is the rich Cosmati work on the pope's foot stool, whose bright colors recall the vault of the *Doctors*. In the *Apparition at Arles* we are given a remarkable oblique view of the chapterhouse, its back wall pierced by three openings. The massive figures of the friars seen from behind anticipate certain features of the Paduan *Lamentation*. The range of attitudes adopted by the friars, the varied colors of their habits and the massive figure of St. Anthony on the left are among the most memorable aspects of this work. In the *St. Francis Receiving the Stigmata*, the rocks take on an almost phosphorescent luminosity on what is the darkest wall in the church.

Giotto's authorship of some parts of the following frescoes is often questioned, and in the case of those in the last bay, denied completely. The fact that a work was painted by the artist himself mattered much less to the public of Giotto's day than it does to us, accustomed as we are to assigning importance (and therefore a price) only to pictures, preferably signed, by an individual artist. In those days the artist worked with a team of assistants, and not every painting that left his studio was entirely his own work, even though it might have been signed by him. If the St. Francis cycle at Assisi had borne a signature it would probably have been Giotto's, however likely it was that his assistants played a key role in the execution.

The final frescoes have a greater affinity with the overall cycle than with the works of other painters who have been suggested as Giotto's assistants. Even the last three scenes have very little relation to the

38-40. Legend of St. Francis: Death of St. Francis, The Appearance to Brother Agostino and the Bishop of Assisi; Verification of the Stigmata

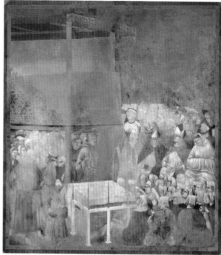

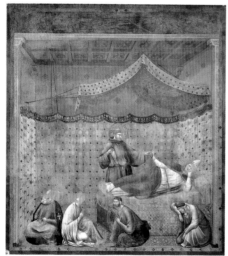

41-43. Legend of St. Francis: St. Francis Mourned by St. Clare; Canonization of St. Francis; The Dream of Gregory IX

meticulously Gothic manner used by the Master of St. Cecilia in the painting, now in the Uffizi, from which he takes his name. They have much more in common with the other frescoes of the St. Francis cycle, a fact we can more readily acknowledge if we admit that some development was inevitable over the course of the execution of such a complex work.

No one can deny the superb quality of certain parts of the frescoes in the second bay of the left wall, such as the beautiful angels flanking the ones bearing the saint's soul to paradise in the Death and Ascen-

sion of St. Francis. The setting of the Verification of the Stigmata inside the church, where the three icons – the Virgin, Christ Crucified and St. Michael – on the rood screen are shown leaning forward, and the curved wall of the apse is shown in the background, is a conception found only in the Institution of the Crib at Greccio. In St. Francis Mourned by St. Clare the facade of an Italian Gothic church is shown in the background, the first representation of its kind, decorated not only with marble and Cosmati work but also with sculpture in high relief.

This and the next scene, the Canonization of St. Francis, in which, despite its damaged condition, we can still perceive the splendid arrangement of the group of onlookers, lead naturally to a consideration of the style of dress Giotto adopted for his lay figures, both male and female – a consideration which can also be extended to other scenes such as the Homage of a Simple Man and the Renunciation of Worldly Goods. He evidently thought it incongruous to use, as the Berlinghieri had done, the semi-classical dress customarily used in Biblical scenes to represent events from the very recent past. So he dressed his lay figures in contemporary clothing, just as he had made the buildings in the scenes reflect the architecture of his own time. This idea was so successful that it inspired artists over the next two centuries to introduce figures in modern dress into their works, even when representing events from the past. In considering the

stylistic differences between the upper wall frescoes and the *Legend of St. Francis* (or the latter and the Paduan frescoes), we should bear in mind the realistic effect created by the use of contemporary dress.

Giotto was not the first to use modern dress: an anonymous artist had already done so in the painting of *St. Clare*, dated 1283, in the church of the same name at Assisi. In this painting the lay figures in the small lateral scenes are dressed in what is unmistakably contemporary clothing. This style of dress, in many respects similar to that of the lay figures in the St. Francis cycle, appears antiquated in comparison to the style of clothing depicted in the Arena Chapel frescoes. We must therefore conclude that the Assisi frescoes were painted much earlier than the Paduan ones.

The *Dream of Gregory IX* is distinguished by yet another remarkable representation of space. The scene is set in a well-proportioned room akin to those in the *Confirmation of the Rule* and *St. Francis Preaching before Honorius III.* However, the fact that the spatial construction is no longer perfectly centralized constitutes a step towards the artist's later treatment of interiors. Of special interest here is the strong definition of the curtain suspended from the ceiling, which heightens the credibility of the spatial setting.

The final scenes of the story – the *Healing of the Man from Lerida,* the *Confession of the Woman from Benevento*, and the *Liberation of the Repentant Heretic* – are characterized by an extremely delicate architectural structure, and slender, elongated

figures. Yet parts of these works are of very high quality, and comparable to the work of Giotto himself. This is true of the beautiful secondary episode of St. Francis kneeling before Christ in the upper left-hand corner of the *Confession of the Woman from Benevento,* and of the delicate, mock bas-reliefs on the round tower, inspired by Trajan's Column, on the right in the *Liberation of the Repentant Heretic.* Moreover, the figure of the prisoner, a man named Pietro d'Assisi, anticipates certain physical types which appear in the Arena Chapel frescoes – for instance, the bearded man kneeling on the far left in the *Prayer of the Suitors.*

The evolution towards the softer effects characteristic of the Paduan frescoes has already been men-

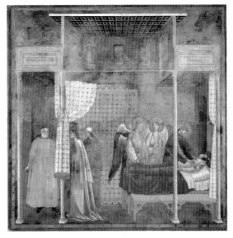

44-46. Legend of St. Francis: The Healing of the Man from Lerida; The Confession of the Woman from Benevento; The Liberation of the Repentant Heretic

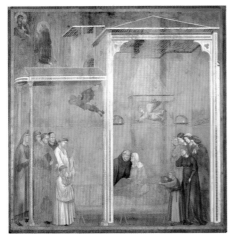

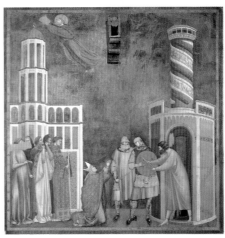

tioned in connection with the *Homage of a Simple Man*, which is the first scene of the story, although the last to be executed. It has even been suggested that these final works were painted after the Arena Chapel frescoes, but all we have to do to exclude this possibility is to consider one detail – the profile. From a strictly naturalistic point of view the profiles in the St. Francis cycle, including the final scenes, appear to be imperfectly realized. By contrast, the profiles in the Paduan frescoes are wholly convincing and, moreover, they are used to create some of the most dramatic moments in the narrative, as can be seen in the *Betrayal of Christ*, where the profiles of Christ and Judas are juxtaposed in the center of the scene.

From the fourth century up until the end of the thirteenth, sacred and important figures were invariably shown frontally. As a result, the use of the profile, which was reserved for representations of evil or marginal figures, became less frequent as time passed. To indicate that one figure was addressing another, the artist would merely incline one head, still seen in full face, towards another. As a result of this convention, the ability of artists to "see" and represent the profile gradually diminished, as is demonstrated by the few works in which it was employed. The presence of this "defect," like that of the archaic form of the "angelic spirits," in the *Legend of St. Francis* provides further proof of the fact that the Assisi frescoes predate those in the Arena Chapel.

The Assisi frescoes would seem to belong to an early stage in Giotto's career, when he and his workshop were still attempting to assimilate the Gothic innovations which were invading the Italian visual arts. If this is true, then the delicacy of the architectural structures and the elongation of the figures in the final scenes of the St. Francis cycle may also justify suggestions that the Master of St. Cecilia worked on them. These Gothic elements, which also appear in the predella scenes of *St. Francis Receiving the Stig-*

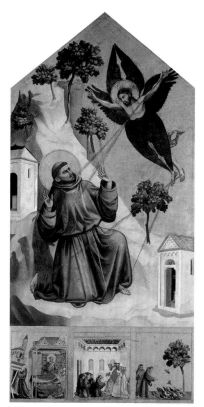

47. St. Francis Receiving the Stigmata
314x162 cm
Louvre, Paris

48. Badia Polyptych
91x334 cm
Uffizi, Florence

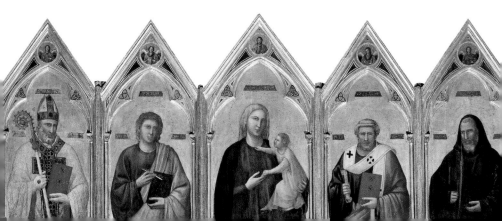

mata in the Louvre, signed by Giotto, go back to the period in which Duccio di Buoninsegna was approaching the mature Gothic style of his late works. The great Sienese goldsmith Guccio di Mannaia, craftsman of the chalice donated by Nicholas IV to the Franciscan basilica between 1288 and 1292, was also an early exponent of the French Gothic style in central Italy.

If we consider the St. Francis cycle as a whole, we are forced to admit that Giotto's interpretation of the famous saint is not particularly mystical: St. Francis is a pious and devout figure, yet solid and earthly, far removed from the ascetic saint in earlier thirteenth-century paintings. The objects in these frescoes have been couched in such concrete form that even the metaphysical episodes seem to have been brought within the sphere of everyday experience.

The fact that this cycle served for so long as a model for the representation of the saint's life is probably due to the dominance of the more worldly interpretation of St. Francis's teaching by the "Conventual" faction in both the papacy and the Franciscan order itself. It was an interpretation particularly agreeable to the rich Roman Curia, and in keeping with the interests of the new middle class which had control of the main cities of central Italy.

The opposing faction in the order, known as the "Spirituals," wished to return to the simple, ascetic life of poverty demanded by St. Francis himself.

I have already touched upon the panel in the Louvre with *St. Francis Receiving the Stigmata*, signed by Giotto and painted for the church of San Francesco at Pisa. The main scene and the three smaller scenes of the predella – the *Dream of Innocent III*, the *Confirmation of the Rule*, and the *Preaching to the Birds* – are obvious variations on the theme of the Assisi frescoes. Critics have tended to concentrate on the unmistakable iconographical similarity of the two groups and pay less attention to their equally evident stylistic affinities. What is most interesting to note in this work is the refined Gothic elegance, apparent in the elongated figures of the predella scenes. The panel is stylistically close to the last Assisi scenes

and was the point of departure for the style of Florentine artists like the Master of St. Cecilia, although he never achieved the degree of spatial coherence shown by Giotto here. It is this signed work, even more than the remains of the *Navicella* mosaic, which constitutes the most important proof of Giotto's authorship of the Assisi frescoes.

The *Badia Polyptych* (Uffizi, Florence), which was mentioned by Ghiberti and discovered some time ago in the church of Santa Croce, must have been painted around the same time. In spite of the very poor condition of the work, we can still clearly perceive the solemnity of treatment which Giotto reserved for these saints. The dignified row of the half-length figures in the five panels and the rhythmical repetition of the nameplate on the gold ground above their heads make this work one of the artist's masterpieces. The Virgin recalls the one in the tondo above the entrance of the Upper Church at Assisi.

Giotto's stay in Rimini, which was recorded by contemporary chroniclers, must have preceded the decoration of the Arena Chapel at Padua. The precocious flowering of a Rimini school of painting clearly inspired by his art bears this out, as does the fact that the Rimini school appears to reflect a stage in Giotto's development still fairly closely tied to the criteria of simple contiguity used to link the architectural settings of many of the frescoes in Assisi, something which appears to have been superseded in the Scrovegni Chapel.

Direct evidence that he worked at Rimini is provided by the *Crucifix* in the Tempio Malatestiano in Rimini, which has unfortunately lost the panels once attached to the arms and apex (one of these, a painting of *God the Father*, has been found in a private collection in England). It is a nobler version of the Santa Maria Novella *Crucifix*, already showing signs of the artist's mature treatment of the subject. However, its pronounced plastic emphasis and definition of the features link it to somewhat earlier works, such as the *Badia Polyptych* and the *St. Francis Receiving the Stigmata* in the Louvre.

49. Crucifix
428x299 cm
Tempio Malatestiano, Rimini

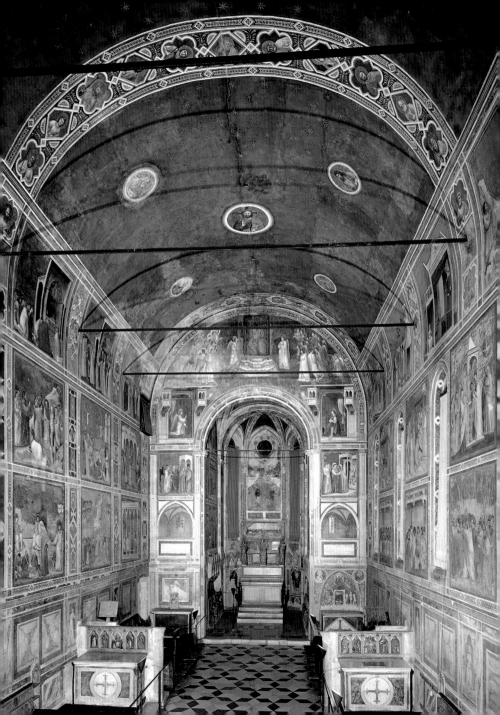

The Arena Chapel at Padua

The fresco decorations in the Arena Chapel at Padua have long been considered the greatest of Giotto's works, and one of the major turning points in the history of European painting. He was probably about forty years old when he began work on the chapel.

His Paduan patron, Enrico Scrovegni, was a wealthy, politically ambitious merchant who in 1300 had acquired the ruins of the old Roman arena at Padua as a site for his house and adjoining chapel. Although existing documents are somewhat vague on the subject, it seems that the chapel was built, decorated and consecrated between 1303 and 1305. The date of the frescoes is not certain and is variously placed between 1304 and 1312-13, although a date of about 1305 appears the most acceptable to this author.

A fairly compelling argument is provided by the indications, not very numerous but precise, that come to us from the style of the clothing: judging by these, the frescoes in Padua predate a polyptych painted by Giuliano da Rimini in 1307, now in the Gardner Museum at Boston.

Owing to the small size of the chapel, illuminated by six windows on the right wall, Giotto had at his disposal a wall space that was both restricted and asymmetrical. In order to carry out the extensive iconographical scheme, he took the areas between the windows as his point of departure, planning to depict two scenes one above the other in each of these. Using this as the basic unit of measure, he divided up the walls of the chapel into panels.

Here too the system of frames used to separate the scenes sets out to create the illusion that it is the architectural structure of the church's own walls. Certainly, it is a less conspicuous framework than in Assisi, but clearly visible nonetheless. Besides, the situation was different: here a series of images had be to arranged on four different levels, whereas the scenes in San Francesco were laid out horizontally on a single level.

The scenes on the walls are arranged in four tiers, and are surrounded by a structure that seems to form part of the architecture of the chapel. However, the framing is less accentuated than in the *Legend of St. Francis*, on just one level, since exaggerated projections would have been unsuited to the modest proportions of the Paduan chapel. Furthermore, the simulated projections of the Assisi framework had been suggested by the real projection of the lower walls, whereas the walls of the Arena Chapel are perfectly

flat. The scenes are separated vertically by wide bands of mock marble which are richly decorated with Cosmati work and interspersed with small, lobed panels containing representations of minor figures.

A significant innovation is the dado painted to imitate veined marble and topped by a slightly projecting cornice, which, as at Assisi, is supported by a row of tiny corbels. Between the mock marble panels are small monochrome frescoes imitating sculptural reliefs, representing the *Seven Virtues* and *Seven Vices*. These were also carved on Giotto's Campanile. The simulated monochrome reliefs gave rise to a kind of fresco decoration that was to flourish in the fifteenth and sixteenth centuries (the most famous examples are the frescoes by Paolo Uccello in the Green Cloister of Santa Maria Novella and the ones by Andrea del Sarto in the cloister of the Scalzo, both in Florence). A parallel development can be seen in the imitation statues that Flemish painters included in the side panels of their altarpieces, beginning with Jan van Eyck's polyptych of the *Adoration of the Lamb*.

An illusionism even more daring than that at Assisi is found in the frescoes flanking the chancel arch, just above the dado. Instead of "stories," Giotto painted two views of the interiors of what appear to be sacristies or a choir, in perfect perspective. The effect is

50. View of the Arena Chapel

119

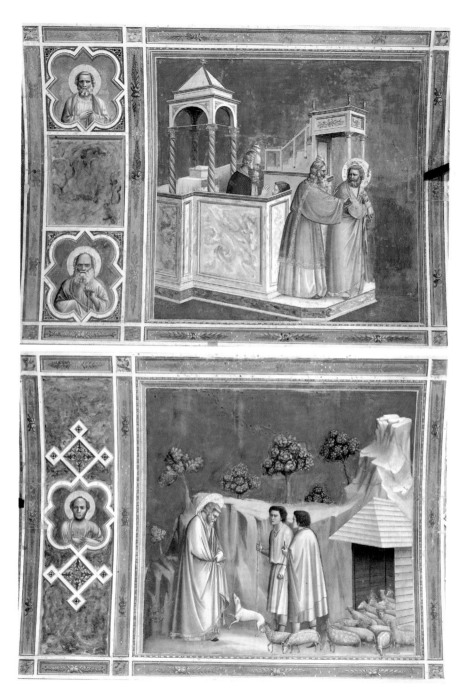

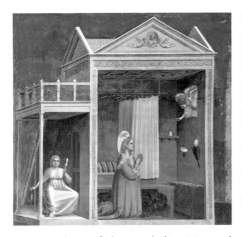

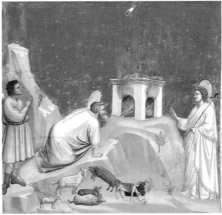

so realistic that we feel we are looking into actual rooms. Our gaze moves beyond the pointed arch to the groin vault of each room, and thence to the Gothic mullioned window. In front of the window a lamp hangs from the ceiling by a rope, with a small ring at the end used to raise and lower it (as in the *Vision of the Thrones*). The sky visible through the window is not the abstract blue of the background of the frescoes, but a much lighter shade clearly intended to represent the real sky, something quite exceptional for its time. That the two symmetrical chapels appear to have approximately the same vanishing point is an astonishing anticipation of fifteenth-century perspective. Though their significance was once ignored, these small scenes are now recognized as an extremely important phase in the development of Giotto's conception of pictorial space.

Since the chapel is relatively small, and the right hand wall is interrupted by the windows, Giotto had to divide the wall surface into smaller panels than those at Assisi (the Paduan frescoes measure 200 x 185 cm, those at Assisi 270 x 230 cm). This explains the different dimensions of the figures in relation to the panels and to the space that encloses them, since the figures in a fresco had to be as close as possible to life size. It is also one of the reasons the Paduan frescoes acquired the extraordinary sense of concentration and pictorial unity that is so appreciated today, and a possible explanation for the unusually stocky proportions of the figures.

Compared with the Assisi frescoes, the painting has grown softer; the subtler modeling gives the figures and objects a greater volume. All harshness has been eliminated. The figures' gestures maintain an

51, 52. Scenes from the Life of Joachim: The Expulsion of Joachim from the Temple; Joachim among the Shepherds

53-55. Scenes from the Life of Joachim: Annunciation of the Angel to St. Anne; The Sacrifice of Joachim; The Meeting at the Golden Gate

56. Scenes from the Life of Joachim: The Dream of Joachim, detail

equilibrium between the *gravitas* of antiquity and the grace of French Gothic art. The narrative tone is solemn and elevated, yet relaxed and serene. The most important and dignified figures have a majestic air, an expression of conviction and a profound, concentrated gaze, yet they are warm and reassuringly human.

However, the scenes are not made up exclusively of prominent characters; there is a supporting cast of minor ones whose lesser dignity is invariably emphasized by the expressiveness of their features and live-

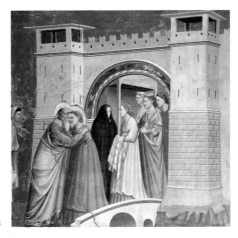

57. Scenes from the Life of Mary: The Birth of the Virgin

liness of their attitudes (as well as their style of dress).
We need only observe the faces of the servants waiting
to pour the wine in the *Marriage at Cana*; or of
Christ's tormenters in the scenes of the Passion, which
are close to caricatures; or the smiles of St. Anne's
companions in the *Meeting at the Golden Gate*, or
the bustling midwives in the *Birth of the Virgin*.

This more prosaic tone characterizes the personi-
fications of the virtues and vices, in which the more
mundane atmosphere is accentuated by the use of
contemporary dress. In this respect the *Virtues* and

Vices bear the same relation to the other frescoes in
the chapel as the *Legend of St. Francis* does to the
frescoes on the upper walls of the Upper Church. It
is no mere coincidence that the extent of Giotto's in-
tervention in the *Virtues* and *Vices* has also been the
subject of controversy, while the sublime tone of the
scenes from the lives of Mary and Christ has often led
critics to overlook the weakness of certain parts, such
as some of the marginal figures in the frescoes in the
upper rows (for instance, the three figures on the far
right and the shepherd on the left in the *Meeting at
the Golden Gate*, clearly executed by his less skilful
assistants).

124

Let us now take a closer look at the frescoes, following the sequence of the narrative and pausing to examine some of them in detail. We begin with the six scenes of Joachim and Anne in the top row on the right wall. They tell of how Joachim was expelled from the temple because of his childlessness, how he took refuge among the shepherds in the mountains, how the angel appeared to Anne with the news that she would bear a child, how Joachim made a sacrificial offering that was favorably received by God and how the angel appeared to him in a dream to tell him of the coming birth of Mary. The series concludes with Joachim's return to Jerusalem, where he meets his wife Anne at the Golden Gate and Mary is conceived in the kiss that Anne bestows on her elderly husband. This is a story with a happy ending, and the scene has a quiet, pastoral atmosphere suggested by the rocky landscape and the shepherds with their sheep, whose soft, lifelike fleece has been meticulously rendered.

If we compare these scenes with the Assisi frescoes, we notice that here the space is more confined, the figures take up more room and the architectural settings have been limited to a single structure in almost every scene, necessary for the telling of the story. Although all the scenes have their memorable aspects, one in particular, the *Annunciation to St. Anne*, is well worth examining in detail.

St. Anne's house consists of a bare framework that is intended to indicate an actual dwelling. It has been given the same concreteness as the buildings in the Assisi frescoes, but since it is the only one in the scene it acquires greater prominence and clarity. It is a symbolic house, and as such decidedly small for its inhabitants, as is demonstrated by the tiny window. But it is just this lack of room that underlines its con-

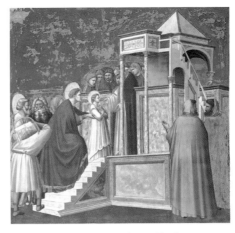

58-60. Scenes from the Life of Mary: The Presentation of the Virgin in the Temple; The Rods Brought to the Temple; The Prayer of the Suitors

creteness and depth. The interior and furnishings of Anne's room are so beautifully depicted that their only counterparts are the ones in some of the Assisi frescoes. The sole witness to the event is the servant, who sits out on the porch, spinning; the skirt of her dress is stretched between her knees, creating deep folds that heighten the solidity of her form. Her dress has the same tangibility as the cloak given away by St. Francis in one of the scenes at Assisi, though it has been modified by a softer, thicker application of paint.

The following six scenes on the opposite wall show the *Birth of the Virgin*, the *Presentation of*

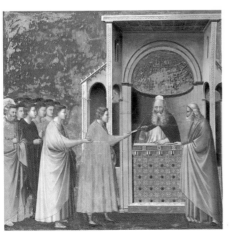

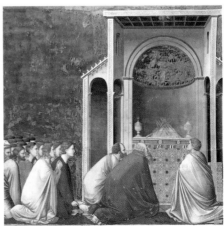

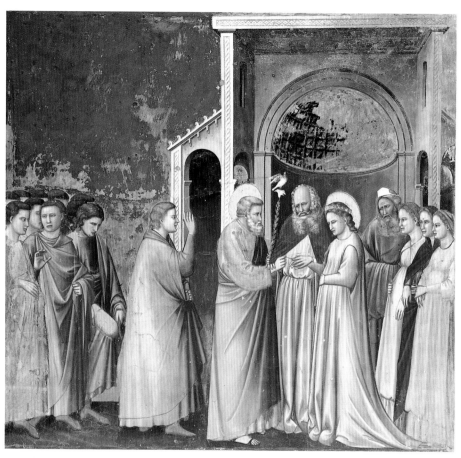

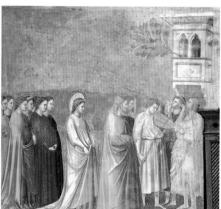

61, 62. Scenes from the Life of Mary: The Marriage
of the Virgin; The Wedding Procession

the Virgin in the Temple and the four episodes pertaining to her marriage: the Rods Brought to the Temple, the Prayer of the Suitors, the Marriage of the Virgin and the Wedding Procession. This series also remains faithful to the principle of the single architectural structure. St. Anne's house in the Birth of the Virgin is a repetition of the one in the Annunciation to St. Anne. The Presentation of the Virgin takes place in the same building as the one in the scene of the Expulsion of Joachim from the Temple, but viewed from the opposite side. The temple in the Marriage of the Virgin appears three times in the series. The kneeling figures in the Prayer of the Suitors are seen from the side or from behind, and display that massiveness so typical of Giotto's Paduan

126

63, 64. Scenes from the Life of Mary: Annunciation

period, an effect obtained by simplifying the drapery and anatomy to such an extent that the bodies appear to be perfectly solid.

The lunette above the chancel arch and the areas on either side of it, the most conspicuous wall surface in the chapel, is occupied by the *Annunciation*, the event to which the chapel was dedicated. In the upper section *God the Father Enthroned* is painted on a poorly preserved panel which also serves as a door. The striking mosaic decorations on the steps of the throne, which are painted in fresco, call to mind the Assisi frescoes, especially the *Doctors of the Church*. The group of angels round the throne is so skillfully arranged that we are given the impression that even Heaven has depth. They calmly move about, play their instruments, sing and take each other by the hand as if they were about to dance. This extraordinary conception anticipates the solutions adopted by Fra Angelico's for his images of Paradise by more than a century, while the small angels playing wind instruments at the ends call to mind the ones that make up the procession in Nanni di Banco's relief of the *Assumption of the Virgin* above the Porta della Mandorla in Florence Cathedral, also executed more than a century after the frescoes in the Scrovegni Chapel.

The *Annunciation* takes place in the lower section of the fresco, in the two spandrels flanking the chancel arch. Each of the two protagonists, Gabriel and Mary, kneels within a shrine which has been set at an angle to suggest that it faces the other; for this reason we see only the exteriors and a small part of the interiors of the two structures. Of all the buildings

in the Paduan frescoes, these shrines are most reminiscent of the architectural settings at Assisi, because of the curtains and the complicated consoles supporting the balconies. The self-possessed figures of Gabriel and Mary, especially the latter, have been given an extraordinary solidity. The foreshortening of Mary's arms has been carried out with a precision that anticipates the technical accomplishments of the fifteenth century.

The illusion of depth in these scenes is heightened by another of Giotto's innovations which appears throughout the chapel. Although by this time he had mastered the technique of representing figures in profile, he was left with the problem of how to represent their haloes, since the halo of a figure seen frontally appears as a solid disk attached behind the head, whereas that of a figure in profile should, logically, appear foreshortened. He attempted to solve the problem by making the haloes of figures in profile oval, like those of Gabriel and Mary in this scene. Later he was to abandon this solution, but it should certainly be seen as part of his research into space and one of the problems that he was continually tackling in his effort to represent three-dimensional reality on a two-dimensional surface.

The narrative continues with the scene of the *Visitation*, which appears in the panel directly below the Virgin of the *Annunciation*, on the right-hand side of the chancel arch. Here the figures are more conspicuous since they are painted to the same scale as those of the other frescoes, though the area itself is quite small. The five scenes on the right wall represent the *Nativity*, the *Adoration of the Magi*, the *Presentation in the Temple*, the *Flight into Egypt*, and the *Slaughter of the Innocents*. The well-constructed

shed in the first scene reappears in the second, set at a slightly different angle. The temple in the third scene is the same one that appears in the *Expulsion of Joachim from the Temple* and the *Presentation of the Virgin in the Temple*, but this time we are shown only the shrine over the altar.

The *Flight into Egypt*, one of the most famous of the Arena Chapel frescoes, is set in a rocky landscape like the one in *St. Francis Receiving the Stigmata* at Assisi, although it is softer in appearance. Mary and her child form an isolated group in the center of the scene, their solemnity enhanced by the rich, beautiful-

65. *Scenes from the Life of Mary: Visitation and the "choir" underneath*

ly rendered folds of her cloak. Her profile is much more convincing than any of those in the frescoes at Assisi, a sign that once the artist had freed himself from the medieval prejudice against the profile he lost no time in mastering it. We can only imagine the startling effect this Virgin in full profile must have had on Giotto's contemporaries, accustomed as they were to the pictorial conventions still respected by other painters.

The *Slaughter of the Innocents* is the only scene in the chapel in which two buildings appear. The octagonal structure on the right recalls a baptistery (an allusion to the baptism of blood of the unfortunate infants?), and is depicted with even greater clarity than the structures at Assisi. One feels that it is a real building, an effect that is heightened by the subtle distinction made between the walls of the radial chapels and the buttresses that divide them; by the moldings of green marble; by the sky visible through the mullioned windows, which suggests that the alternation of buttress and chapel continues beyond our view; and by the interplay of light and shade. Giotto's handling of the shadows in this scene (note the shadow under the roof of Herod's balcony) is even more skilful than in his Assisi frescoes, and provides yet another demonstration of the realism of his art. There are no sacred figures in this scene, and the center of the composition has been reserved for the figure of an executioner, who is drawing his sword to kill a child still clinging to its mother's breast. His attitude is echoed in the figure behind him, Herculean and ominous under his hood.

The six scenes on the opposite wall – *Christ among the Doctors*, the *Baptism of Christ*, the *Marriage at Cana*, the *Raising of Lazarus*, the *Entry into Jerusalem*, and the *Expulsion of the Moneychangers from the Temple* – have the most solemn narrative tone of all the frescoes, perhaps because they deal with Christ's adult mission.

Christ among the Doctors is the most poorly preserved of all the frescoes in the chapel, but we can still make out its splendid architectural setting. It was the first of the Paduan frescoes to be set wholly within an interior and was laid out according to a scheme which recalls scenes in Assisi like the *Confirmation of the Rule* and *St. Francis Preaching before Honorius III*. It is even more reminiscent of the *Apparition to Gregory IX*, which has the same, slightly off-center viewpoint. In both cases this was determined by the position of the fresco, the Assisi scene being at the end of its bay and the Paduan scene next to the entrance, at the far end of the left wall of the chapel.

The very high quality of parts of the *Baptism of Christ* becomes evident if we consider the awe-inspiring face of Christ, the skilful foreshortening of God the Father and the masterly execution of the

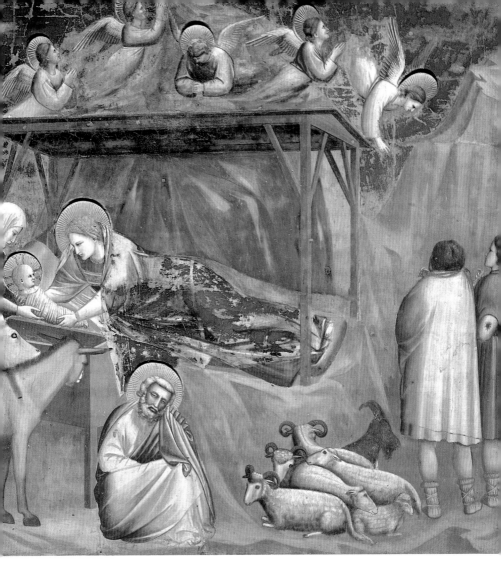

66. Scenes from the Life of Christ: Nativity

heads of John the Baptist and the two disciples behind him. However, the water in which Christ stands is painted in a completely irrational manner, since if it rises to his navel it should cover part of the rocks and at least the feet of the other figures. This strange river has its origins in a deeply rooted iconographical convention which could be considered emblematic of the medieval artist's inability to "see" the reality of

this world (or, if we prefer, of his desire to render that reality abstract). We do not know if this inconsistency is a result of an oversight on the part of the artist, if it was imposed on him by his patron or if it represents a surrender to iconographic tradition in order to avoid showing Christ completely nude. At all events, it demonstrates that Giotto was still capable of being influenced by the conventions of medieval painting.

The dramatic tension of the two preceding scenes is temporarily relieved in the *Marriage at Cana*,

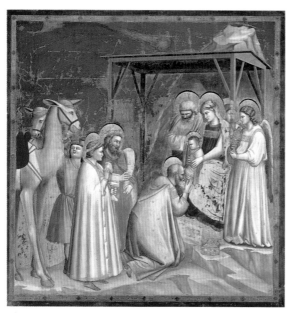

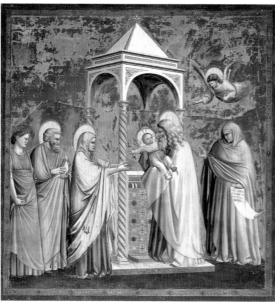

67-69. *Scenes from the Life of Christ: The Adoration of the Magi; The Presentation in the Temple; The Flight into Egypt*

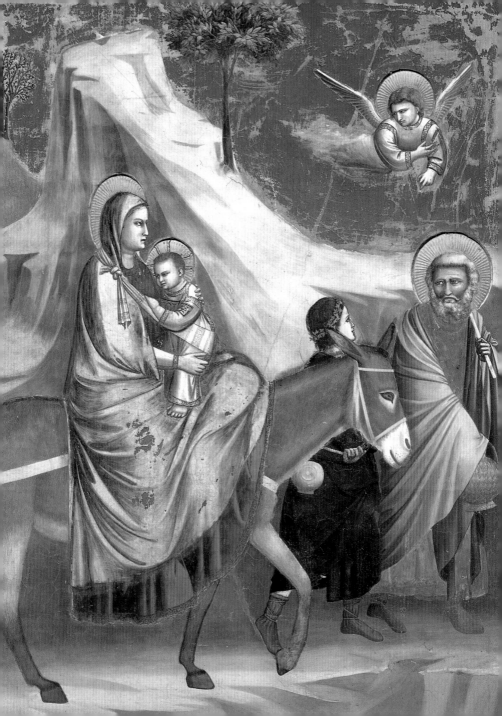

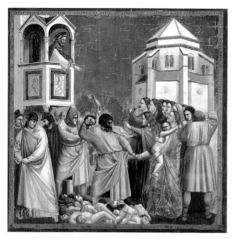

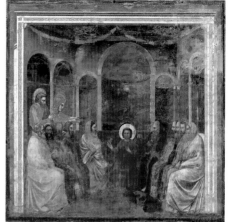

70-73. Scenes from the Life of Christ: Slaughter of the Innocents; Christ among the Doctors; Baptism of Christ; The Raising of Lazarus

where the homeliness of the interior is emphasized by the striped wall hanging, the round-bellied amphorae and the comic characterization of the guests and servants. The tone becomes solemn again in the three scenes that follow, but even here Giotto never misses an opportunity for heightening the realism of such things as the wooden cages and stalls in the *Expulsion of the Moneychangers from the Temple*. The cage held by one of the moneychangers was an afterthought, added when the plaster was almost dry and for this reason barely visible today. We now come to the scene on the left side of the chancel arch, *Judas Receiving Payment for His Betrayal*. Judas is shown in profile, with a black halo and with the devil standing behind him. His portrayal is in keeping with those simple didactic precepts that would have evil revealed by an ugly face.

The story continues in the row below, on the window side of the chapel. Here we have a symmetrical arrangement of scenes (an outdoor scene flanked by two indoor scenes) from the Passion of Christ – the *Last Supper*, the *Washing of Feet*, the *Kiss of Judas*, *Christ before Caiaphas*, and the *Flagellation*. The quiet solemnity of the first two scenes, which have been given the same setting, is followed by the frenzied activity in the *Kiss of Judas*, where the scene is dominated by the massive figure of Judas, one of the most impressive of Giotto's creations, and the

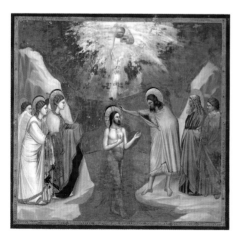

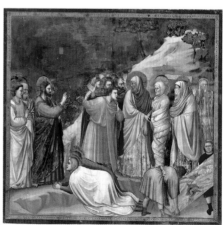

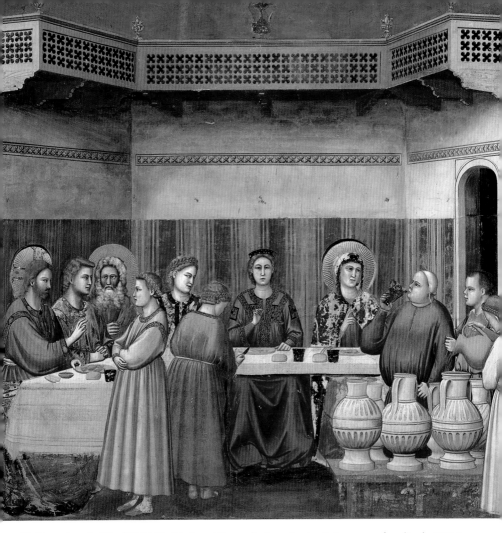

74. Scenes from the Life of Christ: The Marriage at Cana

sweep of his cloak as he reaches out to embrace Christ. The proximity of the beautiful profile of Christ and the repellent one of Judas becomes a confrontation of absolute good and absolute evil. The scene of *Christ before Caiaphas* provides yet another demonstration of the artist's increasing independence from the pictorial conventions of his day. This is a night scene in which a torch, now darkened because of alterations in the pigment, illuminates the wooden ceiling from beneath, an effect of unprecedented subtlety in a period when most artists continued to adhere to the anti-naturalistic canons of medieval painting.

In the corresponding tier on the opposite wall are the *Road to Calvary*, the *Crucifixion*, the *Lamentation*, the Resurrection represented by the *Noli me tangere* scene (instead of the three Marys at the tomb), the *Ascension*, and the *Pentecost*. Apart from the *Road to Calvary*, these scenes all appear on the upper walls of the Upper Church at Assisi.

The *Road to Calvary*, which, like the scene above it, *Christ among the Doctors*, is in very poor condition, shows the procession to Calvary leaving from the same city gate through which Christ passes in triumph in the *Entry into Jerusalem*. Although the

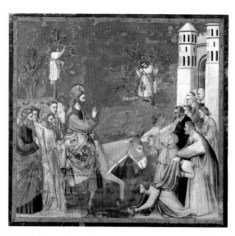

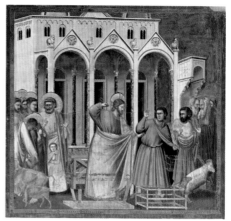

75-77. *Scenes from the Life of Christ: The Entry into Jerusalem; Expulsion of the Moneychangers from the Temple; Judas Receiving Payment for His Betrayal*

scene has certain affinities with some famous fourteenth-century representations of the same subject, like Simone Martini's panel in the Louvre (the similarity is especially close in Christ's backward glance at his mother), the tone is much less emotive.

Some of the most dramatic parts in the *Crucifixion* and the *Lamentation* are played by the small angelic spirits, who appear to have the lower part of their bodies hidden by clouds, a much more effective solution than the one devised for the angelic spirits at

Assisi, whose bodies are merely truncated. These small beings communicate their almost savage desperation through an extraordinary variety of attitudes and facial expressions not given to their human counterparts.

The main figures in the *Lamentation* express their grief with a restraint of gesture reminiscent of the art of antiquity, as can be seen, for instance, in the figure of St. John, bent over with his arms outspread, or the saint on the far right, standing with his arms at his sides and his hands clasped – a gesture which appears in the same scene at Assisi. In this fresco Giotto has abandoned the frenetic movement typical of Byzantine scenes of the Deposition to return to an older, fuller, more solemn expressiveness reminiscent of Greek tragedy. Like an arrow, the rocky ridge in the background descends to indicate the emotional fulcrum of the composition: the juxtaposed heads of Mary and Christ. The figures in this scene have been given a solidity that makes them some of the most impressive in fourteenth-century art.

The dramatic tension of the *Lamentation* is relieved in the more tranquil scene that follows it. In conformity with the Bible, Christ's Resurrection is represented indirectly, through events that bore witness to it – in this case the empty tomb with the two angels and the *Noli me tangere*. The sleeping soldiers gave Giotto the opportunity to do some virtuoso foreshortening, as in the *Resurrection* at Assisi.

The *Ascension* and the *Pentecost* are not among the most famous of the Arena Chapel frescoes, despite their very high quality, and the richness of decoration and color that underlines their spiritual significance. The striking mantle worn by one of the apostles is as magnificent as the gold-trimmed garments of the souls freed from limbo, who ascend into heaven with Christ. It is worth noting that the setting of the

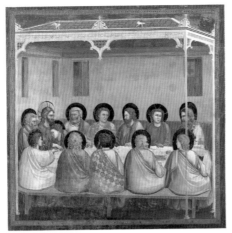
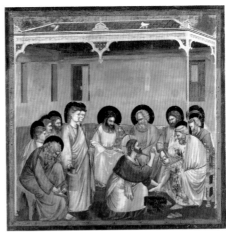
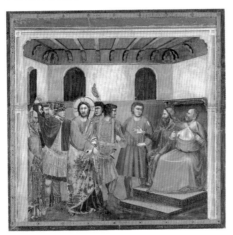
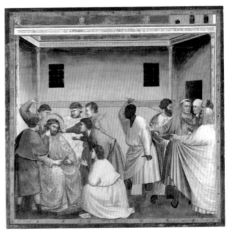

78-81. Scenes from the Life of Christ: The Last Supper; The Washing of Feet; Christ before Caiaphas; The Flagellation

82. Scenes from the Life of Christ: The Kiss of Judas, detail

Pentecost is almost the only one at Padua that directly reflects contemporary Gothic architecture.

The inclusion of the *Seven Virtues* and *Seven Vices* in the chapel decoration was in line with the didactic program of many thirteenth- and fourteenth-century decorative schemes. I have already referred to the novelty of the mock marble dado, a device in keeping with Giotto's conception of architectural illusionism, where these images are inserted as if they were sculptural reliefs. I have also touched upon the prosaic aspect of these works in comparison with the lofty narrative tone of the scenes of the life of Christ. This prosaic aspect has often been considered a defect, which has in turn led to a certain degree of skepticism over Giotto's authorship. This is probably the result of a commonplace notion that poetry is superior to prose, the tragic to the comic, the sublime to the normal, the solemn to the everyday. Furthermore, there is a mistaken idea that an artist bound to the representation of a set theme is necessarily limited in his freedom of expression, and that his inspiration and the quality of his work are therefore impaired – as if a prescribed theme had prevented Ambrogio Lorenzetti from painting some of the most original frescoes of the whole of the fourteenth century, the *Good and Bad Government* cycle in the Sala della Pace in Siena's Palazzo Pubblico. These works were foreshadowed in the Arena Chapel, in the simulated

135

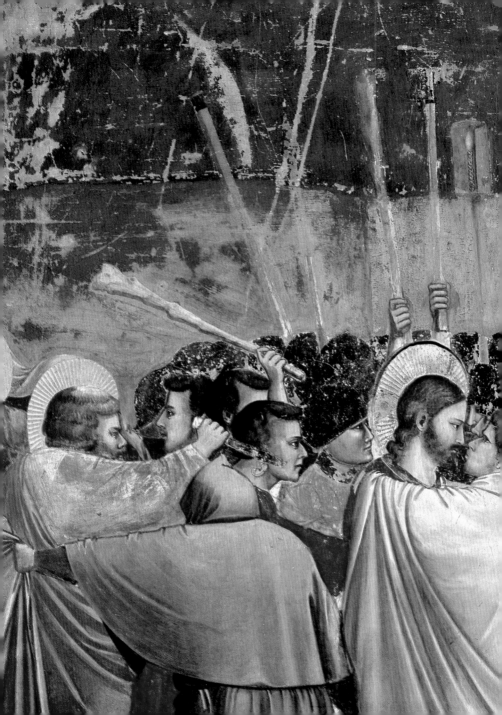

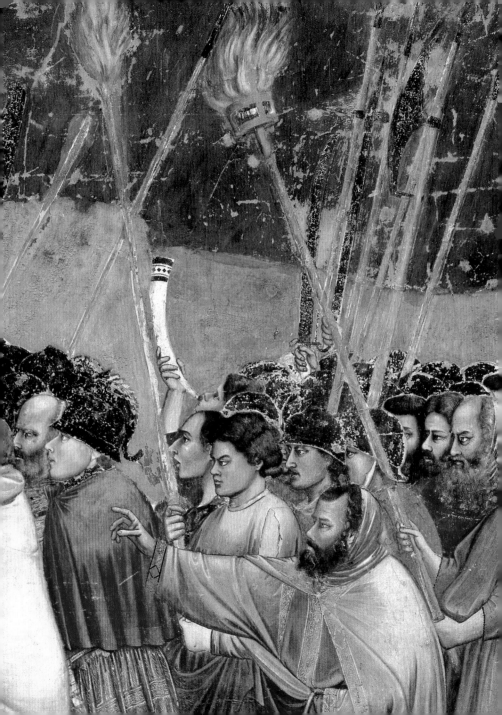

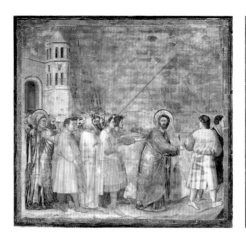
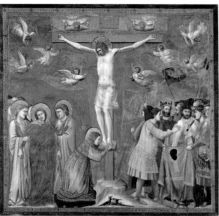

83-85. Scenes from the Life of Christ: The Road to Calvary; Crucifixion and detail

138

bas-relief on the throne of Justice, where the horsemen on the sides and especially the dancers in the middle anticipate features of Lorenzetti's frescoes.

The figures of *Justice* and *Injustice* are larger than those of the other virtues and vices, and occupy a central position on the dado. Both are represented as rulers – Justice wears a royal crown, and Injustice is depicted as a tyrant. Their role as symbols of good and bad government respectively is indicated in the small reliefs on their thrones. Here it is plain that Enrico Scrovegni's political ambitions came into play: the allusion was to the eventuality of his own govern-

86-89. Scenes from the Life of Christ: Lamentation over the Dead Christ; Noli me tangere; Ascension; Pentecost

90. Scenes from the Life of Christ: Lamentation over the Dead Christ, detail

ment of the city, a rule that would be based on justice.

The other allegories are perhaps of lesser importance, in spite of the complexity of their symbolism, which is not immediately comprehensible. However, many of these figures have been represented with extraordinary subtlety and delicacy: *Prudence*'s second face, for instance, is represented by the profile of a bearded man at the back of her head.

Each of these figures should be considered first and foremost in its emblematic value, this being the main reason for its inclusion in the decorative scheme, and should always be seen in relation to its opposite. *Prudence*, which also symbolizes the virtue of intelligence, is shown as a mature lady seated at a desk, as if she were a schoolmistress, while her opposite, *Foolishness*, appears as a dimwitted youth dressed as a buffoon. The Herculean *Fortitude* (she

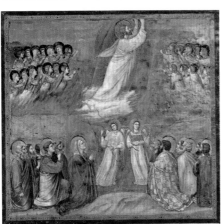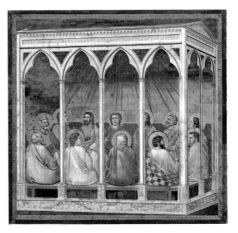

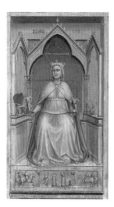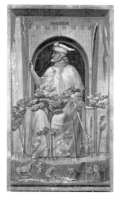

*91-98. Allegories of the Virtues and the Vices
representing: Justice, Injustice, Prudence, Foolishness,
Inconstancy, Wrath, Infidelity, Charity*

99. Last Judgment

wears a lion skin, the attribute of Hercules) is armed
with mace and shield and stands with her feet set
firmly on the ground. Her opposite, *Inconstancy*,
struggles to maintain her balance as she sits on an un-
steady wheel on a sloping floor. *Temperance is*
serene and tranquil, while *Wrath* tears the dress from
her breast, repeating Caiaphas's gesture of rage be-
fore Christ. *Justice* is shown as the personification of
prosperity, while the tyrant *Injustice* occupies a
crumbling, turreted throne. *Faith*, hieratic in pose, is
contrasted with the figure of *Infidelity* (idolatry), who
is led on a rope by his female idol, his helmet making
him impervious to the word of God from above. The
smiling figure of *Charity*, also a symbol of generosi-
ty, fecundity and happiness, has her opposite in the
grotesque figure of *Envy*. The youthful *Hope* flies up-
ward to receive the crown that awaits her, while *Des-*

peration has hanged herself (note how the pole
bends slightly with the weight of her body).

The decorative bands on the walls above contain
several scenes from the Old Testament and busts of
saints and prophets. The Old Testament scenes are of
a very modest standard, and owe their presence in
the chapel to the Gothic tradition of representing par-
allels between the Old and New Testament. Some of
the figures of saints and prophets are of very high
workmanship and among the most impressive of
Giotto's repertoire.

The entrance wall is filled with the imposing *Last
Judgment*. This scene is as complex and crowded as
the frescoes on the side walls are concentrated and
reduced to essentials, and does not give the same im-
pression of order and balance as the others. Indeed,
the composition of the various parts of the mystical
vision of Judgment Day doubtless presented a serious
problem to an artist whose style depended on clarity
of both subject and form. The figure of Christ the
Judge is enclosed within a mandorla, ringed by an-
gels, which seems to be independent of its surround-

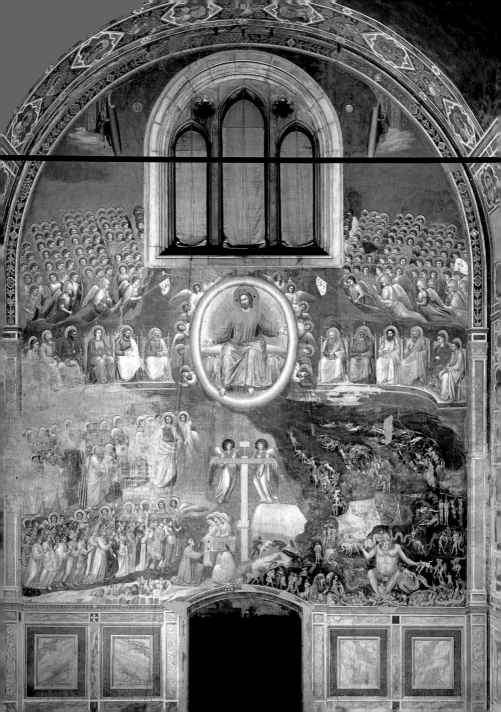

er works like the *Last Judgment* in Sant'Angelo in Formis, the one in Santa Maria Assunta on the island of Torcello or the image in the dome of Florence Baptistery, all of which are divided into a series of independent, horizontal compartments, we can see just how much unity Giotto was able to introduce into this work by eliminating the traditional subdivisions and putting all the groups in the same pictorial space. The fact that the iconographic tradition still exerted a considerable influence is evident in the differentiation of the various groups, but even here Giotto's desire for unity led him to innovate, to make Christ's mandorla a sort of centripetal force toward which the various groups gravitate.

Christ sits within his rainbow-hued mandorla, majestic and commanding, both in pose and scale (though compared to earlier representations he appears human). With his left hand he rejects the damned while, still frowning, he turns his face towards the elect, offering them his right hand. The apostles sit solemnly on their thrones, the richest of which is occupied by Peter. The youthful Virgin, brown-haired and with a gentle face, seems to offer her hand to the first figure in the top row of the elect, prob-

100. Last Judgment, detail showing Enrico Scrovegni presenting the Arena Chapel to the Virgin

ably St. John the Baptist, as if to lead him toward Christ. Unfortunately, this part of the fresco is in very poor condition, and we can barely make out a procession of elders and important personages characterized in the same way as Joachim, the aged Simeon, St. Joseph and the older apostles.

ings. It occupies the center of a hollow created by the curve of the ledge supporting the thrones of the twelve apostles (a conception which calls to mind certain late fifteenth- and early sixteenth-century works like Raphael's *Dispute over the Holy Sacrament* in the Stanza della Segnatura in the Vatican). The space is given an impression of even greater depth by the downward slope of the rows of angels above, who look like a heavenly battalion drawn up on parade.

Also noteworthy are the figures of the two angels in the uppermost part of the fresco who roll out the sky as if it were a scroll, revealing the gem-studded walls of the heavenly Jerusalem, as well as the two angels holding the cross below the mandorla and the river of fire that flows from the mandorla down into Hell. The rigid scheme of painting figures on different scales according to their importance does not contribute to a harmonious relationship of parts in a work like this: from the enormous figure of Christ to the Lilliputian figures of the saved and the damned there is a continuous gradation of size which confounds the artist's attempt to instill order into the huge composition.

Yet if we compare this *Last Judgment* with earli-

The group of elect immediately below is in a better state of preservation. The figures have not been given haloes, even though they include such important saints as Francis and Dominic and others, like Catherine, who had inspired a vast number of legends. Men and women, laymen and ecclesiastics move in procession towards Christ, accompanied by a row of smiling angels. Their arrangement in parallel lines receding into space gives rise to those curious rows of heads in profile which Giotto relied on to indicate a crowd arranged in orderly fashion in space. The same device was used in the group of kneeling friars in the *Confirmation of the Rule* at Assisi and in the group of apostles in the *Ascension* at Padua.

The damned, who are shown in the lower right hand corner, fall into a Hell dominated by the figure of Satan. This Hell teems with hopeless diminutive figures subjected to a variety of comically indecent humiliations and torments by apish devils. It is a far cry from Dante's tragic vision of Hell and recalls only a few verses of the *Inferno* about the area of Hell

known as the Malebolge. Almost all these figures can be attributed to Giotto's assistants, though here, too, the master's guiding hand can be discerned in the rich play of imagination that characterizes the whole and in the execution of certain parts, which suggest his direct intervention. This is true of the wonderfully immediate episode that takes place on the brink of Hell, below the cross, where two devils lead a struggling man back to the damned, dragging him by his clothes, which are pulled over his head to reveal his disproportionate genitals.

Below the cross, on the left, is the dedicatory scene in which Enrico Scrovegni kneels before the Virgin and two saints, offering a model of the Arena Chapel held by an Augustinian friar. The portrait of Scrovegni, who is shown in sharp profile, is a faithful representation of the youthful features of the same man shown in old age on his marble tomb. His clothing and hairstyle reflect the fashions of the day and provide valuable information about contemporary costume. The figure of Scrovegni is on the same scale as the sacred figures he is addressing – evidently it was enough to show him kneeling before these figures to indicate his "inferior" status.

A few decades later Simone Martini was to paint an autonomous portrait at Avignon, although the earliest example of such a picture to have come down to us is the profile of King John the Good of France, now in the Louvre, painted around the middle of the fourteenth century by a French artist. From the fifteenth century onward, this was to become an artistic genre in its own right.

The model of the chapel presented by Scrovegni differs in a few details from the real chapel, a fact which suggests that the *Last Judgment* may have been painted before the exterior of the chapel was completed. This is a strong possibility since the most pictorially advanced parts of the cycle, i.e. those most similar to Giotto's later works, appear on the wall opposite the *Last Judgment,* above and on each side of the chancel arch. The warm, rich colors of the angels surrounding God and the figures of Gabriel and Mary are related to the fresco decorations in the Magdalen Chapel in the Lower Church at Assisi, which are the closest to the Paduan frescoes of all of Giotto's surviving cycles.

The *Crucifix* painted by Giotto for the Arena Chapel (now in the Museo Civico at Padua) also displays a striking similarity to the frescoed *Crucifixion* in the right transept of the Lower Church. But before going on to examine the Lower Church cycle, it is worth lingering for a moment over two works that are closely related in style to the Paduan frescoes, and which may have been painted a short time before: the *Ognissanti Madonna*, now in the Uffizi, and the *Dormition of the Virgin*, now in the Staatliche Museen of Berlin.

The *Ognissanti Madonna* is the greatest of Giotto's panel paintings. The subject is the same as that of Duccio's *Rucellai Madonna* and Cimabue's *Santa Trinita Madonna*: the enthroned Virgin and Child among saints and angels, facing the observer, and the Child raising his hand in a gesture of benediction. However, much had changed in the few years that separate this work from the others. The sad, remote, inscrutable Virgin of the thirteenth century has been transformed here into a very human woman who gazes serenely outward, her lips parted in a hint of a smile that reveals the white of her teeth. The earthly

*101. Crucifix
223x164 cm
Museo Civico, Padua*

weight of her body is set off by the delicacy of the Gothic throne, which appears to have undergone the same process of attenuation as the Temple of Minerva in the *Homage of a Simple Man* at Assisi.

In reality what we see here is the juxtaposition of two elements – human figure and architectural object – that are still treated separately, with the same criteria as were used at Assisi.

Compared with similar works by the great painters of the late thirteenth century, this image of the Madonna seems to have been greatly simplified, although by no means impoverished. The cloth of the Virgin's gown and mantle are of the finest quality. The rich coloring of the throne makes it both sumptuous and more convincing than the elaborate structures of thirteenth-century painting. The groups of angels on each side of the throne occupy real space and look like the elegant retainers of a royal court.

The panel of the *Dormition of the Virgin* in Berlin, which was also painted for the church of Ognissanti in Florence, appears to be directly related to the *Ognissanti Madonna*. It has an unusual format and its gabled shape suggests it was meant to be placed above an altarpiece. There are very strong similarities between it and the *Ognissanti Madonna*;

for instance, the angel standing behind the two smaller angels holding candles, on the right, has a profile identical to that of the angel kneeling on the right in the *Ognissanti Madonna*.

The composition is made slightly asymmetrical by the disposition of the group of angels and patriarchs on the right, who form a diagonal rising to a point above Christ's left shoulder. The group on the left forms a similar, lower diagonal which is interrupted by the figure of a young apostle (John?), bending forward and clasping his hands. The simple sarcophagus, ornamented with Cosmatesque decoration, is also asymmetrical, having been set at a slight angle so that both the side and front are visible. The scene represents the moment at which the Virgin's body is lowered into the marble tomb. Angels hold the ends of the shroud, and an apostle is bent over the sarcophagus, supporting the body. In his arms Christ holds an infant in swaddling clothes, a symbol of Mary's soul. As in the Paduan frescoes, the tone is solemn, yet warm and down to earth. Certain parts, such as the angel blowing into the censer and the female figure on the left, who is so covered by her drapery that only a small portion of her profile is visible, anticipate later fourteenth-century painting.

102. Death of the Virgin
75x178 cm
Gemäldegalerie, Berlin

103. Ognissanti Madonna
325x204 cm
Uffizi, Florence

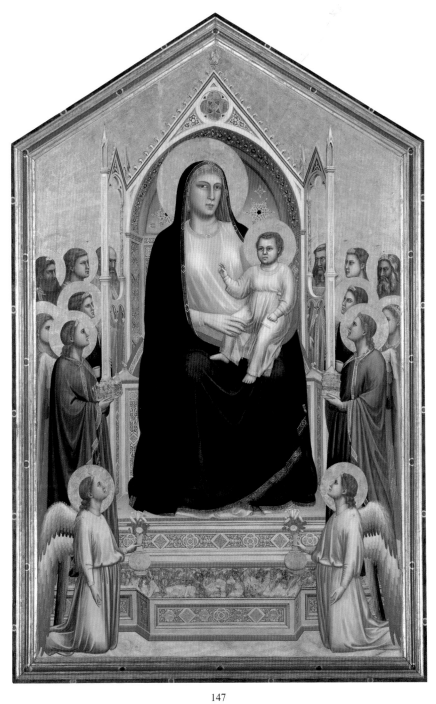

The Lower Church at Assisi

The similarity between the last frescoes to be painted in the Arena Chapel and the frescoes in the chapel of the Magdalen in the Lower Church at Assisi has already been mentioned. The fact that Giotto's assistants were allowed greater freedom in the execution of the Assisi frescoes does not mean that he was not directly involved. There was more wall space at the artists' disposal in the Magdalen Chapel than at Padua, and the two scenes that appear in both places, the *Raising of Lazarus* and *Noli me tangere* are consequently larger and more imposing. The former, in particular, is far more monumental in character than its Paduan counterpart, despite the presence of the same figures in more or less the same attitudes. But because the wall space permitted larger gaps between the figures, Christ's gesture has become more dramatic and the figures of the two Marys more accentuated. If we observe Christ's head we see how much softer and more mel-

low Giotto's painting has grown. The landscape has become gentler, and by comparison the scenery in Padua appears to have much of the harshness of the stony mountains in the *Legend of St. Francis*.

The frescoes on the lower walls of the chapel are enclosed within mock architectural projections supported by lovely twisted columns, and the ones on the upper walls are surrounded by flat decorative borders (as in the Arena Chapel). The chapel houses seven scenes from the life of Mary Magdalene. The narrative starts on the middle row of the left wall, with the *Supper in the House of the Pharisee* (where the saint washes Christ's feet and dries them with her hair), and the *Raising of Lazarus*. It continues on the same level of the right wall, with the *Noli me tangere* (where the

104, 105. Scenes from the Life of the Magdalen: Raising of Lazarus; Noli me tangere

148

resurrected Christ appears to Mary in the guise of a gardener) and the *Miraculous Landing at Marseilles* (Mary Magdalene, Lazarus, Martha and others arrive safely in the French port after having been placed in a rudderless boat by their persecutors). In the lunettes are *Mary Magdalene Speaking to the Angels* (right wall), the *Communion and Ascent into Heaven of Mary Magdalene* (left wall), and *Mary Magdalene and the Hermit Zosimus* (wall above the entrance to the chapel).

Minor frescoes are painted on the soffits of the windows and the two side entrances, while at the sides of the windows, arranged in two rows, are a *Penitent Saint*, *Mary, Sister of Moses* (as we are told by the inscription), *St. Helen*, and a *Martyred Saint*. On the soffit of the entrance are twelve saints, arranged in pairs on three levels: from top left, *Peter and Matthew*, a saint with a cross (Simon of Cyrene?) and one in armor (Longinus?) and two more saints; on the right *Paul and David*, an elderly saint and *Augustine* and another pair of saints. On the lower section of the side walls we see, on the left, *St. Rufinus*, patron of Assisi, with *Bishop Teobaldo Pontano* (who commissioned the chapel and is shown kneeling at the saint's feet) and the *Penitent Magdalen*; on the right, *Mary Magdalene* with *Cardinal Pietro di Barro* and the bust of a saint. On the vault, within four tondi, are set *Christ Giving His Blessing*, *Mary Magdalene*, *Lazarus* and *Martha*.

These frescoes were formerly thought to have been painted after 1314, before it was discovered that Teobaldo Pontano, who commissioned them, did not become bishop of Assisi in that year but in the late thirteenth century. We now know they were executed not long after the Paduan frescoes, probably before 1309 (a recently discovered document mentions that Giotto was in Assisi a short time before that date). The contribution of Giotto's assistants, who were given a free hand here, appears to revert to a pre-Paduan, almost "Master of St. Cecilia" phase of

106, 107. Scenes from the Life of the Magdalen: Mary Magdalene Speaking to the Angels; Mary Magdalene and the Hermit Zosimus

Giotto's development, while the parts where Giotto's own work predominates are characterized by a pictorial and chromatic softness that is much more advanced than at Padua.

The human types found in the Paduan frescoes reappear here, but the colors are warmer and creamier. The dark hair of their Paduan days has turned reddish-blond, and their eyes are often pale. Their features seem more varied and the figures are on a larger scale. The immense rock which dominates the scene of *Mary Magdalene and the Hermit Zosimus* in the lunette above the entrance is as white and soft as a cloud. The bearded profile of the hermit has been rendered with such subtlety that it calls to mind the naturalistic effects that Giottino and Giusto dei Menabuoi were to achieve half a century later.

The angels who bear Mary Magdalene aloft in the scene in the lunette on the right wall have extraordinary faces, with expressions that are much softer than anything seen at Padua. Many of the sacred figures are more imposing and dignified than their Paduan counterparts as well, as is apparent in the splendid group of Christ and Mary in the *Supper in the House of the Pharisee*.

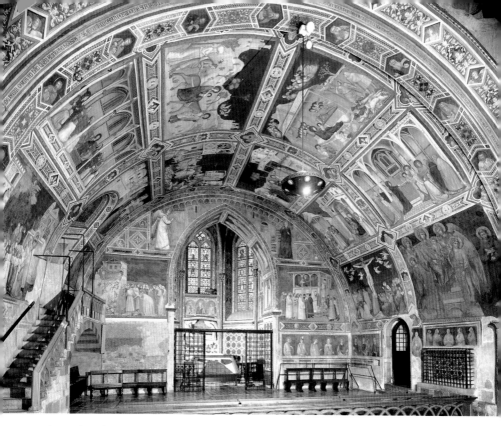

Some of the figures of saints on the soffit, or underside, of the entrance arch are also highly expressive. And in the magnificent dedicatory scene, Mary Magdalene, wearing a pinkish-red dress sumptuously trimmed in gold, takes the hand of Pietro di Barro, who kneels before her. She stands to one side of the large, rectangular fresco, her figure set off by the blue background. The scene is enclosed within a marvelous frame painted to imitate red marble, trimmed in white and ornamented with mock mosaic inlays. At each side is a solid twisted column embellished with a spiraling strip of Cosmati work.

The Magdalen Chapel was the starting point of the work carried out by Giotto and his assistants in the Lower Church, which was to include the right transept and the vault. It has recently been demonstrated that these areas were frescoed before

Pietro Lorenzetti painted the scenes of the Passion in the left transept, executed before 1320. It seems that when the frescoes in the Magdalen Chapel were completed, Giotto and his workshop were asked to redecorate the right transept and vault. This area had been frescoed in the late thirteenth century, as is indicated by Cimabue's large fresco of the *Madonna Enthroned with Angels and St. Francis*, which was spared.

In these frescoes, where Giotto's role was probably that of designer rather than painter, what emerges is the personality of one or two of his assistants – the so-called Relative of Giotto and the Master of the Vaulting Cells – who translated his ideas into their own style. The frescoes include various miracles performed by St. Francis after his death, *St. Francis with a Crowned Skeleton*, a tondo with *Christ Giving His Blessing*, the *Crucifixion* and eight scenes from

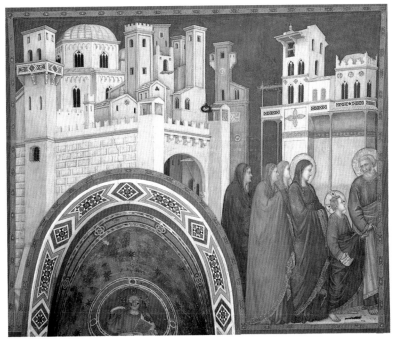

151

the childhood of Christ: the *Visitation*, *Nativity*, *Adoration of the Magi*, *Presentation in the Temple*, *Slaughter of the Innocents*, *Flight into Egypt*, *Christ among the Doctors* and the rare episode of the *Return of the Holy Family to Nazareth*. The rest of the frescoes in the right transept were painted by other artists: Cimabue, the Master of the Chapel of St. Nicholas, Simone Martini and Pietro Lorenzetti.

The frescoes create an impression of splendid chromatic richness. The blues of the backgrounds are the most brilliant in the whole of the fourteenth century. The pinks, whites, yellows and greens are the softest, warmest, densest and brightest in Giotto's palette (it seems as if the walls and the dark tunnel vault of the transept were encrusted with precious stones). Here the artist reveals a capacity for giving concrete form to objects that is reminiscent at times of the extraordinary *trompe-l'œil* effects of the St. Francis cycle. His skilful construction of pictorial space in frescoes such as the *Presentation in the Temple* and *Christ among the Doctors* constitutes perhaps the most advanced use of perspective in the fourteenth century. These frescoes became a model for Umbrian painters of panel pictures, frescoes and miniatures. Proof of their contemporary fame is provided by a few fourteenth-century drawings that have survived, reproducing details from them or whole scenes.

The standard of the frescoes, however, is lower than that of works in which Giotto's participation was more direct. In certain parts we notice a tendency to attenuate the figures, and to refine their features in the Gothic manner. In other parts the wide-eyed figures have the somewhat pathetic look which is first seen in the Lazarus on the vault of the Magdalen Chapel and reappears in the frescoes of the vault.

However, Giotto must have supervised the painting of these frescoes fairly closely as his hand is evident here and there, especially in the sublime *Crucifixion*, which is perhaps the most beautiful, refined, colorful and moving of all his representations of this subject. We have already mentioned the evident similarity of this Christ and the one on the *Crucifix* made for the high altar of the Arena Chapel, a similarity which provides further proof that the Lower Church frescoes were painted not long after those in the Arena Chapel. It has recently been observed that, apart from the figures standing on the right, clearly the work of the Master of the Vaulting Cells, this fresco is entirely by Giotto.

None of his creations is more delicate or more moving than this crucified Christ, whose milky-white body is covered with the marks left his scourging. Only the whites of his lifeless, half-closed eyes are visible. Kneeling at his feet, on the right, are three Franciscans whose features are so lifelike that they could almost have been painted by Masaccio. They are portraits even more intense and individualized than that of Enrico Scrovegni at Padua. The three solemn mourners standing on the left, St. John and the two Marys, reveal their grief through beautifully modulated gestures and an expressiveness that ranges from the

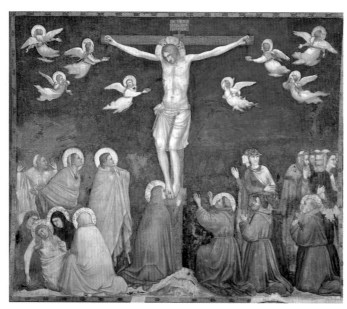

112, 113. Scenes from the Life of Christ: Crucifixion and detail

114. Vault with the Franciscan Allegories

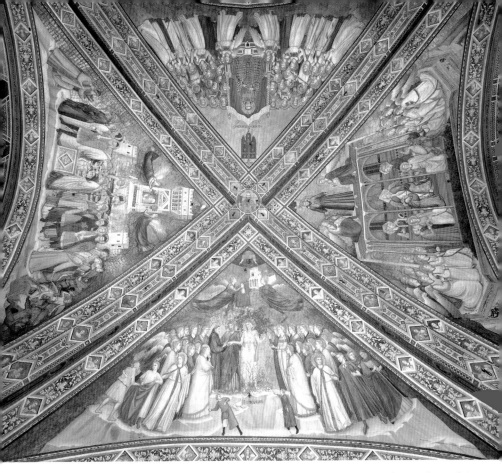

quiet weeping of St. John to the scream of the beautiful, ardent Mary and Mary Magdalene's grimace of pain. The small angelic spirits are borne by cloudlets that seem to have suddenly materialized on the blue background. Their profound expressiveness has been united with a solidity of form and an articulation of features that is rendered with great freedom yet admirable control.

When the right transept was finished, Giotto's team of painters went on to fresco the vault above the high altar. In the most striking of these frescoes, *St. Francis in Glory*, gold leaf has been used lavishly in the embroidery on the saint's clothing and in the background. Though common in panel paintings, the use of gold in a fresco was unusual, considering the cost of the material and the scale of the undertaking. The fact that the fresco decorations in the Lower Church reach the height of their magnificence in the

vault bears witness to the prevailing tendency of the Franciscan movement at the time: a rejection of the basic tenet of poverty preached by the order's founder. The emergence of this trend, particularly from the time of the generalship of Giovanni da Murro, is reflected in the increasing splendor of the fresco decorations of the basilica of San Francesco, which is evident if we compare the Upper and Lower Church.

The vault contains four complicated Franciscan allegories: *St. Francis in Glory*, the *Allegory of Obedience*, the *Allegory of Chastity* and the *Allegory of Poverty*. Filled with smiling, joyful figures, they are painted in the same style as the scenes from Christ's childhood in the right transept. The hand of the assistant traditionally known as the Master of the Vaulting Cells, whose style is characterized by the astonished expressions of his figures, predominates in these frescoes.

155

The Peruzzi Chapel

It is difficult to say what degree of affinity there is between the new style of Giotto's workshop and the decoration of the Peruzzi Chapel in Santa Croce, which was probably carried out not long after the works described above. There is reason to believe that the *Kress Collection Polyptych* (Raleigh, North Carolina), which includes *Christ Giving His Blessing*, the *Virgin, St. Francis*, and the two *St. Johns*, to whom the chapel was dedicated, is the lost altarpiece of the Peruzzi Chapel. Whether this is true or not, it must be admitted that the figure of Christ has close links with the *Christ Giving His Blessing* in the tondo above one of the entrances to the right transept of the Lower Church. However, the quality of this "slavishly Giottesque" polyptych,

as it has been described, leaves one reluctant to accept that Giotto was directly involved in its execution.

Unfortunately the Peruzzi cycle was extensively repainted, and what remains of the original frescoes, revealed during a recent restoration, is in a poor state of preservation. There is still much controversy over the dating of this chapel and that of the Bardi family adjoining it, but the author favors a date of between 1310 and 1316.

The cycle consists of scenes from the lives of St. John the Baptist (left wall) and St. John the Evangelist (right wall): the *Annunciation to Zacharias*, the *Birth and Naming of the Baptist*, the *Feast of Herod* (including the episode of Salome giving John the Baptist's head to her mother), *St. John on Patmos*, the *Raising of Drusiana* and the *Ascension of the Evangelist*. The small heads framed by hexagons are the most interesting of the minor paintings. They are so lifelike and individualized that they are thought to be portraits of members of the Peruzzi family.

The frescoes were planned on an exceptionally large scale. In this respect the cycle would appear to be a continuation of experiments begun in the chapel of the Magdalen (the Evangelist in the *Raising of Drusiana* is strongly reminiscent of Christ in the *Resurrection of Lazarus* at Assisi). The large areas of wall in the Peruzzi Chapel permitted a far greater pictorial complexity than did those of the Arena Chapel, and consequently the majestic figures that populate the frescoes and the architectural structures in which they move so convincingly are grander than anything at Assisi. As the chapel is very high, fairly long and narrow, Giotto employed

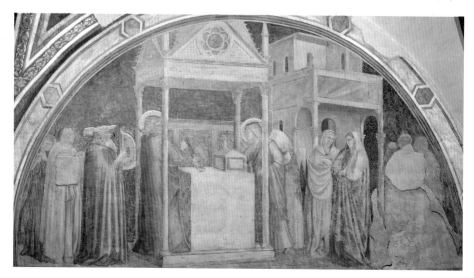

115. *View of the Peruzzi Chapel Santa Croce, Florence*

116. *Scenes from the Life of St. John the Baptist: The Annunciation to Zacharias Santa Croce, Florence*

117, 118. *Scenes from the Life of St. John the Evangelist: The Raising of Drusiana; The Ascension of the Evangelist Santa Croce, Florence*

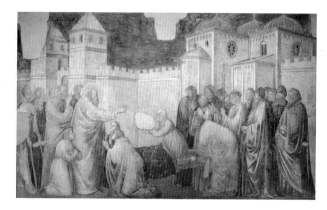

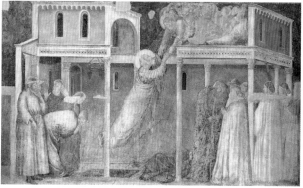

an oblique rather than frontal point of view, imagining the observer would be standing at the chapel entrance. Consequently, the buildings are set at an angle, so that the side nearest the entrance is visible.

The relationship of figure and architecture has become much more harmonious than at Padua, and each architectural structure has more than enough room for the figures it contains. In the *Raising* of *Drusiana*, the architectural backdrop formed by the walls of an Eastern city is perfectly coherent (no longer the series of separate boxes seen in the Assisi frescoes), and is on approximately the same scale as the figures. The orderly, well-constructed space evident in the *Feast of Herod* and the *Ascension of St. John the Evangelist* was to be adopted by Maso di Banco, one of Giotto's greatest followers, whose work can be seen in the Bardi di Vernio Chapel in Santa Croce.

However, our judgment of the Peruzzi Chapel frescoes has to remain suspended. It is difficult to envisage their original splendor, and to gauge how much they reflected Giotto's new style. We can only admire the single well-preserved fragment in the chapel, the

hand of St. John the Evangelist in the scene where he resuscitates Drusiana. It is a work of such strength that we are reminded of Masaccio, and regret deeply the almost total loss of these frescoes.

According to Ghiberti, Giotto decorated four chapels in Santa Croce and painted altarpieces for each chapel. A group of paintings probably executed between the decoration of the Peruzzi and Bardi Chapels may have constituted one of these altarpieces. It consists of seven square panels (average size 45 x 44 cm) representing the *Adoration of the Magi* (Metropolitan Museum, New York), the *Presentation in the Temple* (Gardner Museum, Boston), the *Last Supper* and the *Crucifixion* (both in the Alte Pinakothek, Munich), the *Entombment* (Berenson Collection, Settignano), the *Descent into Limbo* (Munich), and the *Pentecost* (National Gallery, London). The presence of St. Francis in the group of figures kneeling at the foot of the cross in the *Crucifixion*, which must have been the central panel, suggests that the work was done for a Franciscan church or chapel.

Although the poor state of preservation of the

157

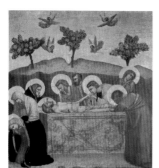

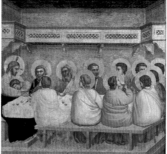

119. Deposition
44.5x43 cm
Berenson Collection,
Settignano (Florence)

120. Last Supper
42.5x43.2 cm
Alte Pinakothek, Munich

121. Pentecost
45x44 cm
National Gallery, London

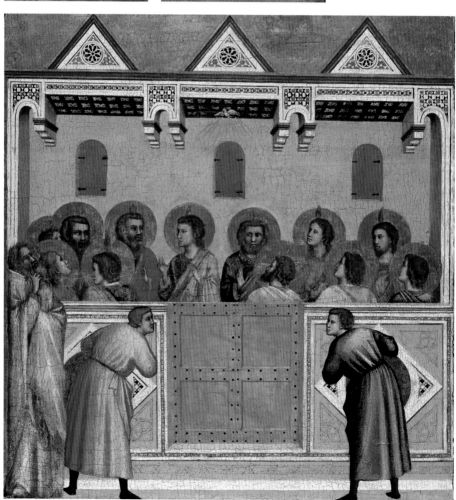

panels makes their assessment somewhat difficult, Giotto's participation in their execution cannot be doubted. His hand is especially evident in the *Last Supper*, which bears a direct relation, even in the faces of the apostles, to the same scene in the Arena Chapel, while the gallery running along the wall echoes the idea used in the *Marriage at Cana*. The construction of the work is so carefully studied that one suspects that the small hole visible in the center of the panel was made by a nail placed there to secure a string used to draw the perspective lines, a practice that was to become common among the fresco painters of the fifteenth century.

The *Christ Crucified* in the central panel appears to be closely related to the large painted *Crucifix* in San Felice, Florence, a work whose high quality is more apparent now that restoration has freed the surface of its thick layer of dirt. The early date of the San Felice work is revealed not only by its simple rectilinear shape, but also by the weight of Christ's body, which recalls the early *Crucifix* in Santa Maria Novella.

The poorly-preserved *Crucifix* in the Louvre and the one in the church of Ognissanti in Florence must have been painted much later. The elegance and pathos of the latter reveal its affinities with the frescoes in the right transept and on the ceiling of the Lower Church at Assisi.

The most important of Giotto's later panel paintings is the *Stefaneschi Altarpiece*, executed for the high altar of St. Peter's in Rome and mentioned as a work of his in the obituary of Cardinal Jacopo Stefaneschi, who commissioned the work. It is a double-sided triptych and has been preserved almost in its entirety (only two of the three panels of the back predella are missing). It is in the Pinacoteca Vaticana and was recently cleaned.

The scenes on the altarpiece are dominated by the solemn, sacramental tone of the central panel on each side: a tone which, precisely because it is unusual in Giotto's work, demonstrates his ability to adapt his art to the requirements of each new commission. On the front of the central panel Christ sits on his throne, raising his right hand in a gesture of benediction and holding the Book of Revelations in his left. As in thirteenth-century paintings of the *Maestà*, the throne is surrounded by a group of angels, but here their slightly circular disposition has been subtly adapted. Cardinal Stefaneschi is shown kneeling in the foreground. The crucifixion of St. Peter is depicted on the left panel and the beheading of St. Paul on the right. The predella shows the enthroned Madonna, flanked by two angels and the twelve apostles, standing. The predella figures have a detached, arcane air, one that calls to mind the rows of saints in Byzantine mosaics.

The central panel on the back of the altarpiece shows St. Peter enthroned in the same pose as Christ (he is in fact the Vicar of Christ), flanked by two angels and Sts. George and Sylvester. The figures kneeling in the foreground are Celestine V, canonized in 1313, and Cardinal Stefaneschi, who is offering a model of the altarpiece. Attention has often been drawn to the singularity of this last detail, which has been conceived with such naturalistic acumen that it calls to mind Flemish painting. On each of the side panels are the solemn figures of two standing apostles.

As a whole, the *Stefaneschi Altarpiece* is of high standard, and certain parts are remarkable in both conception and execution. This is true, for instance, of the episode of the beheading of St. Paul on the far left of the scene, where the very tall Plautilla, standing on a rock, stretches out her hands to receive the cloth – dropped by the saint when he was taken up to Heaven by the angels – as it floats earthward. The perfect harmony of space and volume (especially in the scene of St. Peter enthroned and the predella scene of the Madonna), the richness of color, the subtle Gothic refinement of some of the figures and the enchanting, enigmatic expressions of others closely link this complex work to the frescoes in the Lower Church. We also notice here that the draped female figure shown in profile on the left of the decapitation scene has been represented in the same attitude as Mary standing behind St. John in the *Crucifixion* at Assisi.

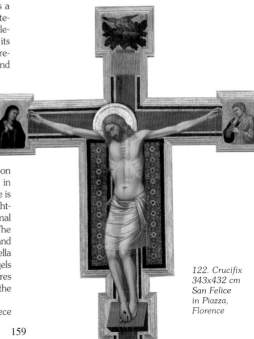

122. Crucifix
343x432 cm
San Felice
in Piazza,
Florence

123, 124.
Front and
back of the
Stefaneschi
Altarpiece
Pinacoteca
Vaticana

The Bardi Chapel

There are two fine if badly-preserved panel paintings of the *Crucifixion* which appear to have a close affinity with the *Stefaneschi Altarpiece* in their delicate proportions, rich colors and pathos. One is a gabled panel in the Staatliche Museen of Berlin, the other a rectangular panel in the Musées Municipaux of Strasbourg. The latter forms a diptych with the Wildenstein *Madonna Enthroned with Saints and Virtues*, a work which can be attributed with some certainty to the Master of the Vaulting Cells. The novelty of these Crucifixions consists in the treatment of the crowd at the foot of the cross: one gets the impression that the picture frame has abruptly cut off a small portion of an immense crowd. A subtle innovation in the Strasbourg panel is the reduction in scale of the horsemen, who thus appear to be on a different plane and at a greater distance from the figures in the foreground. The broad sweep of St. John's mantle as he raises his hands to his face has so pure a rhythm that it calls to mind Greek stelae. In both paintings Christ's body has become elongated. This Christ is far removed from the realism of the one in the Santa Maria Novella *Crucifix*.

This new Gothic tendency characterizes much of Giotto's late work, which is best represented by the frescoes in the Bardi Chapel of Santa Croce. By then the great Sienese painter Simone Martini had developed a refined and sophisticated version of Giotto's art, one deeply influenced by the French Gothic style. He was fast becoming Giotto's most serious Italian rival (he, too, was receiving many commissions from abroad), and Giotto's response to Martini's success

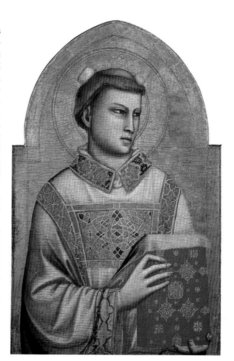

was to modify his own painting, making it more refined and ornate.

The partially reconstructed polyptych consisting of the *Madonna and Child* (National Gallery, Washington), *St. Stephen* (Museo Horne, Florence) and *Sts. John the Evangelist and Lawrence* (Musée Jacquemart-André, Châalis) is so close stylistically to the Bardi Chapel frescoes that some of the faces seem to be almost interchangeable. Although they have the solemn bearing found in all of Giotto's large-scale paintings, the figures in these panels are distinguished by their aura of luxury and wealth. The *Madonna*, who has the long narrow eyes of her counterpart on a French ivory, seems to have arrayed herself magnificently in a mantle whose folds anticipate the impression of warm, velvety luxury created by certain of Gentile da Fabriano's paintings. St. Stephen is dressed in a sumptuously ornate dalmatic and carries a richly bound book. Even though the tone is not as exquisitely worldly and courtly as that of a Simone Martini painting, one feels that Giotto intended these panels to challenge his young Sienese rival.

The Bardi Chapel frescoes did not provide the op-

125.
St. Stephen
84x54 cm
Museo Horne,
Florence

126.
Crucifixion
39x26 cm
Musées
Municipaux,
Strasbourg

portunity for such richness, given the rule of poverty imposed by St. Francis. However, the elongated figures, delicate colors and pictorial softness are in keeping with the tendency described above. The characters in the scenes from the life of St. Francis, again shown in contemporary dress given their close proximity in time, have been given a more earthy, realistic appearance than those in the Peruzzi Chapel. The St. Francis cycle at Assisi still served as the model for the scenes from his life, though the limited space in the chapel made it necessary to restrict the number of episodes represented.

The *Renunciation of Worldly Goods* appears in the lunette of the left wall and the *Confirmation of the Rule* in the lunette on the opposite wall. *St. Francis before the Sultan* and the *Apparition at Arles* are set immediately below them. At the bottom of the left wall we see the *Death and Ascension of St. Francis*, while the *Vision of the Ascension of St. Francis* is on the opposite wall. *St. Francis Receiving the Stigmata* is painted on the outer wall above the entrance arch. Only three of the original four Franciscan saints represented next to the window have survived: *Louis of Toulouse, Clare* and the badly damaged *Elizabeth of Hungary*. The painted tondi on the vault enclose poorly preserved allegorical figures: *Chastity, Poverty* and *Obedience*; the fourth tondo has not survived.

The Bardi Chapel was completely whitewashed in the eighteenth century, as was the Peruzzi Chapel, and tombs were built against its walls, destroying parts of the frescoes. The frescoes were uncovered in 1852, the missing parts filled in and the whole surface repainted. When the repainting was removed by the Florentine

127. View of the Bardi Chapel Santa Croce, Florence

128. Scenes from the Life of St. Francis: The Appearance to Brother Agostino and the Bishop of Assisi, detail Santa Croce, Florence

Fine Arts Service in 1958-59, the original frescoes reemerged in fair condition, save for the unsightly gaps.

We know from both contemporary sources and thirteenth-century paintings that St. Francis was bearded, yet he appears without one in the Bardi Chapel frescoes. This iconographical irregularity is doubtless linked to the revisionist current in the Franciscan movement, represented by the Conventuals, and to subsequent attempts to modify the image of the most popular saint in Christendom, a change that

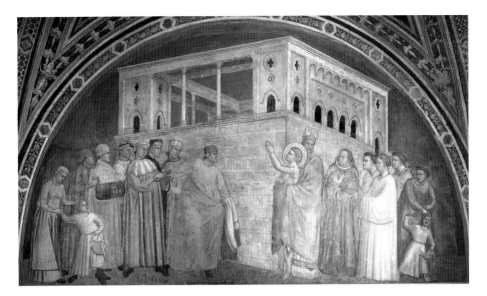

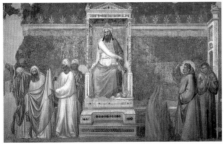

129-131. Scenes from the Life of St. Francis:
The Renunciation of Worldly Goods; The Ordeal by Fire
before the Sultan; The Funeral of St. Francis
Santa Croce, Florence

involved not only denying his traditional association with poverty but also his physical appearance. At a time when beards were regarded with distaste by members of polite society, a subtle intention lay hidden in the omission of St. Francis' beard, an iconographical deviation that originated in the papacy toward the end of the thirteenth century.

The Bardi Chapel frescoes condense the saint's life into a series of representative events: his renunciation of worldly goods, papal recognition of the Franciscan Order, his vocation as missionary to the East (at the time of the Crusades), a miracle performed during his lifetime, the appearance of the stigmata and two miracles performed after his death. The plan differed from that of the Peruzzi frescoes in that the

observer was envisaged as standing approximately in the center of the chapel, facing either of the side walls. The arrangement of the scenes on different levels was taken into account and the buildings in the uppermost scenes accordingly foreshortened. This is evident in the splendid construction in the background of the *Renunciation of Worldly Goods*, which was to provide a rich source for Giotto's faithful follower, Taddeo Gaddi, whose studies of oblique buildings were to culminate in the magnificent structure in the *Presentation in the Temple* in the Baroncelli Chapel of the same church. Just as the Peruzzi frescoes were important to the formation of Maso di Banco, the ones in the Bardi Chapel greatly influenced the development of Gaddi, who drew inspiration from them for a series of scenes from the life of St. Francis he painted on the panel of a cabinet door in the sacristy of Santa Croce (now in the Galleria dell'Accademia, Florence). He was also to remain faithful – to the very

end of his long career – to the robust but long-limbed figures of the Bardi Chapel frescoes. The *Confirmation of the Rule* was the direct source of Giovanni da Milano's *Expulsion of Joachim from the Temple*, a solemn symmetrical construction of buildings and figures painted in the Rinuccini Chapel of Santa Croce around 1365.

The St. Francis cycle in the Bardi Chapel lacks the liveliness of its Assisi counterpart, and gives the impression of being separated from us in time by a curtain of sanctity. Yet certain features, like the angry father in the *Renunciation of Worldly Goods* and the figure of St. Anthony in the *Apparition at Arles*, were clearly inspired by the Assisi cycle. The scenes here are much more unified and symmetrical, the paint is full and velvety, the colors light and delicate. Clarity and order are still the fundamental principles. Notice the careful arrangement of the friars behind St. Francis in the *Confirmation of the Rule* and the balanced composition of the *Apparition at Arles*, which is prevented from being monotonous by devices such as the row of heads placed behind the low dividing wall to suggest greater depth, the inclusion of the marvelous figure of the young friar absorbed in thought and the gradual darkening of the shadow cast by the roof on the white wall, which produces an effect so subtle that it anticipates Fra Angelico's fresco of the *Annunciation*, painted over a century later, in one of the cells of San Marco.

We cannot help but admire the balance maintained between the studied precision of the composition and the eloquent expression of grief in the *Death and Ascension of St. Francis*, where a small group of friars is gathered round the pale figure of the dead saint, expressing their profound sorrow with great dignity. A comparison of this scene with the Paduan *Lamentation* clarifies the distinction that Giotto intended to maintain – to speak in Dantesque terms – between the "tragic" level of the life of Christ as told in the Bible and the "comic" level of the legend of an almost contemporary saint.

The presence of Louis of Toulouse among the saints represented at the sides of the window provides one indication of the date of the Bardi frescoes, as they cannot have been painted before 1317, the year he was canonized. The stylistic similarity of these frescoes to Giotto's last works, and even to the frescoes in the Bargello Chapel in Florence, which were completed by his workshop a few months after his death, place them at a late stage of the artist's career.

In the last years of his life Giotto's energies were divided between his role as master builder of Florence Cathedral (this was when he began work on the Campanile, known as "Giotto's Tower") and prestigious commissions throughout Italy (between 1329 and 1333 he was working in Naples for Robert of Anjou;

in about 1335, according to Villani, he was in Milan, working for Azzone Visconti). But he still found time to oversee the activity of his efficient workshop, which was producing ambitious, richly colored works such as the *Bologna Polyptych* (executed for the church of Santa Maria degli Angeli and now in the Pinacoteca) and the altarpiece in the Baroncelli Chapel of Santa Croce, both of which bear his signature.

Flanked by four stern saints, the Madonna of the *Bologna Polyptych* sits on a throne that is the most Gothic of all the thrones painted by Giotto. She has the demeanor of an elegant, almost worldly lady. The lovely decorations and the brilliant, shimmering colors contribute to the richness of this work. The resplendent *Coronation of the Virgin* in the Baroncelli Chapel, which cannot have been decorated before the end of the 1320s, is undoubtedly one of Giotto's last great conceptions. The neat, colorful rows of beatific souls on the side panels suggest that Paradise is a place of perfect order – and perspective! One feels that the side panels could continue into infinity, making it a boundless Paradise. In contrast, the central panel with the elegant figures of Christ and the Virgin has something of the refined worldliness of a court ceremony.

Giotto's influence on the frescoes in the Bargello Chapel is most evident in the scene of the *Last Judgment* on the back wall (although badly deteriorated, we can still make out a few beautifully painted heads of the blessed). He died in early 1337, before the frescoes had been completed. He had followed a path which led from the revolutionary vitality of the frescoes in the Upper Church at Assisi, through the more serene classical narrative of the Arena Chapel frescoes, to the warm chromatic frescoes of his second sojourn at Assisi, the starting point for his last, refined Gothic period.

In his lifetime Giotto had raised painting to a prestigious level among the arts, to such an extent that it now influenced sculpture rather than the other way round, as is demonstrated by the work of the great Andrea Pisano. Italian painting can be said to have changed more radically with the appearance of Giotto than ever before. The impulse that Giotto gave to the arts was so great that it shaped the destiny of European painting. By the middle of the fourteenth century the rest of Europe had already become aware of Giotto's innovations, which accorded with the growing secular tendency in European society. His rediscovery of the third dimension, of real and measurable space, of the natural appearance of surfaces, of the individualizing aspects of reality, all this became the heritage of European art, which turned to the figurative world of Italy with ever growing curiosity. And there can be no doubt that the great reform carried out by Jan van Eyck in the Flemish painting of the fifteenth century had its deepest roots in Giotto's revolution.

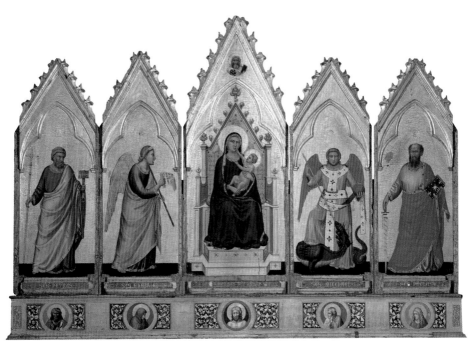

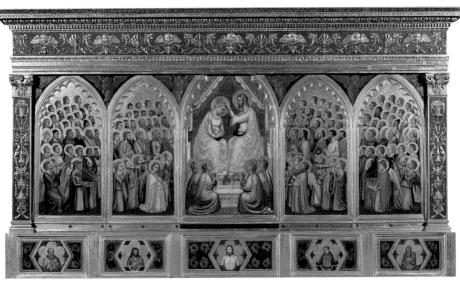

132. Bologna Polyptych
91x340 cm
Pinacoteca Nazionale, Bologna

133. Baroncelli Altarpiece
185x323 cm
Santa Croce, Florence

SIMONE MARTINI

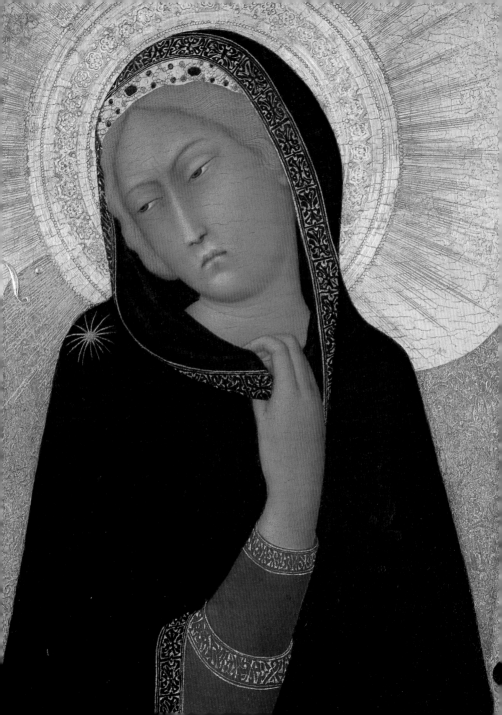

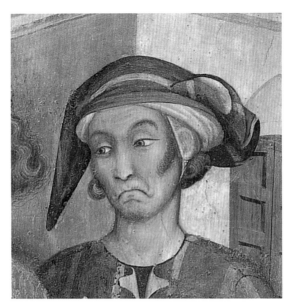

1. *Miracle of the Resurrected Child*
Detail of the presumed self-portrait
Assisi, San Francesco

The Life of Simone Martini

If one were to reconstruct the life of Simone Martini using only documented facts one would have a very short account, with a great many gaps. So, in this text, we will also be making use of many of the elements that have been handed down by traditional accounts, even though most of them find no direct confirmation in the documents of the time. But by comparing and relating them to the nature and the style of Simone's works, we shall be able to reconstruct the great artist's life story.

Let us begin this short historical and chronological account from the date of Simone's death, which we know for certain. An obituary notice in the monastery of San Domenico in Siena, dated 4 August 1344, reads as follows: "Magister Simon (pictor) mortuus est in Curia; cuius exequias fecimus in Conventu die iiij mensis augusti 1344" (Master Simon, painter, died in the Curia; his funeral was held in the convent on the 4th day of the month of August 1344). If we are to believe Vasari, who tells us that on Simone's tomb there was an epitaph stating that he had died at the age of sixty, then the artist must have been born around 1284.

What did Simone look like? He was probably not a very handsome man, at least according to Petrarch, who was a close friend of his. Some scholars claim that the Christ before Pilate on the back of Duccio's *Maestà* in the Palazzo Pubblico in Siena is a portrait of Simone; others believe that he is the knight with the blue hat who is witnessing, half amused, half in disbelief, the *Miracle of the Resurrected Child* in the Chapel of San Martino in the Lower Church of San Francesco in Assisi.

Unfortunately, we know nothing of the first thirty years of his life; but, despite this rather discouraging lack of concrete information, a good number of fairly plausible suggestions have been made. He may have been born in Siena, in the neighbourhood of Sant'Egidio; or perhaps, according to the theory of Enzo Carli, he was born in the countryside around Siena, near San Gimignano, the son of a Master Martino specialized in the preparation of the *arriccio* (or first coat) applied to wall surfaces to be frescoed. Simone most probably learnt the trade in the workshop of Duccio di Buoninsegna, but he only became well-known as an artist when he painted the *Maestà* in

the Sala del Mappamondo in the Palazzo Pubblico in Siena: the inscription around the frame of this fresco gives the date, "mille trecento quindici" (1315), and the author, "a man di Symone" (by the hand of Simone). If we consider that the Commune of Siena chose Simone as the artist to paint such an important fresco, we can assume that he must already have had quite a good reputation before he was commissioned the *Maestà*. Working for the Commune on the decoration of the Palazzo Pubblico, the heart of the city both literally and symbolically, was an experience shared by all those who are today considered the greatest Sienese painters of the late 13th century and the first half of the 14th: Duccio, Simone and Ambrogio Lorenzetti. From the documents recording this commission we also learn something about Simone as an artist: he was very meticulous and took great care in his realistic landscape views. As we can see in the *Blessed Agostino Novello Altarpiece*, Simone was very accurate in his depictions of town scenes and details: arcades, mullioned windows and rooftops (and also the interior of a house) offer us a very realistic picture of 14th-century Siena. But his love of realism made him go even further: when the government commissioned a series of paintings showing the castles that the city's troops had conquered in neighbouring areas, "Maestro Simone dipegnitore" actually went in person to look at the places, "chon un chavallo et uno fante a la terra d'Arcidosso et di Chastel del Piano" (with a horse and a servant he travelled to Arcidosso and Castel del Piano). Simone painted the capture of Arcidosso and Castel del Piano in the Sala del Mappamondo in December 1331: most scholars agree that this fresco has been destroyed, but some believe that it is the one discovered a short while ago below the *Guidoriccio*.

According to Ferdinando Bologna's plausible reconstruction of Martini's life and work, it appears that he travelled frequently from Siena to Assisi and viceversa. It seems that between 1312 and 1315 he did the drawings for the stained-glass windows in the Chapel of San Martino in the Lower Church in Assisi, for these windows certainly look earlier and more archaic from a stylistic point of view than the frescoes in the same chapel (finished by 1317). In 1315 he painted the *Maestà* in the Palazzo Pubblico in Siena and probably also did some more work in Assisi, on the frescoes in the Chapel of San Martino. Also in 1315, as a result of the canonization of Louis of Toulouse, Simone probably received the commission for the *Naples Altarpiece*, a signed painting which is traditionally supposed to have been painted in Naples, although there is no evidence to support this theory. There is an interesting document, an order of payment dated 23 July 1317, in which Robert of Anjou instructs that "Simone Martini milite" be paid: Simone is not referred to as a painter, but as a "miles," a term used in the Middle Ages to mean a knight. According to Bologna's reconstruction, Simone must have been knighted for having paid tribute to King Robert, his family and the French royal lineage both in the frescoes in Assisi and in the *Naples Altarpiece*. It was fairly common procedure in the late Middle Ages for a sovereign to knight an artist for such merits.

We have already spoken of Simone's realism, but it is interesting to hear what Vasari had to say about it: "He loved to portray from nature and in this he was considered the best master of his day." In mediaeval painting the first individual portraits are to be found in the work of Simone, who appears to have noticed before his contemporaries the uniqueness of the features of his single subjects. Take, for example, the sharp profile of King Robert in the *Naples Altarpiece*, or the obsequious expression of Cardinal Gentile Partino da Montefiore above the arch over the entrance door to the Chapel of San Martino: both of these are indicative of the extraordinary talent that Simone showed in his portraits. What a shame that the portrait of the beautiful Laura that Simone painted for Petrarch has not survived: it must indeed have been quite splendid, for the great poet wrote two sonnets inspired by its beauty.

A large and quite varied group of panel paintings is normally dated around the late 1310s and the early 1320s. By examining them we shall be able to follow Simone's artistic development: the pre-Giottesque style of Assisi and the reminiscences of Duccio's art are filtered through a more openly Gothic style expressed in innovative volume constructions, with images set in bright and spacious areas, with sinuous and sharp lines. Our documentation on this group of paintings is so scarce that we know for certain the dates of only two of them: the polyptych for the church of Santa Caterina in Pisa (1319) and the one in the Museum at Orvieto (1320). As far as the others are concerned, especially the numerous polyptychs produced in the Orvieto workshop, most recent scholars tend to date them at the early 1320s, but entirely on stylistic grounds, for there is no documentary evidence at all. In any case, an

2. *Madonna and Child (no. 583)*
88 x 57 cm
Siena, Pinacoteca

See you when you get home.

www.metmuseum.org

Visit The Metropolitan Museum of Art's Web site and enjoy our collection at home.

What's online: www.metmuseum.org

- More than 6,000 works of art from the Permanent Collection
- **Met Store** reproductions and publications for year-round gift giving
- Features designed to complement our **Special Exhibitions**
- **Now at the Met**, where you can plan your next visit to the Museum
- An interactive **Timeline of Art History**, with art from around the world
- **My Met Museum**, where you can create your own gallery, customize the calendar, and request email newsletters

Become a Member and receive free admission for one year to the Museum and The Cloisters, and much more!

The Metropolitan Museum of Art Web Site
5,000 Years of Art in the Galleries and Online

By the Seashore, 1883
Pierre-Auguste Renoir (French, 1841–1919)
Oil on canvas; 36 1/4 x 28 1/2 in.
(92.1 x 72.4 cm)
The Metropolitan Museum of Art, New York
H. O. Havemeyer Collection,
Bequest of Mrs. H. O. Havemeyer, 1929
(29.100.125)

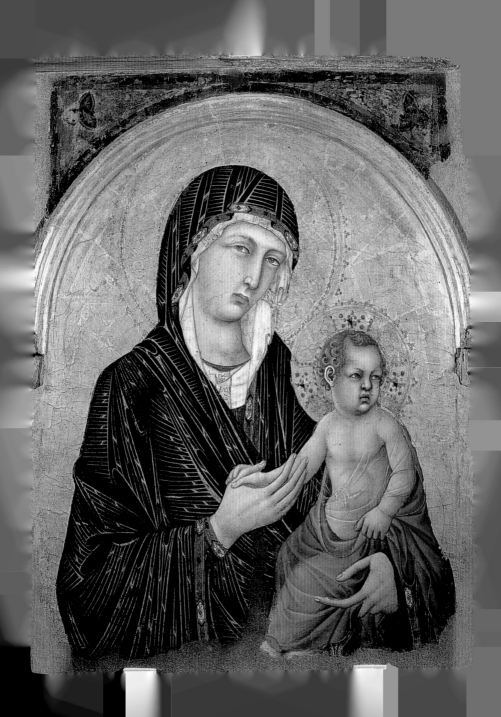

accurate study of Simone's production in Orvieto is extremely difficult, for all the paintings attributed to him show quite considerable interventions by assistants.

All through the 1320s the Biccherna registers (the Commune of Siena's accounting ledgers) record payments to Martini, evidence that he must have worked a great deal in Siena before leaving for Avignon. These documents refer to a variety of paintings, many of which have not been identified or have not survived. In 1321 Simone was paid to restore his own *Maestà*, which had been damaged already by rainwater infiltrations in the wall, and for the work he had done on a painted Crucifix (which was eventually completed by his pupil, Cino di Mino Ughi). In 1322 and 1323 "Maestro Simone Martini depintore" was paid for a variety of works, not specified, painted for the Palazzo Pubblico. In 1324 he married Giovanna, the daughter of Memmo di Filippuccio and the sister of Lippo Memmi. Simone may have been a rich man, for his activity as a painter certainly provided him with a substantial revenue. Shortly before his marriage, in January or February 1324, he bought a house from his future father-in-law and presented to his wife-to-be a "propter nuptias," a wedding gift, of two hundred and twenty gold florins: almost thirty times as much as he was paid a few years later for the paintings of the castles of Arcidosso and Castel del Piano! Perhaps with an excess of sentimentalism, this gift has been interpreted as a sign of gratitude: after all, Simone was already past forty and not very handsome, so he was grateful to the young girl for accepting to marry him. Whatever the truth may be, the gift is undoubtedly evidence of his generosity, a trait that comes across quite clearly in his last will and testament as well. Simone married into Lippo's family, then, and this further strengthened a bond of friendship and artistic collaboration that lasted throughout their careers, reaching its highpoint in the *Annunciation* in the Uffizi where it is actually quite difficult to distinguish Simone's work from Lippo's.

Also presumably dating from the 1320s are the Altarpiece of the *Blessed Agostino Novello* and the small tempera portrayal of *St Ladislaus, King of Hungary*. Not all scholars agree on this dating, but Max Seidel's perceptive theories about the altarpiece formerly in the church of Sant'Agostino and now in the Siena Pinacoteca and those by Bologna concerning the painting in the Museum of Santa Maria della Consolazione (formerly in the church of the same name) in Altomonte, have helped us reconstruct the history of the two works. In 1326 Simone must have painted a panel for the Palazzo del Capitano del Popolo: we know this must have been a very important painting, both because of the huge sum of money he was paid for it and because Ghiberti, in his 15th-century *Commentaries*, described it as "molto buona," and we know that Ghiberti was never a great admirer of Simone's, since he thought Ambrogio Lorenzetti was a better painter. The following year Simone painted two banners which have not survived; they were presented by the Commune of Siena to Duke Charles of Calabria, the son of Robert of Anjou. In 1329/30 he painted "two little angels on the altar of the Nine" in the Palazzo Pubblico in Siena and a portrayal of the rebel Marco Regoli (who was hanged by his feet, a form of execution reserved for traitors and forgers) in the Sala del Concistoro; neither of these frescoes has survived. Also in 1330 Simone painted in the Palazzo Pubblico one of his most celebrated works, the fresco of *Guidoriccio da Fogliano*, a commemoration of the conquest of the castle of Montemassi in 1328 (the date, "MCCCXXVIII," under the fresco refers to the conquest and not to the fresco). The recent discovery of another fresco below this one depicting a similar scene, has raised some doubts as to the attribution. The history behind the Guidoriccio, its meaning and iconography, have been the object of a very animated debate amongst the most authoritative art historians.

The date 1333 appears on the frame of the *Annunciation* painted for Siena Cathedral: this is the last painting we know of that Simone worked on before moving to France. The primary consequence of the Papal See being transferred to Avignon in the early 14th century was that it transformed that small Provençal city into an artistic centre of European renown: paintings, artists and entire workshops, incentivated primarily by the Italian cardinals, were transferred to Avignon, and Simone, too, moved there in 1336. In what became the busiest art centre of the century, the style of the northern artists soon blended with the aristocratic elegance of Italian painting, especially the art of Simone, laying the foundations for the International Gothic style, an art of exquisite courtly refinement, of which Martini is generally considered a forerunner.

Although a member of a very stratified society (common citizens, imperial power and feudal hierarchy, the Pope and the Papal State), Simone was always associated with the highest social levels. His career evolved from one important commission to the next, always at the service of the highest powers. While in Siena he worked for the Government of the Nine, decorating the palace

3. Madonna, detail
San Gimignano, Oratory of San Lorenzo in Ponte

where they held their meetings; then he worked in the Basilica of San Francesco in Assisi, the most important institution of the Franciscan Order, but one which was temporal enough to be influenced by the current political situation. Then he gained the favour of the House of Anjou working at the Court of King Robert; and lastly he moved to Avignon to work for the most powerful members of the Church. From local painter to artist of European renown: his art went from secular subjects commissioned by the city's lay government, to holy subjects painted for Church patrons and even for royalty. But he always remained faithful to his style, an elegant, realistic and cultured art. His growing reputation as an artist must also have contributed to the general esteem he was held in, and we find his name appearing in documents in roles that required public trust: in 1326 he was a witness in a land rental contract, in 1340 he was given power of attorney in a legal dispute, and just before his death he was reimbursed the sums that he had advanced in order to obtain four Papal privileges for a Sienese hospital. These are all incidents that have nothing to do with his career as a painter, but they help us reconstruct his life history and his temperament.

The contrasting opinion of scholars on Simone's later works is the result of the lack of information available. Apart from the fragments of frescoes in Notre-Dame-des-Doms in Avignon, all that has survived from this period is the frontispiece of Petrarch's copy of Virgil (now in the Biblioteca Ambrosiana in Milan), the *Holy Family* in the Walker Art Gallery in Liverpool, dated

1342 and the polyptych of *Stories from the Passion* now belonging to the museums of Antwerp, Paris and Berlin.

Simone Martini died in Avignon in the summer of 1344. As Vasari tells us "he was overcome by a very serious infirmity. . . and not being able to withstand the gravity of the illness, he passed away." Clearly Simone was already ill and must have been aware that the end was near, for on 30 June he had already drawn up a will. The true nature of Simone, an extremely generous man, deeply attached to his family, comes across from this document, written and witnessed by the Florentine notary Ser Geppo di Ser Bonaiuto Galgani. All his worldly possessions (two houses, country properties with vineyards and a considerable sum of money) were divided between his wife, two nieces, Francesca and Giovanna, and his brother Donato's children. Since he had had no children of his own, Simone left almost all his wealth to his nieces and nephews. And his family loved him as much as he loved them, especially his wife Giovanna who returned to Siena from Avignon in 1347 (perhaps she was escaping the Black Death) all dressed in black, still in full mourning for her beloved Simone.

Simone Martini and Tuscany: Early Works

When Simone painted the *Maestà* in the Palazzo Pubblico his personal artistic style was fully developed, able to express original ideas and innovative compositions. This is consistent with what we know about him: he painted it in 1315, when he was about thirty years old. But we don't really know what he painted before then. He was probably working in Siena at the very beginning of the 14th century, learning the trade in Duccio's workshop, as some paintings recently attributed to his very early period would appear to suggest.

The *Madonna and Child*, no. 583 in the Siena Pinacoteca, after a variety of attributions, thanks to the research done by Giulietta Chelazzi Dini, is now accepted as the earliest known painting by Simone. It was the central panel of a polypytch (on either side there are holes to fasten the side panels to it) and the attribution is based on stylistic considerations: on the one hand, close ties to Duccio's painting; on the other, typical features of Simone's art. The Madonna is looking at the spectator: her erect position, the cloak enveloping her body, her sweet but sad eyes, are all elements typical of Duccio's art. But alongside these we find some totally new features: the sculptural quality of the veil around the Virgin's face and the play of light and shadow (notice how similar she is to Mary Magdalene in the *Maestà*); the restless movements of the Child, who turns his head towards the Saint to his left (the figure originally depicted on the side panel) and holds onto his mother's hand; his round body, his mouth, his curly hair and the perfect shape of his ear are all given exact volumes and concrete forms (similar typologies are to be found also in the Child between Saints Stephen and Ladislaus of Hungary in the Basilica in Assisi).

It is interesting here to draw a parallel with another early work, discovered by Carli who believes that Simone painted it between 1311 and 1314. It is the *Madonna* in the Oratory of San Lorenzo in Ponte at San Gimignano; or rather, the head of the Madonna, since in 1413 the fresco was almost entirely redone by Cenni di Francesco: the face survived only thanks to a legend according to which the good state of conservation of Mary's face was the result of a miracle and it should therefore not be touched. Despite the terrible conditions of the painting, the edge of the cloak, the clear veil and the lighter areas of the chin and cheeks are reminiscent of *Madonna* no. 583; but, as Chelazzi Dini has so correctly pointed out, the latter's archaic composition suggests that it must have been painted a few years earlier than the San Gimignano fresco, around 1308-1310.

The *Madonna of Mercy* from Vertine also dates from this period. It is a splendid tempera painting only recently attributed (and not unanimously, at that) to Simone. Here, we can still clearly see the influence of Duccio, especially in the positioning and typology of the characters sheltered under Mary's cloak. But a new spirit prevails: a sense of real space between the heads and a feeling of life and movement in the imposing figure of the Virgin (the drapery folds do not conceal the position of her legs and she is quite noticeably turning in order to embrace all her protégés) are evidence of the evolution of the artist's more archaic ideas towards new forms of expression. The effect of rich and precious ornamentation (a striking feature of the *Maestà*) is reproduced in the use of gold and silver, colourful gems set in the surface, and transparent varnishes. Although we cannot be sure that this Madonna was actually painted by Simone, no one can deny the analogies, both in technique and style, with *Madonna* no. 583.

4. Madonna of Mercy
154 x 88 cm
Siena, Pinacoteca

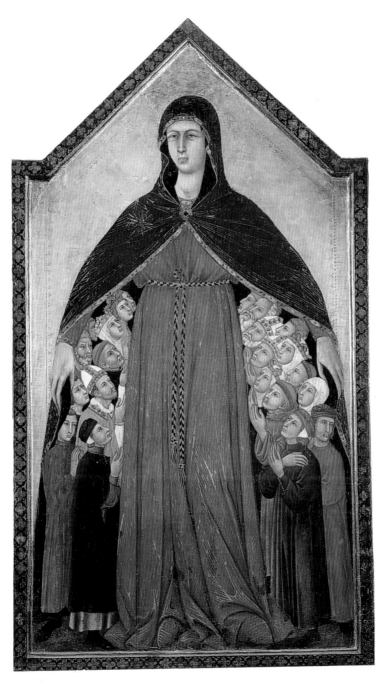

Simone and the Commune of Siena: His Fame Grows

In our investigation of the mysteries behind the development of the art of Simone, after the early works that have been attributed to him in a fairly plausible way, although purely on stylistic grounds, we come to a concrete element: the *Maestà* in the Palazzo Pubblico, which is still the oldest painting that we can safely attribute to him. The end wall in the Sala del Mappamondo is entirely covered by this fresco. Surrounded by a frame decorated with twenty medallions depicting the Blessing Christ, the Prophets and the Evangelists (in the corners, each one with his symbol) and with smaller shields containing the coats-of-arms of Siena (the black and white standard) and the Sienese people (the lion rampant), the fresco shows a host of angels, Saints and Apostles, with the Madonna and Child in the centre. To the left of the splendidly decorated throne, Saints Catherine of Alexandria, John the Evangelist, Mary Magdalene, Archangel Gabriel and Paul; to the right, in almost identical positions, Barbara, John the Baptist, Agnes, Archangel Michael and Peter. Below, kneeling, are the four patron Saints of Siena: Ansano, Bishop Savino, Crescenzio and Vittore, accompanied by two angels who are offering Mary roses and lilies. The whole scene, set against a deep blue background, is surmounted by an imposing canopy of red silk, significantly held up by Saints Paul, John the Evangelist, John the Baptist and Peter. In the lower section of the fresco, on the inner frame, are the remains of an inscription which has been reconstructed as follows: "Mille trecento quindici era volto/ E Delia avia ogni bel fiore spinto/ Et Juno già gridava: I' mi rivolto!/ Siena a man di Simone m'ha dipinto" (1315 was over and Delia had made the lovely flowers blossom, and Juno cried: I'm turning over. Siena had me painted by the hand of Simone). There is no doubt that the artist mentioned was indeed Martini, but the interpretation of the date is controversial: some think that it refers to June 1315, others believe that it means June the following year, for 1315 was over, Delia (Spring) had already made the flowers bloom, whereas Juno, to whom the month of June was dedicated, was about to show her second half. The most obvious innovations present in Simone's style, an art that was very different from traditional forms, are his ideas of three-dimensional space. The canopy's supporting poles are placed in perspective, thus giving a sense of depth to the composition. Under the canopy there is a crowd of thirty people: no more processions of people in parallel rows, but concrete spatial rhythms and animated gestures. Simone was quite clearly acquainted with the perspective constructions that Giotto had used in Assisi, an acquaintance that might have come to him through the work of the Master of Figline or that of Memmo di Filippuccio. But his art also contains a personal interpretation of elements of the French Gothic (not necessarily the result of a journey abroad, for he could have seen ivory carvings, miniatures and goldsmithery): the pointed arch structure of the throne, the precious ornamentation of the materials and the golden reflections give the whole scene a vaguely secular mood. But there is something more. Simone has developed a new way of understanding art: the wall is not simply painted, but carved, incised, set with coloured glass, raised surfaces, strong and bright colours. The various materials, like glass, tin and so on — everything that is not tempera or coloured earth — are all handled with great confidence by Simone. As Luciano Bellosi has suggested recently, Simone Martini owes a great deal to the work of Sienese goldsmiths. The Gothic shapes and the sophisticated and shining surfaces were undoubtedly influenced by the artefacts produced in the workshops of goldsmith artisans, who decorated the most precious metals with the new technique of translucid enamels. This tendency towards perfectionism and use of imaginative techniques produces surprising effects. As Alessandro Bagnoli has pointed out, the scrolls held by the Child and by St Jerome are made of paper (and not parchment) and the words are written on them in real ink.

In 1321 Simone Martini and the assistants of his workshop restored the fresco, retouching some of the figures that had been damaged: the faces of the Virgin, the Child, the angels and the patron Saints, Ansano and Crescenzio. The two different periods when Simone worked on the *Maestà* are very important in our reconstruction of the development of his art: the restored sections, with their more linear design and more transparent colours, are much more self-confident than the earlier parts. But let's not forget that between his first intervention and the second one Simone had been to Assisi. And that's not all. Tests carried out recently have shown that in the lower section (more or less at the height of the thighs of the kneeling Saints, about four metres from the floor)

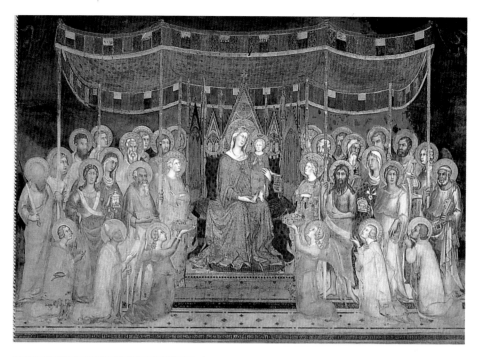

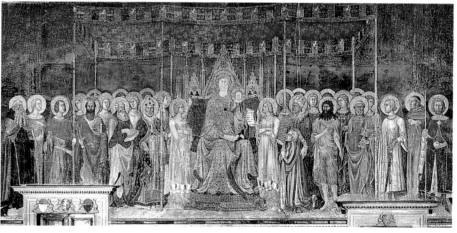

5. *Maestà*
763 x 970 cm
Siena, Palazzo Pubblico

6. *Lippo Memmi*
Maestà
San Gimignano, Palazzo Pubblico

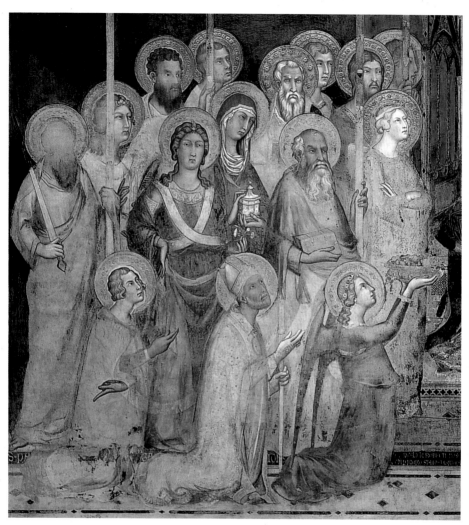

there is a clearly visible line where the colour to-
nality changes. Since it does not look simply like
the demarcation between two different days'
work, Bagnoli has suggested that it indicates a
short period of interruption on the work on the
fresco (notice how the intonaco does not blend
perfectly, as the result of being applied at different
times). Therefore, we can say that even the first
painting of the *Maestà* was carried out in two
separate sessions. One can but wonder where Si-
mone was while the host of Saints was waiting to
be completed, and what superior power (it had to

7. Maestà
Detail of the left side
Siena, Palazzo Pubblico

8. Maestà
Detail of the right side
Siena, Palazzo Pubblico

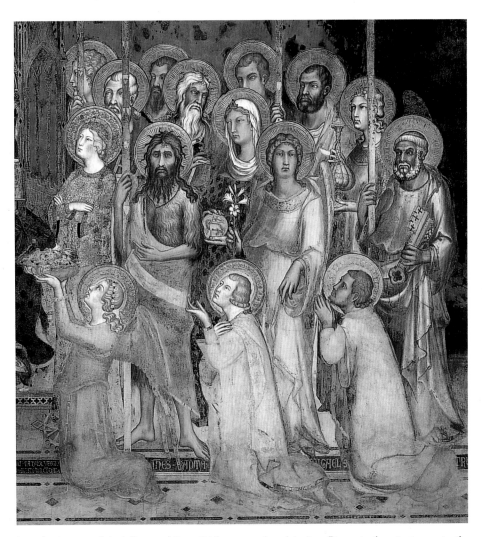

be indeed superior!) had distracted the artist from such an important fresco. He was probably in Assisi, measuring the wall surfaces of the chapel of San Martino, planning the scenes and perhaps even drawing his first synopias on the walls.

The lines in Italian that appear on the steps of the throne are composed in *terzine* rhyme, like the *Divine Comedy*. They explain the meaning of the fresco: the Virgin is addressing the Council of Nine, who had commissioned the fresco, and is exhorting them to govern in the name of those moral and religious principles that guarantee con-

cord and justice. Peace in the city is constantly threatened by internal struggles between the two enemy factions, led by the Tolomei and the Salimbeni. And these Mary condemns: "Li angelichi fiorecti, rose e gigli, / Onde s'adorna lo celeste prato, / Non mi dilettan più ch'e' buon consigli. / Ma talor veggio chi per proprio stato / Dispreza me e la mia terra inganna: / E quando parla peggio è più lodato: / Guardi ciascun cui questo dir condanna. / Responsio Virginis ad dicta sanctorum: / Dilecti miei, ponete nelle menti / Che li devoti vostri preghi onesti / Come vorrete

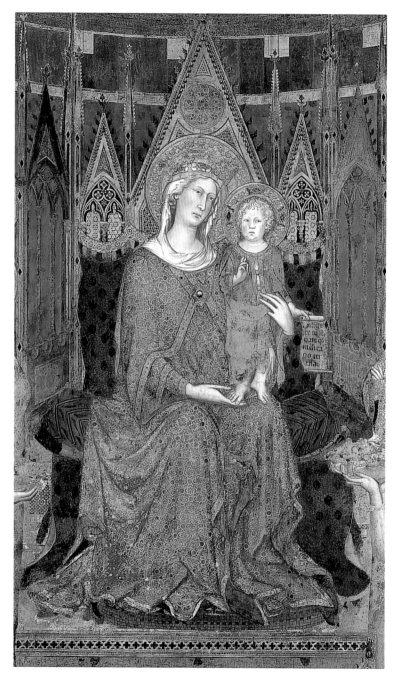

9. *Maestà*
Detail of the Madonna and Child
Siena, Palazzo Pubblico

10. *Maestà*
Detail of the medallion with St Gregory
Siena, Palazzo Pubblico

11. *Maestà*
Detail of the medallion with the Allegory of the Old and the New Law
Siena, Palazzo Pubblico

12. *Maestà*
Detail of the medallion with Madonna and Child
Siena, Palazzo Pubblico

181

voi farò contenti, / Ma se i potenti a' debil fien molesti / Gravando loro con vergogna o danni, / Le vostre orazion non son per questi / Né per qualunque la mia terra inganni" (The angelic little flowers, roses and lilies, that adorn the heavenly meadow, do not please me more than good council. But at times I see men who despise me and betray my land: and the worse they speak, the more highly they are praised: Meditate, each one of you who is condemned by this accusation. The Virgin's response to holy prayers: My beloved ones, remember that your devout and honest prayers, as you request, I shall answer; but if the powerful are wicked with the weak, weighing them down with disgrace and harm, then your prayers are not for those men, nor for anyone who betrays my land). The glorification of the Virgin is the iconographical element on which the painting is based: Mary's function is to protect the city, and the four patron Saints are her intermediaries. The fresco was painted in the room where the government held its meetings to discuss the future of the city: the Nine are the highest representatives of the citizenry and the Madonna's protection must first of all cover them. Political messages in depictions of holy scenes were not a novelty for the Sienese; Duccio's *Maestà*, carried in triumph into the Cathedral in 1311, includes both the patron Saints and a prayer to the Virgin; although in a more veiled way, its purpose was the same. But in Simone the civic and secular content is developed fully: the sacred elements are included in a slightly ambiguous dimension, in which the heavenly court becomes the highest exaltation of a very worldly and real court. Simone's social ideals, "courtly" and aristocratic, are the same as those of his clients: the *Maestà* is both sacred and profane and the courtly gestures of the characters reflect a noble and elitist vision of religion.

Simone and the House of Anjou: Assisi and the Naples Altarpiece

It was only in the late 18th century that an antiquarian from Gubbio, Sebastiano Ranghiasci, first attributed the frescoes that decorate the chapel of San Martino in the Lower Church in Assisi to Simone Martini. About a century later Cavalcaselle confirmed this attribution and wrote about it in his studies on Italian painting. As far as the dating is concerned, scholars have still not reached an agreement. Bologna's suggestions are probably the most convincing: he believes that the frescoes were finished by early 1317, which is in contrast with the opinion of traditional scholars who always considered them a late work. Although surprising, Bologna's theory is solidly supported by

13. St Francis and St Louis of Toulouse Assisi, San Francesco

14. St Elizabeth, St Margaret and Henry of Hungary Assisi, San Francesco

15. Madonna and Child between St Stephen and St Ladislaus 100 x 200 cm Assisi, San Francesco

stylistic comparisons with the older sections of the *Maestà* and with the contemporary Altarpiece of St Louis of Toulouse (probably painted in 1317) as well as by a careful reconstruction of the historical events involving the House of Anjou (who commissioned the frescoes) and Simone himself around this period.

Bologna has pointed out a discrepancy between the iconography of the fresco cycle (which is clearly a celebration of the life of St Martin of Tours) and the frescoes on the underside of the entrance arch depicting eight saints: as Bologna writes, these figures are like an autonomous cycle celebrating a special event. They were not part of the original programme and were painted in 1317 in honour of St Louis of Toulouse who had just been sanctified, and the figure of St Louis, with his shining halo, stands out. According to normal decorating procedures, the underside of the arch would have been the last part of the chapel to be frescoed so that by that year (1317) we can presume that the chapel was already painted. Further elements supporting this dating have been supplied by Bellosi in his fascinating studies on late mediaeval clothing: the female costumes, and especially the necklines, are of the shape and size popular in the first twenty years of the century, so that "1317 is more likely to be the year the frescoes were finished, rather than the year in which they were begun." And these eight saints also help us determine the patron who commissioned the frescoes, and not just the date. The in-

16. *Diagram of the fresco cycle in the Chapel of
San Martino in the Lower Church, Assisi*
St Louis of France and St Louis of Toulouse (19)
St Clare and St Elizabeth (20)
Burial of the Saint (42)
Miracle of the Resurrected Child (34)
Division of the Cloak (26)
Meditation (35)
Dream (27)

Stained-glass windows (24, 25)
Miraculous Mass (37)
St Martin is Knighted (28)
Death of the Saint (40)
Miracle of Fire (39)
St Martin Renounces his Weapons (31)
St Catherine of Alexandria and St Mary Magdalene (18)
St Francis and St Anthony of Padua (17)

fluence exerted by the House of Anjou is clearly noticeable here: together with Saints Francis, Clare and Anthony (tributes to the Order that administered the Basilica), we find other saints connected to Robert of Anjou. Louis of Toulouse was his older brother; Elizabeth of Hungary was the aunt of his mother, Mary; Louis IX, King of France, was his great-grandfather; Mary Magdalene and Catherine were saints his father Charles II was particularly devoted to (especially Catherine, and stories from her life appear also in the fresco cycle in Santa Maria Donnaregina in Naples, another decoration commissioned by the House of Anjou).

But let us examine the chronology more carefully. The consecration and decoration of the chapel were commissioned in 1312 by Gentile Partino da Montefiore, a Franciscan friar who was made Cardinal with the title of San Martino ai Monti, which explains the subject matter of the cycle — the life of St Martin. Cardinal Gentile left

the friars of Assisi the considerable sum of six hundred gold florins. He had been a powerful prelate, always very active in Church affairs and closely connected to the House of Anjou: it was thanks to his good offices that Robert of Anjou's nephew, Charles Robert, was made King of Hungary. But the relationship between the Anjou of Naples and the Franciscan Order, or more precisely that part of the Order that favoured a more rigid interpretation of the vow of poverty, the Spirituals or Fraticelli, had been good and close for a long time. Louis gave up his throne in order to take his vows in the Order, and he was a very strict observer of the original Franciscan Rule of absolute poverty. The group of saints painted alongside the altar dedicated to St Elizabeth in the right transept of the Basilica is a further expression of the political and religious feeling that bound the House of Anjou to Hungary and the Spirituals. Scholars have found plausible historical explanations for their presence and identified them,

17. St Anthony and St Francis
218 x 185 cm
Assisi, San Francesco

18. St Mary Magdalene and St Catherine of
Alexandria
215 x 185 cm
Assisi, San Francesco

although, as Bologna writes, "these figures probably date from about ten years later than the chapel of San Martino and still present many problems that we have yet to solve."

Proceeding from left to right, after Saints Francis, Louis of Toulouse and Elizabeth of Hungary, we find St Margaret: this figure had always been identified as St Clare, until a recent cleaning revealed a small cross, the symbol of St Margaret. Next to her is a young and very beautiful saint, who is probably Henry, Prince of Hungary (and not Louis IX of France, as had been suggested: how could he be a king without a crown?), the son of St Stephen, shown on the next wall with St Ladislaus and the Madonna and Child. The presence of all these members of the House of Anjou in the frescoes in Assisi is justified, in other words, by the close connection existing between

the Order and the royal family, and it is quite suitable that they be placed here, in the chapel of Cardinal Gentile da Montefiore who was both a Franciscan and a good friend of the Anjou.

But let us now describe the frescoes more in detail. Next to the eight saints on the underside of the arch, on the entrance wall we find the scene of the *Consecration of the Chapel*. A mood of deep humility pervades the whole scene and provides the psychological link between the two characters: Cardinal Gentile is shown in humble adoration at the feet of St Martin who is gently helping him to get up. The very ecclesiastical setting, depicted in a perspective seen from below, consists of a splendid ciborium, a Gothic construction with a trefoiled ogival arch and corner pinnacles, and a polychrome marble balustrade in the background. The pictorial decoration continues with ten episodes from the life of St Martin, each surrounded by a frame consisting of geometric ornaments that originally contained inscriptions with commentaries for the scenes; unfortunately, the inscriptions have almost totally faded and are now illegible.

Starting from the entrance, from left to right and from top to bottom, the side walls and barrel-vaulted ceiling are frescoed with the following

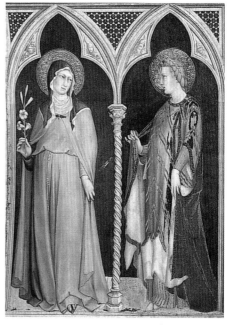

scenes: on the lower level, the *Division of the Cloak*, the *Dream*, *St Martin is Knighted* and *Renounces his Weapons*; on the middle level, the *Miracle of the Resurrected Child*, *Meditation* (on the ceiling), the *Miraculous Mass* and the *Miracle of Fire* (on the ceiling); on the top level we find the last two episodes, *Death and Burial of the Saint*. Placed inside the small trefoiled aediculae (very similar to the ciborium in the *Consecration*) in the jambs of the two-light windows there are eighteen busts of saints: they are very difficult to identify, especially since the inscriptions have almost totally disappeared. Figures of men of the church alternate with laymen. Those on the central window would appear to be by Simone himself, whereas the others seem to be almost entirely the work of assistants. The stained-glass windows also deserve mention. We know nothing about who actually carried out the work, although it is quite likely that Simone designed them, and they show considerable analogies with the older parts of the *Maestà* in the Palazzo Pubblico and the stained-glass windows in Assisi, so much so that, as Bologna states, "we can assert not only that the windows of the chapel of San Martino date from around 1321, but also that they indicate before his other works in which direction Si-

19. *St Louis of France and St Louis of Toulouse*
215 x 185 cm
Assisi, San Francesco

20. *St Clare and St Elizabeth of Hungary*
215 x 185 cm
Assisi, San Francesco

21. *Detail of St Elizabeth of Hungary*
Assisi, San Francesco

mone's art will develop in the years to come." The dates suggested by Bologna are based on the dates of external events. In 1321 Gentile da Montefiore not only commissioned the decoration of the chapel, he also spent a few months in Siena: he probably met Simone and chose him as his "personal" painter. The procedures normally followed in the building and decorating of churches also suggest an early date. In areas which were going to be frescoed the windows were put in first, because the coloured glass changed the colour of the lighting, altering the effect of the frescoes. In the lower section of the central window we find Cardinal Gentile and St Martin. The patron of the chapel is shown kneeling in front of the Saint, who is in the act of blessing: this same iconogra-

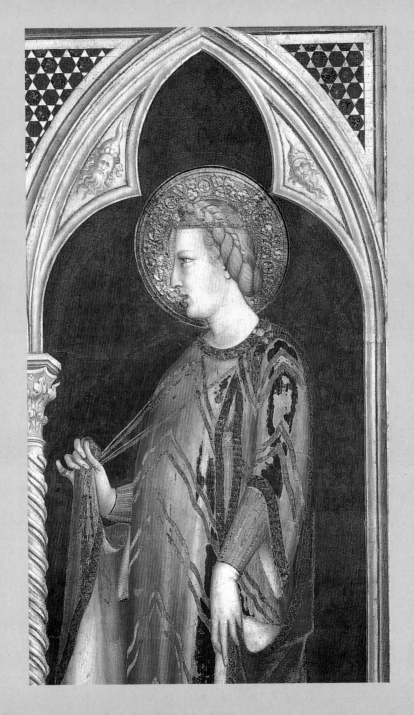

phy will be repeated, with the addition of many more details, in the scene of the *Consecration*.

The chapel's decoration is completed by a wide marble wainscoting with white and red inlay that runs around the bottom of the walls, as well as vermilion granite columns and ribbing with geometric decorations; the deep blue ceiling is dotted with gold stars.

The spirit in which the Stories from the Life of St Martin are recounted is totally new and personal. The Saint's life unfolds in a lay and secular atmosphere, with courtly emblems, knights, grooms and musicians clearly recreating the setting of 14th-century aristocratic Courts, in particular the Anjou royal palace in Naples. And in any case the story of St Martin was quite well suited to this iconographic interpretation; before devoting himself to religious matters, Martin had been an officer in the Roman army and he would have continued in his family tradition (his father was an infantry commander) had he not undergone a profound religious conversion in 344. The courtly characteristics of the layman Martin are all included and stressed: as well as the scene of the *Investiture*, there are two other episodes depicting Martin in his role as Roman *miles*. Obviously, the chivalric element, a fundamental element in the hierarchical division of mediaeval society, ap-

22. Consecration of the Chapel
330 x 700 cm
Assisi, San Francesco

23. Consecration of the Chapel, detail
Assisi, San Francesco

pears to be more important than other aspects of the story. For example, no mention is made of Martin's period as a disciple, as a hermit, nor of his monastic life (events that cannot really be considered minor, especially in the life story of a bishop saint!). But we must remember the nature of the patrons who had commissioned the frescoes, as well as Simone's innate inclination towards courtly circles; bearing this in mind, we can explain the very worldly and mundane characteristics of the cycle. The four scenes on the lower level deal with the period in Martin's life before his conversion in 344. He is portrayed as a man of the world, dressed as a layman and with long, flowing hair (his fair hair shows under his cap in the scene of the *Dream*, too).

The first fresco depicts the famous episode of the *Division of the Cloak*, the story for which Martin is best known: having come across a beggar dressed in rags on a cold winter morning, Martin gave him half of his cloak. To the left, the city of

24. *Righthand stained-glass window*
400 x 200 cm
Assisi, San Francesco

25. *Central stained-glass window*
Detail of the Madonna
Assisi, San Francesco

Amiens, where the incident occurred, with its crenellated fortifications and defence towers. To the right, in the upper section, a head: to try and justify this strange presence we must examine the synopia of the fresco in the Museum of the Basilica. Originally Simone had planned the composition differently: the beggar was shown with his arms outstretched towards the cloak and the city gate was on the opposite side. This helps us understand the position of this solitary profile, very close and parallel to the side frame. But then Simone changed his mind, covered the wall with another layer of *intonaco*, drew a new synopia and with a brushstroke of blue paint cancelled that first face which has now resurfaced.

Martin's generous gesture is followed by a *Dream*, in which Christ reveals to him that he was really the beggar. Wrapped in the cloak, and pointing at Martin, Jesus addresses the host of angels accompanying him: some are shown praying, others listen to him with their arms crossed,

26. *Division of the Cloak*
265 x 230 cm
Assisi, San Francesco

while the mass of gold haloes helps give a sense of depth to the architectural setting. Meanwhile, Martin is sleeping under a blanket of typically Sienese fabric and Simone's realism is evident from one detail in particular: the border of the white sheet and the pillow are decorated with an embroidery called "drawn-thread" work, very fashionable at the time. The rigidity of the out-

27. *Dream of St Martin*
265 x 200 cm
Assisi, San Francesco

28. *St Martin is Knighted*
265 x 200 cm
Assisi, San Francesco

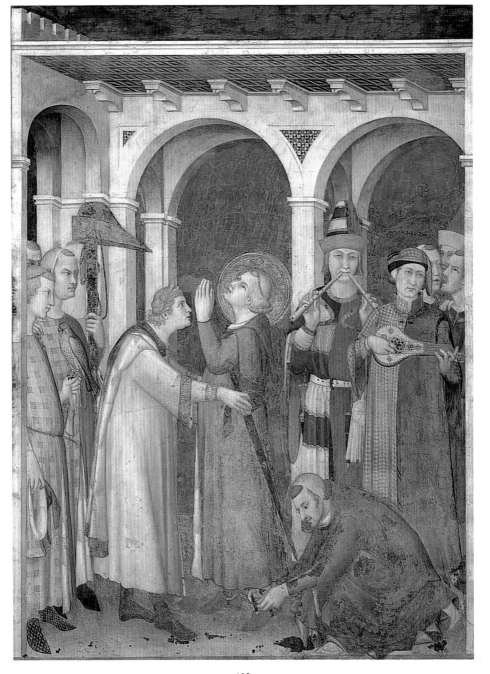

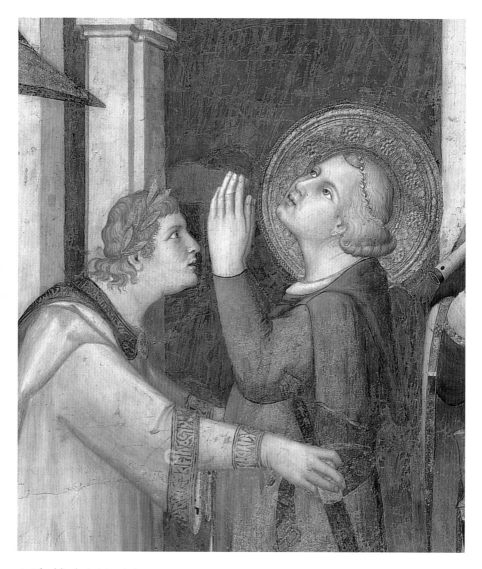

stretched body is intended to convey an intense spiritual participation in the message of Christ, and the way Martin's hand rests on his chest reveals excitement, as though he really were listening to the voice of the Lord.

The stories of the life of St Martin that Simone could have used as sources, although none of them mention an actual investiture, do contain references to his military promotions. We can

29. St Martin is Knighted
Detail of Emperor Julian and St Martin
Assisi, San Francesco

30. St Martin is Knighted
Detail of the musicians
Assisi, San Francesco

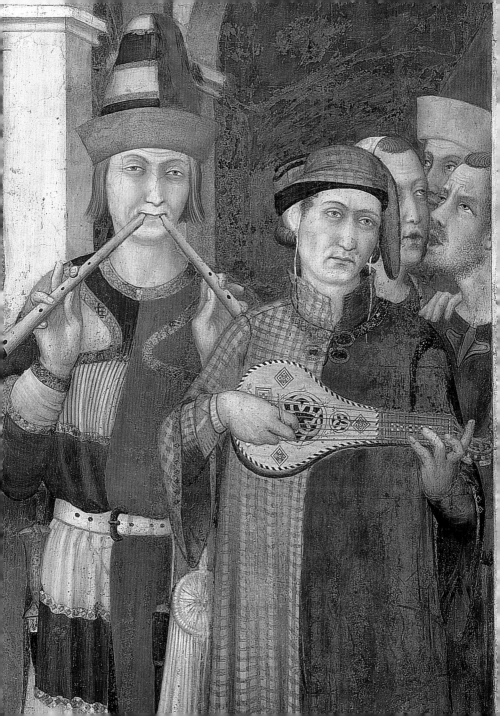

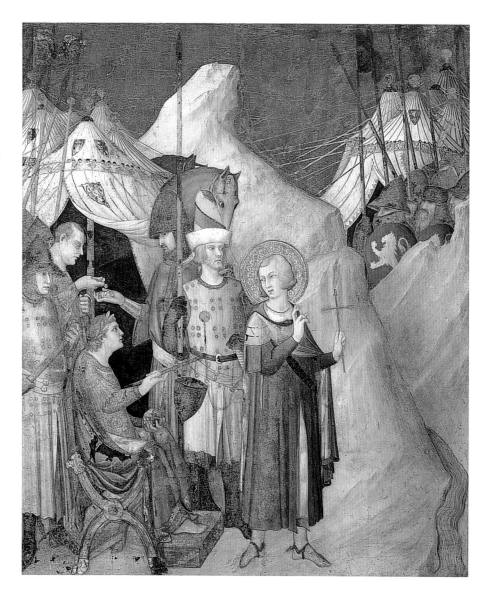

therefore suppose that our painter, surrounded
by a world of tournaments and hunting expedi-
tions, pictured a Roman soldier rather like a medi-
aeval *miles* and simply transposed a ceremony
typical of his times to the late classical world. It is
not merely a matter of Panofsky's "theory of dis-
tance," according to which mediaeval painters

31. St Martin Renounces his Weapons
265 x 230 cm
Assisi, San Francesco

196

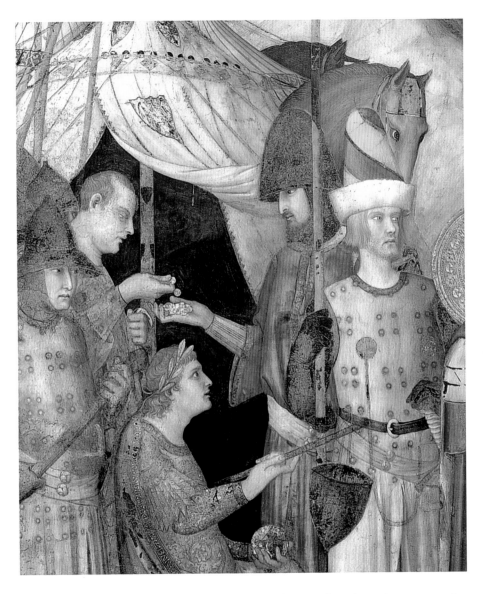

32. *St Martin Renounces his Weapons*
Detail of the Emperor with his soldiers and
treasurer
Assisi, San Francesco

made characters from the past appear more im-
mediate and closer to their public by placing them
in Gothic architectural settings and dressing them
in 13th-century costumes. Simone (and even
more so his patrons who had commissioned the
frescoes) used the scene of Martin's investiture to
focus attention on courtly and aristocratic cus-

33. *St Martin Renounces his Weapons*
Detail of the camp
Assisi, San Francesco

34. *Miracle of the Resurrected Child*
296 x 230 cm
Assisi, San Francesco

toms. Musicians, singers, equerries with weapons and falconers all witness the scene taking place inside a palace with loggias and wooden ceilings. Nothing could be more secular than the figure of the Roman Emperor fastening the sword, the symbol of his newly acquired dignity, around the knight's waist. The Emperor's immobile profile, with his half-open mouth and fixed gaze, is

35. *Meditation*
390 x 200 cm
Assisi, San Francesco

36. *Meditation*
Detail of St Martin
Assisi, San Francesco

37. *Miraculous Mass*
390 x 200
Assisi, San Francesco

38. *Miraculous Mass*
Detail of the elevation of the host
Assisi, San Francesco

reminiscent of the portraits carved on ancient Roman coins, which Simone probably used as a model: even though it must be Julian the Apostate (and historically it could not be any other emperor), it has been suggested that the features are actually those of Constantine the Great.

In the next fresco we see Martin, as an officer in the Roman army face to face with the enemy, announcing his decision: "I am a soldier of Christ and I cannot fight." To the left, the Roman camp, with Emperor Julian, a group of soldiers and the treasurer distributing money to the mercenaries. To the right, waiting for the battle, behind the hill, the barbarian army with their armour and their spears. Martin (still a knight, but carrying a cross and shown in the act of blessing) is looking towards the Emperor but walking towards the enemy. His battle is the struggle against paganism, and his only weapon is the word of Christ.

The episodes depicted in the middle level illustrate the last part of the saint's life, after 371 when Martin was nominated Bishop of Tours, as we can see from his mitre. In the bay to the left of the entrance we find the scene of the *Meditation*. In a state of profound spiritual ecstasy, Martin sits on a simple faldstool (the same one that Emperor Julian was sitting on in the scene of Martin renouncing arms), while two acolytes try to bring him back to reality so he can celebrate mass in the chapel nearby: one of them is shaking him gently, and the other is handing him his missal. The two architectural spaces, parallel but of different depth, are geometrically so simple and bare that they appear to reflect the Saint's mood of profound absorption in prayer: the only decorative elements are the horizontal Greek key design on the wall and the quatrefoiled ornament in the arch above the mullioned windows.

In the bay to the right we find the scene of the *Miraculous Mass*, an episode that is only very rarely included in Italian fresco cycles. This was the first time it was depicted. The event took place in Albenga and was similar to what happened in Amiens. After having given a beggar his tunic, Martin is about to celebrate mass. During the elevation, the most deeply spiritual moment in the mass, two angels appear and give Martin a very beautiful and precious piece of fabric. There is extraordinary spontaneity and beauty in the deacon's expression of surprise, in his almost fearful gesture: his astonishment is so great that he instinctively reaches out towards his bishop. The scene is a masterful composition of volumes and shapes with the linear elements (the candlesticks and the decoration of the altar-cloth) alternating with the solid structures of the altar and the dais, beneath a barrel-vaulted ceiling.

To the left of the *Meditation* is the fresco of the *Miracle of the Resurrected Child*; like the *Miraculous Mass*, this episode had never been included in a fresco cycle before. While Martin is praying he is approached by a woman holding her dead child in her arms; she begs him to do something and the Saint kneels in prayer. Amidst the astonishment of those present the child is resurrected. Joel Brink has pointed out that Simone does not follow the official biographies (which all report the incident as having taken place in the countryside around Chartres), but blends this event with a legend that was popular in Siena at the time. This legend was a longstanding oral tradition, which we know of from a 1657 source; it tells the story of Martin stopping in Siena while on his way to Rome on a pilgrimage. In Siena he performed a miracle so great that a church consecrated to him was built in the city. The miracle was a resurrection and this is the connection that justifies Simone's blending of the two episodes and changing the setting to Siena. The city centre is symbolized by the building to the right: the square-topped battlements, the three-light mullioned windows on the piano nobile and the Sienese arch above the entrance door help us identify it as the Palazzo Pubblico. This is how the town hall appeared before 1325 when the bell tower, the Torre del Mangia, was added to the left. The need to make the event recounted more immediate, to modernize an episode that had occurred almost a thousand years before, made Simone go even further. The crowd does not consist only of pagans, as the written accounts of the event described it; Simone portrays a most varied group of onlookers. A plump friar is shown looking up at a tree above the scene: he looks very much like Gentile da Montefiore. Some of the figures are praying devoutly, while others, such as the knight in the blue hat, express astonishment and even scepticism (notice how the other knight looks at him frowning, as though in reproach).

In the scene next to the right bay Simone has painted the *Miracle of Fire*, a fresco which, like the scene of the resurrected boy, is very badly damaged. The scene illustrates the event immediately after the miracle, when a tongue of flame burst down from Emperor Valentinian's throne after he had refused to grant audience to the Saint. The sovereign, more 14th-century than his colleague Julian, is shown stretching out towards Martin, as though about to embrace him. The figure at the far left is very natural, covering his mouth with his hand in astonishment. The scene

39. Miracle of Fire
296 x 230 cm
Assisi, San Francesco

is composed of several different architectural structures, including a variety of arches: pointed arches, round arches, four-centred arches. The two-light mullioned windows also appear in two versions: the ogival Gothic variety and the more typically Romanesque. The pilasters, battlements and loggias create an effect of movement and dynamism.

The frescoes of the *Death* and *Funeral* on the

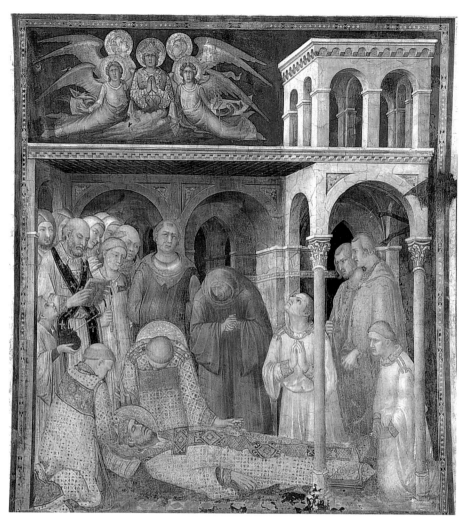

upper level are the last scenes of the cycle. Animated by light, colour and spatial depth, both these scenes have the same composition, with a crowd of acolytes and followers witnessing the events. The same characters, with the same features but depicted in different poses and with different gestures appear in both scenes: the priest celebrating the ritual of the deceased in the scene of Martin's *Death* appears in the fresco of the *Funeral* between the two figures with haloes; the tonsured acolyte dressed in green and red who in the *Death* is gazing meditatively upwards, in the

40. Death of St Martin
284 x 230 cm
Assisi, San Francesco

41. Death of St Martin, detail
Assisi, San Francesco

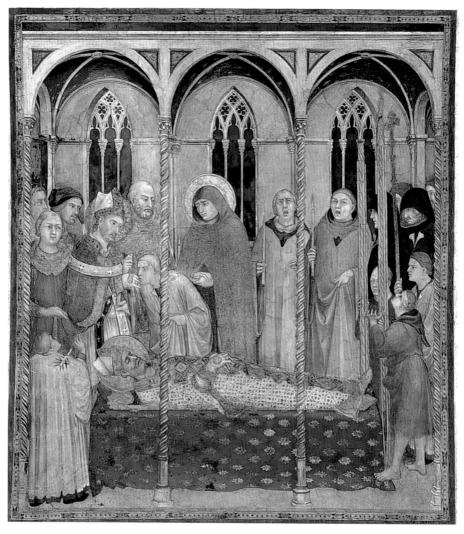

Funeral is shown holding the celebrant's dalmatic. And lastly, notice how much the knight under the little aedicula in the fresco of Martin's *Death* looks like the portrait of Robert of Anjou in the *Naples Altarpiece*. Another interesting element is the way the architectural style of the scenes follows the mood of the events: while the building in the scene of the *Death of St Martin* is a severe geometrical structure with bare walls, the *Funeral* takes place in a Gothic chapel with graceful and delicate decorations.

42. Burial of St Martin
284 x 230 cm
Assisi, San Francesco

43. Burial of St Martin, detail
Assisi, San Francesco

The most important and noticeable element in these frescoes is the spatial construction of each scene. As far as the construction of volumes and perspective is concerned, Simone certainly owed a great debt to the Florentine Giotto. The Stories from the Life of St Francis in the Upper Church in Assisi are the prototype of the spatial organization of the cycle of the life of St Martin. And Giotto's influence is noticeable in the subject-matter of the frescoes as well. Some of the episodes of the story of St Martin (*Division of the Cloak*, *Martin Renounces his Weapons*, *Miracle of Fire*) are clearly modelled on scenes from the Franciscan cycle (*Francis Donates his Cloak*, *Renounces his Worldly Possessions*, *Trial by Fire*), as though Simone wanted to attribute to Martin the role of predecessor of the more recent mediaeval Saint. Giotto's compositions become almost involuntary quotations in these frescoes, but Simone does not simply use and exploit this great model, he elaborates on it and transforms it. The art of the northern Gothic civilization attracts Martini and draws him into a new world of sophisticated colours and lively naturalism which, thanks to his talented personal interpretation, succeed in creating effects of wondrous beauty.

St Louis of Toulouse Crowning Robert of Anjou

There is considerable stylistic similarity between the Assisi frescoes and the painting of *St Louis of Toulouse Crowning Robert of Anjou*, now in the National Museum of Capodimonte in Naples but formerly in the Franciscan monastery of San Lorenzo Maggiore. Probably painted in 1317 on the occasion of the canonization of Louis, Bishop of Toulouse, the altarpiece shows the scene of the coronation set in a lilied frame with a truncated cusp and a predella panel with five scenes illustrating episodes from the Saint's life. The painting actually depicts a double coronation and its iconography is strongly celebratory: while Louis is offering the worldly crown of the Kingdom of Naples to his brother Robert (he himself had renounced the crown in order to take his vows), he receives the heavenly crown, the symbol of his sanctity. On the one hand Simone is stressing an event of great spiritual value, while on the other he does not forget to draw attention to a gesture of political significance. And the scene is actually described like an investiture, with lavishly decorated costumes; the coat-of-arms of the French kings and the great quantities of gold used in the decorations exalt the solemn and formal nature of the gesture.

The predella scenes, on the other hand, are much more lively and realistic; their animated narrative quality is more like the St Martin cycle. Bologna has studied these scenes carefully and we shall follow his interpretation of them. From left to right, in the first panel we find Louis accepting the nomination to Bishop of Toulouse on condition that he be allowed to enter the Franciscan Order. This event took place in secret in Rome in December 1296, in the presence of Boniface VIII; Louis's father, Charles II, for political reasons

44. St Louis of Toulouse Crowning Robert of Anjou
Detail of the predella
Naples, National Museum of Capodimonte

45. St Louis of Toulouse Crowning Robert of Anjou
200 x 138 cm
Naples, National Museum of Capodimonte

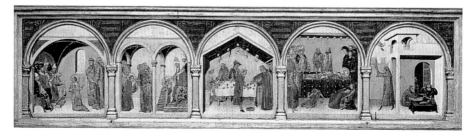

wanted his son to become Bishop of Toulouse, for he needed to have direct control over an area that was particularly important for the King of France, Philip the Fair. And who could be a more trustworthy Bishop than his own son? But Louis had already given up his throne in order to follow the example of St Francis, and he had no intention now of becoming a pawn in a political manoeuvre, for this went against his spiritual aspirations; so, in return for accepting this religious office (which was not religious at all. . .), he requested to be allowed to enter the Franciscan Order. In the following panel Louis publicly takes his vows and is consecrated Bishop: this is the official conclusion, on 5 February 1297, of the secret agreement made between Pope Boniface and the Saint. The third scene is based on the proceedings for the canonization of Louis in 1308: with great modesty, the Bishop Saint served and fed the hungry. These scenes relate perfectly to the subject-matter of the altarpiece, the coronation of King Robert, for they exalt the humility of Louis: he is humble because he gave up his throne, he is humble in the presence of Boniface VIII, he is humble in his daily life. But the truth was different. Even more important than his humility, Louis was poor: poor like St Francis, poor like the unpopular Spirituals, and above all poor unlike a King's son, especially one who was a Bishop and had just been canonized. The patron who commissioned the painting (Robert of Anjou, Mary of Hungary, or any other member of the royal family) clearly requested Simone to conceal, or at least not to emphasize, this aspect of the Saint's virtue; he was to celebrate another aspect of it, equally valid from a spiritual point of view, and totally innocuous politically: Louis is a follower of Christ in his humility, not in his poverty. After the scene of Louis's *Funeral*, depicted as a magnificent ceremony worthy of a high prelate (actually, it appears that it was an austere and simple service), in the last panel we find the scene of a miracle involving a small child: a man prays with a statuette of St Louis in his hands asking for his intervention and his child, who had died shortly before, miraculously comes back to life. With its lively narrative quality and especially because of the iconography involving the death of a child, this scene is very similar to the episodes depicted in the altarpiece of the *Blessed Agostino Novello*. The spatial construction of the altarpiece, both in the main panel and in the predella scenes, shows a very conscious elaboration of Giotto's methods, which Simone had already used in the Assisi frescoes. The drapery of the cope, the lion's feet on the faldstool half-hidden by the dais, the geometric patterns on the carpet, as well as the arcades, loggias and the shadowy areas in the episodes below, are the product of very subtle perspective observations which reveal to what extent Simone had by this stage developed a mature approach to spatial construction and the reproduction of volumes.

Simone and his Workshop

By the end of the second decade of the 14th century Simone's fame had spread beyond the walls of Siena, and his art, which had incorporated the new northern trends that transformed even the most devout moods into worldly scenes, had developed its own recognizable style. A large group of followers, who worked together in a workshop, gathered round the illustrious figure of the master and his fervent entrepreneurial ability. For many years the artists of his workshop continued to imitate the style and innovations of Simone: his brother Donato and his future brothers-in-law Lippo and Tederico Memmi are the only ones whose name has come down to us. Alongside them there was certainly a large number of other artists and assistants who worked together as a composite team and produced the paintings of the so-called "Simone Martini school." It would appear that already as early as the years when Simone was working on the Siena *Maestà* and the Assisi frescoes the master's collaboration with his assistants was very intense, for in 1317 Lippo painted a remarkably faithful copy of Simone's *Maestà* in the Palazzo Comunale in San Gimignano, in which he followed Martini's style practically to the letter. It also appears that the polyptych mentioned by Vasari was painted around this time for the church of Sant'Agostino in San Gimignano. For a long time it was thought that this polyptych had been destroyed but recently a

46. Polyptych
Cambridge, Fitzwilliam Museum

group of scholars have reconstructed its original
appearance and traced the various pieces in
several museums and collections throughout the
world: the central panel was the *Madonna and
Child* now in the Wallraf-Richartz Museum in
Cologne, while the side panels are the three
panels in the Fitzwilliam Museum in Cambridge
and a *St Catherine* in an Italian private collection.
The design of the polyptych with all the panels on
a single register, the round-arch shape of the
panels, as well as a rather archaic solidity of the
figures and their severe and solemn rhythms, all

47. Madonna and Child
79 x 56 cm
Cologne, Wallraf-Richartz Museum

48. Polyptych
Pisa, National Museum

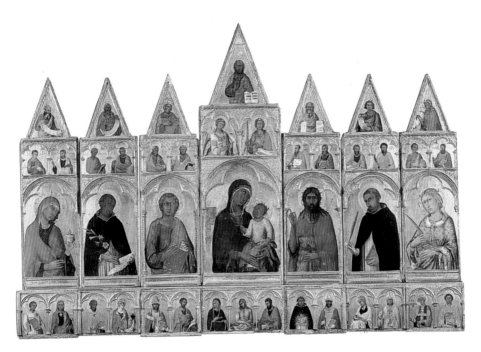

suggest a fairly early dating: after Assisi (and there is a great similarity with the saints on the underside of the arch), but undoubtedly before the more Gothic *Pisa Polyptych*. Scholars almost unanimously agree that this polyptych is the autograph work of Simone, who probably also painted a *Blessing Christ* to be placed above the central panel.

The Polyptych of Santa Caterina

From the "Annales" and the "Cronaca" of the convent of Santa Caterina in Pisa we learn that in 1319 "Frater Petrus Conversus" ordered that a very beautiful painting done by "manu Symonis senensis" be placed on the high altar of the church. This polyptych, now in the Museum of San Matteo, is without doubt the most important and grand of Simone's signed paintings: forty-three busts of apostles, martyrs, bishops and prophets are placed in the cusps and under the trefoiled arches of the panels. The altarpiece consists of seven elements, each one in three parts: a cusp, a smaller panel divided into two sections, and a larger panel depicting a single saint. There is also a predella consisting of seven smaller size panels.

Over the centuries the polyptych has been reconstructed according to many different theories, but presently it is arranged as follows: in the cusps, next to the Blessing Redeemer, we find David playing the harp, Moses with the Tables of the Law and the prophets Jeremiah, Isaiah, Daniel and Ezechiel. On the level below, on either side of the Archangels Gabriel and Michael in the middle, we find the apostles, arranged in pairs below trefoiled arches: each one is carrying a copy of the Gospel and is identified by an inscription on the gold background. From left to right, Thaddaeus, Simon, Philip and James the Less, who are talking animatedly about the Scriptures; they are followed by Andrew and Peter. Then, on the other side of the archangels, Paul and James

Major (a shell in relief has been placed between the letters of his name); Matthew writing his Gospel, resting the book on the frame of the panel, together with Bartholomew, followed by Thomas and Mathias. On the middle level, together with Mary Magdalene, St Dominic, John the Evangelist, the Madonna and Child (and above the frame there is the inscription "Symon de Senis me pinxit"), and John the Baptist, we find Peter Martyr and Catherine of Alexandria.

The reconstruction of the predella, on the other hand, is much more certain. It revolves around the central panel where the Man of Sorrows is assisted by the Virgin and St Mark. At the sides, from left to right, we find Saints Stephen and Apollonia, Jerome and Lucy (?), Gregory and Luke, Thomas Aquinas and Augustine, Agnes and Ambrose, Ursula and Lawrence.

With a composition so full of movement, the *Pisa Polyptych* is extremely innovative, especially in its structure. The seven elements, the predella panels and the ones on the upper level, each consisting of two sections, not only allow the artist to include a vast number of characters, but they also allow him to describe each one with a wealth of iconographical details. For this reason, alongside characters who would traditionally be included in any polyptych, we also find figures connected to the religious Order who commissioned the altarpiece: Jerome, Gregory and Augustine as well as

49. Polyptych
Detail of Saints Mary Magdalene, Dominic and John the Baptist
Pisa, National Museum

more recently canonized saints, such as the founder of the Order, Dominic, and Peter Martyr. Notice that Thomas Aquinas is portrayed with a halo, whereas he was not actually canonized until 1323. There is a wide range of different connections between the various characters, although they are all portrayed here as part of a vast propaganda programme, aimed at spreading the ideological message of the Dominicans. Just one example. Preaching, the most important way of enacting the "imitatio Christi," is the primary activity of all the monks portrayed; scrolls, parchments, books (half hidden, half open, fully open like the text Thomas Aquinas is holding, very small ones like the one of the Child) are a subtle reference to the evangelizing mission of this Order. In all, there are 27 books in this polyptych.

As far as the iconographical composition of the painting is concerned, Joanna Cannon's observation is very interesting: "A non-narrative programme which is original but not unorthodox, clear but not simple." Simone's absolute mastery of volumes and shapes, obtained thanks both to

50. Polyptych. Detail of Saints Peter Martyr and Catherine in the middle level, and Saints Agnes, Ambrose, Ursula and Lawrence in the lower level
Pisa, National Museum

Duccio's chiaroscuro technique and to his own recent experience in Assisi, is here blended with a very fluent use of vertical lines, of subtle and elegant modelling. The Gothic mood that Simone is here interpreting in terms of light, with a wide range of bright colours, creates a new relationship between image and space, between each individual measurement and the proportions of the whole composition. Some scholars believe that both the St Dominic and the Peter Martyr are to be attributed to assistants. However, the problem of autography and attributing the various sections to the master or to his collaborators does not become a serious one until the following period, the years from 1320 to 1324, with the paintings produced by Simone's workshop in Orvieto.

The Orvieto Years

The new concept of a painter's workshop in the Middle Ages, with such a close collaboration between the master and his assistants, so close that they frequently exchange paintbrushes and even signatures, does not help us in our examination of the group of panel paintings dating from the early 1320s. Without going into the extremely difficult question of the identification of the various different hands, at least in many cases the presence of collaborators is unmistakable.

The *Orvieto Polyptych* is one such case. Even though we cannot be entirely certain of the year in which it was painted (despite the suggestion that there is a missing letter in the inscription "MCCCXX"), the style of the work is very much under the influence of the art of Giotto and the overall mood is one of great solemnity. The frontal composition and the use of certain stylistic elements (such as a fairly rigid volumetric construction) that the *Pisa Polyptych* appeared to have surpassed, suggest that only the figure of the Madonna is actually by Martini. Originally consisting of seven elements (and while St Peter, Mary Magdalene and St Dominic are all shown in exactly the same pose, St Paul is facing towards the right), this polyptych is now in the Cathedral Museum, although it was painted originally for the church of San Domenico. The painting was commissioned by the Bishop of Sovana, Trasmundo Monaldeschi, the former prior of the Dominican monastery, who paid a hundred gold florins for this altarpiece; he is portrayed in the panel together with Mary Magdalene.

Although recently some scholars have expressed their disagreement, in the past the *Polyptych* in the Isabella Stewart Gardner Museum, Boston, was always considered contemporary to the *Orvieto Polyptych*, or at the most dating from just a short while later. Originally in the church of Santa Maria dei Servi in Orvieto, the altarpiece consists of five panels: in the middle, the Madon-

na and Child; on either side, from left to right, Saints Paul, Lucy, Catherine of Alexandria and John the Baptist, all within a trefoiled ogival frame. In the cusps, the musician angels and the symbols of the Passion (the column and the whip of the Flagellation, the cross, the crown of thorns, the spear and the sponge) as well as the figure of Christ showing his wounds, suggest the iconography of the Last Judgment. Stylistically this polyptych is closer to the *Pisa Polyptych* than it is to the one painted for the Dominicans in Orvieto, especially in details such as the slender figures, the long and graceful hands, more fluent and lighter volumes. In recent years it has become almost unanimously recognized as being by Simone, except for the St Paul, about whom there is still a fair amount of doubt.

There is another group of works that are dated by scholars at the early 1320s. From the stylistic point of view they are very close to the production of Simone and his assistants in the Orvieto workshop. The *Madonna and Child with Angels and the Saviour* in the Orvieto Cathedral Museum (it is the central piece of a polyptych that also included the panel showing a martyred saint, now in the Ottawa National Gallery, and perhaps also the two panels of St Lucy and Catherine of Alexandria, now in Harvard University's Berenson Collection in Settignano, near Florence) and the two Madonnas in the Siena Pinacoteca, one from Castiglione d'Orcia and the other from Lucignano d'Arbia, are clearly related and must date from more or less the same period. But we have no dates, no signatures and no documents containing any information at all regarding the dating of these works: stylistic analysis is the only element that critics have been able to use. This justifies the widely varying opinions that have been expressed on the subject: some scholars believe that they are totally autograph, while others think that Simone is responsible only for the drawings or for certain

51. *Polyptych*
Orvieto, Cathedral Museum

52. *Polyptych*
Boston, Isabella Stewart Gardner Museum

sections of the painting, while others still consider them entirely the work of the workshop assistants. Nonetheless, there are many analogies between the various paintings, such as for example, the features of the Madonna in the *San Domenico Polyptych*, with her gentle and slightly dreaming eyes, repeated almost exactly in the Madonna in the *Orvieto Polyptych*; or the lively pose of the

Child in the panel from Castiglione d'Orcia which is exactly the same as that of the Child in the Boston painting.

A great deal has been written about the iconography of the *Madonna* from *Lucignano d'Arbia*, very unusual in Sienese painting. Mary is shown looking to the right, instead of to the left, and she holds a Child who is not yet a "puer" (as was the

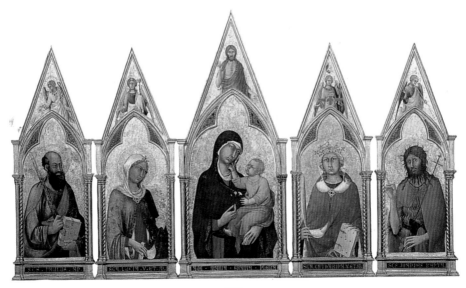

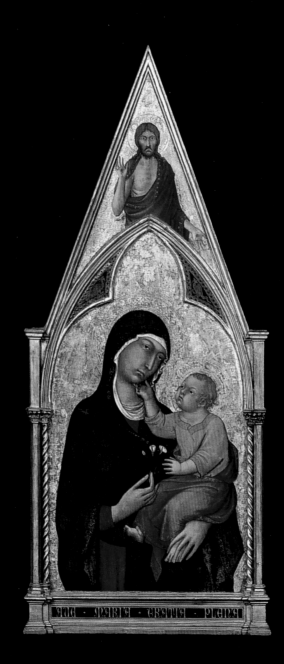

case in all the earlier paintings) but still an "infans" in swaddling clothes. The reason that led Martini to choose this iconography has yet to be explained, and it may have been a specific request from the client; but scholars do agree on the attribution of the panel to Simone.

The *Crucifix* from the church of the Misericordia in San Casciano Val di Pesa, first discovered and attributed to Martini in the early years of the 20th century, is undoubtedly contemporary to the paintings described above. Although there is no

53. *Polyptych*
Detail of the Madonna and Child
137 x 102 cm
Boston, Isabella Stewart Gardner Museum

54. *Madonna and Child with Angles and the Saviour*
165 x 57 cm
Orvieto, Cathedral Museum

55. *St Catherine*
54 x 41 cm
Florence, Berenson Collection

56. *St Lucy*
51 x 40 cm
Florence, Berenson Collection

221

*57. Madonna and Child (from Castiglione
d'Orcia)
Siena, Pinacoteca*

*58. Madonna and Child (from Lucignano
d'Arbia)
88 x 51 cm
Siena, Pinacoteca*

59. Crucifix
164 x 147
San Casciano (Florence), Church of the
Misericordia

documentation at all regarding it, some scholars have suggested that it is the Crucifix that Simone painted in 1321 for the Chapel of the Nine in Siena. This theory is not very convincing, however, because if we examine our sources carefully it becomes clear that what Simone painted in that chapel was a fresco and not a panel — a fresco which was then destroyed by a fire. The closest analogies that this Crucifix presents are with the Pisa and Boston polyptychs.

Simone's Second Sienese Period

After having spent several years in Assisi, Pisa and Orvieto, only occasionally returning to Siena for very brief periods during which he worked in the Palazzo Pubblico (on one occasion to retouch the *Maestà*, on another to paint some works that are no longer extant), Simone actually returned to Siena on a stable basis. This appears to have been a rather calm period of his life and it was at this time that he married Giovanna Memmi: perhaps feeling tired after his travels, working for so many different patrons in different places, Simone decided to settle in his home town. It was sometime around 1325 and Martini was a well established painter, at the height of his artistic maturity. His experiences working for the House of Anjou and the Franciscans, in international environments where political interests frequently took the place of religious spirit and where art became an effective means of visualizing and promoting temporal power, had made Martini much more a man of the world: he had set off from Siena as a talented but simple Sienese painter, and he returned as a famous artist, self-confident and experienced. Back in Siena, Simone worked for the Government of the Nine adding more and more splendid works to the Palazzo Pubblico, year after year; most of these paintings have not survived and we only know about them from the payments recorded in the Biccherna ledgers. It was during this second Sienese period that Simone painted some of his most famous paintings, such as the *Blessed Agostino Novello Altarpiece*, the celebrated fresco of *Guidoriccio da Fogliano* and the *Annunciation* now in the Uffizi, the only one that is actually signed and dated.

The Blessed Agostino Novello Altarpiece

The story of the Blessed Agostino Novello is an example of that form of popular religious spirit that grew up in the towns of Tuscany in the late 13th century and the early 14th. The Church's official saints were considered too remote by the people and spiritually so different from the reality of the times that they could not entirely satisfy the religious fervour that developed in those years. The people felt that they needed more tangible examples of holiness, more closely connected to daily reality, rather like St Francis of Assisi had been. As a result, some of the better known citizens, whose charitable and religious deeds were known to all (and in may cases miracles were attributed to them), were canonized as saints or blessed.

Agostino Novello was one of these figures. After a brilliant career both as a layman and as a cleric (he studied law at the University of Bologna and became personal councillor to King Manfred, the son of Ludwig II; when he joined the Augustinian Order he became Prior General), Agostino Novello then renounced community life and retired to the hermitage of San Leonardo al Lago, near Siena. After his death in 1309, the worship of this saintly man spread so fast that the monks of his Order tried to have him nominated patron saint of the city: through the veneration of a member of their Order, the Augustinians were sure to gain prestige and power. But Agostino was not made patron saint of Siena, despite the fact that he must indeed have been the object of great veneration to judge by the impressive funerary monument that was built for him.

Thanks to Max Seidel's research we are now able to reconstruct the history of the altarpiece that portrays the Blessed Agostino Novello and four of his miracles. Now in the Pinacoteca in Sie-

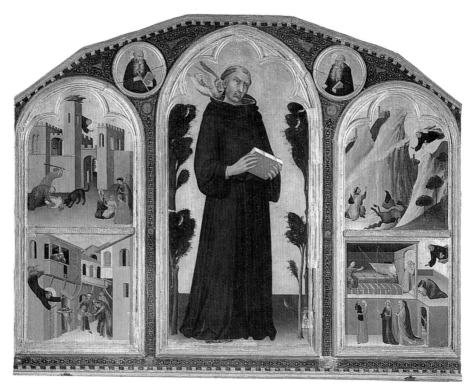

na, the painting hung originally in the church of Sant'Agostino, probably above the wooden sarcophagus in which the Blessed Agostino was buried; together with the altar consecrated to him, these two elements formed a burial monument rather like the one constructed for St Ranieri in Pisa Cathedral by Tino di Camaino about twenty years earlier. The dating of this altarpiece can only be approximated. We can only suppose that it was already finished and in place on the occasion of the celebrations in honour of the Blessed Agostino held in 1324 and for which the Commune of Siena allotted a huge sum of money.

The iconography, at least for modern observers like us, is clear but not that simple to understand. The central area, framed by a multifoiled ogival arch, encloses the figure of Agostino, who is given a saint's halo even though he had not been canonized. The wooded landscape, the old hermits in the medallions and the scene of the conversation with the angel (an episode that does not appear in any of the biographies) are all references to the hermit's life he led at San Leonardo al Lago. On the other hand, the face of Agostino,

portrayed still as a young man, the red book he carries (perhaps the *Constitutiones* of the Order, which he had drawn up himself), as well as the fact that the miracles are all taking place in a very realistically described Siena, all suggest Agostino's political commitments and the pastoral duties he performed in the city. As Seidel correctly suggests, "the status perfectissimus, which Agostino reached in imitation of Augustine of Hippo, consisted in a synthesis between active life and contemplative life." The miraculous powers of the Blessed Agostino are fully displayed in the scenes depicted at the sides of the central area; they are framed by trefoiled round arches and illustrate four miracles. The idea of Agostino's holiness, stressed by the sudden appearances of winged angels, was intended to capture the mediaeval public's religious sensitivity: the victims of the terrible accidents are for the most part children. The scenes are organized according to the composition of ex-votos, each one being divided into two sections: the accident and the miracle, followed by a thanksgiving prayer. The architectural settings of the scenes depict an overall view of Siena

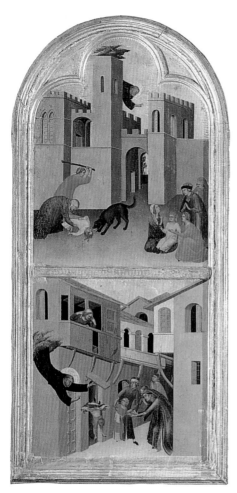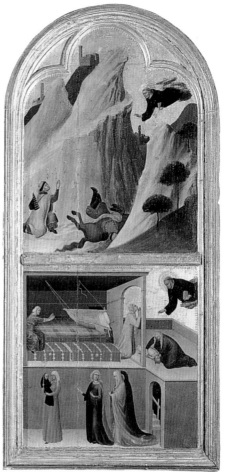

60. Blessed Agostino Novello Altarpiece
198 x 257 cm
Siena, Pinacoteca

61. Blessed Agostino Novello Altarpiece
Detail of two scenes: a Child Attacked by a Wolf
and a Child Falling from a Balcony
Siena, Pinacoteca

62. Blessed Agostino Novello Altarpiece
Detail of two scenes: a Knight Falling down a
Ravine and a Child Falling out of his Cradle
Siena, Pinacoteca

(in the *Child Attacked by a Wolf*), a view of the narrow streets of the city (in the *Child Falling from a Balcony*) and even an interior scene (in the *Child Falling out of his Cradle*, also known as the Paganelli Miracle); and in fact one could say that the city of Siena is indeed the co-protagonist of this painting. The buildings of the city centre are counterbalanced by the rural landscape in the scene of the *Knight Falling down a Ravine*, probably a depiction of the countryside immediately outside Siena, with the towers of faraway castles standing out amidst the bare hills.

The Altomonte Panel

In 1326 Filippo di Sanguineto, Count of Altomonte and an Anjou Court dignitary, came to Siena as part of the retinue of Charles, Duke of Calabria, the heir to the throne of Naples. When the Duke later left Tuscany, Count Filippo stayed behind as a royal deputy; his task was to keep under control the animosity of the Ghibelline forces, led by the very bellicose Castruccio Castracani. It seems quite likely that during his stay in Siena the Lord of Altomonte met the artist who had given such a masterly portrayal of the Anjou of Naples and of Hungary on the walls of the Lower Church in Assisi and in the *Naples Altarpiece* commissioned by King Robert. So he presumably seized this opportunity to commission a small painting himself, probably a diptych; the little panel showing *St Ladislaus, King of Hugary*, now in the Museo della Consolazione in Altomonte, was probably part of that diptych. The choice of St Ladislaus is perfectly justified by the ties of loyalty that bound Filippo di Sanguineto to the Hungarian branch of the House of Anjou, a loyalty which will later play an important role in the dynastic conflicts. Although the spatial construction of this small panel is very close to that of the *Blessed Agostino Novello Altarpiece*, the volumes are deeper and there is a wider range of colour. The gold background, with its elaborate and delicate etching, surrounds the saint; standing in a rigidly frontal position, armed with his battle-axe, he reminds us of his valour and his heroic actions in war.

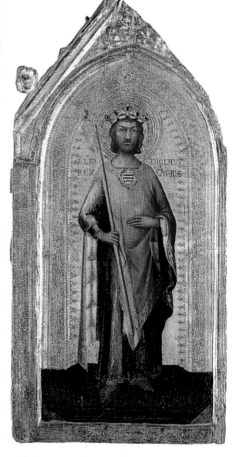

63. *St Ladislaus*
45.5 x 21.5 cm
Altomonte (Cosenza), Museo della Consolazione

64. *The wall with the Guidoriccio da Fogliano*
Siena, Palazzo Pubblico

228

Guidoriccio

About ten years ago, the famous fresco of *Guidoriccio da Fogliano*, which had always been considered the greatest example of Martini's artistic excellence, was re-attributed by Gordon Moran to a much later artist. The controversy that followed this re-attribution, further stimulated by the discovery of a fresco below the Guidoriccio (a very beautiful one, and certainly much older as we can see from the overlapping of the intonaco), turned into an animated diatribe that has not yet been placated. It wasn't just a question of pronouncing oneself in favour or against the attribution to Martini of the Guidoriccio, it also became important to interpret the iconography of the newly discovered fresco and to identify the extremely talented artist who had painted it. The following are the suggestions made by some of the most eminent art historians: Seidel and Bellosi believe that it shows the Capture of Giuncarico

and is the work of Duccio; Frugoni and Redon think that it is by Martini and depicts Guidoriccio Conquering Arcidosso; Brandi attributes it to Pietro Lorenzetti and Carli to Memmo di Filippuccio. This incredible difference of opinions is justified by the fact that most scholars have based their theories entirely on stylistic analysis. The observer may be surprised by this variety of attributions, especially since the artists mentioned are all so different. But for the public in general, informed by the unusual amount of space the press devoted to the matter, and also for those who take a professional interest, the main problem was how to form one's own opinion. How disorienting... when learned art historians contradict one another so drastically? It is difficult to find one's way through this maze of facts that have been used to support first one theory and then another — accurate biographies of Guidoriccio have alter-

nated with research on Siena's expansionistic policy in the 14th century, or with essays on the restoration procedures that the fresco has undergone and studies of recent techniques, or detailed studies in topography or heraldry, or on the costumes of Trecento condottieri.

Those who don't believe that the Guidoriccio fresco is by Simone suggest that it may well be the overall repainting of an earlier fresco. A recent cleaning has shown that the whole of the lefthand section, including the Castle of Montemassi, was repainted in the 15th or 16th century. An ultrasound echogram has also shown that in the righthand section, where the camp appears in the foreground, there are four overlapping layers of intonaco on the wall. In other words, the silent landscape of the Guidoriccio fresco probably conceals something much older. In order to clarify matters, it is necessary not only to remove the

65. Guidoriccio da Fogliano
Detail of the village
Siena, Palazzo Pubblico

66. Guidoriccio da Fogliano
Detail of the knight
Siena, Palazzo Pubblico

large stucco patch that extends vertically along the righthand edge (by doing so we would be able to determine precisely the order in which the intonaco was applied, thereby establishing the chronological relationship between the *Guidoriccio* and the *Battle of Valdichiana* that Lippo Vanni painted in 1363), but also a small patch of sky to verify whether this pale blue-grey expanse conceals some precious treasure.

67. *Guidoriccio da Fogliano*
Detail of the castle
Siena, Palazzo Pubblico

68. *Guidoriccio da Fogliano*
Detail of the camp
Siena, Palazzo Pubblico

69. *Annunciation*
265 x 305 cm
Florence, Uffizi

70. *Annunciation*
Detail of the angel
Florence, Uffizi

71. *Annunciation*
Detail of the Madonna
Florence, Uffizi

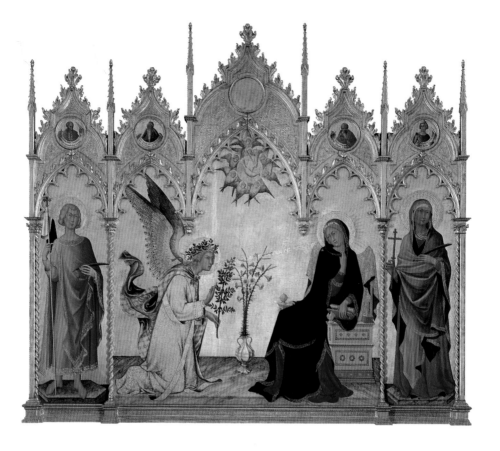

The Annunciation

In 1333, with the assistance of Lippo Memmi, Martini painted for the Chapel of Sant'Ansano in Siena Cathedral an *Annunciation* that is now in the Uffizi in Florence. The double signature visible inside the 19th-century frame, "Symon Martini et Lippus Memmi de Senis me pinxerunt anno domini MCCCXXXIII," has given rise to the problem of distinguishing between the parts that are by Simone and those that are by Memmi. The following are the theories expressed most recently by art historians: some suggest that Lippo is responsible for almost the entire painting; others attribute to Martini the St Ansano, the Archangel and Mary, and to Lippo only the figure of St Giulitta; others still feel that the altarpiece is a perfect example of the artistic collaboration of the

two masters, the best product of their joint workshop.

The iconography of the painting is extremely clear. At the top, within the medallions, there are four prophets, identifiable thanks to the inscriptions on their scrolls: from left to right, Jeremiah, Ezechiel, Isaiah and Daniel. The roundel in the cusp (which is now empty) probably contained an image of God the Father, since the dove of the Holy Ghost, immediately below, was usually portrayed together with an image of the Almighty. Gabriel's greeting, "Ave Gratia Plena Dominus Tecum," is inscribed on the gold background, and there are other words inscribed along the edges and on the sash of the Archangel's robe, but they are not easy to read. This splendidly linear com-

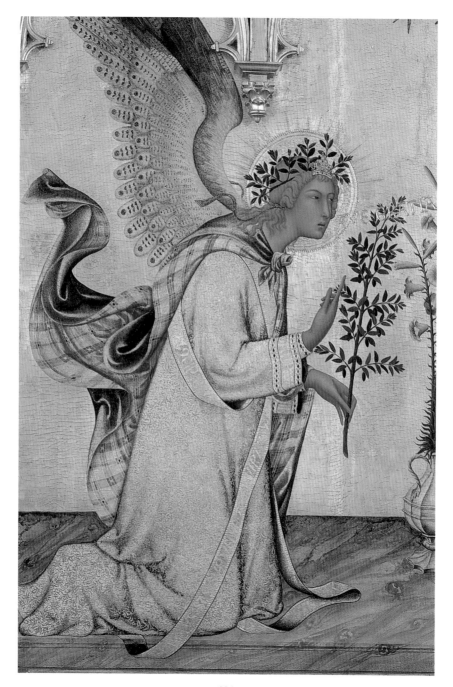

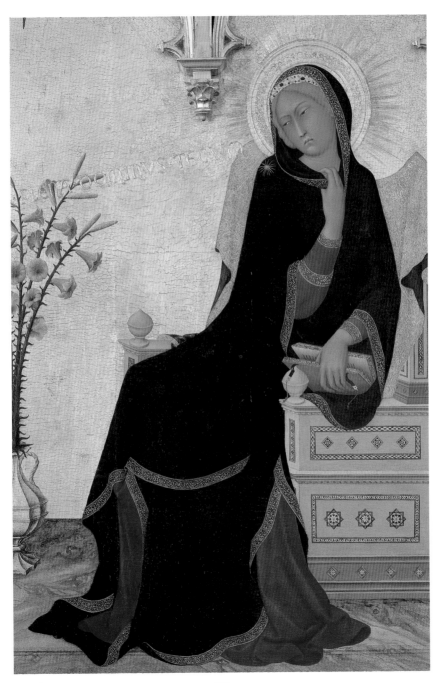

position, in which the two-dimensional feeling does not prevent the volumes from being well-defined and the edges sharp, is full of acute and realistic observations: the veined marble on the floor, the half-opened book, the vase in the middle with the lilies, the inlaid decorations on the throne.

Simone Martini in Avignon

Thanks to the evidence provided by two sonnets by Petrarch, written on 4 November 1336, "Per mirar Policleto a prova fiso" and "Quando giunse a Simon l'alto concetto," we know that Simone arrived in Avignon, accompanied by his family and several collaborators, around the beginning of 1336. He had been called to Avignon by one of the Italian Cardinals, probably Jacopo Stefaneschi, who had also moved to the new papal seat. It was for Cardinal Stefaneschi that Simone frescoed the church of Notre-Dame-des-Doms in Avignon. The portal frescoes, the *Saviour Blessing* and the *Madonna of Humility*, the synopias of which are now in the Palace of the Popes, although in very bad condition, are interesting and reveal a very high quality.

Also thanks to Petrarch's sonnets we know that the poet and the painter became very good friends. Simone must undoubtedly have been influenced by the proto-Humanist cultural world of Petrarch, and we can see clearly how the manuscript illumination of Petrarch's Virgil in the Biblioteca Ambrosiana in Milan, with its classical and naturalistic overtones (sophisticated gestures, white cloth drapery, the delicate figures of the shepherd and the peasant), anticipates the typical style of early 15th-century French manuscript illumination.

The altarpiece known as *Passion Polyptych*, with panels now in a number of European museums, is signed "Pinxit Symon "on the two panels of the *Crucifixion* and the *Deposition*. It presents several problems, both in terms of stylistic analysis and dating. Some scholars, stressing the fact that it is so different stylistically from all the other works of Simone's Avignon period (nervous lines and expressions), think that it may have been painted earlier and then transported to France; others believe that it may be a late work, commissioned by Napoleone Orsini, who died in the Curia in Avignon in 1342. Orsini's coat-of-arms appears in the background of the *Road to Calvary*. The polyptych was probably transferred to the charterhouse of Champmol, near Dijon, in the late 14th century.

The last known work of Simone's career as a painter is the Liverpool *Holy Family*, signed and dated "Symon de Senis me pinxit sub a.d. MCCCXLII." The iconographical subject, so rare, and actually used here for the first time, comes from the Gospel according to Luke, as we can see from Mary's book, "Fili, quid fecisti nobis sic?" (Son, why hast thou thus dealt with us?, Luke, 2:48). The scene shows Joseph leading Jesus back to his mother, after the three days he had spent with the doctors in the temple. The characters are bound by a feeling of intimacy and familiarity; they are portrayed in natural and spontaneous poses, with Mary reproaching her son, and reveal a deep and totally human family love.

Whatever Simone may have painted during the last two years of his life, nothing has survived.

72. *The Saviour Imparting His Blessing*
Avignon, Notre-Dame-des-Doms

73. *Madonna of Humility*
Avignon, Notre-Dame-des-Doms

237

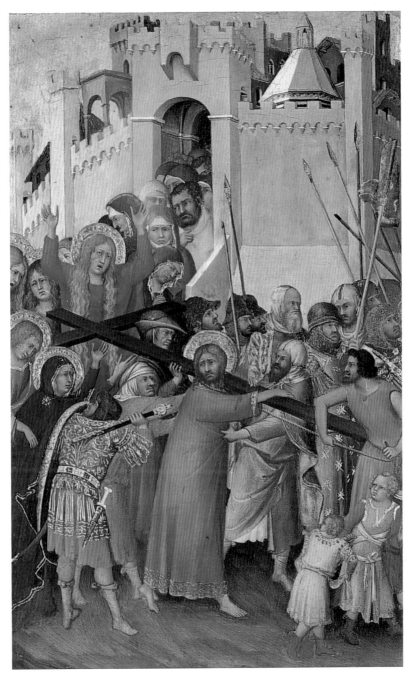

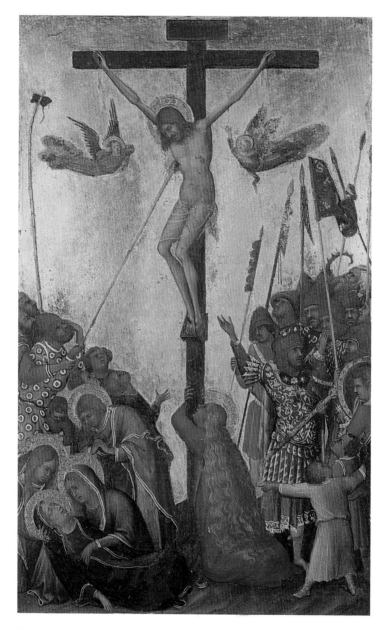

76. Orsini Polyptych
Panel of the Crucifixion
24.5 x 15.5 cm
Antwerp, Musée Royal des Beaux Arts

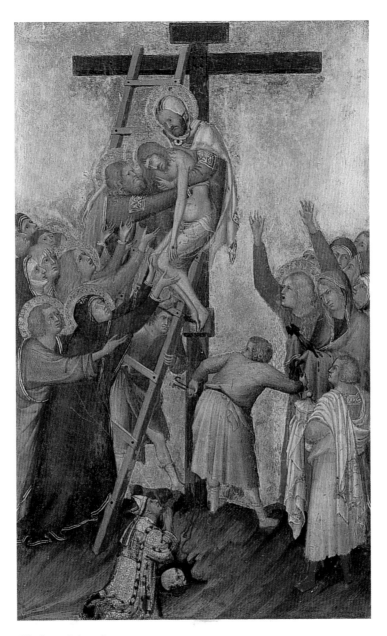

77. *Orsini Polyptych*
Panel of the Deposition
24.5 x 15.5 cm
Antwerp, Musée Royal des Beaux Arts

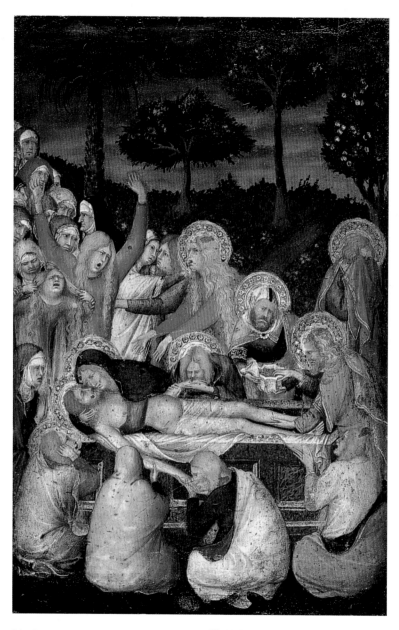

78. *Orsini Polyptych*
Panel of the Entombment
22 x 15 cm
Berlin, Gemäldegalerie Dahlem

79. *Holy Family*
50 x 35 cm
Liverpool, Walker Art Gallery

PIETRO AND AMBROGIO LORENZETTI

Pietro Lorenzetti: Biographical Notes

Vasari was the first to write a biography of Pietro Lorenzetti: an unfortunate beginning, for he misunderstood the artist's name. This mistake was repeated for centuries and, as a result, critics did not know that he was Ambrogio's brother and were not able to analyze the stylistic similarities and the mutual influences, the obvious consequences of a professional collaboration which was in fact much closer than the documents and the inscriptions on surviving paintings suggest. In any case, Vasari thought his name was Pietro Laurati, because that was the signature he thought he read on a painting done for the church of San Francesco in Pistoia, now at the Uffizi, showing, as he described it, "Our Lady with a few Angels very well arranged around her." But his interpretation of the signature, *Petrus Laurati de Senis*, was both incomplete and incorrect, for it reads: *Petrus Laurentii de Senis me pinxit anno Domini MCCCXL*. Despite the praise Vasari bestowed on Pietro, he must have had a fairly limited knowledge of the works and style of the artist, for it would have been enough for him to have observed with more attention those frescoes that he indicated as revealing Pietro's special talent: "Throughout his life, he was loved and called all over Tuscany, for he had first become known from the stories he frescoed in the Sienese Spedale della Scala; in which he imitated in a way Giotto's manner as it was known throughout Tuscany, so that it was believed that he would become, as indeed happened, a greater master than Cimabue and Giotto and all the other earlier artists; because the figures of the Virgin climbing up the steps of the temple, accompanied by Joachim and Anne and greeted by the priest, and then the Wedding, are so beautifully ornamented and so simply wrapped in the folds of their clothes, that the heads give an impression of majesty and the arrangement of the figures shows great talent."

Had Vasari been less careless he would have read the inscription on these frescoes, which was first mentioned by Ugurgieri in *Pompe senesi* (1649): *hoc opus fecit Petrus Laurentii et Ambrosius eius frater, MCCCXXXV*. These frescoes, which must indeed have been quite splendid, were destroyed in 1720, when the roofing above them was removed; not long afterwards, they had obviously been irremediably damaged, for the wall was whitewashed over.

Ghiberti, who strangely enough never mentions Pietro, thought they were the work of Ambrogio alone—he, too, like Vasari looked at the images without reading the writing. Ghiberti described them in a slightly different manner, for although he mentions the Presentation in the Temple, he talks of a Nativity instead of a Wedding of the Virgin. Since the frescoes were painted in the Hospital of Santa Maria della Scala, the fresco of the Presentation, with the child Mary climbing the steps, was probably chosen also as a reference to the name of the building; this simple game of images and words was a favourite of Ambrogio's as well, as he showed in his fresco in the Sala della Pace in the Palazzo Pubblico in Siena, where he puts a carpenter's plane in Concord's hands, to symbolize the figure's ability to smooth out all discord.

Vasari did not only get Pietro's name wrong and not realize that he and Ambrogio were brothers, he attributed the artist's most important work, the frescoes in the lefthand side of the transept of the Lower Church in Assisi, to three different painters, Puccio Capanna, Pietro Cavallini and Giotto. Whereas, on the other hand, he attributed to Pietro, and praised him lavishly for it, the fresco of the Desert Fathers in the Camposanto in Pisa, which is certainly not by him; recent scholars tend to think it is the work of Buffalmacco.

Unfortunately, we have also lost the frescoes that Vasari describes as "painted in the tribune and in the large niche of the high altar chapel" of the Pieve in Arezzo, with twelve stories from the life of the Virgin, ending with the Assumption; the Apostles were painted life-size and Vasari comments "in this he showed greatness of spirit, and was the first to try and make art more monumental. . . In the faces of a choir of angels flying about the Madonna with graceful movements so that they appear to be singing while dancing, he portrayed a truly angelic and divine joy, for he has made all the angels, while playing different instruments, look at another choir of angels, on an almond-shaped cloud, carrying the Madonna up to heaven. . ." Here, Vasari has succeeded in grasping some of the characteristics of Pietro's art, in particular the way he conveys the complexity of relationship between figures by their eyes (we will notice this above all in the Madonna and Child paintings, where both figures are always seen as intent on a silent conversation) and his ability to give expressions to the faces, smiling or in pain in a natural way, without conveying feelings solely through an over-emphasized and clumsy mimicry which, in the work of earlier artists, resulted in mask-like grimaces (like, for example, all those St Johns kneeling at the foot of the cross, with faces contorted and distraught). And, still according to Vasari, it was thanks to the beauty of these frescoes that Pietro was awarded the commission of painting the altarpiece for this same

Pieve; this painting we still have, and we will be talking about it shortly.

We do not even know Pietro's dates: he was born around 1280 and died around 1348, the year of the Black Death, which probably killed his brother Ambrogio as well. The few documentary sources that mention him give us no biographical information whatsoever. In 1342 he bought some land for Cola and Martino, the orphan sons of the sculptor Tino da Camaino; this fact backs up even further the stylistic similarity noticeable between the Madonna and Child in the Carmine altarpiece (1328) and Tino da Camaino's Madonna for the tomb of Bishop Antonio Orso (died 1321), now in the Museo dell'Opera del Duomo in Florence.

This is not the only instance of the influence of sculpture on the work of Pietro, for on several occasions he appears to have studied in depth the work of Giovanni

Pisano. In the polyptych of the Arezzo Pieve mentioned above, we can easily distinguish the influence on Pietro of Giovanni's sculptures on the facade of Siena Cathedral. (This is another feature that he has in common with his brother Ambrogio, who was an ardent admirer of classical art and loved to draw statues; for example, Ghiberti tells us, he made a drawing of a Venus by Lysippus which had been discovered by chance in Siena by workmen digging the foundations for the Malvolti palaces.) Since our documentary information is so scarce and so discontinuous — and Vasari is certainly no great help, for he never bothers even to give the dates of dated paintings — we shall proceed by examining the four surviving works that are datable with certainty, either from inscriptions on the paintings themselves or from documentary sources; in this way we shall be able to establish a valid stylistic development.

Dated Altarpieces
The Arezzo Polyptych

The polyptych that Pietro Lorenzetti painted in 1320 for Bishop Guido Tarlati is still today kept above the high altar of the church of Santa Maria in Arezzo, commonly called the Pieve or parish church. Unfortunately, the predella has been lost. In the contract for this painting the artist is referred to as *Petrus pictor, quondam Lorenzetti qui fuit de Senis* (Pietro, painter, the son of the late Lorenzetti who was from Siena). Giovan Battista Cavalcaselle, the art historian who first really discovered Pietro's talents, stresses the importance of this painting, as one of the main works of the first half of the 14th century.

In the centre, the Madonna gazes tenderly at the Child, who is portrayed in a mood of calm trust and faith; he rests one hand on his mother's shoulder, while with the other he is holding her veil. The lower part of the Virgin's body is parallel to the background plane, whereas the upper part, at the level of her shoulders, is slightly twisted, in a movement that is reminiscent of Giovanni Pisano's Madonna done for the facade of Siena Cathedral; with this movement, the figure of the Virgin makes room for the Child, and the faces are seen in three-quarter profile. The artist has also portrayed, from left to right, Saints Donatus, John the Evangelist, John the Baptist and Matthew.

The Baptist indicates the Christ Child with his thumb: this gesture was never used before and became typical of Pietro's painting whenever he wanted to emphasize the relationship between two characters, in this case between he who announced the coming of the Saviour and Christ who, made flesh in the Virgin, fulfilled that promise. The entire sequence is admirably constructed; the continuity between the different panels is achieved by the joining wings of the angels, arranged in pairs in the spandrels of the individual sections: here we can distinguish without doubt the influence of Duccio's great altarpiece (now in the Museo dell'Opera in Siena). Yet, at the same time, the figures are very firmly and solidly placed in space, in a way that is more reminiscent of Giotto: and, in fact, John the Baptist and John the Evangelist, who are placed diagonally and in converging lines towards the Madonna, a line emphasized by their hand-pointing gestures, suggest the depth of a third dimension, which almost creates an ideal throne for the Virgin.

This horizontal pattern is counterbalanced by the small pilasters dividing the individual sections and also by the complex architectural shapes surrounding the upper figures. Again from left to right, we have Saints John, Paul, Vincent, Luke, James Major and Minor, Marcellus and Augustine. They are arranged in pairs, and each pair takes up the same amount of space as one saint in the lower section; in the spandrel in the middle of this sort of diptych, in a roundel, we have the figure of a prophet who is looking towards the Annunciation in the panel just above the Madonna and Child. (In this way Pietro maintains and repeats the

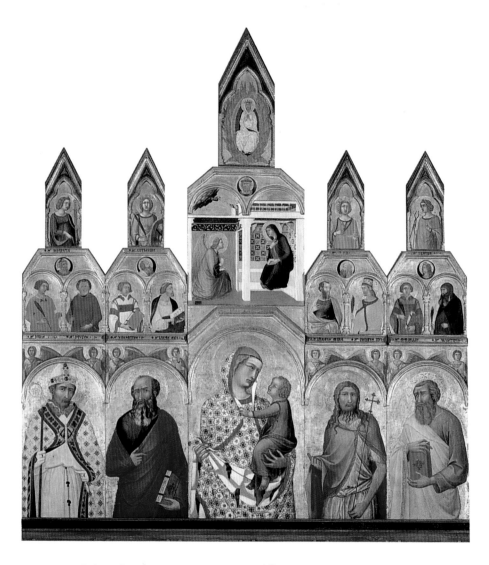

same pattern of relationships and the same converging of figures towards the central element he had created in the lower part of the polyptych.) Each pair of saints is then surmounted by a female saint, this time placed within a tall and narrow trefoiled arch.

In the Annunciation we find another characteristic feature of Pietro's art, that is his tendency to use elements outside the painting itself, like the small pilasters and the arches of the frame, as an integral part of the composition; here, for example, they are used as the front wall of Mary's room. But the Angel is placed in a different room, which has a different depth from Mary's room; this way, not only does Pietro manage to create movement of volumes, but the scene also acquires greater dynamic quality since the Virgin is placed in a real relationship only with the ray of God's light that enters her room, and the Angel is quite clearly just an intermediary, who is not really taking part in the dialogue between the Virgin and God. The Assumption is the final, triumphal episode in the life of the Virgin, who rises to heaven to be joined once again to her divine Son.

2. *The Arezzo Polyptych*
cm. 298 x 309
Arezzo, Santa Maria

3. *The Carmine Altarpiece, detail*
Madonna Enthroned with St Nicholas and the
Prophet Elijah
cm. 169 x 148
Siena, Pinacoteca Nazionale

The Carmine Altarpiece

In the Pinacoteca in Siena we can today see almost the entire polyptych, which has been dismantled and reassembled several times, commissioned by the Carmelite monks of Siena between 1327 and 1328. Pietro had certainly finished it before 26 October 1329, when the Commune of Siena, following a request made by the Order, granted a contribution of fifty Lire with which the monks could finish paying the artist, for he was refusing to deliver the painting before

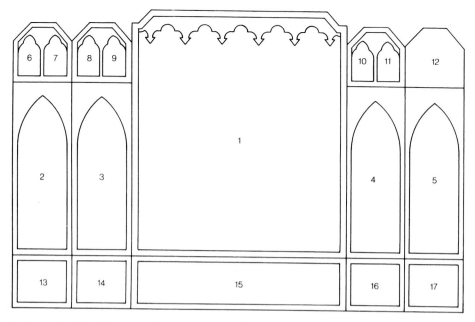

having received the full payment. In view of this, the date on the painting itself, near the signature, must be interpreted as MCCCXXVIIII, rather than MCCCVIII as it appears today. This episode, involving the political establishment of Siena, gives us an idea of the prestige that Pietro held at the time, and how high his prices were, since the Carmelites had agreed to purchase his painting for 150 gold florins, a considerable amount of money at that time.

The altarpiece remained in the church of San Nicolò in Siena, that is the church of the Carmine, for about two centuries; then, with the changing artistic fashions, it was relegated to the little church of Sant'Ansano a Dofana, where it was subjected to some slight alterations. The prophet Elijah, to the right of the Virgin, was changed into a St Anthony Abbot, the patron saint of animals and therefore more suited to a country oratory; part of the predella was also painted over with stories from the life of St Ansano. Other parts of the polyptych stayed in the Carmelites' monastery in Siena, but since the painting was by this stage already dismantled these other sections were dispersed and sold to antique dealers. One cusp, showing St Andrew and St James, was found by Venturi in 1945, and is now in the museum of Yale University in New Haven; two side panels, showing St John the Baptist and the prophet Elisha, were recognized as being part of the polyptych by Federico Zeri in 1971, and are now in the Princeton University Art Museum in New Jersey. The sections that stayed in Siena and the part that had been transferred to Dofana have now been reassembled and are on ex-

hibit in the Siena Pinacoteca.

The subject-matter of the polyptych is very specific and, for the period in which it was commissioned, even quite provocatory. The Carmelites are a mendicant Order, founded around the 12th century by a group of Crusaders who had settled on Mount Carmel in Galilee "following the example of the saintly and solitary prophet Elijah, near the spring that bears the name of Elijah," as James of Vitry recalls in his *Historia Orientalis*. (Elijah is connected to Mount Carmel because that is where he defeated the prophets of Baal). The Carmelites built a little church dedicated to the Virgin Mary on this mountain, and made her their patron and protectress. They claimed to be the descendants of Elijah and his successor Elisha through "the sons of the prophets who continued to live on Mount Carmel"; they even claimed to have received approval by the Virgin Mary herself. Still according to the legend, the Carmelite hermits had been baptised by the Apostles: this made their Order a sort of bridge between the two worlds, of the Old and the New Testament. The first official approval of the original nucleus of hermits was given around 1210 by the Patriarch of Jerusalem, Albert; this was followed by papal approval in 1226 and by various other instances of papal assent until the hermits became an actual Order. After the fall of the Latin Empire in 1261, the Order was forced to move from the Holy Land to the West, where it was united to other mendicant Orders. In 1286 Honorius IV changed the Carmelites' habit, which had originally been of white and dark stripes (in memory of Elijah's cloak that had been charred by the

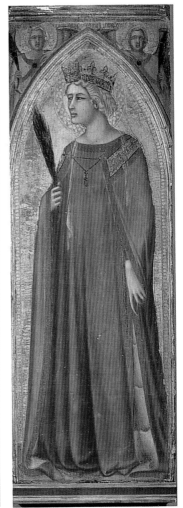

5. The Carmine
Altarpiece, detail
St Agnes
cm. 128 x 45
Siena, Pinacoteca
Nazionale

6. The Carmine
Altarpiece, detail
St Catherina of
Alexandria
cm. 127 x 46
Siena, Pinacoteca
Nazionale

flames as he rose to heaven on his chariot of fire); the new habit was pure white and was also the symbol of the reconfirmation of the new Order. Papal approval was renewed by Boniface VIII in 1298 and by John XXIII in 1317 and 1326; on this last occasion the Carmelites were included in the papal bull *Super Cathedram*, already extended to the Franciscans and the Dominicans. These continuous appeals to the authority of the pope indicate the difficulties encountered by the Order, for the other mendicant Orders constantly questioned the historic truth of their descendance from Elijah and Elisha; this situation continued until 1447. I thought it was necessary to give a summary of all these facts in order to understand the complex message — almost a challenge made by the Order — of this altarpiece.

The polyptych is divided into two sections: in the cusps and the main panels we find the "historic" tradition of the Order, whereas the predella illustrates the "modern" events. In the centre of the altarpiece is the Madonna Enthroned, surrounded and crowned by angels, with St Nicholas, patron of the church of the Carmine, to the left, and the prophet Elijah, wearing a Carmelite habit and unrolling a scroll on which is inscribed a verse from the Bible (I. Kings, 18: 19): *verumtamen nunc mitte et congrega ad me universum*

Israel in monte Carmelo et prophetas Baal quadrigentos quinquaginta. . . (Now therefore send, and gather to me all Israel unto Mount Carmel, and the prophets of Baal four hundred and fifty. . . which eat at Jezebel's table). It is with these words that Elijah addresses Ahab, challenging Baal's prophets; it is with these words that Elijah proves that his is the true God; this quotation was therefore extremely relevant to the current situation, for it referred to the acceptance and credibility that the Order was demanding. The Child, from the throne, turns towards Elijah in a gesture of approval, stressed also by the way John the Baptist in the panel immediately next to the main one (now in Princeton) indicates with his thumb. The Baptist has often been called the second Elijah, and iconographically they are very much the same type: both ascetics in the desert, emaciated by long fasts, clothed in rough animal skins. This assimilation is the result of Malachi's prophecy, according to which the coming of the Messiah will be preceded by Elijah, who will come down from Paradise to prepare His way (therefore, Elijah is the precursor of the precursor of Christ, who is John the Baptist). In the panel to the left, next to the group of the Madonna and Child, is the prophet Elisha (also, unfortunately, now in Princeton), with a scroll in his hands and wearing the Carmelites' white habit. The words on his parchment are those of II. Kings (2: 11-l): *ascendit Helias per turbinem in caelum; Heliseus autem videbat et clamabat: Pater mi, pater mi, currus Israel* (and Elijah went up by a whirlwind into heaven. And Elisha saw it, and he cried, My father, my father, the chariot of Israel). It is the moment when Elisha is acknowledged successor of Elijah, and he takes up the master's mantle which had fallen from him on his flight to heaven.

In the Carmine altarpiece, Elisha is seen as the second founder, the first link in that long chain that connects the biblical prophets, generation after generation, to their last descendants, the Carmelites. The two outside panels show Saints Agnes and Catherine. Lorenzetti's altarpiece stood in the main chapel of the church, the Chapel of the Arte della Lana, or Wool

7. The Carmine Altarpiece, detail of the predella Dream of Sobach
cm. 37 x 44
Siena, Pinacoteca Nazionale

8, 9. The Carmine Altarpiece, detail of the predella Elijah's Well
cm. 37 x 45
Siena, Pinacoteca Nazionale

10. The Carmine Altarpiece, detail of the predella Handing Over of the Rule
cm. 37 x 154
Siena, Pinacoteca Nazionale

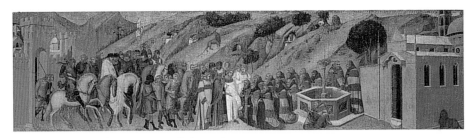

Guild, which explains the connection with Agnes, interpreted by a great flight of etymological fancy as meaning *agnus* or lamb, in other words the animal that provides wool. As far as Catherine is concerned, her presence is justified both because she is the patron saint of wool carders and also because she was of Oriental origin. The cusps, which were probably surmounted by spandrels (one cusp is lost), portray the Apostles in pairs; each pair is lovingly watched over by a prophet, once again stressing the Order's rightful heritage.

The Virgin, truly majestic in her ermine-lined cloak and in the austere way she looks out at the spectator, sits on an extremely wide throne, forming a large niche which accentuates the monumentality of her figure. Once again, the inspiration for this figure comes from a statue by Tino da Camaino. The hand on which the Child rests his foot almost hints at a gesture of blessing in the direction of Elijah, and therefore addressed to the Carmelite Order: the Order can thus claim the patronage even of the Mother of God.

The most innovative and interesting parts of the polyptych are, however, the predella panels, extraordinarily lively narrative scenes placed against charming architectural backgrounds and landscapes, with almost enamel-like bright colours. The first one shows the dream of Sobach, the legendary father of Elijah. Sobach lies sleeping in an alcove of the room which the angel bursts into; the room is perfectly empty except for a towel hanging from a rod, the windows either open or half-shut, the row of arches that allow one to see through to the stairway, the slim columns of the loggia above the room —all these communicate wonderfully the idea of a silent but bright dream.

The following panel shows a miniature Thebaid, for it illustrates the joy and sweetness of solitude. The medieval desert is here transformed into barren rocky hills, softened by trees and by occasional unexpected clumps of grass, against which are placed the huge figures of the hermits, intent on their simple chores or engrossed in their reading. The life-giving centre is the sculpted fountain; on the edge of the fountain there are two glasses full of water, a masterly touch, which makes Pietro, we might say, the innovator of a new genre in painting, the still life.

In the rectangular panel in the centre of the predella there is a large group witnessing the handing over of the rule from Albert, Patriarch of Jerusalem, to St Brocard, the first Carmelite prior. The contrast be-

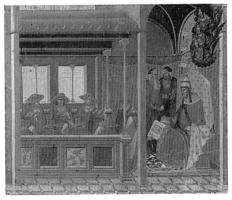

11. *The Carmine Altarpiece, detail of the predella* Approval of the Rule
cm. 37 x 41
Siena, Pinacoteca Nazionale

12. *The Carmine Altarpiece, detail of the predella* Honorius IV Approves the New Habit
cm. 37 x 45
Siena, Pinacoteca Nazionale

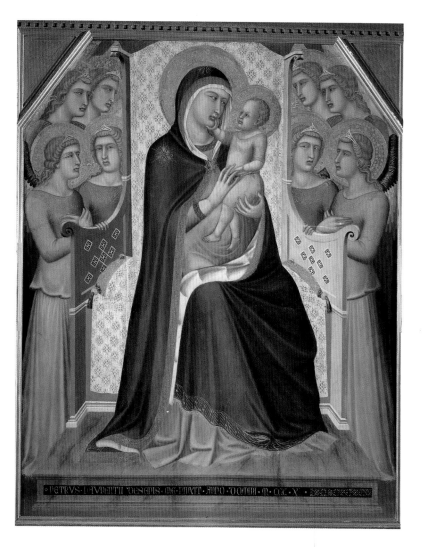

PETRVS·LAVRENTII·DESENIS·ME·PINXIT·ANNO·DOMINI·M·CCC·X·

tween the smooth hilltops, with the solitary wild animals and isolated flowers, and the cluster of figures in the foreground is intentional. In the group scene Pietro gives us an example of his ability as a miniaturist, capable of giving each figure his own individual features, gestures and poses. The procession of people coming out of the red city walls of St John d'Acre to reach the bluish church of the Carmelites is like a visual bridge between two epochs, the age of the glorious and almost mythical Anchorites of Galilee and the modern age, characterized by the return to the West and the acceptance within the official structures

of the Church. This is the subject of the last two panels. In the first we see the pope, surrounded by the cardinals, approving the Carmelite rule (again this emphasizes the legitimacy of the Order, for three popes have come down from heaven to confirm the validity of the historical tradition). In the second, Honorius IV replaces the striped Carmelite habit with the new white one. The architectural background is basically the same one that Ambrogio will use two years later in his fresco in the church of San Francesco in Siena, showing Boniface VIII accepting St Louis as a novice. In the panel illustrating the institution of the new habit there

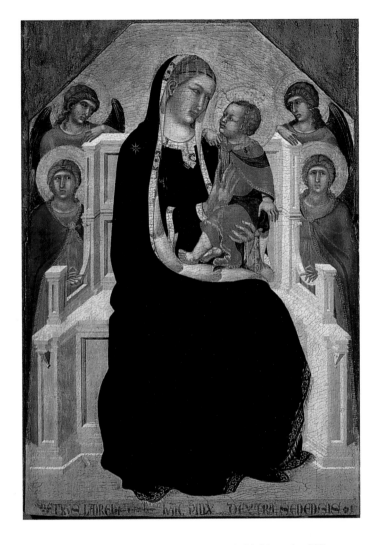

is an interesting cubic loggia painted above part of the Curia: it expands the spatial background and gives depth to the immobile gold sky. As far as the subject-matter of the previous panel is concerned, it is possible that the pope portrayed is neither Honorius III nor Honorius IV as he is normally identified, for this would not justify the three popes descending from heaven to help him. The final solemn approval of the Order was given by John XXIII in 1326, and we know that the polyptych was commissioned in 1327; we can there-fore suggest that this was the occasion for commission-ing such an openly propagandistic painting.

The Madonna and Child in the Uffizi

This painting is signed and dated 1340; the predella, described by Vasari, has been lost. In this work, Lorenzetti shows his ability to provide constant varia-tions on the subject of the Mother and Child, as well as his keen powers of observation of children and their little gestures. Jesus grabs Mary's chin with one hand, while with the other he holds a finger of the hand that is supporting him. In this painting, Pietro has concen-trated primarily on the light effects, showing, for ex-

15. *Birth of the Virgin*
cm. 188 x 183
Siena, Museo dell'Opera del Duomo

The Birth of the Virgin in the Museo dell'Opera in Siena

ample, one side of the throne bathed in bright sunlight, while the other stands in deep shadow. The large patches of solid colours give the figures added volume. Pietro does not, however, stop experimenting with new effects in order to draw the attention of the observer: he makes the Virgin's cloak on the lefthand side fall straight down, without respecting the horizontal plane of the throne which should have interrupted the vertical lines; this creates an ambiguous image, that makes us spectators slightly uneasy.

We have come to the last of the dated paintings, completed in 1342, but we know from our documentary sources that it had been commissioned as early as 1335. The frame of the triptych has here become part of the architectural construction of the painting itself, which is full of new and interesting solutions. The slanted perspective, used in order to give the foreshortenings greater depth, is purposely arranged so as to have different points of view and very daring connecting passages: if we take the central section of the triptych as the main point of view, the lefthand and righthand sections appear to be opening outwards, in a fan

16. *Madonna and Child ("The Monticchiello Madonna")*
cm. 68 x 46
Siena, Pinacoteca Nazionale

17. *St Margaret*
cm. 55 x 33
Le Mans, Musée Tessé

shape. This allows the figures at the outer edges of the painting to move about freely in a wide space, instead of being crammed in by the walls of the room and the pilasters supporting the ceilings, as they would have been had the laws of perspective been respected. The room where Joachim is sitting, anxiously leaning forward to hear the news from the young boy, opens at the back onto another room (beyond which we can see a courtyard), which has more depth than the one in which St Anne lies, surrounded by her friends and midwives. The details, described by Pietro with loving care, are quite justly famous: the clean towels with the lovely lozenge decoration, the black and white straw fan held by the woman seated next to the bed, the bowl with floral decorations where the water for the infant's first bath is poured, and the tartan blanket whose large checks are almost like a continuation of the lively floor tiles. Anne, lying on her bed, is strongly reminiscent, as Enzo Carli pointed out, of Arnolfo di Cambio's Madonna of the Nativity, formerly on the facade of Florence Cathedral, while the midwife pouring water from the jug, seen in three-quarter profile, is quite definitely Giottesque. Solidity of volumes and great attention to details are blended in Pietro's work with splendidly flowing lines and extremely elegant drawing. Yet, there is never a figure that appears too polished, and therefore distant; on the contrary, they all communicate an intense inner life. See, for example, the gentle Madonna from the Pieve dei Santi Leonardo e Cristoforo in Monticchiello, now in the Siena Pinacoteca. The face of the Child, who is almost exaggeratedly turned around so as to meet his mother's gaze, resting his hands on her shoulder in a pose of complete abandon, blends with the elaborate depiction of the Madonna's hands holding Jesus's little legs and his hand in an abstract play of lines and barely suggested chiaroscuro. The same can be said of the lovely painting of St Margaret, now in the Gallery at Le Mans. Her right hand is bent backwards and, with daring foreshortening, fits into the niche in the slightly raised cloak, while her dress opens up on her breast, allowing us to see a precious embroidered border, weighed down by a row of gold buttons, shining like a bunch of gold blackberries.

The Frescoes in the Lower Church at Assisi

It was Cavalcaselle in 1864 who first attributed the frescoes in the Lower Church at Assisi to Pietro Lorenzetti, and this attribution is now universally accepted. The great art historian suggested that they dated from 1320, and recent scholars tend more or less to agree. Hayden Maginnis, who has studied the intonaco and the different workdays (that is the portions of the fresco that were painted at each session), has recently established that the cycle was begun from the ceiling and that work progressed moving downwards; in her analysis, she also took into consideration the information resulting from Leonetto Tintori's restoration work. The cycle was painted in a single pictorial campaign and must have been completed before the serious political upheavals that lead to the expulsion of the Guelphs from Assisi in 1319 and the institution of the violent Ghibelline government led by Muccio di Ser Francesco from Bologna.

The first of the six stories from the life of Christ *ante mortem* frescoed on the ceiling of the left arm of the transept is the Entry into Jerusalem; this is followed by the Last Supper, the Washing of Feet, the Capture of Christ, the Flagellation and the Road to Calvary.

The fresco of the Entry into Jerusalem is a collection of extraordinary inventions, starting from the procession of the Apostles meeting the inhabitants of the city, who have come to see Christ; they are structured in two groups, like the two sides of a very wide angle at the summit of which, in the point closest to the onlooker, stands the Saviour, slowly making his way riding on the little donkey. Inside this angle there is another one, perfectly parallel to the first, but smaller; it consists of the clustered buildings of Jerusalem, held together by the steep walls shown in daring foreshortening, and continued by a broken but enveloping line that leads our gaze to beyond the city gates. The architectural composition thus almost appears to be pushing Christ on, to be forcing him towards the spectator, while at the same time it expands the three-dimensionality of the space. The sky is no longer an immobile dull background, for a transparent blue can be seen through the two-light window and the single-light one in the pink tower, between the tall arches of the greenish temple, amidst the crenellations of the slim twisted colonnettes of the lilac tower (notice also these imaginative colour harmonies, so unpredictable and yet so perfect). Each Apostle is given his own individuality, like for example the one to the right of Judas (portrayed here already without a halo, and with a stern expression, wrapped up in the red cloak which both isolates him and makes him stand out from the others), who turns to the left, distracted by the children collecting olive branches on the hillside. From Judas's red cloak our gaze is drawn to Peter's yellow one, right next to him, and then to Christ's very bright

blue one; then down to the large pink patch of the young boy bending over to stretch out his cloak, marking the last element of this collection of colours begun with Judas's red mantle. The young boy marks the beginning of another wave; the first was formed primarily by the variation of strong patches of colour against the rather dull background of the procession, made up of sombre colours, in which Pietro Lorenzetti has created his volumes according to Giotto's models; the second, on the other hand, is formed by the flowing and elegant lines of the group of children taking their costumes off, while the rhythms of calm and orderly dance (and here, too, Pietro does not neglect realistic details lovingly rendered, like the little boy whose head appears between the two youths in blue, almost as though he was peeping out from the curtains of a stage).

Ambrogio will remember this group clearly when he comes to paint the group of the dancing girls in the Good Government, with the head of a blonde child just barely peeping out from the doorway of his father's cobbler shop.

In the Washing of Feet, Lorenzetti overcomes the difficulty of a real arch "by arranging the scene," as Enzo Carli points out, "on two different levels: the upper one shows us the Apostles seated behind a balustrade, alternately with their back to us or facing us, while the actual Washing of the Feet in the lower lefthand part becomes the dominant event." Our attention is drawn to the lively discussion between the kneeling Christ and the Apostle, who raises his hand to his head in a gesture of determined refusal, by an oblique line which ideally goes from the shoulder and the face turned to the left of the Apostle with his back to us, obviously turning because he is attracted by the discussion, to the black sandal of the Apostle nearby, who is getting ready to have his feet washed. The gesture of the Apostle holding his chin with a thoughtful air is exactly the same as the knight in the Crucifixion (on the lefthand wall of the transept), who lowers his gaze to the feet of the Good Thief: this observation was first made by Maginnis, together with several others which for reasons of space we cannot mention here, but which are evidence of the stylistic continuity and chronological proximity between the stories of Christ before his death, painted on the ceiling, and those from after his death, painted on the walls. (Some critics, in fact, such as Carli for example, date the latter between 1324 and 1328).

The Last Supper has a composition that was obviously very clearly thought out, starting with the hexagonal pavillion painted in overturned and widened perspective: the focal point is marked by Christ and John, who stand like a pearl between the valves of a half-opened shell, that is the beams of the ceiling

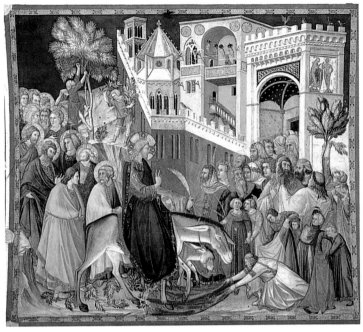

18. Entry into
Jerusalem
Assisi, Lower Church

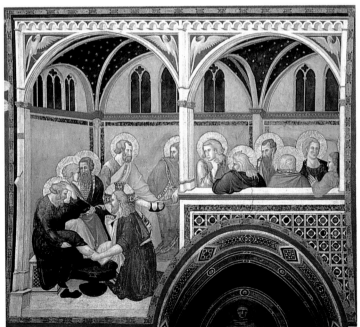

19. The Washing
of Feet
Assisi, Lower Church

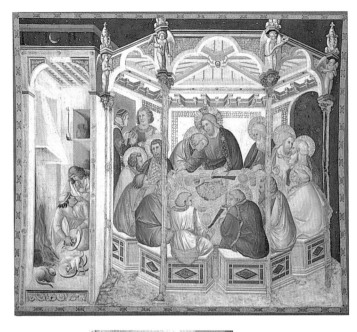

20. *Last Supper*
Assisi, Lower Church

21. *Last Supper,*
detail of the kitchen
with two servants
Assisi, Lower Church

spreading outwards like sunrays and the decreasing group of the Apostles. To the left we can just see a kitchen, a real piece of virtuoso perspective, with its slanting chimneypiece and the niches containing the utensils, a little patch of "still life" that Pietro so liked to place in his works. The connection between the two rooms is made by the pointing hand of the servant leaning on the shoulder of his kneeling companion, who is scraping the plates next to a blazing fire. The servant is pointing to a lavishly dressed man who is standing talking to another figure, wearing more modest clothing. This is probably a conversation between the master and the servant whom Christ had ordered the Apostles to follow in order to ask his master for permission to celebrate the Passover. The two men are therefore presumably discussing the servant's encounter with the Apostles.

This kitchen scene is normally considered a great innovation, and interpreted as the insertion of a realistic detail in a subject so full of symbolic implications as the Last Supper. But the importance given to the high flames in the fireplace, used as the source of light within the painting, hints at the possibility of a different meaning, more in tune with the gravity of the scene: it is because of the light shed by the fire that the figures are alternated in light and shadow. (Incidentally, two details that really are innovative are the shadows of the sleeping cat and of the dog dashing over to lick the plates piled on the ground). A recent interpretation by Carra Ferguson O'Meara suggests that this genre scene is the visualization of a theological message con-

22. *Arrest of Christ*
Assisi, Lower Church

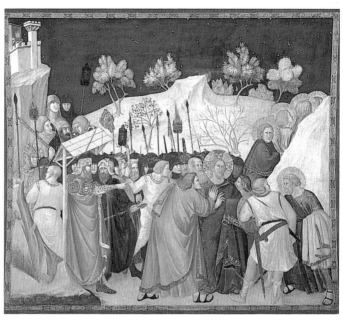

cerning the nature of Christ's sacrifice on the cross, and the repetition of this sacrifice in the Eucharist; according to the Christian commentators of the Old Testament all episodes containing sacrifice with fire, ritual victims and ritual immolation sites were to be interpreted as symbolic references to the Crucifixion and the Eucharist.

Christ, dying at Easter time, becomes the Easter lamb of the new era, the Eucharist, the unleavened bread, says Thomas Aquinas for example. In the Last Supper the celebration is the Hebrew Passover, and we can perhaps say that the last live victim has been roasted. These two rooms can therefore be seen as representing the sacrifice in the Old Testament, where the victim is the real lamb (the kitchen), and the sacrifice in the New Testament, the new Easter with the spiritual lamb (the room of the Last Supper). Even the little dog has a hidden meaning. St Bonaventure in his third sermon dealing with the Lord's Supper compares those who only desire real flesh rather than the flesh of the Immaculate Lamb to dogs, who must be denied access to the Eucharistic table. We know of the extraordinary abilities of symbolic exegesis developed by medieval ecclesiastical commentators, who were not daunted even by the most explicitly erotic descriptions in the Song of Songs which they managed to transform thanks to their ingenious interpretations into perfectly chaste images of Christ and the Church; so it is possible, in theory, to interpret the presence of a fire as a sign of a hidden reality. But there must not then be any elements that do not fit

23. *Judas Hanging Himself*
Assisi, Lower Church

263

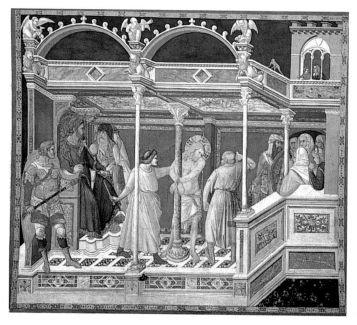

into that interpretation, for if we apply the method of a continuous concordance, there must be consistency between reality and symbol. It is not possible to interpret the dog as a sinner, and then see the cat sleeping next to him purely as a decorative element; just like we cannot think that the towels with which the servants are cleaning the plates are liturgical shawls for the sacrifice, for the Apostles are not wearing them (and, in any case, why should they reappear, exactly identical, in the scene of the Birth of the Virgin, where they are used to cover the baskets of food brought to St Anne by her friends?). In other words, this theory, rather more ingenious and imaginative than it is persuasive, doesn't hold.

Another extraordinary innovation of Pietro Lorenzetti's is how he draws the onlooker's attention to the passage of time. He is possibly the first artist in the history of medieval painting to attempt this, and he succeeds in giving greater dramatic power to the scenes telling the story of the last period of Christ's earthly life. Outside the brightly lit pavillion, where the Apostles have gathered, it is night time, the stars are shining and the moon has just risen. The same moon that is inexorably setting in the next scene, the scene of the Arrest of Christ, marking the high speed at which events are following on each other. The moon's movement in the sky also emphasizes the connection, already implicit in the story of the Passion, between one episode and the next. In the Arrest of Christ the various characters move in a circular pattern, entering from the rocks stage left and exiting — the movement

of the figures and the layout of the barren mountain scenery quite literally bring to mind a stageset — to the right disappearing behind the rocks. Against the compact background made up of the heads of the soldiers, hidden away inside their sinister armour, stands out the loosely arranged group of Christ and Judas, who looks huge in his wide red cloak, and Peter, who is in vain being held back by a soldier dressed in pink as he cuts off Malchus's ear. Christ's head, portrayed frontally, is therefore placed at the summit of an ideal triangle, the sides of which are formed by the faces in profile, expressing very different emotions, of Judas and Malchus; this triangle continues in another ideal triangle, this time overturned, where the summit is the back of the head of the soldier dressed in pink, and the other two points are the faces in profile of Malchus and Peter. The whole scene is masterfully isolated by the empty space Lorenzetti leaves between Christ and the soldiers who are about to arrest him but haven't yet arrived; the dramatic sense of the event is increased by the fact that it has been caught just an instant before its final conclusion, suggested by the imperious arm of the centurion, still distant yet so imminently threatening.

Judas's Betrayal is not illustrated by the kiss, as is customary in traditional iconography, but by a much more emotional and dramatic representation: the scene of the Apostles fleeing, abandoning their master, running off and bumping into each other like a flock of frightened sheep, hiding their faces behind the rocks to the right.

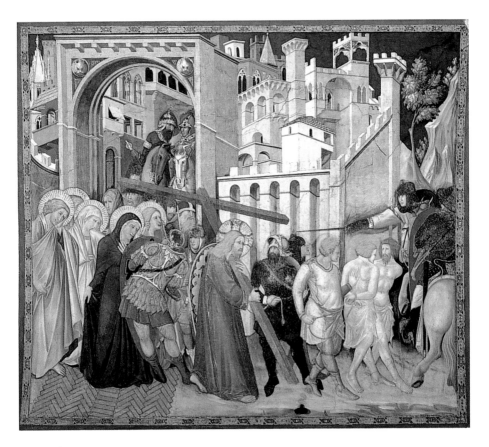

The following scene is the extraordinary representation of Judas hanging himself; this is also the only fresco that is accompanied by an inscription, *(I)scariotas*. This episode is recounted only by the Gospel according to Matthew, with the following terse line: "And he cast down the pieces of silver in the temple, and departed, and went and hanged himself" (Matthew, 27:5). In the Acts of the Apostles (1:15 ff.), on the other hand, we are given another version of how Judas killed himself, and it is this account that traditional iconography normally follows. Peter is addressing the disciples and says: "Now this man purchased a field with the reward of iniquity; and falling headlong, he burst asunder in the midst, and all his bowels gushed out" (this detail is explained by the fact that many ancient civilizations believed that the demons resided in the belly of the possessed person, which then burst when he died to let the evil spirits out). Whereas normally painters, following the popular legends which combined elements from the Scriptures with other totally invented ones, show the disembowelled Judas

hanging from a fig tree (the tree that Christ himself damned), Lorenzetti appears to be following Nicodemus's Apocryphal Gospel, which tells of how Judas, in desperation, fled home to his wife to confess his crime, in terror because of Christ's imminent resurrection; seeing no way out of this anguish, "he made a noose with a rope and hanged himself." And, in fact, Judas is shown hanging from a beam inside his own house, with his neck tendons horribly dislocated: this is a detail Lorenzetti would have picked up from the sight of hanged men, for it was the custom to leave the bodies hanging for days after the execution as a kind of admonition to the population. And equally, the spectator today will find this Judas difficult to forget, with his body hanging inertly, entirely slackened in the heaviness of death, his belly rent open, and his swollen neck with his matted hair sticking to it.

In the Flagellation before Pilate — it is by now daytime and the moon and the stars have disappeared — it is the architectural background that moves the story along. Against this background of broken lines and

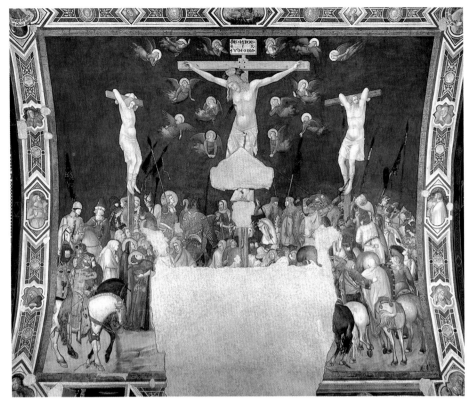

daring foreshortenings, the figures are placed alternately behind and in front of the slim columns, until we reach the enclosed figure of the Jew seen from behind, embracing the last colonnette on the extreme right. "He is the living link between the two adjacent rooms of the Praetorium," Enzo Carli points out. And the figurative architectural elements are also, to some extent, "living": the lions and the putti bearing cornucopias that adorn the capitals and the cornices of the room—see, for example, the lion raising his head towards the putto with the little dog above him. They are also disquieting, like the monkey who has escaped from the boy looking out from the three-light window to the right (he is perhaps Pilate's son, with his mother next to him). And precisely because they are animated by this impossible participation they communicate an impression of unease and tension.

But everything becomes calmer and less tense in the slow procession of the Road to Calvary, where we can observe the same circular pattern of the procession going out from the walls of Jerusalem. But here an interesting variation is afforded by the group of the Holy Women, the Virgin and St John, who appear to have joined the procession coming from a different side

road. The figures in the procession are tiny compared to the turreted Jerusalem and the two knights on horseback riding towards them from the city gate. The protagonist of this scene is the bare cross that Christ holds in his arms, placed in foreshortening; the sword of the soldier at the far right points towards it and he stretches out his gloved hand almost as though he was trying to reach it. The tragedy is drawing to a close, and is marked by the definite division created by the soldier with his back to us who is violently pushing back the Virgin; she, with a desperate but dignified gesture, pulls her cloak around herself. With one hand she clasps it round her throat, with the other she barely manages to raise the lower edge. The soldier standing with his legs apart indicates yet another separation, between the city street, paved with bricks laid in a herring-bone pattern, and the naked earth, which leads only to the sacrifice; Christ has just put his foot on it, and he is preceded by the two thieves, naked and tied together in a position which reminds us of the position of Christ in the previous scene, the Flagellation. This is a visual tie between the two scenes, introduced by the repetition of the iconographical model, used as a replacement for the changing time of

26. *Crucifixion*
Assisi, Lower Church

27. *Crucifixion,*
detail of two knights to the left of Christ
Assisi, Lower Church

28. Crucifixion,
detail of the two
portrayals of Longinus
Assisi, Lower Church

day Pietro had used as a connecting element in the earlier stories, because by now both episodes take place in full daylight.

And so we come to the huge Crucifixion, on the lefthand wall of the transept. Pietro Lorenzetti has made use of the topographical layout of Mount Calvary, making the crowds and the knights on horseback arrive gradually at the foot of the crosses, so as to preserve the individuality of each character: "Here, the multitude has a face," as Cesare Brandi so rightly points out. The heads of the people furthest away from the onlooker, instead of simply forming a dark hedge, hidden behind those in the foreground, are spread out in a fan-like pattern against the horizon, arranged in groups and in a variety of gestures and poses, and yet related to each other by the exchange of looks full of expression—a variation on the theme of visual communication Lorenzetti had invented for the Madonna and her Child. Even the horses exchange looks and, with their noses pressed close together, make their way through the thronging crowd. This emphasizes the contrast with the empty void of the sky against which the three bright crosses stand out; the gold haloes of the little angels shine like the stars of a constellation, fluttering about in the sudden nightfall that has darkened the sun, announcing

*29. Crucifixion, detail
Assisi, Lower Church*

the death of Christ. Next to the Good Thief, already immobile in the calm of death, we can see Longinus, with a halo, holding in his crossed arms the long spear with which he has just wounded Jesus in the side. The Apocrypha attributed the name Longinus to the spear-carrying soldier, perhaps confusing him with the centurion who, in the Gospel according to Mark, stood opposite Christ. This character, said to be blind in some versions of the Apocrypha, and therefore immediately cured by the blood that flowed from Christ's side (and this miracle appears in many paintings) over the years has actually been made a saint, with his own feastday (15 March), regardless of the fact that he is totally legendary: how unlikely that the Romans would have sent a blind man to inspect whether Christ was dead! Lorenzetti, as was frequently the case in paintings of the Crucifixion, has duplicated the charac-

ter of Longinus, who appears twice with a halo, as the spear-carrying soldier and as the centurion. The latter is the knight coming forward at the far left of the scene, with his hand on his breast as a sign of realization. He is riding a white horse, purposely cut off by the frame of the wall, a device intended to suggest a much larger scene, almost as though it was only the frame that prevents us from seeing it all.

On the next wall the cycle continues with the Deposition, possibly the most beautiful of all the frescoes, because of its masterly composition placing all the characters, with a strongly asymmetrical effect, into a pyramid off-centre to the left, leaving the visual field empty except for the huge, bare cross. From Nicodemus, who is prying out the nails from Christ's bleeding feet, to John, to Joseph of Arimathaea, to the Maries: it is an uninterrupted line that envelops them all,

269

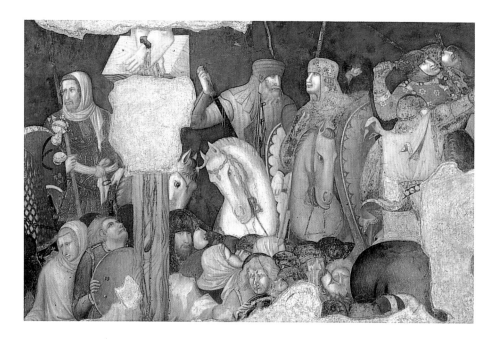

rhythmically scanned by the spreading grief that flows from one to the other. Each one, with gestures of love and devotion, supports the body of Christ, almost disjointed by the torture he has been through: it is almost as though it had been drawn out and stretched, and Lorenzetti portrays it like a group of broken profiles, with the side so twisted away from the rest of the body that it might have been painted according to the perspective rules of an Egyptian frieze. Also extremely beautiful is the expression of the Virgin, whose eyes are staring exactly into the closed eyes of her Son, while his blonde hair hangs down in a soft and flowing mass. Another splendid detail is the bloodstain on the rock, between Nicodemus's feet, which has just fallen from the cross, before Christ's body was removed; again, one of those indications of the passage of time that Pietro manages so skilfully to introduce in his frescoes. Here it marks dramatically the end of Christ's earthly life.

The peak of this tragedy lies in the Entombment: the same characters are now arranged around the tomb, and the body of the Saviour, supported by the winding-sheet which is about to envelop it, is laid out on the slab, as though it were a bed. The Virgin, stretched out alongside the body of her Son, clutches him in a desperate embrace, covering his nakedness with her cloak, as though she wanted both to protect him and to give him warmth, beyond the barriers of death. Mary Magdalene fits into the space left empty between John and Nicodemus (Lorenzetti dearly loved to fit characters into all available spaces), and as

her blonde hair lifts off her face, like two heavy curtains, we notice that her expression is one of withheld and controlled grief.

And so finally we come to the Resurrection. Once again Lorenzetti has made clever use of the triangular space created by the summit of the two arches, giving us a totally asymmetrical composition which expands the actual size of the wallspace. Christ is placed off-centre to the left, with one foot already firmly placed on the edge of the sarcophagus, while the lid falls backwards, to the right. The angels, carefully arranged one next to the other in close rows, are placed next to the wall frames, leaving the Redeemer as isolated as possible, in the uniform expanse of the blue sky, holding in his arms the banner, blowing in the wind. All around the sarcophagus, like a deck of overturned playing cards, the sleeping soldiers are portrayed in sharp foreshortenings; notice in particular the beautiful figure of the soldier to the left, lying disjointedly like an abandoned puppet, with his head hanging back, sound asleep, and with a row of white teeth visible through his half-open mouth; this figure is counterbalanced by the other soldier, at the far right, whose head is also hanging backwards. These two sleeping soldiers appear to open up the space of the fresco in a fan shape; the lefthand soldier is noble and elegant, with his handsome shoes and his hand resting on the splendid saddle, whereas the one to the right has coarse features and looks in general rather clumsy and crudely painted.

The last fresco of the cycle of stories from the Pas-

30. Crucifixion, detail
Assisi, Lower Church

31. Deposition
Assisi, Lower Church

32. Entombment
Assisi, Lower Church

sion, the Descent to Hell painted on the other side of the arch, was presumably painted to a great extent by Lorenzetti's assistants, for the scene is rather unimaginative. In any case, there is one splendid detail, placed against the barren rock: the joined hands of Christ and Adam, the first man to be saved, set in contrast to the open hand, caught in a violent gesture, of Satan, whose monster-like feet are frozen in an expression of rage at his defeat. Also beautiful is the figure of Christ, shown in profile, with an expression of gravity and intensity, as tense as a taut bow.

The Master of the St Francis stories in the nave of

this same church had already suggested the parallel to be drawn between the life of Christ and the life of St Francis, for he painted on the two walls, facing each other, the stories from the Passion and some episodes from the life of Francis. Here, Pietro Lorenzetti develops further this idea of the parallel and, after the scene of the Arrest of Christ, paints in the same transept the Stigmatization of St Francis. He has in a sense replaced one episode from the story of the Passion, the Agony in the Garden, with this scene, and it fits in in perfect harmony. We must not forget that in the first biography of Francis by Thomas of Celano, written

33. Descent to Hell
Assisi, Lower Church

shortly after the saint's death in view of his canonization (1228), the stigmatization is related to the fact that three times Francis opened his Bible, and each time it fell open at the Prologue to the Passion, which made him realize that his death would come after much pain and suffering. This interpretation is completely different from the one suggested by St Bonaventure, the only official biographer of Francis after 1266 (he even ordered that any source other than his *Legenda Maior* be destroyed). Bonaventure, in recounting the same episode as Thomas of Celano, writes that the Gospels opened in the middle of the Passion, thereby carrying the parallel between Christ and Francis to its logical conclusion, and presenting the saint as the "new Christ."

Lorenzetti has found a compromise between the two versions: on the one hand, the seraphin is no longer just an ordinary angel covered in wings and without a cross, as he had been portrayed about thirty years earlier by the Master of the St Francis stories in the same church; the wings are lowered, so that we can see Christ's wounded side through them; it is in fact Christ, nailed to the cross, who appears in the sky; his wounds like darts injure the saint in the same parts, on his hands, feet and side; only the wings, purely decorative, are still there as evidence of the earlier appearance of the angel. On the other hand, though, Francis, like Christ in the Garden of Gethsemane, is kneeling in prayer, amidst the rocks of La Verna mountain, but there are two olive trees here as well. In the Gospel according to Luke (22: 39-46) we are told that the pain that Christ felt, just imagining his future suffering, was such that it made him sweat blood (like Francis!), so much so that an angel (like the seraphin) appeared to him to give him strength. The other friar that Lorenzetti has painted is completely absorbed

in his reading and does not even notice the extraordinary apparition, for he is separated from Francis by a deep ravine; from an iconographical point of view he is analogous to the Apostles who cannot follow the Master either physically or spiritually, for they keep on falling asleep, at a distance from Christ who is totally immersed in prayer.

In the same transept, on the wall that leads to the Orsini Chapel, Lorenzetti painted Francis again, but this time as part of a devotional image: in the middle is the Madonna and Child, with Francis to her right and John the Baptist to her left. The Baptist holds a scroll with the inscription (John, 1:23): *ecce vox clamantis in deserto, parate viam Domini* (I am the voice of one crying in the wilderness, Make straight the way of the Lord). The two saints, who are portrayed, like the Madonna, in half length looking out over a balustrade, are pointing downwards towards something that the onlooker cannot see, but can well understand. Both are in fact indicating the path they have come to prepare; this is confirmed by the grave look they exchange and the stigmatized bleeding hand that Francis raises, as the equivalent of the Baptist's scroll. Francis, too, spent all his life preaching the coming of Christ and his sacrifice, to the extent that he suffered the same pains; and it is to him that the Virgin turns her eyes, while holding in her arms her Son, still a child.

Below the huge Crucifixion we talked of earlier we see Francis again, looking out over the balustrade of a fake altar together with the Madonna and Child and St John the Evangelist, this time in an open space, with no frames or decorations. Mary, looking at the Christ Child, makes the usual Lorenzetti gesture of indicating with her thumb backwards, in the direction of St Francis, who raises his stigmatized hand to his

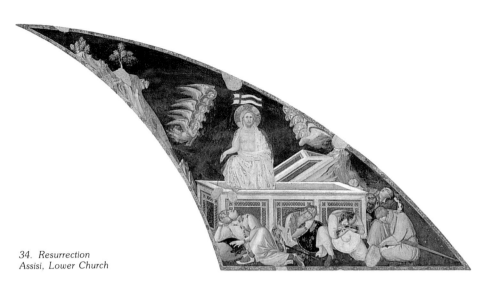

34. Resurrection
Assisi, Lower Church

breast to show that he accepts the calling. On the other side John, with the book of his Gospel in his hand, makes a gesture of assent. Here, too, the two saints gaze at each other intently. Of the two, Francis is definitely the privileged one: the stigmata are equated to the Scriptures and the true evangelical message is entrusted not to the sacred texts but to the real imitation of Christ, who appears, crucified and alone, im-

mediately underneath the Virgin. Perhaps Francis's right hand (now lost) indicated the devout painting below, which has also been lost; this is suggested by the presence on the other side of the fresco of a man kneeling devoutly in prayer, perhaps the person who commissioned the work. Lorenzetti has thus created a very strong relationship between the two Crucifixions: the first, monumental, takes place in a past that is very

35. Stigmatization of
St Francis
Assisi, Lower Church

remote, while the second is brought closer to the age of the onlooker and made more relevant and meaningful precisely because of the presence of Francis, the living symbol of Christ's sacrifice and the man who dedicated his entire life to making the memory of that sacrifice relive in the hearts of men.

We cannot end our study of Lorenzetti's work at Assisi without at least mentioning the strange image that is painted on the end wall, below Saints Rufino, Catherine of Alexandria, Clare and Margaret, at the foot of the wall: it is a *trompe l'oeil* bench, empty, placed against the wall, with a soft fur spread over it. But this is not the only *trompe l'oeil*, for in the lower part of the fake altar from which Francis, the Madonna and Child, and John the Evangelist appear to be looking out, there is a little painted niche containing a book and a mass-cruet. The *trompe l'oeil* is below a real wall cupboard, which must have contained the objects that have been painted in below. Since the bench is painted on the wall adjacent, it seems likely that the niche, the pew and the fake altar were probably intended to be seen as a fake chapel. A 19th-century photograph makes it easier to understand Lorenzetti's intentions, for it shows a real altar right next to the painted altar, giving a more concrete impression of a chapel: we must bear in mind that the Orsini Chapel is in the end wall of this side of the transept. Lorenzetti thus multiplies his spaces, suggesting the idea of another chapel, consecrated presumably to the devout figure or figures portrayed in the fake altar: an extraordinary invention, that no artist was able to match for a long time thereafter.

Around 1336-37 Pietro moved to Siena where, together with his brother, he painted a cycle of frescoes in the Chapter Hall of the monastery of San

36. Madonna and Child with St Francis and St John the Baptist Assisi, Lower Church

37. Madonna and Child with St Francis and St John the Evangelist Assisi, Lower Church

38. The Empty Bench Assisi, Lower Church

Francesco (Ambrogio also painted a cycle in the cloister, but it has been destroyed). The date of these frescoes has been established thanks to the recent discovery by Max Seidel of two painted coats-of-arms above the door leading from the cloister to the Petroni Chapel (later called Martinozzi); they are dated 1336 and are part of the cycle designed by the two brothers. The fact that the cycle is to be considered a unit is proved by the same ornamental frieze which recurs throughout. Of the work done by Pietro the scenes that have survived are a Crucifixion detached from the wall in 1857 and placed in one of the church's chapels, which is very similar to the Crucifixion in Assisi, and a splendid Resurrection, at present on loan to the Pinacoteca in Siena. In this painting Pietro has organized the composition in a completely different way, dividing the onlookers into two groups according to their degree of sainthood. Thus, at the left, we have the group of the Holy Women crowding around the Virgin who is about to faint and the desperate John; while to the right is the crowd of Romans and Jews, and two figures among them, standing near the cross, have hexagonal haloes: the centurion and Longinus, with the same doubling of the character of Longinus

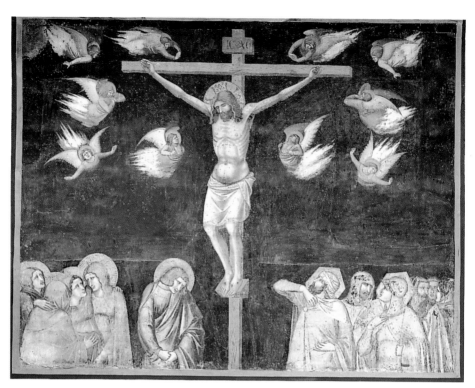

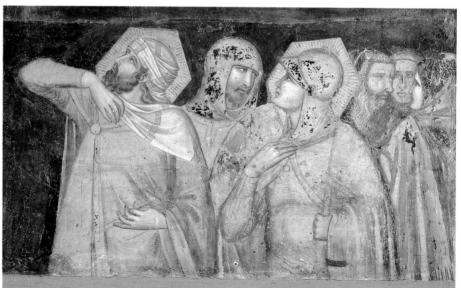

39. Crucifixion
Siena, San Francesco

40. Crucifixion,
detail of the centurion and Longinus
Siena, San Francesco

41. Resurrection of the Saviour
Siena, Pinacoteca Nazionale

that Pietro had already carried out in Assisi. The hexagonal halo, the same halo that we freqently find above the heads of the Virtues, indicates the goodness of the character, but it is one degree lower on the scale of sainthood (haloes with rays are the attributes of the blessed, normal round ones are those of saints). In other words, Pietro portrays these men as being miraculously converted, but not sanctified yet. The splendid gesture of the man bringing his hand to his breast implies the sudden recognition that the crucified man is Christ.

The other fragment from this cycle of frescoes illustrates, as we said earlier, the Resurrection of the Saviour. The innovation here, as Enzo Carli pointed out, is that Christ is seen in front of the empty tomb. Lorenzetti spent a great deal of time in the study of classical statues, as can readily be seen from this standing figure, with his powerful bare chest, dressed like an ancient Roman, with his winding-sheet worn like a toga. But notice also the elegant flowing of the folds, clearly influenced by the work of Duccio, and "the pure profile, almost like a painting on a vase, which descends from the neck down to the right hand holding the slim rod of the flag."

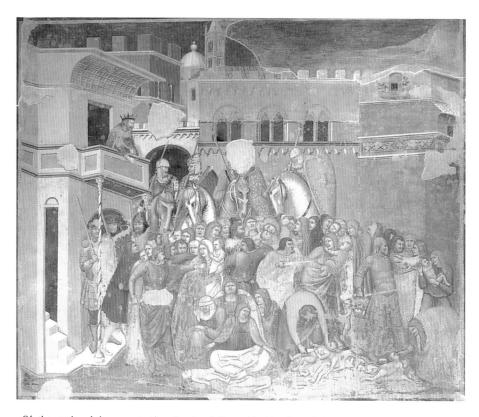

Of the cycle of frescoes in the church of San
Clemente ai Servi in Siena, only the Slaughter of the
Innocents, in the second chapel to the right of the
choir, can be said to be the work of Pietro. In it we find
the same dramatic force as in the Assisi frescoes:
the desperate mothers, for example, are reminiscent of
the grieving Mary Magdalene in Assisi, or the group of
knights exchanging glances from atop their restless
horses.

After this nothing more is known of Pietro Lorenzet-
ti: he was probably killed in the terrible plague of
1348, like his brother Ambrogio, who however has
left us an anguished testament.

42. Slaughter of the Innocents
Siena, San Clemente ai Servi

43-45. Stories from the Life of the
Blessed Humilitas
cm. 128 x 185
Florence, Uffizi

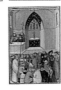

Ambrogio Lorenzetti: Biographical Notes

We have very little information concerning the life of Ambrogio, as is the case with his brother Pietro: his date of birth is unknown, although he was presumably born in the 1290s, since his Madonna from Vico L'Abate, the first dated painting that documents the artist's activity, was painted in 1319. We then find his name mentioned in the occasional document, in some payment registers; only two other paintings of his are dated, the Presentation in the Temple (1342) and the Annunciation (1344). Shortly before dying, however, he drew up a testament: this was found recently. It was written by him personally, on 9 June 1348, and in it he tries to arrange for the disposal of his property, foreseeing that very soon he will die, along with his wife and three daughters, the entire family killed by the Black Death of 1348. And that is obviously what happened, since the Company of the Virgin Mary, to whom he had left all his belongings in case none of the family survived, in 1348 and 1349 is recorded as selling some of his properties.

In order correctly to assess the greatness of Lorenzetti, we must bear in mind that unfortunately some vast cycles of frescoes have been lost. It was on these works that Ghiberti, for example, founded his enthusiasm: "A most noble composer," is Ghiberti's judgment of his work in the cycle he frescoed in the cloister of the church of San Francesco and in the Chapter Hall of that monastery, as well as in the frescoes of stories from the life of St Catherine in the Chapter Hall of the church of Sant'Agostino, both in Siena. Only a few fragments of these two cycles survive today. And nothing survives of the paintings on the facade of the Hospital of Santa Maria della Scala in Siena. It is interesting to note that Ghiberti only spends one line of comment on the frescoes painted in the Palazzo Pubblico in Siena (which, today, are responsible almost entirely for Ambrogio's celebrity), while he gives us an analytical description of all those

works which have not come down to us; yet another reason to regret our enormous loss and to admire his great talent, which can be appreciated despite these important losses.

Unlike his brother Pietro, who was influenced by Duccio and by Giotto, Ambrogio was inspired more by Byzantine painting and by classical Roman art in forming his own extremely personal and highly original pictorial language, through which he expressed the qualities of his speculative mind and his great intellectual curiosity. As George Rowley so correctly points out, Ambrogio tackled a series of problems that we are normally accustomed to think of as belonging to a later period, to the Renaissance: the problems of perspective and of the realistic and not conventional rendering of situations, studies of the nude, attention to the artistic language of classical antiquity, awareness and sensitivity to weather and seasons in his subjects, effort to grasp individual and characteristic features in the faces and gestures of figures. And Ghiberti, in fact, called him "a most unique master . . . a man of great genius. He was a most noble draughtsman, he was expert in the theories of that art" and, going against the opinion of those who thought that Simone Martini was a greater artist, he concluded "to me Ambrogio Lorenzetti seemed much better and far more learned than any of the others." It is easy to understand how Ghiberti, who had just completed his Doors of Paradise for the Florence Baptistry, was primarily interested in problems of composition within a narrative cycle; but it is precisely the other qualities that he praises in Ambrogio, those of a man of great culture and intellectual originality, that allow us to picture him also as an active creator or co-originator of the elaborate painting cycles, and not just the man who carried out compositions conceived by others. A painter, in other words, in whom intellectual qualities were equal to artistic talent.

The Madonnas

It was only in 1922 that Giovanni De Nicola discovered the earliest dated painting (1319) by Ambrogio Lorenzetti, formerly in the church of Sant'Angelo at Vico L'Abate near Florence, and now in the Cestello Archiepiscopal Museum in Florence.

This Madonna and Child immediately strikes one because of its unusual composition and appearance, so much so that some scholars have even suggested that perhaps Ambrogio was following his client's orders in imitating images from much earlier periods. This Madonna, portrayed in a rigidly frontal pose, is modelled on the Byzantine idea of the Virgin as the Throne of God; according to this model, however, the Child should be placed in front of the Madonna, also in a frontal position, and the Virgin should be barely touching him with her fingers. Lorenzetti, though, has softened this sense of detachment, and has placed the Child firmly in his mother's arms; and the Child is shown as a lively baby (notice his restless foot) looking at his mother with love and trust. In this painting we can already see one of the characteristic features of Ambrogio's work: his ability to convey the monumentality of the figures without making use of chiaroscuro, which carves the shapes, but rather using large patches of compact colour, delimited by a particularly sharp outline, which here stands out in the geometrical divisions of the throne. The overturned perspective of the throne, Carli points out, "appears to push the image forward and to impose it, with forceful grandeur, on the onlooker."

The peaceful mood expressed by Ambrogio's figures is noticeable also in the three paintings originally in the church of the former convent of Santa Petronilla in Siena (originally it was the church of the Umiliati), which are now in the Siena Pinacoteca where they have been recomposed into a triptych. Their provenance justifies the scroll held by the Child: *beati pauperes*, blessed be ye poor: for yours is the kingdom of God (Luke, 6:20). The Child lovingly has one arm around his mother's neck, while the Virgin holds her face next to the Child's, gazing at him with an intense and penetrating look. It is this look of Mary's, fully aware and in sorrow for she already knows of the Saviour's Passion and the grief that awaits them both, that is the entirely new and original feature of Ambrogio's paintings of the subject of the Madonna and Child; and he devotes a great deal of attention to this expression. The two saints at the sides, Mary Magdalene to the left and St Dorothea to the right, participate in this moment of deep intimacy with their calm gestures. In the Middle Ages there was a great deal of confusion between several different female characters and they were frequently blended into one person: one is the nameless woman sinner who spread ointment over Christ's feet in the house of the Pharisee and was pardoned precisely because of her great love

46. Madonna and Child (of Vico L'Abate)
cm. 148 x 78
Florence, Museo Arcivescovile del Cestello

for Christ, whose feet she had washed with her tears, and kissed and dried with her hair (Luke, 7: 36-46); another is Mary Magdalene, possessed by the evil spirits and healed by Christ (Luke, 8:2), who was the first to see him after the Resurrection (Mark, 16:9); and lastly, Mary of Bethany, the sister of Martha and Lazarus, who foresees the imminent death of Christ and pours a precious ointment on his head during the feast in Bethany (Matthew, 26: 6-13). Lorenzetti, too, blends together these different characters: Mary Magdalene holds in her hand a precious ointment pot and, because of her beauty and red dress, she is probably the blonde sinner Christ saw in the house of the Pharisee; but on her breast we see the bleeding face of the crucified Christ, which is the dramatic forebod-

ing that Martha's sister had in Bethany, although it is placed on the heart, to symbolize, once again, the great love shown by the sinner. On the other side, St Dorothea, with her lap full of flowers, offers a bunch of flowers while looking at the Christ Child in a serious and intense way: this is a reference to the culminating moment of her story, when while she is being led off to her martyrdom she meets the unbelieving Theophilus, who asks her to send him flowers and fruit from the gardens of Paradise. The saint then concentrates in prayer and just before she is decapitated a child (the Christ Child) appears to her, bearing a basket of flowers and fruit which will succeed in converting Theophilus. In the triptych both the saints continue with the sorrowful meditations of the Virgin (on the halo we can read the words of the angel, *Ave Maria, gratia plena*, a reference to the Virgin's humble submission); Mary Magdalene shows the Man of Sorrows on her heart and the pot of ointment, in memory of the one she took to the already empty sepulchre; Dorothea, on the other hand, who is looking straight at Jesus, is showing him the bunch of flowers, the symbol of her martyrdom and of the gardens of Paradise where the Saviour is waiting for her. Christ's earthly life is recounted in the splendid predella containing the Lamentation over the Dead Christ.

This expression of total awareness is conveyed even more movingly in the embrace of Mother and Child in the painting that comes from the church of San Loren-

zo at Serre di Rapolano (near Siena); it was probably part of a triptych and is now on exhibit in the Siena Pinacoteca. The Virgin holds the Child to her in a protective gesture and lowers her head so that she can touch his cheek with her own: her melancholy gaze is lost in space. The Child's arm is wrapped around her and grabs her veil from behind: his expression, too, is one of astonishment and bewilderment. In his hand he holds a robin, considered in the Middle Ages an omen of death because of its blood-red plumage. In the Maestà in the church of Sant'Agostino in Siena (which we shall deal with later) Jesus actually appears to be frightened and draws back from the little animal that the Virgin is offering him.

In the Madonna del Latte, too, now in the Archbishop's Palace in Siena (formerly in the Seminary of Lecceto), which is possibly one of Ambrogio's most popular paintings, motherly love is expressed as suffused with melancholy.

The Madonna is almost forcefully holding the Child in her arms for he is rather older than in the previous paintings, and he is heavy and restlessly kicking about, with an extremely realistic movement, pressing his foot against his mother's arm, who is forced to spread her fingers and hold on to him with strength to stop him from slipping away. Unlike the traditional early 14th-century altarpieces, here Mary is not placed in the centre: she has been moved slightly to the left so that the Child can be seen to be the true protagonist.

47. *Madonna and Child with Mary Magdalene and St Dorothea*
cm. 90 x 53 (central panel)
cm. 88 x 39 (side panels)
Siena, Pinacoteca Nazionale

48. *Madonna and Child*
cm. 85 x 57
Milan, Pinacoteca di Brera

49. *Madonna del Latte*
cm. 90 x 48
Siena, Palazzo Arcivescovile

In this painting, too, the words of the angel of the Annunciation are inscribed on the Virgin's halo; her lowered and sorrowful face shows that she is aware of holding in her arms the Divine Son, contemplated through the Passion that awaits him. The Child is suckling with infantile greed, with his hands pressed against his mother's breast in a very realistic gesture; but his eyes are turned towards the onlooker and this detail is enough to convey a deeply devotional meaning, for it is as though the Christ Child had stopped suckling in order to listen to the prayers of the onlookers. This group achieves an extraordinary degree of monumentality, obtained by making the Virgin's body continue outside the frame (a purple ribbon also painted by Ambrogio) which, as Rowley suggests, seems to project the Madonna and Child in an illusionistic way towards the spectator. This is a totally original invention of Lorenzetti's, who thus gave a new interpretation to the old subject of the nursing Mother from the Byzantine tradition.

Since we have so few certain historical data, several other splendid Madonnas were in the past attributed to Ambrogio Lorenzetti and then later re-attributed to other artists. We shall therefore only deal with those paintings that scholars agree upon at present.

From the youthful (?) Madonna in the Brera in Milan, where the tightly swaddled Child succeeds in ex-

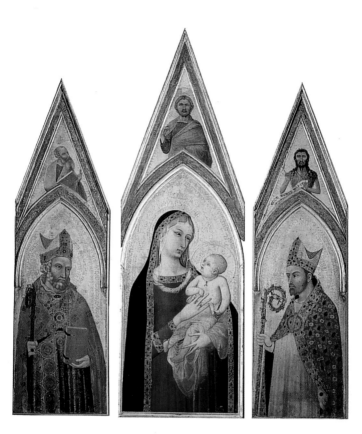

pressing his vitality by the movement of his feet and his hand outstretched towards his mother, Lorenzetti began to study the subject of motherly love, seen as protecting the tiny defenceless Child; this theme is continued in the Madonna, dating from about 1332, formerly in the Berenson Collection at Villa I Tatti in Settignano (near Florence). In this painting, the Virgin looks at the Child with an intense and anxious expression; Jesus holds the forefinger of her graceful and elegant hand as reassurance. This Madonna, together with the paintings of St Nicholas and St Proculus from the Bandini Museum in Fiesole, has now been reconstituted as a triptych in the Uffizi in Florence. Similar in many ways to this Madonna, is a Madonna and Child that is part of an altarpiece contained in a lavish 16th-century frame in the Museum in Asciano, where the Child is holding on to his mother's veil, not her finger. In the central panel we see an Archangel Michael full of movement, killing a dragon, and this figure can be used as an example of the incredible disparity of opinions between art historians: according to Rowley, this Archangel dates from the mid-15th century because of the marked Late Gothic style of the lines

50. Madonna and Child with St Nicholas and St Proculus
cm. 166 x 57 (central panel)
cm. 147 x 43; cm. 145 x 42 (side panels)
Florence, Uffizi

and the drawing, whereas in Carli's opinion it is "one of the most extraordinary creations of Trecento painting and, despite the hand of some assistant, it bears the unmistakable mark of Ambrogio."

284

The Maestà Paintings

In 1944 a very complex Maestà was discovered in the Piccolomini Chapel in the church of Sant'Agostino in Siena; it is the only surviving fresco of the cycle described with such admiration by Ghiberti. The subject of the frescoes was the exaltation of St Catherine of Alexandria, and more specifically of her dramatic meeting with the Emperor and her disputation with the pagan philosophers; these two scenes were separated by a Crucifixion. There is no scene of St Catherine's martyrdom, but in the Maestà she is portrayed in the act of offering her head on a gold plate, and this is iconographically very unusual. Ghiberti praised Ambrogio's remarkable ability to make crowds move, showing them as they progress naturally through buildings or in the open.

St Catherine's meeting with the Emperor has been lost, but we can get an idea of the compositional innovations from the fresco on the same subject that Andrea da Bologna painted in the Lower Church at Assisi, for he undoubtedly used Ambrogio's painting as his model. The scene is entirely portrayed from an angle, and there are large wooden pews used as elements of separation and communication at the same time: "It is as though there was a celebration that day in the temple (there are musicians and dancers), and there are great crowds both inside and out."

A recent study by Max Seidel has connected this cycle of frescoes in a very convincing way to the subjects of the Augustinian historiography of the time and to the problems being debated by the Order of Augustinian Hermits; and in 1338 the Order had held a meeting of its Chapter to discuss precisely these questions, in what is now the Piccolomini Chapel. We can therefore safely say that the frescoes were painted around this time, probably immediately after the Chapter meeting. Seidel also explains the presence of St Catherine and the logical coherence of the iconographical plan. Her story is to be related to the Crucifixion of Christ, because her disputation with the Emperor was on the subject of the *misterium crucis*, or mystery of the cross; Catherine attempted to convince the pagan philosophers, with learned quotations from the Scriptures, of the truthfulness of Christ's Passion. This connection is repeated in the Maestà which we are about to look at; here, the martyred saint offers her own severed head to the Child, who draws back in terror from the little robin that his mother is showing him. In the centre of the painting there is the Virgin, whose melancholy expression is turned towards the spectator. The throne, and this is a truly daring innovation, consists in the spread wings of the seraphim, indicating that the Madonna is no longer on earth. A group of saints, each with his own attribute, is addressing the Virgin; but four of them are saints who appear very rarely in paintings and some of the others are difficult to identify with certainty, so that we cannot offer an acceptable overall explanation.

Seidel's recent study, which has certainly increased our understanding of this complex work, unfortunately only deals with some sections of the painting, not mentioning others.

To the left we see St Agatha offering her amputated breasts and St Catherine with her severed head; behind them is St Augustine carrying three books and St Bartholomew with the knife used to flay his skin. To the right, a female saint whose identity is uncertain and St Apollonia, wielding an enormous pair of pliers with a tooth in it, a symbol of the torture she was subjected to (all her teeth were torn out). Behind, a very old monk and the Archangel Michael.

In his analysis of St Catherine, Seidel quotes a passage from her *Passio*, when the saint declares that it is her intention "to offer my flesh and my blood, as Christ offered himself for me in sacrifice to God the Father." This justifies, in my opinion, the presence of those saints with the gruesome attributes of their horrific tortures (Agatha, Apollonia, Bartholomew). Catherine also wears a ring, a symbol of her mystic marriage to Christ, which she recounts in her *Passio*: "I was wedded to Christ with an indissoluble tie, to him, my glory, my love, my sweetness, my beloved." And it is this detail, which stresses the love that is the foundation for Catherine's faith, that is paralleled perfectly in the attribute carried by the saint placed symmetrically on the other side of the throne: she bears, in fact, a vessel from which emerges a pulsating and fiery little cherub. I do not think that this is St Clare as Rowley suggests; Clare stopped the Saracens with a monstrance, and in the polyptych by Giovanni di Paolo in the Siena Pinacoteca she holds a vessel with a cherub in her hand, but she is portrayed, as usual, in a nun's habit, while here she has a lavish red dress, with a wide red cloak covering her head, through which we can see her elegantly coiffed blonde hair; and furthermore the transparent veil around her chin clearly indicates that she is not a virgin. Nor do I agree with Seidel, who attempts to relate the light cast by the seraphim to the etymology of the name of St Lucy, because this would not explain the vessel and also because Lucy, too, is a virgin saint. I am of the opinion that she is to be identified as Mary Magdalene, bearing in mind, as we said earlier, that in the Middle Ages several different stories of different women were all attributed to this one saint. The blonde hair, the red dress and the wimple all fit perfectly with the iconography of Mary Magdalene, a sinner redeemed by her love for Christ. This love is symbolized by the gesture of pressing her hand to her breast and by the pulsating seraphim, also a symbol of deep love; the vessel of ointment is a reference to the precious ointments with which she anointed Christ, for she predicted his imminent death and was overcome by love for him. In the polyptych now in the Siena Pinacoteca, which we spoke of earlier, Mary Magdalene, also blonde, dressed

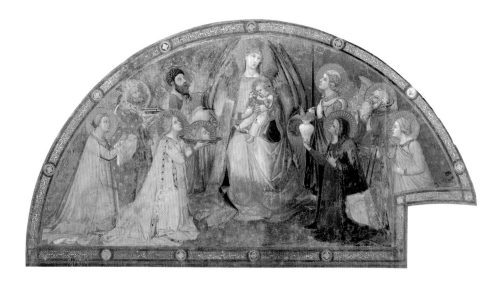

in red and bearing an ointment jar, has the face of Christ covered in blood painted on her breast within a shining halo, again a reference to this same combination of love and prediction of the Passion. And furthermore, among the saints of a dismembered polyptych now in the Siena Museo dell'Opera del Duomo, Ambrogio has included St Francis with the stigmata: above his chest wound there is a fiery seraphin, which almost appears to suggest that the wound was actually caused by Francis's great love, for he meditated on Christ's Passion (or rather, as Thomas of Celano says in his *First Legend*, on the passage that deals with Christ's future Passion). Mary Magdalene, therefore, like St Catherine, recalls the great love that binds them to Christ, experienced in different ways, either through wisdom or emotional impetus, in the sufferings of the imminent Passion. St Augustine, the saint to whom the church is consecrated, also holds an unusual attribute and his garments are not those in which he is normally portrayed, for he is dressed like a bishop (and even has a mitre) but underneath is wearing the black habit of the Hermits. Quite rightly Seidel points out that this fresco is the earliest evidence of a new historical conscience of the Hermits of St Augustine, who consider Augustine himself the founder of their Order, in contrast and disagreement with other Orders, who also follow the Augustinian Rule but consider him merely a leader *ex devotione* and not *ex institutione*. The three books that Augustine is carrying in this painting refer to an issue that was debated at the meeting of the Chapter General in 1338: that Augustine had written a Rule for the Hermits and the Canonicals, and two further ones solely for the Augustinian Hermits. The old bearded monk, on the other side of the throne, according to Seidel's theory is either St Anthony Abbot, considered one of the *primarii funda-*

tores of the Order together with Paul, or William of Malavalle, a hermit who lived a very austere life and died in 1157. In my opinion, however, this attribute is equally justifiable for St Anthony Abbot, who lived in the desert. For St Anthony seems to me to fit in better with the propagandistic intentions of the painting, all the more so since Henry of Friemar, in the treatise that deals with the origins and the development of the Hermit monks and with their real title, in 1334 had established that Augustine's work had been carried on by Anthony, "the primary founder of the Order," using the metaphor of the root whose virtue naturally produces luxuriant branches.

The presence of St Catherine, who was also praised at the meeting of the Chapter in 1338 by Jordan of Saxony for having succeeded in harmonizing human and divine knowledge, is totally in line with the decision made at that meeting to devote greater energies to scholarship; the monastery and church of Sant'Agostino since 1315 had housed a *Studium Generale* and a large library, which expanded very rapidly as we learn from the catalogue of its contents drawn up in 1360. The unusual representation of the Creed on the ceiling of this room is a confirmation of the new desire to pursue learning and knowledge that the Order had so clearly expressed. What is still unexplained, at present, is why the Archangel Michael (allusion to St Galgano?) was placed among the other saints; Seidel's explanation, that he is portrayed because this image was carved on a reliquary belonging to this church, is certainly not a sufficient answer.

Equally mysterious, at least in some respects, is the complex Maestà painted in the Monte Siepi Chapel, a few hundred yards from the Abbey of San Galgano, in the countryside near Siena. Thanks to a document that was discovered recently by Alison Luchs, we

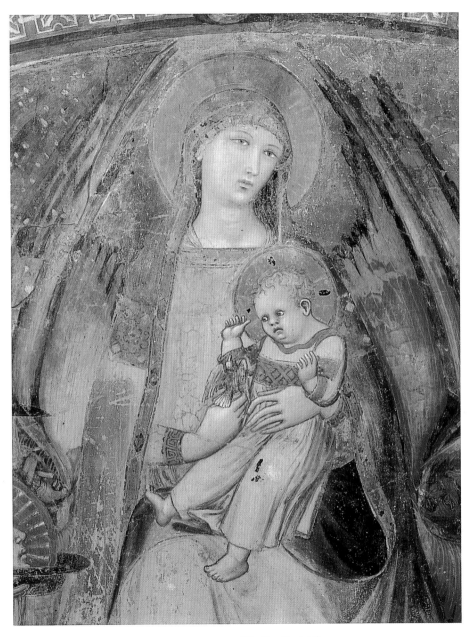

51. *Maestà*
Siena, Sant'Agostino

52. *Maestà, detail*
Siena, Sant'Agostino

know that Lorenzetti was in Monte Siepi in 1334, and this information was confirmed by the lost inscription (which we know of because it was recorded in 1645) in the chapel: "This painting and the chapel were commissioned by Ristoro da Selvatella, 1336." The walls of the chapel are covered with frescoes in extremely bad condition illustrating the life of St Galgano. Even the lunette containing the Lorenzetti Maestà has suffered alterations and been painted over in parts; the Annunciation below it was entirely repainted. During the 1966 restoration work, the sinopias under the frescoes were brought to light, and they allow us to admire at least the compositional innovations of Lorenzetti's work. In the Maestà the Madonna with the Child is placed on a throne with steps, which rests on a platform with more steps leading up to it; alongside the steps there is a group of saints. At the Virgin's feet, in striking contrast, there is the stretched out figure of Eve, wearing a white dress (her pose recalls the later figure of Peace in the Palazzo Pubblico frescoes), with a goatskin over her shoulders, a figtree branch in one hand and a scroll in the other, unfortunately both very clumsily retouched during attempts at restoration. The text, as it appears at present, is: FEI PECCHATO P(ER) CHE PASSIO/NE SOFERSE XNO CHE QUES/TA REHA SORTE NEL VENTRE / A MOSTRA REDENTIONE which, interpreting the abbreviations in use at that time, is probably to read as FEI PECCHATO P(ER) CHE PASSIO/NE SOFERSE CRISTO CHE QUES/TA REINA PORTO' NEL VENTRE / A NOSTRA REDENTIONE (I committed

the sin for which Christ, whom this queen bore in her womb, sufferred the Passion for our Salvation).

The title of queen attributed to the Virgin is probably a reference to the original version of the fresco which, as we learnt from the restorations, showed the Madonna wearing a crown and bearing in her gloved hands a sceptre in the left, and the orb in the right instead of the Child. This extremely unusual, and rather daring, iconography was eliminated shortly after the completion of the fresco and replaced with what we see at present, a much more traditional form. The only other time that Lorenzetti was this daring was in the Maestà (which, unfortunately, is all but destroyed) that he painted in the Siena Palazzo Pubblico, where the Madonna, seated on the throne, holds the Child in her right hand and an orb in her left; but the orb is black and white, the colours of the city of Siena, and the Christ Child is directly blessing it with one hand, while in the other he holds a scroll inscribed with a verse from John (13:34): *scribe mandatum novum do vobis ut diligatis invicem* (A new commandment I give unto you, That ye love one another). According to the medieval chronicler Agnolo di Tura, who dates this fresco at 1340, at the feet of the Virgin Lorenzetti had painted the Cardinal Virtues, arranged so as to form a sort of predella, rather like the Theological Virtues that form an ideal predella of the Massa Marittima Maestà. The Siena Madonna was painted after the frescoes of the Good Government, in which the Commune (or the Common Good) is portrayed seated on his throne and assisted in his work by all seven Virtues, and also after the "Cosmography" mentioned by Ghiberti, the *mappamondus volubilis* (or revolving globe) which Lorenzetti painted for the Main Hall of the same Palazzo Pubblico, to this day still called Sala del Mappamondo (in which, however, according to Sigismondo Tizio the artist had illustrated all Siena's territorial possessions). It is therefore quite understandable that a painting of the Virgin holding an orb which was in fact a representation of Siena was tolerated in this Palazzo Pubblico; the orb is presented not as a majestic attribute of the Madonna, but rather as a symbol of the protection she granted to the city (it is basically after the battle of Montaperti that the Virgin becomes the patron of Siena); it is also blessed by the Christ Child.

In Monte Siepi, on the other hand, the Madonna was portrayed as a queen, bearing the symbols of an entirely human power (and one usually held by males), and without the Child although it is the extraordinary nature of her motherhood that is normally taken as the main aspect of her sanctity. We can therefore easily understand why this innovation did not meet with the client's approval. On the same wall, Lorenzetti had attempted another iconographical innovation, painting the Virgin Mary as being disconcerted by the arrival of the Angel and by his announcement to her; she reaches out for a column and holds on to it, as though she needed steadying. All of this is visible in the sinopia, whereas the fresco on the wall now simply shows an Annunciation according to

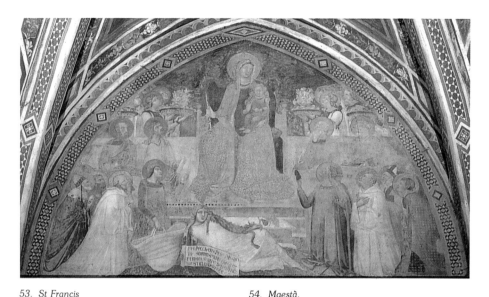

53. *St Francis*
cm. 110 x 44
Siena, Museo dell'Opera del Duomo

54. *Maestà,*
San Galgano, Monte Siepi Chapel

the usual model, with the Madonna, her arms humbly crossed, accepting the Angel's message.

Let us return to the Maestà and the unusual figure of the blonde Eve. The goatskin covering her shoulders (we know it is goat because of the little cleft hoof that hangs across the figure's stomach, and which has always been interpreted as a snake, in fact *the* snake) has a twofold meaning: on the one hand, it is a reminder that Eve only gave birth after having sinned, after having felt shame and the need to cover her body, and this is echoed also by the figtree branch Eve bears in her hand. (*Eva in paradiso virgo fuit: post pelliceas tunicas iniptio sumpsit nuptiarum. . . virginitatem esse naturae, nuptias post delictum* in the words of St Jerome: All the while she was in Paradise, Eve remained a virgin; her marriage took place after she began to cover herself with animal skins. . . Virginity is a natural state, marriage is a consequence of sin). On the other hand, the reason why the animal skin is a goatskin, is that in the Middle Ages the goat was the traditional symbol of lust.

At the sides of the throne, to the left and the right of Eve, there are two female figures of a very unusual appearance; one carries an enormous straw basket from which she pulls out a bunch of fruit and flowers, while the other has a flaming crown on her blonde hair and is offering a heart. In order to understand their meaning we must make a short detour, and briefly look at the treatise by Robert Freyan on the changing idea and representation of Charity in the 13th and 14th centuries. Already in the writings of St Augustine

this Virtue had a twofold nature, since she was both *amor Dei* and *amor proximi* (the love of God and the love of one's neighbour). Precisely because Charity had this human aspect, she was soon combined with the portrayal of Mercy. And as such we see her coming to the aid of the six poor people who are hungry, thirsty, naked, imprisoned, travellers or sick, in the representations of the Acts of Mercy on the Hildesheim baptismal font of the 12th century (the burial of the dead, as the seventh act of mercy, was only added to the others in the 13th century). In one of his sermons, Innocent III interprets the transformation of water into wine at the wedding at Cana as the transformation of the Virtue of Mercy into the Virtue of Charity. As a result Charity gains the attributes of the cornucopia, or horn of plenty, full of fruit and flowers and a child whom she feeds (a misunderstanding of the naked man she clothes). From this point of view she is above all Charity-Mercy, love of one's neighbour. But Charity is also *incendium amoris* (the fire of love) which, according to St Bonaventure's expression pushes man towards God. This spiritual love is extraordinarily close to human love, and actually, according to the penetrating observation made by St Bernard, "there shall never be charity without desire, for we are men born of the flesh." It therefore becomes understandable how the iconography of profane love, seen as a flame that sets the heart alight (just to quote Ovid), interfered in the formation of the iconography of Charity as *amor Dei*. In a song attributed to St Francis, one verse reads: *Amor di caritate / perché m'hai si ferito?*

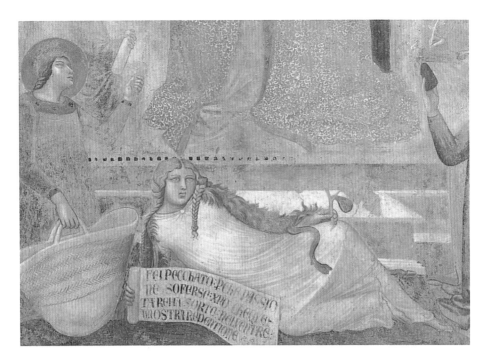

Io tutt'ho partito / et arde per amore (Love of Charity, why have you wounded me thus? My heart is all broken and it burns with love). In the pulpit of Siena Cathedral Nicola Pisano portrays Charity with a horn of plenty which ends in the shape of a goat's head, with a huge flame coming out of it: a symbol, according to the ideas of St Bernard, of the passage from earthly to spiritual love, to the love of God. In the figure of Charity in the Scrovegni Chapel in Padua, Giotto has illustrated the various aspects of this Virtue, for he shows her in her merciful role as she offers fruit and flowers standing on a pile of open bales of wheat, and in her aspect of more spiritual love, as *amor Dei*, offering a heart; and, in fact, Baldwin of Ford in his treatise *De dilectione Dei* writes, "if truly you shall offer your heart unto God, by giving it to God you shall make it your own."

If we now return to our fresco in Monte Siepi, it will be clear that the women are to be interpreted as the two aspects of Charity, *amor proximi* to the left and *amor Dei* to the right. (We must also bear in mind that Tino da Camaino had sculpted a Charity with a flaming crown for the church of San Lorenzo in Naples, but with the addition of two putti.) If we think back for a minute to the fresco as it was originally conceived, that is when the Virgin was still shown as queen, we realize that Eve with her figtree branch and her scroll, the Madonna and the two figures of Charity, with two angels above them bearing two large baskets of fruit

and flowers, can be interpreted as the visualization of a prayer, the *Salve Regina*, which was written in the 12th century. The Virgin, whose help is invoked as an intermediary between God and men, is called the *Mater Misericordiae* (Mother of Mercy): the prayer begs her to turn her merciful eyes towards mankind, towards the exiled children of Eve and to show *fructum ventris tui* (the fruit of your womb).

The figure of Eve, stretched out so languidly, is a reference to the dawn of humanity, marked by sin symbolized by the fruit of the evil tree, the figtree, which she is showing (after the first sin, mankind uses figleaves to cover its nakedness, but the figtree is also the tree that was cursed by Christ, and the tree from which Judas hanged himself, at least according to a traditional legend). The New Eve is the Virgin, and the fruit of her womb is blessed (the pun on the words *Eva* and *Ave*, the first word pronounced by the Angel of the Annunciation, was common at the time). The scroll in Eve's hand also refers to the Virgin as queen, bearing Christ in her womb; this allows us to understand why Mary is portrayed without the Child, as a queen with the orb in her hand, the equivalent of the vale of tears mentioned in the prayer.

The fresco below is a further development of the subject of the scroll Eve is holding: it shows the Annunciation, that is the moment of the Incarnation. Precisely because she is *Advocata Nostra* and *Mater Misericordiae*, the Virgin can be portrayed with both

55. *Maestà*,
detail of Eve holding the scroll
San Galgano, Monte Siepi Chapel

56. *Sinopia of the Annunciation*
San Galgano, Monte Siepi Chapel

aspects of Charity at her feet. But we might also attempt a more circular reading, seeing Eve and the two female figures as the gradual transition of love from carnal lust to love that is sublimated in the love of God, as St Bernard believed; and Bernard may well be one of the two Cistercian monks, probably the one to the right, the one that the figure of Charity with the fiery crown is pointing towards. This would also be justified by the fact that it was St Bernard, in his commentary to the Song of Songs, who first proposed the anagramme Ave/Eva and who used the metaphor of the Virgin's womb flowering like the rod from Jesse's tree, and who, in a sermon on the Annunciation, spoke of Charity, Mercy and Peace as the "Advocates" of the human race.

This unusual Maestà has been included in the story of St Galgano because it was at the top of the hill of Monte Siepi, guided by Archangel Michael, "that he had his second vision of the Son of God and of the Queen of the Angels: the mother of God surrounded by the twelve Apostles, seated on a large and majestic throne." Ambrogio and his client chose to portray only Peter, Paul and the two Johns (this choice lends credibility also to another document, the testament of Vanni, or Giovanni, di Messer Toso dei Salimbeni, dated 1340, who wanted a chapel to be built near the Abbey of San Galgano and for it to be decorated with frescoes). The other eight Apostles described in the vision have been replaced by a pope (possibly Lucius III, the pope who canonized St Galgano), two Cistercian monks and other monks: for all of them identifications have been proposed with local saints and blessed, but there is no certainty for any one of them. It is in any case clear that Ambrogio did not hesitate to give St Galgano's vision a mood of local colour; even the iconography of the Annunciation, which is based on the text of the Apocryphal Gospel called Pseudo Matthew, is drawn from a story that circulated in Siena at the time; we know of it from Niccolò da Poggibonsi, among others, from his diary of a journey to the Holy Land in 1346, in which he wrote that "at Nazareth one can still see Our Lady's chamber: in it there is the column that Holy Mary embraced, out of fear, when the Angel announced his message. . . above the column there is a large window, through which the Angel entered for the Annunciation." In Monte Siepi, the scene of the Annunciation is divided into two by a real window, the one that lights the chapel; once again we can but admire Ambrogio's ability to make use of the surroundings, incorporating them with great naturalness into the narrative.

The Massa Marittima Maestà

Around the same period (it is usually dated at about 1335), Lorenzetti painted a large Maestà in Massa Marittima, mentioned by Ghiberti. The painting, divided into five separate sections, was discovered in 1867 in the monastery of Sant'Agostino in that town, stored away in an attic; it was transferred to the Town Hall, where it still hangs today. (The Theological Virtues seated at the foot of the throne are very strongly reminiscent of some of the personifications in the Good Government frescoes, and may therefore indicate a later date for this painting).

The composition of this Maestà is truly monumental: the Virgin sits on a throne atop three steps, each one painted the same colour as the Theological Virtue seated on it. The name of the Virtue also inscribed on the step: on the lower one is *Fides* (Faith), dressed in white, looking into a mirror where she sees the figures of the Trinity (the dove has almost entirely disappeared); on the second we find the green *Spes* (Hope), with a crown and lilies; on the third, *Caritas* with her fiery costume, bearing in her hands a heart and an arrow. Six musician angels carrying thuribles kneel at the foot of the throne, around which are crowded another four angels, two of whom uphold the Virgin's cushion and form the cusps of the throne with their wings (just like in the Maestà of Sant'Agostino), and two are casting flowers over the Madonna and Child. The rest of the composition is taken up by a numerous crowd of patriarchs, prophets and saints, among whom we can make out St Cerbone with his geese, the patron saint of the city of Massa Marittima. The multitude of haloes is so crowded that it is difficult even to distinguish the faces: a device borrowed from

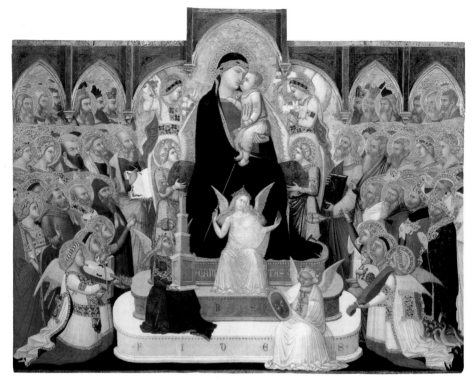

Byzantine iconography to indicate a multitude of witnesses. The scene takes place somewhere which is both earthly and heavenly. The musician angels, in their various functions, suggest Paradise: the idea is rather reminiscent of Dante's vision of Beatrice, dressed in the three colours of the Theological Virtues, when she appears to him in Canto XXX of Purgatory, "through cloud on cloud of flowers Flung from angelic hands and falling down Over the car and all around in showers." Whereas the all too human embrace of the Virgin bending her face close to her Child's, almost as though she were about to kiss him, is entirely earthly. Her expression is unforgettable, an expression of sweet sorrow, while the Child clings to her, seeking protection, that protection which the mother will not be able to offer against the future suffering of the Passion. The three Theological Virtues mark the transition from earth to heaven; according to Petrus Cantor's definition, Faith lays the foundations of the spiritual edifice, Hope builds it and Charity crowns it.

In this part of the painting, too, where there is a preponderance of theological interpretation and of allegorical elements, Ambrogio does not forget human reality: and Charity is portrayed in a transparent gown of classical style (unlike the other two Virtues who are dressed in medieval costumes), and carries an arrow

57. Maestà
cm. 155 x 206
Massa Marittima, Palazzo Comunale

58. The "Little" Maestà
cm. 50 x 34
Siena, Pinacoteca Nazionale

in her hand as well as a heart: both the nudity and the arrow are an allusion to Venus, to the earthly aspect of love. Undoubtedly Ambrogio's intention is to portray Charity according to St Bernard's interpretation, which connects Charity to Lust, even though the attribute of the heart is a reference to the love of God; as Gilbert of Hoyland writes, "The power of Charity is great and violent, and reaches all the way to the love of God, penetrates it and, like an arrow, pierces his heart. . . God Himself has encountered the wound of violent love." Ambrogio succeeds in combining, with great mastery, the ideas of adoration, of doctrinal meditation and of strong emotional feelings, in order to offer the spectator a painting in which the devotion of the faithful might move through the illustration of concepts and symbols to reach the sphere of the most intense and profound emotions.

292

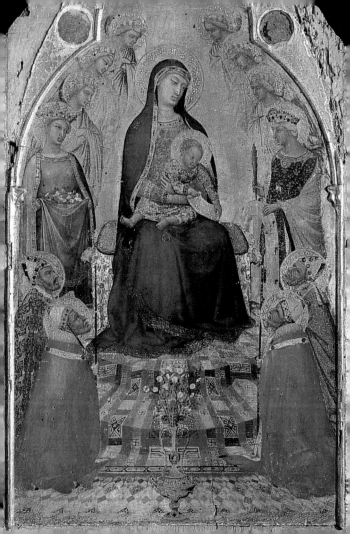

Around 1340 Ambrogio painted another, smaller Maestà, now in the Siena Pinacoteca. It was probably part of a triptych, the side panels of which Gordon Moran and Charles Seymour have identified as the two fragments showing St Nicholas of Bari giving alms (in the Louvre) and St Martin and the poor man (now in Yale University Art Museum, New Haven). These two saints also appear in the central part of the triptych. Also from the document discovered by the two scholars, we learn that the work was originally painted for the Hospital of Santa Maria della Scala in Siena, who presumably commissioned it to begin with, as can be inferred also from the choice of stories of charitable behaviour. In the central part we see the Madonna enthroned surrounded by angels, with St Dorothea offering flowers, St Catherine with the spiked wheel on which she was tortured and a palm frond (the symbol of martyrdom), and two bishops, Martin and Nicholas, as well as two popes which can be identified thanks to a partially missing inscription on their stoles as Clement and Gregory. Once again, the Virgin has the same sad and sorrowful expression as in the Massa Marittima Maestà: crossing her arms, she clutches to her breast the Child who is, on the contrary, turning in a rather carefree and lively way to the right, displaying the scroll on which is written *Fiat v(oluntas tua)* between two red lines that are rather reminiscent of a ladder. . . probably not by chance for the painting is in the hospital "della Scala." It was with these words

that the Virgin accepted humbly the Angel's message, and they are to be considered an invitation to the sick, or to those who in any case have been sorely tried by life, who prayed in front of this little altar, to accept with the same humility the sorrows assigned to them by God. Another suggestion of Charity, in its twofold meaning of *amor Dei* and *amor proximi*, is in the figures of the two female saints, for Dorothea is given the attribute of flowers and can therefore be interpreted as merciful Charity, and Catherine bears the wheel of her martyrdom, the symbol of her love for God, for whom she did not hesitate to sacrifice her life. The same meaning can be attributed to the other pair of saints, frequently to be found in Ambrogio's work, St Dorothea and Mary Magdalene (in the polyptych in this same Pinacoteca, where Mary Magdalene bears the object of her love on her breast, and in the Sant'Agostino Maestà, all the more so since the two figures of Charity in the Maestà in Monte Siepi are portrayed according to an iconography which makes them very similar to these two saints).

This small painting has been quite rightly praised by scholars and considered a true masterpiece, for its splendid colours and chromatic combinations, for its masterful composition and the original use of perspective, as well as for its overall sense of dramatic pathos, all in just these few centimetres: it is, as Paolo Torriti has pointed out, like a shining jewel.

The Stories of St Nicholas at the Uffizi

The four small paintings with stories from the life of St Nicholas, which were originally probably placed at the sides of a large painting of the saint, come from the church of San Procolo in Florence; these four panels are now at the Uffizi, like the triptych from the same church we mentioned earlier. Once again, Ambrogio illustrates the subject of Charity, one of the recurrent themes of his work, which he will continue to use, as we shall see, in the frescoes of the Martyrdom of the Franciscan Monks in Siena, an example of total self-sacrifice; even the subject of the Madonna del Latte, which owes its popularity at this period to Ambrogio's painting, is conceived as an illustration of this Virtue, for we must not forget that one of the representations of Charity shows her feeding two infants at her breasts.

In these four panels Lorenzetti principally concen-

trates on the problem of organizing within such a small space scenes with a very complex narrative structure, and he also studies space and perspective representation, resorting to daring superimposition of different planes and depths. Let us begin with the Ordainment of St Nicholas, which Lorenzetti places in a three-aisled church, with the altar situated in a raised crossing and the apse surmounted by a dome. The protagonists of the scene not only move amongst the pillars of the nave in a very natural way, but they even go down some steps around the back of the altar, thereby suggesting a spatial depth that goes well beyond what has actually been painted.

In the scene of the Resurrection of the Little Boy, Lorenzetti deals with the same problems of spatial organization, as well as the more specifically narrative ones. The story begins on the upper level, where the

59. Stories of St Nicholas: Ordainment
cm. 92 x 49
Florence, Uffizi

60. Stories of St Nicholas: Resurrection of the Boy
cm. 92 x 52
Florence, Uffizi

father is celebrating his saint's day with a banquet in honour of his youngest son. This is the first time, in Italian painting, that a narrative account begins at the top; by doing this the artist manages to unravel the story leading the spectator along a shell-shaped path down the steps, to the ground-floor room, where the miracle actually takes place; at the same time he makes the characters of the story move from the back of the room to the foreground, to the steps and in front of the bedroom, and then go back inside the dark interior for the bed scene. In the banquet room Ambrogio has placed two servants in strategic positions: one is leaning against the wall that divides the room from the stairway and thus draws our attention and makes us leave the room, together with the child; the other, looking out from the door at the back of the room, suggests a depth of space that goes beyond the spectator's vision. The sense of depth is further increased by the sharp foreshortening of the L-shaped table, with a perspective which is slightly overturned. Then the boy goes down the stairway, attracted by the fake pilgrim, who is portrayed again on the other side of the steps (another way of indicating a spatial depth which continues beyond one's range of vision), as he strangles the boy with his claw-like hands. The scene now moves to the right, to the bedroom, where first the dead child is mourned and then, like a film screened in slow motion, he comes back to life amidst the wonder of his family. The life-giving rays which pour forth from the mouth and the hand of St Nicholas, shown in mid-air to the left, reach the head of the boy as he lies on the bed through the open window; these rays move perpendicularly to the stairway and mark an intermediate level between the foreground, where Lorenzetti has placed the members of the fami-

ly, already aware of the miracle that has taken place, and the women in the background, still mourning the child's death. Another interesting element, and a novelty as well, is the attention given to the child, rarely taken into consideration in the Middle Ages, who here becomes the protagonist of the story; too many children died before reaching adulthood, so that they were not normally thought of as having their own identity and individuality — this is why the Christ Child was so often portrayed as a little adult. And Lorenzetti is quick to grasp the development of this new feeling of love and fondness for children: in the Good Government frescoes, amidst the animated view of the city, there are a few barely sketched children's heads.

The third episode, St Nicholas and the Poor Girls' Dowry, shows the saint, who is still a layman, intervening to solve a difficult family situation: a father, since he cannot provide a dowry for his three daughters, decides one evening that the following day he will force them into prostitution. So Nicholas throws three gold balls (and they will be his attribute thereafter) through the window; this will make it possible for the girls to be married. And, in fact, Lorenzetti, always a careful observer of reality, transforms the symbolic gold balls of traditional iconography into gold bars, undoubtedly closer to the spectator's experience.

In this painting Lorenzetti has given us a particularly Sienese scene, especially the doorway of the palace in the background with its two arches, one round and the other pointed, and a wealth of realistic details: arched windows divided into sections by little colonnettes, seats along the street. And it is these seats, shown in foreshortening one in the foreground and the other in the background, that convey the idea of the depth of

295

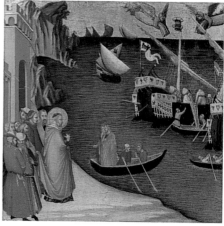

the street. Even the house where the miracle takes place is shown at a slanting angle: inside, the worn mattress is placed diagonally, the niche in the wall with the jugs further divides the space, a metal rod stands out from the wall and holds the towel, and the simple chests placed at the corners and the lantern at the edge of the inner arch are used to give more movement to the space. In this scene, too, the story continues out of doors, and the exterior has the same psychological importance as the interior. The splendid portrayal of Nicholas, standing on the tips of his toes, with his red cloak, stands out against the white wall, as he stretches up to the little window; the saint's body, a collection of foreshortenings and acute angles, is echoed in the background architecture, also portrayed from that same perspective angle; the architectural background culminates in the roof of the terrace, even though here the actual execution is not that successful.

The Miracle of the Wheat, which two angels pour from open bales in the sky down onto the boats of the poor fishermen, is the first example of a seascape in painting and marks the birth of a new genre: the landscape. Even though Lorenzetti is still a painter of his times, in the sense that the scene is not yet organized around a single vanishing point, he nevertheless succeeds in giving the water a sense of depth, thanks to the buildings and the rocks along the shore which mark the increase in distance, as well as the boats that become smaller against the vast horizon (a long line painted at the end of the green wall of water), which communicates, with its incumbent mass, a sense of limitless size. This painting is normally dated around 1332, which means at more or less the time as the San Procolo triptych; it is evidence of how Ambrogio investigates the problems of narrative composition and of perspective at the same time, with great constance and coherence.

61. Stories of St Nicholas: The Poor Girl's Dowry
cm. 92 x 49
Florence, Uffizi

62. Stories of St Nicholas: Miracle of the Wheat
cm. 96 x 52
Florence, Uffizi

63. Presentation in the Temple
cm. 257 x 168
Florence, Uffizi

The Presentation in the Temple and the Annunciation

In 1342 Ambrogio painted a Presentation in the Temple for the Chapel of San Crescenzio in Siena Cathedral; the painting is now in the Uffizi. It is one of his few dated works (1342) and, as a young American scholar, Kate Frederick, has recently demonstrated, it was part of a wider programme, which had been carefully organized from the beginning and took twenty years to complete. The four chapels placed at the corners of the crossing, where the nave and the transept of the Cathedral meet, contained, starting from the chapel to the left, the Chapel of San Savino, and moving clockwise: Pietro Lorenzetti's Birth of the Virgin, painted in 1342; Simone Martini's Annunciation, painted in 1333, in the Chapel of Sant'Ansano; Andrea di Bartolo's Birth of Christ (now lost), painted in 1351, in the Chapel of San Vittorio; and lastly, Ambrogio's Presentation, painted in 1342, the same year as his brother's altarpiece.

Here Ambrogio continues and perfects the research he had begun in the painting of the Ordainment of St Nicholas. He gives us the same perspective representation of the three-aisled church, shown at the crossing; here, however, he attempts a much more complex perspective study, with the columns of the three aisles, the view of the triumphal arch at the height of the dome with the figure of Christ supported by two angels, and at the same time the portrayal of the exterior of the building as well, crowned by the octagonal lantern. The artist is illustrating the passage from the Gospel according to Luke (2: 22-39), which in fact combines two different stories: the Presentation of Jesus in the Temple, thirty days after his birth, and the Purification of the Virgin, forty days after childbirth; Luke also adds here the prophecies of Anna and Simeon. Ambrogio decided to portray the scene at the moment when the two prophets are speaking. All the characters are motionless, fully aware of the gravity of the occasion. The sense of magic suspension is emphasized by the empty space that divides the two groups, further stressed by the presence of the priest who is about to circumcise the Child, for he is indeed at the centre of the scene, but he is placed at a distance, behind the altar, where Lorenzetti has also painted the sacrificial doves, also totally motionless. The perfect balance that Ambrogio has succeeded in creating between the speculative aspect and the emotional one is evidenced by the strongly human juxtaposition of the old Simeon, so tired and wrinkled, and the carefree gesture of the infant, sticking a finger in his mouth; a rather surprising gesture, when attributed to Christ, but which on the one hand shows the loving attention that Ambrogio devotes to the world of childhood, and on the other conveys the real humanity of this God made man.

The task of explaining the scene and the importance of the occurrence is entrusted to the prophetess Anna, who points towards the Child with her forefinger and unravels a scroll with the following inscription: *Et haec ipsa hora superveniens confitebatur Domino et loquebatur de illo omnibus qui expectabant redemptionem Israel* (And she coming in that instant gave thanks likewise unto the Lord, and spake of him to all them that looked for redemption in Jerusalem); the passage is from the Gospel according to Luke (2: 38). The theme of salvation is announced by Moses and Malachi, who are added, as "extras" as it were, on either side of the dome; Moses carries a scroll with an inscription from Leviticus (12: 8): *(Quod) si non invenerit manus eius nec potuerit offerre agnum, sumet duos turtures vel duos pullos columbarum (unum in holocaustum et alterum pro peccato)* (And if she be not able to bring a lamb, then she shall bring two turtles, or two young pigeons; the one for the burnt offering, and the other for a sin offering). Malachi holds

64. *Presentation in the Temple, detail*
Prophetess Anna
Florence, Uffizi

65. *Annunciation*
cm. 122 x 117
Siena, Pinacoteca Nazionale

another scroll, with a passage from the third chapter of his prophecies (Malachi, 3: l): *et statim veniet ad templum suum Dominator, quem vos quaeritis, et angelus testamenti, quem vos vultis* (And the Lord, whom ye seek, shall suddenly come to his temple, even the messenger of the covenant, whom ye delight in). The two biblical characters, in perfect harmony, introduce the two themes of purification and redemption.

In the case of the Annunciation, the last work signed and dated by Ambrogio before he died in the 1348 epidemic, the artist has also selected a single instant, the most profound moment, from the account of the event given in the Bible. This painting comes from the Sala del Concistoro in the Palazzo Pubblico in Siena, and is now in the Pinacoteca of the same city. Inscribed along the base of the painting is the year, 1344, and the name of the artist, Ambruogio Lorenzi, as well as the name of his clients, the Tax Magistrates of that year, among whom the Camerlengo (or chamberlain) was Francesco, "a monk from San Galgano," further evidence of the long-standing relationship between the Commune of Siena and San Galgano and Monte Siepi. Unfortunately this painting has been subjected to retouching and clumsy restoration. Scholars are not in agreement, for example, about the problem of the angel's wings (at present he has four, two folded and two open), although, in a recent article, Norman Muller maintains that the open ones are to be considered original, whereas the others were added during a later restoration, for the original ones were obviously thought to be too small. But his opinion is not agreed upon by all scholars. What is certain, though, is the demonstration, also proposed by Muller, that the angel's words, inscribed on the gold background of the painting, were originally in the future tense, and not in the present as they are now. The inscription should read: *non erit impossibile apud deum omne verbum* (For with God nothing shall be impossible, Luke, 1: 37).

In the Gospel according to Luke (1: 28-38), the narration covers five different moments: the arrival of the Angel and his greeting, which causes such wonder in Mary; the message; the explanation of how this event will take place, since Mary "knows not a man"; the moment when she accepts; and, lastly, the Angel's departure. Ambrogio has chosen to illustrate the last part of the dialogue between Mary and the Angel, but according to an iconography that is totally original. The Virgin, who still has her book open on her lap, for she was deep in meditation, folds her arms on her breast and utters the phrase that indicates her acceptance: *Ecce ancilla Domini* (Behold the handmaid of the Lord). But she does not look at the Angel: she turns her gaze towards heaven, where Christ, and not God the Father, is sending her the dove of the Holy Ghost. Ambrogio is therefore emphasizing the moment of the Incarnation, which is referred to also by the Angel's thumb pointing backwards, indicating someone who is not present. The separation between Mary and the messenger, who has concluded his mis-

sion with his final words, is stressed by the colonnette, so that the two figures, although sharing the same space, are separated for they are meditating in different ways on the same idea. And this is why the Angel's greeting, *Ave Maria, gratia plena, Dominus tecum* (Hail Mary, full of grace, the Lord be with you), has been placed on the Virgin's halo, to indicate that she is saintly; otherwise they would have implied a direct dialogue. Another unusual feature is the palmfrond that Lorenzetti places in the Angel's hand, for it is a symbol of victory in martyrdom (Dante, in *Paradise* XXXII, 112, talking of Archangel Gabriel, describes him as "he who brought the palm below to Mary"). Medieval commentators interpreted it in this way, that is that Mary took the prize over all other creatures in pleasing God, because of the humility with which she accepted her destiny.

The olive crown, resting on Gabriel's blonde hair, is the symbol of Peace and reconciliation between God and all his creatures; but, since in the Middle Ages peace could only be achieved by the defeat and annihilation of the enemy (and we shall see this better when we examine the figure of peace in the Good Government), this green crown is also a reference to Christ's definitive victory over Satan: another detail which was intended to make the spectator meditate on the mystery of Incarnation.

As is common in the work of Ambrogio, the architectural construction blends admirably with the meaning of the scene itself. Here, the moment of magical suspension, the subtle instant between the understanding of the heavenly message and the immediate consequences, is conveyed also by the deliberate ambiguity of the spatial construction. On the one hand, in fact, Lorenzetti makes the tiled floor converge with geometric precision towards a single vanishing point, whereas then this realistic perspective reconstruction is thwarted, for he makes it clash against the immaterial end wall, where the gold light suggests the abstraction of Paradise.

66. City by the Sea
cm. 22 x 32
Siena, Pinacoteca Nazionale

The Disputed Paintings: Which of the Brothers is the Author?

In the Siena Pinacoteca there are three small paintings, an Allegory of Redemption and two landscapes, a City by the Sea and a Castle on the Shores of a Lake, which have been the subject of much debate by scholars, both in terms of attribution and also as to their possible original function. We shall analyze them following the opinion that seems most likely, without any certainty of being correct. Let us start with the two landscapes.

These two famous paintings, if they had been painted as we see them now, according to Enzo Carli (whose opinion I shall follow also in other statements) would be the first example in Italy of "pure" landscapes. Various other scholars, however, see them as fragments of the revolving globe, a work that was so famous that the Council Hall it stood in was named after it. Recent technical analyses of the wood fibre, looking for traces of supports or of cuts, have led us to conclude that the paintings are substantially whole and that they were originally laid out one above the other (together with other panels now lost) and surrounded by frames. It seems most likely that they formed the doors of a cupboard "which contained documents concerning the places illustrated on the paintings." Carli has identified the city by the sea as the fortress-town of Talamone, also since the little

figure of a naked woman in the small bay to the right is sitting in an area which to this day is still called "women's bathing place." The castle on the shores of a lake, on the other hand, is a castle built at the border of the Sienese state, on Lake Chiusi or Lake Trasimene. The suggestion that the two panels were part of the globe is refuted by the fact that, since the globe was revolving, the paintings could not be placed vertically above each other. Carli quite rightly stresses that "even though their role was a purely functional one, comparable to the illustrations on the covers of the Biccherna or Gabella registers, this did not prevent Ambrogio from imbuing these two 'topographical' documents with an unmistakable sense of poetry."

Our modern artistic taste is very much taken by this illustration of a deserted city in the full sunshine, with all the roofs and streets seen from above, to which a touch of mystery is added by the bather shown from behind and the little boat, all alone sailing across the gulf. This same sense of silence is conveyed by the other empty boat, moored on the shore of the greenish lake, in the second landscape, where the barren clay hills and the spur of rock in the foreground separate and sever all communications between the woods and the other darker hills on one side and the softly swelling waves of the lake on the other.

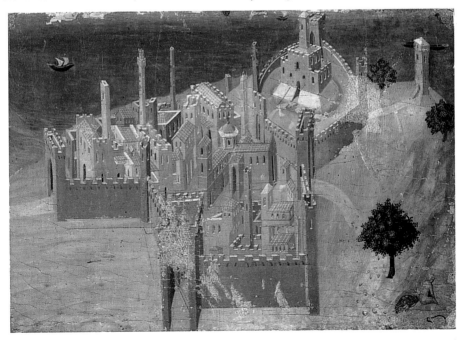

67. Castle on the
Shores of a Lake
cm. 22 x 33
Siena, Pinacoteca
Nazionale

68. Allegory of
Redemption
cm. 57 x 118
Siena, Pinacoteca
Nazionale

These two paintings are splendid examples of Ambrogio's great pictorial mastery, and we feel that we cannot accept the theory proposed by Federico Zeri, that they are about a century later and the work of Sassetta, painted between 1423 and 1426 for the altarpiece commissioned by the Arte della Lana.

Let us now look at the Allegory of Redemption, which is unfortunately in very bad condition, making our appreciation of this masterpiece more difficult. The daring conception of this painting is so extraordinary that we believe it can only be the work of Ambrogio: for he does not hesitate to place amidst the pile of corpses of the Triumph of Death the body of Christ himself, whose life was also terminated by the huge scythe that the terrifying winged skeleton, flying above the cross, is wielding. To have assigned to Death such

enormous power is the mark of an artist with a truly exceptional mental freedom, ahead of his times. Although the painting is small, the scene has an extraordinary narrative intensity (the scrolls without inscriptions may suggest that the painting was just a preparatory sketch for a fresco or for a larger work).

The narration begins in the upper lefthand section, with Adam and Eve's sin, their shame and expulsion from Earthly Paradise, chased away by the fiery angel. In front of them is Death, with bat's wings and a huge scythe, and this means that from this moment onwards spiritual death (the monstrous creature has the appearance of a demon) and physical death are part of the world: and, in fact, below we see Cain killing Abel. In the middle, the crucified Christ is shown above a pile of decomposing corpses. Little groups of

living people comment the scene; they are chosen to represent different social categories and different ways of life. Thus we have a hermit, a group of poor and derelict people, two knights hunting and some splendidly dressed ladies (gay and pleasure-seeking, unaware of the afterlife) and what are perhaps two philosophers strolling. To the right, Christ the Judge, with his feet on a rainbow, is surrounded by angels bearing the symbols of his passion with the Virgin and John in the role of intermediaries, while other angels force the souls of the damned down into Hell. In this gloomy vision of the afterlife there is no Paradise, and this and other analogies in the choice of the symbolic groups suggest that Lorenzetti studied in depth the frescoes in the Pisa Camposanto. The artist, possibly in the midst of the raging plague epidemic, conceives of Death not simply as a divine law or decree. As Alberto Tenenti so rightly says: "(Death) has become a terrifying reality, a force that does not hesitate to use its power at any moment: even against the man-God." Death conquering even Christ "is an element which no one had suggested before or since. "

For all the reasons mentioned and also because of some obvious analogies with the Good Government frescoes (the turreted city of Earthly Paradise is very much like the splendid building in the countryside just outside Siena; the figure of Death is reminiscent of Timor, while the dying Abel recalls the outstretched woman, both in Bad Government), I believe that this panel was painted in the last period of Ambrogio's life.

The Frescoes in the Church and Cloister of San Francesco in Siena

The frescoes in the cloister of San Francesco, mentioned for the last time in 1730 when they were barbarously whitewashed over, were the works by Lorenzetti that Ghiberti appreciated most and the ones on which he had based his very high opinion of the Sienese master ("it seems to me a wondrous thing for a painted story"). Ghiberti does not give us the names of the Franciscan martyrs illustrated in the frescoes, nor does he report the inscription, now lost, but which was recorded in the 16th century by Sigismondo Tizio. This inscription is decisive for the identification, for it refers to a Sienese Franciscan, Pietro; but at least two Sienese martyrs, both honoured in the church of San Francesco, bore this name. Thanks to the interpretation given by Ghiberti and his long and glowing description, Seidel has recently been able to reconstruct the programme of the eastern wall painted by Lorenzetti, and to give the fragments of frescoes that have recently been rediscovered a correct explanation. This fragment illustrates the city of Thanah in India (present-day Bombay), where on 9 April 1321 the martyrs Tommaso da Tolentino, Jacopo da Padova and Demetrio da Siena were put to death (the young Pietro was killed elsewhere). In the fragment of the fresco we can clearly make out the storm of rain and hail that followed the execution, and which had so impressed Ghiberti: "and when the said monks were beheaded, there began a storm with darkened sky, hail, lightning, thunder, earthquakes; it seems from the painting that both heaven and earth are in danger, it appears that everyone is overcome by great fear and seeks shelter; men and women covering their heads and the armed soldiers shielding their heads with their flags, and it truly appears that the hailstones are bouncing off the flags pushed by wondrous gusts of wind. You can see trees bending to the ground, and some breaking, and everyone is fleeing. . . It seems to me a wondrous thing for a painted story."

Together with his brother Pietro, Ambrogio Lorenzetti is the first medieval painter to record weather changes. Ghiberti's lengthy description of the other frescoes, where the artist had been particularly successful in his portrayal of feelings and emotions (for example, the two henchmen who are worn out after having flagellated the monks, "with matted hair, dripping sweat, panting and breathless, it is a wonder to see the master's art"), makes us realize what a terrible loss the whitewashing over of these frescoes has been. So we learn that Lorenzetti, shortly before the Good Government frescoes, had worked on a monumental composition, painting on the east wall seven scenes illustrating the journey, the disputation in front of the Sultan and lastly the execution of the four Franciscans martyrs. The frescoes continued in the Chapter Hall of the monastery, where he had painted the death of another Franciscan martyr, and his brother Pietro had painted a Crucifixion. As Seidel points out, in observance of the principle of *imitatio Christi*, in Siena and in other Franciscan monasteries the representation of the sacrifice of Christ was extended to the illustration of the martyrdom of Franciscan friars. Seidel also proves in a very convincing way that the cycle was conceived as a single work of art and all at the same time. In 1857 two scenes painted in the Chapter Hall were removed from the wall and placed in the church, where they still are today. They depict the Martyrdom of seven Franciscans in Ceuta in Morocco and St Louis being received by Boniface VIII (some very

beautiful portraits of Poor Clares are today in the National Gallery, London).

In the fresco of the Martyrdom, inside an octagonal temple we see the sultan, with his drawn sword resting on his knees and a fearful angry expression on his face; at a lower level, on a wide step, Lorenzetti has placed two groups of soldiers and court dignitaries with splendid Oriental headdresses, each one portrayed in great detail and showing a wide variety of emotions, from a rather self-contained reserve to an open expression of horror (particularly strong in the group of Tartar women). And finally, in the foreground, the actual scene of the martyrdom: the severed head of a monk, with his mouth gaping in an expression of all too human suffering, is an unforgettable detail, like the executioner, at the far right, who is putting his sword back into its sheath and whose hair is all rumpled, his face a mask of cruelty, the muscles of his arms bulging with terrifying strength. By placing the three groups on three different planes, the artist achieves an immediate sense of depth, conveyed also by the octagonal building with cross-vaults; on the pinnacles of the temple and at the intersections of the arches there are seven statuettes, showing four women and three warriors, each with attributes (animals or objects) of classical origin: in his book on Ambrogio,

Rowley has attempted to interpret these figures as Virtues, suggesting that the evil sultan and his wicked rule were opposed by the civic Virtues of a good government. This theory is very ingenious, but it would imply a very cynical idea of power in the sultan (and in Ambrogio); and, in any case, how could the Virtues be shining bright at precisely the moment when so much cruelty is being practised? The correct interpretation is the opposite one proposed by Meyer L. Shapiro, who identifies the seven figures as the seven Deadly Sins: starting from the left, the woman with the two baskets in her hooked hands, a lighted candelabra on her head and a dog is Avarice, and the source for this description is in Boethius (*De Consolatione Philosophiae* II, V, 25) when he says that the "love of possession burns more furiously than the fires of Etna." The dog, as we learn from Phaedrus's fable (I, 27), is an appropriate symbol, for he dies rather than stop guarding the treasure. The following figure is Gluttony: a woman pouring out the contents of two jars, that is wasting as long as she can satisfy her insatiable appetite (there is a play on the word *effundere* here, meaning both pouring out and exhausting, or satisfying); the bear in the Bible (Proverbs 28: 15) is the symbol of insatiable appetite. Avarice and Gluttony, to be understood also in the sense of prodigality,

form a perfect antithesis. The third woman, bearing the Gorgon's severed head and with an unsheathed dagger, a flame on her head and a wolf at her feet, is Bellona, the sister of Mars: she symbolizes Wrath, always ready to bring discord and death. The fourth woman, with a bow and arrows and being embraced by a winged Cupid, is Venus: lust, therefore, and more specifically the form of lust that leads to Sloth and to weakness, as Ovid writes in his *Remedia Amoris* (lines 135-150). Here, too, the two women form an antithesis. Between them, at the top of the pediment, there stands a warrior entirely clad in armour, with an enormous shield and a threatening arrow: this is Mars, connecting element between the two women, portrayed here, because of his ties with Venus, as Lust (see, once again, Boethius, *De Consolatione* III, 10, 1-3, for the detail of the crossing bands on the armour). The horse at his feet is the *equus luxurians* mentioned by Virgil (Eneid 11, 49). On the pediment to the left there is another warrior, a bold young man accompanied by a lion, the symbol of Pride (St Paul, I. Tim. 3: 6). This warrior is Alexander the Great, described by Seneca (*De beneficiis* V, 6, 1) as "a man swollen with a superhuman and measureless pride." Lastly, the warrior standing on the main pediment, now covered by an ornamental border, must be Envy; he was probably portrayed as blind, as Dante imagines sinners being punished for this sin (Purgatory XIII, 67), playing on the etymology of the word *invisus*; or perhaps Lorenzetti intentionally portrayed him like this, cut off in the middle by the frame? One thing is for sure, that Ambrogio arranged the Sins or Vices in a very careful hierarchical order, in distinct contrast to the Virtues of the Franciscans, and of these Franciscans in particular, about to be slaughtered. At the top he has placed Envy, for it is the opposite of Charity, the greatest Virtue of these martyrs, and also because, as the Book of Wisdom (2, 24) says, it was as a result of "the devil's envy that death was introduced to the world." Poverty, obedience, chastity and humility, the four main Virtues of the Franciscan Order, are contrasted to the Vices of Avarice and

Gluttony, Wrath, Lust and Pride.

Ghiberti, in his enthusiastic praise of Ambrogio, admires his interpretation of doctrine and his special attention to classical antiquity; and, in fact, when a statue of Venus (a Roman copy of an original by Lysippus) came to light during the excavations for the foundations of a house in Siena, Lorenzetti made a drawing of it. And these are the two aspects that are most to be admired here: the speculative aspect, his uncommon originality of inspiration, blends with an extraordinary compositional talent and a perfect rendering of the emotions depicted.

In the fresco of St Louis being received by Boniface VIII the representation of space, which had already been investigated in the previous fresco, reaches a level of considerable coherence. We need only compare

70. Martyrdom of Seven Franciscans, detail Siena, San Francesco

71. Martyrdom of Seven Franciscans, detail Siena, San Francesco

72. Louis Being
Received by
Boniface VIII
Siena, San Francesco

73. Louis Being
Received by
Boniface VIII,
detail of the high
prelates and the
laymen
Siena, San Francesco

the composition of this scene with the same subject painted by Pietro in a section of the predella of the Carmelites' Altarpiece (the Approval of the New Habit), to notice how Ambrogio is able to make crowds move in space in a much more convincing way. Ambrogio has arranged the onlookers on four

different planes. In the foreground we have the cardinals seen from behind and, symmetrically, on the opposite side, the high prelates, with Robert of Anjou among them. With a crown on his head and a weary, meditative expression, he looks at his brother in the centre, who is delivering his regal dignity in the hands of the Pope; to make the scene even more full of movement, the Pope is seated high above, on a throne placed inside a large niche. Behind the row of cardinals, we see the approaching laymen anxious to witness the ceremony: this is a splendid collection of portraits, of gestures and detailed costumes, arranged in small groups, emphasizing the different perspective views of the hall where the ceremony is taking place.

The Frescoes in the Palazzo Pubblico of Siena

A series of payments documented between 1338 and 1339 proves that this was the period in which Ambrogio Lorenzetti frescoed in a hall in the Palazzo Pubblico the scenes of Good and Bad Government and the effects of both on the city and on the countryside. The frescoes were commissioned by the Council of Nine who ruled the city of Siena at the time. These titles, which are by now universally accepted, in fact come from the interpretation and description of the famous frescoes given by Achille Lanzi in 1792; before that, as we learn from Ghiberti's *Commentaries* among others, they were simply called Peace and War.

Ambrogio made the most of the layout of the room itself, for he painted on the short wall (to one's right as one enters) the allegorical representation of Good Government, which is thus entirely bathed in the sunlight coming from the window on the opposite wall. On the adjacent wall (to the right) we see the city of Siena and the surrounding countryside, and here, too, Lorenzetti uses the natural lighting of the room. On the wall opposite (the wall facing the observer when he enters the room), we have the depiction of Bad Government and War, and of their effects on Siena (where they have already taken up residence) and on the countryside, ravaged and barren; this spectacle of atrocities and violence, where fire and death reign supreme, forces the spectator to meditate on the grave consequences of a mistaken political conduct. But this scene also makes the spectator turn towards the positive elements of this fresco cycle, which are thus presented as the only possible solution. Above and below the frescoes there are two friezes containing medallions; unfortunately over the years they have been restored and repainted several times. In the part of the cycle depicting Peace, the frieze below the frescoes showed the Liberal Arts, divided into the Trivium (Grammar, Dialectics and Rhetoric — the latter has

been lost) and the Quadrivium (Arithmetic, Geometry, Music, Astronomy, with the addition of Philosophy); the frieze above the frescoes illustrates the planets and the seasons, portrayed in the traditional order, Venus, Spring, Mercury, Summer and the Moon. The frieze below the scene of War, on the other hand, contained portrayals of the tyrants of antiquity: the only one that has survived is Nero, shown as he flings himself onto his own sword. In the frieze above are the remaining planets, Saturn, Jove and Mars, and the remaining seasons, Autumn and Winter. The distribution is such that the negative elements of planets and seasons, like the weapons of Mars or the cold weather of Winter, fall in the "negative" part of the cycle. A collection of inscriptions is provided to illustrate the various images: *Timor* and *Securitas* within the frescoes hold two large scrolls, and another scroll has been placed below the procession of the twenty-four characters in the allegorical section of the Peace scene, to emphasize the positive aspect of the well-governed city; a long inscription runs just under all the frescoes, right above the friezes, providing a continuous sort of running commentary to the images above, many of which are further explained, in the fresco itself, by other annotations.

Let us turn to the wall of the Bad Government, the wall the spectator is obliged to see before the rest. The fact that both the allegory and its effects are confined to a single wall surface creates a rather cramped depiction of reality, which is in line with the painter's intentions: to convey, at first glance, an immediate and meaningful vision of an impolitical situation. At the centre of the dais sits *Tyrannia*, with the appearance of a demon, with horns and fangs, a horrifying face that also exhibits the features attributed to Babylon, the infernal city, in Revelation (17: 3-4). For the figure of Tyranny has flowing woman's hair, a cloak with

74. *Allegory of Grammar, detail of the frieze*
Siena, Palazzo Pubblico

75. *Portrayal of Nero, detail of the frieze*
Siena, Palazzo Pubblico

gold embroidery and precious stones, a gold cup in her hand and a goat, the traditional symbol of lust, at her feet. According to Revelation, the golden cup has the same meaning, for it was "full of abominations and filthiness of her fornication." At her feet is vanquished *Iustitia*: the scales are broken and scattered around her on the ground. Around Tyranny's throne, just a little below her, are gathered the other Vices: (from the left) *Crudelitas*, a horrifying old woman shown in the act of strangling an innocent child, *Proditio* (Betrayal) holding a lamb whose tail ends with a scorpion's poisonous sting, and *Fraus* (Fraud) with bat's wings and clawed feet, demon features. And then there is *Furor*, a monster who is half man and half beast and who resembles the Minotaur described by Dante in Canto XII of the *Inferno* (11-13) and who symbolizes "*l'ira bestial*" (animal wrath); in his hand he holds a short dagger and at his feet there is a mound of stones, the instruments for sudden and recurring urban uprisings. Next is *Divisio*, another female figure bearing the colours of Siena, sawing her body in two with a large saw, a reference to the disagreements that were tearing the city apart: the words *Si* and *No* are visible on her two-coloured costume. And so we come to the last Vice, a warrior entirely clad in armour, with *Guerra* (War) written on his shield. Above Tyranny there are another three wicked female figures: *Avaritia*, again an old woman with bat's wings and claws holding a press that produces sacks full of coins; *Superbia* (Pride), waving a sword and a completely crooked yoke, for there can be no peace and no concord where the good of the individual prevails upon the good of the community; and *Vanagloria*, a woman looking at herself in the mirror. It is interesting to note how Ambrogio changes his use of language as soon as he moves from a general allegory to the more concrete reality of the city, which at the time the fresco was commissioned was overrun by famines, epidemics and continuous insurrections: in fact, the *Si* and *No* are in the language of the people and appeal to their everyday experience, and on the warrior's shield it says *Guerra* and not *Bellum*. The dagger, the stones,

the saw and the sword are clearly references to the violent contemporary events and are a sort of distorted mirror image of the necessary use of the sword and the severed head carried by *Iustitia* (one of the Virtues in the allegory of Peace), which symbolizes the inflexibility of the law as guarantor of the common good.

Inside the city surrounded by crenellated walls (another reference to the constant need for self-defence), houses are torn down and set ablaze, the streets are full of rubble, the palaces collapse, while all around hoards of soldiers commit acts of violence, killing and maiming. In this city, where loneliness reigns, no one is working; just one artisan, a blacksmith, is forging weapons. In the hilly countryside, too, the only activities are ones of death and destruction, setting fire to isolated houses and whole villages. The countryside is bare and barren, the trees bear no fruit and no one is cultivating the land. *Timor*, a horrid old hag dressed in rags, with claws instead of hands and feet, hovers about in the air, wielding a sword and a scroll with the inscription: *per volere el ben proprio in questa terra / sommesse la giustizia a Tyrannia: unde per questa via / non passa alcun senza dubbio di morte / che fuor sirobba e dentro de le porte* (to establish her own good in this land / she subjugated justice to tyranny / so that along this road / no man shall pass without risking his life / for there is stealing outside and within the gates). Fear is in fact the protagonist of this part of the fresco, for it is fear that paralyzes communal life and slams shut the huge city gates while the soldiers on horseback, on their way to wreak havoc and destruction, are still going out.

Let us now look at the allegory of Good Government and of Peace. Above, in the sky, is *Sapientia*; she holds in one hand the Scriptures and in the other huge scales that the figure of Justice, below her, is balancing. On the two scale-pans there are two angels administering justice, *comutativa* and *distributiva* as the inscriptions tell us. In fact, a later restoration is undoubtedly responsible for having exchanged the two words (we know that already in the 15th century some words of the fresco were no longer legible). To the left must be the representation of *comutativa* Justice, with the angel busy re-establishing the correct balance, rewarding one man with a symbolic crown and punishing the other, cutting off his head. On the other side of the scale, the angel is administering *distributiva* Justice, since he is offering a strongbox full of money, a spear and a staff, the symbol of public office, to two men of high rank, as we can see from their clothes. These two terms come from Thomas Aquinas's commentary of Aristotle's *Nicomachaean Ethics*. The two

SVPBIA

AVARITIA

VANAGLORIA

TYRAMIDE

...LITAS · PRODI... ...TIO · FRA... ...VS

IVSTI

...DDOL · SIE · P · SUO · MERTO · DISCACCIATE · OISERTO · IN · SILME · CON · OUALM · OUE · STA · SEGUACIE · FORTIFICM...

78-80. Effects of Bad Government in the City and in the Countryside, details
Siena, Palazzo Pubblico

concepts that this fresco most wanted to stress, as Nicolai Rubinstein so rightly suggested, were the Aristotelian concept of justice in its twofold interpretation, scholastic and juridical, and the concept, also Aristotelian, of the Common Good seen as the subordination of the good of the individual to that of the community; these concepts had also been expounded by the Dominican monk Remigio de' Girolami, who between 1302 and 1304 wrote *De bono pacis, De bono communi* and the unfinished *De iustitia*. The two angels show clearly how the rulers of Siena intend to administer justice, carefully spending public money, distributing honours and public offices, but also distributing punishments.

The gigantic figure of Justice seated on the throne is framed by the inscription *diligite iustitiam qui iudicatis terram* (love justice, you who govern the world) which is the first line of the Book of Wisdom and is also the foundation of Lorenzetti's whole allegory, because it is from the figure of *Sapientia*, who undoubtedly holds the *Liber Sapientiae* or book of Wisdom in her hand, that *Iustitia* is inspired. It is interesting here to remember Dante's complex political allegory in *Paradise* (Canto XVIII, 90-117), when in order to illustrate the concept of justice he makes this very line appear in heaven: *diligite iustitiam primai: fur verbo e nome di tutto il dipinto; qui iudicatis terram fur sezzai* (Diligite iustitiam: verb and noun, These words came first, and following afterward: Qui iudicatis terram last were shown).

Completely original is the figure of *Concordia*, just below Justice from whom she receives the ropes (or cords) of the scales, which she then delivers to the procession of twenty-four citizens moving towards the Commune of Siena. In her lap she holds a large carpenter's plane, obviously symbolizing this Virtue's abil-

ity to smooth out any discord, the opposite of the saw with which *Divisio* in the Bad Government fresco was mutilating her own body. Concord, who compared to the other Virtues is much larger, and therefore in medieval interpretations of size proportionate to importance is clearly one of the most important elements of the allegory, sits at the same level as the citizenry: another detail, together with the carpenter's plane, that indicates that she belongs to the real life of the city, for it is Concord that allows the existence of the Commune. The two cords are intended as an explanation of the name, even though the etymology is incorrect; this was a common medieval way of reaching the hidden meaning of a word. So, instead of the correct etymology of *concors* ("with the same heart"), Lorenzetti explains the word as deriving from *cum chorda* ("with a cord"), an interpretation previously proposed by Quintilian. In Cicero, the comparison between the harmony of sounds and the good accord in the city was already explicit: "that harmony which musicians display in song can be compared, as far as the city is concerned, with concord" (*De Republica*, II, 69). Another obvious play on the words concord and musical chords appears in *Paradise* (Canto XXVI, 45-51). In this fresco, right in the midst of the city bustle, there is a group of nine young girls dancing in a circle to a rhythm kept by a tenth girl playing a tambourine; this stresses once again, visually this time, the harmony and concord that reign in the city. And all the inscriptions in the painting are also references to the mu-

sical origin of the word: *laddove sta legata la Iustitia / nessun al ben comune giamay sacorda* (where Justice is fettered / no one is ever in accord with the common good), while below Tyranny the inscription reads: *per adempir la sua nequitia / nullo voler ne operar discorda / dalla natura lorda / de vitii che con lei sono qui congionti* (to satisfy her iniquity no intention nor action can discord from the foul nature of the vices that are together with her here). Another important fact that explains the presence of the two ropes or cords is that in the Middle Ages a good harmony in music was not, as it is today, made of three notes (such as C-E-G), but of two sounds, as Isidor of Seville explains in his *Etymologiarum Libri* (III, 20).

Since dancing in the streets was forbidden by law in the city of Siena, and also since the young girls are much too large in proportion to the other people portrayed in the fresco, this scene is clearly intended as a symbolic representation rather than as a real event. There are many possible interpretations: the nine Muses and a reference to the Council of Nine who ruled the city, or the concord among the citizens that reigned in Siena.

The procession of the twenty-four citizens, all dressed in rich and elegant clothes, is obviously a collection of the most influential members of Sienese society, bankers, rich merchants, learned scholars (but there is also a knight among them). It is possible that the Council of Nine, instead of having themselves portrayed, asked Lorenzetti to portray the government of

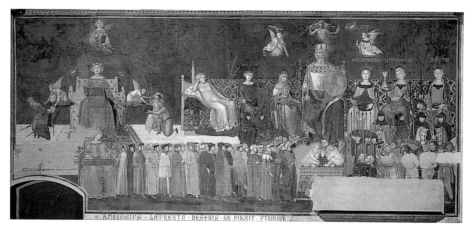

the Twenty-four, which had ruled Siena from 1236 to 1270, opposing the absolute power of the Podestà and the great families; they had formed the council which was called the "Elected Consistory" and had marked the entrance of the *populus* in the government of the Commune. In a propaganda instrument, like this fresco, a reference to the past was intended probably to provide the reassurance of tradition and history and to suggest, precisely because of the experience of the past, the existence of a greater opening to the lower classes, much more than was actually the practice of the Council of Nine, although they undoubtedly were inspired by the 13th-century example.

At the time this fresco was painted, the government of the Council of Nine had been threatened several times by conspiracies organized by the aristocracy (countered by laws prohibiting certain noble families from holding positions in the magistratures) and by revolts of the working classes. These insurrections, however, made the Council of Nine promise that they would form a council also of "good men" from the populace, to work alongside the Nine, who were primarily bankers and powerful merchants. This was dictated by the fear of rising discontent.

The procession of the twenty-four offers the rope to the imposing figure of an old man, dressed like a royal judge, with a sceptre, shield and crown. He is the Commune of Siena, and his black and white garments reflect the colours of the city. Around his head are the letters CSCV (a further C is the result of a recent restoration), meaning *Commune Senarum Civitas Virginis*. He is the "Bene Comune" in all the ambiguity of the Italian term, both the "Common Good" and the "Good of the Community", that is of all its citizens. The inscription along the border of the fresco further explains the concept: *Questa santa virtù la dove regge / induce adunita li animi molti. Equesti accio riccolti / un Ben Comun perlor signor sifanno* (This holy virtue—Justice—where she rules leads many spirits to unity. And they, gathered together, make a Common

Good for God). On the shield there is a depiction of the Madonna and Child, the protectress of Siena after the battle of Montaperti. At the feet of Good Government are the twins Senius and Ascanius and the she-wolf, symbolizing the ancient and noble Roman origins of the city. Above the head of the old man are the three Theological Virtues, Faith, Hope and Charity; the first bears a cross, the second turns her eyes towards Christ and the third, above the others, carries a heart and an arrow symbolizing not only *amor Dei et proximi* (as in the Massa Marittima altarpiece), but also *amor patriae* according to the definition of Tolomeo da Lucca: "the love of one's fatherland has its roots and foundations in charity." This Virtue is placed here in the highest position for it is the one that considers the good of the community most important. Just as Justice is an emanation of divine wisdom, in the same way its practical application in the reality of the Common Good is also connected to God, for it is inspired by the highest principles. On the same dais as the throne of the Common Good are seated the Cardinal Virtues, Fortitude, Prudence, Justice and Temperance; Lorenzetti has added Magnanimity and Peace to the traditional four.

The extremely famous figure of Peace, all dressed in white, reclines on a couch resting on a mound of weapons; she is set apart from the other Virtues, to emphasize the importance of her presence. Around her head is a garland of olive and she holds another olive branch in her hand. Her iconography is based on Roman coins depicting *Securitas*, who is also portrayed, with a little model of a hanged man in her hand, just outside the city gates, according to the classical iconography of Victory. *Securitas* and *Pax* are the two foundations of concord: in the city, security lies in the peace of its inhabitants, for there are no enemies; from the distant horizons there might be a danger of attacks, but all roads are victoriously peaceful. On the scroll held by *Securitas* it says: *Senza paura ognuuom franco camini / e lavorando semini*

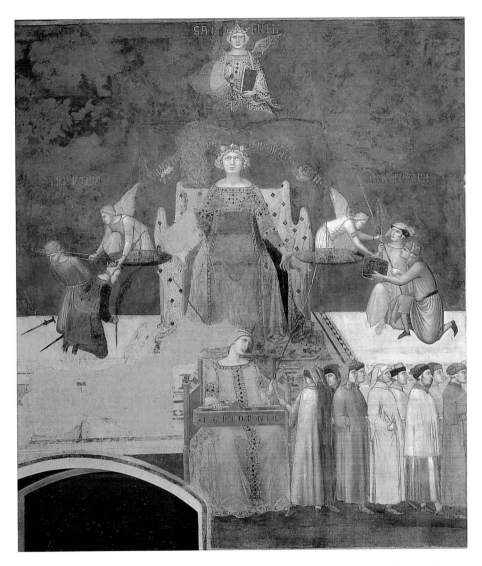

81. Allegory of Good Government
Siena, Palazzo Pubblico

82. Allegory of Good Government,
detail showing Sapientia, Iustitia and Concordia
Siena, Palazzo Pubblico

ciascuno / mentre che tal comuno / manterrà questa donna in signoria/ chel alevata a rei ogni balia (Without fear every man shall walk freely / and each, working, shall sow / while this commune / shall keep this woman [*Securitas*] in power / for she has removed all power from the wicked). Next to Peace sits Fortitude, armed with a mace and a shield, indicating firmness, the same firmness that the soldiers at her feet are doubtless ready to demonstrate. In the same way, at the feet of Justice and the others to the right of the

83. *Allegory of Good Government, detail Siena, Palazzo Pubblico*

84. *The Good Government painted on the cover of a "Biccherna" ledger Siena, States Archives*

85. *Allegory of Good Government, detail showing Peace and Fortitude Siena, Palazzo Pubblico*

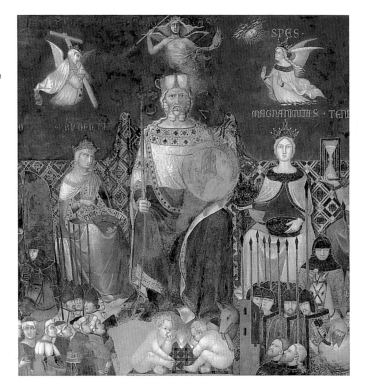

old man, there is a crowd of armed soldiers, watching over a group of prisoners. This is an armed, military peace, achieved by the defeat and conquest of the enemy, frequently only after his physical destruction. In the Middle Ages, as we said earlier, the olive branch was a symbol of peace or of a truce, but only after the defeat of the enemy (see G. Villani, *Cronica*, vol. VI, 75). Next to Peace, calmly resting but well-guarded by weapons, and Fortitude, comes Prudence, an elderly queen holding a shield with the inscription *praeterita, praesentia, futura*, a recommendation to govern with wisdom and only after having taken all things into consideration.

The next Virtue is Magnanimity, with a tray overflowing with coins, followed by Temperance with an hour-glass (from the incorrect etymology: *tempus*); this attribute replaces the traditional two ewers of water being poured from one to the other, where the etymology was obviously derived from *temperare*. Clearly, with the growing importance of urban life, time was considered more precious, since it was also seen as a source of income. The last Virtue is Justice, holding a severed head in her lap and a sword in her hand, threateningly; one of the armed soldiers on horseback watching over a group of prisoners looks up at her. To conquer one's enemies, not to be crushed

by defeat, to pardon those who surrender: these are the soldier's virtues. And, in fact, also in this part of the fresco there are two kneeling men offering up their castles, while nearby is a group of fettered peasants, obviously the symbol of a crushed revolt. On this side of the Common Good we see the Virtues of civic power, which help to govern in peace and wisdom, but always with firmness.

The city of Siena, bathed in the light of justice and

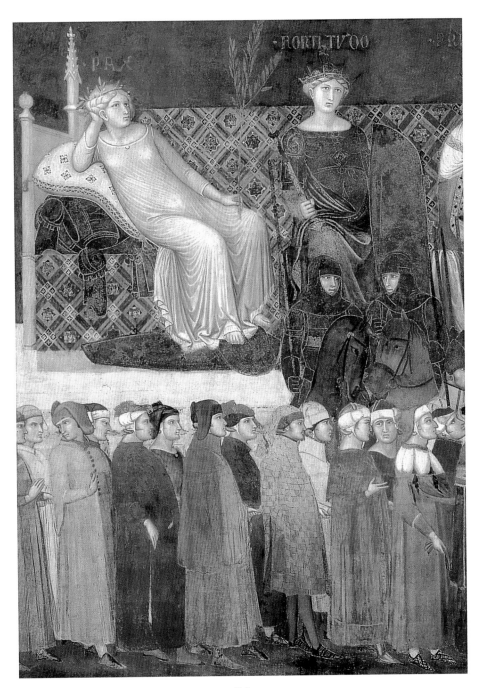

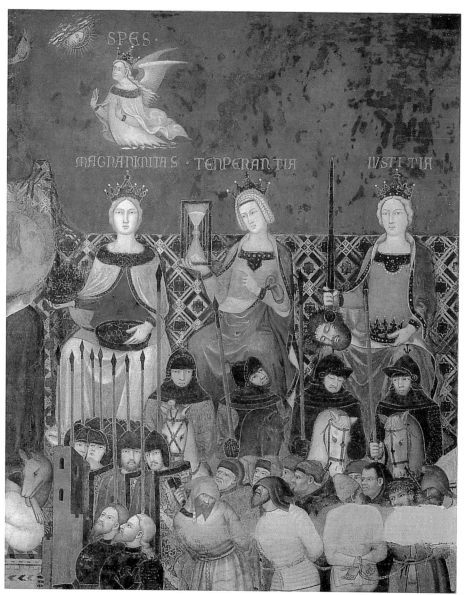

86. Allegory of Good Government,
detail showing Magnanimity, Temperance and
Justice
Siena, Palazzo Pubblico

87. Effects of Good Government in the City
Siena, Palazzo Pubblico

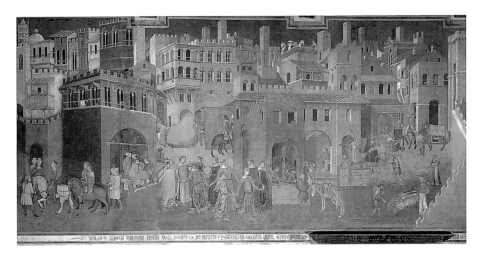

divine wisdom, appears joyful and sunny. Men go about their work with calm, almost without effort, and there is even time for happiness. To the left, in fact, we see a wedding procession, with the bride being led to the ceremony; then we see a tailor, with his back to us, sewing, and a little further away, a goldsmith's workshop, a merchant examining his ledgers, and some noblemen on horseback. To the right, in the foreground, a cobbler's workshop (there is even a little child peeking out), a teacher with his pupils, a shop selling wines and meats, where a peasant with a basket of eggs on his arm and his donkeys laden with wood is headed. A shepherd with his flock is leaving the city for the countryside, while a peasant with his mules carrying bales of wool is arriving; he is taking the wool to a nearby shop, where a group of men and women are busy weaving and examining fabrics. There are also two peasant women arriving from the country with all sorts of provisions and hens. The city walls are like an architectural stage-set, placed there to stress this constant to and froing of people and animals; the gates are open, indicating that there is no fear of enemies. Already fairly well out into the countryside there is a merry party of gentlemen on horseback, setting off on a hunting expedition, stopped for a minute by a blindman begging. A peasant, coming from the other direction, is leading a piglet to market in the city, and other peasants, alone or in groups (there is even a whole family), are moving along the roads leading to and from the city. In the city, the buildings are very beautiful, and quite recognizably Sienese, even though it is impossible to establish exactly what part of the town Lorenzetti has portrayed. Precisely because the fresco is in a sense the political manifesto of the Council of Nine, and their architectural achievements were what they were proudest of, the view of the city is to be seen as a realistic, but not a real, depiction, clearly identifiable as Siena. On the

rooftops there are masons at work, and there is even a woman among them. In this exaltation of manual labour, practical activities and crafts (formalized in the Mechanical Arts), together with the Liberal Arts, Lorenzetti was emphasizing a new social reality: in the city all professions are mutually "useful and necessary," as long as no one attempts to change his status, setting in motion dangerous revolts. The social order is imposed by God and as such it must be respected. Therefore, although the fresco is a manifesto of political propaganda, the empty orbs of the blindman can co-exist with the gentleman's entertainment, and the hunting party's horses sweeping across the wheat fields and vineyards of the beautiful Sienese countryside can be tolerated by the peasants hard at work tilling the fields.

It has been pointed out that this depiction of the countryside is not realistic, for Lorenzetti has shown the produce of both winter and summer, and peasants are sowing, ploughing and harvesting wheat while the vineyards are still green. But the artist has scattered peasants at work throughout his vast landscape with the subject of the Months of the Year in mind, and he has included even the storing of wood for the winter, and of meat (the piglet being led to the city); and he has not forgotten olive oil, with the lovely olive tree just outside the city walls. He has also painted wide expanses of golden wheat fields, a rather reassuring answer to the revolts that were so frequently breaking out in the early 14th century because of food shortages. Amidst the hills and through the plains, everywhere there are rivers and streams, occasionally opening up into small lakes; in the distance the dark patch of the sea, with the harbour of Talamone, Siena's commercial port. All these sources of water are part of the propaganda message of the fresco as well, for we know that Siena was constantly searching for new water supply sources. These elements taken from real-

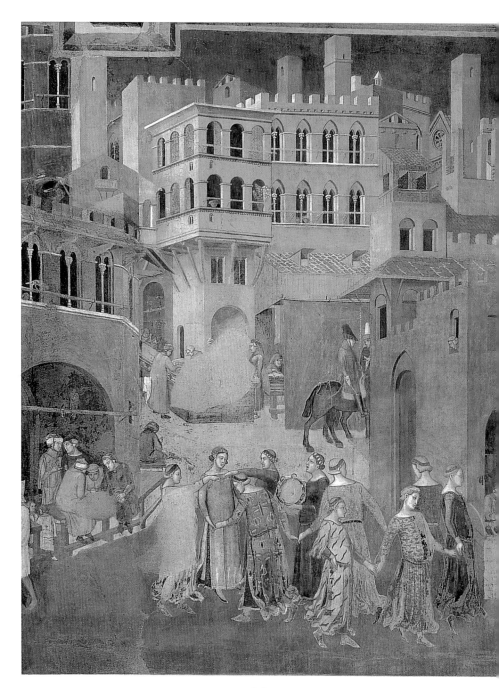

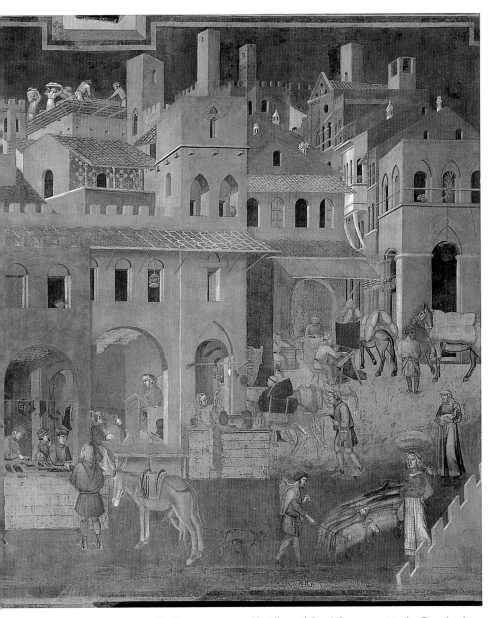

88. *Effects of Good Government in the City,*
detail of the group of nine young girls
Siena, Palazzo Pubblico

89. *Effects of Good Government in the City, detail*
Siena, Palazzo Pubblico

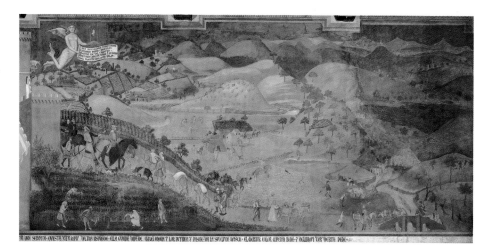

ity, in some cases quite a distant reality, but all gathered together in this fresco give us an imaginary landscape which, in the mosaic-like juxtaposition of concrete details, is unmistakably the Sienese countryside. The roads that divide the countryside into regular patterns are also based on reality, for they are wide, just as the magistrates in charge of road construction and maintenance ordered them to be. The road that leads to the city is actually paved with flagstones and bordered by a low stone wall. A lovely brick three-span bridge (and not a temporary construction in wood), with an impressive caravan crossing it, stands in the foreground, and there are several other bridges in the background. The donkeys are laden with bales of wool bearing the same mark as those already being unloaded at the weaver's workshop. Documents of the period stress the fact that roads had to be in good condition in all weather, even in winter, therefore not interrupted by mud or landslides; and also safe from brigands and enemies. The pride of these fully efficient roads that purvey riches, always kept in perfect condition and free from dangers, is emphasized by the words and the attribute of *Securitas*: *senza paura ognuuom franco camini* (without fear every man shall walk freely). On the contrary, *Timor* proclaims: *per questa via non passa alcun senza dubbio di morte / che fuor si robba e dentro de le porte* (along this road no man shall pass without risking his life, for there is stealing outside and within the gates). The nobles, the merchants and the bankers all have large properties in the countryside, and they represent, in the eyes of the contemporary observer, just like the splendid palaces in the city, the symbol of extraordinary economic wealth. It is not by chance that in the countryside near Siena the only buildings we see are scattered houses next to vegetable gardens, huts, and other construc-

tions with no defence structures at all, whereas castles, fortifications and towers are all placed very far away, in the background or along the edges of the hills, indicating a need for defence that the settlements near the city do not have: the peace and security that reigns within the walls is extended to the immediate surroundings.

The interest that Ambrogio shows in the depiction of Siena's daily life, his rediscovery of landscape and nature in its most varied aspects, is something totally new, which breaks away from a consolidated tradition; and the painters of the generation immediately following his were quick to notice the fact.

In this part of the painting as well the subject is didactic and political, but placed in the observer's natural environment. We can say that it is the daily practicalities of city life, the interest for all things that concern man, that is responsible for this innovation in Ambrogio's allegorical language. It is in this light that we must also see the extremely large part of the painting devoted to the countryside and peasant activities, which in earlier paintings had been restricted almost exclusively to illustrations of Adam's curse in the Bible. With the development of the city, of a differentiated and specialized kind of manual labour, the values change, and each form of activity is judged according to its usefulness to society; so, even the peasant is seen as contributing to economic progress. And, in any case, the constantly growing population of the city needs more and more food from the country. The realistic portrayal of nature and of the life in the city and its inhabitants, with the simple language of familiar scenes, contributes to making the whole even more convincing, as though this was a faithful depiction of reality, the reality that probably only existed in the political propaganda of the Council of Nine.

90-92. *Effects of Good Government in the Countryside, details*
Siena, Palazzo Pubblico

93. *Effects of Good Government in the City, detail*
Siena, Palazzo Pubblico

322

VOLGIETE GLIOCCHI ARMIRAR COSTEI VOCHE REGGIETE CHE QVI FIG

MASACCIO

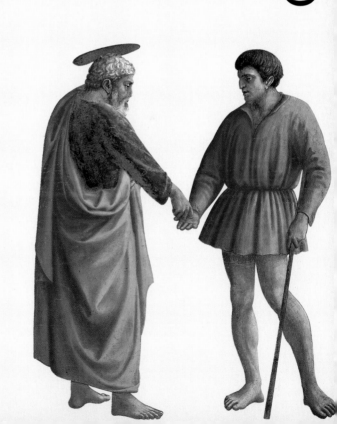

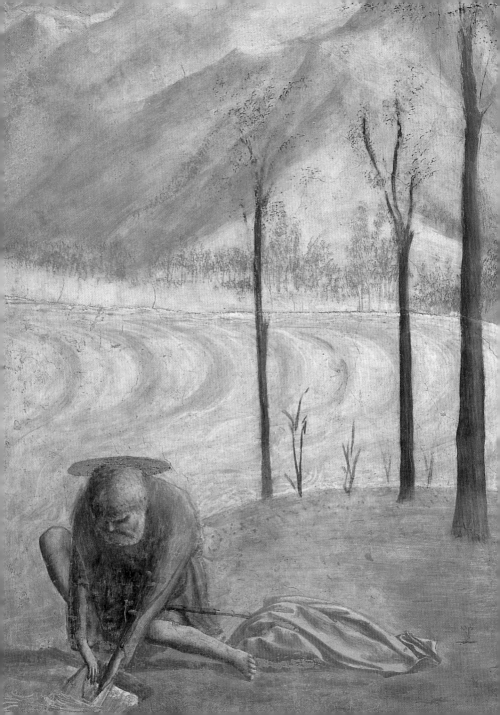

1. *Adoration of the Magi, detail*
Berlin-Dahlem, Gemäldegalerie

"...He was a very absent-minded and careless person, like one who has concentrated all his heart and will on art alone, and thinks little of himself or others. And he did not wish to concern himself with worldly matters, not even dress, and did not make a practice of recovering money from his debtors, except when in great need, instead of Thomas (which was his name), he was called Masaccio (clumsy Thomas) by everybody: not because he was a person of bad habits, being naturally good, but because of his extreme carelessness; in spite of this he was very affectionate and rendered services and favours to others, so that none could wish for more." This was written by Vasari in the Life of Masaccio.

He was born on December 21st 1401 at San Giovanni Valdarno and soon moved to Florence (1417) where he was already known as a painter in 1419.

In 1421 his brother, nicknamed Lo Scheggia, was in the modern and flourishing workshop of Bicci di Lorenzo in Florence, where Masaccio is also believed to have worked. His sister married the painter Mariotto di Cristofano, who was also from San Giovanni Valdarno but lived in Florence. Here too was Masolino, another native of the Valdarno transferred to Florence, where he was highly esteemed chiefly by the Florentine aristocracy and artistic circles: he was already back from a trip to Hungary (Procacci) where he had gone with Pippo Spano. In the Bremen *Madonna* of 1423 he is as up-to-date and refined as Gentile da Fabriano and has captured something of the best spirit of the early Ghiberti (Berti) whom he had helped with the north door of the Baptistry.

Although acting within the complicated late Gothic representation which was not in contrast with the classicist innovations, Masaccio was above all involved in the humanistic avant-garde of Brunelleschi and Donatello.

The tendency of both to exalt human value in every way and to restore dignity to the vulgar tongue is already evident in his first known painting: the *San Giovenale Triptych*, dated 23rd April 1422.

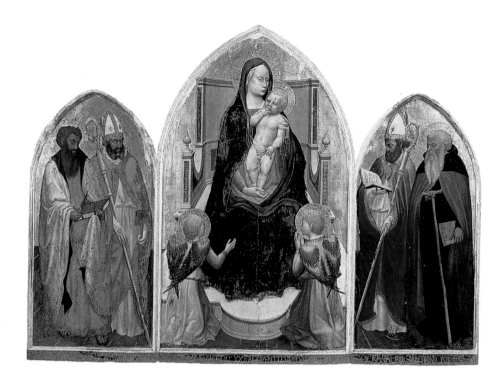

The San Giovenale Triptych

This shows the Madonna and Child enthroned in the central panel and four saints, two on each side panel. St Bartholomew and St Blaise on the left and St Ambrose and St Giovenale on the right.

In 1961 this work, which was discovered by Luciano Berti in the little church of San Giovenale, was shown at an exhibition of "Ancient Sacred Art" and attributed to Masaccio. Immediately afterwards Berti announced it to be the first original work by Masaccio because of its strong similiarities with the figures in the *Madonna and Child with St Anne* in the Uffizi, the *Madonna* of the Pisa Polyptych and the Santa Maria Maggiore Polyptych in Rome.

It is dated along the bottom with the inscription in modern humanist letters, the first in Europe not in Gothic characters: ANNO DOMINI MCCCCXXII A DI VENTITRE D'AP(PRILE). This inscription appeared during restoration begun after the exhibition of 1961: the original frame had been tampered with and the letters covered up with

another piece of frame stuck on over them.

In 1890 Guido Carocci, who attributed the triptych to the Sienese school, revealed that the three panels had been rejoined. They had been previously meddled with and separated, thereby almost totally destroying the gilt frames and carvings. After restoration the triptych was shown at the "Metodo e Scienza" exhibition in 1982, where it again drew the attention of art critics, and is now in the church of San Pietro at Cascia di Reggello (Caneva 1988).

According to recent documentary research by Ivo Becattini the work could have been commissioned by the Florentine Vanni Castellani who had the patronage of the church of San Giovenale. His monogram composed of two linked croziers with two Vs

2,3. San Giovenale Triptych
108 x 65 cm (central panel)
Reggello (Florence), church of San Pietro at Cascia

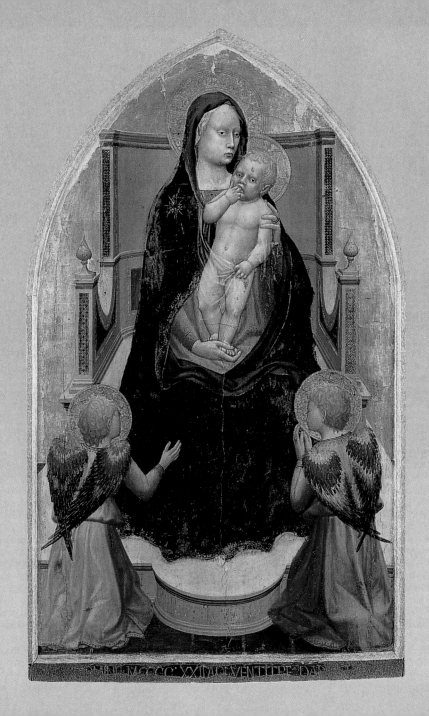

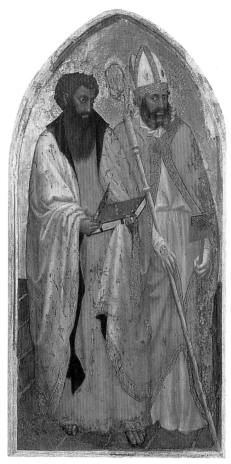
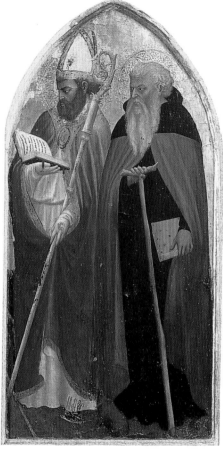

underneath is re-echoed in the painting by two saints' croziers, placed so as to form a space containing the Madonna, with the two Vs repeated in the angels' wings. In connection with this commission Becattini suggests that the triptych was painted in Florence and remained there for several years, since it does not appear until 1441 in the inventory of possessions of San Giovenale.

No mention of the triptych appears in any source, although Vasari refers to works by the young Masaccio in the area round San Giovanni Valdarno, yet it represents a milestone in early Renaissance painting. Already containing elements of innovation, the new treatment of perspective and new plasticity are in the spirit of the great Florentine contemporaries

Brunelleschi and Donatello (who was then working on the *St Louis* in the Museo dell'Opera di Santa Croce: the crozier is held in a "scissor grip" similar to San Giovenale). The spectator is drawn in among the characters by the space defined in the three panels: the two angels below the step with their backs to us and profiles disappearing, create intermediate space between the onlooker and the painting. They mark as it were the boundary beyond which the scene opens out. This device of arranging and articulating space is recurrent in Masaccio's style and one which he was to make use of again in the Brancacci Chapel. One example is the tax-collector with his back to us in the *Tribute Money*, on the extreme edge of the spatial dimension with the onlooker; another is the

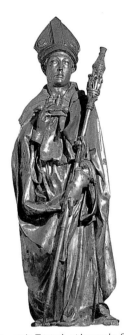

episode of the *Distribution of Alms* where the child seen from behind in its mother's arms marks an exact point between the characters of the scene and the observer. But it is to be found earlier than this, in the Pisa Polyptych, in the out-stretched figure of Mary Magdalene in the *Crucifixion* at the top and in the executioner of the *Martyrdom of St Peter* in the predella.

The Child, as in the central altarpiece of the Pisa Polyptych (now in London), is sucking his fingers which taste of grapes. There is a definite allusion to the Eucharist although the gesture has its inspiration in ancient models and the child, in order to affirm its "naturalness," is naked like the classical putti.

When it first appeared critics were uncertain of the triptych's attribution to Masaccio. Now however it is generally agreed that he painted it and that it is the earliest known work by him. The unity of style which binds the whole work ideally and pictorially leads us to discard suggestions of collaboration on the side panels.

4,5. San Giovenale Triptych, side panels: St Bartholomew and St Blaise, St Ambrose and St Giovenale
88 x 44 cm
Reggello (Florence), church of San Pietro at Cascia

6. Donatello, St Louis
Florence, Museo dell'Opera di Santa Croce

The Sagra

Masaccio, who since January 7th 1422 had been enrolled in the Arte (Guild), took part in the great celebrations of April 19th of the same year for the consecration ceremony of the church of Santa Maria del Carmine with Brunelleschi, Donatello and Masolino. He had the job of immortalizing it in a fresco executed in chiaroscuro and terra verde "above the part towards the convent, in the cloister" with many figures: "five or six to a row.... decreasing...according to the line of vision.... and not all the same size, but with discernment, which distinguishes those who are short and fat from the tall and thin..."(Vasari).

Before this undertaking (which is dated by some around 1424), he probably made a trip to Rome for

the Jubilee of 1423. This would explain his humanistic development: the Sagra procession could have reflected examples drawn from ancient reliefs. He certainly made a careful study of painting of the late Roman empire and early Christian era, as Vasari says, to "learn to be better than the others," and saw with his own eyes the ancient world and the historical-civil character of Imperial Roman art. It has been suggested that he was perhaps accompanied by Masolino, or even Donatello and Brunelleschi who, "never stopped working among the ruins of those buildings." The *Sagra* was destroyed at the end of the 16th century because of alterations to the convent and is now only partially recorded by drawings. One, by an anonymous Florentine of the second half of the 16th

century published by Berti (1966), but in 1968 attributed to Commodi, is in the Procacci collection in Florence, while there are drawings in Folkestone, at the Albertina in Vienna, and in Florence at the Casa Buonarroti and the Prints and Drawings Rooms of the Uffizi. One other drawing in a private English collection, attributed to Federico Zuccari, has been recently published by Berti at the suggestion of Piero Pacini. Almost all the drawings refer to the same group of people, amongst whom several of those already mentioned by Vasari are recognisable.

Vasari wrote that "he painted the portraits of a great number of the citizens in cloaks and hoods following the procession: among these were Filippo di Ser Brunellesco in clogs, Donatello, Masolino da Panicale, who had been his master..." Besides these, Vasari noted the presence of a Brancacci, Niccolò da Uzzano, Giovanni di Bicci de' Medici, Bartolomeo Valori, Lorenzo Ridolfi and even "the doorkeeper with the keys in his hand."

The Sagra is the origin of Masaccio's portrait painting, as Vasari clearly indicates. The information is in the 1568 edition of the Lives, at which time there were still to be seen in Simone Corsi's house the portraits of Brunelleschi, Donatello, Masolino, Felice Brancacci, Niccolò da Uzzano, Giovanni di Bicci de'

Medici and Bartolomeo Valori, painted by Masaccio on panels taking the likenesses from the Sagra: in profile, in "cloaks and hoods" and half-length. This is a direct study of human reality, a glorified testimony to the succession of ancient and modern events; the same subtle and accurate reality which will later be found in the numerous contemporary portraits on the walls of the Brancacci Chapel.

Three of the portraits mentioned by Vasari — which would not have been the only ones — were grouped together by art historians: the portraits of a young man now in the Gardner Museum in Boston, in the Musée des Beaux Arts of Chambery and in the National Gallery of Washington. Most critics now agree that the last two are not by Masaccio because of their inferior quality and certain characteristics which suggest a later date or at most copies of works by him. Berenson's attribution of the Boston portrait to Masaccio was accepted by Salmi, Giglioli, Langton Douglas, Mesnil, Ragghianti, Laclotte, Hatfield and now by Berti, who agrees with Ragghianti that it is a portrait of Leon Battista Alberti. It should be dated between 1423 and 1425, that is earlier than the portrait of Alberti in the Brancacci Chapel in the episode of St Peter Enthroned.

The Madonna and Child with St Anne

In 1424 Masaccio was again in Florence enrolled in the Compagnia di San Luca. Critics date the beginning of his collaboration with Masolino, visible in the *Madonna and Child with St Anne*, a panel for the church of Sant'Ambrogio now in the Uffizi, from this year, the same in which Masolino finished working in the church of Santo Stefano in Empoli. It is the first work in which the association of the two painters, which continued on the scaffolding of the Brancacci Chapel and then in Rome until Masaccio's death, is evident.

Vasari mentions this painting in the second edition of the Lives (1568), but attributes it entirely to Masaccio, indicating where it was placed "in the chapel next to the door which leads to the nuns' parlour."

The painting was first in the church of Sant' Ambrogio in Florence, then in the Galleria dell'Accademia, and then in 1919 it went to the Uffizi where it remains today.

At first art critics assumed the work to be entirely by Masaccio, following Vasari's opinion, but it soon became clear that it was the work of more than one artist. Masselli in 1832 and Cavalcaselle in 1864 were the first to notice affinities with Masolino's style.

D'Ancona in 1903 was the first to make out two distinct hands in the painting, separating the "graceful and delicate parts" (the faces of the Madonna and angels) from the "full and rather coarse forms" (the Child and St Anne). However it was Roberto Longhi in 1940 who tackled the problem of the collaboration between Masaccio and Masolino, attributing the Madonna and Child and the angel holding the curtain at the right to Masaccio and the rest to Masolino. Masaccio is thus considered the independent collaborator of Masolino, who perhaps had been commissioned to paint the panel. Ragghianti subsequently assigned to Masaccio the foreshortened angel at the top holding the curtain. Salmi (1948) and Salvini (1952) considered St Anne to be by Masaccio mostly because of "the hand exploring the depth of the picture" in a daringly foreshortened position above the head of the Child, which Procacci too (1980) thought to be Masaccio's invention. But in Berti's opinion these spatial innovations belong to Masolino and are related to the "similarly extended" hand of Christ in the *Adoration of the Magi* by Gentile da Fabriano, 1423, in the Uffizi.

As far as dating the work is concerned, scholars all agree that it was executed in Masaccio's earliest period. Before the discovery of the *San Giovenale Triptych* dates varied between 1420 and 1425 and have since been put beyond 1422. Because of the tendency to make the date coincide with the presumed period of collaboration between the two artists the preference is for sometime between 1424 (November) and 1425 (September) when Masolino had several commitments to fulfil. As in the *San Giovenale Triptych*, the writing in capital letters "AVE MARIA...," is again present, while in St Anne's halo another inscription in Italian can be read, interpreted by Longhi: "SANT'ANNA È DI NOSTRA DONNA FAST(IGIO)."

The space is articulated in parallel planes, as in the spatial composition of some of the Brancacci Chapel episodes: the Madonna's knees on the first plane, the Child clasped by his mother's hands on the second, then the Madonna's body, the throne and the angels, St Anne, the curtain and the other angels and lastly the gold background.

The composition with St Anne placed third in respect of the Virgin and Child, is coherent in its entirety and the figures achieve a sculptural massiveness. The presence of St Anne has been interpreted with a particular meaning (Verdon, 1988): the rule of filial obedience of the Benedictine nuns towards the Mother Superior.

It is in the Brancacci Chapel that the collaboration between Masaccio and Masolino increases and becomes habitual. Here they painted the stories of St Peter commissioned by Felice Brancacci. Although no clear documents exist on hiring or contracts of any kind, it is assumed that the two received the commission together. It would be otherwise inexplicable why Masaccio was obliged to paint a St Paul as a test to set beside Masolino's St Peter, praised by the patrons of the chapel.

9. Madonna and Child with St Anne
175 x 103 cm
Florence, Uffizi

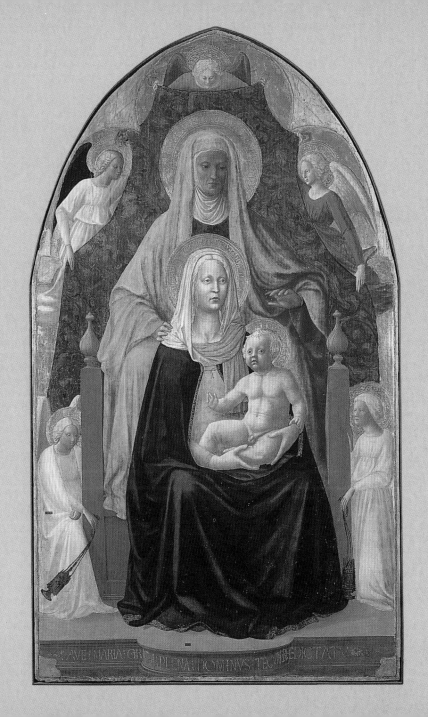

AVE MARIA GRA PLENA DOMINVS TECVM BEDICTA T

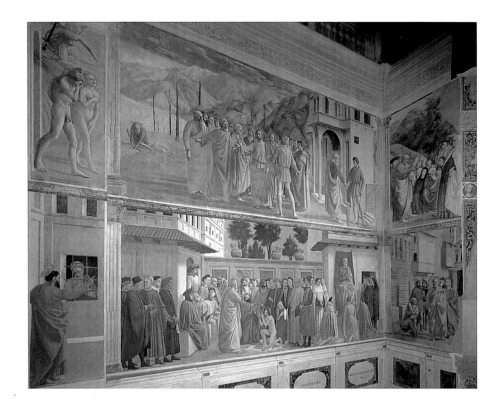

The Brancacci Chapel

The chapel in the righthand arm of the transept in the church of Santa Maria del Carmine is consecrated to the Madonna del Popolo, and a painting of the Virgin stands on the altar. The patrons of the chapel were the Brancacci family, from the second half of the 14th century until 1780, when it was taken over by the Riccardi family.

Felice, the son of Michele Brancacci, was the patron of the chapel from 1422 till at least 1436, as we learn from the testament that he drew up on 26 June of that year before he set off for Cairo, where he had been sent as Florentine Ambassador. Felice was a member of the Florentine ruling class and held a number of important public positions: as early as 1412 he was already one of the sixteen Gonfalonieri di Compagnia, and in 1418 he was one of the twelve Buonomini. Later he was nominated Ambassador to Lunigiana, before taking up his post in Cairo in 1422, together with Carlo Federighi, a man of letters,

described in the documents as a philosopher and an expert in legal matters. In 1426 Felice held the post of Commissario, or officer in charge, of the troops that besieged Brescia during the war against Milan. He also administered his own profitable silk trading company, and in 1433 he married Lena, the daughter of Palla Strozzi. Felice was a rich and powerful man and he commissioned the fresco decoration of the chapel shortly after he returned from Cairo in 1423. Berti has in fact suggested that work on the frescoes began in 1424, at a time when Masaccio and Masolino were working together, and that it continued until 1427 or 1428, when Masaccio set off for Rome, leaving the fresco cycle unfinished.

The appearance of the chapel today is the result of the alterations begun immediately after Felice Brancacci fell out of favour: he was exiled in 1435 and declared a rebel in 1458. Further changes were carried out in the 18th and 19th centuries.

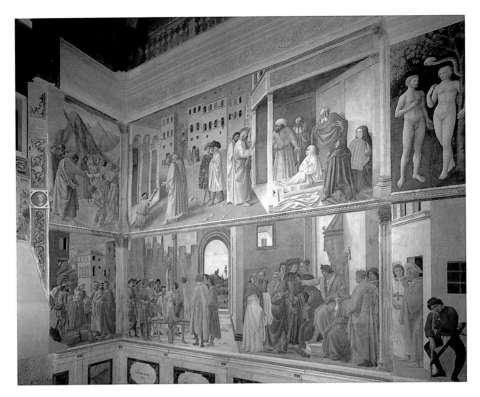

10,11. Stories from the Life of St Peter
Florence, Brancacci Chapel

Originally the chapel was cross-vaulted and lit by a very tall and narrow two-light window; the last of the stories from the life of St Peter, his *Crucifixion*, was probably painted on the wall below the window, but this fresco was destroyed soon after Brancacci was declared a rebel so as to cancel all traces of a patron who had become politically embarrassing. The chapel, formerly the chapel of St Peter, was reconsecrated to the Madonna del Popolo and an ancient painting of the Virgin was hung on the wall, above the altar. This painting, recently restored, has now been attributed to Coppo di Marcovaldo (Paolucci).

It appears that Felice Brancacci was subjected to an operation of *damnatio memoriae*, for all the portrayals of people connected to the Brancacci family were eliminated from Masaccio's fresco of the *Raising of the Son of Theophilus*. The scene was then restored in 1481-82 by Filippino Lippi, who also completed the cycle.

After the chapel was reconsecrated to the Virgin a number of votive lamps were installed: the lampblack they produced coated the surface of the frescoes, causing such damage that as early as the second half of the 16th century they had to be cleaned.

In 1670 further alterations were carried out: the two levels of frescoes were divided by four sculptures set in carved and gilded wooden frames. A short while later, in 1674, the chapel was furnished with marble balustrades and the floor and steps leading up to the altar were rebuilt.

It was probably at this time that the leaves were added to conceal the nudity of Adam and Eve in the two frescoes, Masolino's *Temptation* and Masaccio's *Expulsion from the Garden of Eden*. In fact, we know that they had not yet been added in 1652, and they were probably conceived as a sort of censorship operation during the reign of the notoriously bigoted Cosimo III.

12,13. Details of the Tribute Money, before and after restoration
Florence, Brancacci Chapel

In 1680 Marquis Francesco Ferroni, interpreting the aesthetic taste of the time which considered "those ugly figures dressed in long flowing coats and wide mantles" quite unseemly, offered to buy the chapel and to get rid of the frescoes. He suggested that the chapel should be entirely renovated and made more like the Corsini Chapel, in the other arm of the transept. Fortunately, Grand Duchess Vittoria della Rovere stepped in and prevented the destruction of the frescoes: Marquis Ferroni's alternative plan, "to have the wall sawed off so as to preserve the most precious paintings elsewhere," thus renovating the chapel without causing severe damage to the frescoes, was also vetoed by the Grand Duchess.

In 1734 the painter Antonio Pillori cleaned the frescoes at the same time as the whole church was undergoing an operation of redecoration. But the most detrimental alterations in the chapel were carried out in 1746-48. Because of the dangerous infiltrations of damp reported by Richa, the cross vault was demolished entirely, and with it the ceiling frescoes of the Evangelists that had been painted by Masolino. The frescoes in the lunettes were also destroyed.

Vincenzo Meucci redecorated the ceiling, painting the scene of the Madonna giving the scapular to St Simon Stock, while Carlo Sacconi painted a series of architectural motifs in the side lunettes. And the "beautifully wrought and finely decorated window" was also added.

During the surveys carried out during the recent restoration programme nothing was found underneath the decorations in the lunettes, whereas under the frescoes on the end wall, on either side of the window, the restorers found two 15th-century sinopias of scenes from the St Peter cycle by Masaccio and Masolino.

And so we come to the terrible fire that ravaged the church, on the night between 28 and 29 January 1771: luckily it did not cause any irreparable damage to the chapel. The wooden frames that separated the two tiers of frescoes caught fire, and the heat from the flames altered the colours in that area; also, some pieces of *intonaco*, or plaster, fell off from the steps behind the tax collector in the *Tribute Money* and from the loggia behind the cripple in the *Raising of Tabitha*.

The fire did not damage the painting of the Madonna del Popolo which had been removed to the monastery the previous year.

In 1780 Marquis Gabriello Riccardi became the new patron of the chapel; after having it restored, he opened it to the public. The conditions of the chapel were carefully monitored throughout the 19th century: redecorations were carried out, and all signs of damage caused by humidity, by the lampblack from the candles, and by wax splashing onto the frescoes were reported and studied, until the decision to intervene again was taken.

In October 1904 the decision was taken to clean the frescoes again, under the supervision of expert restorer Filippo Fiscali. But on this occasion the restoration did little more than

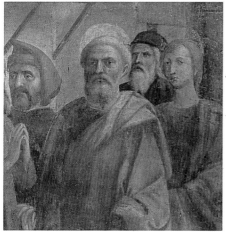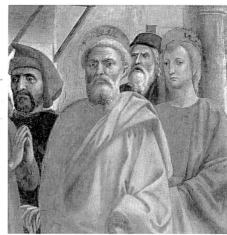

14,15. Details of St Peter Healing the Sick with his Shadow, before and after restoration Florence, Brancacci Chapel

remove the dust from the surface of the frescoes.

Under the supervision of Ugo Procacci two small slabs of marble, placed on the same level as the altar's tympanum, were removed, revealing two sections of painted wall surface; the colour tonality of these two small sections is evidence of what the frescoes must have looked like before the 1771 fire. Fifty years after this unique discovery, an accurate survey and investigation of all the painted surfaces was carried out, as background research to the recent restoration project.

On either side of the Baroque window and beneath the 18th-century *intonaco* two sinopias were found: they were the preparatory sketches for the scenes destroyed during the modernizations carried out in 1746-48. One depicts St Peter in despair after his denial of Christ, while the other shows Christ nominating Peter his universal shepherd with the words "*pasce agnos meos, pasce oves meas*."

The striking differences between the two scenes enable us to attribute one to Masaccio and the other to Masolino: this also reinforces the theory that the two artists were working together on the fresco cycle from the very beginning, conceiving and planning the scenes together, so that the stories illustrated by one were perfectly in harmony with those painted by the other.

The discovery of these two sinopias has filled some of the gaps in the documentation, as well as allowing us now a complete reconstruction of the stories from the life of Peter, preceded by the portrayals of

Adam and Eve and the Evangelists. The overall programme is a *historia salutis*, that is a history of the salvation of mankind through Christ, mediated by the Church, represented by Peter.

Another important part of the restoration procedure was the dismantling of the marble altar. This revealed surviving fragments of decoration in the jambs of the original two-light window: two medallions containing heads, again one by Masaccio and the other by Masolino, as well as foliage motifs. These ornamental details are perfectly preserved and therefore of great interest, for they give us an excellent indication of what the original colour tonality of the frescoes must have been like.

Equally important was the rediscovery of further fragments of a scene that Masaccio had painted on the wall above the altar: they were probably part of a *Crucifixion of St Peter*, the final episode in the *mysterium salutis*, man's salvation through Christ and the Church. Starting from the two frescoes in the upper section, to the right and the left, we have the facts leading up to the events in the story, as recounted in the Acts of the Apostles and the Golden Legend. The two episodes depict the end of man's harmony with God, and since this is occasioned by man, the move towards reconciliation can only come from God, through His Word, as witnessed and communicated by the Evangelists, who were portrayed on the ceiling. And then, of course, came the stories from the life of St Peter, beginning in the left lunette, above the *Tribute Money*, with the scene of *Peter's*

16. *Tribute Money, detail*
Florence, Brancacci Chapel

17. *Paolo Uccello, Battle of San Romano, detail*
Florence, Uffizi

18,19. *Healing of the Cripple and Tribute Money, details*
Florence, Brancacci Chapel

20. *Donatello, St George, detail of the predella*
Florence, Bargello Museum

Calling; the stories continued on the opposite wall with the scene of the shipwreck, from which one can be saved only through faith in Christ. Next come the frescoes on either side of the window: the scene showing Peter repenting, which marks the beginning of salvation, and Peter being nominated representative of Christ's Church on earth and universal shepherd of souls (the sinopias of these last two scenes were the ones rediscovered beneath the 18th-century additions and Baldini has attributed the former to Masaccio and the latter to Masolino). The story continues with the scene of the *Tribute Money*, where the entire idea of salvation is placed in a context of historical reality; the *Healing of the Cripple and the Raising of Tabitha*, symbolizing the life-giving power that emanates from Christ the Lord; *St Peter Preaching*, which is the announcement of mankind's salvation and the promise coming true; the *Baptism of the Neophytes*, signifying the Church's power to forgive man's sins through baptism in the name of Jesus Christ. The story continues on the level below with *St Peter Healing the Sick with his Shadow*, symbolizing salvation granted by the Church through Peter;

the *Distribution of Alms*, an indictment of those who sin against the sanctity of the Christian way of life for love of money or out of treachery; the *Raising of the Son of Theophilus*, preceded by *St Paul Visiting St Peter in Prison*, states once again that the True Word will save mankind and perform miracles; Peter and Paul's *Disputation with Simon Magus*, preceded by *Peter Being Freed from Prison*, teaches us that there is no connection between magical practices and the signs of salvation; and lastly the *Crucifixion* is the sublimation and the essential moment of man's reunion with Christ.

Although not underestimating the importance of the theological message, critics and scholars have also pointed out the relationship between the stories and the patron who had commissioned the frescoes, a seafarer, a sailor-fisherman, like Peter (in the Calling): like Peter praying for God's help during the storm (in the scene of the Shipwreck), and Felice Brancacci must certainly have been caught in storms during his travels as a merchant or as an ambassador. Nor should we forget the fact that Brancacci had his name included in the Catasto, accepting his duty to pay taxes to the city (*Tribute Money*).

Let us now see how the two artists divided up their work. Masolino is entirely responsible for the *Raising of Tabitha and the Healing of the Cripple* and for the fresco of the *Temptation*, while Masaccio painted the *Baptism of the Neophytes* on the wall space to the right of the window. On the other side, the lefthand side, Masaccio painted the *Expulsion from the Garden of Eden* and the *Tribute Money*, whereas Masolino painted the fresco to the left of the window, *St Peter Preaching*.

If we repeat this alternating pattern, with the artists dividing up the wall space equally, we can speculate how they must have worked on the upper level as well, on the frescoes in the lunettes that were destroyed during the 18th century. Assuming, as we

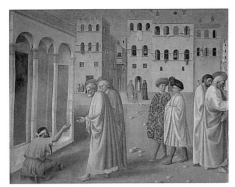

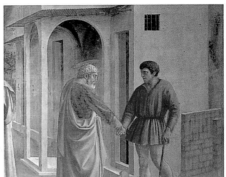

have shown, that the two painters began working on the chapel's frescoes together, there would have been an equal division of labour on this level as well: this would explain not only the terms of their collaboration, but the fact that the two artists obviously were working from a single project they had probably drawn up together.

The division of spaces and episodes between the two would have given the chapel a perfect internal unity: the two artistic styles, thus presented in alternation, would not have created any glaring contrasts. The pattern of alternating styles would have been noticeable not only in the horizontal arrangement of the scenes, but also vertically. This would have conveyed a remarkable feeling of order and harmony.

This method of division of labour avoided the problem of having a whole wall painted by Masaccio standing opposite the other one, entirely painted by Masolino, in obvious juxtaposition; both groups of paintings are fully integrated and balanced in the overall design. It will be enough to mention the two most famous scenes: the *Tribute Money* and the *Raising of Tabitha*. Although the two scenes are conceived in a very different manner, in both frescoes the main characters are set on stages that share the same perspective and that were obviously planned at the same time. Another important unifying element is provided by the fluted pilaster strips at the edge of the scenes and in the corners where the side walls meet the end wall: they are elements of architecture within the architecture and open up the spaces and the different planes on which the characters are placed.

But this project for a perfectly equal division of labour and space was never completed. After the upper level was finished, and when the time had come to start work on the lower one, Masolino abandoned the project; and not long afterwards Masaccio himself left Florence for Rome, to join Masolino

who had just returned from Hungary (1427).

Another dominant architectural element is the depiction of the city: although none of the buildings are exact reproductions of existing constructions, the general mood of the city is recreated. The scenes are set in an urban reality reminiscent of Florence, and this gives the stories great credibility, suggesting that the events did not take place "once upon a time" in a distant past, but in a world which is a mirror image of our present-day surroundings.

The *Healing of the Cripple and the Raising of Tabitha* takes place in a setting that looks very much like a Florentine square. And the architectural background in the other frescoes, both Masolino's and Masaccio's, also share this mixture of ancient and contemporary buildings: in the *Distribution of Alms*, for example, the bell tower on the right has two-light mullioned windows just like those of Santa Maria Novella; the tower house in the background looks like the castles which will later be known as Medici castles, similar in size and shape to Palazzo Vecchio; the foreshortened building which divides the space in the middle is clearly reminiscent of Brunelleschi's constructions.

In the scene of *St Peter Healing the Sick with his Shadow* the street, shown in perspective, is flanked by typically Florentine mediaeval houses and a splendid palace in rusticated stone, the lower part of which looks like Palazzo Vecchio, while the upper section is reminiscent of Palazzo Pitti. And the house of the tax collector in the *Tribute Money* is also modelled on early Renaissance buildings: it bears a resemblance to the palace in the predella of Donatello's *St George*, but it also exhibits an entirely new approach towards perspective, reminiscent of Brunelleschi's Loggia degli Innocenti (and the roundels are clearly modelled on that construction).

Even Filippino, in his *Crucifixion of St Peter*, includes contemporary characters witnessing the event, as well as realistic architectural constructions, some of which are loosely modelled on real buildings, while others are exact portrayals. But it would have been difficult to place the protagonists of the story in these contemporary Florentine settings without creating a contrast, without them losing their credibility. So the artist has added an almost exact reproduction of sections of ancient Rome, with the old walls, the landscape beyond the city gates, the city above the walls: a portrayal of a city done in the manner of the Northern painters who were just beginning to become well-known in Italy. But Filippino could not avoid adding a detail that is uniquely Florentine: the roof of the Baptistry.

Other elements of visible and recognizable contemporary life can be found in the landscape backgrounds, in the characters' gestures and actions: notice, for example, in the *Tribute Money*, Peter catching the fish and the detailed description of his rod with its fishing line made of twine, or the presence of people dressed in Quattrocento costumes amidst the Apostles wearing Roman togas, or the countryside divided into small plots where different crops are cultivated (this detail we shall find again in paintings by Domenico Veneziano and Paolo Uccello); the flowing river in the *Baptism of the Neophytes*, the drops of water on the neophyte's head, splashing off and into the river; the shadows of the bodies invested by rays of light; the stubble on the face of one of the onlookers, the ear of another folded over by his turban; the shadow projected onto the wall by one of the characters in the *St Peter Enthroned*, the man undressing, and, of course, the trembling nude in the *Baptism*.

In all the episodes the main character is always St Peter, shown as he performs the actions described in the Scriptures. His portrayal was based on an iconography that remained fairly constant in Italian art, and of all the Apostles he is easily the most recognizable: a strong, middle-aged man, with grey, curly hair, slightly receding or tonsured. He wears a yellow cloak over a blue tunic. Masaccio and Masolino, and later Filippino, follow this physical model exactly in all the scenes, although the actual facial features vary slightly, for each artist elaborated his own Peter.

Masaccio painted Peter's face with wide expanses of colour, depicting his hair as flowing and wavy in the early scenes (the ones on the upper level); while he portrays him with a tonsure in the later episodes from his life, the ones on the lower level (for, according to tradition, it was Peter who introduced the practice). On a foundation of *terra verde*, which frequently resurfaces through the skin colour, Masaccio portrays St Peter in the following ways in the *Tribute Money*: on the right, together with the tax collector, he is shown in profile, his face consisting of broad patches of colour, and his hair dishevelled; in the centre, as he listens to Christ's instructions, his face is more carefully executed and his position is almost frontal, so that he conveys an impression of gravity: he could almost be an ancient philosopher, Plato perhaps. He is clearly a thinker, a mature man: his hair is nearly white, and even his eyebrows have some white in them.

In the *Baptism of the Neophytes*, his powerful neck is lit from behind by the stream of sunlight coming in from the chapel's window. His profile, in the half-shadow, has a strongly sculptural effect.

In the scene of the *Raising of the Son of Theophilus*, where Peter performs the miracle, his hair is different: here he displays the tonsure which, as we mentioned, was a practice apparently introduced by him. According to the traditional account, when he was in Antioch preaching the Christian faith, the heathen rulers ordered that his hair be shaved at the top of his head as a punishment and a sign of contempt. In all the later episodes Masaccio portrays him with the triple tonsure, consisting of three concentric circles, which in some ways resembles the conical headdress made up of three crowns, the tiara, worn by the Pope on the most solemn occasions. The papal tiara is also called the Triregnum, for the three crowns also symbolize the three powers of the head of the Church: imperial, regal and ecclesiastic. And this is how Peter is portrayed in the *St Peter Enthroned*, in *St Peter Healing the Sick with his Shadow*, and in the *Distribution of Alms*, where the tonsure is even more obvious because his head is shown in profile.

Masolino's St Peter is more controlled: his curly hair is portrayed in greater detail and the skin tone (and, as a result, his expression) is rendered with numerous tiny brushstrokes, creating shapes and

volumes with a sfumato technique, with gradual tonality changes.

Filippino, in his stories on the lower level recounting the last episodes from Peter's life on earth, portrays him simply as a mature man: a full head of white hair, with no tonsure, in the scenes of St Paul Visiting Peter in Prison, their Disputation with Simon Magus and the Crucifixion. Whereas in the scene of the Angel Freeing St Peter from Prison, he portrays him with the triple tonsure.

The Expulsion from the Garden of Eden

This fresco was cut at the top during the 18th-century architectural alterations (1746-48). By comparing the height of the fresco to the height of the Tribute Money next to it, we can see by how much it has been reduced, for the two scenes must have met in the corner, separated only by the painted pilaster strips (the same occurs below, at the join between St Peter in Prison and the Raising of the Son of Theophilus). This is one of the frescoes which has suffered the greatest damage, for the blue of the sky has been lost. This deterioration must have been noticeable already at the time of Cavalcaselle, for he wrote that the blue of the sky had lost a great deal of its original brilliance. But the blue that Cavalcaselle saw was not actually the original blue paint, but rather a dark monochrome substance which had been spread over the painting's surface after the fire.

The recent restoration removed that substance, but all that was found underneath it was the grey-blue primer that Masaccio applied a fresco, before then adding the azurite a secco, that is after the plaster had dried. The azurite layer, as in the case of Masolino's painting opposite, was already gone before the monochrome substance was added.

If we take the giornata, or day's work, that includes the figure of Adam, we see that the background colour is more intense; this might suggest a mistake in the application of the blue-grey colour for the sky (for example, that the colour applied on the following day did not match it perfectly). But that is not the case: it is simply evidence of the total loss of the original colour.

Accepted by scholars as entirely by Masaccio, this scene has been compared to Masolino's fresco of the Temptation: Masaccio's concrete and dramatic portrayal of the figures, his truly innovative Renaissance spirit, stand in striking contrast to Masolino's late Gothic scene, lacking in psychological depth. In Masaccio's painting, man, although a sinner, has not lost his dignity: he appears neither debased nor degraded, and the beauty of his body is a blend of classical archetypes and innovative forms of expression.

As far as Eve is concerned, one cannot help thinking of earlier interpretations of the Graeco-Roman Venus Pudica in 14th-century examples, such as Giovanni Pisano's Temperance on the pulpit in Pisa Cathedral (incidentally, two of the damned on that same pulpit, holding their heads in their hands, were clearly the models that inspired the figure of Adam). Masaccio's Eve is also reminiscent of the one in the relief of the Expulsion on the fountain in Perugia, also by Pisano; nor can one deny the resemblance, especially in the expression of her mouth, with the Isaac on Brunelleschi's panel for the competition for the Baptistry Doors. But Masaccio's Eve is only similar to a Venus Pudica in her gesture, because her body expresses dramatically all the suffering in the world. Scholars have also pointed out the likely precedents for the figure of Adam: from classical models such as Laocoon and Marsyas, to more contemporary examples, such as Donatello's Crucifix in Santa Croce.

And yet, all these borrowings from classical and more recent art were then used by Masaccio in a very personal way, to build up a totally original end product which must have truly impressed his contemporaries. Think, for example, of the foreshortened angel, shown in flight, in the process of landing on a fiery cloud, as red as his robe. And add to this the importance that Masaccio attributed to his nudes (and this is an element that we can now judge properly since the recent restoration has removed the leaves added during the 17th century). By the use of the nude, Masaccio removes his characters from the sphere of everyday life and places them in an ideal world, but one which is depicted realistically. The nudity of the figures is no longer used simply to imply that the scene is taking place in a remote past, but rather to suggest a form of ethical idealization. And, in fact, the nudity of Adam and Eve can indicate both the innocence of the Garden of Eden (Masolino) and the transient nature of human beings (Masaccio). The two themes are frequently used side by side in the frescoes.

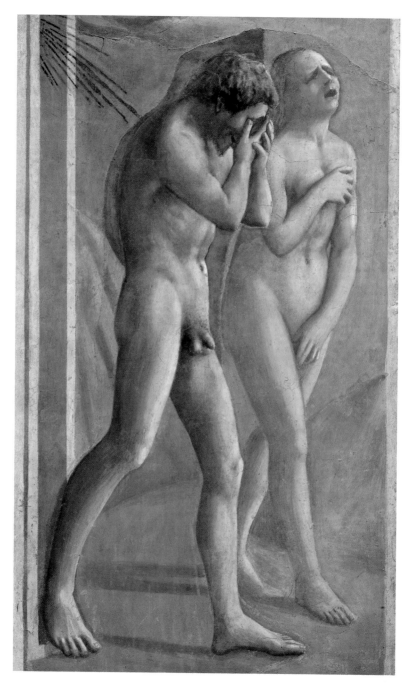

21. Expulsion from the Garden of Eden
(Masaccio) 208 x 88 cm
Florence, Brancacci Chapel

22. Medici Venus
Florence, Uffizi

24. Marsyas
Vatican, Gregorian Profane Museum

23. Giovanni Pisano, Pulpit, detail
Pisa, Cathedral

25. Donatello, Crucifix
Florence, Santa Croce

26,27. Expulsion from the Garden of Eden, details
Florence, Brancacci Chapel

28. Tribute Money (Masaccio)
255 x 598 cm
Florence, Brancacci Chapel

From the tall and narrow opening of the gate to Paradise, steeped in deep shadows, bright rays of light stream out, symbolizing God's will expelling man after his sin: this command is repeated by the angel who indicates the way down to earth with his left hand. Outside Paradise, in a barren landscape, two small mounds of earth appear to accompany the movements of the two figures: the lefthand one, with its steeper slope, echoes the movement of Adam's left leg, while the other one, with its more rounded shape, matches Eve's left leg, and reinforces the idea that they are walking away, in a sense propelled by God's command.

The shadows, which have now been restored to their original strength, emphasize this difficult progression towards the trials and tribulations of life on earth. The event is one of extreme gravity, and no superficial or unnecessary actions are allowed: the overall dramatic intensity permeates everything, for everything is an expression of God's will. The rhythm of the two figures is further stressed by the movement of their arms and their heads: Adam's is bent forwards, suggesting a painful awareness and repentance, while Eve's hangs backwards, as though intent on communicating her suffering to the whole world.

The Tribute Money

The episode depicts the arrival in Capernaum of Jesus and the Apostles: the description is based on the account given in Matthew's Gospel (17: 24-27). Masaccio has included the three different moments of the story in the same scene: the tax collector's request, with Jesus's immediate response indicating to Peter how to find the money necessary, is illustrated in the centre; Peter catching the fish in Lake Gennesaret and extracting the coin is shown to the left; and, to the right, Peter hands the tribute money to the tax collector in front of his house. This episode, stressing the legitimacy of the tax collector's request, has been interpreted as a reference to the lively controversy in Florence at the time on the proposed tax reform; the controversy was finally settled in 1427 with the institution of the Catasto, an official tax register, which allowed a much fairer system of taxation in the city (Procacci, 1951; Meiss, 1963; Berti, 1964).

But there are other allusions and references which have been pointed out by scholars. Peter's action could be a reference to the strategy of Pope Martin V, aiming at reconfirming the supremacy of the Church, and the coin found in the lake of Gennesaret refers to Florence's maritime concerns, promoted through the activity of Brancacci, the city's maritime consul (Steinbart, 1948). Masaccio's reference

to the Gospel according to Matthew is perhaps intended as a reminder of the principle that the Church must always pay its tributes with funds obtained from external sources and not from its own properties (Meller, 1961).

It is our opinion, and one we have expressed before (Casazza, 1986), that the episode is just one element of the *historia salutis* (and one must not forget that Meiss in 1963, basing himself on Augustine's interpretation of the episode, had already stated that the religious meaning of this story is redemption through the Church). This does not, however, exclude further possible meanings and references: such as, for example, a reiteration of the political supremacy of the Church, occasioned perhaps by the Hussite heresy and the Church's reaction against it, led by Pope Martin V and Cardinal Branda Castiglione (Von Einem, 1967); or the connection with the scene of the *Expulsion*, since Jesus Christ's gesture points towards the gate to the Garden of Eden in that fresco (in other words the Kingdom of Heaven), whereas the tax collector's gesture points towards the chipped wooden pole, symbolizing the corruption of the world (Wakayama, 1978).

Ever since the earliest scholars began writing about this fresco they showed special interest in the realistic details, which they noticed and pointed out despite the disappearance of the colour caused by the lampblack and the thick gluey substance that misguided restorers repeatedly applied to the surface of the frescoes over the centuries. Today it has finally become easier to appreciate the wealth of fascinating details, thanks to the recent restoration: Peter's fishing rod, the large open mouth of the fish he has caught, described down to the smallest details, the transparent water of the lake and the circular ripples spreading outwards, toward the banks.

The awareness that they are about to witness an extraordinary event creates in the characters an atmosphere of expectation. Behind the group of people we can see a sloping mountainous landscape, with a variety of colours that range from dark green in the foreground to the white snow in the background, ending in a luminous blue sky streaked with white clouds painted in perfect perspective. The hills and the mountains that rise up from the plains, dotted with farmhouses, trees and hedges, have an entirely new and earthy concreteness: a perfect use of linear perspective, which will be taken up by Paolo Uccello, Domenico Veneziano and Piero della Francesca.

A more important element that contributes to the solemn gravity of the characters is their relationship to a new kind of classicism, a re-elaboration of Graeco-Roman models, which Masaccio had either studied first-hand or through the works of Giotto, Nicola, Giovanni and Andrea Pisano, or even in the more recent sculptures of Nanni di Banco or Donatello.

The figures are arranged according to horizontal lines, but the overall disposition is circular: this semicircular pattern was of classical origin (Socrates and his disciples), although it was later adopted by early Christian art (Jesus and the Apostles), and interpreted by the first Renaissance artists, such as Brunelleschi, as the geometric pattern symbolizing the perfection of the circle (Meiss, 1963). A circular arrangement had already been used by Giotto in Padua and by Andrea Pisano in the Florence Baptistry and in Orvieto.

The characters are entirely classical: dressed in the Greek fashion, with tunics tied at the waist and cloaks wrapped over their left shoulder, around the back, and clasped at the front, below their left forearm. And even Peter's stance, as he extracts the coin from the fish's mouth, with his right leg bent and his left one outstretched, is reminiscent of the postures of many statues by Greek artists, as well as reliefs on Etruscan funerary urns and Roman carvings.

In 1940 Longhi suggested that the entire episode was not autograph, and that the head of Christ was by Masolino: other scholars later agreed with this theory, including Meiss (1963), Berti (1964-68), Parronchi and Bologna (1966).

Thanks to the recent cleaning we are now able to study the pictorial technique in detail, since the surface has finally been freed of the substances added over the centuries. Technically, the head of Christ is not identical in execution to the rest of the fresco. And, according to Baldini, it is not executed in the same manner as the head of Adam in the fresco of the *Temptation* either.

29. Tribute Money, detail
Florence, Brancacci Chapel

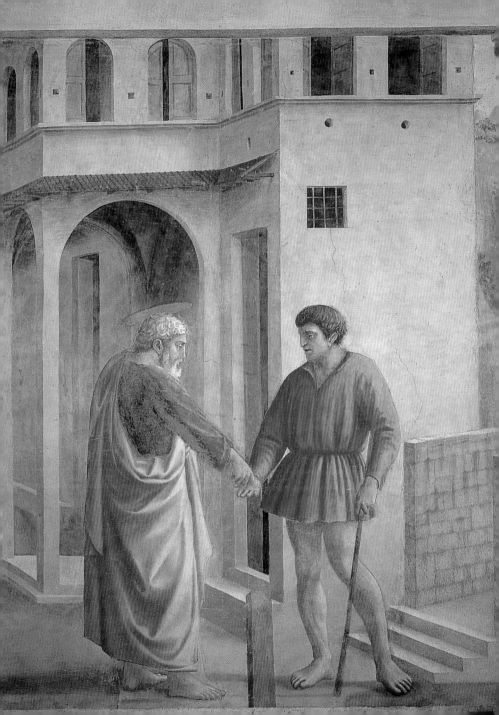

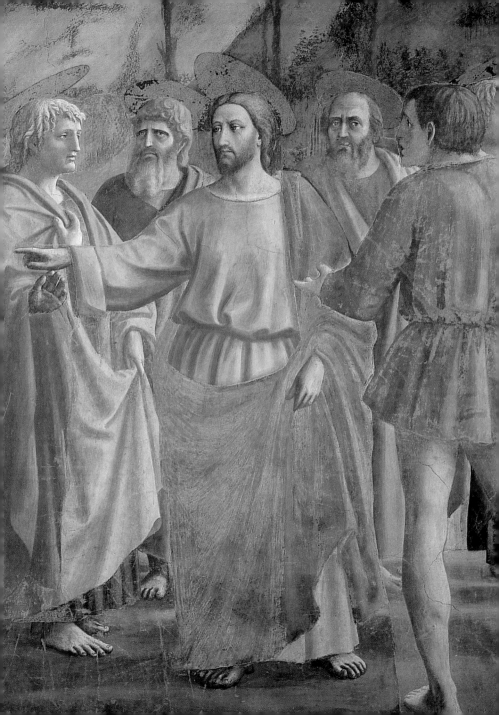

30,31. Tribute Money, details
Florence, Brancacci Chapel

32,33. *Tribute Money, details*
Florence, Brancacci Chapel

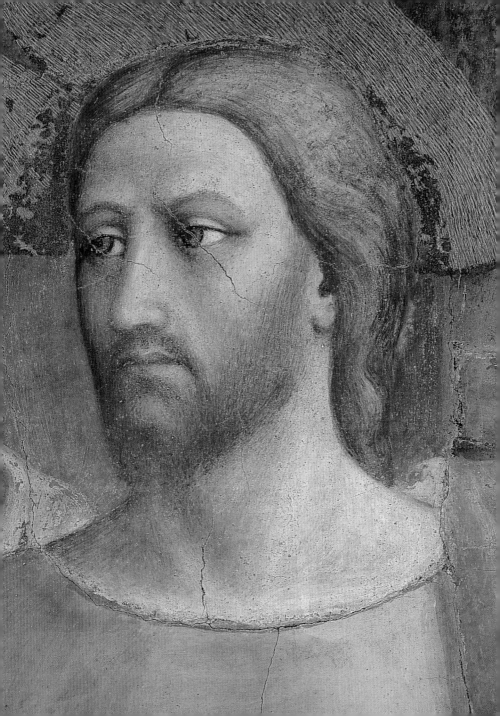

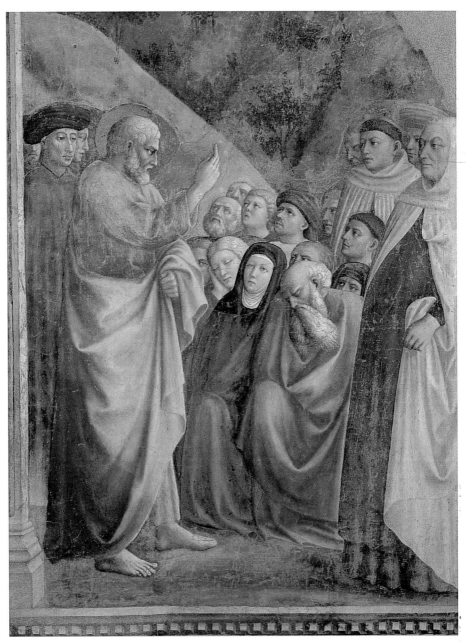

34. St Peter Preaching (Masolino)
255 x 162 cm. Florence, Brancacci Chapel

St Peter Preaching

This scene refers to Peter's sermon ("Ye men of Judaea, and all ye that dwell at Jerusalem, be this known unto you, and hearken to my words"), as recounted in the Acts of the Apostles, which he preaches in Jerusalem after the descent of the Holy Ghost on Pentecost. The fresco actually illustrates the final part of the sermon, when Peter says: "Repent, and be baptized every one of you in the name of Jesus Christ for the remission of sins, and ye shall receive the gift of the Holy Ghost."

It was Longhi in 1940 who first suggested that Masaccio must have had a hand in this fresco. He attributed to Masaccio the three bystanders to the left, behind St Peter ("their grim expression is truly modern"); this theory was accepted by Bologna (1966) and Parronchi (1966), who continued to support it even after Berti (1964) drew a different conclusion from a careful analysis of the *giornate*, or work days, dismissing the idea that Masaccio had had anything to do with the fresco at all (for he discovered that these three heads were painted on the same day as the head of St Peter).

Berti, who had already (1966) ruled out the possibility that there had been collaboration on the two frescoes ("the *Sermon* is entirely by Masolino, just as the *Baptism* is entirely by Masaccio"), has recently changed his opinion: after seeing the restored paintings, he now (1988-89) believes that this fresco was begun by Masaccio, who actually only executed the mountains. Conversely, he believes that the *Baptism of the Neophytes* was begun by Masolino, who also only painted the mountains in the background. But he still maintains that the three figures (which Parronchi now, in 1989, believes are by Masaccio) are indeed the work of Masolino, because of their resemblance to the three elegant men in the story of Tabitha.

According to Baldini (1989), the cleaning has given such a clear vision of the pictorial fabric that we can now attribute the fresco entirely to Masolino, who was working in total autonomy, following an established division of spaces and subjects, in harmony with the corresponding scene of the *Baptism* painted by Masaccio, according to a project that had been drawn up by the two artists together.

The Baptism of the Neophytes

This episode is taken from the Acts of the Apostles (2:41): "Then they that gladly received his word were baptized: and the same day there were added unto them about three thousand souls." In the overall plan, this episode provides the link between the scenes on the upper level and those below, which are arranged from left to right.

Compared to the situation before the recent cleaning, this is the fresco that appears to have benefitted the most from the operation: the splendid colour tones have been rediscovered, as well as the lighting and the draughtsmanship, justifying the fact that this fresco has always been considered a work of unparalleled beauty, from the Anonimo Magliabechiano ("among the other figures, there is one shown trembling ... an extraordinary sight") to Vasari ("a nude trembling because of the cold, amongst the other neophytes, executed with such fine relief and gentle manner, that it is highly praised and admired by all artists, ancient and modern").

Behind this nude, there is another neophyte still fully clothed, in a red and green iridescent cloak. The execution of this figure displays such skill and a sure hand, as well as such a novel pictorial technique, especially in the shimmering iridescence of the cloth, that it almost seems to herald the art of Michelangelo in the Sistine Chapel, or the reddish and purple garments so dear to the early Mannerists.

The cold, flowing water of the river presses against the legs of the kneeling neophyte; the water that Peter pours from the bowl, with a gesture rather like that of a farmer sowing his seeds, splashes onto the man's head, drenching his hair, and dribbling off in rivulets. Again, as it falls into the river, it splashes and forms little bubbles. These realistic details are not fully visible from the ground, just as it is difficult to make out the stubble growing on the face of one of the onlookers, or the ear of another folded over under his turban.

There are twelve neophytes, plus St Peter. In the *Tribute Money* the group of the twelve Apostles form a "human Colosseum," whereas here the characters give rise to an endless procession, which appears to continue into the valley, beyond the painted pilaster strip.

In the past several scholars have suggested that Masaccio must have been helped in this fresco by Masolino or Filippino. Longhi (1940) suggested that

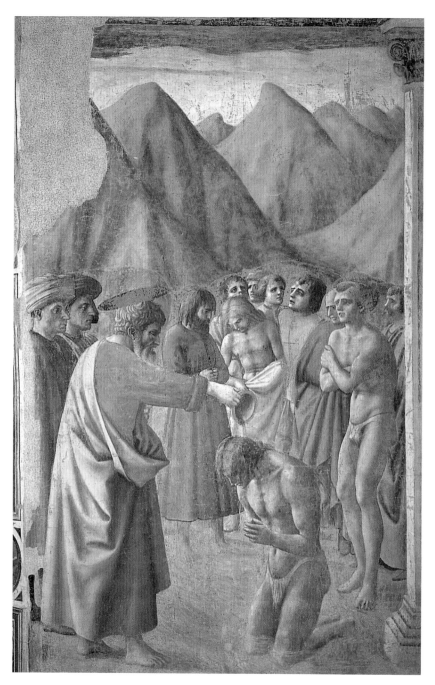

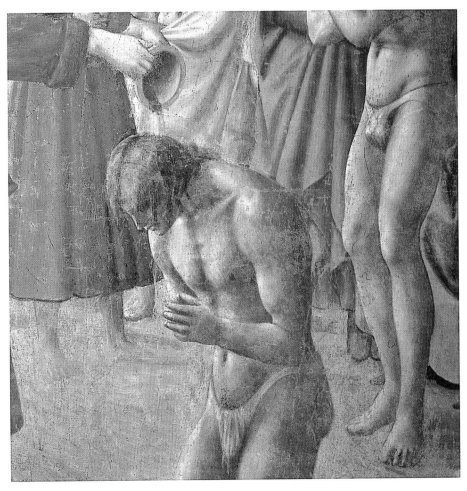

35,36. Baptism of the Neophytes (Masaccio) 255 x 162 cm. Florence, Brancacci Chapel

the two figures to the left, behind St Peter, were the work of Filippino. This attribution, although accepted by Bologna (1966), was rejected by Salmi (1947), who defined the *Baptism* "a terribly badly damaged painting, but one which can still be judged": he believed that the head of St Peter had been repainted by Filippino, but that all the other figures were definitely the work of Masaccio, albeit retouched and disfigured by alterations carried out at a later date. Procacci (1951), followed by Parronchi (1966), believed that the head of St Peter and the two onlookers were by Masolino; but today, after the restoration he has no doubts that the entire scene is by Masaccio. Parronchi (1989) now suggests that the two portraits are the work of some unidentified assistant of Masaccio's, while he considers the head of St Peter a very weak piece of work, of such inferior quality that it is certainly neither by Masaccio nor by Masolino.

And once again, after the cleaning, some scholars have brought up again the theory of a collaboration between Masaccio and Masolino on this fresco as well: for example Berti (1989), who suggests that Masolino was entirely responsible for the landscape.

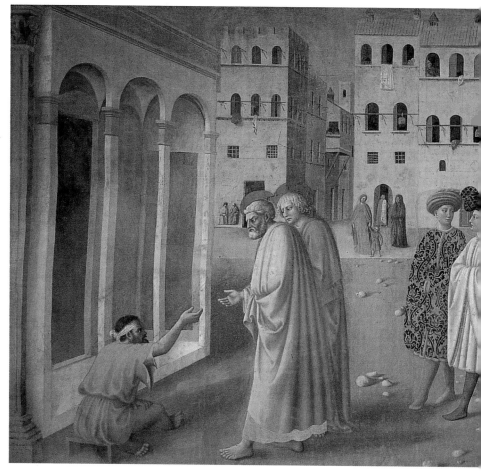

The Healing of the Cripple and the Raising of Tabitha

Both the events depicted in this fresco are recounted in the Acts of the Apostles: the healing of the cripple in Jerusalem (3: 1-10) and the raising of Tabitha in Joppa (9: 36-43). Masolino sets both events in the same town, although they had actually taken place in different cities and at different times.

In the square there are two elegantly dressed characters, in the centre of the scene, who separate but also provide the link between the two miraculous events. The presence of these two figures, and also the characters depicted in the background in front of the houses, makes the two events look like normal everyday occurrences in the life of a city. The square

resembles a contemporary Florentine piazza and the houses in the background, although none of them is strictly speaking an accurate portrayal of an existing building, convey the idea of Florentine architecture, as we still know it today. Even the paving of the street, different from that of the square, is a note of pure realism: the cobblestones, decreasing in size as they recede, also serve to emphasize the perspective of the composition.

And there are other elements which contribute to this description of everyday city life: the flower pots on the window sills, the laundry hanging out to dry, the bird cages, the two monkeys, the people lean-

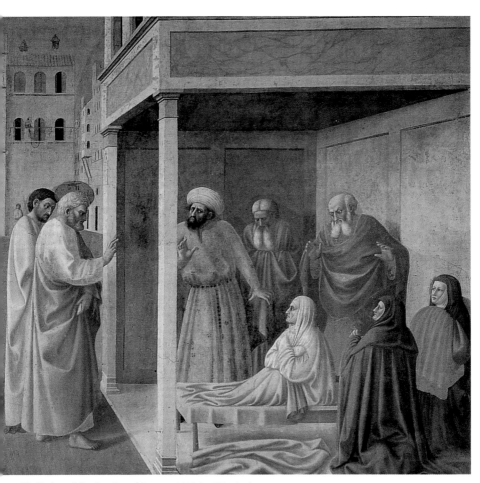

37. Healing of the Cripple and Raising of Tabitha (Masolino)
255 x 598 cm. Florence, Brancacci Chapel

ing out of the windows to chat with their neighbours, and so on.

In the past the loggia to the left had been considered by critics to be architecturally fragile and unconvincing. But now, thanks to the restoration, we can make out the structural elements: from the smooth capitals of the pilasters, to the red plaster inside the cross-vaults.

And even in the righthand loggia, where the miracle of the raising of Tabitha takes place, the classical, Albertian colour pattern of the surfaces and the entablatures increases the solidity of the architecture.

Throughout the 19th century and the first deca-

des of the 20th, scholars attributed this fresco to Masaccio, until Mesnil (1929) re-attributed it to Masolino. Other critics, although basically agreeing with Mesnil's attribution, claimed that there were sections painted by Masaccio. Longhi was the first (1940) to suggest that Masaccio was responsible for the entire architectural background of the scene, including the figures in the background. This theory was accepted by almost all later scholars.

Since the restoration, now that the pictorial techniques can be clearly distinguished, we can rule out any intervention by Masaccio at all, at any rate in the actual execution.

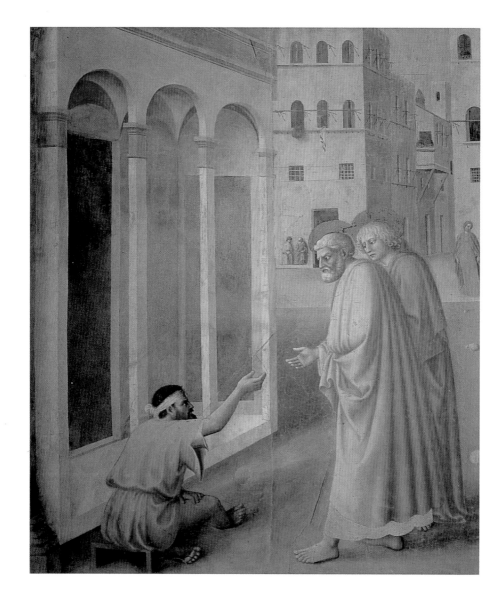

38,39. Healing of the Cripple, details
Florence, Brancacci Chapel

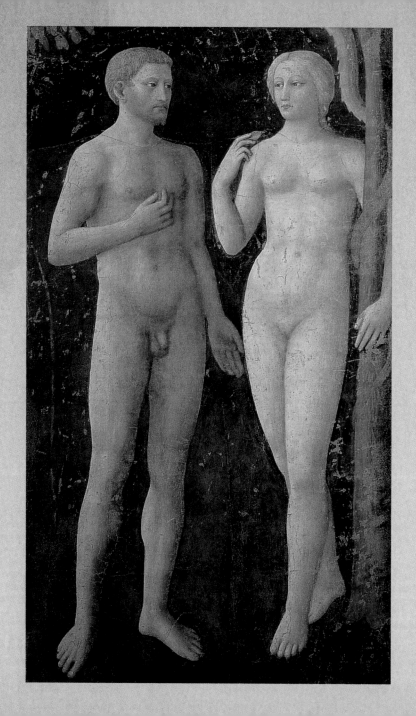

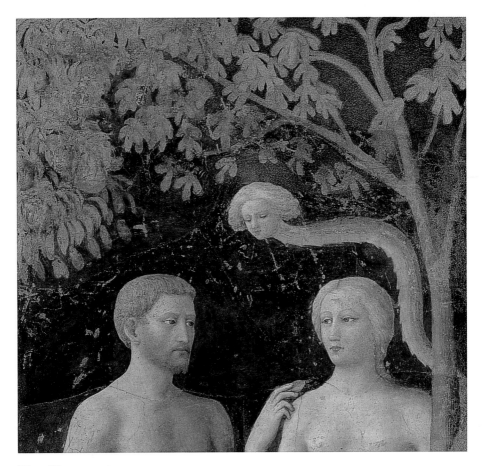

The Temptation

The construction of the new entrance arch to the chapel in the 18th century damaged the top of this fresco, as well as the neighbouring *Expulsion from the Garden of Eden*. The top of the trees and the portion of sky which must presumably have appeared above them is missing.

In this scene Masolino makes use of the most popular and traditional iconography of the period and the two figures, both in their gestures and in their expressions, are courtly and elegant: a mood which has always been contrasted with the atmosphere in Masaccio's fresco opposite, interpreted as a power-

ful manifesto of a new cultural and artistic vision, one of great spiritual harmony and technical ability.

Although traditionally attributed to Masolino, there was a period during which it was believed to be a very early work by Masaccio. In this century, however, all critics and scholars have always agreed that it was painted entirely by Masolino: in fact, it is considered so typically a work by Masolino that it is used as the perfect example to distinguish between the art of the two painters.

Here, too, the foliage that had been added to cover the nude bodies has been removed.

40,41. The Temptation (Masolino)
208 x 88 cm. Florence, Brancacci Chapel

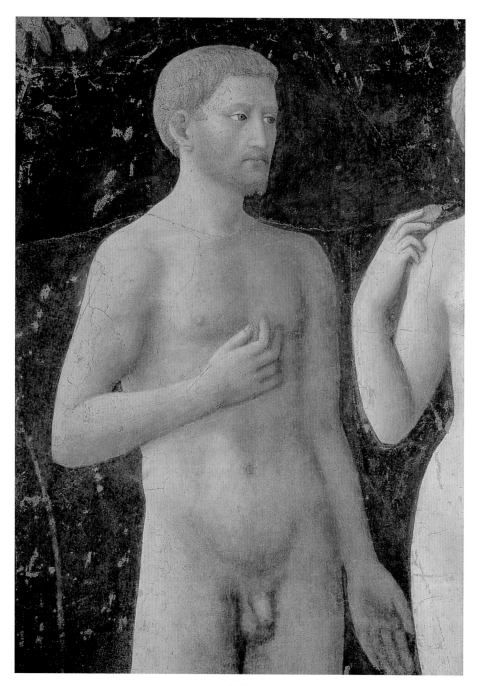

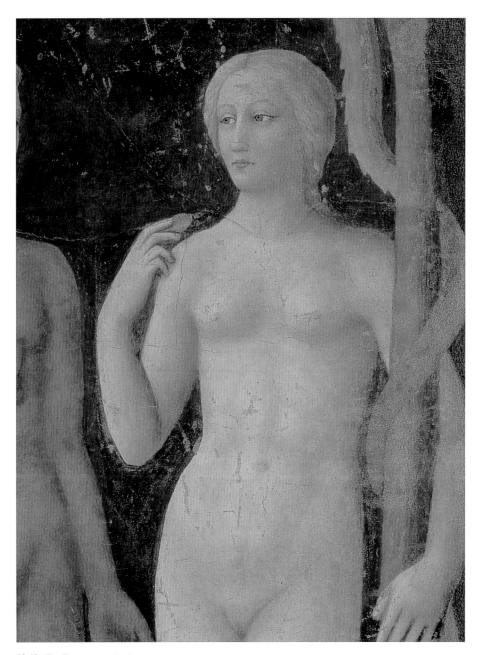

42,43. The Temptation, details
Florence, Brancacci Chapel

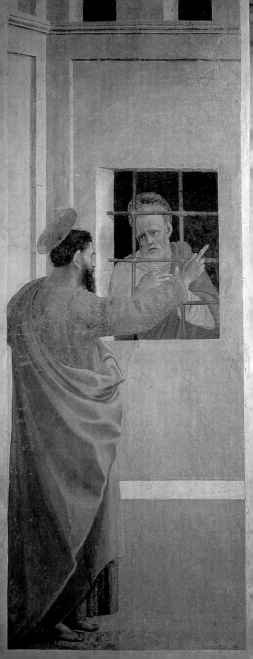

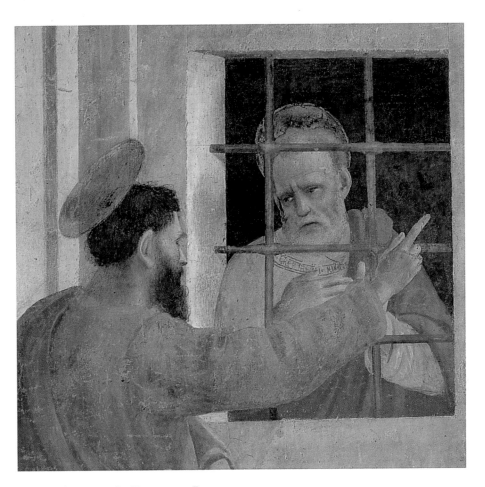

St Paul Visits St Peter in Prison

This episode comes before the *Raising of the Son of Theophilus*. The Golden Legend tells the story of Theophilus, Prefect of Antioch, who put Peter in prison; and there the Apostle would certainly have languished for the rest of his days, had not St Paul, who frequently visited him in his cell, gone to Theophilus and told him that Peter had the power to resurrect the dead. Theophilus was very interested and told

Paul that he would have Peter released immediately if he were able to resurrect his son, who had died fourteen years previously.

For a long time the fresco was attributed to Masaccio. Actually, it is the most Masaccesque of Filippino's paintings, so much so that it has been suggested (Salmi, 1947; Fiocco, 1957) that he may have been working from a sinopia prepared by Masaccio.

44,45. St Paul Visits St Peter in Prison (Filippino Lippi)
230 x 88 cm
Florence, Brancacci Chapel

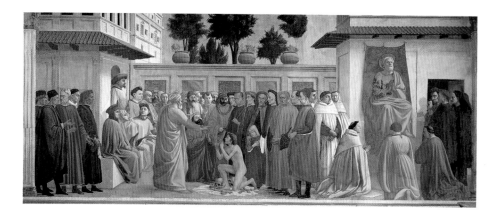

The Raising of the Son of Theophilus and St Peter Enthroned

This scene illustrates the miracle that Peter performed after he was released from prison, thanks to Paul's intercession. According to the account in the Golden Legend, once out of prison, Peter was taken to the tomb of the son of Theophilus, Prefect of Antioch. Here St Peter immediately resurrected the young man who had been dead for fourteen years. As a result, Theophilus, the entire population of Antioch and many others were converted to the faith; they built a magnificent church and in the centre of the church a chair for Peter, so that he could sit during his sermons and be heard and seen by all. Peter sat in the chair for seven years; then he went to Rome and for twenty-five years sat on the papal throne, the cathedra, in Rome.

Masaccio sets the scene in a contemporary church, with contemporary ecclesiastical figures (actually the Carmelite friars from Santa Maria del Carmine) and a congregation that includes a self-portrait and portraits of Masolino, Leon Battista Alberti, Brunelleschi.

Vasari, in his Life of Masaccio, mentions the work of Filippino, but later chroniclers refer to all the frescoes in the chapel as by Masaccio, with only a few rare exceptions (Borghini, Richa). It was not until the 19th century that Rumohr, followed by Gaye, once again pointed out the work of Filippino, distinguishing it from that of Masaccio; and since then critics have been in almost total agreement with his theory.

Scholars have suggested that Filippino was com-missioned to complete the work that Masaccio had left unfinished or to repair sections which been damaged or destroyed because they depicted characters that were enemies of the Medici, like the Brancacci. There is no doubt that the Brancacci family was subjected to something similar to a *damnatio memoriae* after they had been declared enemies of the people and exiled.

Vasari had already identified a number of contemporary figures in those painted by Filippino: the resurrected youth was supposedly a portrait of the painter Francesco Granacci, at that time hardly more than a boy; "and also the knight Messer Tommaso Soderini, Piero Guicciardini, the father of Messer Francesco who wrote the Histories, Piero del Pugliese and the poet Luigi Pulci."

In a study of the possible portraits and of the iconography of the fresco, Meller (1961) confirms the identifications made by Vasari and suggests others, presumably already planned in Masaccio's original sinopia, indicating that the fresco was intended to convey a political message: the Carmelite monk is a portrait of Cardinal Branda Castiglione; Theophilus is Gian Galeazzo Visconti; the man sitting at Theophilus's feet is Coluccio Salutati. And the four men standing at the far right are, starting from the right, Brunelleschi, Leon Battista Alberti, Masaccio and Masolino.

46,47. Raising of the Son of Theophilus and St Peter Enthroned (Masaccio and Filippino Lippi)
230 x 598 cm
Florence, Brancacci Chapel

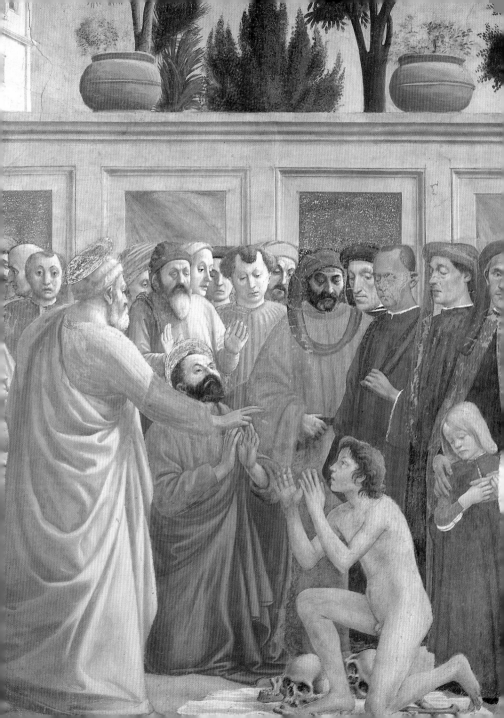

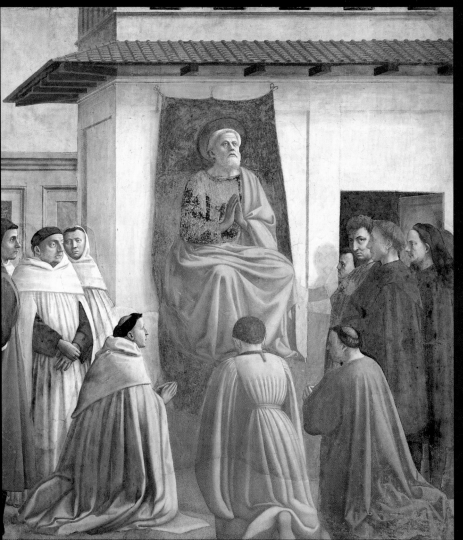

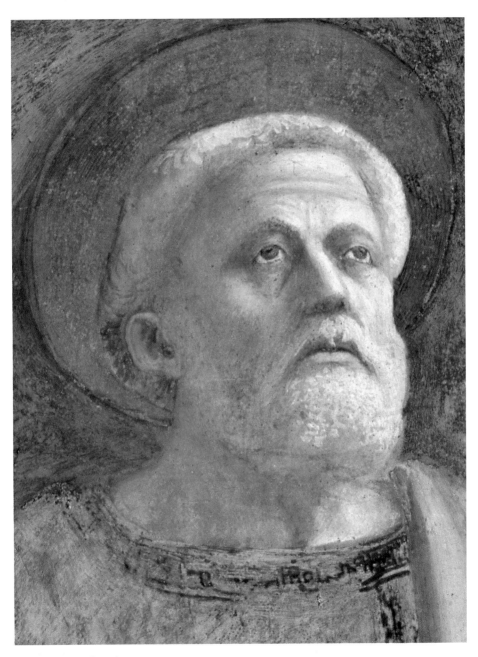

48,49. St Peter Enthroned
Florence, Brancacci Chapel

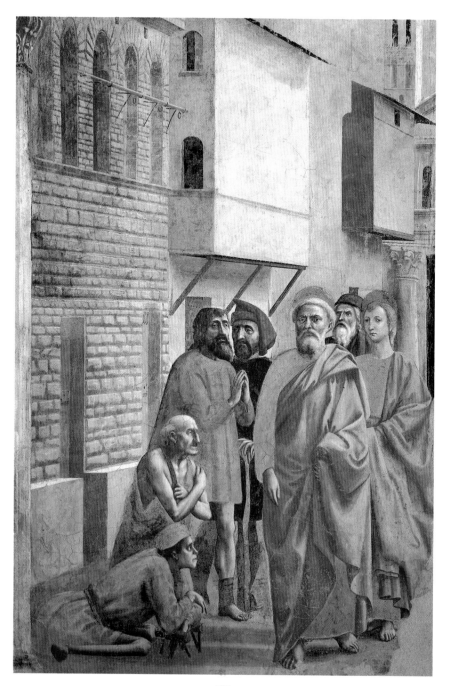

50. *St Peter Healing the Sick with his Shadow (Masaccio)*
230 x 162 cm
Florence, Brancacci Chapel

51. *Palazzo Antinori in Florence*

St Peter Healing the Sick with his Shadow

In the Acts of the Apostles (5: 12-14) this episode is recounted immediately after the story of Ananias, illustrated in the fresco to the right.

Scholars have never doubted that this scene is entirely by Masaccio. Starting with Vasari (1568), who used the man with the hood as the portrait of Masolino he put on the frontispiece of his biography of the artist, all later scholars have tried to identify the contemporary characters portrayed in the scene. Poggi (1903) noticed that the bearded man holding his hands together in prayer is the same person as one of the Magi in the predella of the Pisa Polyptych, now in Berlin; Meller (1961) has suggested that it may be a portrait of Donatello, while Berti (1966) thinks that Donatello is the old man with a beard between St Peter and St John. But for Parronchi (1966) this character is Giovanni, nicknamed Lo Scheggia, Masaccio's brother; while Meller (1961) believes that he is a self-portrait.

The removal of the altar has uncovered a section of the painting, at the far right, which is of fundamental importance in understanding the episode: this section includes the facade of a church (Baldini, 1986), a bell tower, a stretch of blue sky and a column with a Corinthian capital behind St John. Also extremely important is the way Masaccio conceived the right-hand margin of the composition: as Baldini (1986) pointed out, to give the space a more regular geometrical construction, Masaccio has created "a complex play of optical effects and of perspective, as we can see in the lower section of the window jamb, where he has solved graphically an architectural problem, pictorially adjusting the faulty plumb-line of the edge of the jamb and the end wall; he makes the story, and therefore some of the background constructions, continue on the jamb."

The street, depicted in accurate perspective, is lined with typically mediaeval Florentine houses; in fact, the scene appears to be set near San Felice in Piazza, which had a commemorative column standing in front of it (Berti, 1988). But the splendid palace in rusticated stone looks like Palazzo Vecchio in the lower section (the high socle that we can still see on the facade along Via della Ninna, with the small built-in door), although it is much more similar to Palazzo Pitti in the upper part (the windows with their rusticated stone frames). And in some details, such as the exact geometrical scansion of the ashlars, it is an anticipation of later facades, first and foremost Palazzo Antinori.

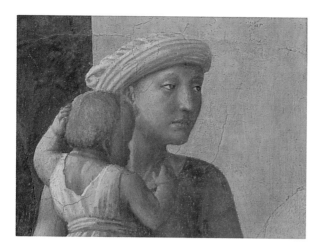

52,53. Distribution of Alms and
Death of Ananias (Masaccio)
230 x 162 cm
Florence, Brancacci Chapel

The Distribution of Alms and the Death of Ananias

This episode is taken from the account in the Acts of the Apostles (4: 32-37 and 5: 1-11): "For as many as were possessors of lands or houses sold them, and brought the prices of the things that were sold, and laid them down at the apostles' feet: and distribution was made unto every man according as he had need. ... But a certain man named Ananias, with Sapphira his wife, sold a possession, and kept back part of the price, his wife also being privy to it, and brought a certain part, and laid it at the apostles' feet. But Peter said, Ananias, why hath Satan filled thine heart to lie to the Holy Ghost, and to keep back part of the price of the land? ... why hast thou conceived this thing in thine heart? thou hast not lied unto men, but unto God. And Ananias hearing these words fell down, and gave up the ghost."

Masaccio brings together the two moments of the story: Peter distributing the donations that have been presented to the Apostles and the death of Ananias, whose body lies on the ground at his feet. The scene takes place in a setting of great solemnity, and the classical composition is constructed around opposing groups of characters.

No scholar has ever doubted that the entire scene is by Masaccio, except for minor cases of details having been retouched (pointed out by Salmi, 1947), such as certain parts of Ananias's body, small sections to the far left where the colour had come off, and even tiny areas on St Peter himself.

The recent restoration has provided us with interesting information: for example, we can now see that there are several details that are not the work of Masaccio, such as St John's pink cloak and his tunic, and Ananias's hands. Baldini (1986) has suggested that all these elements were repainted by Filippino, all in one day's work, over Masaccio's original fresco.

As well as a reference to salvation through the faith, this fresco has also been interpreted (Berti, 1964) as another statement in favour of the institution of the Catasto, for the scene describes both a new measure guaranteeing greater equality among the population and the divine punishment of those who make false declarations. And it has also been suggested (Meller, 1961) that the fresco contains a reference to the family who commissioned the cycle: the man kneeling behind St Peter's arm has been identified as Cardinal Rinaldo Brancacci, or alternatively as Cardinal Tommaso Brancacci.

Due to the interference of the altar and marble balustrade set up in the 18th century, no scholar (with the exception of Mesnil, 1912, who hazarded a suggestion along these lines) had been able to notice that the two episodes on the end wall are ideally part of a single composition, although they are intended to be seen from different viewpoints: the *Distribution of Alms* along the corner axis of the building in the centre, from a position to the right of the entrance, while the scene of *Peter Healing the Sick with his Shadow* is intended to be viewed from the middle of the chapel, from fairly close up. The connection between the two scenes is further emphasized by the fact that on the window side neither has pilaster strips framing the outer edge. The original two-light window, so narrow and tall, did not really interrupt the

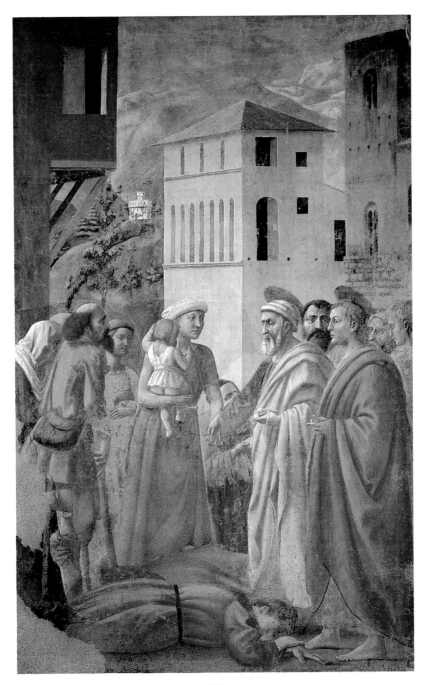

continuity of the wall space: on the contrary, its concave surface provided an ideal connection with the space outside, not as a further background element, but rather as a real source of light, enhancing the three-dimensional features of the characters and contributing to the contrast between light and dark areas (Rossi, 1989).

The Disputation with Simon Magus and the Crucifixion of Peter

This fresco depicts the two last episodes from the story of the life of Peter: to the right we see him, with St Paul, in his dispute with Simon Magus in front of the Emperor; to the left, his *Crucifixion*.

Baldini (1984) suggests that Masaccio had originally painted the last scene of the cycle, the *Crucifixion of Peter*. But that fresco was then destroyed when the Madonna del Popolo was placed on the altar, so that when Filippino was called in to complete the unfinished cycle and repair the damaged sections, he was also asked to add the scene of the death of Peter on the empty wall space.

Among the portraits Filippino has included in his fresco, the most interesting are the following: a self-portrait (the first figure to the left, looking towards the spectator); the first man to the right of the three

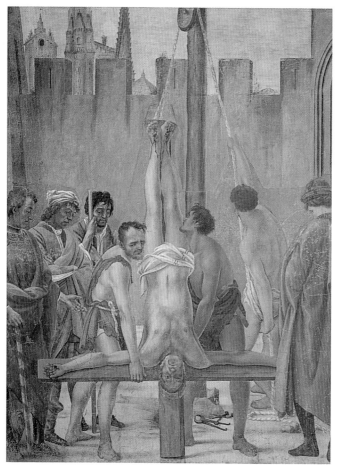

54-56. *Disputation with Simon Magus and Crucifixion of Peter (Filippino Lippi)*
230 x 598 cm
Florence, Brancacci Chapel

378

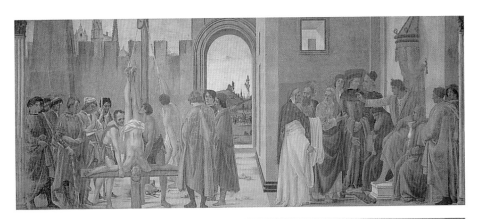

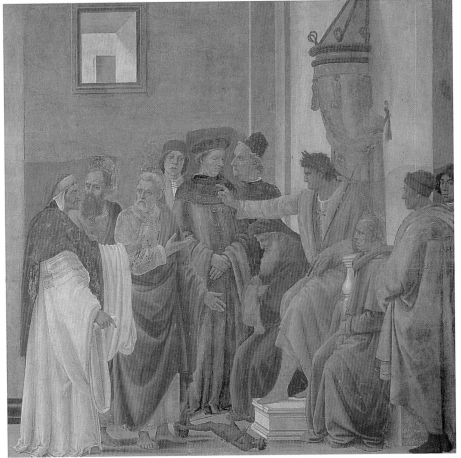

57,58 Crucifixion of Peter, details
Florence, Brancacci Chapel

59. *St Peter Freed from Prison (Filippino Lippi)*
230 x 88 cm. Florence, Brancacci Chapel

60,61. *The two medallions discovered behind the altar in the Brancacci Chapel*

men standing between St Peter and Nero is Antonio del Pollaiolo, while the one to the left is probably Raggio, a merchant's broker mentioned by Vasari (Berti, 1957), and not Botticelli as had been suggested previously; whereas in the group of three to the right in the *Crucifixion of Peter*, the man looking towards the audience is probably Botticelli.

St Peter Freed from Prison

This episode is recounted in the Acts of the Apostles (12: 1-6). The scene shows Peter being awoken by the Angel and taken out of his cell, while the guard is sound asleep and notices nothing.

The fresco was originally attributed, along with all the others, to Masaccio. Gaye (1838) was the first scholar to attribute it to Filippino and this theory was immediately accepted by the authors of the critical edition of Vasari's Lives published in Florence in 1848, but not by Rosini. In 1864 Cavalcaselle confirmed the attribution to Filippino; all later critics have been in agreement.

The Heads in the Medallions

The two heads that have been discovered in the jambs of the original two-light window behind the altar are, according to Baldini (1984), the work of two artists: the lefthand one is by Masolino, the righthand one by Masaccio, for the former is painted with a clearly marked outline and the latter is modelled directly with the use of light. But there are many scholars who disagree and believe that both heads are by Masolino: Boskovits (1987), Berti (1988), Wakayama (1987) and Bologna (1989).

And the foliage pattern decorations that cover the jambs also appear to be the work of two different artists: the floral ornamentations above the two heads and the motif that frames the scene at the top, just under the window sill, are to be attributed to Masolino, whereas the decorations below the two medallions are more probably the work of Masaccio. But there is one scene that everyone agrees is by Masaccio: there are only two small fragments left of it, above the altar, but it was originally the scene of the *Crucifixion of Peter*.

383

The Pisa Polyptych

On February 19th 1426 Masaccio agreed to paint an altarpiece for a chapel in the church of the Carmine in Pisa for the sum of 80 florins, having received the commission from Ser Giuliano di Colino degli Scarsi, notary from San Giusto. On December 26th of that year the work must have been already completed since payment for it is recorded on this date.

Vasari describes the work as follows: "In the church of the Carmine in Pisa on a panel, which is inside a chapel in the transept, is an Our Lady and Child, and at her feet are some angels playing instruments, one of which, playing a lute, is listening attentively to the harmony of the music. Our Lady is between St Peter, St John the Baptist, St Julian and St Nicholas, all alert and lively figures. Underneath in the predella are stories from the lives of the saints, in miniature, and in the centre the three Wise Men paying homage to Christ; in this part are some horses painted wonderfully from life, so that one could not wish for better; and the courtiers of the three kings are dressed in garments in fashion at that time. And on top, to finish off the said panel, there are many paintings of saints around a Crucifixion."

This detailed description related in the second edition of the Lives in 1568 was the basis for art critics for the attempt at reconstruction and for the recovery and identification of the work which was dismantled and dispersed in the 18th century.

Only eleven pieces have so far come to light and they are not sufficient to enable a reliable reconstruction of the whole work. St Peter and St John the Baptist, St Julian and St Nicholas, who were on either side of the central part, are missing; only their recovery could sort out the problem of the structure of the painting. According to some scholars the saints were in pairs, within a single space, while others consider it as a triptych in three sections clearly divided by small pillars or columns according to the standard Gothic practice.

The *Madonna and Child Enthroned with Four Angels*, in the National Gallery since 1916, had been recorded in London in the Woodburn Collection in 1855 and then in the Sutton Collection with attribution to Gentile da Fabriano. In 1907 it was seen here by Berenson who recognised it as a work of Masaccio and the central part of the Pisa Polyptych.

The *Crucifixion*, since 1901 in the Museo di Capodimonte in Naples, was attributed to Masaccio by Venturi and connected with the Pisa Polyptych. *St Augustine, St Jerome, Elijah the Prophet* and

Albert the Patriarch, once in the Butler Collection in London and attributed to Masaccio, were subsequently bought by the Berlin Museum where they are now. They were connected with the Pisa Polyptych by Schubring 1906 and, with others now lost, are generally thought to have adorned the pilasters which framed the polyptych on each side.

The Berlin Museum bought the panel with the *Crucifixion of St Peter* and the *Beheading of St John the Baptist* in 1880 in Florence, where it was in the Capponi Collection, together with the panel of the *Adoration of the Magi* also in this collection.

In 1908 the Berlin Museum acquired a third panel with the *Stories of St Julian and St Nicholas* thus gaining possession of the whole recovered predella of the Pisa Polyptych. While the Masaccio attribution is undisputed for the first two panels, the third is considered to be a product of the workshop (lo Scheggia, in Salmi's opinion, or Andrea di Giusto in Berenson's).

The *St Paul*, now in the Museo di San Matteo in Pisa, is the only piece left in the city for which it was painted. In the 17th century it was attributed to Masaccio (as can be seen from an inscription on the back of the panel) and all through the 18th century when the painting was still in the Opera della Primaziale, which it left in 1796 to go to the Museo di San Matteo; but some critics still favoured Andrea di Giusto. The subsequent attribution to Masaccio is now generally accepted by all critics.

The *St Andrew* went from the Lanckoronski Collection in Vienna to the royal collection of the prince of Liechtenstein in Vaduz, and today is in the Paul Getty Museum, Malibu.

These pieces are all that has been rediscovered and is referrable to the Pisa Polyptych up till the present date. A possible addition is a small tondo depicting an *God the Father Blessing* which is now in the London National Gallery. According to Philippi, who noted it in 1919, it could have been at the top of the central panel above the Crucifixion, as sometimes found in contemporary or earlier works. However not everyone agrees on the authorship: this writer too considers it a product of the workshop, without excluding a possible connection with the Pisa Polyptych, in which the workshop participated in the *Stories of St Julian and St Nicholas* in the predella.

62. Madonna and Child Enthroned with Four Angels
135 x 73 cm. London, National Gallery

63. Crucifixion
83 x 63 cm. Naples, Museo di Capodimonte

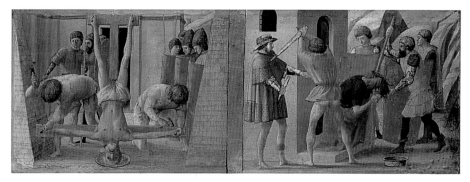

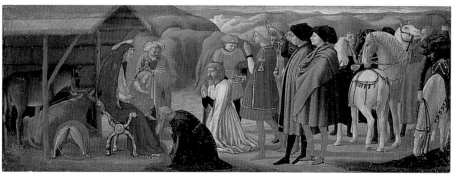

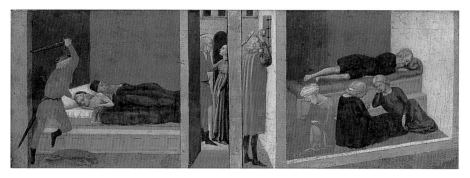

64. *Crucifixion of St Peter and Beheading of St John the Baptist*
21 x 61 cm
Berlin-Dahlem, Gemäldegalerie

65. *Adoration of the Magi*
21 x 61 cm
Berlin-Dahlem, Gemäldegalerie

66. *Stories of St Julian and St Nicholas*
22 x 62 cm
Berlin-Dahlem, Gemäldegalerie

67,68. A Carmelite Monk and St Augustine
38 x 12 cm
Berlin-Dahlem, Gemäldegalerie

The *Madonna of Humility*, now in the Natio-
nal Gallery of Washington, is another work attri-
buted to Masaccio by Berenson, followed amongst
others by Longhi, Salmi, Pope-Hennessy, Shapley
and Volpe. In this writer's opinion the work is
not by Masaccio but a connection with Andrea
di Giusto is apparent; but it is difficult to judge
because there are signs of extensive repainting
on a wornout base. Brandi considered attrib-
ution to Paolo Schiavo while Berti now thinks it is
probably an early Filippo Lippi: "beginnings in

Masaccio's footsteps" and after the Pisa Polyptych.

The execution of the Pisa Polyptych took place
during intervals in the work on the Brancacci Chapel
in the church of the Carmine in Florence, and is a
splendid testimony of the artist's maturity.

The connection of the polyptych with the Florentine
church of the Carmine can be seen in the features
of saints Paul and Andrew, who appear in the *Trib-
ute Money*. Here they appear more introspective and
in rapt meditation rather than in action. This portrayal
emphasizes the solemn monumentality of the en-

69,70. St Jerome and a Carmelite Monk
38 x 12 cm
Berlin-Dahlem, Gemäldegalerie

throned Madonna. The echoes and the study of ancient and contemporary sculpture, from Nicola Pisano to Donatello, are enhanced in a new idiom of realism in its most penetrating forms in this rendering of the Madonna. The throne in perspective and rendered realistically in relation to the height of the work on the altar (consequently to the position of the observer), is undoubtedly the focal point of the whole composition. It gives each figure its right place in a proportionate space, as in the vision looking up from below of the *Crucifixion* which stood directly over the central part, and confirmed by the gold monochrome background. This assumes, as critics have pointed out (e.g. Parronchi), a greater significance than Gothic conventionalism, and gives a sense of dazzling atmosphere capable of creating a real space in which the figures appear intensified, although firmly planted on the ground.

Space, the arrangement of figures, objects, animals and buildings — no longer on a gold ground but against horizons of mountains, sky and clouds — lend depth to the land and the foreground as in the *Trib-*

71. St Paul
51 x 30 cm. Pisa, Museo di San Matteo

ute Money and the other Brancacci Chapel episodes and in the predella stories now in Berlin. Thus the story of the Martyrdom of St Peter is clearly associated with a fragment found in the Brancacci Chapel and thought to be part of a lost Crucifixion of St Peter. In the Beheading of St John the Baptist the executioner's body is the same as the tax-gatherer seen from behind in the Tribute Money; in the Adoration

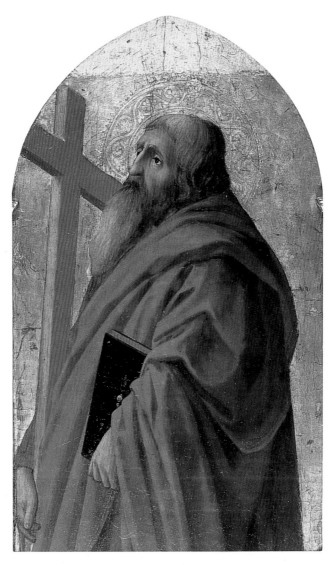

72. St Andrew
51 x 31 cm. Malibu, Paul Getty Museum

of the Magi more than one set of features is common to the stories in the church of the Carmine; and in the other *Stories of St Nicholas and St Julian* (in this last note the figure of the repentant saint which repeats the gesture by Masaccio in the *Expulsion from the Garden of Eden*) even though they are considered to have been executed by the workshop, as mentioned earlier.

The Agony in the Garden

This small panel in the shape of a small altarpiece is now in the Lindenau Museum in Altenburg and contains two episodes: the *Agony in the Garden* and the *Communion of St Jerome*. The execution is usually fixed at immediately after the Pisa Polyptych.

At the end of the last century they were attributed by Schmarsow to Masaccio, but this opinion did not get much support from later critics, from Berenson, who assigned the work to Andrea di Giusto, up to Longhi and Salmi, who thought it was by Paolo Schiavo. The value of the work was revealed by Oertel in 1961, followed by Berti (1964) and Parronchi (1966) who both opted for Masaccio, seeing in it a forcefully expressed originality.

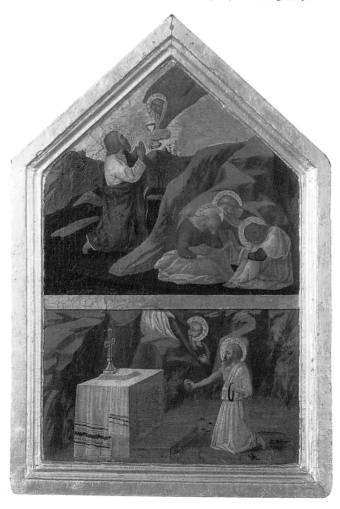

73. Agony in the Garden and Communion of St Jerome
50 x 34 cm. Altenburg, Lindenau Museum

The Madonna and Child

Dating from the same time as the Pisa Polyptych is a small painting on a gold ground, depicting the Madonna holding the Child and stroking him under the chin with her right hand. Her robe of bright blue, bordered with gold and decorated with cubic letters, follows the movement of the figure. The panel is also painted on the back with a coat-of-arms in a shield showing six red stars on a yellow field divided across the middle by a dark band with a golden cross at the centre, the whole surmounted by a cardinal's hat: it was the coat-of-arms of Antonio Casini who was made a cardinal on May 24th 1426.

Longhi, who brought the picture to public notice for the first time in 1950, put it at the time of the Pisa Polyptych, 1426, because of the chromatic harmony and the "wonderful spatial effects." The attribution to Masaccio is accepted by most critics.

From a private collection, it was shown in Rome in 1952 at the "Second National Exhibition of Works of Art Recovered from Germany," then at a similar exhibition in Florence and finally in 1984 at the Palazzo Vecchio with other works recovered by Rodolfo Siviero. It was assigned to Florence by the state in 1988 and is now in the Uffizi.

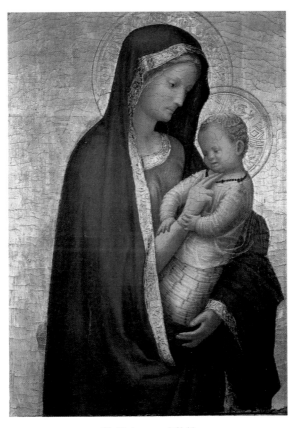

74. Madonna and Child
24 x 18 cm. Florence, Uffizi

The Story of St Julian

The *Story of St Julian*, a small panel thought by some to be connected with the Pisa Polyptych and now in the Museo Horne in Florence, was considered by Ragghianti to be the first draft of the section of the predella on the same subject. Brought to light by Gamba in 1920 and attributed to Masaccio, the work is accepted by all critics as definitely original. The stylistic connection with the Pisa Polyptych is important not only because of the subject (the story of St Julian) but also because of the placing of events in space and the view of landscape to the left, which seems to be a repetition of the rhythmic sequences in a space bordered by distant mountains outlined against a strip of sky (as in the *Adoration of the Magi*).

The Trinity

There are various opinions as to when the fresco of the *Trinity* in the church of Santa Maria Novella was painted. Some date it with the early work on the Brancacci Chapel (c. 1425, Borsook, Gilbert, Parronchi), or in a phase half-way through it (c. 1427, Salmi, Procacci; 1426, Brandi), or right afterwards and just before the departure for Rome (c. 1427-28, Berti). It is mentioned in the earliest sources, and was described in detail in the 1568 second edition of the Lives by Vasari, who emphasized the virtuosity of the "trompe l'oeil" in the architectural structure of the painting: "a barrel vault drawn in perspective, and divided into squares with rosettes which diminish and are foreshortened so well, that there seems to be a hole in the wall."

Only two years after Vasari's book was published, the erection of a stone altar caused the fresco to be covered up by a panel of the Madonna of the Rosary painted by Vasari himself. Thus the fresco remained unknown to future generations from 1570 to 1861 when owing to the removal of the 16th-century altar it was again uncovered. After being removed and placed on the internal facade of the church between the left and the central doors, it was put back in its original position in 1952, as a result of Procacci's discovery, beneath the 19th-century neo-Gothic altar,

75. *Story of St Julian*
24 x 43 cm
Florence, Museo Horne

76. *The Trinity*
667 x 317 cm
Florence, Santa Maria Novella

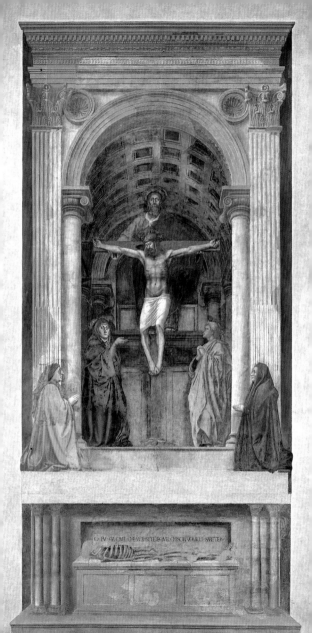

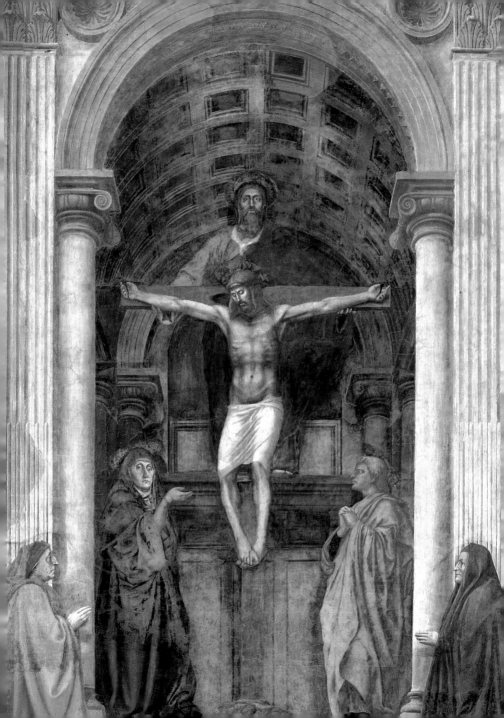

of the lower section of the fresco with Adam's skeleton and the painted altar table, once part of the whole work.

One of the most extraodinary pages in the history of art was thus reconstructed and taken up by critics as the symbol and revelation of Brunelleschi's principles in architecture and the use of perspective, to the point that more than one critic believed Brunelleschi to have had a direct hand in the work. Thus Kern, Frey, Sampaolesi, Gioseffi, Parronchi, Berti and Rossi are against Mesnil, Pertel, Pittaluga, Salmi, Baldini, Cristiani Testi, Del Bravo, and Procacci who maintain instead that the work is entirely by Masaccio, here interpreting the rule laid down by Brunelleschi.

When the fresco was painted, the wall received daylight from two sources: one was the round window in the facade; the other, now no longer existing because blocked up, was the entry to the church from Via degli Avelli. These sources of light, which are also points of access for the visitor, are the basis on which Masaccio makes use of light effects and perspective.

As Carlo del Bravo realized (1978), the protagonists of the scene and the scene itself were meant to appear, not as narrative picture but interpreted in the sense that "the central figures, rather than representing sacred characters, are themselves solid images, polychrome statues in a niche, with whom the sculptural forms of the donors are in a spatial, rather than a narrative, context." In view of this unity of presence, reflecting Brunelleschi in one sense and Alberti in another, the entire work may be confidently attributed to Masaccio. A "ficta et picta" chapel for the painting of which every technical device of graphics and lighting which could create an illusion of reality was made use of. It was in accordance with the canons of Alberti — as recently observed by Mallé, Borsook and now Berti — the use of the technical procedures of the squared film, codified in the *De Pictura* shortly afterwards (1436).

Apart from doubts as when the work was executed, it is uncertain who commissioned it: some think it was Fra Lorenzo Cardoni, prior in Santa Maria Novella from 1423 to early 1426, or Domenico Lenzi (who died in 1426 and is buried right next to the fresco). Another possibility is Alessio Strozzi, who was Cardoni's successor in Santa Maria Novella and the friend and counsellor of Ghiberti and Brunelleschi.

The most likely interpretation of the Trinity — as Rossella Foggi recently observed (1989) — is that the painting alludes to the traditional medieval double chapel of Golgotha, with Adam's tomb in the lower part (the skeleton) and the Crucifixion in the upper part (Tolnay, 1958; Schlegel, 1963). But it can also assume the significance of the journey the human spirit must undertake to reach salvation, rising from this earthly life (the corruptible body) through prayer (the two petitioners) and the intercession of the Virgin and saints (John the Evangelist) to the Trinity (Simson, 1966).

A close-up view of the skeleton in the sarcophagus also revealed the ancient warning, in clear letters: I WAS WHAT YOU ARE AND WHAT I AM YOU SHALL BE. The sarcophagus was underneath the altar-table which was also "ficta et picta"; only later a real and perhaps portable table must have been attached to it, in order to be able to officiate at it. The *Wooden Cross* by Maso di Bartolommeo now in the Sacristy was part of this altar.

Associations with real buildings have been noted by critics: taken from Brunelleschi in the Barbadori Chapel (Salmi) or from Donatello (the Merchants' Tabernacle in Orsanmichele), but also inspired by Masaccio, as in the Cardini Chapel of Buggiano, and in the church of San Francesco in Pescia.

The Berlin Tondo

This *round plate*, with a Nativity on the front and a putto and a small dog on the back, was in San Giovanni Valdarno in 1834 in the possession of Sebastiano Ciampi, and has been in the Berlin Museum since 1883, having come from Florence. It dates from Masaccio's last period in Florence, before he went to Rome.

It was attributed to Masaccio (Guerrandi Dragomanni in 1834, seconded by Müntz, Bode, Venturi, Schubring, Salmi, Longhi and Berenson) but others preferred Andrea di Giusto (Morelli) or Domenico di Bartolo (Brandi) or an anonymous Florentine between 1430 and 1440 (Pittaluga,

Procacci, Meiss). Baldini, Berti, Parronchi and Ragghianti considered it to be by Masaccio. It was defined as the "first Renaissance tondo" by Berti, who with the others drew attention to the important innovations and the correct architectural perspective reflecting a greater knowledge and affirmation of the classicism of Brunelleschi. Here the Florentine idiom is evident in the colour sequences of the geometrical patterns on the walls of the building and in the court. This is in perfect classical harmony, and was to appear again in the stories of Fra Angelico and the architecture of Michelozzo in San Marco.

78,79. Plate of Nativity, putto and a
small dog
diam. 56 cm
Berlin-Dahlem, Gemäldegalerie

80. Michelozzo, Library of San Marco in
Florence

399

The Santa Maria Maggiore Polyptych

In 1428 Masaccio left Florence for Rome to work on the polyptych in Santa Maria Maggiore, interrupting for good the work on the Brancacci Chapel, but he only had time to begin the left hand side with the panel of *St Jerome and St John the Baptist* (now in London) before he died aged only 27.

Once again Masaccio and Masolino worked together, but this time Masolino had to finish the job alone. According to Vasari, Masaccio had acquired "great fame" in Rome, enough to be commissioned to paint a fresco for the cardinal of San Clemente, in the chapel with the stories of St Catherine. However some scholars (Venturi, Longhi and Berti with reservations) consider that Masaccio probably only had a hand in the sinopia of the *Crucifixion*, in the knights on the left.

The *Santa Maria Maggiore Polyptych* is no longer in its original place. The panels making up the front side were separated from the back ones, like those of the Duccio Maestà in Siena Cathedral. Although in the 17th century the six major panels were still in Rome in Palazzo Farnese, in the 18th century they were dispersed again for good.

According to a reconstruction of Clark based on the existing and recognised pieces, the central part of the triptych must have represented the episode of the *Foundation of the church of Santa Maria Maggiore*, with *St Jerome and St John the Baptist* on the left side and *St John the Evangelist and St Martin of Loreto* on the right. On the other side the *Assumption* was in the centre with *St Peter and St Paul* on the left and *St Liberio and St Matthias* on the right. The whole work was perhaps completed by three cuspidated elements and a predella. Of these, scholars believe that some components are recognisable: the *Crucifixion* in the Vatican Pinacoteca which was one of the central cusps, the *Burial of the Virgin* also in the Vatican and part of the predella and a *Marriage of the Virgin* once in the Artand de Montor Collection but lost during the last war.

The six major panels of the triptych are now scattered in various museums as follows: *St Jerome and St John the Baptist* and *St Liberio and St Matthias* in the London National Gallery; the *Foundation of Santa Maria Maggiore* and the *Assumption* in the Capodimonte Museum in Naples; *St Peter and St Paul* and *St John the Evangelist and St Martin of Loreto* in the Johnson Collection in Philadelphia. All these works are by Masolino, excluding the left hand panel with *St Jerome and St John the Baptist* which is by Masaccio. This attribution was made by Clark in 1951 and has been generally accepted by all critics, but a few scholars assigned it to Masolino or even Domenico Veneziano, dating it as late as the 1430's.

Dating varies from as early as 1422-23, on the occasion of the Holy Year of 1423 (Parronchi, Hartt) and coinciding with a first trip to Rome, to 1425-26 (Clark, Longhi, Bologna) and to 1428 (Salmi, Brandi, Procacci, Baldini, Mancinelli and Meiss, who had previously agreed on an earlier date). This last date would better explain his participation in this panel only. It would also fit in more satisfactorily with the style of the whole work which "constitutes a mature achievement of the collaboration between Masolino and Masaccio," since Masaccio's influence is distinctly noticeable even in the minor parts of the painting, such as the predella panel with the *Burial of the Virgin*. Whatever the event, this exceptional panel now in London is the only certain record left to us of Masaccio's activity in Rome. Attempts by critics to detect Masaccio's hand in the frescoes of the Chapel of Santa Caterina in San Clemente are still only a conjecture. Since the work in question, the *Crucifixion*, is badly damaged and the remaining traces are difficult to judge by, no definite conclusion can be reached.

Masaccio died in Rome. When the news of his death reached Florence, it made a great impression. Vasari reports that Filippo Brunelleschi "hearing of his death" said: "This is a very great loss for us."

81. St Jerome and St John the Baptist
114 x 55 cm
London, National Gallery

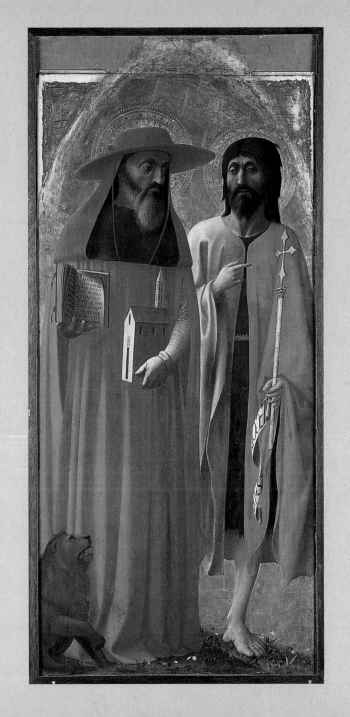

FRA ANGELICO

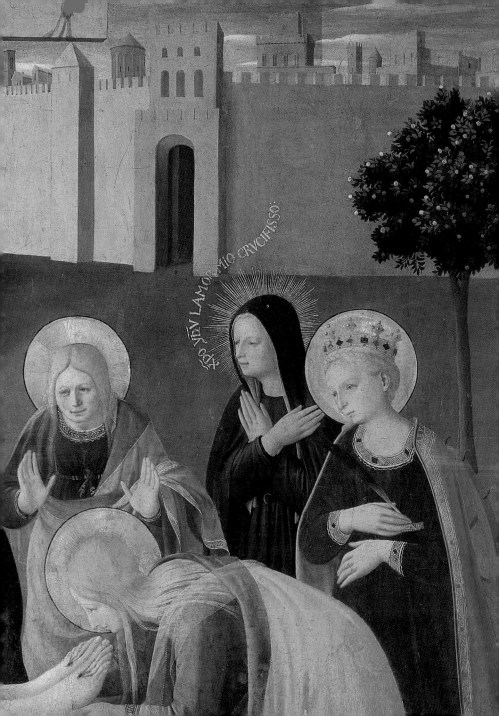

Life

The artist whom we know as Fra Angelico and who was known to his contemporaries as Fra Giovanni da Fiesole, was born in the Mugello in the vicinity of Vicchio, probably at San Michele a Ripecanina. According to Vasari, he was born in 1387 and received the Dominican habit in 1407 at the age of nineteen. But it can be shown that he was still a layman on 31 October 1417, when, as 'Guido di Piero dipintore del popolo di santo Michele bisdomini', he was proposed by a fellow artist, the miniaturist Battista di Biagio Sanguigni, for membership of the Compagnia di San Niccolò in the church of the Carmine in Florence. He is thus likely to have been born between 1395 and 1400, roughly ten years later than is indicated by Vasari. In January and February 1418, again as Guido di Piero, he was paid for an altarpiece for the Gherardini chapel in Santo Stefano al Ponte in Florence. The decoration of the chapel, like that of two earlier chapels in Santo Stefano, had been entrusted to Ambrogio di Baldese, and in the absence of other evidence it is tempting to suppose that Angelico was trained in Ambrogio di Baldese's workshop, and was initiated into miniature illumination by Sanguigni. Not till June 1423 does his name occur in the familiar form 'frate Giovanni di San Domenico di Fiesole', in connection with a painted Crucifix for the hospital of Santa Maria Nuova. During the first year of his novitiate he would have been prohibited from painting, and he must therefore have joined the community of San Domenico between 1418 and 1421.

On 22 October 1429 'frate Johannes petri de Muscello' was present at the capitular reunion of the brethren of San Domenico; he attended other capitular reunions in January 1431 and December 1432, in January 1433, when he was Vicario of the convent in the absence of the Prior, and in January 1435. Throughout this time Angelico's clerical status was no impediment to his fulfilling the obligations of a secular artist, and on 14 January 1434 we find him acting as assessor jointly with the Late Gothic painter Rossello di Jacopo for a painting produced by Bicci di Lorenzo and Stefano d'Antonio for San Niccolò Maggiore.

In 1435 a body of friars from the community at San Domenico took possession of the Florentine church of San Giorgio sulla Costa, and a year later, in January 1436, they were confirmed in the possession of the premises of San Marco, where, in 1438, the building of a new convent by Michelozzo was begun. Angelico was not among the friars who moved to San Giorgio sulla Costa in 1435 or to San Marco in the following year, but remained on as Vicario at Fiesole. The first evidence of his presence at San Marco dates from 22 August 1441. He attended a capitular meeting of the two communities in August of the following year, and in July 1445 signed the act separating the community at San Marco from that at San Domenico in the form: 'Ego frater Joannes de florencia assencio omnibus supradictis in cujus testimonium me manu propria subscripsi'. The probable inference is that Angelico retained his workshop at San Domenico till after 1440, when the painting of the high altarpiece for San Marco was well advanced and the frescoed decoration of the convent was begun, and thereafter transferred it to San Marco. In 1443 he was 'sindicho' of the convent, a post which seems to have involved some measure of financial control.

At an uncertain date, probably in the second half of 1445, Angelico was summoned to Rome by Pope Eugenius IV, who had lived in Florence for some years and was familiar with his work. During the summer of that year the archbishopric of Florence became vacant, and in August a number of names were recommended by the Signoria to the Pope. One of them was a member of the Medici family, Donato de' Medici, Bishop of Pistoia, another was a subdeacon and canon of the Cathedral in Florence, Giovanni di Neroni di Nisio, a third was the Bishop of Fiesole, Benozzo Federighi, a fourth was the Bishop of Volterra, Roberto Cavalcanti, and a fifth was the secretary of the Signoria, Canonico Andrea. For one reason or another the Pope disallowed these candidates, and six months later, on 9 January 1446, he appointed Fra Antonino Pierozzi, then Vicar of San Marco, as Archbishop. There is a persistent tradition first that before this decision was made, the archbishopric was offered to Angelico, and second that Angelico was instrumental in securing the appointment of Fra Antonino. When the process for the canonisation of Fra Antonino was under way in the first quarter of the sixteenth century, no less than six witnesses affirmed that this was so. There is no way of telling whether these statements should be given credence, but the fact that little more than half a century after his death the view entertained of Fra Angelico was of a man capable of administering an archdiocese and of tendering advice on the appointment to the Pope must be reflected in the judgements that we form of his intellectual capacity.

Angelico remained in Rome through 1446 and 1447 (when he was also active during the summer months in the Cathedral at Orvieto), returning to Florence at the end of 1449 or the beginning of 1450. By 10 June 1450 he was Prior of San Domenico at Fiesole. He retained the post for

the normal two-year period, and was still living at Fiesole in March 1452, when, according to the account books of the Duomo at Prato, the Provveditore of Prato Cathedral came to Florence bearing a letter to Sant'Antonino requesting that 'frate Giovanni da Fiesole maestro di dipingere' should undertake the painting of the choir of the Cathedral. Eight days later the Provveditore again visited Florence, this time to interview the painter who agreed to return with him to Prato to discuss the proposal with four deputies of the Cathedral and the Podestà. On the following day horses were hired to take 'el Frate che dipigne' to Prato and back to Fiesole. For reasons we can no longer reconstruct these conversations were inconclusive. On 1 April Angelico returned to Fiesole, and on 5 April the Provveditore was once more in Florence, seeking a painter and master of stained glass to decorate the choir. This time his quest was successful, and the contract for the frescoes was awarded to Fra Filippo Lippi.

After the Prato negotiations Fra Angelico disappears from view. He is mentioned on 2 December 1454, when it was prescribed that frescoes carried out in the Palazzo dei Priori at Perugia should be assessed either by him, or by Fra Filippo Lippi, or by Domenico Veneziano, that is by one of the three living Florentine painters who were most widely admired. In 1453 or 1454 he is thought to have gone back to Rome, but if he did so there is no indication of the work on which he was employed. He died in Rome in February 1455, a few weeks before his patron Pope Nicholas V.

The epitaphs for his tomb in the Dominican church of Santa Maria sopra Minerva were reputedly written by the humanist Lorenzo Valla. That on the wall, now lost, read: 'The glory, the mirror, the ornament of painters, Giovanni the Florentine is contained within this place. A religious, he was a brother of the holy order of St. Dominic, and was himself a true servant of God. His disciples bewail the loss of so great a master, for who will find another brush like his? His fatherland and his order lament the death of a consummate painter, who had no equal in his art'.

On the marble tomb-slab the body of the painter is shown in his habit in a Renaissance niche; beneath his feet is a second inscription:

'Here lies the venerable painter Fra Giovanni of the Order of Preachers. Let me not be praised because I seemed another Apelles, but because I gave all my riches, O Christ, to Thine. For some works survive on earth and others in heaven. The city of Florence, flower of Etruria, gave me, Giovanni, birth'.

Soon after his death, Angelico figures in the De Vita et Obitu B. Mariae of the Dominican, Domenico da Corella, as 'Angelicus pictor ... Iohannes nomine, non Iotto, non Cimabove minor', and later in the century he is mentioned

in a celebrated rhymed poem by Giovanni Santi between Gentile da Fabriano and Pisanello, and alongside Fra Filippo Lippi, Pesellino and Domenico Veneziano, as 'Giovan da Fiesole frate al bene ardente'. With the advent of Savonarola, for whom art was a means of spiritual propaganda, there developed a new attitude towards painting; and after Savonarola's death, his followers adopted Angelico, the friar artist, as the pivot around which their theories could revolve. Already in the first narrative account of the artist's life, a brief biography included in a volume of Dominican eulogies published by Leandro Alberti in 1517, is implicit the case that was formulated in the nineteenth century: that Angelico's superior stature as an artist was due to his superior stature as a man. Alberti's eulogy was one of the sources drawn on by Vasari when in 1550 he printed the first formal life of Fra Angelico. Another source was a Dominican friar, Fra Eustachio, who had received the habit from Savonarola, and who, as a man of almost eighty, transmitted to Vasari the conventual legends woven round the artists of San Marco. A fellow Dominican, Timoteo Bottonio, tells us how Vasari 'used often to come to gossip with this old man, from whom he obtained many beautiful details about these old illustrious artists'. From these and other sources Vasari built up his life. 'Fra Giovanni,' he writes, 'was a simple man and most holy in his habits.... He was most gentle and temperate, living chastely, removed from the cares of the world. He would often say that whoever practised art needed a quiet life and freedom from care, and that he who occupied himself with the things of Christ ought always to be with Christ.... I cannot bestow too much praise on this holy father, who was so humble and modest in all his works and conversation, so fluent and devout in his painting, the saints by his hand being more like those blessed beings than those of any other. Some say that Fra Giovanni never took up his brush without first making a prayer. He never made a Crucifix when the tears did not course down his cheeks, while the goodness of his sincere and great soul in religion may be seen from the attitudes of his figures'. In the mouths of nineteenth-century commentators Vasari's words take on a romantic overtone, and this reliance upon inspiration, these empathetic tears, these acts of faith have been recounted by many writers since. Such stories still fulfil the purpose for which they were designed, that of commending the artist's work to simple-minded people in search of spiritual nourishment. They have no contemporary sanction, but they should not be disregarded on that account. What cannot be denied is that the golden thread of faith does run through Angelico's work. There is no painter whose images are more exactly calculated to encourage meditation and to foster those moral values which lie at the centre of the spiritual life.

Early Works
1418-32

The earliest datable painting by Fra Angelico is a triptych in the Museo di San Marco, which was installed on the high altar of the convent church of San Pietro Martire in Florence before March 1429 and was probably completed in the preceding year. In the central panel the Virgin is seated on a gold-brocaded stool in front of a gold curtain, with the Child standing on her lap. Her body is not set frontally, but is slightly turned, with the right knee thrust forwards in the centre of the panel. Her heavily draped cloak is illuminated from the left, and the light falls on the orb held in the Child's left hand and on his raised right arm. No concession is made to decoration save in the gold-brocaded curtain behind the group, in the lion's feet beneath the stool, and in the edging of the Virgin's cloak, which is caught up at the bottom in a number of small folds.

Though a triptych, this is a reluctant triptych in that

the step beneath the Virgin's seat intrudes into the panels at the sides and the marble pavement at the sides extends into the central panel. That this was a purposive and not a casual device is proved by the four lateral saints. As in a conventional triptych their heads lie on a common horizontal, but the two outer saints stand slightly forward of those adjacent to the throne, and two of them, Saint John the Baptist on the left and Saint Thomas Aquinas on the extreme right, reveal, even more markedly than the central group, a concern with volume and plasticity. Both in the Virgin and the Baptist a debt to Masaccio is apparent, but the Masaccio whom they recall is the artist of the *Virgin and Child with Saint Anne*, not of the Pisa polyptych or the Brancacci Chapel.

An unusual feature of the altarpiece is that the area between the finials is filled with narrative scenes. They represent on the left Saint Peter Martyr preaching and

on the right the death of Saint Peter Martyr, and are
unified at the back by a curved line of trees which is
continued in two panels at the sides. Their date and
attribution have been questioned on more than one
occasion — they have been regarded as accretions to the
triptych by an imitator of Angelico, perhaps Benozzo
Gozzoli — but they must from the outset have formed
an integral part of the painting, and their style is wholly
consistent with that of the figures beneath. The firm
drawing of the pulpit and of the adjacent buildings in
the *Preaching of Saint Peter Martyr* and the triangular
formulation of the figures of the assassin and the slain
Saint anticipate the style of Angelico's predella panels in
the early fourteen-thirties. The views of the deserted
forest at the sides offer an intimation of the part that
nature was to play throughout his work.

A missal at San Marco (No. 558) made for Fiesole
about 1428-30, shows that Angelico was also active as a
miniaturist, but that he was largely unresponsive to the
decorative demands of book illustration, carrying the
style of his panel paintings over to the manuscript page.

Saint Peter Martyr triptych
1428-9
137x168 cm
Museo di San Marco, Florence.

(right)
Annunciation
c. 33v., Missal no. 558.
c 1430
Museo di San Marco, Florence.

(previous page)
*Virgin and Child Enthroned with Saints Thomas Aquinas,
Barnabas, Dominic and Peter Martyr (detail).*
c 1424-5
San Domenico, Fiesole.
*The Altarpiece was rebuilt and the landscape and architectural
details added by Lorenzo di Credi around 1501.*

408

Thus in the *Annunciation* (c. 33v.) the Virgin looks up at the Angel, who floats down towards her from the right, as though she were oblivious of the illuminated letter that impedes her view, while from the top of the initial a foreshortened God the Father drops the Holy Ghost on a gold cord plumb over her head. In a splendid page with the *Glorification of St. Dominic* five circles protrude from the initial I, four of them filled with solidly modelled saints, and the fifth with the scene of the *Meeting of St. Francis and St. Dominic*, treated with the weight of a small panel painting. At the top in a mandorla is the figure of St. Dominic accompanied by four flying angels, whose heads and bodies are lit with the same consistency as the figures in the triptych from San Pietro Martire. The most monumental of the miniatures is *The Virgin as Protectress of the Dominican Order* (c. 156v.), where the upper part of the initial S is filled by a frontal figure of the Virgin with arms outstretched, while below five kneeling Dominicans are grouped round the pink column of her robe.

In 1428, when the Saint Peter Martyr triptych was

executed, Angelico had been active as a painter for upwards of eleven years. The sequence of his works during that time is, and in the absence of further documents is likely to remain, a matter of hypothesis. The most important of them is an altarpiece for San Domenico. In 1418, when the Observant community returned to Fiesole after nine years of exile at Foligno and Cortona, the church and convent of San Domenico were re-endowed under the will of a rich merchant, Bernabò degli Agli, whose patron saint, St. Barnabas, was associated with the dedication of the church. A condition of this gift was that the convent should be rendered habitable within two years. On historical grounds, therefore, the altarpiece painted by Angelico for the high altar could have been painted at any time between 1418 and the dedication of the church in October 1435, but in practice it must date from the middle of the fourteen-twenties, three or four years before the painting of the triptych for San Pietro Martire. Some seventy-five years after it was finished, it was transformed by Lorenzo di Credi into a Renaissance

altarpiece in which the Virgin is shown beneath a baldacchino and the saints stand in an architectural setting before a landscape. In its original form it consisted, like the Saint Peter Martyr triptych, of three Gothic panels, that in the centre containing the Virgin and Child Enthroned with angels, and those at the sides with Saints Thomas Aquinas and Barnabas on the left and Saints Dominic and Peter Martyr on the right. It was completed with a predella, now in the National Gallery, London, showing the Risen Christ adored by saints, prophets, angels and members of the Dominican Order, and with ten pilaster panels, four of which, two in the Musée Condé at Chantilly and two in a private collection survive.

A decisive argument in favour of the view that the altarpiece precedes and does not, as is frequently assumed, follow the Saint Peter Martyr triptych is afforded by the space representation. The figures stand on a tiled pavement, which is solidly constructed in the shallow area before the throne but splays outwards in the lateral panels. This feature recurs, to cite two examples only, in an anonymous Florentine triptych of 1419, of which the central panel is at Cleveland, and in an altarpiece by the same artist with Saint Julian Enthroned at San Gimignano. The lateral saints are set on a single plane, the Saint Barnabas and Saint Peter Martyr turned slightly towards the Virgin and the Saint Dominic and Saint Thomas Aquinas posed frontally. The Virgin's head is thinner and more elegant than in the painting from San Pietro Martire, and the linear movement of her cloak is more pronounced, while the naked Child is shown reaching towards two flowers held in her raised right hand.

In Florence in the field of painting, the first half of the fourteen-twenties was a period of intense activity which is no longer fully reconstructible. In 1422 a painter from the Marches, Arcangelo di Cola, produced an important altarpiece for the Bardi chapel in Santa Lucia dei Magnoli. A year later another Marchigian artist, Gentile da Fabriano, completed the *Adoration of the Magi* for Santa Trinita, and thereafter started work on the Quaratesi polyptych for San Niccolò. In 1423 a polyptych for an unknown destination was painted by Masolino, of which only the central panel, at Bremen, survives, and this was followed, perhaps in 1424, by a triptych by the same artist for the Carnesecchi altar in Santa Maria Maggiore, of which the central panel is known from photographs and one of the lateral panels, with Saint Julian, is preserved. This phase reaches its climax in about 1425 in the more tactile style of Masolino's elaborate *Madonna* at Munich and in a work painted by Masaccio and Masolino for the church of Sant'Ambrogio, the *Virgin and Child with Saint Anne.* The central panel of Angelico's altarpiece for San Domenico shows some affinity to Masolino's Santa Maria Maggiore triptych, but the contrast in the decorative content of the two paintings is very marked. The cloak of Masolino's Virgin sweeps forward in impulsive, self-indulgent folds,

Assumption
c. 73v., Missal no. 558.
c 1430
Museo di San Marco, Florence.

(right)
Glorification of St. Dominic
c. 67v., Missal no. 558.
c 1430
Museo di San Marco, Florence.

Five circles protrude from the initial I, four of them filled with solidly modelled saints, and the fifth with the scene of the Meeting of St. Francis and St. Dominic.

In medio eccle

sic aperuit os

eius 7 impleuit

whereas that of Angelico's Madonna is handled with self-imposed restraint. More important for the structure of the painting is the influence of an artist whose preeminence was recognised by every progressive painter in the half-decade before the emergence of Masaccio, that of the sculptor Ghiberti. In Angelico's painting the carefully rendered throne is surrounded by eight angels, two kneeling in the foreground and the remaining six forming a niche behind the central group. This use of the principle of circularity is not a unique phenomenon but in every case it seems to go back to Ghiberti, and specifically to the stained glass window of the *Assumption of the Virgin* made from Ghiberti's cartoon in 1404-5 for the façade of the Cathedral, where the angels surrounding the massive figure of the Virgin establish the space in which the scene takes place.

The influence of Ghiberti was of continuing importance for Angelico, and so was that of an artist whose shadow also falls across the altarpiece, Gentile da Fabriano. From the time of his arrival in 1422 till his departure three or four years later, Gentile was the dominant painter in Florence, and the decorative splendour and restrained naturalism of his style could not but leave their mark on younger artists. Angelico's prime debt was to the Quaratesi polyptych, as can be seen clearly enough from the type of Angelico's Child in the San Domenico altarpiece, with distended cheeks and curly hair, and of the angels beside the throne. To exponents of the Dominican Observant aesthetic, the highly ornate style of Gentile's *Adoration of the Magi* would have been unacceptable, but the description of natural phenomena in its predella and in the predella of the Quaratesi altarpiece struck a responsive chord in Fra Angelico, and a decade later inspired the vivid lighting of the storm in the Linaiuoli *Martyrdom of Saint Mark.*

Angelico's development in the years which separate the Fiesole high altar from the Saint Peter Martyr triptych was rapid and is marked by the increasing influence of Masaccio over that of Gentile. His evolving concern with space and the increasing lucidity with which his images are formulated are illustrated in a *Virgin and Child* of unknown provenance in the Museo di San Marco. The central panel of a disassembled polyptych, it is based on the central panel of an altarpiece painted by Lorenzo Monaco for Monte Oliveto in 1406-10. The relationship is one of iconography rather than of style, and if the cartoons of the two paintings are compared, it will be found that in Angelico's the linear features of the Virgin's cloak are much reduced and the Child's pose is more erect. New features introduced into the scheme are a carefully rendered marble seat and step. The latter extends to the front plane, and looks forward to the more elaborate step in the central panel of the Linaiuoli tabernacle of 1433. Further proof of Angelico's new-found command of space is afforded by a small *Madonna and Child with twelve Angels* at Frankfurt, which uses some of the same motifs as the central panel of the Fiesole altarpiece, but is enriched by the intro-

duction of a beautifully rendered perspective throne raised on three steps with a hexagonal tabernacle over it. Though the architectural forms are less classical than those used by Ghiberti in the later panels of the first bronze door, the means by which they are portrayed, and the relation to them of the carefully spaced ring of angels, are deeply Ghibertesque.

Virgin and Child Enthroned
c 1430
189x81 cm
Museo di San Marco, Florence.

Madonna and Child with twelve Angels
c 1430
37x28 cm
Staedelsches Kunstinstitut, Frankfurt-am-Main.

The device of the receding rectangle used in the foreground of this *Madonna* is employed in a rather different form in the *Last Judgment* in the Museo di San Marco, which must have been painted about 1430 and may have been commissioned for the Oratorio degli Scolari in Santa Maria degli Angeli in the summer of 1431. The panel formed the upper part of a seat used by the priest during High Mass, and its shape for that reason is unorthodox. The upper lobe, containing the figure of Christ as judge, is extended at the base to form an oval mandorla framed by angels and flanked by the Virgin and St. John, with saints and apostles at the sides set on two shallow diagonals. Paradise and Hell are depicted in two rectangular extensions at the sides, and in the centre is the Resurrection of the Dead, unified by a perspective of open graves which carries the eye through the whole depth of the picture space to the pale blue horizon at the back. The only parallel for this device occurs on the Arca di San Zenobio of Ghiberti, and the system whereby it is projected is also found in Ghiberti, in the *Story of Isaac* on the Gate of Paradise. Angelico cannot have drawn directly on either of these models —

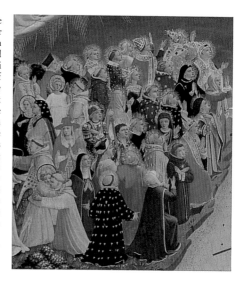

Last Judgment
c 1431
105x210 cm
Museo di San Marco, Florence.

414

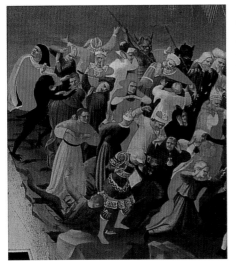

the relief of the *Miracle of St. Zenobius* dates from 1437, and the *Story of Isaac* was evolved at some time between 1429 and 1436 — but the analogies leave little doubt that Ghiberti must have been Angelico's mentor at this time. This applies also to the figures of the condemned, which recall those in the only scenes of violent action by Ghiberti that we know, the *Expulsion of the Money-Changers from the Temple* on the first bronze door and the *Arrest of the Baptist* on the Siena font. Impressive as is its design, it is debatable how far the panel was executed by Angelico. The Christ and the saints and apostles at the top must be in great part autograph, but the angels on the left are much inferior to those in the *Madonna* at Frankfurt and may be due to the assistant of Missal No. 558. The *Last Judgment* was not a major commission, and the decision to entrust part of its execution to members of the studio suggests that at the time Angelico must have been personally involved in the execution of some more important work. This was not the Linaiuoli triptych, which was commissioned in 1433, but the work that immediately precedes it, an altarpiece of the *Annunciation.*

(overleaf)
The Damned, detail from the Last Judgment.

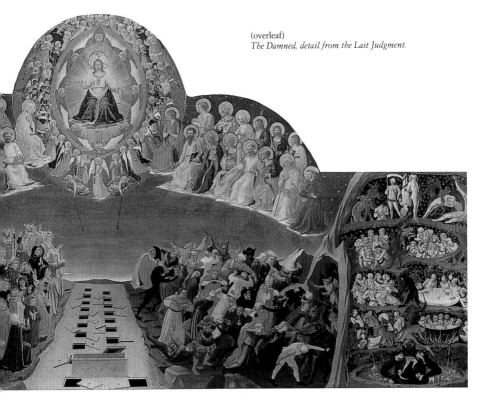

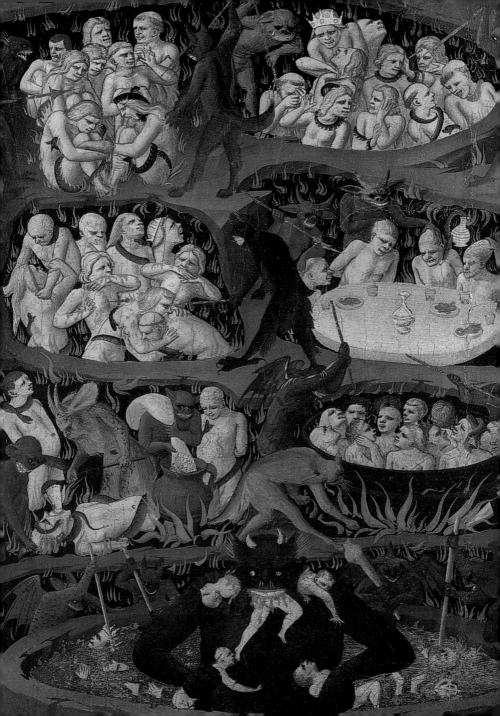

Panel Paintings and Frescoes
1432-8

In 1432 Angelico is known to have been at work on a painting of the *Annunciation* for the church of Sant'Alessandro at Brescia. Nothing further is known about the picture. It has been stated that it was delivered to Brescia and was destroyed, but there is no proof of its delivery nor indeed of its presence in the church. Moreover, eleven years later another painting of the *Annunciation* was commissioned for Sant'Alessandro, an altarpiece by Jacopo Bellini for which payments were made in 1443, and which is still preserved at Brescia. There is, however, one altarpiece of the *Annunciation* by Angelico, formerly in the Gesù at Cortona, now in the Museo Diocesano, which dates from these same years — it has been argued with great cogency that it was already in existence in 1433-4 — and it is possible that this is the painting planned for Brescia, which, for lack of funds or for some other reason, was diverted to a new recipient.

The *Annunciation* at Cortona is Angelico's first indubitable masterpiece and one of the greatest achievements of Florentine painting. The scene is set beneath a loggia closed on two sides by Brunelleschan columns and at the back by an arcaded wall. On the right the Virgin, her hands crossed on her breast, leans forward from her gold-brocaded seat, reciting the words of St. Luke inscribed in gold letters on the surface of the panel: 'Behold the handmaid of the Lord; be it unto me according to thy word'. Confronting her with a half-genuflection is the Angel, his forefinger raised in expostulation as his lips recite the sentence: 'The Holy Ghost shall come upon thee, and the power of the Highest shall overshadow thee'. A golden dove hovers over the Virgin's head. To the left is an enclosed garden with a symbolic palm-tree, and beyond it, at a point to which the eye of the spectator is directed by the pink cornice of the building, is the scene of the Expulsion from Paradise. The painting of the flesh of the two figures is richer than in any previous painting — particularly striking is the Masolino-like facture of the Virgin's hands — and the Angel's wings, so disposed that the forward tip falls in the exact centre of the panel, have a sweep and grandeur that are indeed miraculous.

Just as the altarpiece of the *Annunciation* painted by Simone Martini in 1333 dictated the treatment of this scene in Siena for more than half a century, so the Cortona altarpiece, with its pervasive sense of mystery, its gentle, symbolic lighting and its infectious earnestness, formed the source of countless adaptations and variants.

The predella of the Cortona *Annunciation* is in large part autograph, and contains five scenes from the life of the Virgin and two scenes from the legend of St. Dominic. Two of the most magical are the scenes of the *Visitation* and the *Presentation in the Temple*. In the former the Virgin and St. Elizabeth are isolated against a shady wall; on the left is a distant view over Lake Trasimene, and in front of it is a woman climbing up the hill, painted with such gravity that it has been ascribed, wrongly, to Piero della Francesca. Should any doubt remain that the Cortona altarpiece was planned before Angelico's next documented work, the Linaiuoli triptych, it can be set at rest by comparing the panels of the *Adoration of the Magi* in the centre of the two predellas. In the frieze-like *Adoration of the Magi* at Cortona the Virgin is seated on the right and the three Kings and their retinue are spread across the scene. In the Linaiuoli triptych, on the other hand, the composition is circular; the Virgin is seated on the right with two of the Magi kneeling in the foreground, and St. Joseph is shown in conversation with the third Magus behind. The notion that the Cortona panel could have been evolved after that of the Linaiuoli triptych runs counter to everything we know of Angelico's development.

The project for the triptych commissioned by the Arte dei Linaiuoli, or guild of flax-workers, for the Residenza of the guild in Piazza Sant'Andrea dates back to October 1432, when a wooden model for the tabernacle was prepared to the design of Ghiberti. A contract for the painting destined for the tabernacle, to be painted 'inside and out with gold, blue and silver of the best and finest that can be found', was awarded to Angelico on 2 July 1433, at a cost of 'one hundred and ninety gold florins for the whole and for his craftsmanship, or for as much less as his conscience shall deem it right to charge'. Its content was to correspond with a drawing, presumably prepared by the artist. The frame, with its arched central aperture, dictated the form of the painting, which consists of a central panel of the Virgin and Child enthroned between two mobile wings. On the inside of the wings (and therefore visible only when the triptych was open) are figures of the two Saints John; on the outside (and therefore visible only when the triptych was closed) are Saints Peter and Mark, scenes from whose legends are illustrated in the predella beneath.

If the Linaiuoli triptych were shown today in the Uffizi, and not in the Museo di San Marco, its exceptional size would register more strikingly; among panel

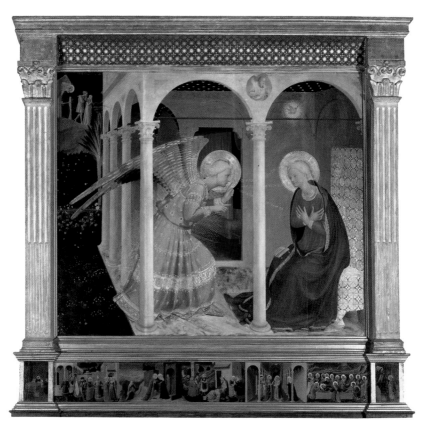

paintings it would be comparable only with Cimabue's high altarpiece from Santa Trinita and Duccio's *Rucellai Madonna*. In the first document relating to the tabernacle there is a reference to the position it was to occupy 'dove oggi è dipinta la figura di nostra donna'; and it may well be that the size of the tabernacle, and therefore of the painted panels, was determined by some dugento *Madonna* which they replaced. The scale of the four saints on the wings is greater than that of any other Florentine panel painting of the time. How then is Angelico's success in rendering them to be accounted for? The most likely explanation is that Ghiberti played a part in the designing not only of the frame but of the triptych as a whole. There is indeed a passage in the *Commentari* which may refer to this commission, in which Ghiberti describes the assistance he gave to painters and sculptors by providing them with models in wax and clay, and continues: 'etiandio chi avesse avuta affare figure grandi fuori del naturale forma, [ho io] dato le regole a condurle con perfetta misura'. The saints in the wings are an equivalent in painting for the statues of

Annunciation
c 1432-3
175x180 cm
Museo Diocesano, Cortona.
The Annunciation originally stood in the church of San Domenico at Cortona. It was moved to the Gesù in the nineteenth century and later installed in the Museo Diocesano.

(above right)
Expulsion from Paradise, detail from the Cortona Annunciation.

(right)
Visitation, from the predella of the Cortona Annunciation.

420

guild patrons on Or San Michele. Particularly striking is the calculated tri-dimensionality of the four figures, the Baptist, whose cross is held forward of his body, St. John the Evangelist, who extends his right hand in benediction and in his left holds a volume of the Gospels with its edge turned to the spectator, St. Mark, whose pose is established by the diagonals of the feet and of the foreshortened book, and St. Peter, whose volume of epistles is supported by both hands, the right held slightly forward of the body and the left thrust outwards beneath his cloak. The two inner figures may indeed be regarded as pictorial transcriptions of Ghiberti's *St. Matthew* and *St. Stephen*, and the outer figures as examples of the statues Ghiberti might have produced had he continued to practise as a monumental sculptor after 1429. The space structure of the much damaged central panel, however, proceeds logically from the painter's earlier works. At the bottom is a receding platform, which is boldly aligned on the front plane and has as its counterpart at the top a star-strewn roof like that in the Washington *Annunciation* of Masolino. The panel is surrounded by a wooden frame decorated with twelve music-making angels, which have become the most popular figures in Angelico's whole oeuvre. They are designed with greater freedom than the angels in the earlier works — so much so that we might once again suspect the intervention of Ghiberti — but are so much damaged that it is difficult to judge whether they were painted by Angelico or by a studio hand.

(above)
Adoration of the Magi, from the predella of the Cortona Annunciation.

(below)
Adoration of the Magi, from the predella of the Linaiuoli Tabernacle.

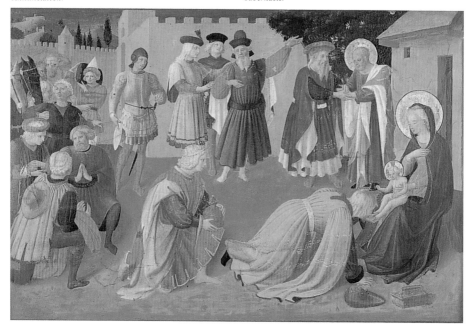

Linaiuoli Tabernacle
1433-5
260x330 cm
Museo di San Marco,
Florence.

What we do not know about the Linaiuoli triptych is the year in which it was installed, but if, as is likely, the main panels occupied Angelico for about two years, work on the predella may have been begun only in 1434 or 1435. The subject of the first panel is not the scene of St. Peter exhorting the faithful depicted by Masolino in the Brancacci Chapel but St. Peter dictating the Gospel of St. Mark. In the centre St. Peter preaches from an hexagonal wooden pulpit, and at the left in profile sits St. Mark taking down his words, with the assistance of a kneeling acolyte, who holds an ink-horn, and of two scribes, who carry the completed manuscript. The type of the Saint Peter seems to contain a conscious reference to the Saint Peter of Masaccio, and the realistic figures in profile framing the composition at the sides likewise recall the lateral figures of the *Saint Peter enthroned and the Raising of the Son of Theophilus* in the Brancacci Chapel. The spatial thrust is deeper than in any previous scene, and the buildings at the sides and in the background are more carefully defined. This too must be due to study of Masaccio. The corresponding panel on the right shows the body of St. Mark dragged in a hailstorm through the streets of Alexandria. Nothing in the artist's earlier work prepares us for this incomparably vivid scene. The figures are portrayed in violent action, with a repertory of gesture on which Angelico, when he came a few years later to portray the legend of Saints Cosmas and Damian in the San Marco altarpiece, made little significant advance; and one of them, the youth with arm raised pulling the body of the Saint, once more recalls Gentile da Fabriano. Still more remarkable is the depiction of the hailstorm and the lowering sky seen over the wall, which have a partial equivalent in Siena in Sassetta's *Miracle of the Snow* but none in Florentine painting. At the time he was working on these panels, in the middle fourteen-thirties, Angelico's must have been the most frequented Florentine studio — its only competitor was that of Fra Filippo Lippi — and it is thither that young artists like Piero della Francesca and Domenico Veneziano would have gravitated when they arrived in Florence. In the central panel of the Linaiuoli predella indeed there is one head, of a youth beside two horses, whose upturned face and flaxen hair suffused with light are painted with a pointilliste technique that is unlike Angelico's and could well be due to the young Piero.

Linaiuoli Tabernacle with the wings closed showing Saints Peter and Mark.

(above right)
Saint Peter dictating the Gospels of Saint Mark, from the predella of the Linaiuoli Tabernacle.

(below right)
Martyrdom of Saint Mark, from the predella of the Linaiuoli Tabernacle.

Lamentation over the dead Christ
1436
105x164 cm
Museo di San Marco, Florence

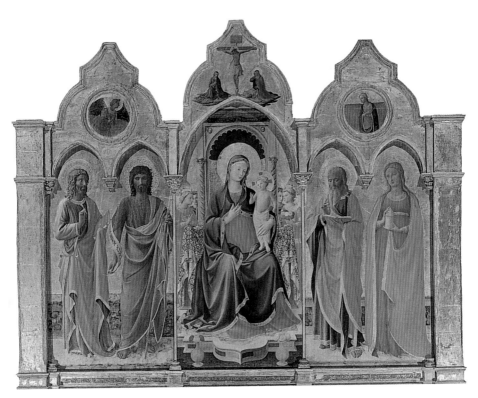

Virgin and Child Enthroned with Saints John the
Evangelist, John the Baptist, Mark (?) and Mary
Magdalen
c 1436
218x240 cm
Museo Diocesano, Cortona.
Painted for the church of San Domenico in
Cortona.

(left)
Virgin and Child Enthroned with Saints Dominic
and Nicholas of Bari
1437
Galleria Nazionale dell'Umbria, Perugia.
The centre and left-hand panels from the altarpiece
painted for the church of San Domenico in Perugia.

(right)
Saint Nicholas saves three men condemned to
execution, from the predella of the Perugia
polyptych.
Galleria Nazionale dell'Umbria, Perugia.

Angelico's next dated work is of a very different character. It is a painting of the *Lamentation over the dead Christ*, now in the Museo di San Marco, commissioned for the confraternity of Santa Maria della Croce al Tempio in April 1436 and completed in December of the same year. The donor, Fra Sebastiano di Jacopo Benintendi, was a nephew of the Beata Villana de' Botti, over whose relics the Confraternity held certain rights. According to a life of the Beata Villana extracted by Razzi from a volume of biographies of the Saints and Beati of the Dominican Order, she ardently aspired to share the sufferings of Christ, her celestial spouse, and 'in her visions had always before her mind the image of her Jesus Christ, beaten and crucified, whose torments she wished to emulate'. She is seen kneeling on the right, with the words CRISTO IESV LAMOR MIO CRVCIFISSO issuing from her mouth. Some of the figures are of inferior quality, but Angelico alone could have painted the elegiac landscape on the left. The long wall of the city of Jerusalem recalls the distant view of Florence on the right of Ghiberti's *Miracle of Saint Zenobius*.

From the following year, 1437, dates a polyptych painted for the chapel of St. Nicholas in the church of San Domenico at Perugia, now in the Galleria Nazionale dell'Umbria. Dismantled before the middle of the nineteenth century, its panels were later reintegrated in a modern frame; they are now shown unframed. Those parts that are autograph, the Virgin and Child in the centre and the fine figures of Saints Dominic and Nicholas of Bari on the left-hand side, are less monumental than the comparable figures of the Linaiuoli tabernacle. The St. John the Baptist and St. Catherine of Alexandria on the right are largely studio work. In the solidly constructed throne and the table covered with a cloth which runs behind each pair of Saints the artist attempts for the first time to escape from the tyranny of the gold ground. The predella panels are unlike those of the Linaiuoli tabernacle in that the scale of the figures is reduced. In the first panel, with the birth of St. Nicholas and St. Nicholas and the three maidens, the effect is a trifle tentative, but in the third, with St. Nicholas saving three men condemned to execution and the death of the Saint, the vanishing point of the city wall depicted on the left falls in the centre of the panel and the perspective of the chamber on the right converges on the friar behind the bier. By one of those strokes of sheer pictorial genius with which Angelico so often surprises us, the two scenes are illuminated from a common source, which irradiates the figures on the left and floods into the chamber on the right-hand side.

The qualitative standard by which the Perugia polyptych must be judged is established by an altarpiece painted for San Domenico at Cortona a year or two before, probably in 1436. Its form, a Gothic polyptych with pointed panels, remains faithful to that of the Fiesole high altar. The painting was transferred from its original wood panels in 1945, exposing in the process the underdrawing beneath. All the underdrawing is by a single hand and yields valuable information on the way in which Angelico's panels were built up. In each the forms are sketched in *terra verde* on the priming, the linear features, hair, eyelids, lips and nostrils being indicated with great refinement and subtlety. While the main areas of light and shadow are established, the volume of the completed figures is no more than hinted at. Not unnaturally the process of completion involved some coarsening of the linear qualities of the cartoon. In those figures that are autograph it is clear that Angelico himself deliberately sacrificed some of the delicacy of the initial image to recession and solidity.

The dilution of quality in the Perugia altarpiece and to a less extent in the polyptych at Cortona reflects the pressure under which the workshop at Fiesole was operating at this time. It was producing small autograph paintings, like the predella panel of the *Naming of the Baptist* in the Museo di San Marco where the figure style is strongly Ghibertesque. It was producing small paintings that are not autograph, like the three reliquary panels from Santa Maria Novella, now in the Museo di San Marco, which were painted for Fra Giovanni Masi before 1434. It was producing more substantial paintings, in which Angelico was responsible for the cartoons, but which were carried out with studio assistance. One of these is the beautiful *Coronation of the Virgin* in the Uffizi, which was painted about 1435 for Sant'Egidio and had as its predella two panels of the *Marriage* and *Dormition of the Virgin* in the Museo di San Marco. If we imagine these paintings drawn out by Angelico with the same exactness as the figures on the Cortona polyptych, and coloured partly by the artist and partly by assistants, we can understand readily enough why their execution is so unequal.

More important for our knowledge of Angelico are the frescoes which he executed for San Domenico at Fiesole at this time. Two of them, a *Virgin and Child with Saints Dominic and Thomas Aquinas*, formerly in the dormitory, and a *Christ on the Cross adored by Saint Dominic with the Virgin and Saint John*, formerly in the refectory, are now in Leningrad and Paris. A somewhat similar fresco of the *Virgin and Child with Saints Dominic and Peter Martyr* was painted by Angelico over the portal of San Domenico at Cortona, probably about 1438. In the history of conventual decoration the paintings from Fiesole mark a new departure in idiom and iconography. They are free from distraction and devoid of decorative accidentals, and in two of them the spectator, in the person of the founder of the Dominican order, participates in the holy scene. Presented with the minimum of incident, they are designed to be filled out by the religious imagination of the onlooker, and represent the first stage in the evolution of an art which was calculated to stimulate and to enrich the community's spiritual life.

Naming of Saint John the Baptist
26x24 cm
Museo di San Marco, Florence.
Part of the predella from an unidentified altarpiece, certainly
painted before 1435.

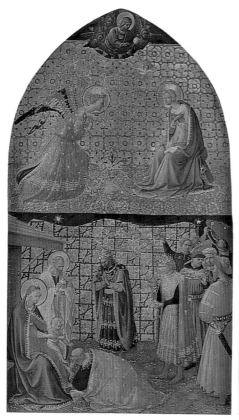

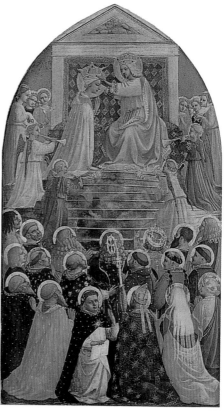

Annunciation and Adoration of the Magi
42x25 cm

Coronation of the Virgin
42x25 cm

Madonna della Stella
60x30 cm

These three reliquary panels in the Museo di San Marco, together with a fourth in the Isabella Stewart Gardner Museum, Boston, were painted in Angelico's workshop for Fra Giovanni Masi, sometime between 1430 and 1434.

Coronation of the Virgin
c 1435
112x114 cm
Uffizi, Florence.

Marriage of the Virgin
19x50 cm

Dormition of the Virgin
19x50 cm

These panels, in the Museo di San Marco, once
comprised the predella of the Uffizi Coronation.

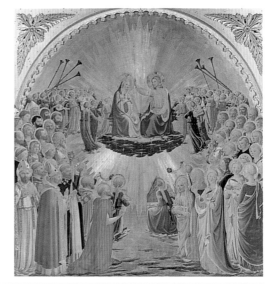

(overleaf)
Christ on the Cross adored by Saint Dominic
c 1435
435x260 cm
Louvre, Paris

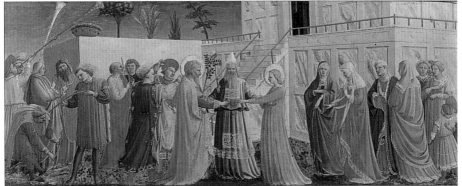

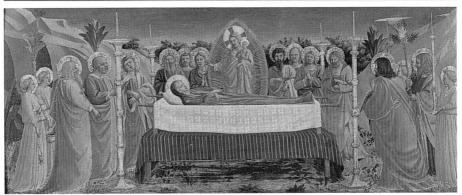

Frescoes at San Marco

The recall of Cosimo de' Medici to Florence in 1434 opened a new chapter in the history of the Dominican Observants at Fiesole. As early as 1420 Cosimo had exercised his patronage in favour of the reformed Franciscan convent of Bosco ai Frati, and two years after his return he obtained the assent of the Pope, Eugenius IV, then resident in Florence, to the requisitioning and handing over to the Observant Dominican community of the Silvestrine convent of San Marco. When the Dominicans took over the premises, the convent buildings were in ruins, and only the church was structurally sound. Since the Dominican title to the convent was contested by the Silvestrine community, rebuilding did not start till 1437, and for two years the friars were housed in damp cells and wooden huts. When the Council of Basle at length confirmed the Dominican claim to the convent, the task of reconstruction was begun, and from this time on work was pressed forward at the commission of the Medici by the architect and sculptor Michelozzo. The sequence of the buildings can be established with a fair measure of certainty from the *Cronaca di San Marco* compiled by Giuliano Lapaccini, a companion of Angelico who received the habit of the order at Fiesole in 1433 and in 1444 became Prior of San Marco. In 1439 the *cappella maggiore* of the church was finished, and by 1442 the church was ready to be dedicated. The convent premises were rebuilt at the same time. In 1438 twenty cells in the central dormitory over the refectory were rebuilt or repaired, and by 1443 all the cells on the upper floor, to a total of forty-four, were fit for habitation. Structural work in one part of the building or another continued until 1452. Close contact must have been maintained between Angelico and Michelozzo during the years in which the convent was being built. The fruits of this are to be found in the convent frescoes, where the settings depend for their effect upon the same unerring use of interval as do the cloister and library of Michelozzo.

Describing the most notable features of the convent Lapaccini mentions the Library (conspicuous alike for its great length and for its thirty-two benches of cypress wood), the residential buildings (so harmonious, yet so convenient), and the garden, and goes on: 'A third feature is the paintings. For the altarpiece of the high altar and the figures in the Sala del Capitolo and the first cloister and all the upper cells and the Crucifixion in the refectory are all painted by the brother of the Dominican Order from the convent at Fiesole, who had the highest mastery in the art of painting in Italy. He was called Brother Johannes Petri de Mugello, and was a man of the utmost modesty and of religious life'. The frescoes on the ground floor of the convent comprise a *Christ on the Cross adored by Saint Dominic* and five lunettes in the cloister and a large *Crucifixion with attendant Saints* in the Sala del Capitolo. A fresco of the *Crucifixion* in the refectory was destroyed in 1554. On the first floor there are three frescoes in the corridor (a *Christ on the Cross adored by Saint Dominic*, an *Annunciation*, and a *Virgin and Child with Saints*) and forty-three frescoes in the forty-five cells opening off it. All the frescoes on the ground floor are wholly or partly by Angelico. On the extent of his responsibility for the remaining frescoes a wide variety of views have been expressed, and at one time or another he has been charged with as many as forty-one and as few as six of the narrative scenes. The *Cronaca di San Marco* proves beyond all reasonable doubt that as early as 1457 (the terminal date for the completion of the chronicle) Angelico was credited with the entire fresco decoration of the convent as it then stood. But this view is sanctioned neither by examination of the frescoes nor by common sense, for the execution of so many frescoes in so short a time was beyond the capability of a single artist, and the frescoes themselves reveal the presence of three or four main hands. That the class of frescoes in the cells was ideated by Angelico and that Angelico himself supervised the decoration of the convent is not open to doubt, but frescoes for which he was directly responsible are vastly outnumbered by the scenes in which assistants were charged with executing his cartoons, or which were conceived by his disciples within the framework of his style.

The *Scenes from the Life of Christ* which decorate the cells follow no natural sequence. Frescoes whose subjects are inter-related are sometimes separated by the whole length of the corridor. The frescoes in the eleven cells on the east side of the corridor represent the *Noli Me Tangere*, the *Entombment*, the *Annunciation, Christ on the Cross with four Saints*, the *Nativity*, the *Transfiguration*, the *Mocking of Christ*, the *Resurrection*, the *Coronation of the Virgin*, the *Presentation in the Temple*, and the *Virgin and Child with two Saints*. With the exception of a fresco of the *Adoration of the Magi* in Cell 39 on the north-west corner of the building (which is considerably larger than the other cells, and was occupied by Cosimo de' Medici, Pope Eugenius IV, and

other distinguished visitors to the convent), these include the only frescoes in the cells for which a direct attribution to Angelico is warranted. Even these scenes vary appreciably in quality, but applying criteria based on his other works, we may credit Angelico with the design and execution of the *Noli Me Tangere* in Cell I, the *Annunciation* in Cell 3, the *Transfiguration* in Cell 6, the *Mocking of Christ* in Cell 7, the *Coronation of the Virgin* in Cell 9, and the *Presentation in the Temple* in Cell 10. The frescoes in Cells 2, 4, 5, 8 and 11 are by a single hand, the Master of Cell 2. All these five frescoes were executed under the general direction of Angelico, who possibly supplied small drawings for certain of the figure groups (the *Entombment* is a case in point), but was not responsible for the cartoons. An indication of the close association that must have existed between Angelico and his disciple is afforded by the presence in the *Maries at the Sepulchre* in Cell 8 of an angel's head painted by Angelico. The Master of Cell 2 seems to have been a member of the master's studio from the mid-thirties on, and was responsible for executing parts of the Croce al Tempio *Lamentation* and of the *Deposition* from Santa Trinita.

Christ as Pilgrim received by two Dominicans
c 1442
Cloister, San Marco, Florence.

(right)
Christ on the Cross adored by Saint Dominic
c 1442
Cloister, San Marco, Florence.

434

The frescoes in the cells on the inner side of the corridor overlooking the cloister are greatly inferior to the frescoes in the outer cells. Cells 15 to 23 (which housed members of the novitiate and were therefore of relatively little consequence) contain figures of *Christ on the Cross adored by Saint Dominic*, which depend from the frescoes of this subject by Angelico in the cloister beneath and by a studio assistant in the corridor; these are seemingly the work of a single artist, and maintain a level of undistinguished competence. They are followed, in Cells 24, 25, 26 and 27, by four scenes (the *Baptism of Christ, Christ on the Cross*, the *Man of Sorrows* and the *Flagellation*), which are almost certainly by the Master of Cell 2, but are less closely indebted to Angelico than the frescoes opposite. A fresco of *Christ carrying the Cross* in Cell 28 is by another hand, and the *Crucifixion* in Cell 29 is by Benozzo Gozzoli. Turning the corner, along the north side of the cloister, we come to six scenes by a single hand (*Christ in Limbo*, the *Sermon on the Mount*, the *Arrest of Christ*, the *Temptation of Christ*, the *Agony in the Garden* and the *Institution of the Eucharist*), where the loose grouping and curvilinear compositions are at variance with the frescoes in the earlier cells. Passing to Cells 36, 37 and 42, we find a *Christ nailed to the Cross* and two frescoes of the *Crucifixion with attendant Saints*, in which the style and spirit, if not the handling, once more conform to Angelico's intentions in the autograph frescoes. The author of these scenes followed Angelico to Rome in 1445, and was employed in the upper cycle of frescoes in the Vatican. He is likely to be identical with one of the

secondary artists listed in 1447 as members of the painter's Roman studio.

We do not know in what year the frescoes at San Marco were begun. From 1437 or 1438 Angelico's principal concern lay with the altarpiece for the high altar of the church, a work of great elaboration which reveals scarcely the least trace of studio assistance. If the altarpiece was finished only in 1440 or 1441, the painting of the frescoes may have started after this time. The single fixed point is that the large *Crucifixion* in the Sala del Capitolo seems to date from 1441-2. The fresco on the upper floor most closely related to it, the *Adoration of the Magi* in Cell 39, is likely also to date from 1442. The conjectural sequence which would most readily reconcile the style testimony of the frescoes with the known facts is that the first to be carried out were those in Cells 1 to 11, some of which are by Angelico and some of which were executed by a close assistant under his supervision. These may date from 1440-1. Thereafter the main focus of interest was the Sala del Capitolo, followed by the *Adoration of the Magi*. The frescoes in Cells 24 to 28, in which Angelico did not participate, may have been painted at this time. The frescoes over the doorways of the cloister, for which Angelico was himself responsible, seem to follow the *Crucifixion* in the Sala del Capitolo, and are in turn followed by what is probably the latest of Angelico's pre-Roman frescoes, the *Christ on the Cross adored by Saint Dominic* on the north wall of the cloister. There is no evidence whatever for the dating of the frescoes in Cells 31 to 37, and no indication whether they were executed before 1445,

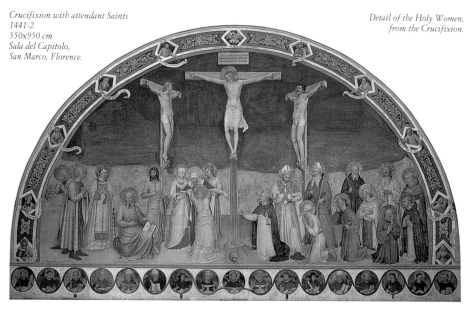

Crucifixion with attendant Saints
1441-2
550x950 cm
Sala del Capitolo,
San Marco, Florence.

Detail of the Holy Women,
from the Crucifixion.

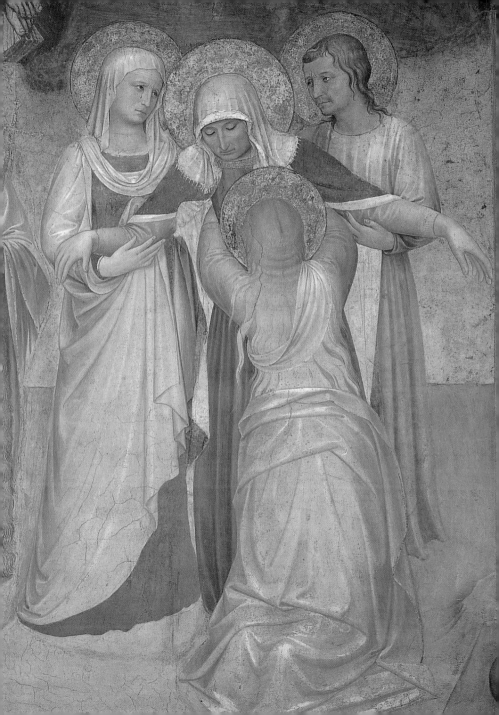

when Angelico was still in Florence, or after that year, when he was in Rome. Two frescoes in the upper corridor, the *Virgin and Child with Saints* and the *Annunciation*, are later in style than the remaining frescoes, and were probably painted in 1450 after his return.

The largest fresco in the cloister, that opposite the entrance, shows *Christ on the Cross adored by Saint Dominic*. Developed from the fresco from Fiesole in the Louvre, where the Saint is shown in profile and a less explicit and emotional relation is established with the figure on the Cross, it establishes the central theme of the frescoes on the upper as well as on the lower floor, the mystical participation of members of the Dominican Order, personified by the figure of their founder, in the life and sufferings of Christ. The shape of the fresco field was changed in the seventeenth century, when an irregular marble surround was added to it. By comparison with the fresco from Fiesole, the body of Christ is modelled more richly and with a new naturalism and tactility. The five lunettes in the cloister are in poor condition. Four of them, the *Saint Peter Martyr* enjoining silence above the entrance to the sacristy, the much abraded *Saint Dominic* holding out his rule, the *Saint Thomas Aquinas* with the *Summa* open on his breast, and the *Christ as Man of Sorrows*, are distinguished principally for their sense of volume and for the masterly placing of the figures on their grounds. The fifth, above the doorway of the hospice, shows *Christ as Pilgrim received by two Dominicans*. The lunettes, like the *Crucifixion* in the Louvre, are surrounded by carefully constructed illusionistic frames.

A work of greater intrinsic importance is the *Crucifixion* in the Sala del Capitolo. This large arched fresco fills the entire north wall of the room. Its programme emerges from the pages of Vasari, who relates how Angelico was instructed by Cosimo de' Medici 'to paint the Passion of Christ on a wall of the chapter-house. On one side are all the saints who have founded or been heads of religious orders, sorrowful and weeping at the foot of the Cross, the other side being occupied by St. Mark the Evangelist, the Mother of God, who has fainted on seeing the Saviour of the world crucified, the Maries who are supporting her, and Saints Cosmas and Damian, the former said to be a portrait of his friend Nanni d'Antonio di Banco, the sculptor. Beneath this work, in a frieze above the dado, he made a tree, at the foot of which is St. Dominic; and in some medallions, which are about the branches, are all the popes, cardinals, bishops, saints and masters of theology who had been members of the Order of the Friars Preachers up to that time. In this work he introduced many portraits, the friars helping him by sending for them to different places'. Like the Croce al Tempio *Lamentation*, the fresco at San Marco is a mystical representation of the Crucifixion and not a narrative scene. The figures of the crucified Christ, the women beneath the Cross, and the attendant saints (on the left Saints Cosmas and Damian, Lawrence, Mark and John the Baptist, on the right

Plan of the cells in the convent of San Marco

1. Noli Me Tangere
2. Entombment
3. Annunciation
4. Crucifixion
5. Nativity
6. Transfiguration
7. Mocking of Christ
8. Resurrection
9. Coronation of the Virgin
10. Presentation in the Temple
11. Virgin and Child with two Saints
12-14. Cells of Savonarola
15-23. Christ on the Cross adored by Saint Dominic
24. Baptism of Christ
25. Christ on the Cross
26. Man of Sorrows
27. Flagellation
28. Christ carrying the Cross
29. Crucifixion
30. Crucifixion
31. Christ in Limbo
32. Sermon on the Mount
32a. Arrest of Christ
33. Temptation of Christ
33a. Entry into Jerusalem
34. Agony in the Garden
35. Institution of the Eucharist
36. Christ nailed to the Cross
37. Crucifixion
38. Crucifixion
39. Adoration of the Magi
40-44. Crucifixion
a. Annunciation (page 70)
b. Christ on the Cross adored by Saint Dominic
c. Virgin and Child with Saints (page 70)

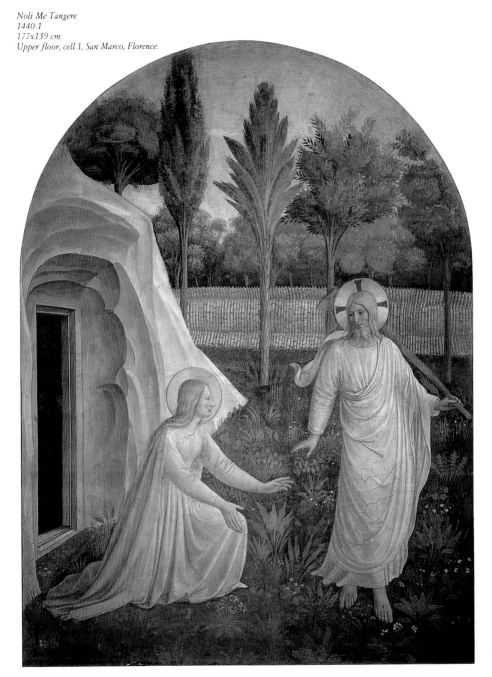

Noli Me Tangere
1440-1
177x139 cm
Upper floor, cell 1, San Marco, Florence.

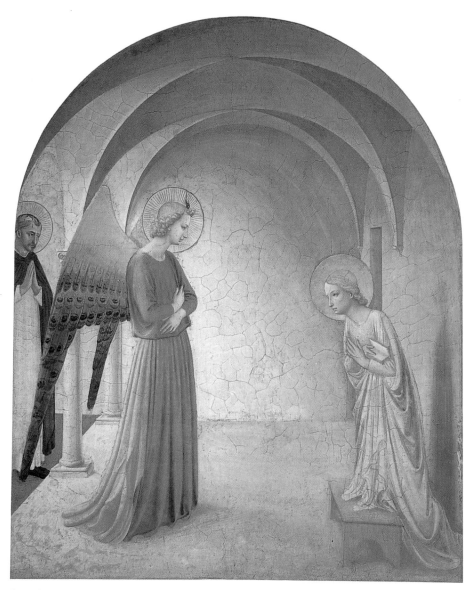

Saints Dominic, once more kneeling beneath the Cross, Ambrose, Jerome, Augustine, Francis, Benedict, Bernard, Giovanni Gualberto, Peter Martyr and Thomas Aquinas) are ranged along the front plane of the painting, and the single intimation of space is in the crosses of the two thieves, which recede diagonally into the dark ground. The vertical shaft of the Cross divides the fresco

Annunciation
1440-1
187x157 cm
Upper floor, cell 3, San Marco, Florence.

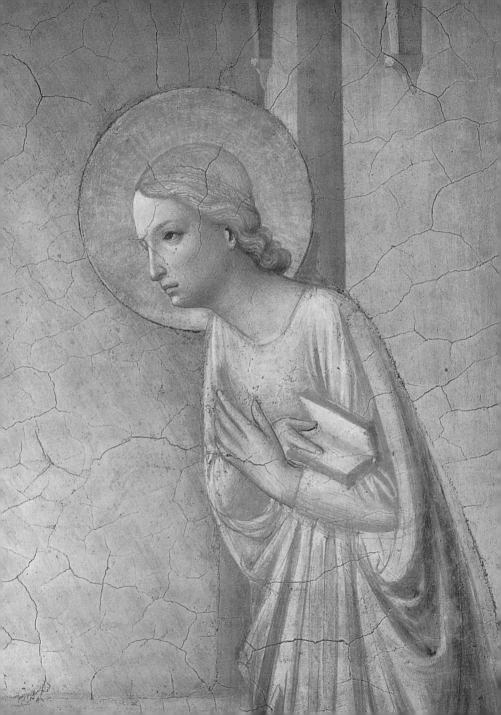

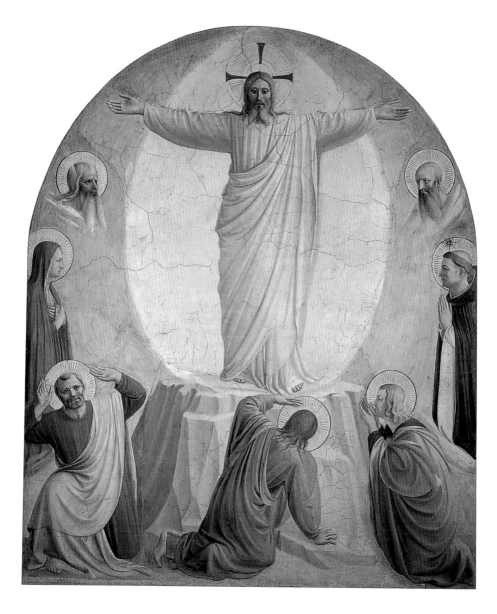

into two halves, and fills the whole height of the fresco
field. The theme of the painting is elaborated in in-
scriptions on the scrolls held by the prophets in the
decorative border surrounding the scene. Among these
are the VERE LANGORES NOSTROS IPSE TVLIT ET
DOLORES NOSTROS of Isaiah, the O VOS OMNES QUI

Transfiguration
1440-1
189x159
Upper floor, cell 6, San Marco, Florence.

442

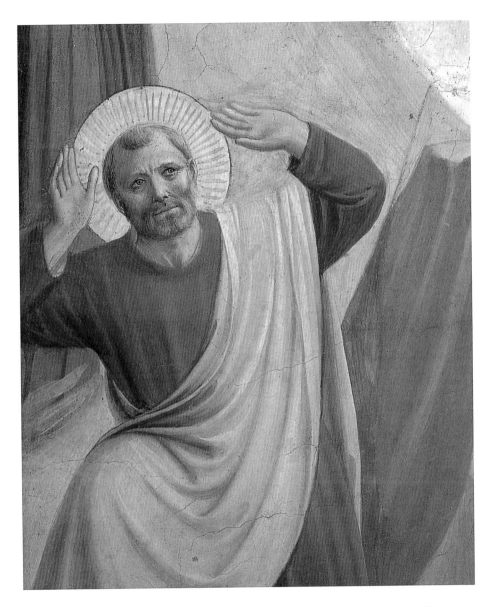

TRANSITE PER VIAM ATTENDITE SI EST DOLOR SICUT DOLOR MEUS of Jeremiah, and the QVIS DET DE CARNIBVS EIVS VT SATVREMVR of Job. An impressive exposition of an intellectual concept, the *Crucifixion* is not one of Angelico's most successful paintings, and owing in part to its condition (the original blue ground has been removed, leaving the figures like cut-out silhouettes on the restored red underpainting) and in part to the weight of its didactic scheme, it remains a manifesto which falls short of a great work of art.

Those who know the frescoes in the cells upstairs only from photographs miss their essential character. In

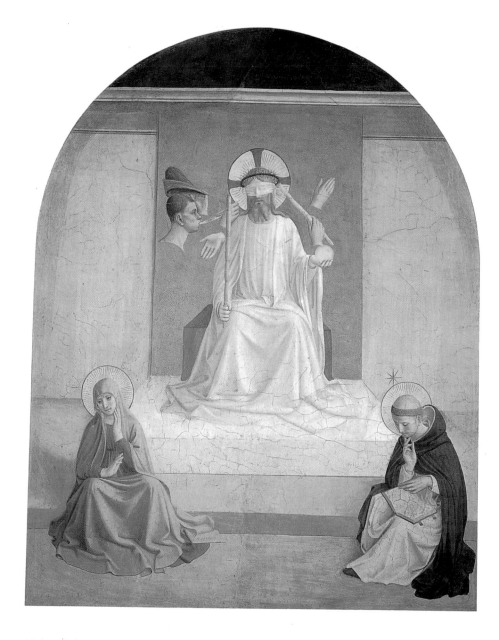

Mocking of Christ
1440-1
195x159 cm
Upper floor, cell 7, San Marco, Florence.

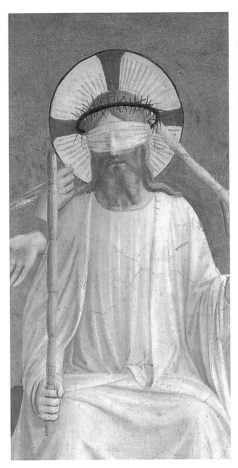

relation to the rooms in which they find themselves, most of the scenes (and all of those associable with Angelico) are relatively large in scale. In each case the scene is represented on the window wall opposite the door, and the wall thus contains two apertures, one opening on the physical and the other on the spiritual world. Dominating their austere surroundings, they were designed as aids to meditation, not as decoration, and were intended to secure for the mysteries they described a place in the forefront of the friar's mind by keeping them constantly before his eyes. In this respect they form a spiritual exercise. The cursory examination of the frescoes which we make as we walk from cell to cell today is the exact opposite of the use for which they were designed. At Fiesole the frescoed decoration of the convent seems to have been confined to public rooms, and we do not know to whom the decision to extend this

decoration to the cells occupied by individual friars was due. Perhaps its instigator was Fra Cipriano, the first prior of San Marco, perhaps Sant'Antonino, who recommends the contemplation of devotional pictures as one of the reasons why the faithful should pay frequent visits to a church. But it is indicative of Angelico's contribution to this conception that the simplest and sparsest of the frescoes in the cells are those for which he was responsible, while those in which he had no hand revert, by some process of natural attraction, to the norm of fresco painting.

One of the finest of the autograph frescoes on the upper floor is the *Annunciation* in the third cell. Here almost all the characteristic features of the *Annunciation* at Cortona and of the paintings based on it are abandoned in favour of a composition of the utmost

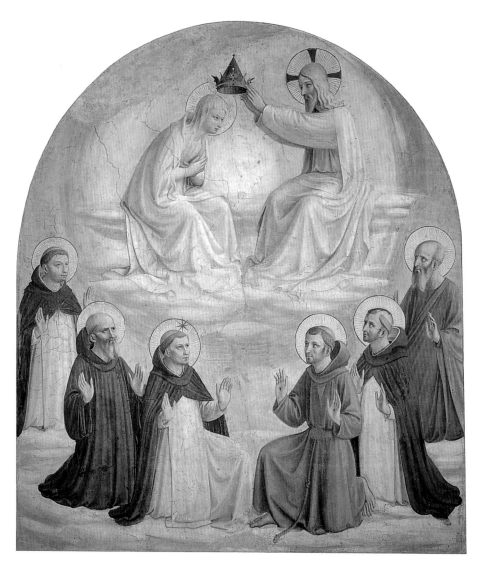

severity. Instead of the Brunelleschan loggia of the earlier painting, with its garden and doorway leading into another room, it depicts a cell-like chamber closed by a blind wall, which has the double function of providing a background for the figures and of discouraging the mind from straying from the confines of the scene. It is characteristic of a tendency to eliminate extraneous detail that even the capitals of the two columns are covered by the angel's wings. Alberti in his

Coronation of the Virgin
1440-1
189x159 cm
Upper floor, cell 9, San Marco, Florence.

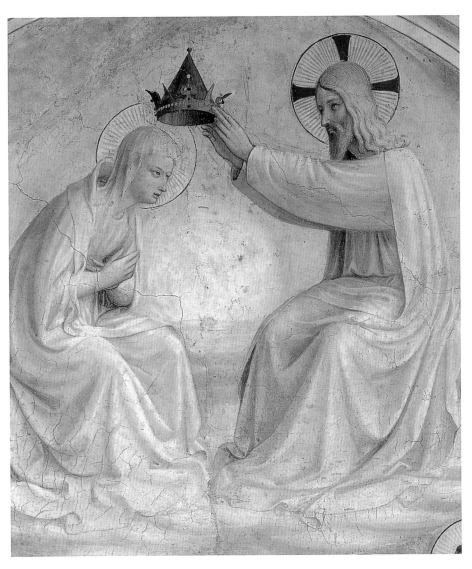

theory of architecture distinguishes between beauty and ornament, the one deriving from a system of harmonious proportion, the other consisting of the columns and other ancillary decorative features of the building. Angelico's consistent avoidance in the frescoes in the cells of architectural features which Alberti would have considered ornamental, and his rigid adherence to a system of visual harmony, suggests that at San Marco he may have had some such distinction in mind. The

Michelozzan vaulting above, realised with the finality of an abstract pattern, is not the least beautiful aspect of the fresco. In the figures the intimation of movement which contributes so much to the appeal of the earlier altarpiece is put aside, and the Virgin and Angel are treated like a sculptured group, restrained and motionless.

The *Noli Me Tangere* in the first cell follows the same compositional procedure as the *Annunciation*. Once again the visual interest of the scheme depends on the relation between two figures in repose, and once again a flat surface, in this case a wooden paling, is used to isolate the head of the main figure. In the foreground is a plethora of minutely observed and carefully rendered flowers, grasses and trees. This scene is the only one of Angelico's cell frescoes into which there obtrudes the interest in nature that we find in the *Deposition* altarpiece and other panel paintings. The sixth cell brings us to what is in some respects the greatest of the frescoes, the *Transfiguration*, where the majestic figure of Christ, with arms outstretched in a pose prefiguring the Crucifixion, is outlined against a wheel of light. Beneath this splendid sculptural figure, there crouch the three apostles in poses instinct with astonishment and awe. The heads of Moses and Elias beneath the arms of Christ illustrate very clearly the strength of modelling of which Angelico was capable. The *Mocking of Christ* shows the central figure seated, again in full face, against a rectangle of curtain, on which are depicted the symbols of his suffering. This use of emblematic iconography, for which precedents occur in the trecento, may have been dictated by the wish to avoid violent action and strong narrative interest in these frescoes. Few forms in the frescoes are realised with greater sureness and accomplishment than the white robe of Christ. Seated on a low step in the foreground are the contemplative figures of the Virgin and St. Dominic. The *Coronation of the Virgin* in the ninth cell is strikingly at variance with Angelico's earlier paintings of this theme, for the act of coronation is performed not, as in the painting in the Uffizi and the reliquary panel at San Marco, before a host of onlookers, but in isolation, with six kneeling saints who proclaim, but do not assist in, the main scene. Apart from these frescoes stands the much-restored lunette of the *Adoration of the Magi* in Cell 39. In design and handling this fresco is more closely related to the *Crucifixion* in the Sala del Capitolo than to the frescoes in the cells. Not only are the figures once more deployed in a frieze along the front plane of the painting, but certain of them seem to have been executed by the same assistant who was responsible for parts of the larger scene. This assistant has been plausibly identified with the young Benozzo Gozzoli. A number of the poses used in the *Adoration* are anticipated in the predella of the San Marco altarpiece, and both the elaborate, studied composition and the light, decorative palette of the fresco are more secular in spirit than those in the frescoes in the other cells.

Presentation in the Temple
1440-1
151x131 cm
Upper floor, cell 10, San Marco, Florence.

Below, before restoration.
Right, after restoration.

A campaign of restoration in the cells of the upper floor at San Marco, currently (1981) in progress, has uncovered the original splendour and intensity of Angelico's frescoes. His colours have proved brighter and of more subtle disposition than could have been imagined before cleaning, while the spatial content and the strength of modelling in the autograph scenes has become more than ever apparent, further accentuating the qualitative difference between the frescoes executed by Angelico and those done, entirely or in large part, by his assistants. The most dramatic change appeared in the cleaning of the Presentation in the Temple. Its repainted red background was removed, re-establishing the intervals of space between the figures and exposing the original architectural background of the scene, with a flaming altar between the Virgin and Saint Simeon. The figures of Saint Peter Martyr, the Beata Villana and the Infant Christ had been repainted before the middle of the nineteenth century, and have emerged as autograph creations of Fra Angelico.

(overleaf)
Saint Simeon with the Infant Christ, detail of the Presentation in the Temple, after restoration.

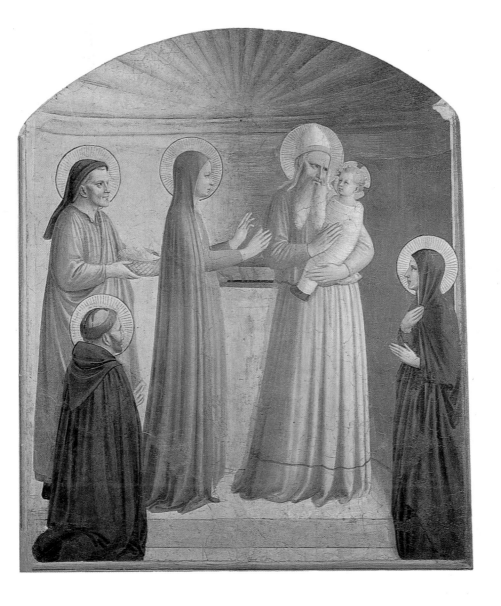

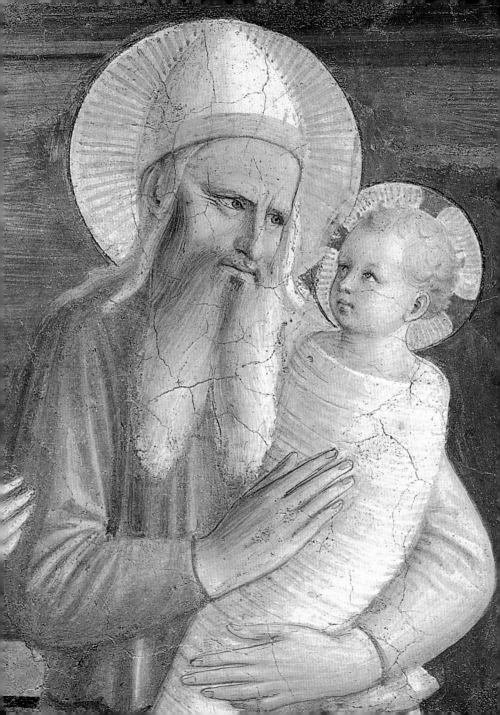

Panel Paintings
1438-45

The Dominican take-over at San Marco was by no means a simple operation. In addition to the Silvestrine claim to the convent, which was disallowed, a certain Mariotto de' Banchi exercised rights over the high altar and tribune of the church. In 1438 an arrangement was made whereby these were made over to the chapter and convent of San Marco, and were then presented by the community to Cosimo and Lorenzo de' Medici, who in turn paid a sum of five hundred ducats to the original owner. The Medici saints, Cosmas and Damian, were associated with St. Mark as titulars of the high altar. On the old altar there stood an altarpiece of the *Coronation of the Virgin* painted in 1402 by Lorenzo di Niccolò with a predella containing scenes from the lives of St. Mark and St. Benedict. It was agreed in 1438, at the instance of the Prior, Fra Cipriano, that this should be transferred to the convent of San Domenico at Cortona as a gift from Cosimo de' Medici, and in 1440 it was installed there, with the names of the Medici donors inscribed on it. The new high altarpiece was entrusted to Fra Angelico, presumably in 1438 when the decision was taken to do away with the old altar, and was not finished ('necdum perfecta erat') in 1440 when the old altar was moved. It must, however, have been completed before Epiphany 1443, when the church and high altar were dedicated, in the presence of Eugenius IV, by the Archbishop of Capua.

A letter written to Piero de' Medici by the young Domenico Veneziano in April 1438 refers to an altarpiece of great splendour which Cosimo was commissioning at that time. The passage reads: 'I have heard just now that Cosimo is determined to have executed, that is painted, an altarpiece, and requires magnificent work. This news pleases me much, and would please me still more if it were possible for you to ensure through your magnanimity that I painted it. If this comes about, I hope in God to show you marvellous things, even considering that there are good masters, like Fra Filippo and Fra Giovanni, who have much work to do'. In view of the coincidence of date, it is very possible that this letter refers to the San Marco altarpiece. Whether it does or not, there is abundant evidence that the commission was regarded as one of exceptional significance. Not only was it a Medicean manifesto, the most important commission for a painting placed by Cosimo de' Medici up to that time, it was also the cynosure of the principal Dominican Observant church in Florence. It had, moreover, one other unusual aspect,

that the architectural setting for which it was destined was under construction at the time the altarpiece was planned. The picture, or rather the complex of paintings, that resulted was a truly revolutionary work.

There are two impediments to an appreciation of the painting. The first is that a number of devices which appear in it for the first time were copied in many later paintings. The carpet in the foreground and the figures kneeling on it recur in the San Giusto alle Mura altarpiece of Ghirlandaio. The line of cypresses and palm trees seen at the back behind the wall was imitated by Baldovinetti in the Cafaggiolo altarpiece in the Uffizi. The looped gold curtains, which enclose the foreground like a proscenium arch, were adopted by Raffaellino del Garbo and Verrocchio. As we look at the main panel we have forcibly to remind ourselves that when it was conceived these expedients were original. The second impediment is that of physical condition; at some time in the past the surface was cleaned with an abrasive, and it is very difficult today to form a clear impression of its drawing, lighting or tonality. What is immediately apparent is that its spatial content is greater than that of any previous altarpiece. Whereas the *Madonna* of the Linaiuoli triptych fills a deep cupboard in the centre of the painting and the Saints in the Perugia polyptych are fortified by the presence of a table at the back which divorces them from their gold ground, in the San Marco altarpiece monumental use is for the first time made of advanced constructional principles. It is projected from a high viewing point, roughly in the centre of the panel, and the orthogonals of the beautifully rendered Anatolian carpet and the steep perspective of the cornice of the throne converge to a vanishing point in the main group. The recession of the unprecedentedly extensive foreground is established by the diminishing pattern of the carpet and by Saints Cosmas and Damian, who kneel in the front plane, one directing his gaze to the spectator and the other facing towards the Child. The planes which separate them from the throne are demarcated by three figures on each side, on the left St. Lawrence with hand raised in wonder and Saints John the Evangelist and Mark in conversation, and on the right St. Francis praying in profile between Saints Peter Martyr and Dominic. In the middle distance, in front of a gold-brocaded curtain, are set the Virgin and Child, flanked by four angels at each side. Behind the angels runs a wall covered with woven fabric, over which we see two palm trees and a grove of cedars and cypresses and between their trunks what must have been the most beautiful of

San Marco Altarpiece
1438-40
220 x 227 cm
Museo di San Marco, Florence.

Saint Cosmas, detail from the San Marco Altarpiece.

Angelico's landscapes. Though the perspective devices are unostentatious — much more so than in the emphatic shallow structure of contemporary paintings by Fra Filippo Lippi like the *Coronation of the Virgin* in the Uffizi and the Barbadori altarpiece in the Louvre — they achieve a continuum of space greater than that in any earlier altarpiece. Of the lighting which once softened and unified the figures no more than a faint indication survives.

Two other aspects of the painting deserve mention. The first (which is best analysed by a Dominican scholar) is its programme. The volume of the Gospels held by St. Mark is open at Chapter VI, 2-8, which begins with the description of Christ teaching in the synagogue, and how his auditors 'were astonished, saying, From whence hath this man these things? And what wisdom is this which is given unto him, that even such mighty works are wrought by his hands?', and which close with an injunction to the apostles 'that they should take nothing for their journey save a staff only; no scrip, no bread, no money in their purse'. On the left, two of the saints reflect the astonishment of Christ's hearers in the synagogue, and opposite are representatives of the two ord-

Saints Cosmas and Damian and their Brothers before Lycias
38x45 cm
Alte Pinakothek, Munich.
From the predella of the San Marco Altarpiece.

(right)
Decapitation of Saints Cosmas and Damian
36x46 cm
Louvre, Paris.
From the predella of the San Marco Altarpiece.

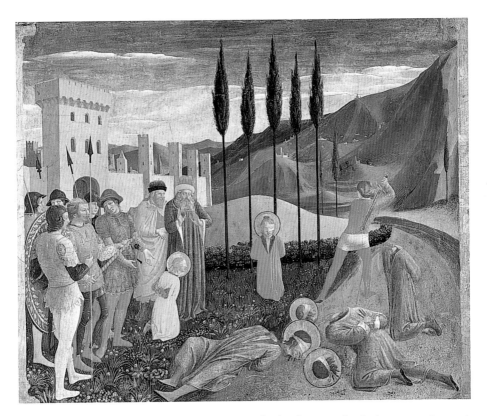

ers which observed the rule of apostolic poverty. Round the edge of the Virgin's robe is a quotation from *Ecclesiastes*, and *Ecclesiastes* is again the source of the palm-trees, cedars and cypresses at the back and of the rose garlands which hang behind the curtains at the front. The second aspect of the altarpiece that should be noted is its highly charged emotional character. The only area in which some impression of this can still be gained is the head of Saint Cosmas, which strikes a note of pathos that is absent from earlier Renaissance paintings. Its implications are underlined in the small *Crucifixion* at the base, which originally surmounted the central panel of the predella with the *Lamentation over the dead Christ.*

The artistic complexion of the altarpiece can be read more clearly in the predella panels, of which all but the first, the *Healing of Palladia by Saints Cosmas and Damian* in Washington, are well preserved. Probably the panels were painted in the sequence in which they stood on the altar, the *Saints before Lycias*, the *Lycias Possessed by Devils*, and the *Crucifixion of Saints Cosmas and Damian* in Munich, and the *Attempted Martyrdom of Saints Cosmas and Damian by Fire* in Dublin following the panel in Washington. At this time Angelico mastered

or developed a system of projection more consistent and more advanced than that used in his earlier works. The device of a flat surface parallel with the front plane of the painting is an indispensable feature of the panels. In the *Decapitation of Saints Cosmas and Damian*, it is established not by architecture, but by a row of cypress trees. The distant city on the left recalls that in the St. Nicholas predella at Perugia, but since the scene is lit from the right not from the left, those faces of the wall which were in shadow in Perugia are brightly lit and those faces which were illuminated are in shadow. Structurally the most remarkable of the narrative scenes is the *Burial Saints Cosmas and Damian*, where the grave is represented in perspective, like the open graves in the *Last Judgment*, but is integrated in an architectural scheme of great complexity, which anticipates that of Domenico Veneziano's *Miracle of St. Zenobius.* Along with the last scene, the *Dream of the Deacon Justinian*, it represents the summit of spatial sophistication achieved in Angelico's pre-Roman works.

Somewhat apart from the narrative panels stands that in the centre with the *Lamentation over the dead Christ*, which is conceived with an incomparable combination

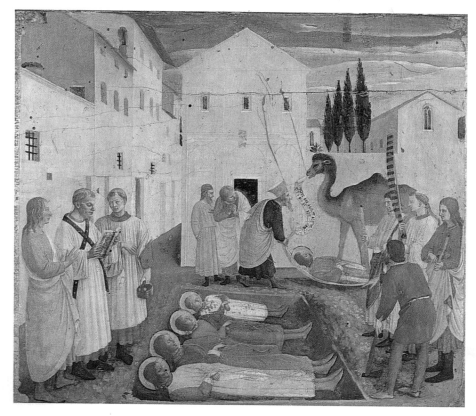

of logic and sentiment. The flat plane is here established by a rectangular void over the tomb, against which Christ's body supported by Nicodemus, is shown with arms raised horizontally by the adoring figures of the Virgin and St. John. Under it is the receding rectangle of the winding sheet, where the delicate naturalism of the folds and of the shadow cast by Christ's body surpasses that in any earlier work. Like the companion panels, the scene is illuminated from the right, but from a lower level, so that the beautifully rendered torso and the upper surfaces of the hands and forearms are strongly lit.

In the first half of the fourteen-forties the style of the San Marco predella was deployed on a larger scale in an altarpiece of the *Deposition*, now in the Museo di San Marco, executed for the Strozzi chapel in Santa Trinita. Painted on a single panel, the *Deposition* is surmounted by three finials by Lorenzo Monaco. In shape it recalls another altarpiece painted for Santa Trinita, the *Adoration of the Magi* of Gentile da Fabriano, and this, in conjunction with Lorenzo Monaco's close association with the church, suggests that it may originally have been commissioned from the older artist. Though the

Burial of Saints Cosmas and Damian
37 x 45 cm
Museo di San Marco, Florence.
From the predella of the San Marco Altarpiece.

(right)
Dream of the Deacon Justinian
37x45 cm
Museo di San Marco, Florence.
From the predella of the San Marco Altarpiece.

composition is deployed across the entire panel, the figures fall into three separate groups. In the centre the body of Christ is let down from the cross. As in the *Lamentation* panel from the San Marco altarpiece, the Christ is shown with arms outstretched, filling the whole of the centre of the scene. One of the two figures letting down the body, the Nicodemus, is said by Vasari to represent the architect Michelozzo. But if Michelozzo is portrayed, this is more probably in the head of a man wearing a black *cappuccio* below the Christ's right arm. Beneath, the body is received by an older male figure and by St. John. The group is completed by the Magdalen, kissing the feet of Christ, and by a kneeling Beato, perhaps the Beato Alessio degli Strozzi. Like the kneeling saints of the San Marco altarpiece, this figure, with eyes fixed on the central group and hand extended towards the onlooker, marks the transition from the real world of the spectator to the false world of the picture space. In the halo of Christ appears the words CORONA GLORIE, and below is a quotation from the eighty-seventh Psalm: ESTIMATVS SVM CVM DESCENDENTIBVS IN LACVM. To the left are the holy women, in their

centre the Virgin kneeling behind the winding sheet, and on the right is a group of male figures, one of whom exhibits the nails and crown of thorns. In the halo of the Virgin are the words: VIRGO MARIA N(ON) E(ST) T(IBI) SIMILIS, and beneath is the inscription: PLANGENT EVM QVASI VNIGENITVM QVIA INOCENS, while under the right side of the painting appears the verse: ECCE QVOMODO MORITVR IVSTVS ET NEMO PERCIPIT CORDE. The deliberate avoidance of the realistic detail proper to a normal narrative of the Deposition, the tender gestures with which the figures in the centre perform their ritual, and the restraint of the spectators, consumed by inner sorrow which finds expression in sympathetic lassitude rather than in rhetoric, are explained by the inscriptions, which lend the painting the character of a homily rather than of a narrative. The crown of glory won by the sacrifice of Christ, the sorrow of the Virgin with which no human sorrow can compare, the lament of the women for the innocent victim on the Cross as for their only sons, and the body of the Saviour, instinct with the promise of the Resurrection, — all these are phases in a meditation on the sufferings of Christ.

Lamentation over the dead Christ
38x46 cm
Alte Pinakothek, Munich.
The centre panel from the predella of
the San Marco Altarpiece.

459

The *Deposition* is at the same time a work of great intellectual inventiveness. Confronted by the Gothic panel prepared for Lorenzo Monaco, Angelico fills it with a composition which makes scarcely the least concession to its form. At the sides the scene is closed by standing figures whose verticality is accentuated on the left by the tower of a distant building and on the right by a tree. In the centre likewise the design is strongly vertical, and is established by the ladders standing against the Cross, by the right arm of Nicodemus lowering the body, and by the upright figure of Saint John. The body of Christ is set diagonally against the flat plane of the ladders, with the arms on an opposite diagonal and the head resting on the left shoulder, so that the long bridge of the nose is depicted horizontally, parallel to the steps of the ladders and the arms of the Cross.

An interesting feature of this painting are the intact pilasters, which are painted on the front and sides with

Deposition
176x185 cm
Museo di San Marco, Florence.
Painted for the Strozzi chapel in Santa Trinita around 1443,
on a panel left unfinished by Lorenzo Monaco perhaps
twenty-five years before.

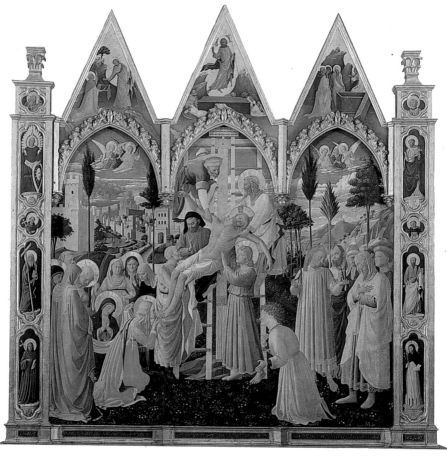

twelve full-length figures of saints and eight medallions. The saints stand on gilded plinths, which are adjusted to the place they were designed to occupy. Thus on the left pilaster at the front the plinth of St. Michael is depicted from beneath, with the upper surface hidden, and in that of St. Andrew, in the centre, part of the upper surface is shown, while the lowest, that of San Giovanni Gualberto, is represented from above.

Immediately before he left for Rome, Angelico seems to have undertaken a second Medicean altarpiece. Now in the Museo di San Marco it shows the Virgin and Child with Saints Peter Martyr, Francis, Lawrence, John the Evangelist and Cosmas and Damian, and is commonly known as the Annalena altarpiece. The Dominican convent of San Vincenzo d'Annalena was, however, founded only in 1450, was not rebuilt till 1453, and had no substantial oratory till after 1455, and we are bound therefore to suppose that the painting was commission-ed for some other purpose and was transferred to the convent in the fourteen-fifties after the painter's death. Support for this view is afforded by the fact that the altarpiece omits the Saints, Vincent Ferrer and Stephen, to whom the convent church was dedicated. It has repeatedly been claimed that the altarpiece was painted in the fourteen-thirties and precedes the high altar of San Marco. For a number of reasons this cannot be correct. First, the concentrated composition must follow, and not precede, that of the San Marco altarpiece. The system of projection used in it is essentially the same, and one device, the use of a curtain stretched across the back to isolate the figures, is common to both paintings, but in the Annalena altarpiece the front step of the throne is extended to a forward plane, and the six saints are grouped on two levels at the sides. Second, the architectural background, with its central tabernacle and arcaded wall unified by a common moulding at the top,

would be inexplicable in the context of the Cortona and Perugia polyptychs. Third, the predella, originally consisting of a central *Pietà* and of eight scenes from the legend of Saints Cosmas and Damian, of which seven survive, though not designed or executed by Angelico, makes use, in the figures on the left of the *Saints before Lycias*, in the onlookers at the back of the *Attempted Martyrdom by Fire*, and in the winding river of the *Decapitation* scene, of motifs which are manifestly drawn from the predella of the San Marco altarpiece. The fact that Angelico did not himself intervene in the predella, even to the extent of supplying the cartoons, suggests that at the time he moved to Rome only the main panel can have been complete.

Annalena Altarpiece
1443-5
180x202 cm
Museo di San Marco, Florence.

Rome
1445-9

In the second half of 1445 Angelico was summoned to Rome by Pope Eugenius IV to undertake frescoes in the Vatican. A sponsor of the Observant Movement, the Pope had lived for upwards of nine years in Florence, and in 1443 was himself present at the consecration of San Marco, when 'for the consolation of the friars in the convent he remained there the whole day, and spent the night in sleep in the first cell looking over the second cloister, which is now called the cell of Cosimo'. Whether or not the *Adoration of the Magi* in this cell was completed at the time of the Pope's visit, Eugenius must have been familiar with the painter and with his works in Florence.

The Rome of 1445 was no longer the desolate city to which Pope Martin V had returned a quarter of a century before. The pagan Pantheon had been restored, and a long line of artists from Central and North Italy — Masaccio and Masolino in San Clemente and Santa Maria Maggiore, Gentile da Fabriano and Pisanello in the Lateran basilica, Donatello and Filarete in St. Peter's — had left their mark upon its monuments. The Vatican, however, was not as yet the main focus of . activity for artists in the papal city, and the work in the palace carried out by Fra Angelico forms the opening phase in a campaign of decoration and improvement that was to be pursued uninterruptedly until the Sack of Rome. At the Dominican convent of Santa Maria sopra Minerva, where he resided while in Rome, Angelico may have come in contact with the painter Jean Fouquet who was engaged at some uncertain date between the autumn of 1443 and the winter of 1446 in painting a portrait of Eugenius IV to commemorate the Pope's election at a conclave held in the convent in 1431.

Eugenius IV died on 23 February 1447, and his successor Nicholas V was elected Pope on 6 March. There is no direct evidence as to the task on which Angelico was engaged in 1445 and 1446, but the documents referring to Angelico's work in the Vatican under the new Pope are more explicit than some writers on the artist have supposed. Between 9 May and 1 June 1447 three documents refer to payments for the only surviving work painted by Angelico in Rome, the frescoed decoration of the Chapel of Nicholas V in the Vatican. On 11 May an arrangement was made, no doubt with the Pope's sanction, whereby Angelico spent the summer months at Orvieto, decorating the Cappella di San Brizio in the Cathedral. During June, July, August and the first half of September the master and his assistants were employed upon this work. The decoration of the Chapel was probably completed by the end of 1448, for by 1 January 1449 Angelico was engaged on another apartment in the Vatican, the 'studio di N.S.' or study of Nicholas V. This room, which had the double function of workroom and library, seems to have been adjacent to the chapel. Work in the study must have been less extensive than in the chapel, and it appears to have been well advanced by June 1449, when Gozzoli, Angelico's principal assistant, returned to Orvieto, and to have been completed by the end of the year or the first months of 1450 when Angelico returned to Florence.

Throughout his years in Rome Angelico must have been on terms of intimacy with the Pope in whose apartments he was employed. As Tommaso Parentucelli, Nicholas V had won fame as a scholar and bibliophile, and during his pontificate the papal court at Rome became a centre of humanistic studies. 'All the scholars of the world', writes Vespasiano da Bisticci, 'came to Rome in the time of Pope Nicholas, some of them on their own initiative, others at his invitation since he wished to see them at his court'. 'Under what pontiff', asks Birago in his *Strategicon adversus Turcos*, 'was this throne more splendid or magnificent?' The humanistic interests of Nicholas V found expression in his patronage of architecture and in his conservation of the monuments of Rome, and led to the commissioning of Piero della Francesca's lost frescoes in the Vatican. In addition to Angelico, two Umbrian painters, Bartolommeo di Tommaso da Foligno and Benedetto Bonfigli, were also employed at the papal court. For Angelico, trained in the sequestered precincts of San Domenico under the gaunt shadow of Dominici, the court of Nicholas V, with its wide intellectual horizons, represented a new world, the impact of which can be traced in the frescoes in the papal chapel.

They fill three sides of a small room, and consist of three lunettes, containing six scenes from the life of St. Stephen, and three rectangular frescoes beneath, containing five scenes from the life of St. Lawrence. Flanking the frescoes on the lateral walls are eight full-length figures of the Fathers of the Church, and on the roof are the four Evangelists. Beneath the frescoes are traces of a green textile design, which originally filled the lower part of the wall surfaces. The scheme was completed by an altarpiece of the *Deposition*, which was noted by Vasari but has since disappeared. The idiom of the frescoes in the Vatican is strikingly different from that of

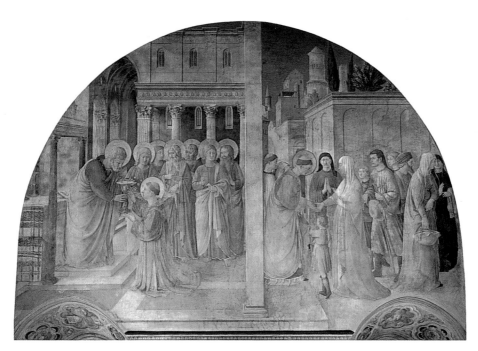

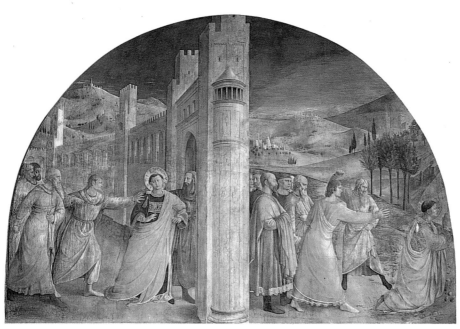

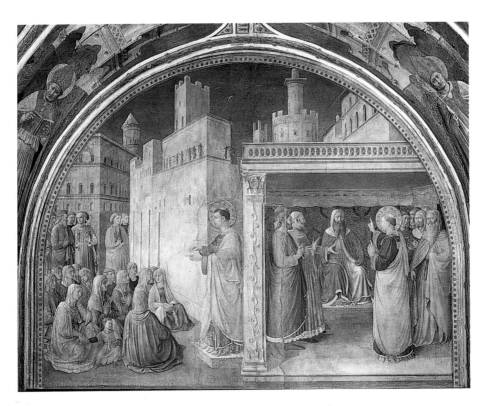

(above left)
Ordination of Saint Stephen and Saint Stephen distributing Alms

(above)
Saint Stephen preaching and Saint Stephen addressing the Council

(below left)
Expulsion and Stoning of Saint Stephen

The scenes from the lives of Saints Stephen and Lawrence in the Chapel of Nicholas V in the Vatican were painted by Angelico between 1447 and 1449. Among his assistants here and at Orvieto was Benozzo Gozzoli, some of whose work can be identified in these frescoes.

the frescoes at San Marco. In wealth of detail and variety of incident, in richness of texture and complexity of grouping, they violate the canons of the earlier scenes. But if we had to reconstruct the probable appearance of a fresco by the author of the San Marco predella, our mental image would resemble the frescoes in the Vatican more closely than those in the convent cells. Not only was the style of the San Marco frescoes governed by considerations which did not apply to the frescoes in the Vatican, but the narrative problem of the Vatican frescoes was, of its very nature, more intimately linked with Angelico's predella panels than with his frescoes. Hence it is wrong to regard the discrepancy between the fresco cycles as a measure of Angelico's development. In the normal course the lunettes above would have been painted before the scenes below. The upper frescoes are divided vertically in the centre by a wall serving a dual function in relation to the two parts of the scene. Thus the raised platform on which the *Ordination of Saint Stephen* takes place is continued in the contiguous scene of *Saint Stephen distributing Alms*; the background of towers and houses in the *Saint Stephen preaching* is common also to the *Saint Stephen addressing the Council*; and a single strip of landscape unifies the *Expulsion of*

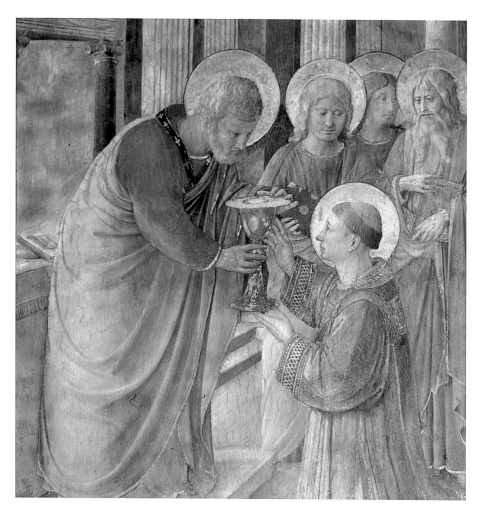

Saint Stephen and the *Stoning of Saint Stephen*. This consecutive narrative has no counterpart in the lower cycle, where each scene is independent of the next and three of the designs are centralised. Whereas the upper scenes have something of the character of enlarged predella panels, the scenes below establish a type of composition which remained constant in Florentine painting till the time of Ghirlandaio.

At the time the Saint Stephen frescoes were begun, Angelico had been in Rome for between twelve and eighteen months, and the change which this effected both in his style and in his architectural preconceptions is apparent in the first lunette, where the background of *Saint Stephen distributing Alms* is recognisably by the same artist as the *Burial of Saints Cosmas and Damian* in the predella of the San Marco altarpiece, while in the scene on the left, *The Ordination of Saint Stephen*, the setting takes on a strongly Roman character. Typically Roman are the ciborium over the altar before which Saint Stephen kneels and the columnar basilica depicted at the back. The stooping figure of Saint Peter and the Saint kneeling in profile are isolated in a forward plane, and behind, in the space between the altar steps and the columns of the nave, are six apostles, posed with the confidence and fluency of the saints in the Annalena altarpiece. Not the least unusual feature of this beautiful design is the use of the patterning of the floor to establish the axis of the scene.

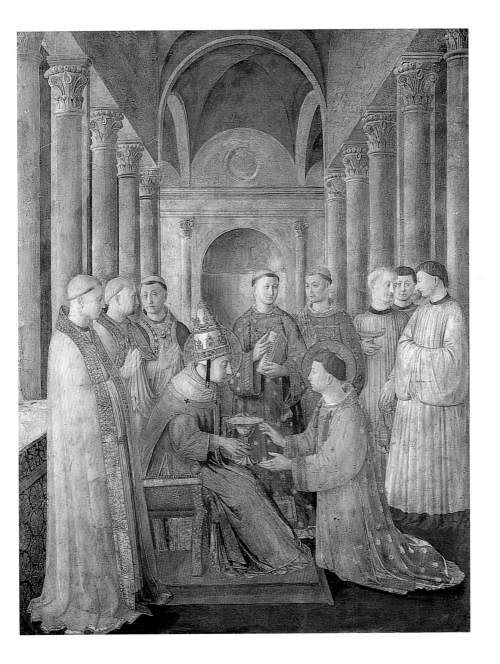

(left)
Detail from the Ordination of Saint Stephen.

Ordination of Saint Lawrence
Chapel of Nicholas V, Vatican.

467

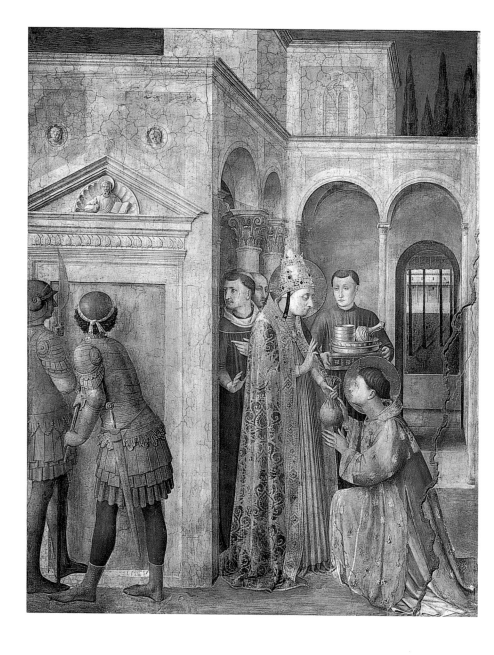

Saint Lawrence receiving the Treasures of the Church
Chapel of Nicholas V, Vatican.

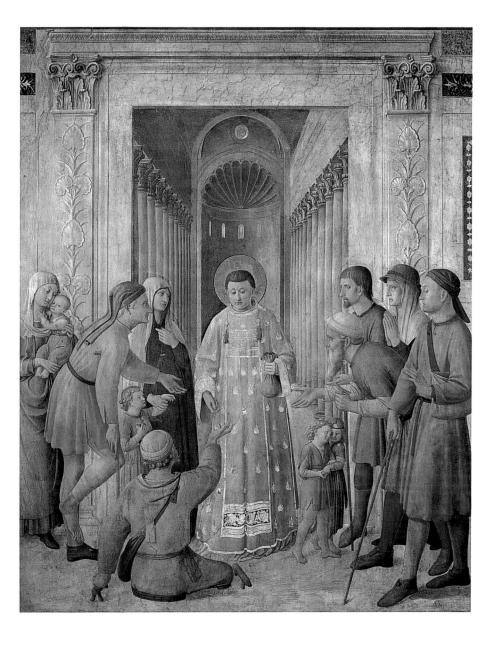

Saint Lawrence distributing Alms
Chapel of Nicholas V, Vatican.

469

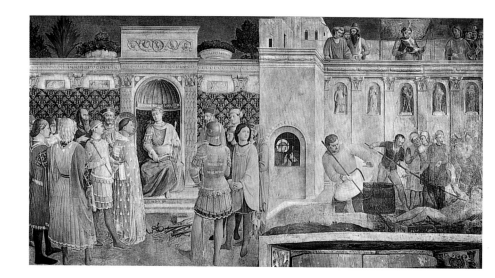

The scene of *Saint Stephen preaching* in the second lunette makes use of a rather different procedure, in which figures are deployed through the whole depth of the constructed space, and contrasts with the right half of the fresco, where the scene of *Saint Stephen addressing the Council* takes place in a low hall closed by a curtain on the wall behind. Here the figure of the Saint is turned inwards, and the orthogonals of the pavement lend force to the gesture of his raised right hand. The third lunette is divided by the city wall, which curves round at the back of the left scene, and like the figures and the distant landscape is illuminated from the right. The figures occupy the foreground of both scenes, and are dominated on the right by the kneeling figure of the Saint and on the left by the beautifully conceived figure of the Saint forcibly conducted through the gate. The landscape develops from the landscape of the *Deposition*, but is at once more panoramic and less intimate; in this it recalls the distant landscape of the predella panel of the *Visitation* at Cortona. In the use of trees on the right to establish the recession of the planes it owes something to the background of Masaccio's *Tribute Money*, and in the cosmic vision of the hill town on the left it recalls Masolino's *Crucifixion* fresco in San Clemente.

The scenes from the life of Saint Lawrence beneath mark the climax of Angelico's surviving work in Rome. Perhaps the most impressive of them is the first, which is set between the windows of the Chapel and can therefore be read as a self-consistent unit without reference to a companion scene. The act of ordination takes place in a columnar basilica of the type represented in the background of the *Ordination of Saint Stephen*, but here depicted from a cross section of the nave with five columns at each side receding to a central niche behind. The figures are not centralised, and the only feature in the foreground that is set decisively on a vertical through the vanishing point is the chalice extended by Pope Saint Sixtus II to the kneeling Saint. The Pope is represented with the features of Nicholas V and thus provides a precedent for the papal portraits incorporated in the Stanza della Segnatura and elsewhere in the Vatican. The second centralised fresco, *Saint Lawrence distributing Alms*, is treated rather differently. The nave, seen through the bold rectangle of the church entrance, is no more than a background, and the apse behind is used to lend emphasis to the figure of Saint Lawrence, who is shown forward of the façade in the centre of the scene. The figures in the *Ordination* scene and the figure of the Saint in the *Almsgiving* fresco are treated with new plastic emphasis.

(above)
Saint Lawrence before Valerianus and Martyrdom of Saint Lawrence
Chapel of Nicholas V, Vatican.

(right)
Detail from Saint Lawrence before Valerianus.

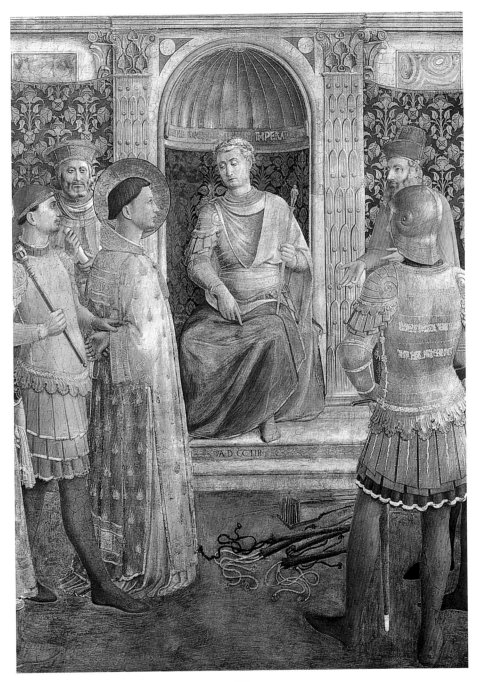

No attempt is made to link the *Saint Lawrence distributing Alms* to the scene of *Saint Lawrence receiving the Treasures of the Church* to its immediate left, though the main action in both scenes takes place in the same plane. The *Saint Lawrence before Valerianus* and the *Martyrdom of Saint Lawrence*, on the other hand, are connected by a cornice, which runs across the whole width of the two scenes. Visually this is not a wholly satisfactory device, the less that the two scenes are not artificially divided from each other, like the paired scenes which precede them, but are separated by the episode of the conversion of the jailer Hippolytus, seen through a window in the centre. The *Martyrdom* is the most seriously damaged of the frescoes. The field occupied by the fresco is considerably less high than that of the contiguous scene, and there must, from the outset, have been an awkward disparity of scale between them, but at least two of the executioners, and especially that on the left with green tights and a mustard-coloured shirt, are executed with great vigour and veracity.

Throughout these frescoes there was, to a greater extent than in any of Angelico's earlier commissions, a premium on enrichment. This is manifest in the architecture, which is less closely related to reality than that in the San Marco predella or in the earlier frescoes and reflects the influence of Alberti. A curious feature which recurs throughout the frescoes is the depiction of pilasters whose surfaces are covered with foliated ornament; these are related neither to classic pilasters nor to pilasters carved in the second quarter of the fifteenth

century. The effect of the architecture is, moreover, weakened by colouristic emphasis. Whereas the buildings in the *Burial of Saints Cosmas and Damian* from the San Marco altarpiece are devoid of local colour, those in the Chapel of Nicholas V are diversified, like the architecture in Masolino's frescoes in San Clemente, with contrasting passages of pink. An extreme instance of this ambivalence is the fresco of *Saint Lawrence receiving the Treasures of the Church*, where the building on the left, largely by virtue of its colouring, makes an effect of artificiality, while on the right the distant vision of a cloister seen through an archway is portrayed with Angelico's customary veracity.

Beside the frescoes in the Vatican, the work completed by Angelico during his fourteen-week residence at Orvieto has attracted comparatively little interest. Engaged at the same salary as in the Vatican to paint for three months a year in the Cappella di San Brizio in the Cathedral, where the venerated corporal of the miracle of Bolsena was preserved, he filled two of the four triangular spaces on the ceiling of the chapel with a *Christ in Majesty with Angels* and *Sixteen Prophets*. Angelico's part in these frescoes was smaller than in the Vatican, and seems to have been limited to the much damaged figure of Christ and a group of angels on the left of the first fresco and to the heads of a number of the seated prophets in the second. A receipt of September 1447 shows that the assistants engaged upon this work were the same as those employed in Rome. The fact that two spaces so large could be painted in three and a half

472

months throws some light on the speed at which Angelico operated, and it is clear both in the Vatican and at Orvieto that the collaborative effort of his studio was the condition of his productivity. The contract for the frescoes must have been abrogated by 1449, when Gozzoli, who was working in Orvieto from July to December of this year, attempted to obtain the reversion of the commission. Forty years later Perugino was invited by the authorities of the Cathedral to complete the decoration of the chapel, and in 1499 this was at length entrusted to Signorelli. Criticism has tended to concentrate on the uneven handling of the ceiling frescoes of Angelico, and to underrate their spacious compositions and their noble forms.

(left)
The ceiling of the Cappella di San Brizio in the Cathedral at Orvieto.

Christ in Majesty
1447
Cappella di San Brizio, Cathedral, Orvieto.

(above)
Annunciation
216x321 cm
Upper corridor, San Marco,
Florence.
Probably painted in 1450
upon Angelico's return from
Rome.

(right)
Virgin and Child Enthroned
with Saints Dominic, Cosmas,
Damian, Mark, John the
Evangelist, Thomas Aquinas,
Lawrence and Peter Martyr
c 1450
205x276 cm
Upper corridor, San Marco,
Florence.

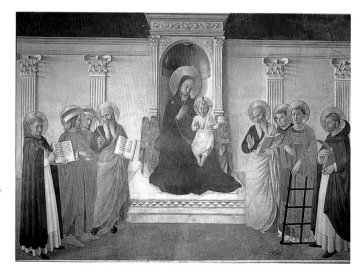

Late Works
1450-5

In documentary terms little is known of Fra Angelico's activity between 1449 or 1450, when he returned to Fiesole as Prior, and 1455, when he died in Rome. Probably the first works he painted in Florence after his return were two frescoes in the upper corridor at San Marco, the *Annunciation* and the *Virgin Enthroned with eight Saints*. In the *Annunciation* the simple Michelozzan architecture of the *Annunciation* in Cell 3 is replaced by heavier columns with foliated capitals of a type which recur in the *Ordination of Saint Stephen* in the Vatican, and the figures are disposed on a diagonal, not as in the cell fresco and the altarpieces on a single plane. It has sometimes been suggested that this fresco is the work of an assistant, but the setting and the placing of the figures in it speak strongly against this view. In the second fresco the screen behind is articulated with pilasters which again recall the *Ordination of Saint Stephen*, and the Virgin's seat is placed well forward of the throne. The new spaciousness in the design and the new equilibrium between the figures and their background are found again in an altarpiece in the Museo di San Marco, which can be shown, on grounds of iconography, to have been executed after Angelico's return to Florence.

This was a commission from Cosimo de' Medici, and was designed for the high altar of the Franciscan church of San Buonaventura at Bosco ai Frati, not far from Cafaggiolo, which had been rebuilt by Michelozzo in the fourteen-thirties at Cosimo's charge. The date of the altarpiece is established by its predella, which contains a *Pietà* and six half-length figures of saints, among them San Bernardino, who was canonised only in 1450. The altarpiece must therefore have been painted after that year. It differs from the Annalena altarpiece in that the Virgin sits not on an architectural throne, but on a wide seat set on a middle plane. Behind her are two angels, whose types and dresses recall those of the angels in the Orvieto vault, and in the foreground are six saints, on the left Saints Anthony of Padua, Louis of Toulouse and Francis, and on the right Cosmas and Damian and Peter Martyr. The marble screen behind recalls the frescoes in the Vatican. In the centre is a niche of exceptional width, and at the sides are narrow arched recesses, where the relation of height to width is similar to that of the recesses in the wall behind the *Martyrdom of Saint Lawrence*. In the closely calculated composition Angelico transposes to panel painting the style he had evolved in Rome.

More problematical is the case of a second altarpiece, the *Coronation of the Virgin* in the Louvre, which seems to have been executed at this time. It was painted for San Domenico at Fiesole, and there has always been a consensus of opinion that it was produced either before 1430 or between 1430 and 1438. If that were correct, the adoption, for the pavement in the foreground, of a low viewing point would be the main fact to be explained, since this system of projection appears in Florence only in the fourteen-forties in Domenico Veneziano's St. Lucy altarpiece. The visual evidence suggests that the altarpiece must have been planned at a considerably later time. One of the features most often cited as proof of its early date is the Gothic tabernacle of the throne. The only true analogy for the tabernacle, however, occurs on the ceiling of the chapel in the Vatican, where the Fathers of the Church are depicted beneath canopies of the same kind. True, the canopy in the altarpiece is supported on spiral columns, not on flat pilasters, but the pilasters above the capitals (and a very odd architectural feature they are) are the same in both and so are the three front faces of the canopy. This dating is corroborated by the angels, who stand so stolidly beside the throne, their curls carefully crimped and their dresses starched in prim regular folds. They have little in common with the angels beside the throne in the San Marco altarpiece, but find an evident parallel in those in the frescoed vault of the Cappella di San Brizio at Orvieto.

A distinguished critic of Italian painting has described the *Coronation of the Virgin* as 'one of the few works in which Fra Angelico was thrown off his stride by strenuous efforts to keep up with the innovations around him'. The truth is rather that the artistic problem presented by the altarpiece was insoluble within the limits of the system of space projection Angelico employed. In the earlier *Coronation of the Virgin* from Santa Maria Nuova, the Saints at the sides sweep back in steady diminution till they reach the distant angels, and the figures of Christ and the Virgin, though smaller in size than the figures in the foreground, receive, by virtue of their isolation, appropriate emphasis. For Angelico about 1450 such a solution would have been unacceptable, and there was no alternative but to transfer the scene from notional space to real space like that of the San Marco altarpiece. If this were done, however, a steeply shelving foreground like that of the San Marco altarpiece would have been a liability since it would have given undue prominence to the foreground figures and insufficient prominence to the figures at the top. The solution Angelico adopted, therefore, was a compromise. The viewing point was lowered — Do-

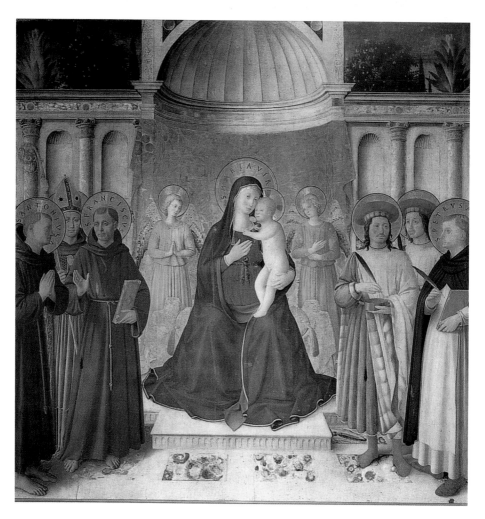

menico Veneziano's St. Lucy altarpiece was already in existence to prove how that could best be done — the foreground was projected on the new system, the canopy was portrayed from underneath, and the intervening area of the steps was filled in empirically. This is the only one of Angelico's large paintings in which the vanishing point and the narrative focus do not correspond, though the jar of ointment held out by St. Mary Magdalen, like the chalice in the *Ordination of Saint Lawrence* in the Vatican, falls on a central vertical.

The *Coronation of the Virgin* suffers from extensive studio intervention, especially on the righthand side. To take three examples only, the weakly drawn wheel held by St. Catherine, the tilted head of the female figure on

the extreme right, and the blank-faced deacons above would be unthinkable in an autograph work. The parts painted by Angelico and especially the figures of Christ and the Virgin, are, however, of great distinction. Probably the altarpiece was still unfinished when Angelico died. Something of the kind is suggested by the predella, in which he had no share, and which seems actually to have been designed as well as executed by another artist.

The only fully authenticated late narrative panels by Angelico are a cycle of scenes from the life of Christ painted for the Annunziata, now in the Museo di San Marco. These panels are assumed, on the strength of a passage in the chronicle of Benedetto Dei, to have been commissioned by Piero de' Medici as the doors or shut-

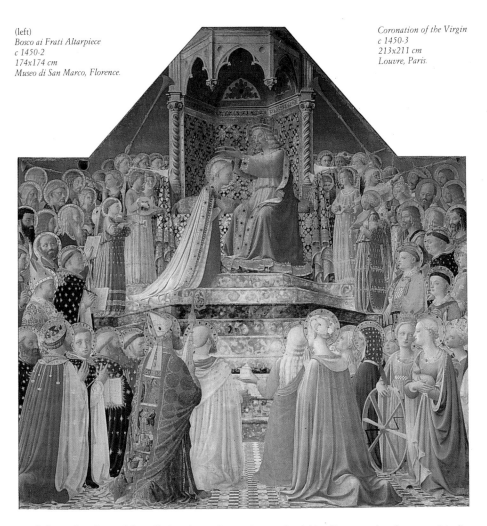

(left)
Bosco ai Frati Altarpiece
c 1450-2
174x174 cm
Museo di San Marco, Florence.

Coronation of the Virgin
c 1450-3
213x211 cm
Louvre, Paris.

ter of the cupboard containing offerings in precious metal presented to the shrine of the Virgin Annunciate. The commission was bound up with a project for developing an oratory for Piero de' Medici's use between the chapel of the Virgin Annunciate and the convent library, and since the oratory was not roofed over till 1451 it is likely that the commission dates from this or the preceding year. The last payment relating to this phase in the production of the silver chest dates from 1453. Probably at this time what was envisaged were two doors opening outwards, but at a later stage, in 1461-3, the conception seems to have been revised, and the panels were incorporated in a single shutter hoisted by a pulley. In the form in which they are preserved,

they consist of thirty-five scenes, but they may originally have comprised an even larger number, since, with one exception the groups of panels read from left to right. The exception is the three scenes of the *Marriage Feast at Cana*, the *Baptism of Christ* and the *Transfiguration*, where the sequence runs from top to bottom; these are likely to be the concluding scenes from a block of nine which would have been devoted to the youth and early manhood of Christ.

The panels are mentioned after 1460 by Fra Domenico da Corella in the *Theotocon* as works of Fra Angelico, and on this account alone it is difficult to follow the many critics who deny his intervention in, or general responsibility for, these little scenes. All the

ECCE VIRGO CONCIPIET 7 PARIET FILIVM 7 VOCABIT NOMEN EIVS EMANVEL. YSA.VI.C

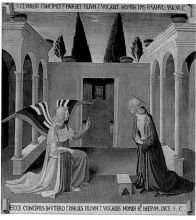

ECCE CONCIPIES IN VTERO 7 PARIES FILIVM 7 VOCABIS NOMEN EI IHESVM. LVCE.I.C.

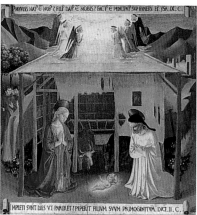

PARVVLVS NAT 7 NOB 7 FILI DAT 7 E NOBIS 7 FACT 7 E PRINCIPAT SVP HVMERV EI. YSA.IX.C.

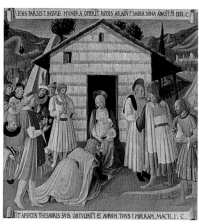

REGES THARSIS 7 INSVLE MVNERA OFFERET REGES ARABVM 7 SABBA DONA ADVCET.PS.LXXI.C

IMPLETI SVNT DIES VT PARERET 7 PEPERIT FILIVM SVVM PRIMOGENITVM. LVCE.II.C.

ET APERTIS THESAVRIS SVIS OBTVLERVT EI AVRVM THVS 7 MIRRAM. MATH.I.C.

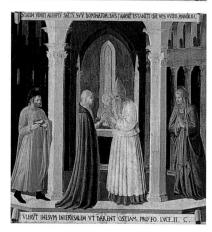

STATIM VENIET AD TEMPLV SVV DOMINATOR DNS 7 ANGEL TESTAMTI QVE VOS VVLTIS. MALCH.II.C

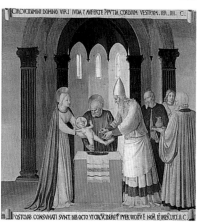

CIRCVCIDIMINI DOMINO VIRI IVDA 7 AVFERTE PREPVTIA CORDIVM VESTRVM. IER.IIII.C

VLERVT IHESVM IN IERVSALEM VT DARENT OSTIAM PRO EO. LVCE.II.C.

POSTQVAB CONSVMATI SVNT DIES OCTO VT CIRCVCIDERET PVER VOCATV E NOM EI IHES. LVCE.II.C.

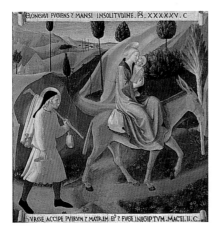

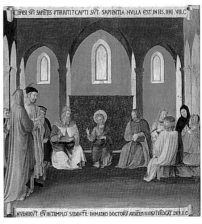

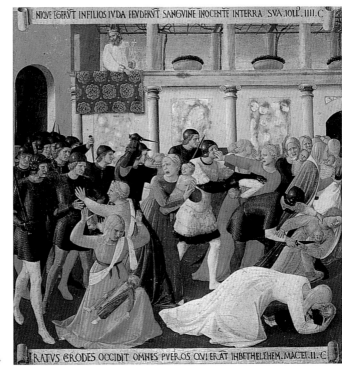

*The Annunziata Silver Chest
1451-3
each panel approx. 39x39 cm.
Museo di San Marco, Florence.
1. Vision of Ezekiel
2. Annunciation
3. Nativity
4. Adoration of the Magi
5. Presentation in the Temple
6. Circumcision
7. Flight into Egypt
8. Massacre of the Innocents
9. Christ teaching in the Temple*

panels directly attributable to Angelico form part of the first block of nine paintings. The three succeeding scenes are by a younger artist, Baldovinetti, and the six missing scenes may have been by Baldovinetti too. The remaining twenty-three scenes are executed in the style of Angelico by another hand. Some of them incorporate motifs from the San Marco frescoes; this is the case with the *Mocking of Christ*, *Christ carrying the Cross* (where the Virgin corresponds with the related figure in the fresco of this scene), and the *Coronation of the Virgin* (where the central group is a variant of the fresco in Cell 9). Despite this, it is extremely difficult to regard these scenes as mere pastiches in the style of Fra Angelico, and a number of motifs — the continuous landscape behind the *Stripping of Christ* and the *Crucifixion*, the cloister in the scene of *Christ washing the feet of the Apostles*, the diagonal rhythm of the *Lamentation* — are so distinguished as to suggest that at the very least drawings for the whole cycle must have been made by the master. In January 1461 a payment was made to an otherwise unknown painter Pietro del Massaio for what is described as 'insegnare dipingere l'armario' (showing how the cupboard is to be painted). This might well refer to the execution in paint of antecedent cartoons. It has been noted correctly that the palette of the later scenes, and especially the extensive use of yellow in the *Betrayal*, differs from the practice of Angelico.

At the top and bottom of each panel are scrolls containing sentences respectively from the Old and the New Testament. Thus in the second scene Isaiah's prophecy of the Annunciation is balanced against the ECCE CONCIPIES IN VTERO ET PARIES FILIVM ET VOCABIS NOMEN EIVS IHESVM of St. Luke, and in the seventh a passage from the Psalms, ELONGAVI FVGIENS ET MANSI IN SOLITVDINE, is accompanied by the words put by St. Matthew into the mouth of the angel warning St. Joseph to flee. The programme must have been drawn up in its entirety before the panels were begun, and was thus planned by or in conjunction with Angelico. A key to the conception is to be found in the first and last panels, one executed under the master's supervision, the other by the artist who completed the chest. The first shows a landscape, in the lower corners of which are the seated figures of Ezekiel and Gregory the Great. Between them flows the River Chobar, beside which Ezekiel received his vision of God. In the upper left corner are passages from the fourth, fifth and sixteenth verses of the first chapter of Ezekiel, describing the appearance of four 'animalia' and a wheel within a wheel. In the opposite corner is the gloss of St. Gregory the Great upon this passage. The greater part of the panel is filled with two concentric circles, that in the centre containing eight standing figures of the Evangelists and writers of the canonical epistles, and that on the outside twelve figures of prophets. Round the perimeter of the smaller wheel run the opening words of the Gospel of St. John, and round the larger the account of the Creation. The last panel shows a flowery field. On the left stands a female figure, the Church, holding a shield inscribed with the words LEX AMORIS. In the centre is a candlestick with seven branches, through which are threaded seven scrolls. On each scroll is the name of a sacrament accompanied to left and right by quotations from the Old and the New Testament. From the middle of the candlestick rises a pennant, surrounded by a twisted scroll, and to right and left, supported by twelve apostles and twelve prophets, are the articles of the Creed and the passages from the Old Testament with which they were habitually juxtaposed.

Though their handling and condition are unequal, the first nine scenes are distinguished by exquisitely lucid schemes, in which the essence of Angelico's late style is distilled. In the *Annunciation* the kneeling Virgin and the Angel are silhouetted against the central wall surface, the Angel pointing towards the Holy Ghost, which is represented naturalistically as a bird flying in the sky. The folds of their drapery are treated with great delicacy, and the haloes are shown in profile, not as in earlier paintings as flat circles on the picture plane. In the *Flight into Egypt*, where the haloes are fully visible, they are portrayed as metal discs which refract light and reflect the shadow of the head. A corollary of this is the exact rendering of the forms, witness the careful way in which the Virgin's forward leg beneath her robe has been defined. In the *Nativity* the stable is set in an alcove of landscape, and the play of perspective, in the handling of the horizontal struts and the forward-tilting manger, is more elaborate than in any earlier painting. In front it is divided by vertical supports into three equal parts, in one of which, behind St. Joseph, the straw comes down to shoulder height, while in the other, behind the Virgin, it is almost entirely torn away. This three-fold division of the picture space is common also to the *Circumcision*, where the planes of the three end walls of the choir repeat the relationship of the three foreground figures, and to the *Presentation in the Temple*. The panel which reminds us most forcibly of the San Marco predella is the *Massacre of the Innocents*, where the wall at the back recalls that in *Saints Cosmas and Damian before Lycias*, but is enriched by a receding trellis. The spatial platform in the foreground is much deeper than before (in this it conforms to the structure of the frescoes in the corridor of San Marco), and the women filling it are treated realistically, with a repertory of posture that must, in its freedom and expressiveness, have appeared unsurpassed. There is, and this must be stressed very firmly, nothing archaic in these paintings. They prove that in the last years of his life Angelico was what he had been in youth and middle-age, a progressive, forward-looking artist.

The readiest explanation for the inconsistency of handling in the silver chest panels is that work on them was interrupted by some other commission; and since the break probably occurred in 1453 and Fra Angelico died in Rome in February 1455, it is a common

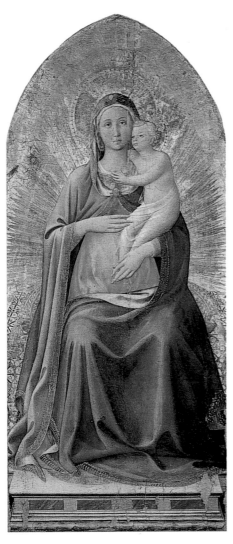

assumption that this was a commission from the Pope. Alternatively it has been suggested that the source of the commission may have been the church of Santa Maria sopra Minerva in Rome, for which, according to Vasari but no other source, Angelico painted the high altarpiece. There is no documentary proof of either supposition. We have, however, two small paintings by Angelico which may date from 1450-5, and a third more substantial picture on which work seems to have been started before his death. The first of the finished pictures is a panel in the Fogg Museum of *Christ on the Cross with*

the Virgin and Saint John adored by a Dominican Cardinal. This was originally the centre of a triptych, and the lower part of one of the two wings, with a cut-down figure of Saint Clement, survives. In type the Christ conforms, not to the fresco in the cloister of San Marco, but to the figure in the *Crucifixion* on the silver chest. The arms of the cross run the whole width of the panel, and above it burgeons a tree with at its tip a nesting pelican. The Virgin and Saint John, set slightly behind the cross, show the same tendency to elongation as the figures in the autograph *Presentation in the Temple* on

the silver chest, and the Cardinal, Juan de Torquemada, kneels in profile in the front. Both in its restrained intensity of feeling and in the severity of its design this is the most impressive of the artist's late paintings. The second work is a triptych with the *Ascension, Last Judgment and Pentecost* in the Palazzo Barberini. The central panel depends from the *Last Judgment* painted for Santa Maria degli Angeli, and among the blessed on the left two figures in the foreground are drawn with little variation from the earlier painting. In place, however, of the perspective view of the double line of open tombs, the foreground is divided by a single line of tombs running irregularly through the centre of the scene. The late date of the panel is asserted on the right by the figure of a woman chastised by a devil which is closely bound up with the women in the *Massacre of the Innocents* on the silver chest, and above in a still more decisive fashion by the Christ, which employs the same rhetorical pose as the *Christ in Glory* at Orvieto.

The more substantial picture is a famous tondo of the *Adoration of the Magi* in the National Gallery of Art in Washington. This is a bewildering work, not least because the bulk of the painting as we know it now was executed not by Angelico but by Fra Filippo Lippi. It was indeed consistently ascribed to Lippi until Berenson, in 1932, suggested that it was planned and partly painted by Angelico and an assistant about 1442 and was then completed by Lippi. This theory was later withdrawn, and the tondo was reascribed to Lippi. In both cases the analysis rested on the figurative content of the panel, not on its design. If, however, we look first at the ruined building on the left, whose structure is typical of Fra Filippo Lippi, and then at the walled city on the right, whose structure is typical of Fra Angelico, the dichotomy between the two appears so great that we are bound to postulate two separate designing minds. This deduction is confirmed by the irregular structure of the stable in the centre, which represents a point of compromise between two inconsistent schemes. That on the right is the more primitive, and we are bound therefore to suppose that work on the panel started in this area. This inference is warranted also by the fact that the figures on the left are in the main by Lippi, while the figures in the distance on the right are either by Angelico or by some member of his shop. The correct point of reference for them is not, however, the San Marco altarpiece or other paintings of the early fourteen-forties, but the panels of the silver chest, and this is corroborated by the only one of the main figures painted by Angelico, the seated Virgin in the centre, where the type and handling of the head are wholly different from those of Fra Filippo Lippi and the hair is braided like the hair of the silver chest *Maries at the Sepulchre*. It follows that the error in Berenson's analysis was not his explanation of the genesis of this great panel, but the date to which it was assigned. Though the panel as a work of art must in great part be credited to Lippi and its dominant style is undeniably Lippesque, it is not to be wondered at that in

Adoration of the Magi
(Cook Tondo)
c 1451-3
137.4 cm diametre
National Gallery of Art, Washington
(Kress Collection).
Completed after Angelico's death by Fra Filippo Lippi.

1492, thirty-seven years after Angelico's death, when it hung in a large room on the ground floor of the Medici Palace used by Lorenzo de' Medici, it was described as being 'di mano di fra Giovanni', that is by the hand of the legendary artist by whom it was begun.

When he died in 1455, Angelico was the most influential Florentine painter of his time, and the five hundred years that have elapsed since have produced no artist with so universal an appeal. The *Annunciation* at Cortona, the *Deposition* from Santa Trinita, the *Transfiguration* at San Marco form part of our common imaginative currency. They eschew the private idiom of other great religious artists, and reflect the serenity, the discipline, the anonymity of communal religious life. In

the case of Fra Angelico, more truly than in that of any other painter, the artist and the man are one. His paintings are informed with a tenderness, indeed affection, that gives tangible expression to the mystical virtue of charity, are undisturbed by profane interests and untinged by doubt. The language he employed resulted not from failure to keep abreast of the developments of his own day, but from intentions which differed fundamentally from those of other artists. For all the translucent surface of his paintings, for all his pleasure in the natural world, there lay concealed within him a Puritan faithful to his own intransigent ideal of reformed religious art.

In the empathy of his approach to religious iconography (it is as though in every painting the artist himself were present as an unseen participant), in the compassion which bulks so large throughout his work, in the sense of divine immanence in nature (which proceeds directly from Dominican Observant doctrine), in the benign light of faith that gives his paintings their warmth and their consistency, in the undeviating single-mindedness with which he followed his allotted path, Fra Angelico is unlike any other artist. No painter's works have been so widely reproduced, and though from the standpoint of good taste we may deplore the copies of them that surround us on all sides, they still perform the function they were originally designed for, and testify to the continuing value of his apostolate.

FILIPPO LIPPI

Critical Appraisal of Lippi's Painting Through the Centuries

"Every Painter Paints Himself"?

"Great minds are heavenly forms and not dray horses for hire." Giorgio Vasari, writing in the 16th century, attributes this statement to Cosimo de' Medici the Elder (1389-1464), who was Fra Filippo's most important patron and commissioned many works from the "great mind." As simple as this brief sentence is, it clearly reflects a Neo-Platonic way of looking at things: the idea that the artist's temperament, the highest meaning of his work, is seen as a mirror of celestial life, inestimable, like a gift of the gods.

In other words, Cosimo the Elder was not in the least concerned with the fact that Fra Filippo was an eccentric artist, whose behaviour was disreputable and dishonoured the monk's habit that he had worn ever since he was little more than a child. On the contrary, it seems that Cosimo, the first great art patron of the Medici dynasty, declared: "Every painter paints himself" (or at any rate Poliziano quotes him as saying so in his *Diary*). For this reason he felt it did not matter that the painter was difficult to deal with——as we learn from our sources——for he had an impatient and excitable temperament, unwilling to abide by rules or honour agreements.

We know that Filippo quarrelled with his clients, both lay and ecclesiastical, very frequently; he even quarrelled with his workshop assistants. He argued over money matters, he was accused by his clients of cheating by making his assistants do the work and he was constantly in trouble for being late in delivering his paintings. The artist was threatened with excommunication several times and even had to go to court. One of the most famous trials took place in 1450, when Filippo was sued by Antonino Pierozzi, the Bishop of Florence: Lippi had not paid 40 florins to the painter Giovanni di Francesco, and had drawn up a false receipt. Filippo, who confessed after being tortured, was described as he "qui plurima et nefanda scelera perpetravit" (who perpetrated many wicked and iniquitous deeds). Another court case took place in 1451, when Antonio del Branca from Perugia, who had agreed to pay Filippo 70 gold florins for a painting he had commissioned, refused to pay on the grounds that the work had not been painted by Lippi himself. Actually, it appears that the painter was acquitted of this charge.

The concept expressed by Cosimo the Elder is perfectly in harmony with the Humanistic atmosphere of the early Quattrocento in Florence and was clearly inspired by Plato's *Symposium*, passages of which had been translated by Leonardo Bruni. This definition of the genius of the painter-monk (who was so different, both in his behaviour and his artistic style, from the other painter-monk, Fra Angelico, only a few years his senior and referred to as "the devout one" by some contemporaries), is also one of the earliest critical comments on the work, but also on the life and the personality of Filippo Lippi. Outstanding genius thus appears to justify, thanks to ethical theories, the more apparently outrageous aspects of the Florentine artist's life (or the legend that has grown up around it). The painter's love story (all too freely embroidered upon) with Lucrezia Buti, a young nun, the daughter of the Florentine Francesco Buti, the owner of a silk shop, did cause a great deal of embarrassment to Giorgio Vasari a century later: Vasari was writing his biography of Lippi in a climate that was dominated by the dictates of the Counter-Reformation. In his first edition of the *Lives of the Artists* (1550) Vasari added a long prologue to his account of Lippi's life as an attempt to give an explanation of the monk's outrageous behaviour. The passage contains a justification for Fra Filippo's conduct which might almost have been inspired by Cosimo's remark mentioned above: "If in a man who is truly virtuous we find a vice, albeit an ugly and reprehensible one, his virtue will compensate for it (. . .); for virtue, as well as having thousands of other wondrous effects, can transform the avarice of princes into generosity, can quell feelings of hatred in the soul, can crush all envy between men, and can elevate all the way to heaven those whom fame has rendered immortal, such as the Carmelite Fra Filippo, the son of Tommaso Lippi."

There is no doubt that in Vasari's opinion Lippi's "vice" was one of love, or rather of lust. As Vasari writes: "When he saw a woman he liked, he would have given anything to possess her: and if he could not buy what he wanted, then he would paint her portrait and reason with himself, until he cooled the fire of his passion. And he would get so carried away by his lust, that when he was in this mood he hardly attended to his work at all." Filippo's forbidden love for the beautiful Lucrezia (whom he used for the first time as a model in 1456, for the figure of the Virgin in a painting for the nun's convent in Prato), still according to Vasari, was the result of an innate attraction for women. But Lucrezia, born around 1433, was a nun. And the love story was an impossible one, one forbidden by all accepted conventions. It seems that Filippo "kidnapped" the girl, and took her away from the convent of Santa Margherita in Prato, where she lived with her sister Spinetta (at least since 1454, after their father's death). The story goes that Filippo then brought both young nuns to live with him in the house that he had bought in 1455 from the Guild of the Holy Girdle in Prato, near the Porta San Giovanni. Lucrezia and Filippo had two children: a son, Filippino, born around 1457, who followed his father's footsteps in painting, and a daughter, Alessandra, probably born in 1465. It appears that in 1459 the two sisters renewed their vows and returned to their convent. But in 1461 Fra Filippo was charged with reprehensible behaviour by the Ufficiali della Notte e Monasteri, for Lucrezia and Spinetta had once again left the nunnery and gone back to live with him.

There are still several aspects of this "illicit" love story that are not quite clear today: for example, we have no reliable evidence to prove that, thanks to Cosimo's intercession, Pope Pius II freed Filippo from his religious vows (a fact mentioned in some documents dating from 1461); but this is not consistent with the information given in later documents, where Lippi is still referred to as a monk. Furthermore, even in his late works, Filippo continues to portray himself in the Carmelite habit.

But the fact remains that Cosimo (and his other patrons as well) were never really scandalized by his love affair with Lucrezia, whereas they did complain about the fact that he was regularly late in finishing commissioned works. Francesco Contasanti, for example, on 20 July 1457, wrote a letter to Giovanni di Cosimo (living at the time in the Medici residence at Cafaggiolo) in which he says that he had gone every day to Fra Filippo to beg him to finish a painting that the Medici family had commissioned and which they wanted to present as a gift to Alphonse V, King of Naples (an intelligent move in the subtle diplomatic relationship between the Medici and the Aragon Court). Contasanti writes: "On Saturday night I stayed with him for an hour, to make sure he worked; then, just after I left him, that other thing happened" (all the contents of Lippi's workshop were confiscated to pay off his creditors). The letter ends: "So you can see what a dangerous situation the man is in!. . ."

Occasionally Fra Filippo's patrons found his bizarre behaviour quite humorous. In answering a letter from Bartolomeo Serragli (the Medici agent at the Naples Court, where Lippi's painting had finally arrived), Giovanni di Cosimo says maliciously: ". . . we laughed heartily over Fra Filippo's mistake." Yet, there is no hint of a moralistic comment about Lippi's relationship with Lucrezia, nor is there ever an unfavourable criticism of his work.

Fra Filippo frequently painted the beautiful young Lucrezia as the Virgin, with gentle and sweet features, in works for his patrons. Today most critics agree that the vast pictorial production of this monk, however scandalous his lifestyle may have been, communicates an overriding spirituality, at times quite introverted, which nonetheless manages to transform the sacred atmosphere of the scenes into one that is totally human and poetic, with great originality and deep psychological insight. Umberto Baldini, writing in 1966, defined Lippi's work as expressing "a renewed faith in man's earthly life"; this is in no way in contrast to the vision of a "heroic mankind" in the work of Masaccio, the undisputed protagonist of early Quattrocento painting in Florence. And it was primarily from the revolutionary message of the Brancacci Chapel frescoes that Lippi drew his inspiration (although he was also very much attracted by the detailed exploration of domestic intimacy, symbolic yet realistic, that he found in the work of Flemish painters).

Some critics have attempted to explain Lippi's singular life story by examining it in relation to the stylistic development of his work. As Nello Forti Grazzini wrote in 1986, there appears to be a parallel between his "freedom in matters of morality and his stylistic freedom." And Hartt (1970) has gone so far as to suggest that his irresponsible conduct corresponds to the undisciplined nature of his style. These are interesting theories that can be supported by several elements and which seem to be just a further development of Cosimo's Neo-Platonic statement: "Every painter paints himself."

Although there can be no doubt that the events of Lippi's life must to a certain extent have influenced the formation of the artist Lippi, I am entirely in agreement with the recent research carried out by Miklos Boskovits, Jeoffrey Ruda, Eve Borsook and E.W. Rowlands, all of whom maintain that Lippi's art cannot be fully understood unless we bear in mind also the importance of the many different patrons who commissioned his work.

Lippi's Patrons

Without in any way wishing to underestimate the personal and original nature of Lippi's art, we must bear in mind in the study of each work the needs and requests of the patrons who had commissioned them. They undoubtedly influenced the artist's choice of iconographical themes and frequently also his interpretation of the subject; in a sense, we might say that they influenced even the most intimate essence of Fra Filippo's paintings. Most recent studies have dealt with these extremely complex aspects of Lippi's art. We have no useful documentation on this matter, so it is difficult to establish with certainty to what extent and in which ways these influences were actually exerted.

In any case, it cannot have been entirely Fra Filippo's "scandalous" lifestyle, or merely his independent nature or his rebellion against all conventions, that contributed, for example, to the development of his vigorous realism, a style that has been defined "vernacular" and which characterizes his early works. His first frescoes and panel paintings (dating more or less from the period when he was a monk in the Carmine monastery in Florence) were influenced, as Miklos Boskovits has so clearly demonstrated, not only by the powerful art of Masaccio, but also by the spirituality of the popular preachers of the Osservanza. At that time, Filippo's popular realism appears to reflect their efforts and spiritual striving towards a reform of the Order, seen almost as the antithesis to the sophisticated classical experience of the Florentine Humanist scene.

When looking at the following stage of Lippi's career, the 1440s and 1450s, we must examine with care all the iconographical and stylistic

changes. Let us take for example all the different versions of the subject of the *Adoration of the Child* or the *Coronation of the Virgin*. These changes were dictated not only by the different cultural and religious attitudes of his patrons, but also (and primarily) by the locations the works were intended for (the church of Sant'Ambrogio in Florence, the church of San Bernardo in the Olivetan monastery in Arezzo, the hermitage of Camaldoli and the monastery of San Vincenzo ad Annalena in Florence).

At this point, it will make matters simpler if we draw up a list of the many religious companies and institutions, churches and monasteries, individual prelates and rich private families who commissioned altarpieces, frescoes, standards, tabernacle paintings (and other types of devotional works) from Lippi. In chronological order they are:

— the Carmelites of Florence (the frescoes in their monastery in Florence, where Filippo spent his youth, as well as the *Madonna of Humility*, today in the Castello Sforzesco in Milan);

— the Carmelites of the Selve monastery, on the road from Florence to Empoli (the *Madonna and Child with Angels and Saints* now in the Empoli Pinacoteca);

— the Antonians of the Basilica del Santo in Padua (a tabernacle to be used as a reliquary and a group of frescoes that have not survived).

— Giovanni Vitelleschi, Archbishop of Flor-

ence (the *Madonna of Corneto Tarquinia*, now in the National Gallery in Rome);

— the Captains of the Guelph party, thanks to a bequest made by the Barbadori family (the altarpiece of the *Madonna and Child with Saints* for the Barbadori Chapel in Santo Spirito, now partly in the Uffizi and partly in the Louvre);

— the Opera del Duomo (the altarpiece of the *Annunciation* in the chapel containing the tomb of Nicolò Martelli in the Basilica of San Lorenzo);

— the Oratory of the Larioni in Pian di Ripoli, near Florence (the *Annunciation* now in the National Gallery in Rome);

— the Canon of San Lorenzo and Chaplain of Sant'Ambrogio, Francesco d'Antonio Maringhi (the altarpiece of the *Coronation of the Virgin* for the church of Sant'Ambrogio, now at the Uffizi; the predella is in Berlin);

— the Franciscans of Santa Croce (the altarpiece of the *Madonna and Child with Saints* now at the Uffizi, formerly in the Chapel of the Novices designed by Michelozzo for the Medici);

— the Medici (many works, including the lunettes of the *Annunciation* and a *Holy Conversation* painted for a room in their family palace in Via Larga; the Washington *Adoration of the Magi*, recorded in 1492 as hanging in Lorenzo the Magnificent's bedroom; the *Adoration of the Child* in Berlin; the *Madonna and Child* still in Palazzo Medici Riccardi; a group of small narrative panels presented by Cosimo to Pope Eugene

IV; the triptych of the *Adoration of the Child and Two Saints* presented to Alphonse of Naples by Giovanni di Cosimo of which the central panel is lost and the two side wings are probably the panels now in the Cleveland Museum of Art);

— Alessandro degli Alessandri, a friend of Cosimo de' Medici (the altarpiece showing *St Lawrence with Saints and Donors*, probably conceived as a tribute to the Medici who are represented in the painting by their patron saints, Cosmas and Damian; formerly in the church of San Lorenzo at Vincigliata, near Fiesole, today at the Metropolitan Museum, New York);

— the Olivetans of Arezzo (the *Coronation of the Virgin* now in the Vatican Pinacoteca);

— the Florentine Seigneury (*The Virgin Appears to St Bernard* now in London and an *Annunciation*, probably the one currently in Washington; the two paintings were commissioned for the doors of the Chancery in Palazzo Vecchio);

— a Tuscan family that has not been identified with certainty, possibly the Scolari, or the Portinari or the Datini (the double portrait now in the Metropolitan in New York);

— the convent of the Murate and the church of Santa Maria in Fiesole (two *Annunciations*, one of which is the one now in Munich, and an altarpiece of *Stories from the Life of Saints Benedict and Bernard*, lost, mentioned by Vasari as hanging in the church of the Murate; the predella, an *Annunciation*, was identified by Zeri in 1971 as the one currently in the Metropolitan Museum in New York);

— Antonio del Branca, from Perugia (a painting which was refused because Branca claimed it was not an autograph work);

— the Roman Cardinal Barbo (two small narrative panels, mentioned by Vasari, now lost);

— the Bracciolini family (a *Birth of the Virgin* mentioned by Vasari as being in the house of Polidoro Bracciolini);

— the Capponi family (a *Madonna* mentioned by Vasari as being in the house of Ludovico Capponi);

— the city of Prato, the patron of the main chapel in the Cathedral, the Compagnia del Ceppo Nuovo and the Opera del Sacro Cingolo in Prato (frescoes in the Cathedral and several panel paintings);

— Francesco Datini, the merchant of Prato (the *Tabernacle of the Ceppo Nuovo* in the courtyard of his own palace in Prato);

— a member of the Florentine family Bartolini (the *Tondo* now in the Palatine Gallery in Florence);

— the Florentine Lorenzo Manetti (a painting of *St Jerome*);

— the Provost of Prato, Geminiano Inghirami (probably the painting showing the *Funeral of St Jerome*, in Prato Cathedral);

— the convent of Annalena in Florence (an *Adoration of the Child*);

— Lucrezia Tornabuoni, the wife of Piero de' Medici (the *Adoration of the Child* in the hermitage at Camaldoli);

— the Podestà of Prato (some standards and other ornaments in the Palazzo Comunale);

5. *Madonna and Child Enthroned with Angels and Saints*
44 × 34 cms.
Empoli, Museum of the Collegiate Church

6. Sketch for the head of St Jerome
Florence, Palazzo Medici Riccardi

7. Madonna and Child
155 × 71 cms.
Florence, Palazzo Medici Riccardi

— the Company of the Priests of the Trinity of Pistoia (the altarpiece of the *Trinity*, left unfinished by Pesellino and completed by Lippi, as well as an altar frontal showing the *Madonna of Mercy*);

— Jacopo di Bartolommeo Bellucci, Archpriest of Pistoia Cathedral (an *Annunciation*, now lost, painted for an altar in the Cathedral);

— Angelo della Stufa (a painting of *St Sigismond*, now lost, which was presented as a gift to Sigismondo Pandolfo Malatesta, ruler of Rimini);

— the Opera del Duomo of Spoleto, following a recommendation by Cosimo the Elder (the frescoes in the apse of the Cathedral).

As we can see from this list, Lippi worked for a wide variety of private families and institutions.

One of the documents that sheds most light on the painter's rapport with his patrons is a letter (today in the State Archives in Florence) that Lippi wrote to Giovanni di Cosimo de' Medici. Dated 20 July 1457, this letter deals with the *Polyptych with two Saints and an Adoration of the Child*, commissioned by Giovanni as a gift for King Alphonse of Naples; except for the side wings currently in the Cleveland Museum, the only thing that has survived of this polyptych is a pen and ink sketch at the foot of the letter. On the one

hand the content of the letter reveals that Lippi was all too ready to comply with his client's requests; but it also hints at the artist's earlier disagreements and conflicts with his Medici patron.

Filippo writes: "I have done as you demanded in this painting, in every detail. The St Michael is now perfect, with his armour painted in gold and silver as well as his clothes, for I met up with Bartolomeo Martello; he told me about the gold and everything that was needed . . . and that I should follow your wishes in every detail; and he also reprimanded me and showed how I was wrong and you were right. Now, Giovanni, I am here to act as your slave, and I shall continue to do so . . . and I wrote to you that the expense would be thirty florins . . . for it is so full of ornaments . . . and so that you be advised, I am sending you a drawing of the wooden structure, so that you can see how tall and wide it is . . . And if I have seemed presumptuous in writing to you, please forgive me. And I shall always act according to Your Reverence's wishes."

So we learn that Filippo paid special attention to his patron's requests for precious "ornaments," which Giovanni wanted in order to make his gift to the King of Naples even more lavish; and we know that Alphonse V appreciated the gift, and his friend, Count d'Ariano, also liked the painting so much that he expressed the desire to have a similar one made for himself.

We also learn that Giovanni de' Medici wanted to know all about the measurements and the wooden structure of the polyptych as well. What we do not know, however, and it would be impossible to establish, is to what extent the style and composition of the work were modified by the Medici patron's requests. If we accept the perfectly plausible identification of the St Michael mentioned by Lippi in the letter as the one now in Cleveland, then we can without doubt agree with his description of the lavish costume, richly embroidered with pearls and jewels. And if we examine the two panels with care, we can add that the cloudy sky that serves as a backdrop behind the constructions and can be seen through the window in the wall, as well as the flowering meadow portrayed in great detail and the com-

8. *Madonna and Child with Saints, Angels
and a Worshipper*
49 × 38 cms.
Venice, Cini Collection

9. *Man of Sorrows*
82 × 101 cms.
Florence, Archbishop's Palace

10. *Madonna of Corneto Tarquinia, detail of the marble throne*
Rome, Galleria Nazionale di Arte Antica (Palazzo Barberini)

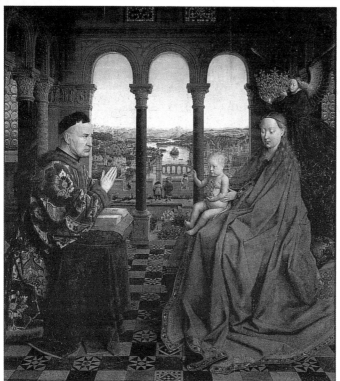

11. *Jan van Eyck*
Madonna of Chancellor Rolin
Paris, Louvre

12. *Madonna of Corneto Tarquinia*
114 × 65 cms.
Rome, Galleria Nazionale di Arte Antica (Palazzo Barberini)

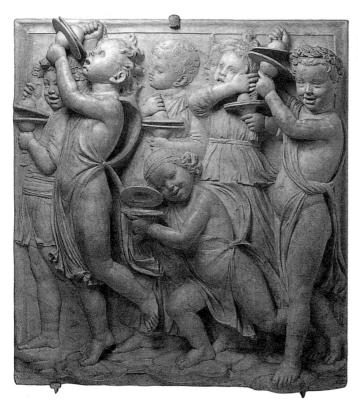

*13. Luca della Robbia
Detail of the Cantoria
Florence, Museo
dell'Opera del Duomo*

plex drapery folds of the garments of both saints, contribute to the creation of a richly varied and refined painting, well suited to the important diplomatic function of the gift. From the drawing the painter adds at the foot of the letter we can see that the frame was a typical late Gothic construction, with carved pinnacles flanked by two vases of flowers, very similar to the decoration of the facade of Prato Cathedral, which was being completed at more or less the same time.

The Opinions of his Contemporaries

Apart from Cosimo the Elder's positive comment and Vasari's two versions of his biography (1550 and 1568) which we shall get back to, what else has been written about Fra Filippo Lippi over the centuries?

The earliest critical mention of his activity as a painter dates from 1438. He is mentioned by another painter, Domenico Veneziano, in a letter he wrote from Perugia on 1 April to Piero, the young son of Cosimo de' Medici. In this letter Domenico says that he is aware that "Fra Giovan- ni (Angelico, that is) and Fra Filippo have a great deal of work to do, especially Fra Filippo who is painting an altarpiece for the church of Santo Spirito." This painting was the Barbadori Altarpiece, now in the Louvre. Only a little younger than the other two artists (Filippo would have been in his early thirties, Angelico just four or five years older), Domenico Veneziano in that letter was asking Piero de' Medici to commission from him a large altarpiece, so that he might compete with the two most respected artists active in Flor-

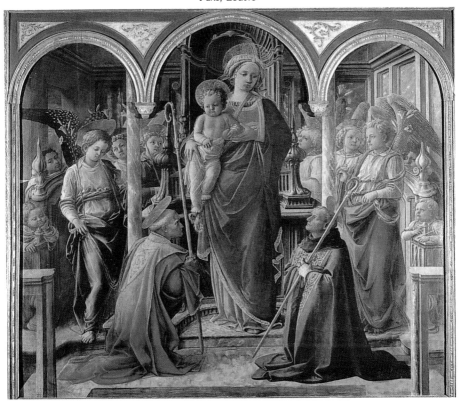

ence at the time. Filippo must already have been quite famous, even outside Florence, for Domenico refers to him as a "bon maestro"; but he does add, with a pinch of malice, that even if he worked on the huge Santo Spirito altarpiece "day and night, he shan't finish it for at least five years, so great is the undertaking."

Over the following years the name of Lippi is mentioned in various documents, but we have no more detailed critical comments, except for Cosi-

mo the Elder's remark, quoted long after it was made.

The rich and erudite Florentine Giovanni Rucellai, related to the Medici, writing his fascinating *Zibaldone* in 1465, states that among the paintings of his small collection there is also one by Fra Filippo, "one of the best masters we have had for a long time, not only in Florence, but in the whole of Italy." A few years earlier, in the 1450s, Antonio Filarete talks of him in his *Trea-*

15, 16. Predella of the Barbadori Altarpiece:
The Vision of St Augustine and St Fredianus Diverts
the River Serchio
Florence, Uffizi

17. Predella of the Barbadori Altarpiece:
Announcement of the Death of the Virgin
Florence, Uffizi

tise on Architecture, but not as a typical exponent of Tuscan art: he relates his work, and Piero della Francesca's as well, to that of Northern Italian artists such as Mantegna, Cosmè Tura and Vincenzo Foppa.

More accurate, on the other hand, was the obituary written by the Florentine monastery of Santa Maria del Carmine, where Filippo had been educated and had taken his vows. Not only is the artist who gave lustre to the monastery (his scandalous behaviour has obviously been forgotten) called "pictor famosissimus," but his frescoes and paintings in Prato, mostly on religious subjects, are praised for their "gratia," that is for the beautiful harmony of the figures and for the charm and power of communication of the whole composition.

And Cristoforo Landino, writing in 1481, less than twenty years after Filippo's death, also speaks of the artist as being "gratioso" (which must also be interpreted in the Humanistic sense of being capable of communicating clearly a sense of harmony and of variety). In his Commentary to Dante's Divine Comedy Landino places Lippi's work in a correct historical perspective: immediately after Masaccio, alongside Fra Angelico, Andrea del Castagno and Paolo Uccello.

Already in this first attempt at an artistic historiography we find a reference to Lippi's love of "ornaments of all kinds, even imitations, or fake ones." And also according to Landino Filippo was especially skilled in elaborate compositions, rich colour schemes and the modelling of figures: "Filippo's graceful, ornate and artful style was primarily precious for its compositions and its variety, use of colour and relief of the figures."

As Michael Baxandall has explained quite clearly, when Landino writes about the ornate style of Lippi's paintings he means, according to the Humanist ideas of the time, that they were "acute, sharp, rich, humorous, joyful and carefully executed." In this sense his style was closer to that of Fra Angelico, whereas Masaccio, whose work on the contrary was defined as "pure and unadorned" (an equally positive criticism, meaning clear and concise), was more concerned with the absolute representation of reality.

The characteristic features of Fra Filippo's art praised by Landino are basically the same ones that we admire most today. The lively colours and tones stress the lighting of the objects and figures depicted, emphasizing their three-dimensionality.

And Lippi's naturally flowing draughtsmanship gives life and movement to the characters. In the manner of the great Flemish artists, Fra Filippo pays attention to details, such as tiny pearls, veined marble and precious fabrics. Finally, last but not least, his art is characterized by an aesthetic and moral interest, typical of the generation of Florentine painters working in the 1440s, in the variety of the visible world, as it was defined by the famous architect and theoretician Leon Battista Alberti in his Treatise on Painting (1436).

Giovanni Santi, the father of the great Raphael, in his poem Disputation over the Art of Painting (pre-1494), mentions Filippo Lippi alongside Masaccio, Andrea del Castagno, Domenico Veneziano, Pesellino and several other famous masters of the early Quattrocento.

Another sign of the painter's lasting fame was the solemn acknowledgement of his greatness tributed by Lorenzo the Magnificent, about twenty years after the artist's death (Filippo died in Spoleto in 1469). Lorenzo de' Medici, who was far less indulgent than his grandfather Cosimo had been towards the capriciousness of artists, commissioned Filippino Lippi to build a monumental tomb for his father Filippo in the Cathedral of Spoleto, a monument that was probably even grander than those built in Florence for Giotto or Brunelleschi. The epitaph was written by the poet Agnolo Poliziano, a close friend of Lorenzo's; but this Latin inscription, although quite solemn, is rather general and does not offer any critical appraisal at all, except for an overall Humanistic recognition of the artist's talents:

CONDITVS HIC EGO SVM PICTVRE FAMA PHILIPPVS
NVLLI IGNOTA MEE EST GRATIA MIRA MANVS
ARTIFICIS POTVI DIGITIS ANIMARE COLORES
SPERATAQVE ANIMOS FALLERE VOCE DIV
IPSA MEIS STIPVIT NATVRA EXPRESSA FIGVRIS
MEQVE SVIS FASSA EST ARTIBVS ESSE PAREM
MARMOREO TVMVLO MEDICES LAVRENTII HIC ME
CONDIDIT ANTE HVMILI PVLVERE TECTVS ERAM.

Here in this place do I, Filippo, rest/ Enshrined in token of my art's renown/ All know the wondrous beauty of my skill/ My touch gave life to lifeless paint, and long/ Deceived the mind to think the forms would speak/ Nature herself, as I revealed her, owned/ In wonderment that I could match her arts/ Beneath the lowly soil was I interred/ Ere this; but now Lorenzo Medici/ Hath laid me here within this marble tomb.

(Translation by George Bull)

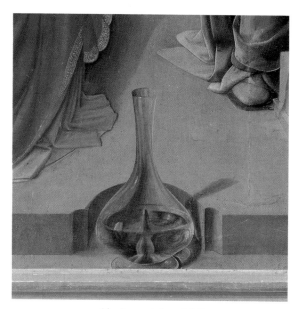

18. Annunciation, detail
Florence, Church of San Lorenzo

19. Annunciation
Florence, Uffizi (Gabinetto dei Disegni e delle Stampe)

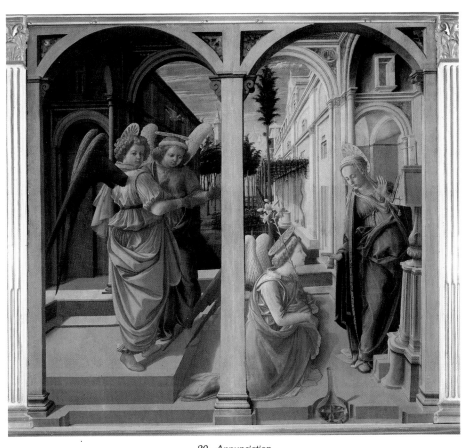

20. Annunciation
175 × 183 cms.
Florence, Church of San Lorenzo

21. Coronation of the
Virgin, detail of the lunette
on the left
Florence, Uffizi

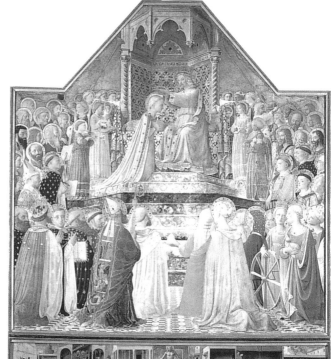

22. Fra Angelico
Coronation of the Virgin
Paris, Louvre

23. Coronation of the
Virgin
200 × 287 cms.
Florence, Uffizi

From Vasari to the Present

There is a sort of direct link in the critical appraisal of Fra Filippo (but perhaps we ought to speak of critical disapproval) which joins Vasari's account of Filippo's passionate love for Lucrezia to the Romantic and fairytale mood that developed in the 19th century around the Florentine artist (think only of the poem *Fra Lippo Lippi* that the British poet Robert Browning composed while living in Florence). Over the years a basically disparaging and inaccurate interpretation grew up, and it lasted until the early years of this century.

As late as 1904 Gabriele D'Annunzio used the following lines to refer to Lippi:

Io ti vedea sopra la sabbia ardente
schiavo in catene; e ti vedea poi sazio
dormir sul seno di Lucrezia Buti.

(*Elettra, Prato, La città del silenzio*)

(I saw you, a slave in chains, on the
burning sand; and then I saw you, sated,
asleep on Lucrezia Buti's breast.)

These lines by D'Annunzio refer to two epi-
sodes that Vasari recounted in both editions of his biography of Filippo (the first one had been already told in a story by Matteo Bandello, I, 58, published in the 1550s, although Vasari probably knew about it even earlier, when he first began work on his *Lives of the Artists*).

Vasari writes that at the age of seventeen the young Filippo had already shown remarkable artistic talent.

"When he heard them all singing his praises, he threw off his habit. . . although he had already been ordained in the name of the Gospel, and abandoned his religion." Later, in the March of Ancona, the young Filippo had gone out to sea on a little boat with some friends. Captured by the Moors, "who scoured those parts," they were all "taken away to Barbary and enslaved and put in chains, where they remained for eighteen months." One day, Vasari's story, "since he was very familiar with his master, he took it into his head to draw a portrait of him; he took a piece of charcoal from the fire and made

24. *Coronation of the Virgin*
167 × 69; 172 × 93; 167 × 82 cms.
Vatican City, Pinacoteca

25. *Madonna and Child with Four Saints*
196 × 196 cms.
Florence, Uffizi

a full-length portrait of him, wearing his Moorish costume, on a white wall. When the other slaves told the master, for they all thought it was a miracle since neither drawing nor painting were known in those parts, he was released from the chains he had been bound by for so long."

A great deal has already been said on the "amorous passion" of Fra Filippo which so stimulated D'Annunzio's erotic literary fantasies. But there is one other interesting anecdote recounted

by Vasari: an event that took place before Filippo fell in love with Lucrezia. It seems that Cosimo had asked Filippo to paint him a picture and, in order to make sure that he did not waste any time, he had ordered the painter to be locked into his room. But Filippo "one evening, with a pair of scissors, cut his bed sheets into strips and let himself out by climbing down from his bedroom window: for several days he went about enjoying himself." Still according to Vasari's account, Cosi-

mo realized his mistake and thereafter "kept a hold on him with affection and kindness, and was served all the more readily." But Vasari does not go into great detail over the story with Lucrezia: he mentions the two "disgraced" sisters who refused to go back into the convent, he talks of their father's unhappiness, and how he never smiled again, and of the son born to Filippo, "who became, like his father, a famous and accomplished painter." And that is more or less all he says. He simply adds that his artistic talents were so great that his scandalous behaviour was forgiven.

And yet these few elements, hardly a collection of outrageous actions, which Vasari recounted in his biography of Filippo, succeeded over the centuries in creating a legend that it is still difficult today to dispel (for example, there is even a Norwegian Rock group that has taken on the name of the sensuous monk).

All this gossip surrounding the life of the artist for a long time prevented any more objective approach to his works, which today are finally recognized as being among the most original and important examples of Italian Quattrocento art. Very little attention was paid to other fundamental concepts which had already been mentioned by Vasari and the early commentators, as well as by 17th-century scholars writing about Lippi's work. Had those ideas been investigated more thoroughly, far more enlightening approaches to the problem could have been followed.

First of all, the correct beginning would have been to refer to the undeniable importance of Masaccio's influence on the young Lippi. For Vasari tells us that one of Filippo's earliest paintings, a fresco that has not survived, painted on a column in the church of the Carmine, "bore comparison with Masaccio's work." The young Filippo used to go every day to study the frescoes in the Brancacci Chapel: "His work improved every day and he came to understand Masaccio's style so well that his own pictures resembled those of Masaccio, and it was often said that Masaccio's soul had entered into his body." This is how Vasari describes Filippo's talent as a draughtsman and his gifts as an artist. He also taught the art of painting to Fra Diamante ("who thanks to his teaching achieved the highest perfection"), as well as to the young Botticelli, to Pesellino, and to Jacopo del Sellaio. Even the great Michelangelo himself "has always sung his praises and in many details has even imitated him."

And yet, it was the legend of the monk in love that became particularly popular, especially in the Romantic climate of the 19th century.

In 1822 the French artist Paul Delaroche paint-ed a canvas which he entitled *Filippo Lippi Falls in Love with the Nun he is Using as a Model* (today in Dijon, in the Magnin Museum). The story of "lust and violence" is transformed in Delaroche's painting into a love scene that is almost too sentimental; the French artist was inspired in fact by a celebrated painting by Ingres depicting another famous story of illicit love, the story of Paolo and Francesca. It seems that Delaroche had learnt about Filippo Lippi from the account Stendhal gave of his love story: in sentimental tones, the great French writer turned the middle-aged Filippo into a young man completely overpowered by a sort of adolescent passion. And Delaroche's painting, which was exhibited in the 1824 Salon in Paris, portrays him like that. In the background of the 19th-century painting there is a canvas on which Filippo is beginning to paint an Annunciation. Despite this realistic detail, rather typical of the art of French Pre-Raphaelites, there is nothing at all in the painting that conveys the true poetic nature of Lippi's art. We learn nothing about Lippi's dramatic force, nor about his calm, colloquial "vernacular" style, which is today quite justifiably considered one of the most original aspects of his art. So, we should not be surprised if a great writer like D'Annunzio, who on other occasions proved so perceptive and farsighted in his appraisal of the work of Italian painters of the past, when faced with Lippi's frescoes in Prato Cathedral concentrated on their more anecdotal, narrative and superficial aspects. I think it is important here to quote briefly some passages from D'Annunzio's writings about Lippi, normally ignored by art scholars. The fact that in the past Lippi's work was always judged rather negatively makes us appreciate even more the efforts of recent scholars who are analyzing and explaining the true greatness of the painter's artistic message. And they can also help us understand how the study of Fra Filippo and his art has only barely begun.

The young D'Annunzio, at school in Prato, became fascinated by the sensual Salome, whom Filippo had portrayed dancing before Herod according to the account given in the Bible, in his frescoes in Prato Cathedral. The young poet decided that he was ideally "Lucrezia Buti's second lover," and began to wonder whether the young nun had been the model for Salome or for Herodias: "I delighted in the torment of this alternative: Which of the two are you, Lucrezia Buti? Sister Lucrezia, are you the one that is dancing, like a sensuous flower made of folds instead of petals, now closed, now half-open, now fully open? Or are you the one who sits at the table,

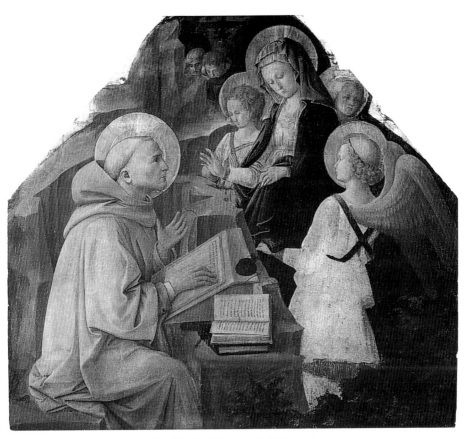

26. The Virgin Appears to St Bernard
69 × 105 cms.
London, National Gallery

raising a calm and merciless hand towards the severed head; or are you the one with the curly hair like a cluster of grapes, crowned with vines like a Bacchante?" (*Faville*, I, 545).

The art teacher who had taken the young D'Annunzio to Prato Cathedral to copy Filippo Lippi's frescoes told his student that all the women that Lippi portrayed "are like Lucrezia, they are of the same blood as Lucrezia Buti," both in the fresco of *Herod's Banquet* and in "all the figures, except for the bishops and the abbess" in the painting of the *Madonna of the Holy Girdle* (now in the Galleria Comunale, this work is more commonly attributed to Fra Diamante, Filippo's assistant).

D'Annunzio is disappointed and takes little interest in the monk's artistic ability. Even in front of Lippi's tomb in Spoleto, D'Annunzio can only think of his love story:

Cerco. . . ne' silenzii dell'Assunta
l'arca di Fra Filippo che dai marmi
pallidi esala spiriti d'amore
(*Elettra*, Spoleto, 176)

(I search . . . through the silence of Our Lady of the Assumption for the tomb of Fra Filippo, and through the pale marble it exhales spirits of love).

And today's observer, too, thinks primarily of Lippi's love life and all too frequently examines the artist's gentle Madonnas in the hopes of discovering a mysterious message from the beautiful Lucrezia. Let us then recover and interpret with less sentimentality the extraordinary heritage that Fra Filippo's painting has left us.

Firstly, we must not forget that the learned art collector Filippo Baldinucci in his *Notizie de' professori del disegno da Cimabue in qua* (1681) warned against several mistakes (some of them concerning dates) contained in Vasari's account of Fra Filippo's life history. As Baldinucci writes, the artist "made works of such infinite beauty . . . all of them venerable, not only because they are antiques, but because of the poetry that surrounds them." Not a word about Lucrezia, and just a vague remark about the obscure circum-

*27. Adoration in the Woods
Detail of the Child
Berlin-Dahlem, Gemäldegalerie*

*28. Adoration in the Woods
127 × 116 cms.
Berlin-Dahlem, Gemäldegalerie*

stances of the monk's death, which according to a traditional account was caused "by poison" given to him by the relatives of a woman to whom he had taken a fancy.

In any case, in basic agreement with all earlier commentators, Baldinucci defined Fra Filippo "an extremely original artist for his times, both for his precise draughtsmanship and for the graceful elegance with which he imbued his figures; for the lovely features of his characters, the variety and nobility of the costumes, and the accomplished talent he always demonstrated . . ." He also saw in his work "a remarkable discernment, and a unique attention to expressions, as well as to actions, and to the feelings of the figures he portrayed."

It is interesting to note that between Baldinucci and the more recent research studies on Lippi there have been very few critical judgements on the artist of any importance (and in fact, it is only

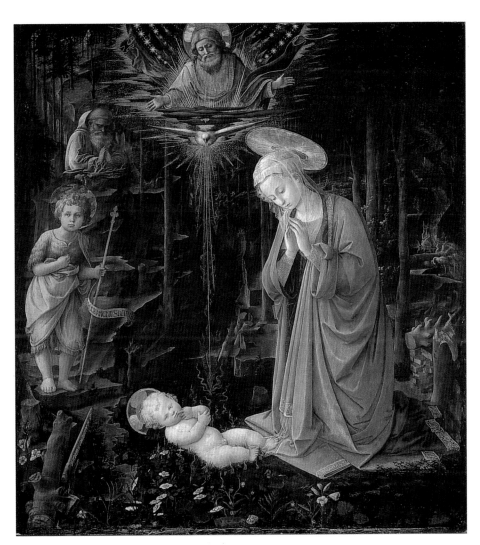

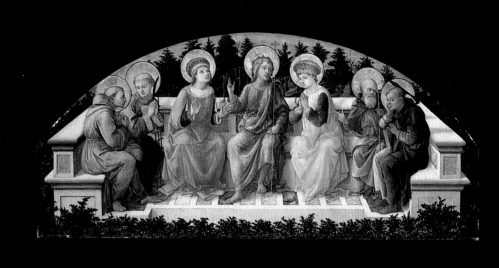

29. Holy Conversation
68 × 151 cms.
London, National Gallery

30, 31. The Four Fathers of the Church
129 × 65 cms. each
Turin, Accademia Albertina

in the last fifty years that we can speak of a serious critical study, begun thanks to the work of Bernard Berenson, Roberto Longhi and Mary Pittaluga, the pioneers of the rediscovery of Lippi as an artist). In his *History of Italian Painting* (1789), Abbot Luigi Lanzi repeated all Vasari's stories and anecdotes practically without alterations. Jacob Burckhardt (in his *Cicero*, 1855) was the first who stressed the features of imagination and lively creativity in Fra Filippo's painting, which

nevertheless, he maintained, was still firmly tied to earlier traditions. Whereas Rio (1861), followed by Cavalcaselle (1864), dealt at length with the events of the friar's private life, expressing quite firmly his disapproval. According to Cavalcaselle (who was also the first scholar to point out the influence of Donatello on Lippi's work), the young Filippo was inspired not so much by Masaccio as by Masolino and Fra Angelico; and he "moved away from these artists' chaste and sublime forms as his amorous passion grew stronger." In his life of Lippi (1902), Igino Supino remarked that in Florentine Quattrocento society "it was not at all surprising to come across a monk who was only a monk because he wore a cassock, and the cassock did not stop him from following in public, and with no restraint, the most violent passions of the heart and the senses."

Taking a position in open contrast to these

32. *Madonna and Child Enthroned with Two Angels*
123 × 63 cms.
New York, Metropolitan Museum of Art

33. *Annunciation*
118 × 175 cms.
Rome, Galleria Doria Pamphilj

moralistic pronouncements, Bernard Berenson declared in an early essay (1896) that Fra Filippo was a first class illustrator. Several years later, in 1932, he formed a different opinion, in open disagreement with the general trend of critical appraisal that had been established by the early research studies carried out by Igino Supino, Henriette Mendelsohn and Adolfo Venturi. These three scholars had proposed an interpretation of Lippi's art in terms of the stylistic evolution from Gothic to Renaissance art forms. Berenson, on the other hand, drew a distinction between a markedly Masaccesque early period (which also included a brief stage in which the artist was strongly influenced by Fra Angelico around 1442) and the more autonomous and independent later works, which are totally innovative and cannot be compared with the work of any other artist of the time.

And of course we must also mention Roberto Longhi's very perceptive and slightly controversial position. Talking about the crowds of people who in the 1430s thronged to the Carmine to admire Masaccio's extraordinary frescoes, Longhi admitted that "the most imaginative and restless must certainly have been the young monk Filippo Lippi." But he then added that we must not praise Lippi's talent too highly because in his work Masaccio's influence comes across almost as a caricature.

Today we are less interested in assessing Lippi's artistic talent (undoubtedly quite unique, especially in matters of perspective construction); what we are more concerned with is a study of the cultural influences, the reasons which led him to be influenced by Flemish art, the circumstances and requirements of his clients and patrons, his relationship not only with the "teachings" of Masaccio, but also the similarities (as well as the divergences) of his work with the painting of Fra Angelico, his frequent references to the lifelike sculptures of Donatello or to the classicism of Luca della Robbia, and lastly the complex problems concerning the chronology of his works, especially his early ones, and the many attributions that are still uncertain.

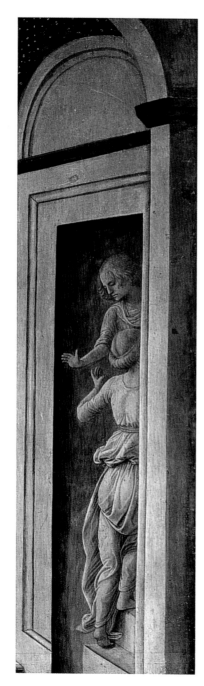

34. Annunciation, detail
Rome, Galleria Nazionale di Arte Antica
(Palazzo Barberini)

35. Annunciation
Detail of the two donors
Rome, Galleria Nazionale di Arte Antica
(Palazzo Barberini)

36. Annunciation
155 × 144 cms.
Rome, Galleria Nazionale di Arte Antica
(Palazzo Barberini)

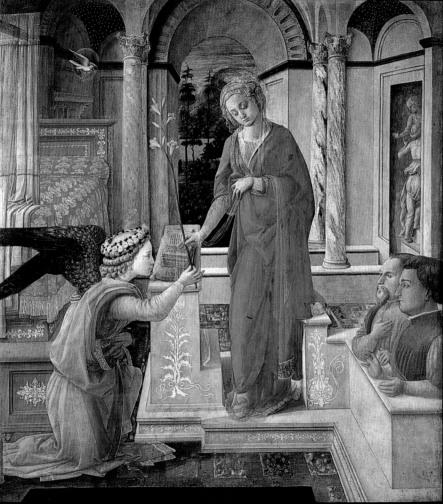

Lippi's Early Works

Paintings for the Carmelite Monks

If until a few years ago at least one aspect of Lippi's pictorial career appeared to be quite clear and presented no great problems for scholars, it was his early period. Everyone agreed on the date 1432 for the fragment of a fresco in the Florentine monastery of Santa Maria del Carmine, the so-called *Confirmation of the Rule*. This fresco (which was first rediscovered in 1860 when the plaster of the monastery's cloister was removed) according to Vasari shows the Confirmation of the Carmelite Rule by Pope Honorius III; later commentators, however, have suggested that it in fact depicts a Modification to the Rule, confirmed by a papal bull passed in 1432. Neither of these theories can be proved, and most of the evidence has recently been shown to be inaccurate. But let us look at the fresco.

The scene takes place in a highly stylized country landscape: clearly influenced by Masaccio, and possibly even by Giotto, as we can see from the few architectural structures that are still visible. The monks are shown in a variety of poses. The group not quite in the foreground, a seated monk with a smiling and peaceful expression and a novice kneeling before him, has been interpreted as the scene of the "explanation" of the advantages that will result from the Mitigation of the Rule. Whatever the intended meaning of this scene is (and matters are further complicated by the poor condition of the fresco), it is clearly a work that was strongly influenced by the art of Masaccio (around 1428 Masaccio had frescoed part of the Brancacci Chapel in the Carmine, and before that he had painted the fresco called the Sagra in the cloister of the same church). Thus, if we accept the attribution to Filippo of this fresco, we will find confirmation for the account given by Vasari: Filippo painted frescoes "on several walls" in the Carmine, following in the footsteps of his talented predecessor.

The influence of Masaccio (and of course the attribution to Lippi) is not a matter of controversy; and Masaccio's influence is clearly visible also in a group of panel paintings dating from this same period that have been almost unanimously attributed to Lippi. Now housed in a variety of museums and collections in Empoli, Venice and Milan, these paintings are very similar in style to the Florentine fresco. They all exhibit the power of Masaccio's three-dimensionality, balanced by a masterful use of chiaroscuro; the only weak points (presumably a result of the artist's lack of experience) are to be found in the psychological portrayal of the characters, at times so overstressed as to become almost expressionistic, and also in the spatial construction.

The first new theory in a critical study of this group of works was expressed by Shell in 1961: he cast doubts on the attribution to Lippi. Basically, Shell attributed both the Carmine fresco and the so-called *Trivulzio Madonna* (Milan, Castello Sforzesco) to the same artist who had painted the fresco decoration in the chapel of Our Lady of the Assumption in Prato Cathedral: in other words they were not the work of Lippi, but of an unidentified artist referred to as the Master of Prato (Pope-Hennessy, writing in 1950, had already attributed some paintings formerly thought to be by Paolo Uccello to this same artist).

Other scholars have accepted Shell's theories, for they saw too great a stylistic difference between this group of paintings, dating from around 1432, and those that were certainly painted by Lippi around 1437 (such as the fascinating, but revolutionary, at least in terms of the Italian art scene of the period, *Madonna of Corneto Tarquinia*).

In 1975 a new discovery changed once again the theories concerning the Carmelite fresco: Ruda discovered that the papal bull ratifying the Mitigation of the Rule dated from 1435 and not 1432. And more recently, also in view of this new information, Boskovits has suggested that if it were really an illustration of that event taking place in 1435, then its style is much too far removed from the splendid results of the *Madonna of Tarquinia* painted only two years later, in 1437. So Boskovits has made another suggestion: the scene, set in the open countryside, is unlikely to be a depiction of a Confirmation of the Rule, which should more logically be represented as a solemn celebration in an interior, presumably the papal Court. Perhaps the scene is intended as a portrayal of the life of anchorites and, as Boskovits suggests, a reference to the very beginning of the history of the Order, before it was transferred from Palestine to Europe. The monk

37. Portrait of a Man and a Woman
64 × 42 cms.
New York, Metropolitan Museum of Art

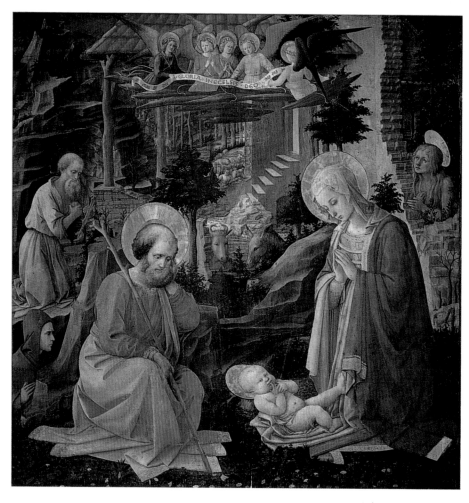

may be hearing the novice's confession, and the landscape may symbolize Mount Carmel, and not the Tuscan countryside at all.

Now let us have a look at the *Madonna of Humility* (or *Trivulzio Madonna*, from the name of the private collection it belonged to before being transferred to the museum in the Castello Sforzesco). What strikes one immediately is the composition, almost a theatrical stage-setting, or a group posing for a photograph: the children around the Madonna are captured as though by the click of the camera's shutter, and the ones further back are leaning sideways in order not to be hidden by the heads of those in front. And notice the rather

38. *Adoration of the Child*
137 × 134 cms.
Florence, Uffizi

39. *Adoration of the Child*
140 × 130 cms.
Florence, Uffizi

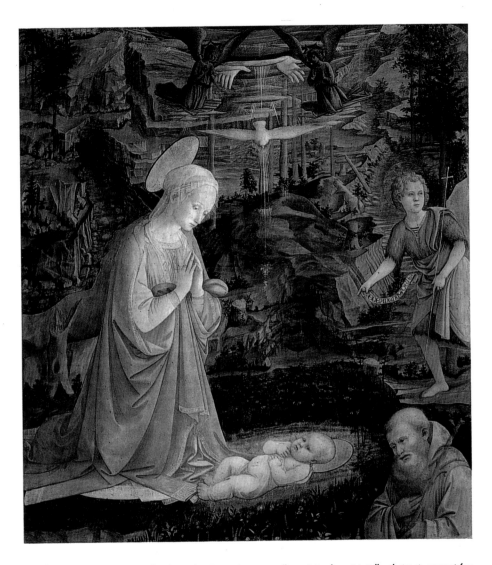

restless Christ Child, captured as he is slipping out of the grasp of his young Mother, just a peasant girl with a slightly distant gaze, looking far away and not communicating with the spectator at all. Here, once again, we have a painting of a holy subject portrayed with total realism, in an atmosphere that is still entirely the result of Masaccio's great lesson, but with the occasional weak point, as we saw in the Carmine fresco, especially in the proportions and the definition of pictorial space (here it is almost totally abstract, except for the flowery meadow, a detail which is still vaguely late Gothic in mood). And yet there are many elements that confirm the attribution to Lippi: the faces of the characters, so typical of Fra Filippo's paintings, with roundish cheeks, slightly swollen eyes, very similar to the much later altarpiece of the *Coronation of the Virgin* painted for the high altar of the church of Sant'Ambrogio in Florence around 1447. There is no element in the *Trivulzio*

40. Head of a Woman
Florence, Uffizi (Gabinetto dei Disegni e delle Stampe)

41. Madonna and Child with Stories
from the Life of St Anne, detail
Florence, Pitti Palace (Palatine Gallery)

42. Madonna and Child with Stories
from the Life of St Anne (Pitti Tondo)
diam. 135 cms.
Florence, Pitti Palace (Palatine Gallery)

Madonna that suggests the work of any other artist dating from after 1430. So it would appear logical to date this painting earlier, probably in the late 1420s. This theory is supported by the style of the work, still rather crudely vernacular and expressionistic (it reminds one in a way of Donatello and Michelozzo's frieze on the pulpit of Prato Cathedral, carved at more or less the same time); and it is also supported by the fact that this *Madonna of Humility*, like the *Madonna and Child with Saints and Angels* now in the Cini Collection in Venice and the *Madonna* in the Collegiate Church in Empoli, were all probably commissioned by the Carmelite Order. It would appear

43. *Madonna and Child with an Angel*
Florence, Uffizi (Gabinetto dei Disegni e delle Stampe)

44. *Madonna and Child*
95 × 62 cms.
Florence, Uffizi

45. *Adoration of the Magi, detail*
Washington, National Gallery of Art

46. *Adoration of the Magi*
diam. 137 cms.
Washington, National Gallery of Art

logical that Lippi worked on these paintings while he was still living in the monastery in Florence, before he began to travel so much.

There is one particular iconographical detail in the *Trivulzio Madonna* that suggests it was commissioned by the Carmelites: the presence of the Carmelite saints, St Angelo from Licata (the one with the dagger in his head) and St Albert of Sicily (carrying a lily). Before arriving in Milan the painting was the property of the Rinuccini family, a Florentine family who had a chapel in the Carmine church. It is therefore quite likely that the *Madonna of Humility* also hung in that same church, perhaps, as Boskovits has suggested, on the altar dedicated to St Angelo in the crossing (this chapel belonged to the friars until it was demolished in 1568 as a result of Vasari's modernizations). The lovely painting in the Collegiate Church in Empoli was also probably commissioned by the Carmelites; before arriving in Empoli it almost certainly hung in the Monastery of Selve, half way between Florence and Empoli. The painting shows the Madonna enthroned with angels and saints Michael, Bartholomew and Albert. Formerly attributed to Masaccio and Masolino (an attribution that is no longer accepted by

528

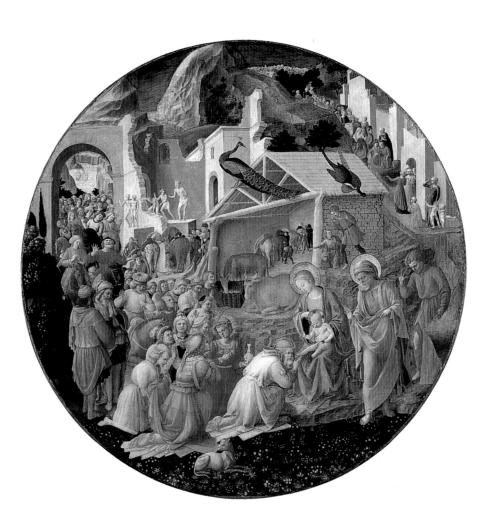

anyone, but which is evidence of how Masaccesque Lippi's early period was), and even to Andrea del Castagno, this painting shows clearly that Filippo was acquainted with the work of the first great artist who understood and interpreted Masaccio's teachings: Fra Angelico. The use of bright and enamel-like colours, a great attention to detail (the carved decoration of the throne) and the muted lighting, and above all the circular arrangement of the figures, are reminiscent both of Masaccio's *Tribute Money* and of Fra Angelico's *Madonna* (c 1428) now in the Staedel Institut in Frankfurt. The painting now in the Cini Collection in Venice, a *Madonna with Saints, Angels and a Patron*, is difficult to date with accuracy. It is the first Italian painting in which a scene of this kind is set in an interior, a fairly common figurative device in Northern painting, especially in Flemish art. This is the painting that marks the break away from Lippi's early works, characterized by their Masaccesque elements, to a more mature style in which he still shows an interest in the fullness of volumes, but is already paying greater attention to the delineation of outlines. It will be this new "twofold" tendency, as Federico Zeri has called it, that will create a sort of dichotomy in Florentine Quattrocento painting. On the one hand, the rhythmic cadence of outline drawing; on the other, the more sculptural interest in volumes—a direction that will be fully developed by a pupil of Lippi's, Botticelli.

The Madonna of Corneto Tarquinia and the Influence of Flemish Art

The *Madonna of Corneto Tarquinia* was painted for the Florentine Archbishop Vitelleschi and is extremely important in order to understand the revolutionary development of Lippi's painting. The date 1437 appears on the scroll resting on the base of the splendid throne made of veined marble. While, on the one hand, the pose of the charming little Christ Child is clearly inspired by classical art, the interior setting, the stretch of landscape visible through the open window to the left, and the courtyard that shows through the open door in the background are all elements that remind one of the work of Jan van Eyck and other Flemish artists; although these elements were common in Flemish painting, no Italian artist, except perhaps Fra Angelico on rare occasions, had ever painted anything like this. An intimate, everyday reality, stressed not so much by the presence of objects connected to daily activities, but rather by the way they are arranged. Take, for instance, the book on the balustrade of the throne. Even the perspective construction, from the semi-circular throne to the corridor behind it, is achieved according to typically Northern rules. A lot has been written in the attempt to explain historically and culturally the Flemish style of this painting by Lippi, a style which he never abandoned in all his later works. We know that Filippo had been to Padua in 1434, and it has been suggested that this is where he first began to follow these new trends. Other scholars believe that he may have travelled to Naples as well, where he could have come into contact with the art scene at the Aragon Court, so open to Flemish influences. For some time now scholars have been suggesting that, despite lack of documentary evidence, Jan van Eyck may have spent some time in Italy; and ever since his early years in the Carmine monastery Filippo might have been in contact with Northern European culture, for in the church of the Carmine there was the headquarters of the Company of St Catherine of Flanders, patronized by northern merchants who came to Florence to trade. They frequently brought with them from their country objects of art, paintings, illuminated manuscripts: this is where Filippo may have seen his first Flemish works of art. And then there is the mystery surrounding Lippi's Paduan period. All we know of the paintings that Filippo carried out in Padua, especially the reliquary of St Anthony and the fresco of the *Coronation of the Virgin* (both in the Basilica del Santo), is what chroniclers of the past have told us: Vasari and Marcantonio Michiel. The transition from his early works painted for the Carmelites to a more mature style, especially as far as spatial construction is concerned (unfortunately today we can observe this new form of spatial construction only in the *Madonna of Corneto Tarquinia*), may not have been so abrupt as it appears. The intermediate stage lay probably in the lost Paduan works. Eliot Rowlands' suggestion is quite plausible: he believes that the young Lippi may well have been fascinated by the crowded late 14th-century compositions which he saw in the frescoes by Altichiero and Guariento in Padua and Venice.

We have no documentation at all, on the other

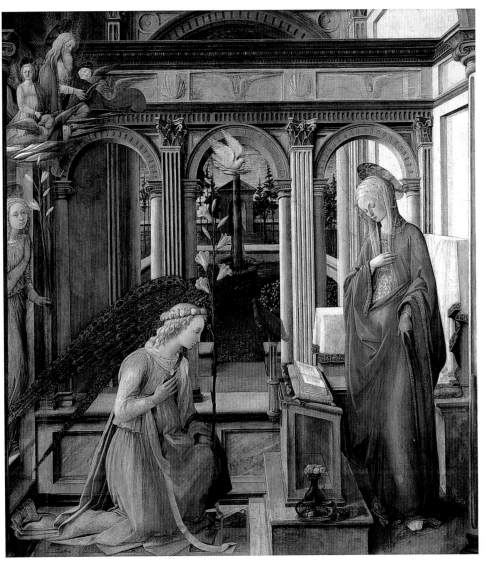

47. Annunciation
203 × 186 cms.
Munich, Alte Pinakothek

48. Tabernacle of the Ceppo Nuovo
187 × 120 cms.
Prato, Civic Gallery

hand, concerning a possible journey to Basle, where Filippo may have gone to attend the Council that was taking place that same year (the same Council that was later transferred to Ferrara and then to Florence). But it is interesting to note that some paintings by the Florentine artist Neri di Bicci (and it appears that he also worked with Lippi at least on one occasion) are copies of works by the Flemish artist Rogier van der Weyden (c 1400-1464). Although we have no evidence of the presence of paintings by Rogier van der Weyden in Florence, this is further indication of the interest that some Florentine painters developed for Flemish masters and also suggests that some works must have been available in Florence for those artists to study.

*49. St John the
Evangelist
Prato, Cathedral*

*50. St Luke the
Evangelist
Prato, Cathedral*

The Large Altarpieces for Florentine Churches

Let us now return to Florence. The splendid *Barbadori Altarpiece* dates from about 1438. This monumental painting (now at the Louvre; predella in the Uffizi) shows a Madonna and Child with Angels and Saints. The Captains of the Guelph Party had commissioned it from Lippi on 8 March 1437 for the altar of a chapel belonging to the Barbadori family in the Augustinian church of Santo Spirito. This is undoubtedly the artist's first truly scenographic masterpiece.

The idea of placing the entire holy scene in a single setting may have been borrowed from Fra Angelico. Behind the balustrade to the left there are two monks peering out: they are very much reminiscent of the young children in Luca della Robbia's *Cantoria* in Florence Cathedral (and the Child in the Madonna's arms resembles them too).

But the great innovation of this work lies not only in the masterful, moody lighting, but primarily in the construction of the scene, which appears to be taking place in a totally realistic setting. In the background, to the left, in the wall with its pre-

cious veined marble panelling, there is an open window through which we can see a real sky with clouds in it. The Saints are no longer placed on the side panels, as they were in Gothic altarpieces; they kneel in front of the Virgin, in a wholly realistic way, and their features are equally realistic, as though they were portraits of contemporaries. Even the frame (although the corbels of the arches do not correspond to the scene's painted columns) appears to stress the idea of a realistic event, taking place in realistic time and space. Filippo is also clearly aware of the most up-to-date iconographical details. In one of the predella scenes, the *Vision of St Augustine*, the symbolism of the three-faced head refers to the *signum triciput, quod monstrum erat in natura* (the mark of three heads, which was a monster in nature),

51, 52. Stories from the Life of St Stephen: St Stephen is Born and Replaced with Another Child
Prato, Cathedral

534

53. *Stories from the Life of St Stephen:*
St Stephen is Born and Replaced with Another
Child, detail

54-56. *Stories from the Life of St Stephen:*
Disputation in the Synagogue
Prato, Cathedral

as St Antoninus was to define it in 1477, because
the image was considered heretical. At the time
this *signum* was used as a symbolic representation
of the Trinity by artists such as Donatello, in the
tympanum of the Guelph Party niche in Orsan-
michele; it appears also in Pollaiolo's allegory of
Theology on the tomb of Pope Sixtus IV.

The altarpiece of the *Annunciation* with *Stories
from the Life of St Nicholas* in the church of San
Lorenzo dates from about 1440-42. It was com-
missioned by the administrators of the church,

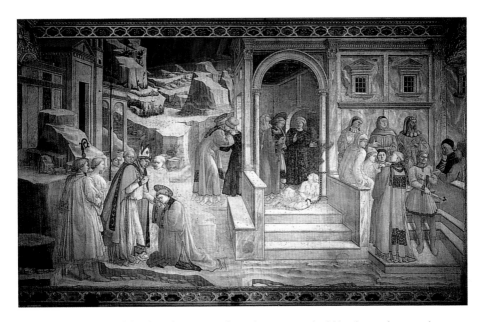

who were the patrons of the chapel containing the tomb of Niccolò Martelli, one of the citizens who financed the reconstruction of the church. This *Annunciation* is like a manifesto proclaiming all the more modern and innovative artistic experiences in Florence in the 1440s. The perspective construction is not based on a single scale and this enlarges and widens the space making it penetrate deeper into the background, where there is a splendid landscape. In the foreground, emphasized by a pavement with several different levels, each one corresponding to different characters or symbolic objects, the spectator's eye is drawn to the left towards two "additional" angels: these two figures appear to have no explanation from either the iconographical or the narrative point of view. Yet, together with several other details that have been masterfully and imaginatively placed in the painting, they enrich the composition. The lovely vase in transparent glass, a symbol of Mary's virginity, almost becomes an independent still life. And in the predella, the two naked figures in the wine vat are references to the classical sculptures of Ares of the Ludovisi type, derived from the detail of the "trembling nude" in Masaccio's *Baptism of the Neophytes* in Santa Maria del Carmine. This is a very sophisticated and deliberate reference, which appears to be a tribute to classical tradition; but the two figures are not anatomically accurate, for their pectoral muscles are stretched like those of a seated person, whereas they are standing.

Already in those same years, between 1443 and 1445, Lippi had begun work on a large altarpiece of the *Coronation of the Virgin* for the high altar of the church of Sant'Ambrogio. This painting had been commissioned as early as 1441 by an important cleric, Francesco Maringhi, Canon of the church, who died only a few months later.

The work was painted anyway, under the supervision of Domenico Maringhi, the heir and executor of the Canon's will. Lippi was helped not only by his young pupil Fra Diamante, but also by a whole team of assistants and at least two carpenters. Among them, Manno de' Cori and Domenico del Brilla, who are also the authors of other important wood carvings, such as the choir stalls in Santa Croce (Manno de' Cori) and Brunelleschi's wooden model for the dome of the Cathedral (Domenico del Brilla). Unfortunately, the original composition of the elaborate frame of this Coronation has been lost.

We must bear in mind that more or less at that time a new confraternity had been founded in the church of Sant'Ambrogio, the Company of Santa Maria della Neve, which was particularly devoted to the worship of the Assumption and Corpus Domini. This presumably explains why the iconography of this painting associates the subject of the Coronation with that of the Eucharist. Mary

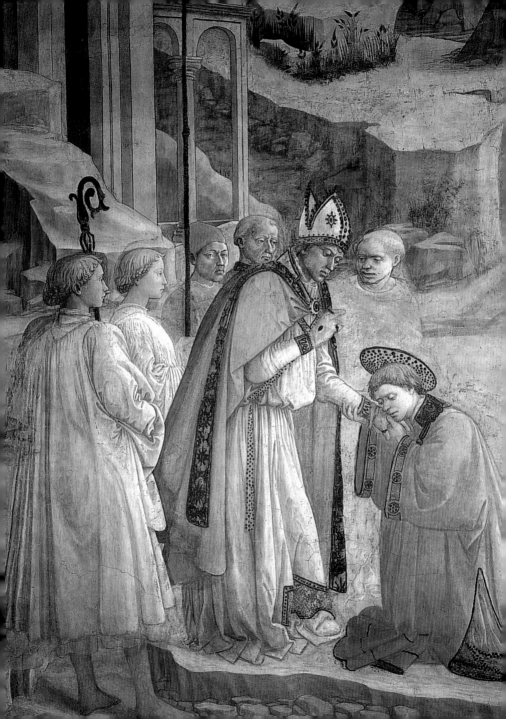

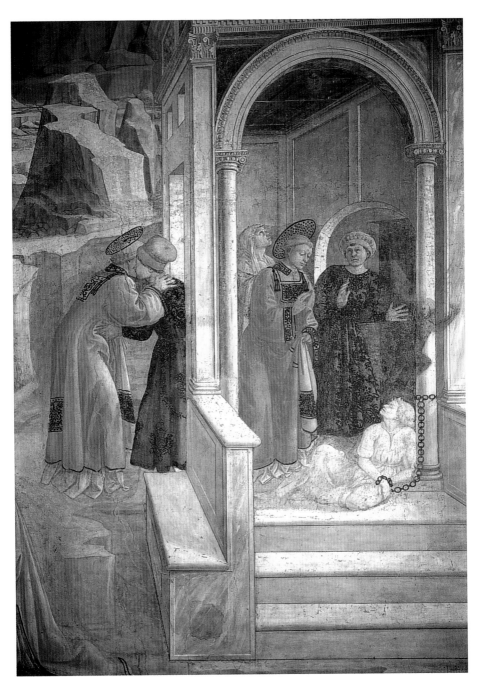

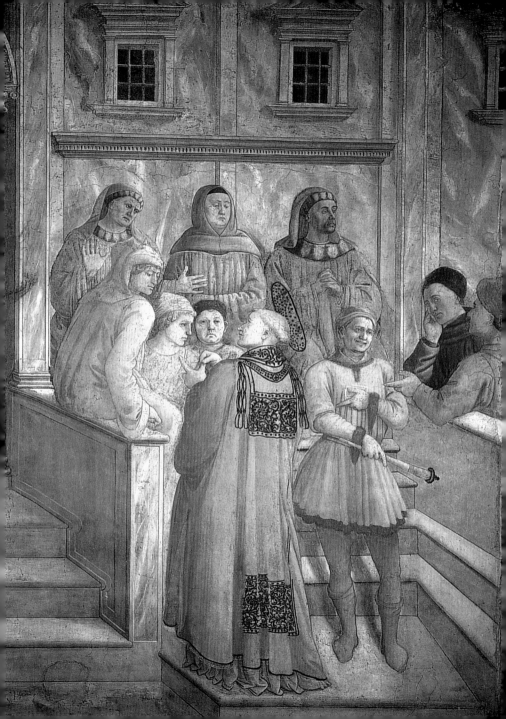

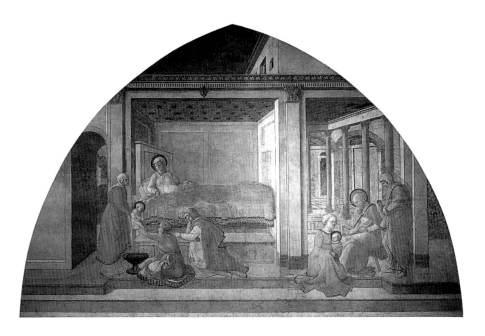

57. *Stories from the Life of St Stephen: Disputation in the Synagogue, detail*

58. *Stories from the Life of St John the Baptist: The Birth and Naming of John the Baptist Prato, Cathedral*

is seen as the "tabernacle" of Christ: she is crowned by God the Father seated on his throne, and not by Jesus Christ, at the moment she reaches heaven. She is not seated next to him, but is shown kneeling. In other words, this scene is more closely related to the idea of the Immaculate Conception and the Assumption than to the subject of the Coronation.

Finished in 1447, this painting exhibits a fairly revolutionary construction, and not only in its iconographical details. In altarpieces on the same subject painted by Lorenzo Monaco, just to take an example of an artist from the generation before Lippi, the scene was always a celestial one; Lippi, on the other hand, although he is dealing with a subject connected to the Virgin's arrival in heaven, sets his scene on a large stage, populated by earthly and totally realistic characters. And indeed Robert Browning, writing centuries later, envisaged a scandalized reaction among the monks of Sant'Ambrogio when they first set eyes on such a "carnal" painting. Many of the characters appear to be exchanging glances with the spectator, an illusionistic device that Leon Battista Alberti wrote about in his treatise on painting.

But the most interesting detail is in the two lunettes in the background, filled with diagonal strips of strong contrasting colours, blue and dark blue, indicating an imaginary sky, perhaps para-

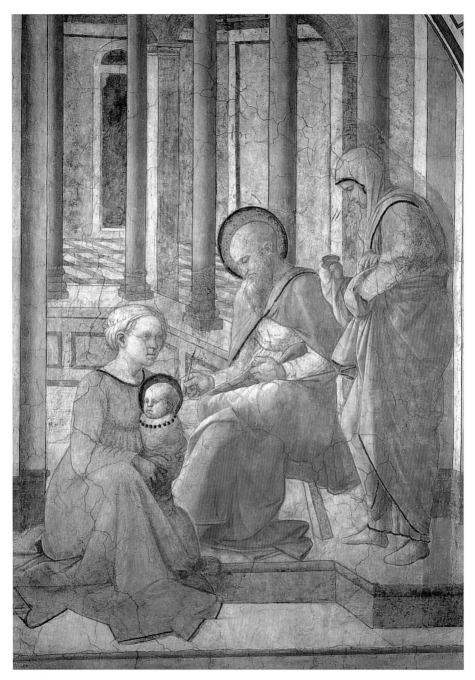

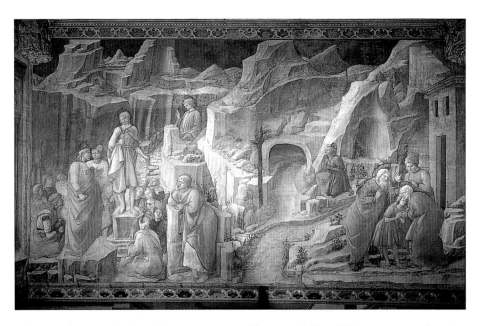

59. *Stories from the Life of St John the Baptist:*
The Naming of John the Baptist

60. *Stories from the Life of St John the Baptist:*
St John Takes Leave of his Parents
Prato, Cathedral

dise or heaven. These colours are similar and create the same effects as those used by Luca della Robbia in his glazed terracottas; Lippi was indeed influenced by Luca's work as we can see from the features of the angels with garlands just below the lunettes.

To what extent the patrons who had commissioned the altarpiece actually influenced the artist in the painting of this subject becomes particularly clear if we compare it to the *Coronation of the Virgin* now in the Vatican Pinacoteca (dating from around 1444). This work was commissioned probably by Carlo Marsuppini from Arezzo; Marsuppini was Secretary of the Florentine Republic but wanted the painting for the Olivetan monastery in his home town. Together with St Gregory the Great, Lippi has depicted other

Olivetan and Camaldolensian saints and monks, as well as two donors. The composition is far more traditional than that of the Sant'Ambrogio altarpiece. And even the iconography is more traditional: Jesus himself is crowning his bride. Also, the sky is no longer fantastic, but very realistic.

Another altarpiece that Lippi painted for an important Florentine church is the *Madonna and Child with Four Saints* now at the Uffizi; this work hung formerly in Santa Croce, in the Chapel of the Novices designed by the architect Michelozzo for Cosimo the Elder and completed in 1445. The painting also had a predella painted by Pesellino (born in 1422); the panels of this predella are now divided between the Louvre and the Uffizi. Our sources suggest that Andrea del Castagno worked with Lippi on this painting, or at least made some later alterations; and indeed the work appears to have been more influenced by classical models than Lippi's other paintings, especially in the spatial construction and in the architectural details. But this can perhaps be explained because it was created to harmonize with an architectural construction designed by Michelozzo.

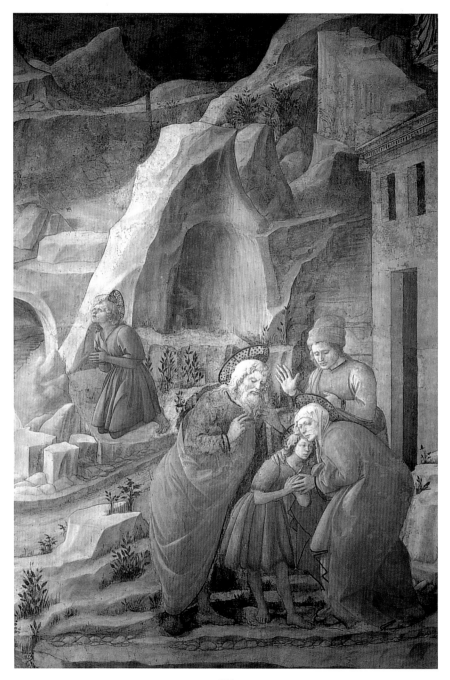

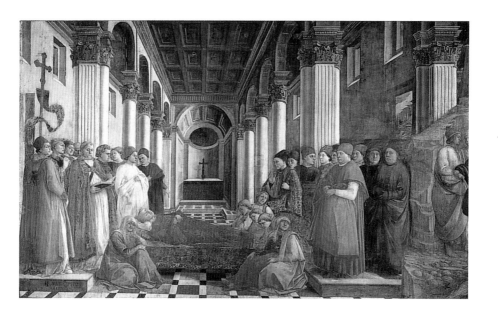

The Madonnas

The ideal of female beauty which appears already in some of the figures in the Sant'Ambrogio altarpiece will become a recurring feature in Lippi's painting, and will later be continued by his most talented pupil, Botticelli. This probably explains why Lippi is famous primarily for his gentle Madonnas, lovely figures whom he painted again and again with many variations and which traditionally are identified with his mistress Lucrezia.

Starting from the 1450s Lippi's works begin to lose a little of their sculptural quality——for the most part created by a masterful use of chiaroscuro——and become characterized by a form of linearism that concentrates on the drawing and modelling of outlines. This tendency is comparable to what Andrea del Castagno and Domenico Veneziano were doing at the same time.

This new trend is clearly visible, for example, in the *Adoration in the Woods* (Berlin), where the Madonna appears to be deep in meditation and the mood is very lyrical, an atmosphere common to many other works of this period. This *Adoration*, painted around 1460, originally hung in the chapel that Benozzo Gozzoli had frescoed for Piero de' Medici in the Medici Palace in Via Lar-

ga; a 15th-century copy now hangs in its place. The meaning of this composition (which includes also the young St John and St Bernard, who was particularly well loved in Florence at the time) and the intimate mood of the painting may be related to the vernacular tradition poems that Lucrezia Tornabuoni, Piero's wife, liked to write. The two lunettes now in the National Gallery, London (a *Holy Conversation* with the Medici saints Cosmas and Damian and an *Annunciation*), were also originally in the Medici Palace, probably in Piero's study, which, as we know from Antonio Filarete's description, was splendidly decorated. Another *Annunciation*, less intense and more openly in the style of Fra Angelico (it may have been altered

61. *Stories from the Life of St John the Baptist: St John Takes Leave of his Parents, detail*

62. *Stories from the Life of St Stephen: The Saint's Funeral Prato, Cathedral*

63. Stories from the Life of St Stephen: The Saint's Funeral Detail of the presumed portraits of Filippo Lippi and Fra Diamante

64. Stories from the Life of St Stephen: The Saint's Funeral detail

in the 19th century) is now in the Doria Gallery in Rome. More interesting is the *Annunciation* now in the National Gallery in Rome: it dates from the 1450s and comes from the Oratory of the Larioni in Pian di Ripoli, on the outskirts of Florence. As well as the two figures who are disappearing out of the door to the right, with their elegant gestures and flowing garments, rather like some of the figures that we will find in the Prato frescoes, an extremely interesting element of this painting is the detail of the two donors, shown in profile, leaning against the balustrade to the right. Lippi obviously loved painting this kind of portrait, as we can see from some of his easel paintings, including the one presently in New York, at the Metropolitan. If we accept the attribution of those "portraits" to Filippo (and scholars are not all in agreement, especially because of the lack of evidence concerning the dating), then, once again, he proves to be an exceptional forerunner. His portraits, occasionally depicting a man and a woman together, are among the earliest in the Italian Renaissance. The most important ones are

the portrait of a woman in Berlin, the double portrait that was recently sold on the antique market and was identified by Boskovits, and the famous double portrait in the Metropolitan. In this last painting, Federico Zeri has discovered a motto with a pledge of loyalty on the sleeve covered in pearl embroidery of the woman's dress, and has suggested that it is probably a portrait of a betrothed couple.

Around 1455 Lippi had painted another *Adoration* (now in the Uffizi) for the convent of Annalena. Although the painting contains clear references to Donatello's *stiacciato* technique, it also shows almost a return to Gothic forms: in the fairytale meadow, the unreal landscape, the distorted perspective, the pervading mysticism.

He was commissioned another *Adoration* (also now in the Uffizi) by Lucrezia Tornabuoni for the hermitage of Camaldoli; she must certainly have influenced the iconography of the work and the intimate mood of the composition which includes the young St John and St Bernard (or perhaps another Camaldolensian saint).

546

Undoubtedly the most famous of Lippi's religious paintings is the *Madonna and Child with Two Angels* now at the Uffizi. We also have the preparatory drawing for this painting. This group, which will later influence the work of Botticelli, appears to stand out from the background of the painting with a delicacy which, once again, is reminiscent of the reliefs carved by Donatello and Luca della Robbia. Yet, the landscape in the background, almost a painting within the painting, is like an anticipation of Leonardo's open landscapes. A similar composition reappears in the *Madonna and Child* now in Munich, although there the emphasis is laid on the direct relationship between mother and child (notice, in the landscape to the right, the interesting architectural design of the little temple). The lovely roundel of the *Madonna and Child with Stories from the Life of St Anne*, now in the Pitti Palace, which Lippi probably painted for a member of the Bartolini family around 1452 when he was just beginning to work on the frescoes in Prato Cathedral, is more like an anticipation of Mannerist compositions, with their unusual spatial constructions. Although the group in the foreground with the Madonna and Child is still fairly traditional in composition, the stories in the background are set in a surrealistic architectural setting, and the figures have already acquired that Hellenistic linearism which is typical of the frescoes in Prato Cathedral.

The roundel of the *Adoration of the Magi* now in Washington is more difficult to identify: it is probably the same one that is described in Loren-

65, 66. Stories from the Life of St John the Baptist: Herod's Banquet and detail of Salome Prato, Cathedral

67. Herod's Banquet, detail
Salome presents Herodias the head of the Baptist

68. Herod's Banquet
Detail of Herodias

69. Pietà
54 × 29 cms.
Milan, Poldi-Pezzoli
Museum

70. Funeral of St
Jerome
268 × 165 cms.
Prato, Cathedral

zo the Magnificent's bedroom in a 1492 inventory of the Medici Palace. The painting contains a wide range of different elements and it would be interesting to analyze its hidden symbolic meanings (such as the half-naked figures among the ruins in the background, some of which appear to be copies of classical statues). This painting is particularly difficult to date; it has been attributed both to Lippi and to Fra Angelico, and some scholars have even suggested that both artists may have worked on it together. In any case, it was obviously a very popular painting in Florence, for Domenico Veneziano and Botticelli both were influenced by it and painted similar compositions.

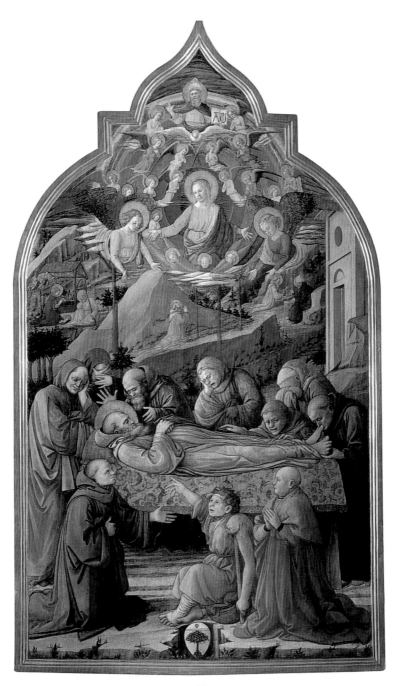

71. *Circumcision*
188 × 164 cms.
Prato, Church of the Spirito Santo

72. *Adoration of the Child with Saints*
146 × 157 cms.
Prato, Civic Gallery

73. *Madonna and Child*
75 × 53 cms.
Munich, Alte Pinakothek

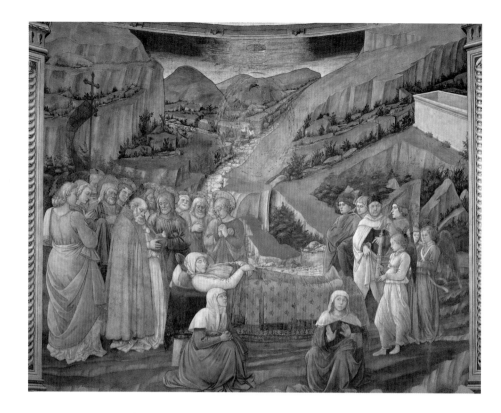

The Great Fresco Cycles in Prato and Spoleto

By the early 1450s Filippo was a very popular and famous artist. In Prato he was commissioned the frescoes for the decoration of the main chapel in the Cathedral, *Stories from the Life of St Stephen* (to whom the church is dedicated) *and St John the Baptist*. Lippi began to work on these frescoes in 1452. An ideal classical style, as Aby Warburg described it, permeates all the figures. The celebrated dancing Salome, for example, is clearly based on a classical model. Her wild movement is stressed by her hair, blowing in the wind, and her flying garments, typical features of ancient portrayals of Maenads, Victories or *Horae*. Leon Battista Alberti had already written about the use of these elements as early as 1435, but they only became a regular feature of Florentine painting in the 1450s and 1460s.

In the scene showing *Herod's Banquet*, and in others in the Prato cycle as well, the composition is very impressive and complex, with a wealth of figures portrayed in a wide variety of poses, frequently in juxtaposition to each other. Lippi's new art is based on this new relationship between human figures and their surroundings, an innovation which goes beyond the revolution brought about by Masaccio in the 1420s. The main novelty of his work is the accelerated, linear rhythm. His space appears to be broadened: he opens up the walls into monumental vistas.

If we look at the scene of *St Stephen's Funeral* we shall be able to observe how the setting in the Basilica offers a realistic relationship between figures and architecture, in an overall atmosphere that is constantly evoking classical antiquity.

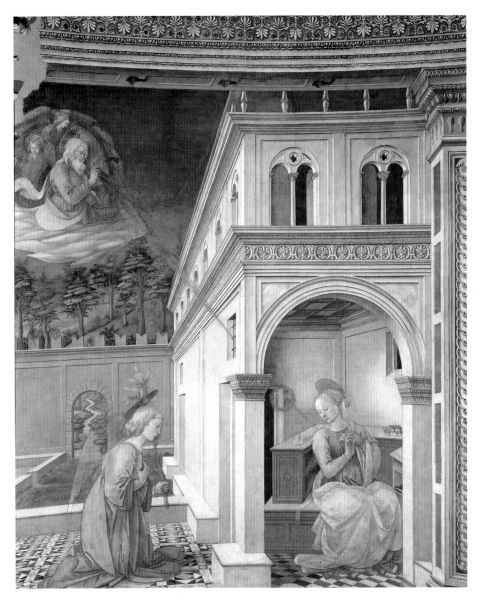

74. *Death of the Virgin*
Spoleto, Cathedral

75. *Annunciation*
Spoleto, Cathedral

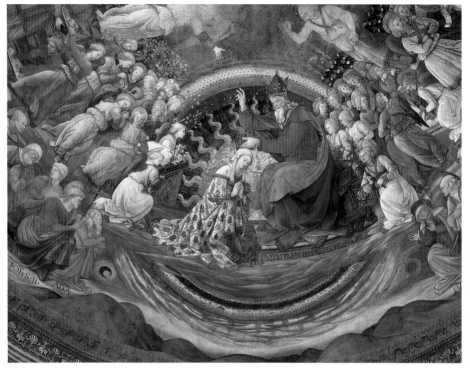

Lippi's style in these frescoes is based on out-line modelling more than it had ever been before; even his colours, which in the earlier altarpieces had been almost enamel-like, appear to become softer, although they still create a warm, light atmosphere.

During his period in Prato Lippi painted several works that are today in churches and museums in that city; in most of them he was helped by Fra Diamante and other assistants. Also dating from those years is the intense, almost tragic *Pietà* now in Milan and the Uffizi *Madonna and Child*. As has been said before, these works are Filippo's swan song, for in the frescoes in the apse of Spoleto Cathedral, where he was helped to a large extent by his assistants, his art never managed to reach these levels again.

In Spoleto, the fresco cycle of *Stories from the Life of the Virgin* was intended to be viewed from a distance; this may explain why the composition is so simple and the arrangements of the figures are so symmetrical. But we must not forget that by this time Filippo was old and sick: he began work in Spoleto in September 1467 and stayed there until he died, in October 1469.

76. Coronation of the Virgin
Spoleto, Cathedral

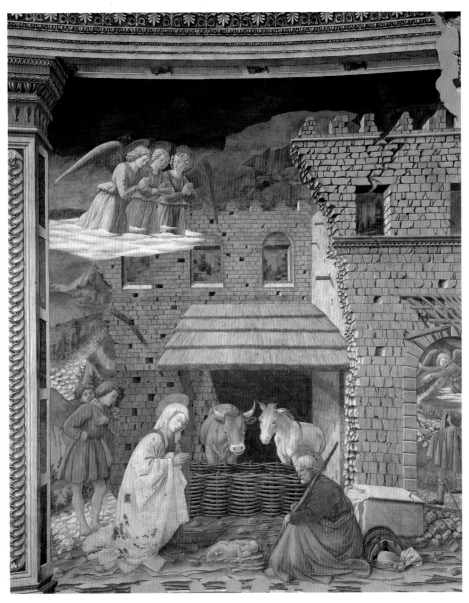

77. Birth of Christ
Spoleto, Cathedral

BENOZZO GOZZOLI

"He who walks with difficulties along the road of virtue, even if it be (as the saying goes) both rocky and full of thorns, at the end of the climb finds himself at last in a broad plain, with all the happiness he yearned for. And looking down, seeing the cruel path he has trodden amidst perils, thanks God that he has led him to salvation, and with great contentment blesses those labors that had earlier caused him so much pain. And so making up for the sufferings of the past with the delight of the present, without toil though he strives to make those who watch him understand how the heat, cold, sweat, hunger, thirst, and hardship he suffered to acquire virtue, may free others from poverty and lead them to that safe and tranquil state, in which to his great content Benozzo took his repose".

With this lengthy introduction Giorgio Vasari commenced the biography of Benozzo Gozzoli in his *Lives of the Artists* in the Torrentini edition of 1550, reproduced without alterations in the Giunti edition of 1568. The elaborate rhetoric of this opening, in which Vasari makes use of the ancient and authoritative literary motif of the attainment of virtue through the ascent of an impassable and precipitous mountain, raises a number of questions owing to its lack of proportion and even relevance to the rest of the biography. This, in contrast, outlines an intense artistic career, studded with gratifications (although short on outstanding successes), but on the whole lacking in dramatic and surprising events. The career of a decent person and "true Christian", as Vasari himself describes Benozzo, that came to an end at a respectable age within a sound, family-based professional structure: his studio, which provided work for his sons Francesco and Alesso as well. So where were the difficulties and perils, the hazards and hardships which, according to Vasari's metaphor, Benozzo had to overcome before reaching a serene old age? In that great, never-ending labor that prevented him from enjoying any other diversion ("and he showed himself to be not much interested in other pleasures"), seems to be the biographer's answer, just a few lines later. But it is difficult to take him completely at his word, if we bear in mind the industriousness of Vasari himself, throughout his life and right up to his death. The true answer lies buried in the text of the narrative, as if censored by the writer's unconscious; and it consists, I believe, in a deprecatory or even subtly negative evaluation of the wandering from place to place among the "minor" centers of Tuscany and Umbria, with rare visits to Rome and Florence, which was the chief characteristic of Benozzo's artistic life. Vasari, it is known, associated the concept of the geographical

1. Saint Augustine leaving Rome detail of the presumed self-portrait San Gimignano, Sant'Agostino

and political "periphery" with that of cultural "backwardness". And the story of a painter who, despite having had the good fortune to be born in Florence, had then chosen to frequent the backwaters of provincial towns and villages, far away from the great commissions of the central authorities, could only appear, to a man who was an artist at the autocratic Medicean court of the sixteenth century, to be an uninterrupted series of tribulations. This secret thought would eventually be voiced by Roberto Longhi, always a shrewd interpreter of Vasari, who described Benozzo as "conditioned by living in the provinces" (Longhi 1960).

This scant esteem for Benozzo's art, inaugurated by Vasari with his unexpressed reservations and even more with his open criticisms (of the type: "even though he was not very good in comparison with many who surpassed him in drawing"; and a little further on: "among so many works there were also some good ones"), has lasted through the centuries right down to our own time, generating the conviction that he was a pleasant painter but confined within the limits of an old-fashioned emphasis on decoration in the Gothic manner, an "illustrator" rather than a genuine artist. A more recent historical viewpoint, distancing itself from the distinctions of remote idealistic origin between art and non-art that have conditioned much of twentieth-century art criticism in Italy, has made it possible to restore Benozzo (as the numerous studies by Anna Padoa Rizzo demonstrate) to his rightful place in the lively production of art and applied art that formed the basis for the flowering of the great masters of the Florentine Renaissance, as a worthy and versatile artist and craftsman, industrious and at the same time much appreciated by a number of illustrious patrons, including the Medici.

Benozzo was born in the fall-winter of 1421 to Lese di Sandro da Lese, from the citified branch of a family of farmers originally from Sant'Ilario a Colombaia, in the region of Badia a Settimo, part of the level district to the west of Florence. His mother was Monna Mea, eighteen at the time of his birth, and he had two brothers, Roberto, a year older, and Domenico, three years his junior. The name "Gozzoli" which, though absent from the 1550 edition of Vasari's *Lives*, appeared in that of 1568, comes from the name "Ghozzolo" common in the other branch of the family, one that had remained in the country, a fact that Vasari had evidently come to know during the eighteen years that elapsed between the two editions.

The first evidence for his activity as an artist and craftsman, already a master of the trade even though there is no record of his having served an apprenticeship in any Florentine studio, dates from 1439, the year in which, according to the documents discovered by Padoa Rizzo (1991-2), he delivered to the Compagnia di Sant'Agnese al Carmine a painting of the *Ascension* ("Christ when he goes to heaven") on a funeral pall. In 1441 he painted a "compass" for Giovanni del Pugliese, which the latter donated to the same confraternity. In the family's declaration to the Cadastre in 1442 Lese stated that Benozzo, aged

twenty, was "learning to paint"; but the modesty of this phrase (certainly prompted by the common desire to emphasize the family's liabilities and play down its earnings) obscured the real nature of an apprenticeship, or rather a collaboration, at a very high level with Giovanni da Fiesole, known as Fra Angelico, on the pictorial decoration of the Dominican convent of San Marco.

The complete integration of the youthful Benozzo's artistic style with that of Fra Angelico, a well-established master of over forty, has meant that it is only in recent times, thanks to the studies of Bonsanti (1990) and Padoa Rizzo, that it has been possible to identify with a fair degree of accuracy a variety of interventions by his hand. These span a period from 1438 to 1444-5, during which the extensive decoration of the convent's rooms and cells was carried out.

Fra Angelico was, for his young collaborator, the go-between with the generation of artists that, born toward the end of the fourteenth century, had been responsible for the sudden surge of innovation in the early decades of the fifteenth century, taking architecture, sculpture, and painting to new heights. This is why, in the view of historians of all ages, the early Florentine quattrocento marked the beginning of a new and splendid era in artistic culture, the Renaissance. From the firmly modeled masses of Fra Angelico, over which the light plays in a crystalline manner, producing pure and absolute colors, Benozzo was able to learn what he needed of the vigorous plasticism and coloring of Masaccio; while from the friar's more sophisticated and meticulous counterpoints of gold and ever-changing tints he picked up, without contrast, the exquisitely ornamental tendency of the International Gothic and the illuminative style of Lorenzo Monaco and Gentile da Fabriano. Benozzo made all this his own, combining it with his own more analytical interest in variety and wealth of detail. Gozzoli's participation in the mural decoration of San Marco has been recognized (thanks in part to the improvement in their legibility resulting from the restoration carried out by Dino Dini over the period 1975-83) both in decorative sections and in those of a more figurative nature. The ornamental fascia on the underside of the arch of the large lunette depicting the *Crucifixion* in the Chapter House has been ascribed to him (Padoa Rizzo 1992), but even greater artistic independence can be seen in the wall paintings of the cells assigned to him. In the beginning these interventions were limited to isolated figures (cell 5, angels in flight; cell 7, the Virgin Mary in the *Meditation on Christ Mocked*; cell 8, the three Marys in the *Marys at the Tomb*). Then he was given greater responsibility for composition and execution in various cells in the east corridor and the Novitiate. His decisive contribution to the *Prayer in the Garden* in cell 34 has been acknowledged, while the question of whether he should be considered the author of the intense *Crucifixions* on the side of the library (cells 41-4), whose high quality has been pointed out by Bonsanti, remains open. Finally there is general agreement that Benozzo was almost exclusively responsible

2. Fra Angelico and Benozzo Gozzoli
Adoration of the Magi
Florence, San Marco (cell 39)

3. Fra Angelico and Benozzo Gozzoli
Meditation on Christ Mocked, detail
Florence, San Marco (cell 7)

4. Fra Angelico and Benozzo Gozzoli
Marys at the Tomb, detail
Florence, San Marco (cell 8)

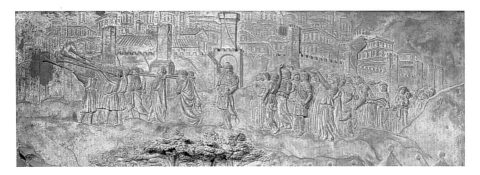

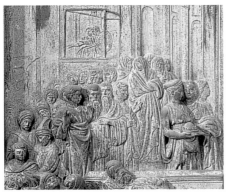

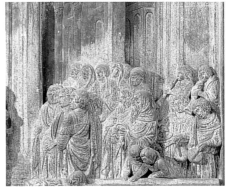

for the *Crucifixion with Saints Cosmas, Damian, John, and Peter* (vestibule, 38) and the *Adoration of the Magi* (cell 39), rooms which were both reserved for Cosimo de' Medici. In the procession of the *Adoration* Bonsanti has rightly indicated the work of another collaborator, "assistant no. 2" (perhaps the friar's nephew Giovanni d'Antonio della Cecca di Mugello), responsible for the more clumsy figures with their more rigid chiaroscuro. Gozzoli's work on the San Marco frescoes, in which he was an interpreter of Fra Angelico's ideas, with their already marked tendencies toward a softening of the range of colors, an attenuation of masses in favor of linear outlines, and more cheerful and lengthy descriptions of landscape in the settings, was certainly excellent. Yet this does not authorize us to regard his future career as "a slow, progressive decline from his youthful achievements" (Bonsanti 1990, p. 167).

The first signs of Benozzo's independent artistic activity appear to be paintings that critics have dated to the years of the decoration of San Marco and shortly afterward, up to 1446-7. They are works of small size and careful execution, that hint at Gozzoli's early vocation for the precious and calligraphic style of the illuminator. And it is in fact from this period that dates the manuscript of the *Profezie di Gioacchino da Fiore*, MS Harley 1340 of the British Library in London, depict-

5. Lorenzo Ghiberti and Benozzo Gozzoli
Capture of Jericho, detail
Florence, Museo dell'Opera del Duomo

6, 7. Lorenzo Ghiberti and Benozzo Gozzoli
Meeting of the Queen of Sheba with Solomon, detail
Florence, Museo dell'Opera del Duomo

ing the Popes (the last of whom is Eugenius IV, who died in 1447), recently assigned with conviction to Gozzoli (Bartalini 1990, pp. 114-16; Padoa Rizzo 1992, p. 23). This isolated venture into the art of illumination, rarely practiced as far as we know by Benozzo, is a sign of the open-minded and experimental attitude that drove him in those years, in his search for a clear vocation and a secure role, to acquire a diverse range of technical skills, to an even greater extent than was required by the integration of the arts in the typical Florentine studio. It was this curious and can-do approach that led him, I believe, to join for a couple of years the numerous group of artists who, under the guidance of Lorenzo Ghiberti, were working on the completion of the Door of Paradise and on "cleaning up" the bronze panels after casting. According to the contract of January 24, 1445 (1444 Florentine style),

Benozzo worked on the door for three years from March 1 of that year (the text is given in Krautheimer 1982); but in March 1447, that is a year before the end of this period, Gozzoli had already left for Rome to undertake an important commission at the papal court. The hypothesis that Benozzo may have played an active part in the execution of some panels, by modeling parts of the reliefs (Ciardi Dupré 1967, 1978), has met with both accord (Padoa Rizzo 1972, 1992) and skepticism (Bartalini 1990). Although the similarity of type and stylistic treatment in a number of minor figures (see the crowds in the *Meeting of the Queen of Sheba with Solomon* and the *Capture of Jericho*) with the already well-defined manner of Gozzoli's paintings renders the supposition highly plausible in my view, this is not of so much importance as far as the development of Benozzo is concerned as is the

8. *Benozzo Gozzoli (?)*
Madonna and Child with Nine Angels
30x22,5 cm
London, National Gallery

9. *Crucifixion with the Madonna, Saints John, Onophry, Anthony of Padua, Mary Magdalen, and Pious Women*
53x37 cm
Paris, private collection

profound assimilation, even interiorization, of the culture of Ghiberti that his continual presence in the workshop of the great sculptor over a period of two years permitted. It was in the artistic and theoretical work of Lorenzo, in fact, that the balanced fusion, in a fertile relationship with Humanism in philosophy and literature, took place between the heritage of International Gothic and the growing influence of classicism, creating an enchanting and unique blend that did not fail to leave its mark on Benozzo. In the same way he was strongly influenced by Ghiberti's empirical approach to perspective, with its differentiated and flexible handling of proximities and distances, combined in an overall harmony that did not necessarily respect the rules of Brunelleschi's *perspectiva artificialis* as formulated by Alberti. Instead, drawing on the subjective medieval Arab point of view, Ghiberti adapted his perspective to the opportunities and necessities of the representation in its guise as a symbolic message and psychological description. Benozzo too — and in this he was following Ghiberti far more than Fra Angelico — was to be the architect of a "graceful mediation" (Morolli 1978) between old and new, between the lively offshoots of the Gothic style and the continual revolutions in artistic language brought about by the age of Humanism.

But let us go back to the works of his juvenile period. For many painters (and Benozzo fits into this broad category) the reconstruction of their early ven-

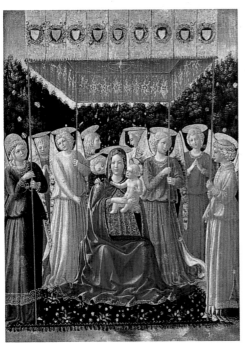

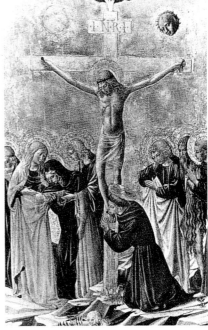

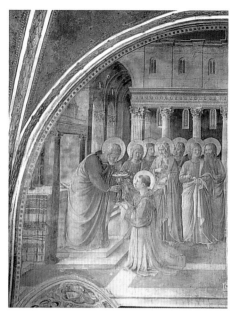

10. Fra Angelico and Benozzo Gozzoli
Ordination of Saint Stephen
Vatican, Nicholas V's Chapel

11. Fra Angelico and Benozzo Gozzoli
Saint Lawrence before Decius and Martyrdom of Saint Lawrence
Vatican, Nicholas V's Chapel

tures into art presents a variety of difficulties. The artist's style is still influenced by that of his master or of an older companion, so that it appears imitative and labored. If the artist, endowed with a lively curiosity, experiments temporarily with the style of other masters, he produces works that are destined to oscillate, in critical interpretation, from one attribution to another. This is what has happened with a very small group, consisting of just two pictures, that critics have most recently tended to assign to Benozzo as youthful works painted under the influence of Fra Angelico (Bartalini 1990, Padoa Rizzo 1992, with references to the previous bibliography), but that present, in their undeniable mutual stylistic consistency that is indicative of an embryonic corpus, points of divergence from the artistic style of the youthful and firmly "Angelican" Gozzoli. This is clearly to be seen in the *Crucifixion* in a private collection in Paris (Longhi 1960), the only work that, in my view, can be definitely assigned to this nebulous pre-Roman and proto-Umbrian phase in Benozzo's career. The *Madonna and Child with Nine Angels* in the National Gallery in London, which has a long and fluctuating history of attribution, having been ascribed in the twenties to Fra Angelico, then to Giovanni Boccati, Domenico Veneziano, and finally, with greater conviction, to Benozzo prior to 1447, is a work of undoubted quality. In this fine painting, where the haloed bodies of the angels divide up the space framed by the tripartite bower of greenery and the red and gold canopy into a sequence of vivid colors, the Madonna is seated amidst the clean-cut folds of a cloak of ultramarine blue. In the luminous transparency of the picture, the flesh tones gleam, the subtly hatched highlights of the fabrics shine, and the locks of the angels glitter like spun gold. The chubby forms of the childish faces, contrasting with the soft hands and limp fingers, together with

12. Fra Angelico and Benozzo Gozzoli
Vault of the Chapel of San Brizio
Orvieto, Cathedral

many other details (including the strip of mottled marble flooring under the carpet of flowers), are well-suited to a painter strongly influenced by Fra Angelico, but inclined to embellish on the friar's style to the point of languidness, but not to the concrete and almost harsh Benozzo of the Parisian *Crucifixion*, another early work. Even the pattern of the haloes in the picture in London, esteemed for its subtlety of perspective (Bartalini 1990, p. 117), produces a sophisticated effect that is largely absent from his other paintings with groups of angels or saints, in which he, remaining strictly faithful to a motif of Fra Angelico, constantly opts for a frontal view of the haloes (even at the cost of detracting from the faces and heads by obscuring them), and foreshortens one or at the most two of the haloes. We are obliged to posit, in order to maintain the attribution of the London painting to him, a Benozzo strongly influenced by experiences that were parallel to, but outside his usual poles of reference, Angelico and Ghiberti. These influences may have come from Domenico Veneziano, present in Florence from 1439 on, and the early Piero della Francesca. Similar influences, together with classical fantasies in-spired by a widespread fascination with antique chests, seem to me to be behind the *Abduction of Helen* in the National Gallery in London, which the latest studies have added to the corpus of Benozzo. Elegant in its details but with a stiff overall composition, largely due to the mechanical juxtaposition of static poses and agitated gestures, almost those of a frenzied dance, the small octagonal painting is a real rarity for Benozzo owing to its profane mythological subject. This would presuppose an active involvement with the artistic and craft workshops specializing in painted chests and coffers; something that, if added to his work as a painter with Fra Angelico, on the cleaning up of Ghiberti's casts, and as an illuminator in the unique London manuscript, presents an unlikely image of the range of Gozzoli's proven experimentalism. One of the problems of this early phase in his career is the question of whether he collaborated on the tondo depicting the *Adoration of the Magi* in the National Gallery in Washington (formerly in the Cook Collection). It has been suggested that this was commissioned by Cosimo de' Medici, and is in fact the "large tondo [...] depicting Our Lady and the Lord and the Magi going to make their offerings, painted by Fra Giovanni" that used to be in the summer chamber of Lorenzo il Magnifico in Palazzo Medici. Filippo Lippi was originally believed to have been responsible for the part of this *Adoration* by Fra Angelico that was

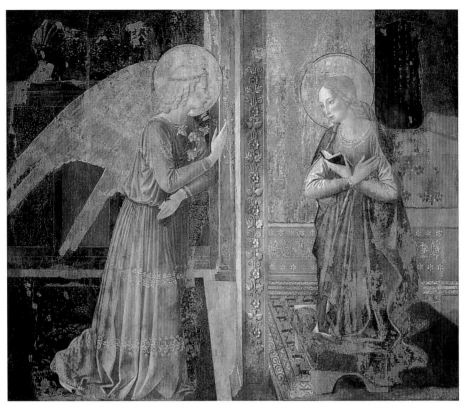

13. Annunciation
120x140 cm
Narni, Pinacoteca Comunale

14. Fra Angelico and Benozzo Gozzoli
Nativity on the Silverware Cabinet
39x37 cm
Florence, San Marco

painted by a collaborator. However, the similarities with the style of Benozzo (Bellosi in *Pittura di Luce*, 1990, pp. 44-5), and the unlikeliness of Lippi having finished a work started and perhaps left incomplete by Fra Angelico (when logic dictates that it would have been done by someone in the studio) justify an attribution of some of the minor figures to Benozzo, although under the influence of Filippo Lippi's style. Another youthful work of Benozzo's may be the *Saint Nicholas and Three Girls* (sold by Sotheby's in London on June 14, 1961, no. 33), with its exquisite clarity in the manner of Fra Angelico.

Gozzoli's first sally out of the Florentine environment was the result of an opportunity of unique importance. Collaborating once again with Fra Angelico, Benozzo left the Ghiberti workshop before his contract was up and went to Rome, where Angelico had been summoned by Eugenius IV to fresco a chapel in the Vatican (probably that of the Sacrament) at the beginning of 1447. He went on to paint in the chapel of his successor Nicholas V and elsewhere, until June 1448. It is not known, and impossible to reconstruct with certainty, the division of tasks in the large group headed by Fra Giovanni, which included, along with Gozzoli, a number of mere assistants or *garzoni* of various origins: the friar's nephew Giovanni di Antonio della Cecca di Mugello, Giacomo d'Antonio da Poli, Pietro Jacomo da Forlì, and perhaps Carlo di Ser Lazzaro da Narni. Benozzo seems to have been responsible for the decorative parts of the basement and the splays of the windows (Padoa Rizzo 1992, p. 34), where his personal style is most evident, and, in the larger scenes, part of the entourage of figures (see for example Decius and the onlookers in the *Martyrdom of Saint Lawrence*). The figures of St Mark the Evangelist, of which there is a drawing in the Musée Condé in Chantilly, and St Matthew the Evangelist, for which there is a study on a folio in the Fitzwilliam Museum in Cambridge, both on the vault, are ascribed to him.

As for the majority of artists of Benozzo's time, the visit to Rome marked a stage of overriding significance in his cultural and professional development. The encounter with the grandiose architecture and sculpture of the ancient world, whose astonishing majesty was not diminished by their ruinous state or concealment amidst the muddle of medieval constructions, together with the discovery of the great basilicas, sanctuaries of art and devotion from the first few centuries of the Christian era, had a profound influence on artists. Like every other visitor and pilgrim, they found themselves caught up in the solemn and magnificent atmosphere, punctuated by ritual events, that was evocatively described by Antonio Paolucci, in his quest for the visual archetypes of a painter of the caliber of Antoniazzo Romano, as "a total spectacle... a religious psychodrama" (Paolucci 1992). In the Papal Curia, the lofty philosophical and artistic Humanism of Leon Battista Alberti and Filarete had created a cultural magnet comparable to that of Medicean Florence in the age of Cosimo, although under the sway of a more charismatic power that (where the

15. *Madonna and Child giving Blessings*
254x130 cm
Rome, Santa Maria sopra Minerva

shrewd Medici tried not to stand out amongst his fellow citizens) aimed instead at the assertion of its own authority through grandiose works of art. Tangible signs of the influence of antiquity on Benozzo can be seen in his graphic works, as reflected indirectly in the notebook in the Boymans Museum in Rotterdam, produced by the circle of his collaborators for teaching purposes (*circa* 1460): copies made from monuments, sculptures, ornamental details, and epigraphs, forming (together with the drawings, that he had certainly obtained for himself, of the sarcophagi in the Camposanto of Pisa) a treasure house of individual figures and ornaments that was to provide him, over the course of the years, with recurrent citations of a cultivated antiquarian stamp. Nevertheless, however formative, the papal commission and the study of the

fascinating ancient world did not tie Benozzo to the city. This may have been because, still being subject to the decisions of Fra Angelico to some extent, he did not succeed in establishing independent links with the Curia, but only with the monastic orders (especially the Dominicans, to whom Fra Angelico had introduced him), which recommended him to the great monasteries of the Papal States. Evidence that he did do some work in Rome independently of Angelico comes from two works that have now been lost: the frescoed panel over a door in the Torre dei Conti depicting the *Madonna and Saints*, recorded by Vasari (Padoa Rizzo, 1992, identifies this with the fragment now in the church of Santi Domenico e Sisto, but the subject is somewhat different and it has been convincingly attributed by Bellosi to the young Antoniazzo Romano); and the frescoes also recorded by Vasari in a chapel in Santa Maria Maggiore, which did not survive the restructuring of the church. What does survive however, rendered legible again and with its authorship confirmed after restoration (Pasti 1985), is the painted silk standard for Santa Maria sopra Minerva, the singular fruit of a grafting of the archaic solemnity of early Christian and medieval images, like the ones he had encountered in the Roman churches, onto the highly plastic rootstock of Fra Angelico's Florentine painting. Peering over the parapet of the elegant ciborium in the Gothic style, but with Renaissance proportions, and framed by a dark and heavy cloak, the Madonna gazes tenderly at the Savior. The latter is not represented in the form of a child but as an adult in miniature, solemnly dressed in a tunic and red pallium. The original synthesis of different artistic languages achieved by the painter in this devotional picture, dating from around 1449, leads one to think that a longer stay in Rome would have been of great significance to the development of his artistic style. So we can only regret that he moved away from the vivid influence of antiquity, whether that of Roman classicism or of early Christian and medieval art, first to follow Fra Angelico and then to carry out his own, independent commissions, apart from occasional and brief returns. In June 1447, suffering from the heat of the Roman summer, the friar interrupted his work in the Vatican and, with the most faithful members of his studio, accepted a commission from the superintendents of Orvieto Cathedral, with whom he had come to an agreement the year before, to fresco the chapel of San Brizio. Benozzo's role in the work (which was

16, 18. Madonna Enthroned and Child with Angel playing Music
Montefalco, San Fortunato

17. Madonna and Child between Saints Francis and Bernardine of Siena
Montefalco, San Fortunato

19. Saint Fortunatus Enthroned
Montefalco, San Fortunato

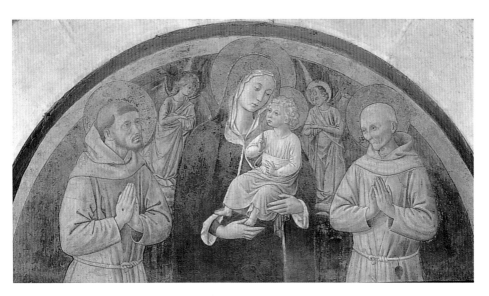

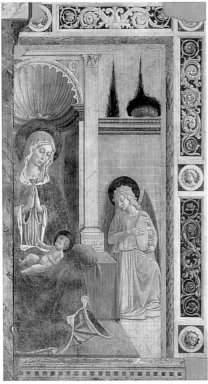

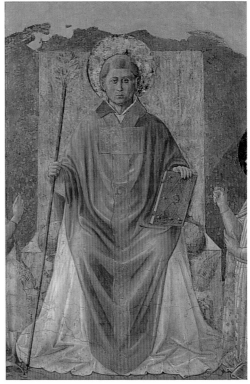

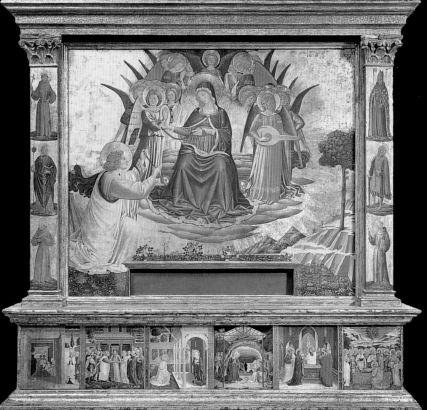

interrupted after the decoration of the great cross vault with *Christ the Judge, Angels, and the Chosen*) is still the subject of debate (De Marchi 1990, p. 102; Padoa Rizzo 1992, p. 32), even though the restoration has restored full legibility to the vaulting cells and the fascias decorated with figured compasses (*La cattedrale...*, 1990). It appears likely, however, that Benozzo painted the decorative borders with heads. Owing to its similarity with these, the splendid drawing of the *Head of a Young Cleric* (Windsor, Royal Library, no. 12812), highlighted in white lead, which some have been tempted to assign to Fra Angelico, could well be attributed definitively to Gozzoli.

In 1450, with the friar's return home to take up the post of prior of Fiesole monastery, Benozzo finally took the grand decision to set himself up on his own (although his collaboration with Fra Angelico did continue a little beyond 1450, painting the *Nativity* for the Silverware Cabinet of Santissima Annunziata in Florence, now in the Museo di San Marco). Staying in Umbria, his reputation among the mendicant orders

and perhaps the recommendation of Nicholas V obtained him a commission from the Franciscans of Montefalco. These were his first fully independent works. A few other paintings in Umbria seem to predate the Montefalco frescoes: a delicate and precise *Annunciation*, probably originally from a church and now in the Pinacoteca Comunale of Narni; some fragmentary decorations formerly in the church of San Domenico in Foligno, in the Museum of Palazzo Trinci; and a parchment with the *Head of Christ* crowned with thorns, or *Vir dolorum*, now in the Treasury of the Basilica of Assisi. Benozzo's passage through Assisi, documented by this last work, is of particular significance not only because it demonstrates the strength of his relationship with the Franciscan order (whose peaceful coexistence with the other great mendicant order, that of the Dominicans, was consistently promoted in Medicean Florence), but also because it proves that he was familiar with Giotto's frescoes. The study of the latter helped to consolidate Gozzoli's profound tie with the tradition of the Florentine Gothic, whose monumental spatiality he was able to revise and rework in up-to-date terms of luminarism and clarity of perspective. A small picture in a private collection in Paris, dated to around 1450 by Roberto Longhi (1960), but to a few years earlier by Padoa Rizzo (1969 and 1992), seems to mark the beginning of the painter's productive relationship with the Franciscans of the hermitage of San Fortunato near Montefalco. In fact it comes from that convent and depicts

20. Madonna della Cintola
133x164 cm
Vatican, Pinacoteca

21. Vault representing Saint Francis in Glory and Saints
Montefalco, San Francesco

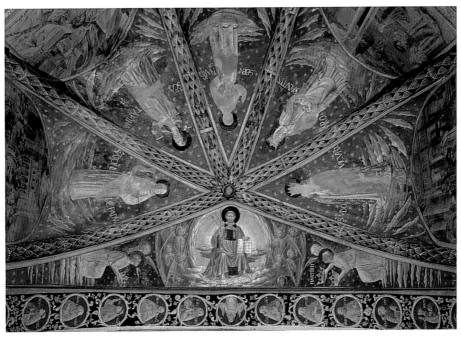

QVALITER B. EFVIT DENVTIATVS A. CPORFOMA PEREGRINI QVOD DEBERAT NASCI SICVT IPS ISTABLO QVALIT OVIDA FATVM PSTERE ISX BEVESPER IN A

QVALIB DENVT VESIEBITVH SVV CVID A RAVPHILITI HOCTE VERO SEQVETI OSTENT SIBICPS HASVH PALATIVARMIS MILITANTIVS CVPHCIVCIVS IIISIGIHTVH

+ QVANDO BEATA VIRGO OSTEDIT DÕ BEATV FRÃCISCV ET BEATV DOMINICV PROREPARATIONE MVNDI +

22. *Birth of Saint Francis and Homage of the Simple Man*
Montefalco, San Francesco

23. *Saint Francis giving away His Clothes and the Vision of the Church Militant and Triumphant*
Montefalco, San Francesco

24. *Meeting of Saint Francis and Saint Dominic*
Montefalco, San Francesco

the *Crucifixion with the Madonna, Saints John, Onophry, Anthony of Padua, Mary Magdalen, and Pious Women*; thus the subject was suited to the Franciscan order by the inclusion of St Anthony, and to the hermitage by that of St Onophry. It is a work that, notwithstanding its small size and subsequent further reduction, achieves an effect of tragic monumentality.

The mural paintings executed by Benozzo in the church of San Fortunato (one of which is dated 1450) form a cycle of considerable importance, but one that has unfortunately come down to us in a fragmentary state. All that survive, in fact, are a lunette over a door with the *Madonna and Child between Saints Francis and Bernardine of Siena*, surmounted by *Seven Archangels*; a *Madonna Enthroned adoring the Child* among angels playing music, of which little more than the right-hand half is left; and a *Saint Fortunatus En-*

throned full of gaps, on the second altar on the right. The master of an expanded and airy style, which reaches an extraordinary psychological intensity in the grave patron saint with his miraculous rod clearly visible, Benozzo completed the pictorial renovation of the church with the picture on the high altar. The rectangular altarpiece, with pillars and predella, depicts the *Madonna della Cintola* in an arc of angels; on the pillars are the figures of Saints Francis, Fortunatus, Anthony of Padua, Louis of France, perhaps Julian, and Bernardine of Siena; the six small scenes in the predella are devoted to the life of the Virgin Mary, from the *Nativity* to the *Dormitio*. Donated by the inhabitants of the town to Pius IX, the painting is now in the Pinacoteca Vaticana. Benozzo's debt to Fra Angelico, his unforgotten partner and master, was still great: and yet the breadth of the distribution of masses, the festive and decisive juxtaposition of tints (with red and blue predominating), the depth of the landscape set against the glitter of the gold background, and even such a delightful decorative digression as the pointed crown of angel's wings around the Madonna all serve to demonstrate the degree of independence of invention and composition that he had achieved. But Benozzo's great opportunity was to come with the commission that followed immediately afterward, once again from the Franciscans, to decorate the apse of the Gothic church of San Francesco at Montefalco with *Scenes from the Life of Saint Francis*. The cycle,

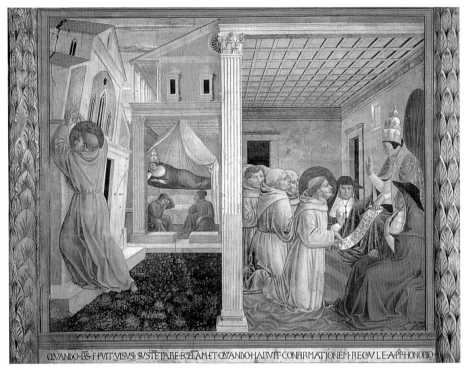

dated 1452, bears the painter's signature (BENOTIUS FLORENTINUS) and the name of the client, the prior Fra Jacopo da Montefalco. The architectural structure of the polygonal apse on a pentagonal plan, covered by a ribbed umbrella vault, obliged Benozzo to make use of an extremely Gothic division of the cycle, which threatened to place limits on his expressiveness. And in fact, while the five Franciscan saints Louis, Rose of Viterbo, Bernardine of Siena, Catherine, and Anthony of Padua fit in nicely, one to each segment, with their backdrop of a starry sky and support of rose-colored clouds, the solid *Saint Francis* seated in glory is almost squashed into the segment bordering on the underside of the arch, with a sculptural force that spills over into the blazing circle of seraphim, "cut" by the triangular field. His secure grasp of the spatial layout is demonstrated by the foreshortening of the cross in the saint's hand. In the twelve scenes from the life of St Francis on the walls, arranged in a series of bands and lunettes, Benozzo found room for an expansive, original narration. In the episodes urban backdrops alternate or coexist with rural ones, resulting, in both cases, in the construction of perspective views that are perhaps not impeccable, but clear and carefully executed: distinct interlockings of stereometric volumes in the first case, and of expanses of trees, fields, or meadows in the second. Particularly effective, owing

25. The Dream of Innocent III and the Confirmation of the Rule
Montefalco, San Francesco

26. The Expulsion of the Devils from Arezzo
Montefalco, San Francesco

to the complexity of the architectural layout and the pattern of light and shade produced by the interior lighting, is the intriguing longitudinal view of the church that forms the setting for the *Greccio Manger*, Gothic in structure but updated to match Renaissance sensibilities by the two rows of fluted pilasters. In the *Expulsion of the Devils from Arezzo* and the *Dream of Innocent III*, Benozzo attempted an almost touching translation of fourteenth-century artistic language into the new perspective-based visualization bathed in light. These took their inspiration from the corresponding scenes in Giotto's cycle in Assisi, perhaps proposed by the clients themselves as an unsurpassed archetype of Franciscan narration. The organization of the cycle into rows and panels that blend with the architecture is underlined by borders on the underside of the arch and at the base, of a highly ornamental character. On the underside of the arch the decorations include portraits of blessed or at least well-known

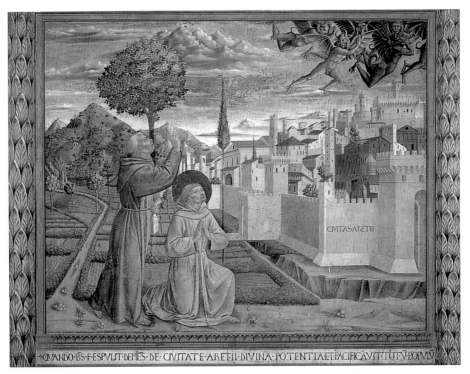

Franciscans, and, in the fascia at the base, of famous men, a typically Humanistic feature. Among them are Francesco Petrarch, Giotto, and Dante. The latter is described as "THEOLOGVS" in the inscription in capital letters that accompanies his portrait, like the others, and is strangely represented in a frontal pose, instead of in three-quarters or profile as was the tradition in the fourteenth and fifteenth centuries.

The same church contains another work by Benozzo, though one that has been slightly reduced in size: the mural decoration of the chapel of San Girolamo. This consists of the *Evangelists* on the vault, a mock altarpiece with panels painted on the altar wall, with *Scenes from the Life of Saint Jerome* at the sides and a *Crucifixion and Saints* at the top, and a *Christ blessing with Saints and Angels* in the entrance archway. The most memorable painting in the chapel is undoubtedly the polyptych, executed with meticulous illusionism (note the long shadows). The painter has enclosed the image, with its Gothic structure of spires and pinnacles, in a frame in the antique style, and therefore of "modern" form, in a combination of the old and new that was not uncommon in certain artful updatings of altarpieces that had gone out of fashion, but were still dear to the descendants of the original clients (examples can be found in the catalogue *Maestri e botteghe*, 1992). Like the "Renaissancized"

Gothic church of the *Greccio Manger*, this imaginary polyptych shows that Benozzo had a shrewd and subtle sense of history, viewed through the alteration of forms. And in the light of this rare sensibility of his, instead of considering him a Gothic artist reluctant to accept the advent of the figurative culture of the age of Humanism, we would do better to see him as the depository of different stylistic languages, capable of mastering and combining them in the full knowledge of their chronological sequence; and as an artist who was not without a hidden trait of acuteness in this ability to reveal, and reproduce *in vitro*, the evolutionary mechanisms of the history of style in these original combinations of images taken from different eras.

The mural paintings of San Francesco in Montefalco, on the whole well preserved and recently restored, provide evidence of Benozzo's growing sense of personal achievement. As well as signing and dating the paintings, he gave expression to his pride in the Latin hexameter "QVALIS SIT PICTOR PREFATVS INSPICE LECTOR." From 1450-2 onward the demand for works of art and figurative cycles from Benozzo intensified, and once again his clients were the Franciscans. The small picture in the National Gallery in Washington, depicting *Saint Ursula* and the Franciscan nun Ginevra, is believed to come from Montefalco, but the similarity of the faces with those executed

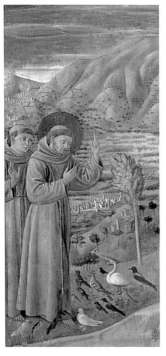

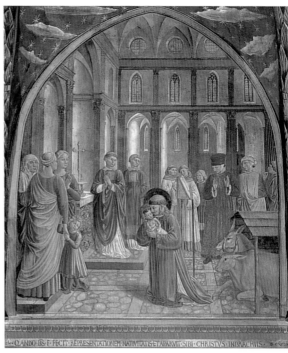

by assistants in the Pisa period suggests that it should be given a later date. Of a much higher quality, on the other hand, is the *Madonna and Child with Saints Francis and Bernardine and Fra Jacopo* in the Kunsthistorisches Museum of Vienna. The Madonna is resplendent amidst gold, red, and pale vair, against a backdrop that appears to be a nighttime view of a wood, although checks need to be made to see if there has been any alteration in the pigments or binders of the greens. In 1543 Benozzo was in Viterbo, where he had been summoned to paint ten scenes from the life of the patron saint in the church of the Franciscan nuns of St Rose. Unfortunately these were lost in the restructuring carried out in 1652. All that remains, as a pale and indirect testimony, are the watercolor copies made by a painter from Orvieto, Francesco Sabatini, prior to their destruction. To this important phase in the maturation of Benozzo, who was now enriching the style he had learned from Fra Angelico with elements of the more recent "painting of light" from Florence and elsewhere, belongs the *Madonna and Child with Saints John the Baptist, Peter, Jerome, and Paul* in the Galleria Nazionale dell'Umbria in Perugia. The painting was commissioned by the Bishop of Recanati, Benedetto Guidalotti for the chapel of the college of San Girolamo in his native city. Signed and dated 1456, the altarpiece with pillars and predella maintains close ties with the Gothic tradi-

27. Preaching to the Birds and Blessing to the Consuls of Bevagna and Montefalco, detail Montefalco, San Francesco

28. Establishment of the Manger at Greccio Montefalco, San Francesco

29. View of the wall of the Chapel of San Girolamo with scenes from the lives of Christ and Saint Jerome Montefalco, San Francesco

tion in the stately splendor of the gold background, but the figures bathed in strong light, set firmly in space by virtue of their forceful drapery, are contemporary in style, with the intriguing result that we can now see to be typical of Benozzo's work in this period.

Between 1456 and 1459 Benozzo put in an irregular appearance in various places in Central Italy. At Sermoneta he painted a *Madonna* crowned by nine choirs of angels for the cathedral, an evident reworking of a much more archaic, cuspidate composition. He was in Rome in 1458, working on the displays for the coronation ceremony of Pius II, where he also frescoed the Albertoni chapel in Santa Maria d'Aracoeli, of which a *Saint Anthony of Padua* between the client and his wife survives.

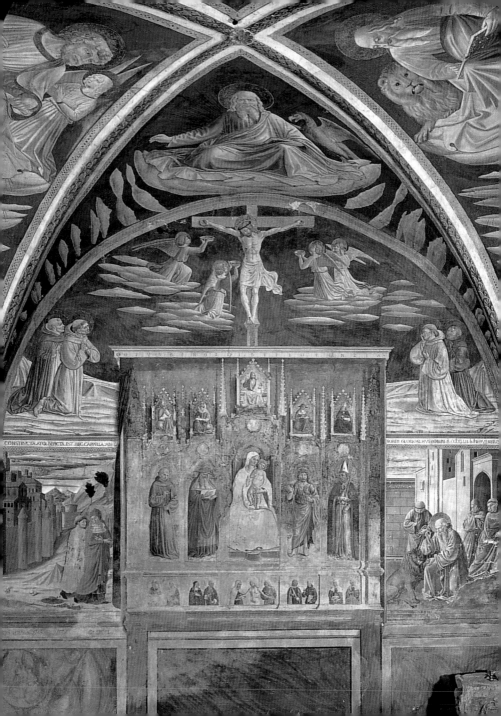

30. *Madonna and Child with Saints Francis and*
Bernardine and Fra Jacopo
34x54 cm
Vienna, Kunsthistorisches Museum

31. *Madonna and Child with Saints John the*
Baptist, Peter, Jerome, and Paul
122x212 cm
Perugia, Galleria Nazionale dell'Umbria

Benozzo must have gone back from time to time to Florence, where he was summoned in 1459 by the city's most illustrious patrons, the Medici, to carry out the prestigious commission of decorating the walls of the chapel in their palace on Via Larga. This, with its refined architectural structure, its wooden ceiling with roses gleaming with gold and colors, and its inlaid floor of ancient marbles, had just been completed under the supervision of the architect Michelozzo di Bartolommeo.

It is perfectly logical that for their private temple, the sacred heart of the palace but also the location for audiences and political meetings (Galeazzo Maria Sforza, son of the duke of Milan, had been received there in April 1459), Cosimo de' Medici chose not one of the many outstanding painters in the city, but the marginal Benozzo, the right-hand man of his trusted painter Giovanni Angelico and whose work he had already seen in San Marco. The assignment of the chapel's altarpiece depicting the *Adoration of the Child* to Filippo Lippi had fallen through, perhaps because Lippi had too many engagements in Prato. In any case, few painters would have been able to satisfy Cosimo's desire to see a sacred subject represented in a setting of ceremonial and worldly pomp, or so willing to meet the Medicean demand for magnificence as to antedate their own artistic style in order to compete, at a distance of thirty years, with the fabulous splendor of the *Adoration of the Magi* commissioned from Gentile da Fabriano by the family's never-forgiven enemy Palla Strozzi, and to surpass it once and for all. The pictorial decoration of the walls, to which the *Lamb* of the Apocalypse over the door serves as a solemn *introibo*, is subdivided between the two rooms of the chapel. The hall is devoted to the *Journey of the Magi* from Jerusalem, the white walled city at top right, to Bethlehem, the place of Jesus's *Nativity* celebrated in the altarpiece. On the narrow strips of wall above the entrances of the two small sacristies, at the sides of the rectangular apse, is depicted the *Vigil of the Shepherds* in the dusk before the Holy Night; while on the side walls of the apse we find the *Angels* rushing from Heaven, as we are informed in the Gospel according to Luke, to worship Christ. Finally, on the much disturbed altar wall (in which a large window was opened in 1837, only to be closed again in 1921), remain two of the symbols of the *Evangelists* painted by Benozzo, the Eagle of John and the Angel of Matthew. At the heart of its religious significance, the extremely carefully studied iconography of the chapel alludes to three sublime offerings made to the Redeemer: the gifts of the Wise Men, the prayers of the angels, and the love of Mary, which the faithful are invited to imitate by offering their own tribute of devotion by heart, word, and deed (Acidini Luchinat 1993). But on the descriptive and narrative plane, Gozzoli's elaborate compositions depict the event related in the Gospel in terms of chivalrous splendor (certainly at the clients' request). Thus to the already rich and fabulous tradition of the representations of the "three Kings" in painting and drama, Benozzo adds unprecedented elements of refinement, comparable, in their technical effort and search for preciosity in every detail, to great miniatures. The triple procession of the kings, composed according to the rules of an exact protocol, parades across the walls, along with a scene of noblemen hunting with hawks, dogs, and cheetahs in the Turkish manner. The royal bands are followed and preceded by two groups of citizens on horseback and foot: on the right can be seen members of the Medici family, including Cosimo, Piero, the children Lorenzo and Giuliano, and perhaps Carlo and Giovanni, together with a self-portrait of Benozzo; on the left Benozzo again (perhaps even twice) and a group of supporters or agents of the Medici, such as Bernardo Giugni, Francesco Sassetti, Agnolo Tani, and perhaps Dietisalvi Neroni and Luca Pitti, who were to become enemies in 1466. In the apse the ranks of angels, with marvelously ornate clothes and wings, are depicted in the act of flying, singing, worshipping on their knees, and weaving festoons of flowers; the verses inscribed in their haloes tell us that the hymn they are intoning is the *Gloria*.

Having begun the work in the spring-summer of 1459, Benozzo completed the work rapidly over the space of a few months, with the help of at least one assistant (probably Giovanni di Mugello), under the supervision of Piero di Cosimo de' Medici or his friend and confidant Roberto Martelli. From their correspondence we learn that Piero did not like the little red heads of the seraphim at the top of the rectangular apse; but, perhaps through Martelli's intercession, the painter was allowed to retain them. The recent restoration (1988-92) has brought to light two blue cherubim in those upper levels of the sky, painted in the same precious ultramarine blue as the background, made of ground lapis-lazuli, which had been covered up by a seventeenth-century repainting. The extraordinary complexity and subtlety of the technique of execution, in which true fresco alternated with dry fresco, permitted the painter to work with meticulous care, almost as if he was engraving, like the goldsmith he had been in Ghiberti's workshop, not just the precious materials of jewelry, fabrics, and harnesses, but even the trees laden with fruit, the meadows spangled with flowers, the variegated plumage of the birds, and the multicolored wings of the angels. Finally, leaves of pure gold were applied generously to shine in the dark, in the dim light of the candles. The modifications made by the Riccardi (owners of the palace after the Medici), have distorted the original symmetry of the small room, but have taken nothing away from its magical splendor, now brought back to life by restoration. It is the greatest testimony to the art of Benozzo, here the unsurpassed interpreter of the aristocratic aspirations of the Medici, to which he gave figurative expression by blending, in accordance with a now tried and tested formula, the ornamental legacy of the recent Gothic past with the new grasp of perspective, all set in the transparency of the clear and revealing light imported from Flanders.

During his stay in Florence, which lasted until 1463,

32. View of the Chapel of the Magi
Florence, Palazzo Medici Riccardi

33, 34. The Vigil of the Shepherds
Florence, Palazzo Medici Riccardi

35. Angels worshipping, left wall of the rectangular apse
Florence, Palazzo Medici Riccardi

36. Angels worshipping, right wall of the rectangular apse
Florence, Palazzo Medici Riccardi

*37-39. Procession of
the Magus Gaspar on
the right wall of the
Chapel
Florence, Palazzo Medici
Riccardi*

40. Detail of the procession of the Magus Gaspar
Florence, Palazzo Medici Riccardi

41. Procession of the Magus Balthazar on the
entrance wall of the Chapel
Florence, Palazzo Medici Riccardi

42. Detail of the procession of the Magus Gaspar
Florence, Palazzo Medici Riccardi

43. Landscape behind the Magus Balthazar
Florence, Palazzo Medici Riccardi

44. Backfill wall of the procession of the Magus
Melchior
Florence, Palazzo Medici Riccardi

45, 46. Procession of the Magus Melchior on the west wall
Florence, Palazzo Medici Riccardi

Gozzoli received a number of other important commissions. His contract with the Compagnia della Purificazione at San Marco (a convent known to have been under the patronage of the Medici) for the execution of an altarpiece with predella, in an elaborate frame, that may have been started but left unfinished by Domenico di Michelino, dates from October 23, 1461. The important painting, which according to the terms of the contract had to be finished by 1462, was dismembered on the suppression of the confraternity and its various elements dispersed. The panel with the *Madonna and Child* among Saints John the Baptist, Zanobius, Jerome, Peter, Dominic, and Francis is now in the National Gallery in London; the scenes from the predella are in the Gemäldegalerie in Berlin (*Saint Zanobius raising a Child from the Dead*), the National Gallery in Washington (*The Dance of Salome*), the Pinacoteca di Brera in Milan (*Saint Dominic raising a Child from the Dead*), the Johnson Collection in Philadelphia (*Purification of the Madonna*), and Hampton Court, London (*Fall of Simon Magus*), while the right-hand pillar with three saints is, together with the left-hand one by Domenico di Michelino, in the Galleria dell'Accademia in Florence. Despite their

small format and the intervention of the less gifted assistant of the Chapel of the Magi, believed to be Giovanni di Mugello, the Benozzo panels have some memorably lively features, especially in the evocation of settings and of figures in movement, including the supple and uninhibited *Salome*. In the altarpiece in London, the brilliant colors and the high degree of embellishment with gold do not make up for the rigidity of the motionless figures or the affectedness of the small garden that blooms at the foot of the throne; two birds taken from the studio's customary repertory are perched on the step of the throne. The *Madonna and Child* among Cherubim and Seraphim in the Ford Collection in Detroit has greater force, owing to its intense and almost visionary plasticism. Dating from around 1460, the painting is particularly effective for its combination of sumptuous detail in the clothing, ornamented more in the manner of the goldsmith than of the painter (see the jeweled border of the Virgin's dress, painted on a slight relief of plaster), with the essential solidity of the brightly colored angels, sheltered by their numerous wings. The same design of the Madonna and Child was used for a far simpler, and badly damaged, painting in the Fogg Art Museum in

597

47, 48. *Details of the procession of the Magus Melchior*
Florence, Palazzo Medici Riccardi

49-51. *Saint Bartholomew, Saint John the Baptist, Saint James*
171x22.5 cm
Florence, Galleria dell'Accademia

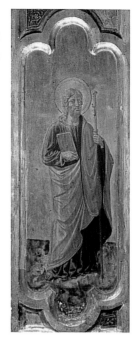

52. Purification of the Virgin Mary
26x36 cm
Philadelphia, Museum of Art

53. The Dance of Salome
23.8x34.3 cm
Washington, National Gallery of Art

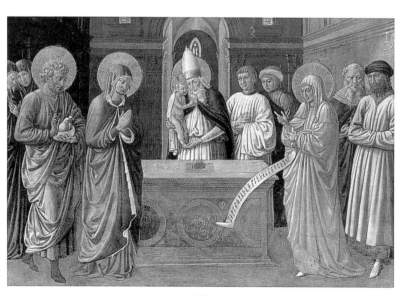

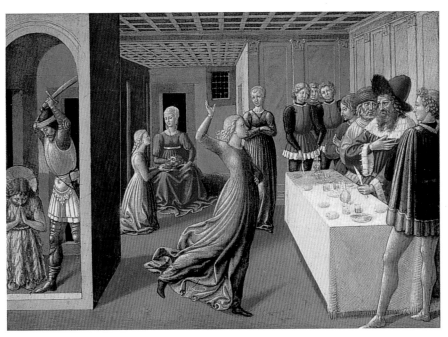

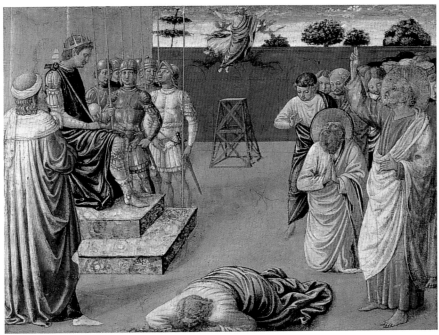

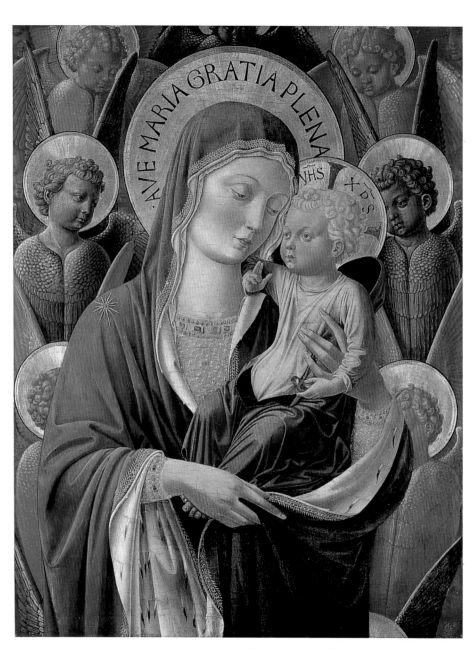

54. *Fall of Simon Magus*
24x35.5 cm
London, Hampton Court, Royal Collection

55. *Madonna and Child*
84.8x50.8 cm
Detroit, Institute of Arts

*56. Mystic Marriage of Saint Catherine; the Death of
Christ with Saint John the Evangelist and Mary
Magdalen; Saint Anthony Abbot and Saint Benedict
21x221 cm
Florence, Museo di San Marco*

Cambridge, Mass. Also from Benozzo's Florentine period date the finely painted panels of a predella from an unidentified altarpiece that were moved from Santa Croce to the Gallerie Fiorentine (and are now in the Museo di San Marco). In the same years he "updated" the altarpiece that the Alessandri had commissioned from Lippo di Benivieni for their chapel in San Pier Maggiore, adding a predella with five scenes, one of which has been lost. The remaining four are now in the Metropolitan Museum in New York: the *Fall of Simon Magus*, the *Conversion of Saint Paul on the Road to Damascus*, *Saint Zanobius raising a Child from the Dead*, and *Totila before Saint Benedict*. Small works in which the movements of the masses and the landscapes in the background are carefully studied, they not only show similarities with the scenes of the *Purification* but also reproduce some of the compositional motifs of the Chapel of the Magi, especially in the very pleasant landscape of the *Conversion*. Also assigned to his stay in Florence are a small picture of the *Crucifixion* among saints, of unknown location (formerly in the Drury-Lowe Collection at Locko Park), and, somewhat doubtfully, a delicate *Madonna dell'Umiltà* in a private collection in Munich.

In 1464 Benozzo, who had just married Lena di Luca di Jacopo Cieco, left Florence to fresco the choir of Sant'Agostino in San Gimignano. This was the first stage in a second and final series of journeys that took him to various places in Tuscany, without returning to the capital. He was accompanied by old and new collaborators: the faithful Giovanni d'Antonio della Cecca, Giusto d'Andrea who had joined the group without pay in order to improve his painting under Benozzo, and perhaps, according to Padoa Rizzo (1972, pp. 65-8), Lippi's pupil Pier Francesco Fiorentino. Thanks to the studies of Cole Ahl, the importance of the client has been recognized. He was the Augustinian Domenico Strambi, formerly a doctor at the Sorbonne and presumably the author of the iconographic program of the *Scenes from the Life of Saint Augustine* along with the relative inscriptions. Benozzo's stay in San Gimignano, which came to an end in 1467, was marked by demanding works, in locations of religious and civic prestige.

The Augustinian cycle consists of three rows of scenes set one above the other under the cross vault of the choir, decorated with the four Evangelists: the eighteen scenes (four of them in the lunettes) cover the whole of St Augustine's life, from childhood to death. A frame of painted pilasters with putti in mock relief amidst foliage unifies the sequence of rectangular panels in a captivating classical style. In the central scene depicting *Saint Augustine leaving Rome*, under the single-light window, the commemorative inscription of the cycle is given suitable emphasis, held up by two flying angels in the pose of ancient winged Victories: "ELOQVII SACRI DOCTOR PARISINVS ET INGENS / GEMIGNANIACI FAMA DECVSQVE SOLI / HOC PROPRIO SVMPTV DOMINICVS ILLE SACELLVM / INSIGNEM IVSSIT PINGERE BENOTIVM", followed by the date MCCCCLXV, 1465, linking in celebration the "Parisian doctor" and the "illustrious" painter. While for the scenes from St Francis's life in Montefalco Benozzo had been able to draw on a well-established iconographic tradition, a cornerstone of which, the Basilica in Assisi, was well known to him, he was unable to rely on significant precedents for the extensive cycle of the life of St Augustine. Here he found himself having to translate into images episodes that were undoubtedly related and glossed by the learned client, Fra Domenico Strambi. Benozzo responded to this challenge with a firm and resolute style of painting, based on a rational clarity that makes it particularly intelligible and in which the integration of the full and majestic figures with the urban or rural setting achieves a harmonious equilibrium. Whether divided in two or unified by an axial perspective, the solemn urban scenes contribute greatly to the stately character of the cycle, filled as they are with learned inventions and architectural citations. The baptismal font on fluted Corinthian pillars in the *Baptism of Saint Augustine*, the great monastery reminiscent of Brunelleschi's Spedale degli Innocenti in the *Funeral of Saint Augustine*, the "ideal" Milanese square of the *Scenes with Saint Ambrose*, with its paving decorated

with an intellectualistic two-color pattern, and other backdrops constitute views of great evocative power, true elements of mediation between the Brancacci Chapel and the cycles of Ghirlandaio, "establishing a dialogue with both Filippo Lippi's cycle in Prato and Piero della Francesca's in Arezzo" (Padoa Rizzo 1992, p. 15). Yet there are also playful touches of everyday life, such as the depiction of a school of grammar, whose severity is represented by the corporal punishment of a reluctant pupil. Standing out among the figures, which are mainly generic typifications, are numerous portraits. This was a practice that Benozzo had tried out extensively in the Medicean Chapel at the Magi and never subsequently abandoned. The face of the client Strambi may be portrayed in the monk on the right holding the clothes of the neophyte in the *Baptism* (Ronen 1988). But it is in the scenes of *Saint Augustine departing for Milan* and *Saint Augustine teaching in Rome*, which are among the most visible owing to their location on the bottom row, that we can guess at the presence of other prominent figures in the city's civil and religious life, including a political personality (the man in a red cloak welcoming Augustine in the *Disembarkation at Ostia*) whose face was damaged at a later date.

The painters too put in an appearance, both as full figures and as heads alone: there is Benozzo, finely dressed in pink cloth, and his group of assistants, including the young man already portrayed in the Chapel of the Magi, and whom I believe to be Giovanni di Mugello, and a young man with curly auburn hair whom Vasari erroneously took as a model for the engraving that accompanies his *Life* of Gozzoli. Beneath the skies of cold ultramarine the festive clarity of the colors (which is not even diminished by the black tunics of the Augustinians, owing to their reflections) is reminiscent of the precious and varied style of the Chapel of the Magi; but the orchestration of complex spatial divisions through a sounder grasp of perspective reveals an indisputable improvement in Benozzo's technique.

Along with the original commission, Benozzo received a number of unexpected requests, including two *Pestbilder*. The arrival of the plague in San Gimignano in the spring of 1464 revived devotion to St Sebastian, who was believed to offer protection against the dreaded scourge. So the Augustinian community, perhaps at the behest of Strambi itself, agreed with the Compagnia di San Sebastiano to have Benozzo execute a wall painting of *Saint Sebastian Intercessor* above the Pesciolini altar in Sant'Agostino. This appears to have been a commemoration of the end of the epidemic in July of that year. The painting, whose delicacy and skill of execution, with lapis-lazuli and white lead applied *a secco*, has been revealed by the restoration (Rossi 1991), has recently attracted the attention of critics for the innovative complexity of its iconography (Ronen 1988, Cole Ahl 1988). The saint, clothed instead of naked and pierced with arrows as in the more usual representations, stands on a pedestal surrounded by devotees of all kinds and

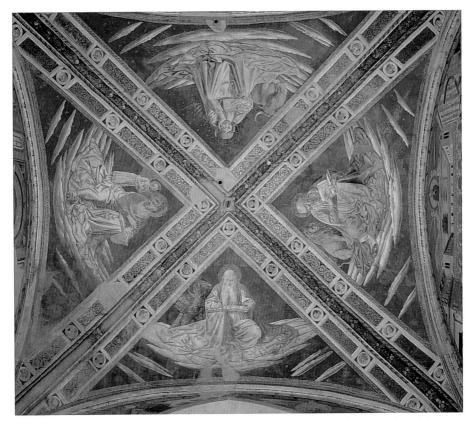

57. Vault representing the Evangelists
San Gimignano, Sant'Agostino

ages; in the upper level, with ancient gestures of inter-
cession, the Madonna shows her breasts and Christ his
wounds to the Eternal Father, enraged and bent on
hurling pestilential arrows with the assistance of hosts
of angels. Below two pairs of angels are trying to break
the arrows. The Augustinian behind the white-haired
man in profile on the left is probably a portrait of
Strambi.

As far back as January 4, 1463 (1462 Florentine
style) the city government had decided to have an im-
age of St Sebastian painted in the chapel dedicated to
him in the old parish church, the Collegiata. It now
took the opportunity of the presence of a "distin-
guished" painter from Florence to entrust him with the
task of painting this second *Pestbild* in February 1465
(1464 Florentine style), even though the epidemic
had been over for seven months. Benozzo signed the
mural in the collegiate church on January 18, 1466
(1465 Florentine style) as part of a long inscription

in capital letters dedicated to the saint: "AD LAUDEM
GLORIOSISSIMI ATHLET[A]E SANCTI SEBASTIA-
NI HOC OPVS CONSTRVCTVM FVIT DIE XVIII.
JANVARII. M.CCCC.LXV. BENOZIVS FLOREN-
TINVS PINXIT." This time the saint is naked and shot
with arrows, as in the usual iconography, and much of
the painting was executed by assistants (see the man-
nered *condottiere* in the foreground, almost certainly
by Giovanni di Mugello). Above, within a radiant
mandorla crowded with cherubim, seraphim, and
other multicolored angelic figures, the praying Virgin
Mary appears to be beseeching her Son to accept the
martyr's soul. The pleasant character of the landscape
in the background and the conscientious care taken
over detail in the figures are not sufficient to redeem
the predictable pictorial representation and static com-
position. A number of other works, on board or wall
and executed with a greater or lesser contribution from
the assistants, also date from the San Gimignano peri-
od. In the city's Museo Civico there is a picture with
an almost square predella depicting the *Madonna and
Child with Saints Andrew and Prosper*, which Benoz-
zo finished painting in August 1466 for the high altar

58-60. Saint Fina, Saint Gimignano, Tobias, and the Angel
San Gimignano, Sant'Agostino

61, 62. The School of Tagaste
San Gimignano, Sant'Agostino

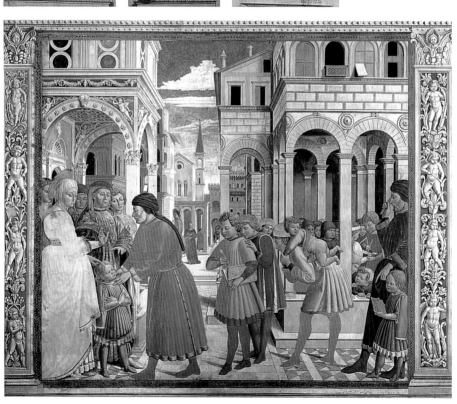

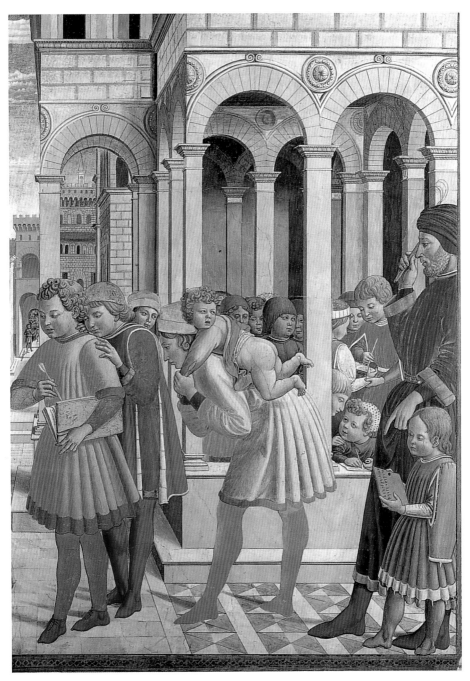

607

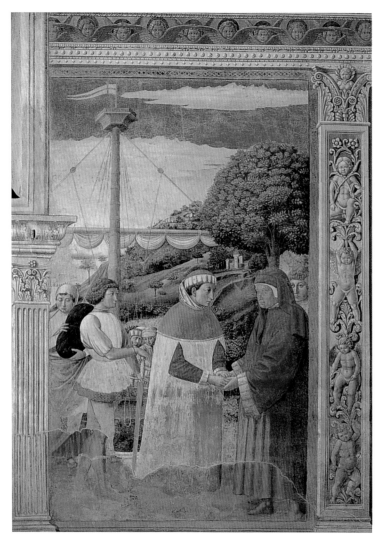

63. Saint Augustine disembarking at Ostia
San Gimignano, Sant'Agostino

64. Saint Augustine teaching in Rome
San Gimignano, Sant'Agostino

65. Saint Augustine leaving Rome
San Gimignano, Sant'Agostino

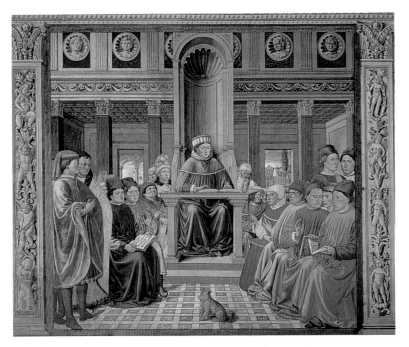

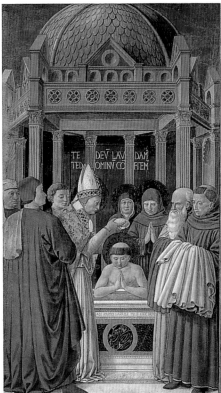

66. *Saint Augustine leaving Rome, detail*
San Gimignano, Sant'Agostino

67. *Arrival of Saint Augustine in Milan*
San Gimignano, Sant'Agostino

68. *Saint Augustine reading the Epistle of Saint Paul*
San Gimignano, Sant'Agostino

69. *Baptism of Saint Augustine*
San Gimignano, Sant'Agostino

70. *Visit to the Monks of Mount Pisano*
San Gimignano, Sant'Agostino

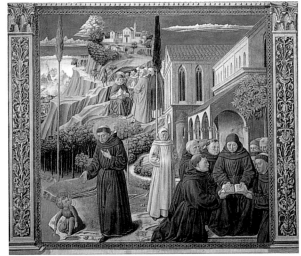

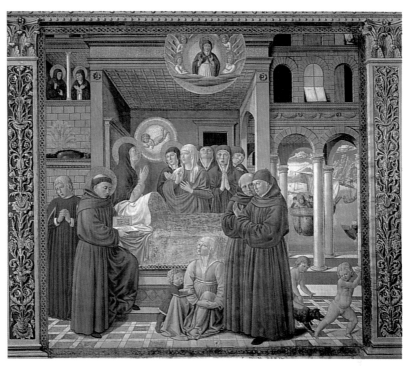

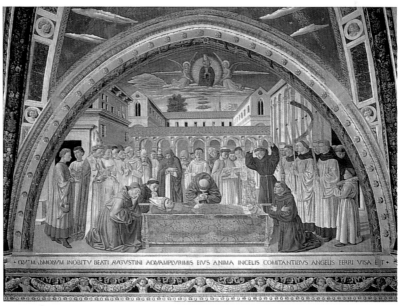

· QVEM AbMORVM INOBITV BEATI AVGVSTINI AQVAMPLVRIMIS EIVS ANIMA INCELIS COMITANTIBVS ANGELIS FERRI VISA E T ·

612

72. *Funeral of Saint Augustine*
San Gimignano, Sant'Agostino

74. *Saint Sebastian Intercessor*
527x248 cm
San Gimignano, Sant'Agostino

75. *Martyrdom of Saint*
Sebastian
525x378 cm
San Gimignano, Collegiate
church

76. *Madonna and Child between*
Saints Andrew and Prosper,
detail
137x138 cm
San Gimignano, Museo Civico

SANCTE SEBASTIANE INTERCEDE
PRO DEVOTO POPVLO TVO

615

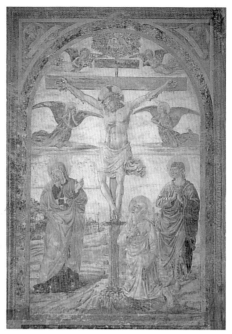

of the church of Sant'Andrea, on commission from the priest Girolamo di Niccolò. Rather than the main scene, accurate but lacking in vitality, it is the predella with *Christ in the Tomb among Mourners and Saints*, with its small figures set against a soothing and unifying landscape, that remains in the memory. The Museo Civico also contains a picture of the *Madonna Enthroned among Saints John the Baptist, Mary Magdalen, Augustine, and Martha* (1466), originally in the monastery of Santa Maria Maddalena. In it great attention was given, around the solid volumes of bodies shaped by the light, to ornaments of the most varied kind: silk hangings, festoons of alternating red and white roses, jewelry, and mottled marbles, not to mention the customary gilded haloes with elegant explanatory inscriptions. A predella in San Gimignano was also the source of the fragments now divided among the Petit Palais in Avignon, with Saints Fina and Mary Magdalen; the Thyssen Collection, with St Jerome and a monk with a burst of rays instead of a circular halo (the Blessed Bartolo Buompedoni according to Bartalini, 1990, but the features are the same as those of the presumed portrait of Strambi); and finally the Pinacoteca di Brera in Milan, with the *Dead Christ and Mourners*.

An appreciation of Benozzo's mural paintings in San Gimignano is hampered by their poor state of preservation. They are the *Crucifixion with Mourners and Saint Jerome* (1466) in the Benedictine convent of Monteoliveto Minore, which was mentioned by Vasari, and the *Crucifixion with Saint Jerome, Saint Francis, and the Donor*, originally in the Palazzo Pubblico but detached in the last century and transferred to the Museo Civico. Between 1466 and 1467 Benozzo was engaged on a work of little quantitative significance but great symbolic importance in that same City Hall. As a clear sign of the trust that was placed in the "distinguished" painter, whose reputation had been established by the recent Medicean chapel, he was asked to restore" the *Maestà* of Lippo Memmi. This he did by redintegrating the figures at the edges and the damaged inscriptions, and retouching the whole composition.

While working on the most important buildings in San Gimignano, Benozzo did not fail to accept other commissions, for which he often supplied no more than the drawings, leaving most of the painting itself to his group of assistants. In 1466 he approved, appending his signature and date, a cuspidate panel depicting the *Mystic Marriage of Saint Catherine* with Saints Bartholomew, Francis, and Lucy for the church of Santa Maria dell'Oro near Terni, now in the Museo Civico of that city (Padoa Rizzo 1972, pp. 135-6). It has an old-fashioned type of composition and was executed with great care.

77. Crucifixion with Mourners and Saint Jerome
350x220 cm
San Gimignano, Convent of Monteoliveto Minore

78. Saint John the Evangelist (?)
21x22 cm
Bergamo, Accademia Carrara

79. *Mystic Marriage of Saint Catherine and Saints*
90x50 cm
Terni, Pinacoteca Civica

80. *Shrine of the Executed*
Certaldo

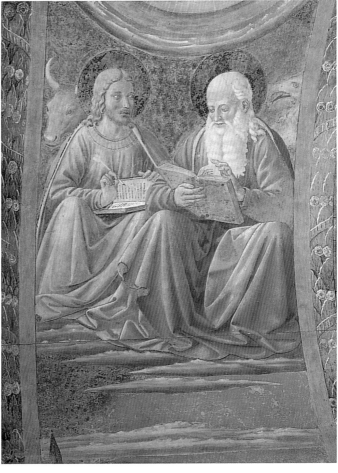

*81. Shrine of the
Executed
detail of the Evangelists
Luke and John
Certaldo*

In 1464-5, at exactly the same time as he was working on the frescoes in the choir of Sant'Agostino, he had painted the interior and exterior of the *Shrine of the Executed*, a small temple that originally stood on the banks of the river Agliena, along the route taken by those condemned to death. After detachment in 1957, the frescoes and *sinopie* are now located in the church near the Palazzo dei Vicari. The complex set of images, hinging, for the consolation of the condemned, on the sufferings of Christ and the protection of the saints, includes: the *Annunciation* on the front arch, the *Eternal and the Holy Spirit among the Evangelists* on the small barrel vault, *Saints Longinus, John the Baptist, James, and Anthony Abbot* on the walls, the *Descent from the Cross* on the rear wall, and the *Crucifixion, Resurrection*, and *Martyrdom of Saint Sebastian* on the outside. Only the first two of these fres-

coes, in the arch and on the vault, have preserved the paint to any great extent, while on the remaining parts it has almost vanished due to the long exposure to atmospheric agents and humidity. The figures are set against a dense blue sky (in those parts where the color has not altered) with an extremely immobile monumentality, except for Longinus and Joseph of Arimathea who, supporting the body of Christ, maintain an elegant equilibrium on both scales. The colors, artfully distributed in accordance with a principle of *varietas* in the alternation of primaries and secondaries, have at times the clarity of Piero della Francesca in their highlights, but the dense red tone of the wings, hose, tablet, and drape have the feeling of the fabulous sumptuosity of the Magi cycle. Much of the execution of the shrine's decoration was entrusted to assistants, including Giusto d'Andrea.

Approaching the age of fifty and with a reputation that had spread throughout Tuscany and Umbria, Benozzo was called on to undertake one of the most grandiose labors that a painter in Central Italy could aspire to in those days: the completion of the frescoes in the Camposanto of Pisa, left unfinished the previous century. On January 1, 1469 (1468 Florentine style), the Operai della Primaziale, as the board of trustees was known, officially entrusted him with the task of painting the long north wall, and he had concluded the work before May 1, 1484, the date of the last payment. Thus over a period of fifteen years he brought to completion an enterprise, at the head of his studio, that "would have rightly scared a legion of painters." There is reason to believe that the bishop of Pisa, Filippo de' Medici, very active in the field of artistic patronage as was the family's custom, may have played a part in the selection of Benozzo; and, though it may be no more than mere coincidence, it is worth mentioning the fact that the day the contract was drawn up was also Lorenzo de' Medici's twentieth birthday. In 1944 a bombing raid, followed by a disastrous fire, destroyed or damaged the greater part of the frescoes. In spite of the restoration carried out after the war, they have remained disfigured and, as they are kept in storage, not on view. Nor can the sight of the sinopie in Pisa's Museo delle Sinopie, made possible by their detachment, do justice to what was the masterpiece, or at least the most demanding work, of Benozzo's whole career. At the time when the Florentine artists of a later generation — Botticelli, Cosimo Rosselli, Ghirlandaio — began to try their hand at the monumental dimension of the walls of the Chapel of Sixtus IV in Rome, in 1482, Benozzo was completing a pictorial undertaking of equal compositional complexity, and one which some of them, especially Rosselli and Ghirlandaio, kept in mind for their works in Rome.

In the Camposanto Gozzoli, with the assistance of the brothers Bernardo and Giovanni and of Fra Angelico's nephew, depicted the Annunciation and the Adoration of the Magi, Apostles, and Saints, but most of his efforts went into the series of twenty-three scenes from the Old Testament: The Vintage and Drunkenness of Noah, The Cursing of Ham, The Tower of Babel, Abram and the Worshippers of Belo, Departure of Abram and Lot, The Victory of Abram, Stories of Hagar, The Burning of Sodom, Stories of Isaac, The Wedding of Isaac and Rachel, Stories of Esau and Jacob, Dream and Wedding of Jacob, Meeting of Jacob and Esau with the Ravishing of Dinah, Joseph's Innocence, Joseph at the Court of the Pharaoh, Moses's Youth, The Crossing of the Red Sea, Moses and the Tables of the Law, The Story of Korah, Dathan, and Abiram, Aaron's Rod and the Serpent of Bronze, The Death of Aaron and Moses, The Fall of Jericho and David and Goliath, and The Meeting of Solomon and the Queen of Sheba.

By describing it as an opera terribilissima, Vasari honored Benozzo's work with the adjective that he chiefly, though not exclusively, used in his Lives for the in-

superable art of Michelangelo. And even though he was referring to the scale and importance of the undertaking rather than to the dazzling grandeur of the results (as with Buonarroti), the term is still an expression of the admiration that the not very indulgent biographer, and to an even greater extent Benozzo's contemporaries, had for his most demanding work. As far as can be judged from the black and white photographs of the frescoes taken before 1944 and recent pictures of the damaged remains, in his planning of the large scenes Gozzoli made use of all the experience and knowledge he had acquired, commencing with his formative apprenticeship with Ghiberti. Traces of Ghiberti's mechanisms of composition, so skillfully contrived that several episodes are able to coexist in the same panel with elegant naturalness, can still be recognized even after so many years. In the large scenes we find the tidy and pleasant landscapes that, painted for the first time on the scale of the fresco in Montefalco, had exquisitely decorated the walls of the Chapel of the Magi. At the same time there is the exact and richly detailed architecture that had framed the Scenes from the Life of Saint Augustine in San Gimignano, here however enhanced by the breadth of the perspective (worthy of Paolo Uccello in the Stories of Noah, with the vertiginous convergence of the pergola and the porticoed building) and magnified even further in the urban groupings (see the city in the Tower of Babel, filled with the transfigured monuments of Rome and Florence). Observing the rigor of the "ideal city" that can be detected in the architectural backdrops of the Pisan cycle, Padoa Rizzo has rightly pointed out that Gozzoli "in this way makes himself a protagonist of the debate over this subject, more Humanistic than any other, alongside the theorizations of Alberti or Filarete and the few practical realizations (Pienza, Urbino) and the visualizations provided by means of inlaid work or painted 'perspective scenes'" (1992, pp. 17-18). Equally remarkable is the organization of the figures in groups into genuine masses: in the latter portraits abound, in accordance with a now established custom in Florentine painting although one of which Benozzo had been a forerunner in the Chapel of the Magi many years earlier (Acidini Luchinat 1993). The extraordinary accuracy of the guiding drawings, as revealed by the sinopie, provides an even better testimony than the ruined paintings themselves to the scrupulous professionalism with which, as was his wont, Benozzo approached this work, following the precepts of traditional buon fresco and probably (though we have no technical proof of this) enriching his means of expression by the use of precious pigments applied a secco.

Although exacting and long, the work in the Camposanto did not prevent Benozzo from accepting other commissions over the period of these fifteen years, and others were to follow in the remaining time that he spent in Pisa, which was abruptly interrupted in 1494 when, with the expulsion of Piero di Lorenzo de' Medici, Pisa rediscovered its ancient enmity with Florence and drove out the Florentines who lived within

82. The Vintage and Drunkenness of Noah
Pisa, Camposanto

83. David and Goliath
Pisa, Camposanto

its walls. One large painting on board of his that, re-
moved during the Napoleonic period, is now in the
Louvre, had a particularly important location: to use
Vasari's expression, "behind the Archbishop's seat" in
Pisa Cathedral. The shaped and arched panel depicts
Christ in the act of approving the writings of St Tho-
mas of Aquinas (in fact the phrase BENE SCRIPSISTI
DE ME THOMMA can be read), while the saint is seat-
ed in the middle, between Plato and Aristotle, and has
at his feet a defeated Oriental sage, presumably a
schismatic, as a sign that the Thomist philosophy, heir
and continuation of ancient schools of thought,
represented a powerful bulwark of religious or-
thodoxy. In the row underneath, in a crowded scene
that the painter has arranged with skillful originality

84. *The Building of the Tower of Babel*
Pisa, Camposanto

85, 86. *"Sinopie" of the Annunciation*
Pisa, Museo delle sinopie

around an empty space, there are, to quote Vasari, "an infinite number of learned men, debating his works, and among them is portrayed Pope Sixtus IV with a number of Cardinals, and many heads and generals of various orders." Once again it is to Vasari that we owe the assessment of the carefully executed work as "the most finished and best that Benozzo ever did." The mention of Sixtus IV allows us to date the picture to the years following his election, in 1471.

In describing Benozzo's activity during the long period he spent in Pisa, it is necessary to bear in mind the increasingly important role played by his collaborators, who in the nineties were joined by his sons Francesco and Alesso. The latter can be identified with the painter of a group of pictures that are conventionally attributed to the "Scanty Master" ("Maestro Esiguo") or "Pupil of Benozzo". One of the paintings that were composed by the master on the basis of now proven schemes and completed by his assistants was undoubtedly the *Madonna and Child with Saints Rock, Lawrence, Anthony Abbot, and Bernardine of Siena* in the Museo dell'Opera of Pisa Cathedral. Originally in the church of San Lazzaro, it was painted in 1470 on a commission from Gian Piero da Porto Venere and Michela "della Spezie" (La Spezia), who are portrayed on a small scale, kneeling at the foot of the throne. Of only slightly better quality is the picture of the *Madonna and Child with Saints John the Baptist, Gregory, Dominic, John the Evangelist, Julian, and Francis*, which Vasari mentions as having been painted for the Compagnia dei Fiorentini, the confraternity of Florentines resident in Pisa (now in the National Gallery of Canada, in Ottawa): commissioned by the influential Lotto di Giovanni di Forese Salviati at a date that does not seem to be the 1473 in the inscription, which may have been altered by an erroneous rewriting in the past (Hurtubise 1981-2, Padoa Rizzo 1992), but 1477 or 1478, that is to say close to the time when Salviati was captain of Pisa (1476-7), the altarpiece has a layout that had been used on many occasions but that retains its effectiveness owing to the smooth circular arrangement of figures in space. There are elements of remarkable intensity in the gazes of the hieratic St Gregory and the elegant St Julian, directed toward the observer. Again for a private client, the Pisan citizen Pietro di Battista d'Arrigo di Minore, in 1481 Benozzo painted a *Pestbild* or votive picture celebrating the avoidance of the danger of plague. Having passed into a collection in Paris, this was acquired in 1971 by the Metropolitan Museum in New York. It portrays the "defenders" *Saints Nicholas of Tolentino, Rock, Sebastian, and Bernardine of Siena*, whose authoritative presence wards off the impending pestilential arrows wielded by angels, here in the guise of executors of divine wrath, from the territory of Pisa and the small kneeling figures of the clients.

The ecclesiastical buildings of Pisa contain, diminished by time and decay, other examples of Gozzoli's art, though none of them can compete with the level of quality achieved at the same time in the Camposanto. Evidence for his continuing ties with the Dominican

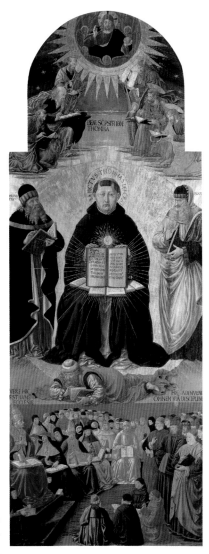

87. Triumph of Saint Thomas Aquinas
230x102 cm
Paris, Louvre

88. *Madonna and Child with Saints John the Baptist, Gregory, Dominic, John the Evangelist, Julian, and Francis*
153x155 cm
Ottawa, National Gallery of Art

89. *Saints Nicholas of Tolentino, Rock, Sebastian, and Bernardine of Siena*
78.7x61.9 cm
New York, Metropolitan Museum of Art

90. *Madonna and Child Enthroned among Saints Benedict, Scholastica, Ursula, and John Gualberto*
153x133 cm
Pisa, Museo Nazionale di San Matteo

order is provided by the mural paintings in the nuns' refectory of San Domenico, mentioned by Vasari. All that remains today is a *Crucifixion* with the Virgin Mary, John, Mary Magdalen, and Martha, along with kneeling saints of the Dominican order: Catherine of Siena, Dominic, Peter the Martyr, Thomas of Aquinas, and Vincent Ferrer, with four nuns. Full of gaps, damaged by flood waters from the river Arno, and altered by the nineteenth-century restoration, the great composition maintains its bipartite character, with the upper section enlivened by the convulsive flight of the angels gathering up the blood of Christ, and the lower one taken up by two rows of kneeling figures, whose distribution of masses is articulated by the alternation of the order's colors, white and black, in the tunics and cloaks.

There is very little left of another important decorative work by Benozzo in a Pisan nunnery, that of San Benedetto at Ripa d'Arno, where according to Vasari he painted the *Scenes from the Life* of the patron saint. A mural painted in fresco depicting the cross surrounded by angels and, at the sides, the Virgin Mary and St John was found in a niche of the convent's church, and restored prior to 1972. The painting, of great artistic quality and expressive force, was evidently accompanied by an image, probably a

statue, representing the dead Christ. From the same convent comes the picture in the Museo Nazionale di San Matteo depicting the *Madonna Enthroned* among Saints Benedict, Scholastica, Ursula, and John Gualberto, personages particularly suited to a community of Vallombrosian nuns. The reduction, not common in Benozzo's work, of the range of colors to a few highly contrasting tints — bright red, the pale blue of the sky, gold, and the dark shades of the cloaks and habits — appears to lend the painting an indefinable fascination, almost an air of melancholy. However it will be necessary to wait for its restoration, which may bring to light colors closer to those of the original, before making a final judgment. The figures of Saint Ursula and the angels appear to be the work of another painter, and the name of Benozzo's son Francesco has been put forward (Padoa Rizzo 1992, p. 126). I would associate this painting with the *Saint Ursula* in Washington, though more for stylistic affinities than for similarities of iconography.

From the monastery of Santa Marta, finally, came the picture now in the Museo di San Matteo, with its charming painted frame in the shape of a shrine, depicting *Sant'Anna Metterza* and female donors. Restoration has confirmed that it is largely Benozzo's own work, along with the date of around 1468-70

91. *The Virgin Mary, Saint John the Evangelist, and Two Angels at the Sides of the Cross*
Pisa, San Benedetto a Ripa d'Arno

92. *Madonna and Child*
75x45 cm
Calci, Parish church

(M.G. Burresi 1992). Further evidence of Benozzo's activity in the territory of Pisa is provided by the arched panel depicting the *Madonna and Child* in the parish church of Calci, originally in the nearby convent of the Dominicans on the Poggio: a picture as archaic and hieratic as a Byzantine icon (perhaps painted, if the hypothesis is not too rash, to replace an old and venerated image that had deteriorated), it glows with color against a damasked ground and with bejeweled finishing touches, setting off the well-shaped volumes of the sacred figures, rapt and remote despite the gentleness of the gestures of blessing.

But to find examples of mural paintings of a monumental dimension (the genre in which Gozzoli was best able to express his compositional and narrative skill) from the Pisan period, other than the Camposanto, it is necessary to move outside the city, following the routes through the territory which were always so congenial and familiar to Benozzo. Here we can find frescoes of shrines as large as small temples and, not without a sense of surprise, recognize in them the grandeur of composition of genuine cycles of sacred themes.

At Legoli near Peccioli (Pisa), where the Gozzoli family took refuge from the plague in 1478-9, Benozzo painted various scenes, which have unfortunately

come down to us in a fragmented and patchy state: the *Madonna and Child with Four Saints, The Evangelists, The Doctors of the Church, Christ giving his Blessing*, the *Annunciation*, the *Journey to Calvary*, the *Crucifixion and Saints, Saint Michael Archangel*, the *Disbelief of Saint Thomas*, and the *Martyrdom of Saint Sebastian*. Vigorous and almost crude, Benozzo here takes the customary language to a higher degree of pathos, translating into the effective and direct formulas of a rather summary and rustic style such courtly prototypes as Verrocchio's bronze group of the *Disbelief of Saint Thomas* in Orsanmichele, which appears to have influenced the picture of the same subject in Gozzoli's shrine. The works in Volterra, to which Vasari makes a vague reference, may date from around the same time. All that has survived is the fresco decoration of a niche in the oratory of the Virgin in the Cathedral, with a *Journey of the Magi* that served as a backdrop to an *Adoration of the Magi* modeled in polychrome terracotta in the Della Robbia style. The fresco contains some distant echoes of the same subject so sumptuously treated in the Medici chapel, but a more sober and everyday tone prevails; with greater fidelity to an established iconographic tradition, the three Wise Men ride alongside one another, instead of being formally separated and escorted.

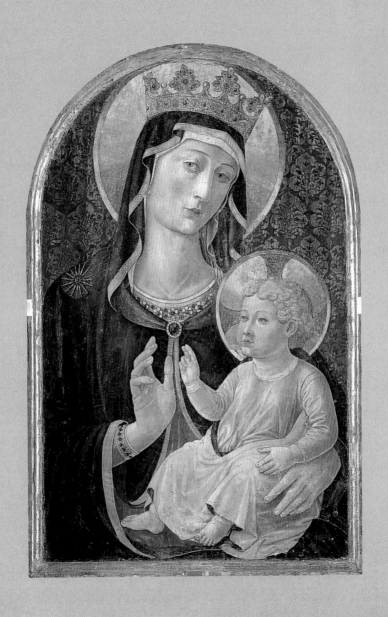

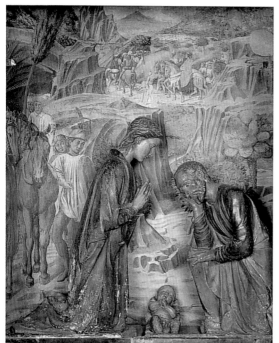

93. Shrine of Legoli
Crucifixion
Peccioli (Pisa)

94. Shrine of Legoli
Disbelief of Saint Thomas
Peccioli (Pisa)

95. *Cavalcade of the Magi*
Volterra, Cathedral

96. Shrine of the Madonna della Tosse
Castelfiorentino, Biblioteca Comunale

Two more monumental shrines, of proportions similar to those of true chapels, were frescoed by the Gozzoli family at Castelfiorentino, on the initiative of a single client, Ser Grazia di Francesco, prior of Santa Maria at Castelnuovo Val d'Elsa. The records cast some doubt on the honesty of this prelate, but he was certainly active in the restoration and commissioning of works of art. In 1484, toward the end of the work in the Camposanto, Benozzo frescoed the shrine of the *Madonna della Tosse* at Castelnuovo for Ser Grazia, where there remains a memorial tablet with the inscription "HOC TABERNCVLVM FECIT FIERI D[OMI]N[V]S GRATIA PRIOR CASTRI NOVI AD HONOREM S[AN]C[T]E MARIE VIRGINIS DIE XXIIII DECEMBRIS MCCCCLXXXIIII", together with a number of fragmentary writings on the paintings. The shrine was transformed into a small chapel in 1853 by the construction of a Neo-Gothic facade, but this was not sufficient to arrest the deterioration of the murals. Detached and restored in 1970, they have been remounted in the Biblioteca Comunale. The decoration hinges around a mock altarpiece with predella (it is actually a fresco) depicting the *Madonna nursing the Child* with Saints Peter, Catherine, Margaret, and Paul, framed by a red drape held up, as always in

Benozzo's paintings, by small angelic figures. On the one hand this illusionistic device is simpler than the subtle and elaborate *trompe l'oeil* of his youthful work in Montefalco, but on the other it is rendered more effective by the additional optical illusion of a cuspidate picture with the *Face of Christ* painted as if it had been left leaning, in a casual act of devotion, against the lower edge of the altarpiece. With details like this Benozzo showed that he was not stuck in repetitive schemes, but capable of keeping abreast of the latest developments in artistic research, which in the eighties had in fact turned its attention to the artifices of illusionism in painting. On the cross vault are depicted the four *Evangelists* and *Christ giving his Blessing*, on the keystone. The *Dormitio Virginis* is on the left wall and the *Assumption*, with the delivery of the Virgin's girdle to St Thomas, on the right wall. The mature prelate kneeling near the Virgin Mary in the *Dormitio* is usually identified as Ser Grazia, while the identities of the two young men on their knees on the right and the small devotee on the left in the *Assumption* are not known. The fading or even complete disappearance of the more fragile zones of color, such as the foliage of the trees and various items of clothing, has greatly impoverished the scenes, in which Benozzo has

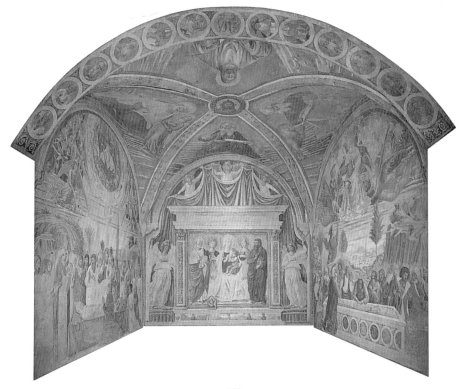

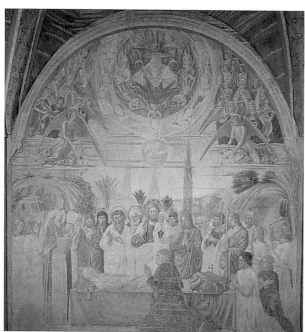

97. Shrine of the Madonna
della Tosse
Dormitio Virginis
Castelfiorentino, Biblioteca
Comunale

98, 99. Shrine of the Madonna
della Tosse
Assumption of the Virgin
Castelfiorentino, Biblioteca
Comunale

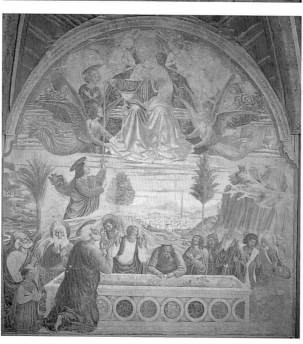

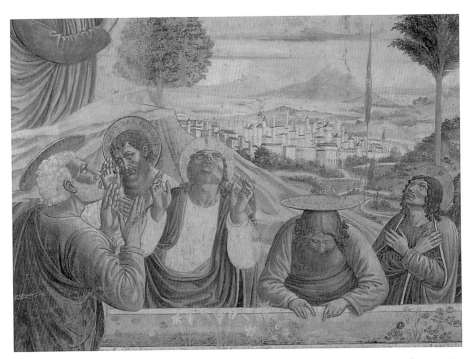

sought variety within symmetry, emphasizing the correspondences between the two wall scenes: note the Eternal in the *Dormitio* and the Virgin Mary in the *Assumption* supported by angels, the catafalque and the sarcophagus, and the group of Apostles in both scenes. The decoration of the sarcophagus with discs of rare marble does not correspond to a now widespread fashion, but evokes the ornamentation of the base of the Chapel of the Magi, in which Benozzo had experimented with a pioneering revival of ancient marble encrustations. Among the assistants who were given the job of translating the master's ideas into painting was probably his son Francesco.

The second shrine painted at the expense of Ser Grazia, known as the "shrine of the Visitation," was located on Via Volterrana in Castelfiorentino, on a piece of land belonging to the Minorite nunnery of Santa Maria. Painted on the outside as well as the inside, it was exposed to the elements until 1872 when the Ministry of Public Education had it enclosed in a small chapel, but without repairing the damage caused by the flooding of the Elsa. As with the previous one, it proved necessary to detach the paintings, which can now be seen in the Biblioteca Comunale of Castelfiorentino. A lost inscription, known to us through an inexact transcription made in the seventeenth century, mentioned Benozzo and his sons Francesco and Alesso as the authors and gave the date as February 12, 1491 (1490 Florentine style). The pictorial ornamen-

tation of the shrine has the consistency of an imposing mural cycle, divided into rows. On the altar wall, perhaps with an effect similar to that of the shrine of the *Madonna della Tosse*, there was an altarpiece depicting the *Madonna and Saints*. All that remains is the upper part of the *sinopia* found during the detachment of the frescoes: it is known from an old description that the saints were Paul, Lawrence, Stephen, Peter, Francis, and Clare (Proto Pisani 1987, p. 36). The arched vault, which has the *Annunciation* on the outside, bears the images of *Christ giving his Blessing* and, underneath, the Evangelists and the four Doctors of the Church, Gregory, Jerome, Ambrose, and Augustine. They are followed, on the outside and inside, by scenes from the life of the Virgin: *Joachim Expelled from the Temple*, the *Annunciation to Joachim*, the *Meeting at the Golden Gate*, and the *Nativity of Mary*. Only the upper part remains of the *Presentation in the Temple*, the *Wedding of the Virgin*, the *Visitation* from which the shrine takes its name, the *Nativity of Jesus*, and the *Adoration of the Magi*. Two drawings (London, British Museum no. 1895-9-15-445, and Munich, Staatliche Graphische Sammlung no. 34520) can be linked with these scenes. Probably by Alesso, they are not so much preparatory drawings as ones made *d'après*. The *sinopie* on the other hand, brought to light during the detachment of the decoration in 1965, are Benozzo's own work and true masterpieces of design. Although much of the execution was en-

trusted to his sons and assistants, the inventions and design of the shrine of the *Visitazione* clearly bear the stamp of Benozzo. Although unable to avoid the occasional clumsiness (see the *Annunciation to Joachim*, with its disproportionately small shepherds, at least one of which was slavishly copied from the Chapel of the Magi), he still maintains control over his typical, unmistakable alternation between Arcadian scenery and urban settings, between courtly atmosphere and everyday events. It looks as if the elderly Benozzo was trying to get his group to compete, at a distance, with the much more experienced one that was assisting Ghirlandaio in his work on the decoration of Santa Maria Novella.

Forced to leave Pisa, along with other Florentine residents of the city, following the invasion by Charles VIII and the expulsion of the Medici, Benozzo returned to Florence. There however, aging and lacking the support of his former Medicean patrons, he would have found it difficult to compete with more established fresco painters. We find him there, in January 1497, in the company of three other famous painters, Filippino Lippi, Cosimo Rosselli, and Perugino, appraising the murals of Baldovinetti in the choir of Santa Trinità. But sometime during the next few months he must have moved to Pistoia, where his sons Francesco, a "painter of boxes", and Giovan Battista, a judge, were already working (Padoa Rizzo 1989, p. 17). He had probably been summoned there by the city government to fresco a large *Maestà* in the City Hall. In fact Benozzo died in Pistoia on October 4, 1497, probably of the plague, and was buried in the cloister of the convent of San Domenico.

The works, not numerous but remarkable, of this last period that came to an end in Pistoia reveal in Benozzo what is, after all, a fairly unpredictable capacity to change the course of his style, under the powerful impetus of a profound and sincere spiritual upheaval. Whether or not he had heard Savonarola in Pisa, when the latter had preached in Santa Caterina in the spring of 1492, Benozzo, who had spent the years of his artistic apprenticeship with the reformed Dominicans of San Marco, was turned by the sense of ardent and tragic piety that Savonarola inspired toward a more severe interpretation of sacred painting, in which the aspect of outer magnificence gave way to impassioned dramatic expression. And we cannot fail to wonder at the fact that a painter of over seventy, and one moreover who was prone to the repetition of pleasing and successful formulas, was able to take a completely new direction, sacrificing, as if on a personal "bonfire of vanities," his most deep-rooted professional habits in order to take the arduous route of a new and penitential austerity.

The day before the master's death, the bishop of Pistoia, Lorenzo Pandolfini, received from the former's sons two paintings in oil on canvas that were a full expression of his new spirituality: the *Descent from the Cross* and the *Raising of Lazarus*. The first picture, of large dimensions (180 x 300 cm), remained in the possession of the Pistoian clergy until the beginning of

this century, when it was acquired on the antique market by the collector and art historian Herbert Horne, and is now in the museum of the same name. The subject, which Benozzo had never previously tackled with such solemn monumentality, retains distant hints of Fra Angelico in the composition, but as a whole is treated with that skillful mastery of the distribution of groups in three-dimensional space that the artist had demonstrated in the Camposanto in Pisa. The forceful asymmetry in the background, where the "void" of the landscape is juxtaposed with the "solid" of the stony tomb on the right, accentuates the sense of painful imbalance that predominates at the center of the painting, in the inert body of Christ lowered by four men, far more forlorn and pathetic than the rigid corpse of the same scene in the *Shrine of the Executed* in Certaldo. It is difficult to make any judgments about the quality of the painting, as the technique was such an unusual one for Benozzo and the picture has suffered extensive damage, which the recent restoration (1991) has been able to remedy only in part. However great delicacy of execution can be seen in the modeling of the bodies and drapery, with their clear and gleaming highlights. In my view the large Horne canvas is most closely related not to the works in Pisa (Padoa Rizzo 1992, p. 122), but to the predella of a painting that has not yet been identified in the Dower House Collection, Melbourne (G.B.), depicting the *Lament over the Dead Christ*. In spite of its small size, this is characterized by a greater complexity and dynamism of composition than any of Gozzoli's other predellas and contains a group of figures very similar, though drawn out to fit the horizontal format, to the one in the Horne *Deposition*, at top right.

The second canvas acquired by the bishop of Pistoia, the *Raising of Lazarus* in the National Gallery in Washington, is smaller but no less solemn. While the open landscape, with large towns and villages, diverges from Gozzoli's conventions and takes on an unprecedented vitality, especially in the high mountain in the background, the figures depicted with a few essential strokes, clumped in astonished groups, observe one of Christ's most disturbing miracles in dumbfounded silence. Although the dull and burned tones of the painting can probably be imputed to the alteration of pigments and binders and to the overall deterioration of the surface, and should not be considered a conscious decision on the painter's part, it is undeniable that this "poor" palette adds an air of mortification and severity to this rare Gospel theme, of distinctly Savonarolan stamp. Another of Gozzoli's last works that is known to us is a small *Saint Jerome in the Desert* on board in the Corsi Collection (Florence, Museo Bardini). It too is penitential in its atmosphere, only edgily enlivened by threadlike highlights.

At the time of his death Benozzo was working on two paintings in Pistoia, very different in their dimen-

100. Shrine of the Visitation
Castelfiorentino, Biblioteca Comunale

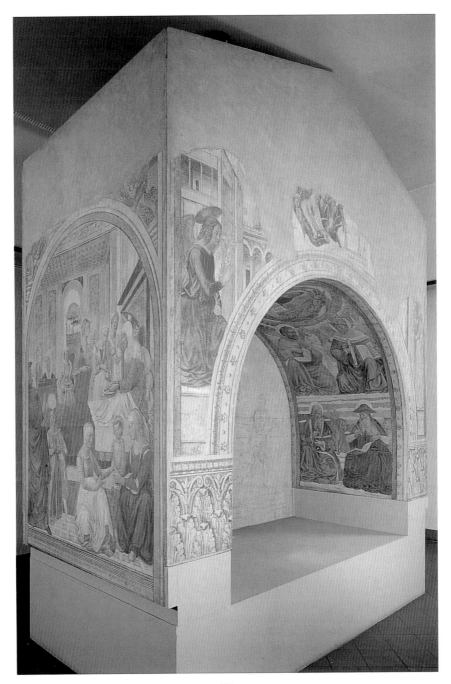

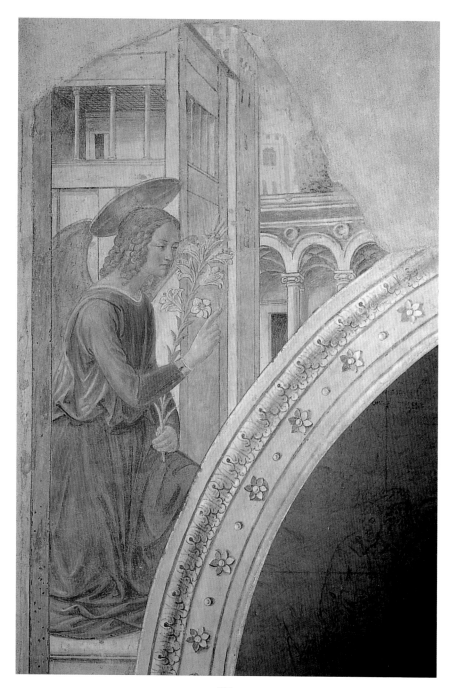

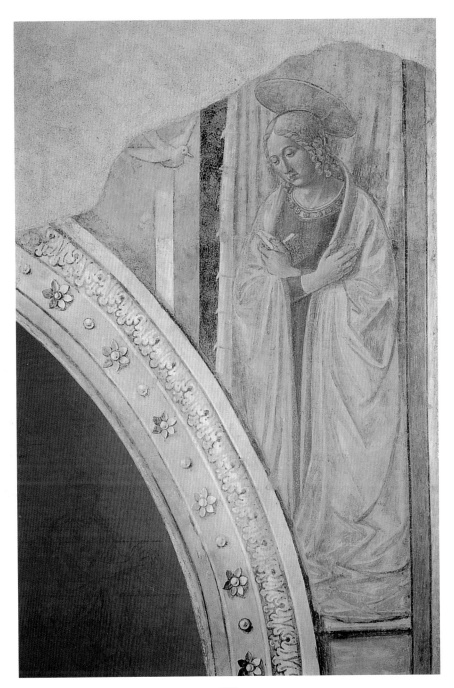

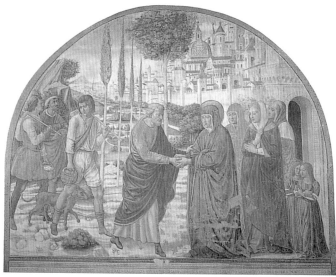

101, 102. Shrine of the
Visitation
Annunciation
Castelfiorentino,
Biblioteca Comunale

103. Shrine of the
Visitation
Meeting at the Golden
Gate
Castelfiorentino,
Biblioteca Comunale

104. "Sinopia" of the
Meeting at the Golden
Gate
Castelfiorentino,
Biblioteca Comunale

sions and the degree of effort involved, in yet another demonstration if more were required of how this truly complete painter, with a "fully rounded" professional figure, was considered capable of taking on any commission and carrying it out to the client's satisfaction. They are a large fresco and a miniature, both attributed to Gozzoli by Padoa Rizzo (1986 and 1989). The fresco, which has already been mentioned, remained in the state of a *sinopia* or drawing on the wall. It was to have represented, on a wall of the "Sala Ghibellina" in the Pistoia City Hall, the *Madonna Enthroned in*

Majesty, surrounded by angels and saints: the latter were either patrons of the city or intercessors against plagues: Agatha and Eulalia, James, perhaps Rock, Zeno, and Atto (or Martin). The idea of summoning Benozzo to paint the *Maestà* may have come from the Florentine Giuliano di Francesco Salviati, captain in Pisa at the time and a relative of the Lotto for whom Benozzo had already worked in Pisa. For the composition, Benozzo combined the usual scheme of the *Sacra conversazione* against the backdrop of a drape supported by angels with the extended and solemn

105. Shrine of the Visitation
Annunciation to Joachim
Castelfiorentino, Biblioteca Comunale

106. Shrine of the Visitation
Joachim Expelled from the Temple
Castelfiorentino, Biblioteca Comunale

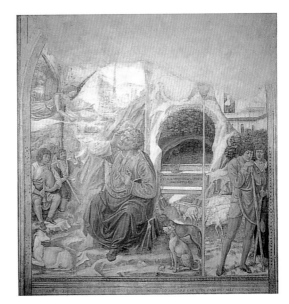

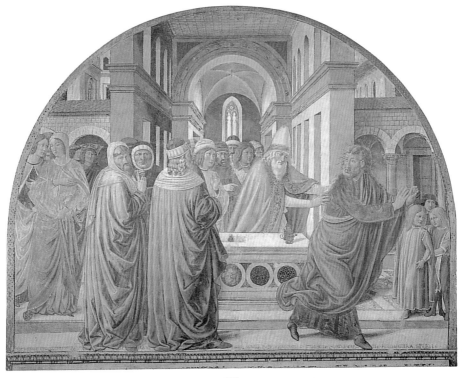

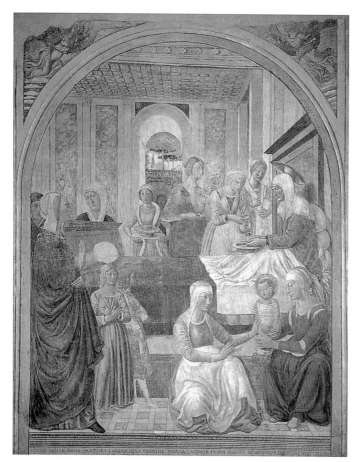

layout of the Gothic *Maestà*, a fine example of which he had encountered during his restoration of Lippo Memmi's painting in San Gimignano. The completeness of the *sinopia* as far as details, attributes, and the marking of light and shade are concerned suggests that Benozzo had no intention of subjecting himself to the fatigue of applying the paint in fresco, but would have left it to his sons and young assistants, having provided them with a detailed design. On the other hand he may himself have painted the decorative scene at the beginning of an anthem book in the Franciscan convent of Giaccherino (MS VI, FF, on c.67) representing the *Dream of Innocent III*, for which a shaded drawing survives. On a very small scale the scene reproduces the layout of the corresponding fresco in Montefalco, but accentuates its sense of drama: in fact the church does not so much loom over St Francis as threaten him, falling on top of him as the

tympanum at the summit and the bell tower collapse.

Even in these last unfinished and moving pictures, Benozzo's art retains its distinctive features: his familiarity with and admiration for the great Tuscan tradition of Gothic painting, whose legacy he inherited and used to advantage; his incorporation of the classical ideas of Humanism, in the measured and delicate manner imbibed from Ghiberti; his seriousness and almost uninterrupted dedication to sacred art, channeled by a Christian *pietas* assimilated from Fra Angelico and practiced with personal conviction. From this perspective, the highest and most successful examples of Benozzo's painting where the richness of composition goes hand in hand with a meticulous use of the brush, paying minute attention to the most exquisite detail, can be considered an unbroken celebration of God's work, as reflected in the beauty of nature and of human works.

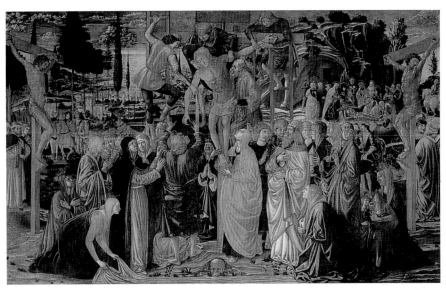

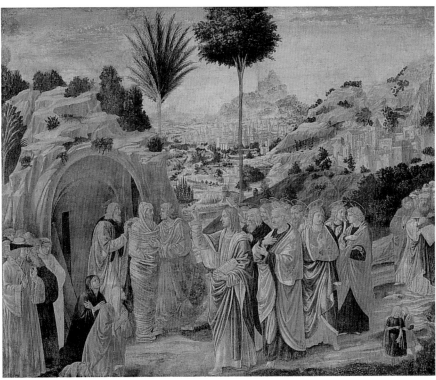